Abbas

South African Miners

Presumably it is evening and the day's work is done, for the sun seems to be low in the sky and the miners are relaxed enough to be sitting around chatting. The pair talking on the left look as though they have just washed and changed, while the trio on the right have stopped in the middle of their preparations to read a letter. Others appear to be content, as

though nothing much more than congenial talk is at issue. The composition, with its even spread of interest in a range of items set around an unobtrusive stove, reflects on the course of events in one of Abbas's more idyllic photographs. The utopian sense which informs this picture has enabled Abbas to recognize and to represent with regret the world's offences and

injustices. Abbas's reputation as a photojournalist is founded on his hard-hitting reports from the 1970s danger zones of Biafra and South Vietnam. Since the late 1980s, Islam and Christianity have been his principal subjects.

☛ **S. L. Adams, Chambi, Notman, Tsuchida**

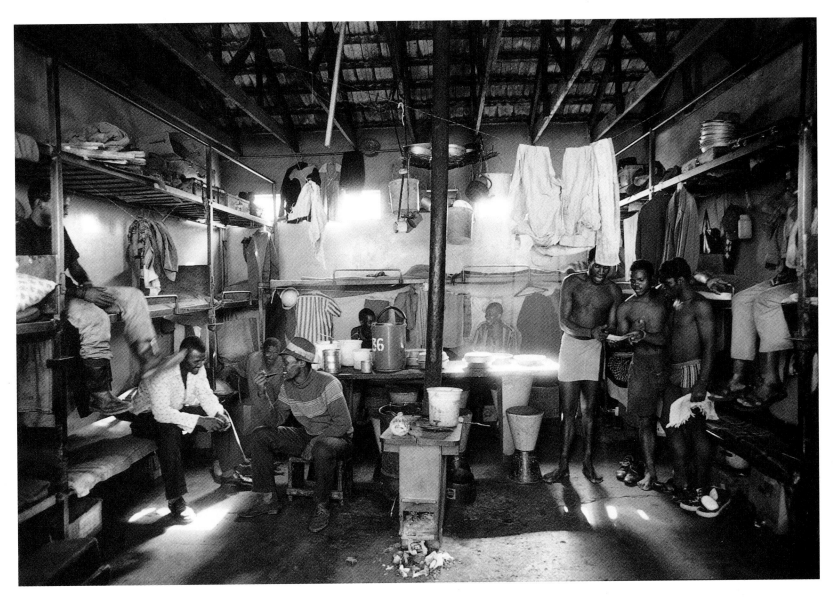

5

Abbas. b (IR), 1944. **South African Miners**. 1978. Gelatin silver print.

Abbe James

Bessie Love

Wearing, it seems, nothing more than a pair of high-heeled shoes, an American movie star called Bessie Love sits warming herself at an iron stove in the photographer's Parisian studio. The moment captured is a break in a modelling session for clothes designed by Jean Patou. It is easy to imagine how the actress might have felt, for her hands are stretched towards the heat of the stove and Abbe has managed his lighting in imitation of firelight. Although an exceptional picture – and one for which Abbe is known – this photograph has a similar feel to other fashion photographs. Fashion itself, with its bias towards insubstantial and clinging fabrics in the 1920s, was premised on ideas of empathy and intimacy, which in turn inspired those who depicted it. Abbe began to take pictures of the stars of stage and screen in 1917 when he moved from his home in Newport News to New York. In the late 1920s he turned his attention to news photography.

☞ Araki, Charbonnier, Durieu, Goldin, Koppitz, Morley, Newton

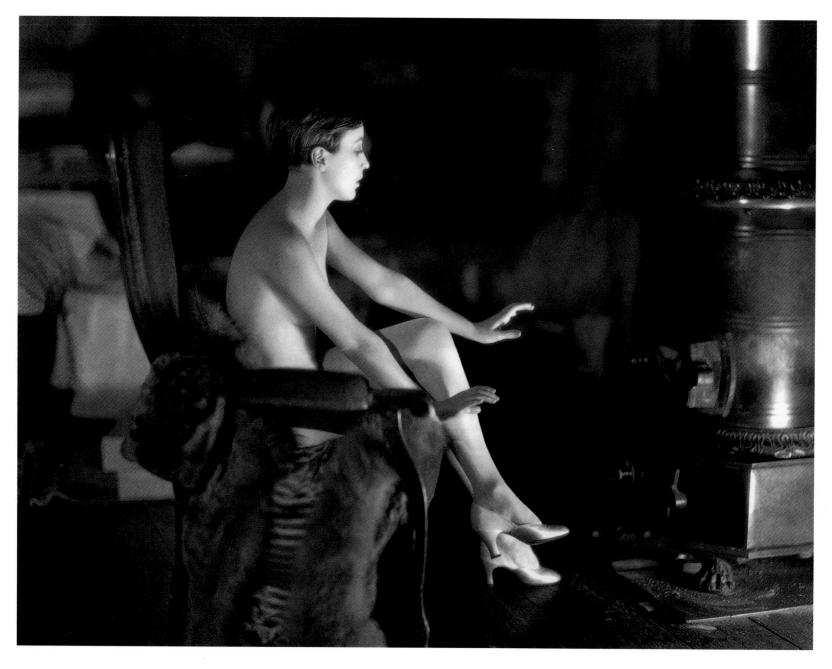

James Abbe. **b** Alfred, ME (USA), 1883. **d** San Francisco, CA (USA), 1975. **Bessie Love**. 1928. Gelatin silver print.

KUBOTA. KÜHN. LACHAPELLE. LANGE. LANTING. LARRAIN. LARTIGUE. LAUGHLIN. LEE. LE GRAY. LEIBOVITZ. LELE. LENDVAI-DIRCKSEN. LENGYEL. LE QUERREC. LERSKI. LE SECQ. LESSING. LEVINTHAL. LEVITT. LÉVY & SONS. LICHFIELD. LIEBLING. LINK. EL LISSITZKY. LIST. LONGO. LUSKAČOVÁ. LYON. MAAR. McBEAN. McCULLIN. McCURRY. McDEAN. MAGUBANE. MAHR. MAN. VAN MANEN. MANN. MANOS. MAN RAY. MAPPLETHORPE. MARK. MARLOW. D. MARTIN. P. MARTIN. MARUBI. MARVILLE. MASPONS. MATHER. MAYNE. MEATYARD. MEISEL. MEISELAS. DE MEYER. MEYEROWITZ. MICHALS. MIHAILOV. MILI. L. MILLER. W. MILLER. MINKKINEN. MISRACH. MODEL. MODOTTI. MOHOLY. MOHOLY-NAGY. MOLENHUIS. DE MONTIZON. MOON. C. MOORE. R. MOORE. MORATH. MORGAN. MORIMURA. MORIYAMA. MORTIMER. MUNKACSI. MURAY. MUYBRIDGE. MYDANS. NADAR. NAUMAN. NÈGRE. NEWMAN. NEWTON. NICHOLS. NILSSON. NIXON. NOTMAN. ODDNER. OHARA. OORTHUYS. O'SULLIVAN. OUTERBRIDGE. OWENS. ÖZKÖK. PANETH. PARKER. PARKINSON. PARKS. PARR. PATELLANI. PÉCSI. PENN. PERESS. PIERRE & GILLES. PINKHASSOV. PLOSSU. POST WOLCOTT. PRINCE. RAI. RAINER. RAY-JONES. REED. RÈGNAULT. REJLANDER. RENÉ-JACQUES. RENGER-PATZSCH. RHEIMS. RIBOUD. RICHARDS. RIEFENSTAHL. RIIS. RIO BRANCO. RISTELHUEBER. RITTS. ROBINSON. RODCHENKO. RODGER. RONIS. ROSENTHAL. ROSS. ROTHSTEIN. ROVERSI. RUFF. RUSCHA. SALGADO. SALOMON. SAMARAS. SAMMALLAHTI. SANDER. SAUDEK. SCHMIDT. SCHUH. SCIANNA. SEEBERGER. SEIDENSTÜCKER. SELLA. SEYMOUR. SHAHN. SHEELER. SHERE. SHERMAN. SHORE. SIEFF. SILK. SILVERSTONE. SILVY. SIMMONS. SIMS. SINGH. SINSABAUGH. SISKIND. SKOGLUND. E. SMITH. G. SMITH. W. E. SMITH. SNOWDON. SOMMER. SORGI. SOUGEZ. SOUTHWORTH & HAWES. STAUB. STEELE-PERKINS. STEICHEN. STEINERT. STERN. STERNFELD. STIEGLITZ. STOCK. STODDART. STRAND. STRÖMHOLM. STRUTH. SUDEK. SUGIMOTO. SUTCLIFFE. TELLER. TESTINO. THOMSON. TILLMANS. TINGAUD. TITOV. TMEJ. TOMASZEWSKI. TOMATSU. TOSANI. TOWELL. TRESS. TRIPE. TSUCHIDA. TURNER. UEDA. UELSMANN. ULMANN. UMBO. UNKNOWN. UT. VACHON. VEDER. VILARIÑO. VINK. VISHNIAC. WALKER. WALL. WARBURG. WARHOL. WATKINS. A. WEBB. B. WEBB. WEBER. WEEGEE. WEGMAN. WEINER. WELLINGTON. WELLS. WESTON. C.H. WHITE. M. WHITE. WILDING. WILLOUGHBY. WINOGRAND. WITKIEWICZ. WITKIN. WOJNAROWICZ. WOLS. WULZ. XIAO-MING. YAVNO. YEVONDE. ZACHMANN. ZECCHIN. VANDERZEE.

THE PHOTOGRAPHY BOOK

Phaidon Press Limited
Regent's Wharf
All Saints Street
London N1 9PA

First published 1997
© 1997 Phaidon Press Limited

ISBN 0 7148 3634 6

Printed in Hong Kong

Note

Dimensions have been included
only where vital for an
understanding of the work.

abbreviations:
c = circa **b** = born **d** = died
h = height **w** = width

ALB = Albania
ARG = Argentina
ARM = Armenia
ASL = Australia
AUS = Austria
BEL = Belgium
BR = Brazil
BUL = Bulgaria
BUR = Burma
CAM = Cambodia
CAN = Canada
CEY = Ceylon
CH = Chile
CHN = China
CU = Cuba
CZ = Czechoslovakia

DK = Denmark
EG = Egypt
FIN = Finland
FR = France
GER = Germany
GR = Greece
HAW = Hawaii
HUN = Hungary
IN = India
IR = Iran
IT = Italy
JAP = Japan
KEN = Kenya
LAT = Latvia
LIT = Lithuania
LUX = Luxembourg
MA = Mali
MAL = Malta
MEX = Mexico
MOR = Morocco
NL = Netherlands
NOR = Norway
NZ = New Zealand
PAK = Pakistan

PER = Peru
POL = Poland
POR = Portugal
PRU = Prussia
ROM = Romania
RUS = Russia
SA = South Africa
SP = Spain
SW = Switzerland
SWE = Sweden
TUR = Turkey
UK = United Kingdom
UKR = Ukraine
USA = United States of America
VIET = Vietnam
WIN = West Indies
YUG = Yugoslavia

THE PHOTOGRAPHY BOOK takes us on a journey through familiar and strange moments in time, immortalized by great, unknown and innovative photographers from around the world. Since its birth over 150 years ago, photography has undergone a number of twists and turns in its progress from a practical means of documentation to an art form with its own icons, heroes, galleries and collectors. Arranged in alphabetical order by photographer, **The Photography Book** brings together 500 inspiring, moving and beautiful images of famous events and people, sensational landscapes, historic moments, sport, wildlife and fashion. Each photograph is discussed in detail, bringing it to life and giving us an understanding of this art form which is so influential in our everyday lives. A simple system of cross-referencing enables easy access to photographers working with a similar approach or using different means to capture the same subject. Glossaries of technical terms are also included, together with an international directory of museums and galleries where photography is regularly on display.

Φ

Aarsman Hans

Renesse 1988

An enterprising farmer has taken the opportunity to store his bales of hay beneath the shelter of a raised road. To judge from the metal kerbs placed on either side of the concrete pier, a dual carriageway was originally intended but was only half-completed. Thus an apparently ordinary place, which at first sight appears to fit seamlessly into the great nowhere-in-particular of developed Europe, discloses on inspection a piece of sensible everyday opportunism and an unfinished project. Transit zones such as this one are among the preferred sites of the so-called New Topographers of the 1980s and 1990s. Their photographs deal with the kind of sub-events which crop up on a daily basis but which are usually taken in at speed and not dwelt on. New Topography is based on the idea of the deceleration of normal time to a point at which scrutiny becomes a possibility once more. This particular image introduced *Hollandse Taferelen* (1990), Aarsman's survey of Dutch everyday life.

☛ **Baldus, Barnard, Clifford, Fox Talbot, Frith, Turner**

4

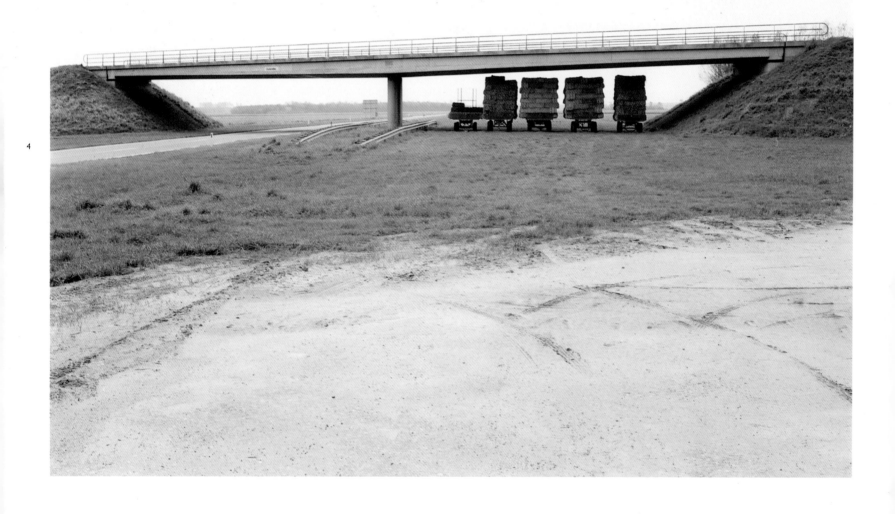

Hans Aarsman. b Amsterdam (NL), 1951. **Renesse 1988**. 1988. C-type print.

Abbott Berenice

El at Columbus Avenue and Broadway

The pedestrians and the statue of the horse seen from above represent traffic in general. It was a European tactic in the 1920s to photograph from bridges and high windows, and to show the street as a manoeuvrable board game with pedestrians as pieces. When she took this photograph Abbott had just returned to New York after spending most of the 1920s in Paris, where she had worked for a period as an assistant to the influential artist and publicist Man Ray. One of Abbott's great contributions to photography was her interest in the veteran photographer and documentarist of Parisian streets, Eugène Atget. She befriended him and in 1929 introduced his work to the USA. Her plan was to make her own documentary survey of New York, as Atget had done of Paris. In 1935 she was given state backing for her project, which was published in 1939 in a book called *Changing New York*. It shows the city richly inscribed and furnished with theatres, hardware stores, bridges and bakeries.

☞ **Atget, Besnyö, Burri, Krull, Man Ray**

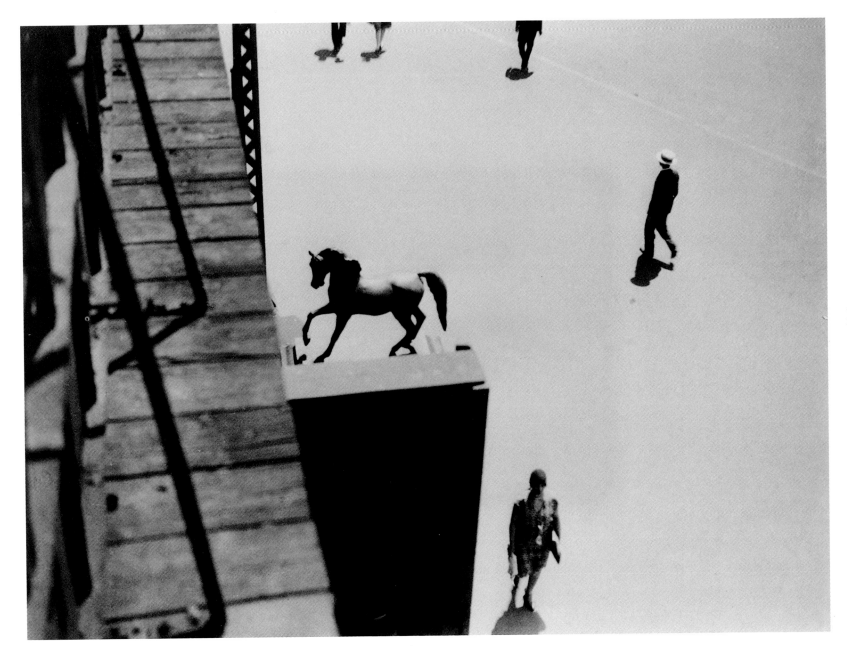

Berenice Abbott. b Springfield, OH (USA), 1898. **d** Monson, ME (USA), 1991. **El at Columbus Avenue and Broadway**. 1929. Gelatin silver print.

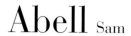

Abell Sam

At Home Outdoors

Australian Aboriginal people at the settlement of Balgo in the Great Sandy Desert are watching television out-of-doors in the evening. Their house, which has been provided by the government, is generally used only for storage. This picture originally appeared in *National Geographic* magazine in January 1991 in a story on the land and people of north-west

Australia. Abell, who is one of the most poetic photographers to work for *National Geographic*, has often been attracted to the idea of being at home in the wilderness. His landscapes, many of them deserts and remote coastlines, call up the small pleasures of the family circle and the comforts of habitation. He is also attentive to any evidence of cultural collision: dreamtime

people, for example, engaged in the very epitome of banal occupations – watching television. Abell began to work for *National Geographic* in 1967 and by the 1980s his name was becoming associated with artistic and literary subjects.

☛ **Christenberry, Johns, Krims, Link, Magubane**

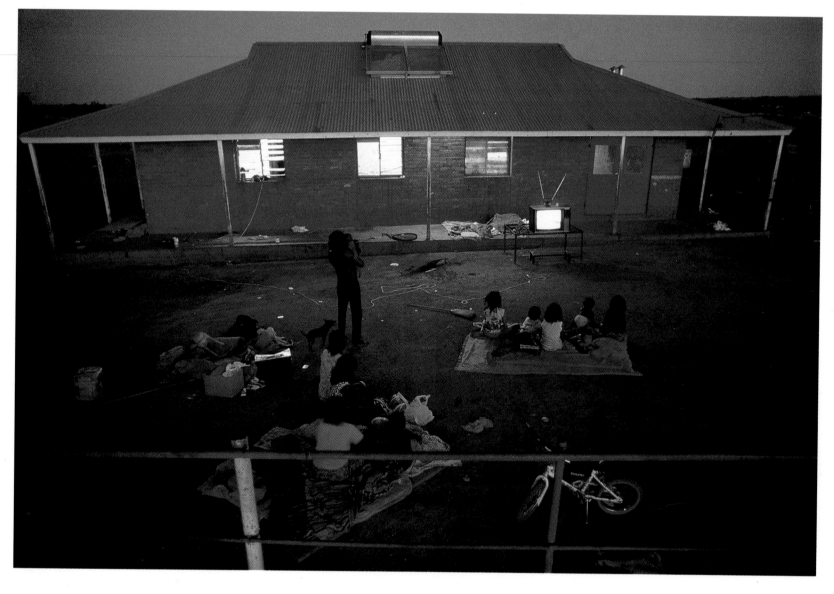

8

Sam Abell. b Sylvania, OH (USA), 1945. **At Home Outdoors**. 1991. C-type print.

Adams Ansel

Moonrise over Hernandez, New Mexico

In this, one of the most epic of Adams's landscapes, humanity is signalled by a field of scattered crosses in the near foreground. The settlement itself makes an irregular diminishing rhythm from left to right, in contrast to the flowing horizontals of the mountain range and the swift, painterly markings in the sky. The whole of this musicality is in turn related to the imperceptible slowness of the moon rising. Adams, who trained as a pianist before turning to photography in 1927, composed most of his landscapes in this way. Nature, represented by the mountain ranges and the skies of California and New Mexico, always takes the larger and more profound part. Adams was known through the 1930s and beyond as an advocate of 'pure' photography. In 1932 he founded the Group f.64 with Edward Weston, Willard Van Dyke and Imogen Cunningham, amongst others. Adams published more than twenty-four photographic books on the National Parks of America.

☛ R. Adams, Cunningham, Davies, Deal, Van Dyke, Weston

Ansel Adams. b San Francisco, CA (USA), 1902. **d** Carmel, CA (USA), 1984. **Moonrise over Hernandez, New Mexico**. 1941. Gelatin silver print.

Adams Eddie

Street Execution of a Vietcong Prisoner

Colonel Loan of the South Vietnamese police shoots dead a Vietcong suspect in a checked shirt. The photograph shows the exact moment at which the colonel's bullet entered the man's head, and was taken during a minor skirmish in the Chinese section of Saigon. Loan explained himself to Adams by saying, 'They kill many of my men and of your people.' Adams took the picture almost as a reflex action, but it quickly became the most famous image from the Vietnam War. *Oz*, the London satirical magazine, reprinted it later in 1968 with the caption 'The Great Society blows another mind'. ('The Great Society' was President Johnson's motto for the USA.) Colonel Loan was badly wounded during the war and afterwards opened a pizza parlour in Virginia, but he never shook off his notoriety. Before the war which irrevocably made his name, Adams was already an experienced photographer of fashion, entertainment, sport and politics.

☞ **R. Capa, Clark, Faas, Gaumy, Jackson, Nachtwey, Ut**

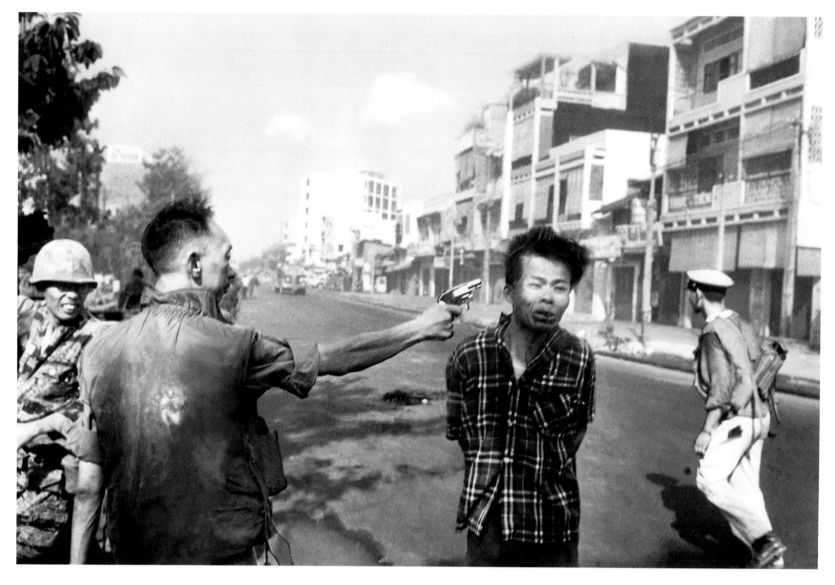

10

Eddie Adams. **b** New Kensington, PA (USA), 1933. **Street Execution of a Vietcong Prisoner**. 1968. Gelatin silver print.

Adams Robert

East from Flagstaff Mountain

The title states that this is the view looking east from Flagstaff Mountain in Boulder County, Colorado. The plain appears to have been urbanized – although, without any distinguishing features, it is hard to pick out a town. The band of shadowed trees in the foreground is as difficult to identify: is it forest, woodland, scrub or plantation? Robert Adams, whose name is synonymous with the New Topography of the 1970s, is not really a social critic, nor is he badly disposed towards his times, even if in a book such as *From the Missouri West* (in which this picture first appeared) he mentions 'evidence of man' and 'our violence against the earth'. However, his awareness of man's power for ill gives his work an edge that distinguishes it from the Western landscapes of Ansel Adams. Robert Adams's photographs demand attentive scrutiny in order to make them out through the shadows and the glaring light.

☛ **A. Adams, Basilico, Davies, Deal, Hannappel, Testino**

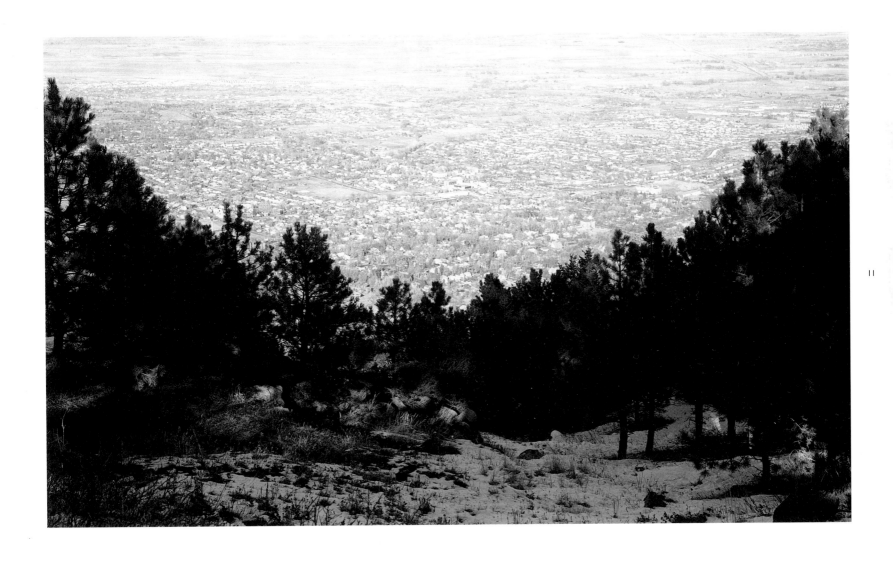

11

Robert Adams. b Orange, NJ (USA), 1937. **East from Flagstaff Mountain**. 1976. Gelatin silver print.

Adams Shelby Lee

Leddie & Children

Leddie Sloan, of Sloan Fork, Kentucky, is sitting surrounded by children in the picture which appeared on the cover of Shelby Lee Adams's *Appalachian Portraits* of 1993. Rightly, it is not explained whether these are all Leddie's children, since lack of that knowledge makes one wonder whether they all look alike and how old they might be. Leddie, who appears in other

pictures by Adams, seems – on the evidence of those pressed denims – to have dressed up for the occasion of this near-formal portrait. Adams's great strength as a documentarist and portraitist is to manage these moments with such delicacy that his subjects invariably appear to be in possession of themselves and to be capable of giving a true account. His procedures, as

explained in the foreword to *Appalachian Portraits* (1993), involve many visits to the same families, sometimes returning year after year, until he has become their portraitist.

☛ **Abbas, Depardon, Lange, Lyon, Mydans, Seymour**

12

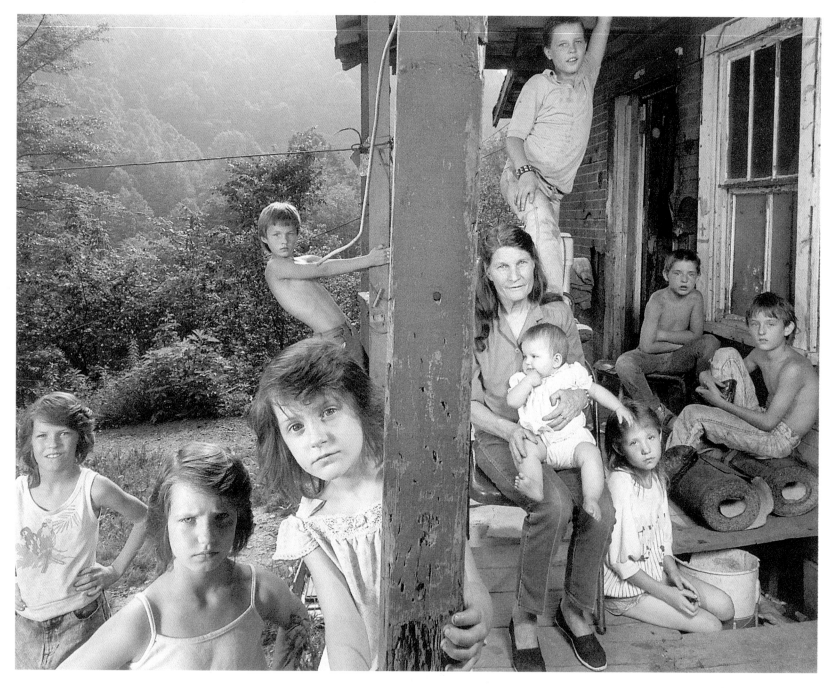

Shelby Lee Adams. b Hazard, KY (USA), 1950. **Leddie & Children**. 1990. Gelatin silver print.

Aeby Jack

The First Atomic Bomb

Although no more than a snapshot, this is the only surviving colour photograph of the first atomic explosion, which took place on 16 July 1945 at the Trinity site, near Alamogordo, New Mexico. A total of 100,000 photographic exposures were made of the explosion, but nearly all of them were in black and white since the intensity of the light tended to blister and solarize the film. Some observers said that the sky was 'aglow with an orange hue', others that there was a deep violet colour that was the result of radioactivity. One witness likened the cloud ring forming above the explosion to 'a pool of spilt milk'; it was the result of the shock wave causing condensation in the upper atmosphere. The mushroom cloud is seen in formation here. Aeby, who belonged to the Special Engineer Detachment, gave this picture to Enrico Fermi, the Italian physicist who was one of the directors of the Manhattan Project set up to produce the atomic bomb.

☛ Edgerton, Man, Shere, Sternfeld

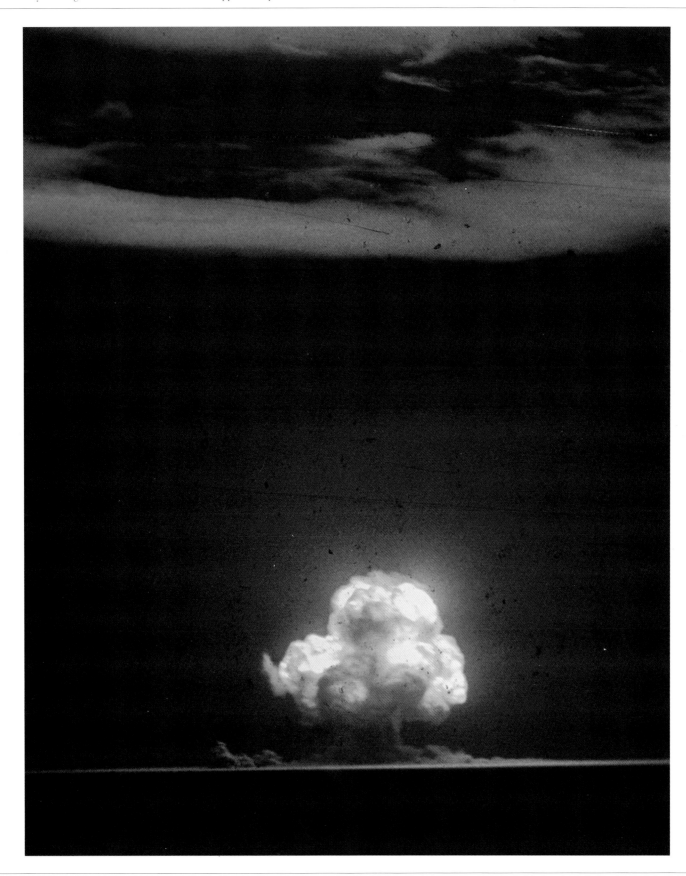

Jack Aeby. b Mound City, MO (USA), 1923. **The First Atomic Bomb**. 1945. C type print.

Aigner Lucien

Benito Mussolini

Aigner considered this picture of Mussolini, who has been captured in mid-sneeze at Stresa railway station, to be his most celebrated photograph. It was taken at the end of a three-day conference, from which even photographers of the official Fascist press had been banned. By good luck and perseverance, however, Aigner happened to be present at the railway station at the end of the conference when the Duce was on his way back to Rome. In his memoirs Aigner noted that Mussolini was a poseur who tried to conceal candid moments like this from the public. Photojournalistic reputations in the 1930s were made by such unsupervised portrayals of the great, and this photograph ranks as one of the most outstanding. Born in Hungary, Aigner began work in Berlin and spent his life working as a photojournalist in Europe and the USA. He was one of the first Europeans to work for *Life* magazine during the late 1930s and the 1940s.

☛ Bosshard, Karsh, Lessing, Reed, Salomon

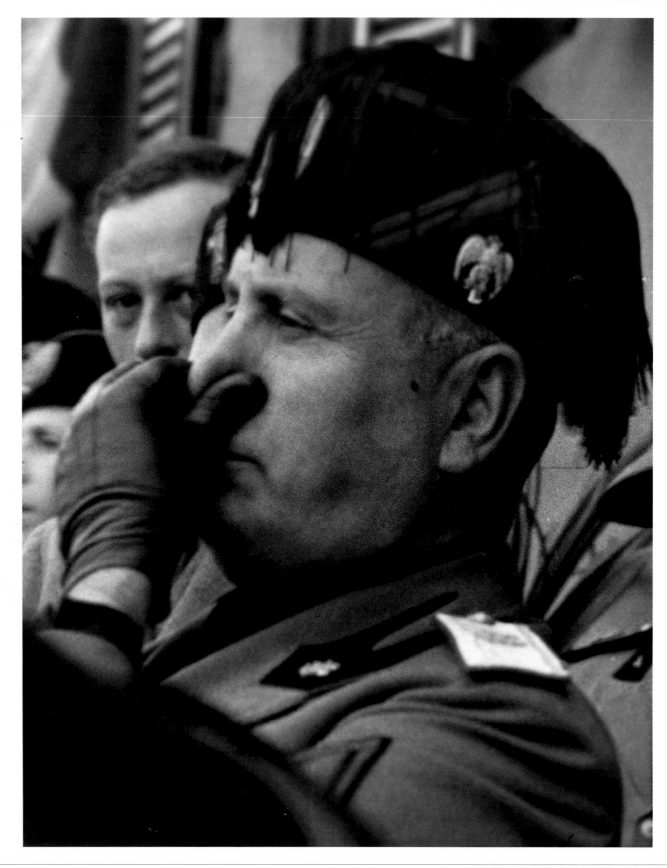

Lucien Aigner. b Ersekujvar (HUN), 1901. **Benito Mussolini**. 1935. Gelatin silver print.

Alinari Vittorio

Cyclists

Two cyclists appear to be moving purposefully against a background of flowers, foliage and clouds. Their bicycles are held at that surging angle by wires which are just discernible, and the whole composition is a compromise solution in which action is only implied. The contrivances on show here explain just why experimenters in photography tried so hard to find an answer to the problem of movement. Leopoldo Alinari set up his photographic company in Florence in 1854 and was soon joined by his brothers Giuseppe and Romualdo. At first they concentrated mainly on documenting masterpieces of art, but in 1892 Leopoldo's son, Vittorio, shifted the company's emphasis to Italian reportage and documentary. Alinari operatives continued to use large plates (measuring 8¼ x 10½ cm) until the 1920s, and composed their pictures with care, often using a frontal perspective. The Alinari archive is the principal record of Italy in formation in the modern period.

☛ Hocks, Misrach, Moon, Singh, Staub, Tress

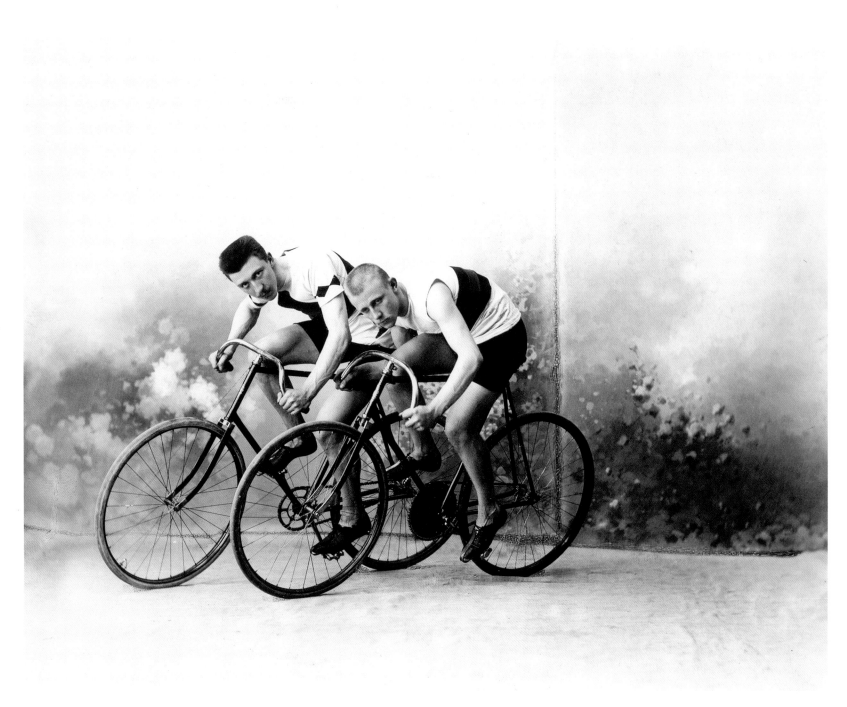

15

Vittorio Alinari. b Florence (IT), 1859 **d** Florence (IT), 1932. **Cyclists.** 1895. Albumen print.

Allard William Albert

Henry Gray, Arizona

Mirrors are not usually associated with grizzled ranchers in Arizona, but this one opens up the picture space at the same time as it makes connections between the Wild West and artifice. Western veterans were conspicuous figures in the 1960s, appearing in the films of Sam Peckinpah, and Henry Gray is at first sight one of their number. The only difference is that he is authentic, being described by Allard as 'a tough old man who had pulled most of his own teeth'. In 1970 he was in dispute with the government, which was trying to turn his land into a state park. This picture, which was taken on a *National Geographic* assignment on the US/Mexico border, featured in 1982 in Allard's first and most famous book, a collection of Western photographs entitled *Vanishing Breed*. By 1986 he had contributed sixteen articles to *National Geographic*, many of them with his own texts. His gift has always been for portraying humanity under pressure.

☛ Berengo Gardin, Frank, Haas, Hawarden, Liebling, Prince

William Albert Allard. b Minneapolis, MN (USA), 1937. **Henry Gray, Arizona**. 1970. C-type print.

Alpert Max

Building the Fergana Canal

The group of musicians on the hillock are playing flutes, drums and dutaras to encourage the builders of the Fergana Canal in Uzbekistan to set to work. Groups of men, all of them covered in dust and undifferentiated from each other, struggle towards the bridge in the foreground. Across it an orderly pair, their tools over their shoulders, are striding purposefully. The idea behind the Fergana Canal was to link the scattered water sources in the Fergana basin, which is located near the Pamirs and Tien Shan. One of the major enterprises of the Soviet Union, the canal was begun in 1935 and completed in 1950. Alpert, who had been a photo-reporter since 1924 after a spell in the Red Army, was given documentary work by *Pravda* in 1928, and began to contribute in 1931 to *USSR in Construction* – a magazine set up by Maxim Gorky to present the Soviet Union abroad. He was a member of the Russian Association of Proletarian Photographers.

☛ **Bischof, Le Querrec, Salgado, Unknown**

Max Alpert. b Simferopol (UKR), 1899. **d** Moscow (RUS), 1980. **Building the Fergana Canal**. 1939. Gelatin silver print.

Alvarez Bravo Manuel Under the Stage

The girl is looking upwards into a gap between the beams overhead. Alvarez Bravo's ostensible subject may be the finely shaped head of the girl and her slender arms, but at another level the subject is vision itself, for any careful scrutiny of the picture involves the kind of attention which she herself is paying to the darkness explored by her raised hands. Bravo began to take pictures in the 1920s, but only became a full-time photographer around 1930. He had numerous contacts with such established artists as Edward Weston, Tina Modotti, Paul Strand and Henri Cartier-Bresson, and in 1931 he worked as a cameraman on Sergei Eisenstein's film *Que viva Mexico*. During the 1940s and 1950s he continued to work in the movies, only returning to still photography in the 1960s. Most of his pictures are of single figures in uncomplicated settings easily described in a word or phrase – pictures sympathetic to speech and the shape of words.

☛ **Cartier-Bresson, Hosoe, Modotti, Strand, Weston**

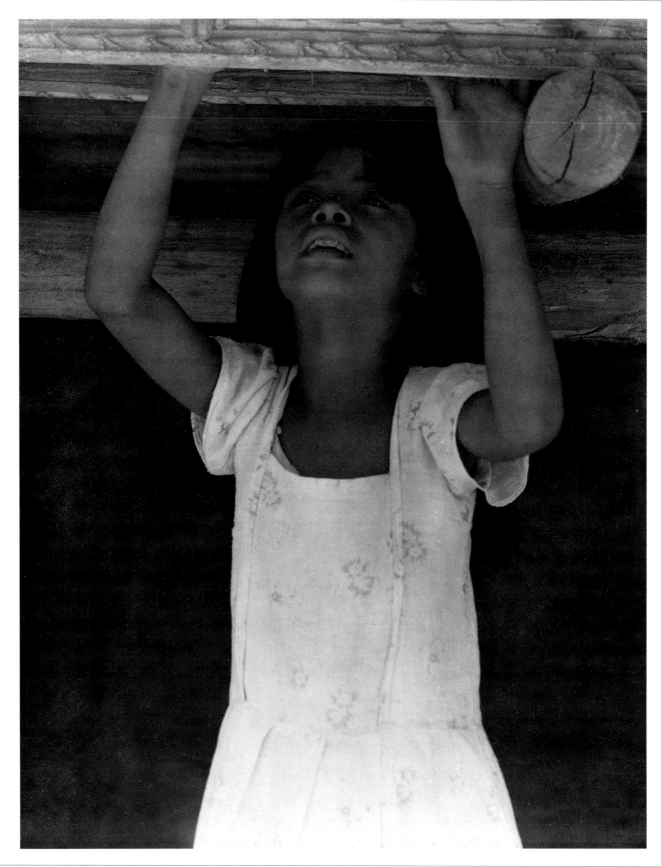

Manuel Alvarez Bravo. b Mexico City (MEX), 1902. **Under the Stage**. 1950. Gelatin silver print.

Andriesse Emmy

Fashion Designer and Model

The young fashion designer Pierre Balmain is delivering what might be last-minute instructions to a model who seems to acquiesce – but sits as if preoccupied by thoughts of her own. Self-engrossed and melancholy, she looks far more intriguing than the situation warrants. Emmy Andriesse might be suspected of trying to subvert the very idea of the fashion photograph – and whatever it entails of male domination. Whether or not that is the message here, style can hardly be projected dispassionately, and at this particular moment in European history a certain depth of character was important to those who had survived terrible hardships. Emmy Andriesse was well known at the time for several very striking pictures of starving children that she had taken illegally in Holland during the Hunger Winter of 1944–5. During the 1930s she had trained in the new photography and typography at The Hague under Gerrit Kiljan and Paul Schuitema.

☞ Billingham, Dührkoop, Pécsi, Teller, Wilding

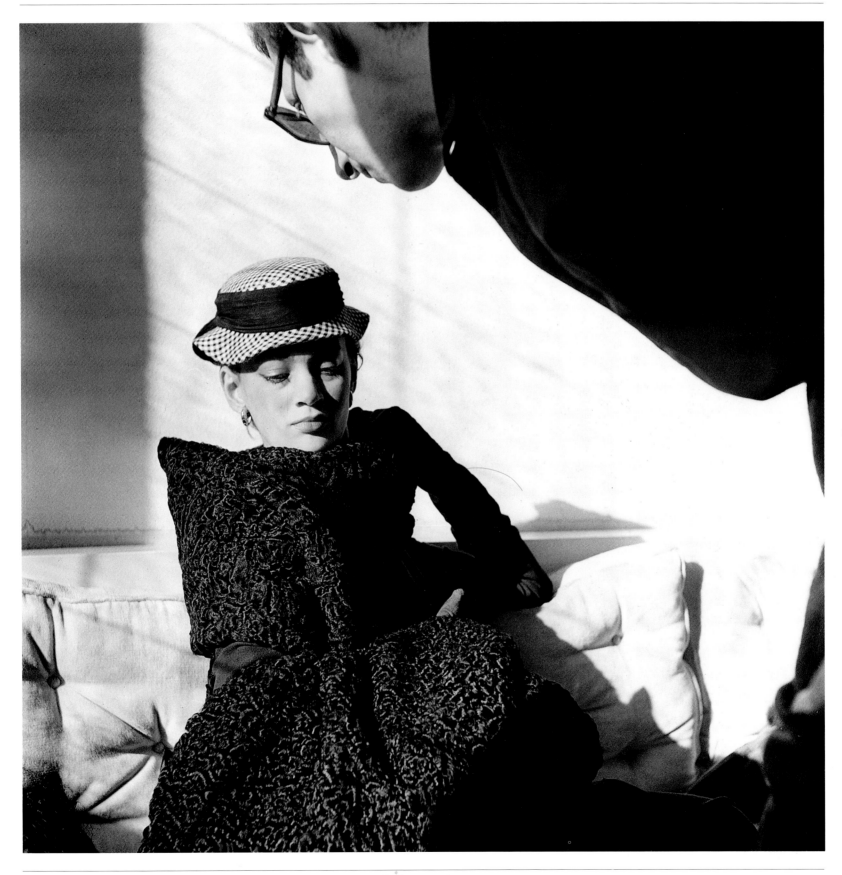

Emmy Andriesse. **b** The Hague (NL), 1914. **d** Amsterdam (NL), 1953. **Fashion Designer and Model**. 1951. Gelatin silver print.

Annan James Craig

A Bullock Cart, Burgos

A man carrying a long wooden staff is leading a laden bullock cart through the streets of the old Spanish town of Burgos. The silhouettes stand out strongly in the murky light, suggesting that this is a deliberately composed scene rather than a chance sighting. The suggestion is also that what looks like a typical glimpse of Old Spain in fact represents a very particular

moment in a process, for it is possible that the cart is being backed towards or held alongside an open doorway in order to be unloaded. Thus the photograph begins to turn into a documentary excerpt from a study of traffic management. This was Annan's usual way of declaring that even if art involved a general idea – in this case, that of archaic and timeless Spain –

it also had to take account of the moment and all its specific characteristics. The most subtle of all the Pictorialists of 1900, Annan (who was the son of the photographer Thomas Annan) was active as an artist-photographer during the 1890s.

☛ Emerson, Howlett, Killip, Manos, Morath

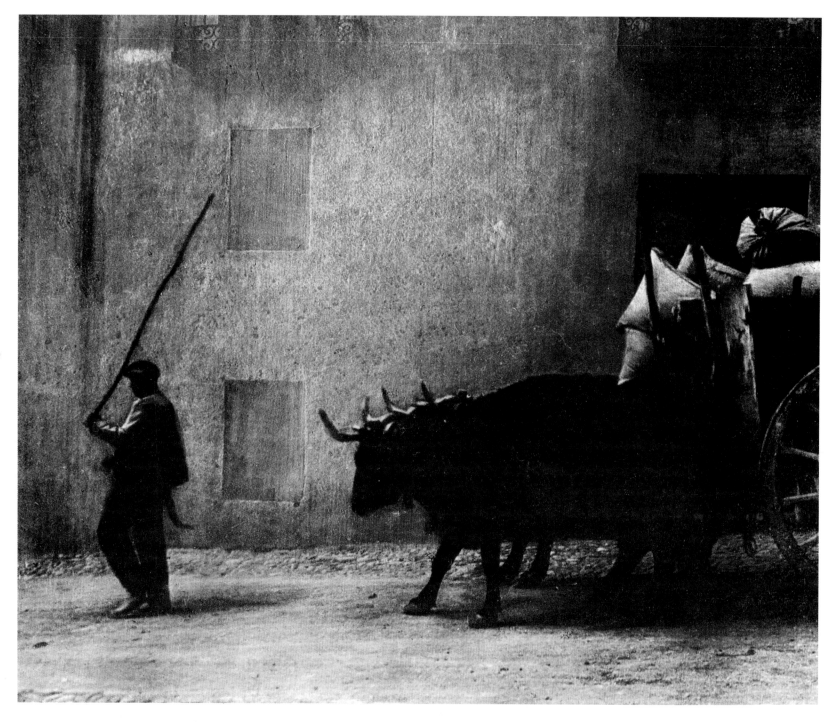

James Craig Annan. b Glasgow (UK), 1864. **d** Glasgow (UK), 1946. **A Bullock Cart, Burgos**. 1913. Photogravure.

Appelt Dieter

Oppedette

Appelt made the wings for this picture himself, using branches covered with white canvas, and then set himself up for the camera in a quarry in the south of France. A deliberate arrangement of this sort ought to have a legible meaning, but here the viewer is given no guidance and has no option but to run through the possibilities. The figure, with its hand-made wings, stands ready for take-off between darkness and light in the mouth of a cavern. He might be intended to represent Daedalus, the supreme artificer who escaped from Crete to Sicily on wings of his own making; or the darkness of the cave might refer to Christ's Entombment and Resurrection. Appelt's intention, though, seems to have been less to illustrate a theme than to stimulate a search for a theme. His practice during the 1980s, when this image was made, was to compose in series of loosely connected images in which repeated motifs suggested a variety of meanings.

☛ **Dater, Holland Day, Morimura, Nauman, Patellani**

21

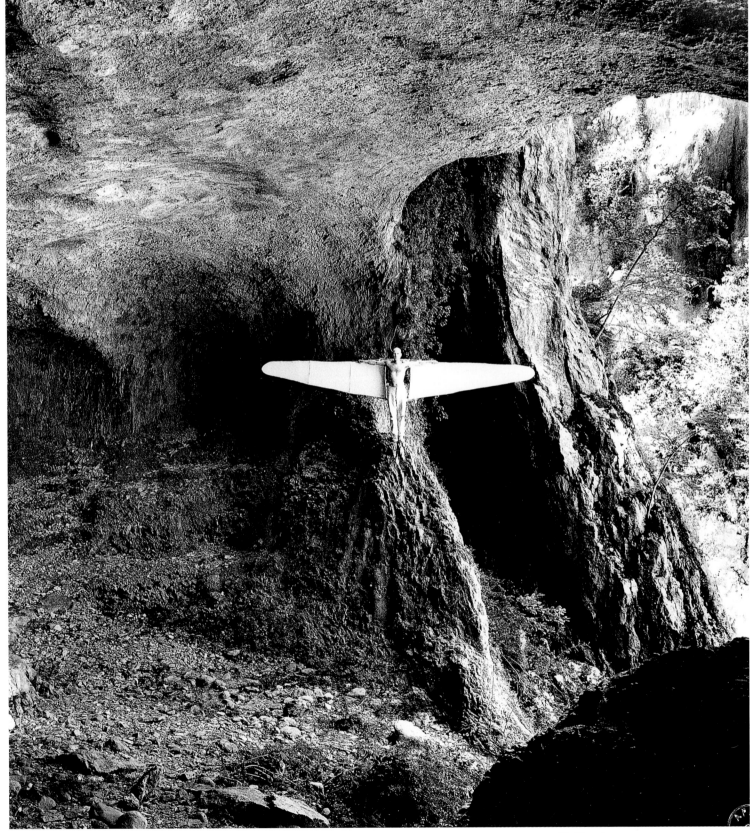

Dieter Appelt. b Niemegk (GER), 1935. **Oppedette**. 1980. Gelatin silver print.

Araki Noboyushi

Untitled

She is deliberately exposing herself to the camera, or at least exposing an oddly whitened torso which contrasts with the pink of her thighs. The picture in general seems to be in two parts, as signalled by the differently tinted matting. This idea is built on further in the exoticism of the woman, with her look of a courtesan, and the channel-tuner in her right hand, with its suggestion of options. The implication is that she might revert – at the touch of a button – to normal life. The most prolific photographer in the history of the medium, Araki, who is the author of around a hundred books, began to publish his work in 1970. Much of his art is centred around Tokyo and includes such projects as *Tokyo Elegy* (1981) and *Tokyo Story* (1989).

His intention has been to combine the fantastical with the everyday, and his preferred tactic is often to juxtapose pictures, making no clear distinctions between the personal, the social and the historical.

☛ Abbe, Charbonnier, Cumming, Gowin, Tillmans

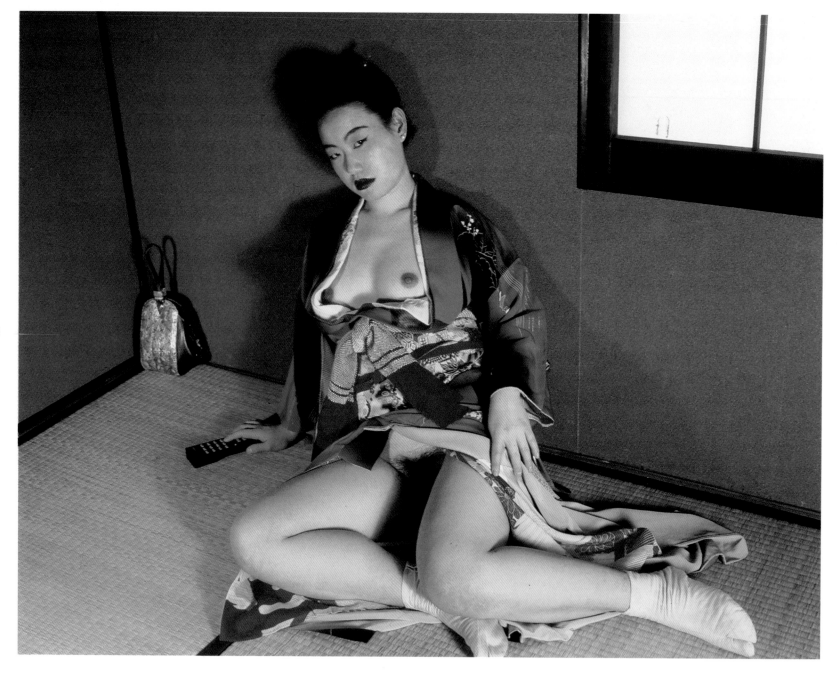

22

Noboyushi Araki. b Tokyo (JAP), 1940. **Untitled**. 1991. C-type print.

Arbus Diane

Child with Toy Hand Grenade in Central Park, New York City

The grenade, grimace and claw-like hand seem to point to a desperate future, hysterical and militarized. The picture works because the strangeness of the boy is staged within a kindly natural scene; there is even a rhyme between those paired tree trunks and the child's spindly legs. Arbus's subject, here and elsewhere, is the discrepancy between imagined and idealized worlds, represented here by the trees and the sunlight in the park, and the violence apparently promised by the child. She imagined dystopia, but always regarded it from the point of view of the Garden of Eden. Arbus's example – which is known mainly through the eighty pictures published in *diane arbus* in 1972 – made a huge difference in documentary photography, even if no-one was able to repeat her achievement. A student of the influential Lisette Model in New York in the late 1950s, she worked principally as a freelance magazine photographer during the 1960s.

☞ Fink, Lendvai-Dircksen, Lengyel, Levitt, Munkacsi

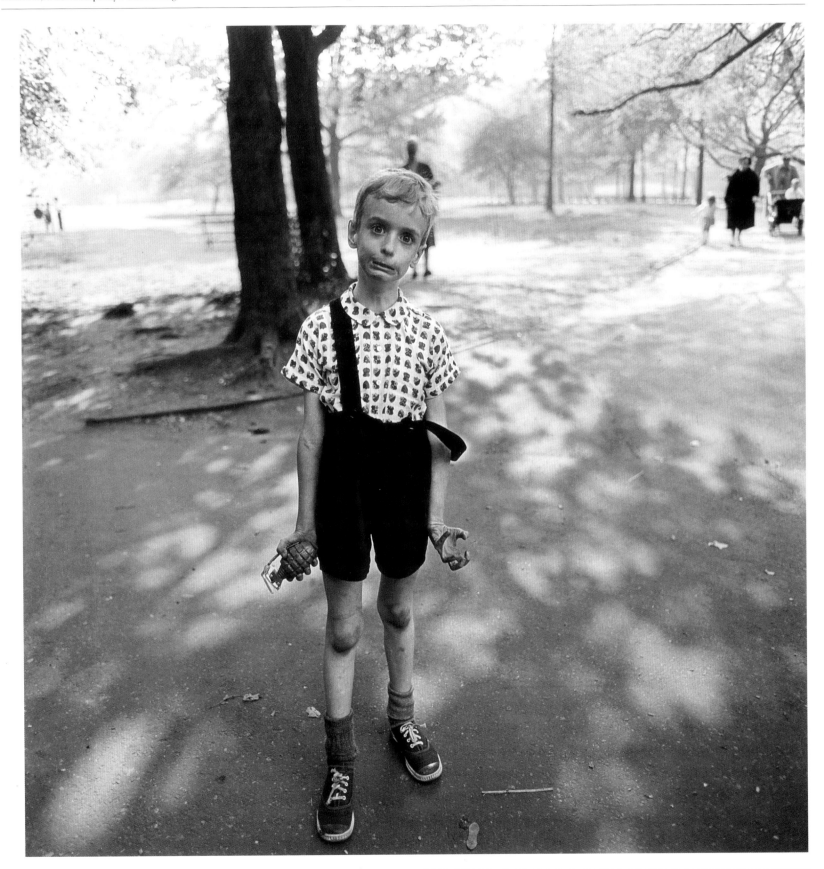

23

Diane Arbus. b New York (USA), 1923. **d** New York (USA), 1971. **Child with Toy Hand Grenade in Central Park, New York City**. 1962. Gelatin silver print.

Arbuthnot Malcolm To Larboard

Even though the boat tilts sharply to the left – to what was once called the 'larboard' – the photographer has kept his footing and his head. Arbuthnot's subject here is not so much the technicalities of sailing as the forward movement of the boat and the swinging axial arrangement of the picture. His hovering view along the sliding deck represents photography's first attempt to establish a viewpoint away from the henceforth reliable earth and to tackle the new notions of the dynamism of material. *To Larboard* looks like a Russian or modernist picture from the 1920s, for by then modernist photographers were taking for granted and revelling in the dynamics of movement. In 1908 Arbuthnot exhibited abstract photographs at the London Salon and in 1909 he was described in *Amateur Photographer* as 'the most advanced of the moderns'. Arbuthnot was a signatory in 1914 to Wyndham Lewis's Vorticist manifesto *Blast*.

☛ **Hurley, Mortimer, Oorthuys, Ulmann**

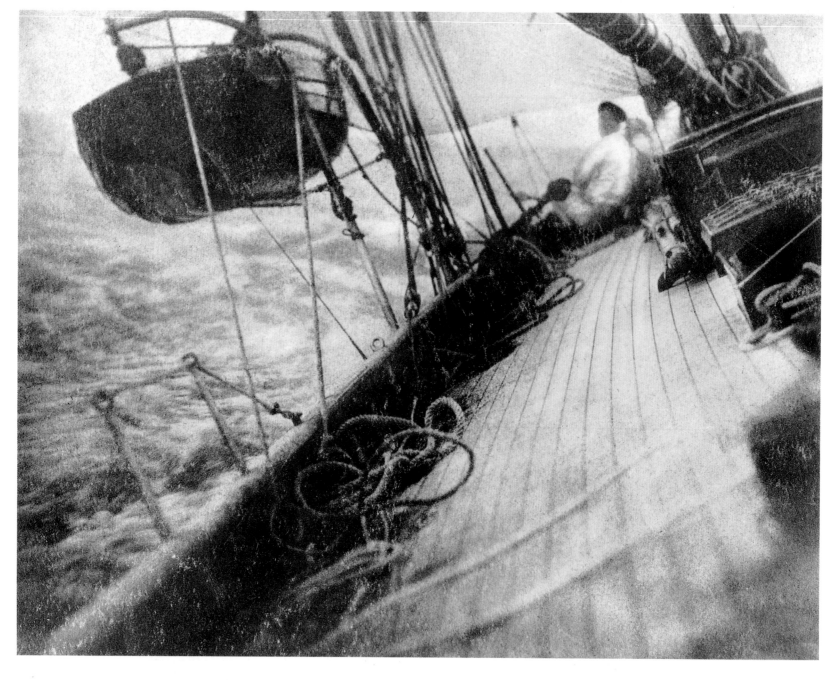

Malcolm Arbuthnot. b London (UK), 1874. **d** Jersey (UK), 1967. **To Larboard**. 1907. Oil print.

Armstrong Neil

Buzz Aldrin on the Moon

This photograph of Edwin E. ('Buzz') Aldrin, one of the first men on the moon, was taken on 20 July 1969 using a specially designed Hasselblad camera. The moment it portrays is so significant that Armstrong's picture quickly established itself as one of the twentieth century's most resonant images. The photograph has other merits, including a miniature moonscape in Aldrin's visor, in which the brightly lit figure of the photographer and the moon-landing craft Eagle appear. The picture also shows short steps, clumsily managed at the beginning of a learning process in a waste environment. Space had been much imagined previously, but never before in terms of first steps and an implied return to childhood. Although a 'first step' for mankind, the moon landing signalled the end of a cultural era in which the nation (the USA) had focused as one on national events and personalities.

☛ Allard, C. Capa, Haas, Hawarden, Titov

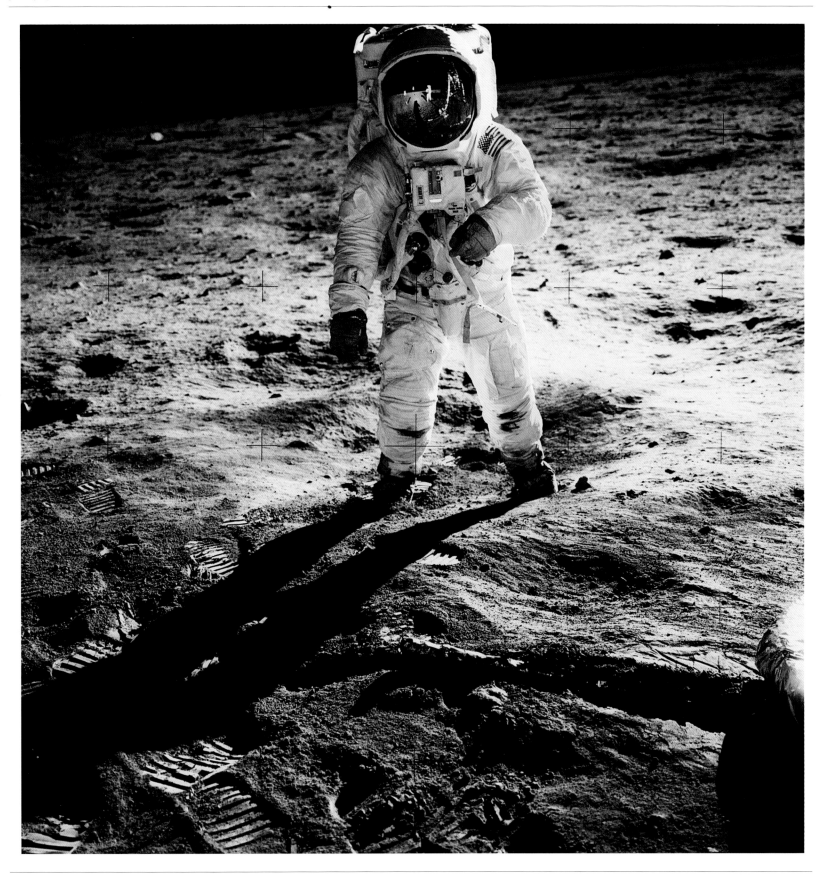

Neil Armstrong. b Wapakoneta, OH (USA), 1930. **Buzz Aldrin on the Moon**. 1969. C-type print.

Arnatt Keith

Object from a Rubbish Tip

This picture, which is introduced as an object from a rubbish tip, is from a series of pictures of discarded objects called *The Tears of Things*. This particular image has a deliberate echo of Michelangelo's painting on the Sistine Chapel ceiling of God turning away after creating the sun and the moon. Arnatt is making the case for old, sublime stories, such as that of the Creation, having a place in a world which seems stuffed to breaking-point with material and imagery relevant only to the moment. The Italians, who were the only ones to develop a phrase for this strategy, called it 'Arte Povera' – art contrived from despised materials. Arnatt is also the creator of a set of pictures which show the rising and setting sun devised from tin-can lids. He came to fame in 1969 with an arrangement of nine pictures called *Self-Burial*, which was made in response to the idea that art was dead.

☛ **Burnett, Florschuetz, Nilsson, Sherman**

Keith Arnatt. b Oxford (UK), 1930. **Object from a Rubbish Tip**. 1989. C-type print. **h** 104 × **w** 104 cm. **h** 50 × **w** 50 in.

Arnold Eve

Marilyn Monroe, Hollywood

An outstretched hand is adjusting the star's hairstyle, as she glances back towards the camera for reassurance. In 1960, stardom was just beginning to be looked on as a contrivance and as an affront to personality. Monroe was interpreted at the time as both a victim of that system and also as its arch-representative. In 1962, she protested: 'I do not consider myself a kind of merchandise but I am sure that many people do not see anything else in me… That is what annoys me: a sex symbol becomes an object. I hate being an object.' Photographers, including Irving Penn, Richard Avedon and Eve Arnold, were fascinated by this process of objectification. Arnold had prepared herself for just such an encounter as this in the early 1950s when she photographed in the bars and workplaces of New York amongst nighthawks and others very ambiguously on show. A pupil of the influential Alexey Brodovitch in New York in 1948, she joined Magnum Photos in 1957.

☛ Avedon, Bellocq, Horst, Morley, Penn, Willoughby

Eve Arnold. b Philadelphia, PA (USA). **Marilyn Monroe, Hollywood.** 1960. Gelatin silver print.

Atget Eugène

Cabaret, Rue Mouffetard

Maison Romano might once have been a restaurant and wine-shop, because that looks like a bunch of grapes in wrought iron above the door. Perhaps it was also an optician's shop, as suggested by the model of a pince-nez. Now it sells newspapers, photographs and useful signs, such as *chambre à louer* (room to rent). This shop on the corner of the Rues l'Arbalète and

Mouffetard has seen heavy use and better days, like much of Atget's Paris. Having worked as a sailor on transatlantic liners in the 1870s and an actor in the 1880s, Atget began to make his inventories of Parisian trades, shops, interiors and street scenes in the 1890s and continued up to the outbreak of World War I. Intended for museums and libraries and as nothing more than

records, Atget's pictures began to catch the eye of artists in the 1920s and in particular of Man Ray and Berenice Abbott. In 1930 *Atget, Photographe de Paris* came out, one of the most revered books in the history of the medium.

☞ Abbott, Besnyö, Caron, Daguerre, Gruyaert, Man Ray

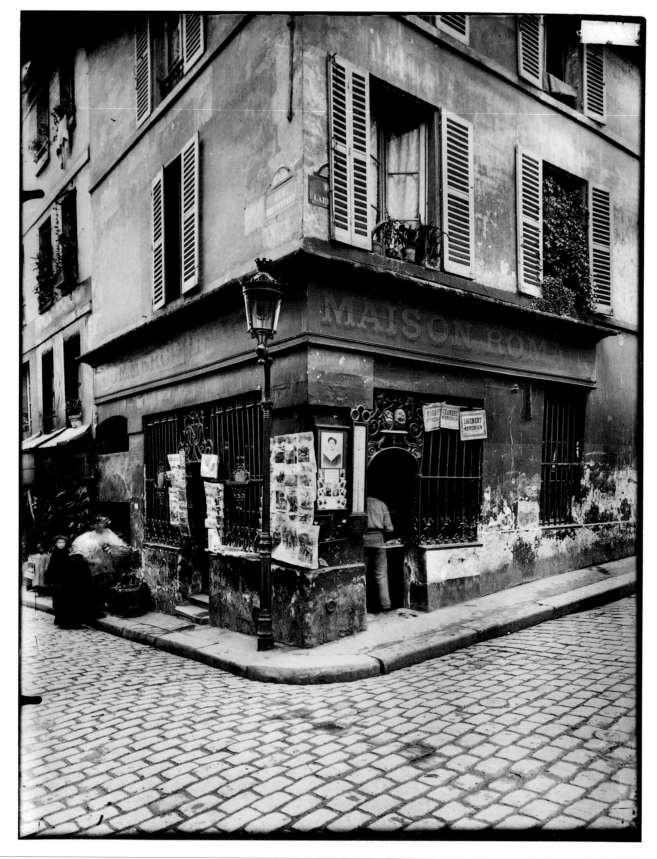

Eugène Atget. b Libourne (FR), 1857. **d** Paris (FR), 1927. **Cabaret, Rue Mouffetard**. c1900. Albumen print.

Atwood Jane Evelyn

Blind Twins, Saint-Mandé, France

These girls are blind and obviously twins. The gridded floor makes the space look like a prison cell. Blind or not, the girls present themselves with an elegance which implies that beauty is a natural bodily quality independent of sight. This picture was taken in 1980 when Jane Atwood was engaged in a study of the blind, for which she was given the first W. Eugene Smith Award. Her practice, as a documentary photographer, is to involve herself with her subjects over a long period, for the sake of sympathy and accuracy. Her main concerns have been the marginalized and disadvantaged, and in 1997 she was awarded Leica's Oskar–Barnack Award for a study of women's prisons worldwide. Of her three books published to date, two have been on the life of prostitutes in Paris and the third on conditions in the French Foreign Legion. Jane Atwood has lived in France since 1971.

☞ Keita, Molenhuis, Oddner, Scianna, Shahn

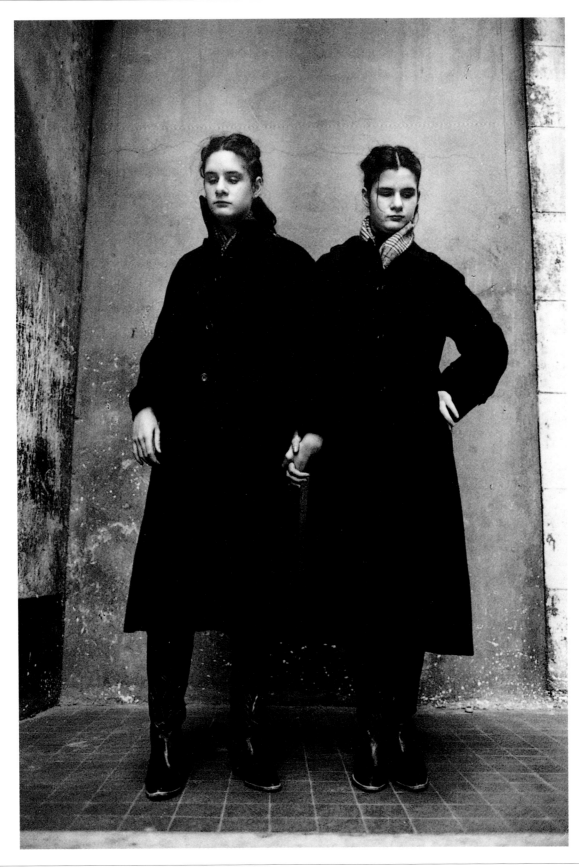

Jane Evelyn Atwood. b New York (USA), 1947. **Blind Twins, Saint-Mandé, France**. 1980. Gelatin silver print.

Avedon Richard Dovima with Elephants

Why place a model wearing a Dior dress between a brace of circus elephants? Because the contrast is a striking one and prompts ideas of Beauty and the Beast. Yet there is more to this picture than that. The model may be everything you would expect in terms of youth and elegance, but the fundamental subject, as in all of Avedon's art, is old age and its stresses – as represented by the mournful and wrinkled elephants. His *Portraits* of 1976, for instance, ends with a series of seven pictures of his father gradually ageing until he seems to have been assimilated into the light around him. Likewise, in his greatest work, *The American West* (taken over five years in the early 1980s and published in 1985), a collection of portraits sets out the variety of damages to which flesh is prone, while either engaged in dangerous occupations or just existing. Avedon has worked in a wide range of different areas, but it is for his fashion photographs that he is best known.

☛ **Bailey, Blumenfeld, Dahl-Wolfe, Sieff, Teller**

30

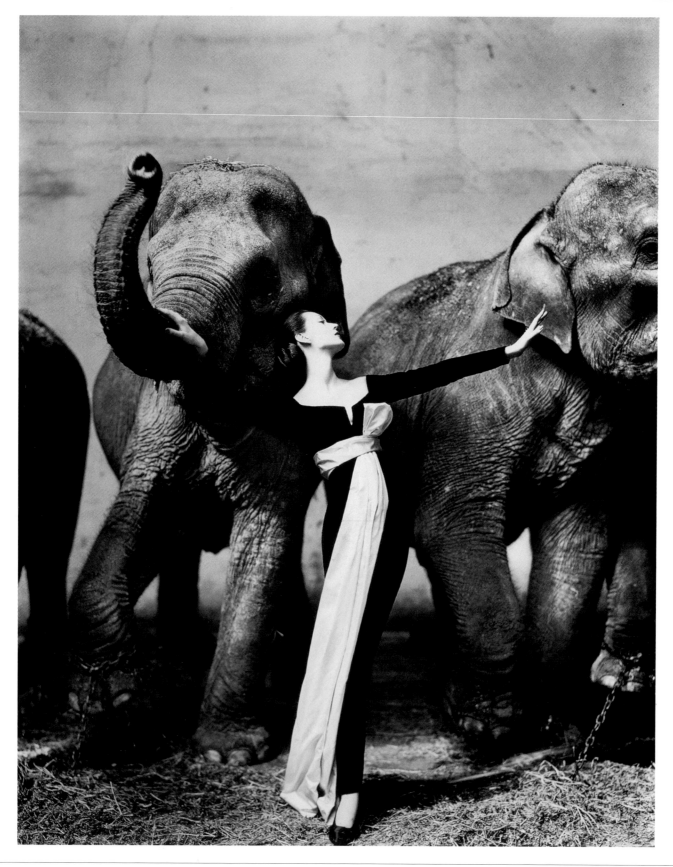

Richard Avedon. b New York (USA), 1923. **Dovima with Elephants**. 1955. Gelatin silver print.

Bailey David

Jean Shrimpton, Tower Bridge

The model Jean Shrimpton is wearing a man's coat, which looks as if it might have been borrowed from the film stars Jean-Paul Belmondo or Humphrey Bogart as protection against the chill of the morning. The cobblestones underfoot lead up to Tower Bridge. But what is she doing standing on a usually busy road in the early morning light? She has the look of someone on her way back from the all-night city. The older style of fashion photography (which dated from the 1930s onwards) seemed to come from an elegant world apart; the new style, put into place above all by David Bailey in London in the 1960s, had been learned from post-war cinema – the French New Wave, in particular – and it was emphatically informal and youthful.

Much of Bailey's trend-setting art appeared in *Vogue* in the 1960s. *David Bailey's Box of Pin-ups*, published in 1965, surveyed the new 'popocracy' then emerging in Britain: the Beatles, for example, and the Rolling Stones.

☛ **Avedon, Blumenfeld, Frissell, Sieff, Teller, Tillmans**

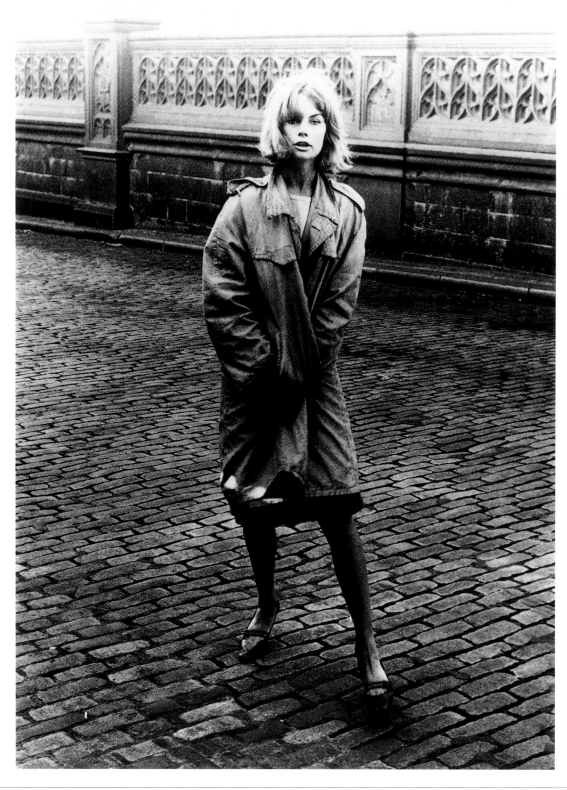

David Bailey. b London (UK), 1938. **Jean Shrimpton, Tower Bridge**. 1961. Gelatin silver print.

Baldessari John — Throwing Four Balls in the Air to Get a Square (Best of Thirty-Six Tries)

From this viewpoint the photographer's aim was almost achieved in the lower right-hand picture, but any of the other formations might have worked when seen from different angles. Why make thirty-six attempts to chart a square by throwing balls against the Californian sky? For the sake of serendipity, or to prove that things can work out the way we want them to.

Many of Baldessari's photographic series of the 1960s and 1970s take time to enact and to study – but it is no more than commonplace time, not the providential moment of photo-reportage where events and appearances coalesce decisively. Baldessari's proposal is that ordinary time is readily available, and that it might as well be used to enact miracles, no matter

how small. Trained as a painter, Baldessari turned to photographic art in the mid-1960s. To mark that turning, in 1970 he had all of the past canvases in his possession burned at the local crematorium.

☛ Becher, Blume, Calle, van Elk, Michals

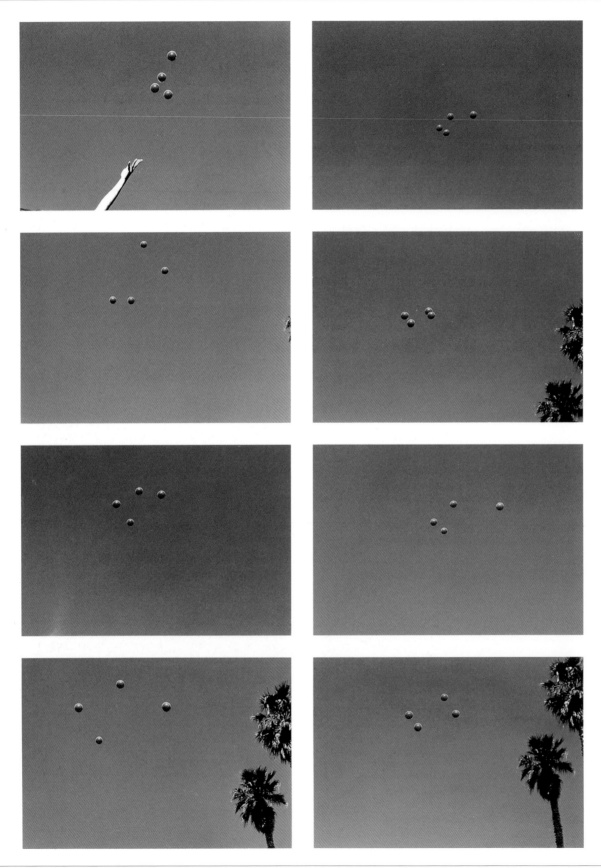

John Baldessari. b National City, CA (USA), 1931. **Throwing Four Balls in the Air to Get a Square (Best of Thirty-Six Tries)**. 1974. Eight C-type prints. Each **h**24 × **w**35 cm. **h**9½ × **w**13¾ in.

Baldus Édouard-Denis

The Chantilly Viaduct

This photograph of a viaduct on the railway line linking Paris with the Channel port of Boulogne-sur-Mer was taken in 1855 for an album which was to be presented to Queen Victoria. Pictures like this are, of course, interesting as records of a time when, for example, the French used Crampton locomotives, but they are far more engrossing as exercises in the representation and reading of landscape. Since the medium was relatively insensitive, photographers had to rely on devices which would allow space to be understood. For this reason Baldus has included the line of fencing which calibrates the hillside from left to right and plays with the possible flatness of the piers at ground level. He has centred the picture around a solitary pine tree, which touches the same point on the picture plane as the tender of the locomotive, casting a shadow on the pier below. Originally a painter, Baldus was one of the most industrious of French photographers during the 1850s and 1860s.

☛ Aarsman, Barnard, Clifford, Frith, Link

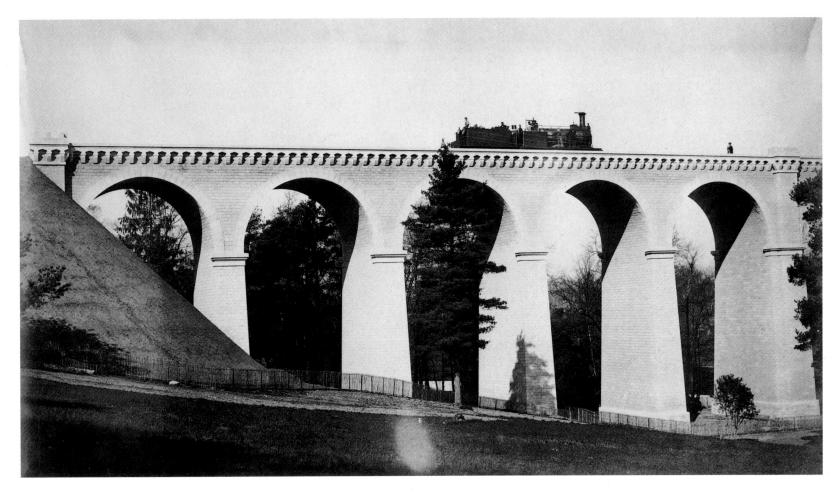

Édouard-Denis Baldus. b Grünebach (PRU), 1813. **d** Paris (FR), 1889. **The Chantilly Viaduct.** 1855. Albumen print.

Baltermants Dmitri Kerch, Crimea (Grief)

It is late winter and a thaw has left mud underfoot with the snow still lying on the footpath which makes its way into the distance. A turbulent sky dramatizes what is really a scene of mourning, even though there are only two people who grieve with all their hearts while the rest stand by, deep in thought perhaps, or drift about casually. The dead, it seems, are villagers who were massacred during the retreat of the German forces into the Crimea. This picture, though, asks questions which cannot be answered from the evidence – such as why the dead should lie so easily and so widely spaced, and why it is only the pair on the left who are paying any attention to the cameraman. Faced with a site so rich in possibilities, Baltermants may well have recognized in this a scene from Homer's *Iliad*, where the souls of the dead rise like smoke from the funeral pyres. Baltermants reported during World War II for *Izvestia* and for the Red Army newspaper *Na Razgromvraga*.

☛ **Burrows, Faucon, Gardner, McCullin, Wall**

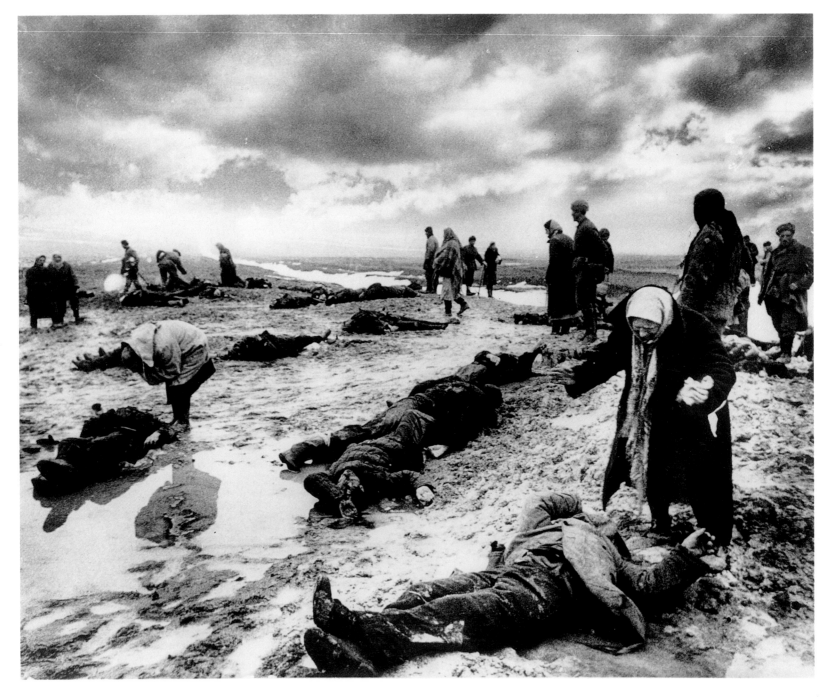

34

Dmitri Baltermants. b Moscow (RUS), 1912. **d** Moscow (RUS), 1990. **Kerch, Crimea (Grief)**. 1942. Gelatin silver print.

Baltz Lewis

Element #27

It might be a half-completed stage holding a show of some of the new art of the 1970s: minimal pieces in wood and plaster and brick. A performer could be imagined in action on the ladders and platforms beyond. Baltz's early photographs, such as this, can be regarded as empty stages, because most of them are actually no more than work sites temporarily abandoned. According to his vision of the USA, which was first announced in detail in his book *The New Industrial Parks near Irvine, California* (1975), the landscape is treated by its owners and by builders as mere material waiting to be shaped. In 1975 Baltz was a participant in the important exhibition, 'New Topographics: Photographs of a Man-Altered Environment', at the George Eastman House in Rochester. He went on to publish *Nevada* in 1978 and *Park City* in 1980, both of which contain photographs of the long-suffering American landscape scarred by new habitation.

☛ Fox Talbot, Ruscha, Sheeler, Struth, Sudek

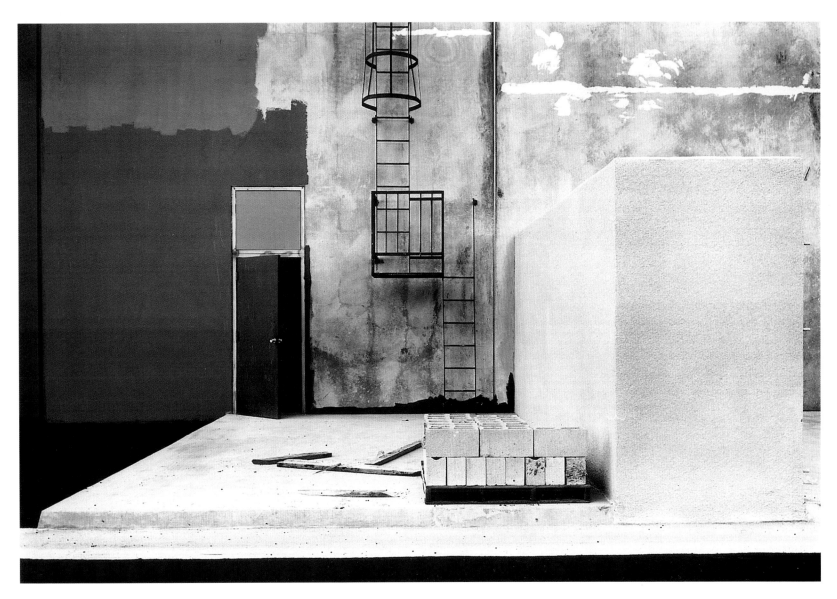

Lewis Baltz. b Newport Beach, CA (USA), 1945. **Element #27**. 1974. Gelatin silver print. **h**20 × **w**25 cm. **h**7¼ × **w**9¾ in.

Bar-Am Micha

High-Security Prison, Beit Lid

The prison inmates, walking two by two, are sufficiently obscured to represent humanity at large, and the barbed wire screen promises to stretch to infinity. This picture of the high-security prison near Beit Lid in Israel could stand for imprisonment in general, irrespective of time and place. Micha Bar-Am's report of 1969 exhibits the prison in detail. Originally intended for Israelis subject to long sentences, the prison was adapted after the Six-Day War of 1967 to house those sentenced for offences against national security. Although known for his reports on the Six-Day War and the Yom Kippur War of 1973, Micha Bar-Am's sympathies appear to lie less with nationalities than with the plight of individuals caught by a system embodied in machinery, barbed wire and spiritual supervision. Prisoners, migrant labourers and Bedouin nomads distressed by the culture of frontiers all figure in his work of the 1970s and 1980s. Bar-Am is a freelance photographer and independent curator.

☛ Freed, Koudelka, de Montizon, Renger-Patzsch

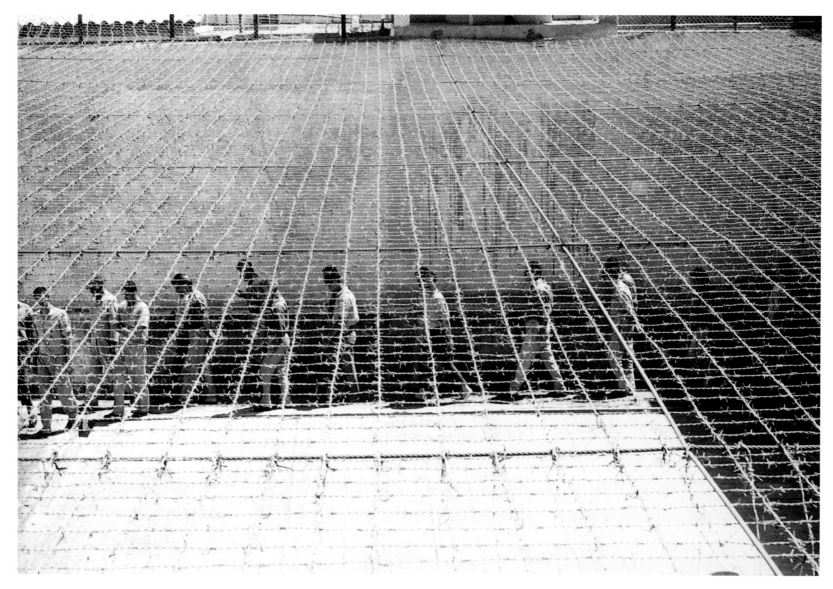

36

Micha Bar-Am. b Berlin (GER), 1930. **High-Security Prison, Beit Lid**. 1969. Gelatin silver print.

Barbey Bruno A Street Scene in Naples

In Naples, near the Vico Scassacocchi in the Quartiere San Lorenzo, a dwarf is begging in the midst of a group of children who respond histrionically to the beggar, to the cameraman and to each other. The participants give their all in their roles, and this has always been a trademark of Barbey's photography. Although he has photographed all over the world, including such war zones as South Vietnam in 1972. Italy has been one of his best sites, for there beggars beg and mourners mourn most fulsomely. Social breakdown may be just over the horizon, but in the meantime Barbey's personnel give themselves willingly to whatever it is they are doing at that moment. He inherited this appreciation of humanity from the generation of the 1950s – from Henri Cartier-Bresson and Robert Frank, for example – but whereas the earlier humanists often thought in representative and heroic terms, his tendency, by contrast, has always been to value the private and the particular.

☞ Bevilacqua, Cartier-Bresson, Doisneau, Levitt, Oddner

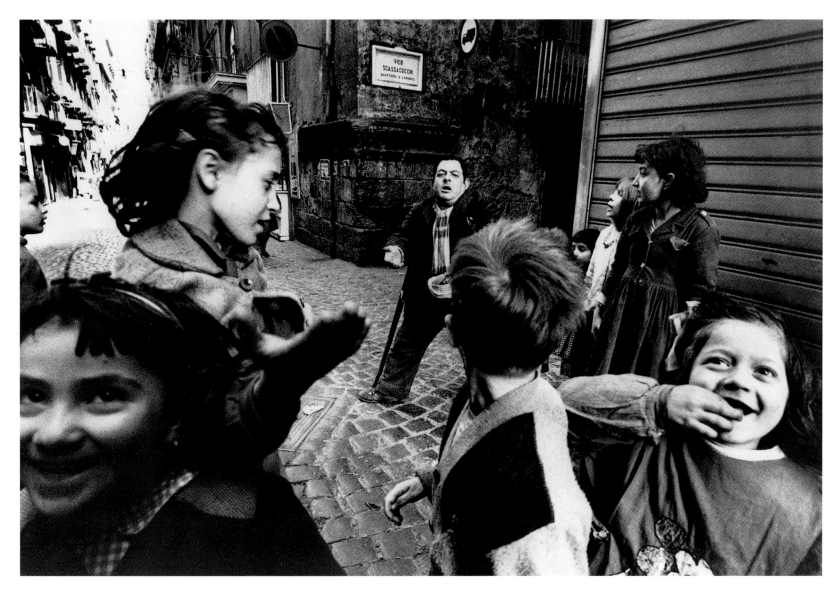

Bruno Barbey. b Berechid (MOR), 1941. **A Street Scene in Naples**. 1963. Gelatin silver print.

Barbieri Olivo

South Tyrol

Either the man is draining nature of its vital forces or vice versa. Barbieri's scene in the South Tyrol carries within it a trace of the old world in the form of the ruined stump, a symbol of the times when Man was pitted against Nature and when oak, pine and the other giants of the forest could stand for a nation. However, the antagonistic matter of ancient and recent Europe is now – at least in 1987 – in the past, overtaken by a small-scale peaceable present, which is represented by plant pots and plastic chairs. The presence of the torpid sunbather, seen next to the slow curve of the hose-pipe, relates this picture to the rest of a body of work dedicated to the slow passage of time, often expressed through long night-time exposures tracked over by the moon and stars. In the late 1980s Barbieri spent time taking photographs in China for a book called *Paesaggi in miniatura*, which shows urban settings littered with goods and inscriptions.

☞ Brigman, Godwin, Goldberg, Joseph

Olivo Barbieri. b Capri (IT), 1954. **South Tyrol**. 1987. C-type print.

Barnard George N.

Charleston Railway Depot

The chimney stack and stove on the right look homely enough. Beyond, stone arcading which could be the remains of a Roman aqueduct marches into the distance. Charleston's railroad depot had been destroyed during the American Civil War by General Sherman's Union forces, who were carrying out a campaign aimed at defeating the Confederacy's armies and destroying its infrastructure. Barnard accompanied the Union armies, and his photographs were published in 1866 as *Photographic Views of Sherman's Campaign*. The American Civil War was fought out between the industrial and democratic North and the agrarian, aristocratic South. These differences were often reflected in the photographic coverage of the war, in which the South – which had none of its own photographers – was presented in terms of classical masonry, often in ruins, and the North by ingenious temporary structures such as trestle bridges and pontoons, evidence of industrial ingenuity.

☛ **Aarsman, Baldus, Clifford, Coburn, Frith**

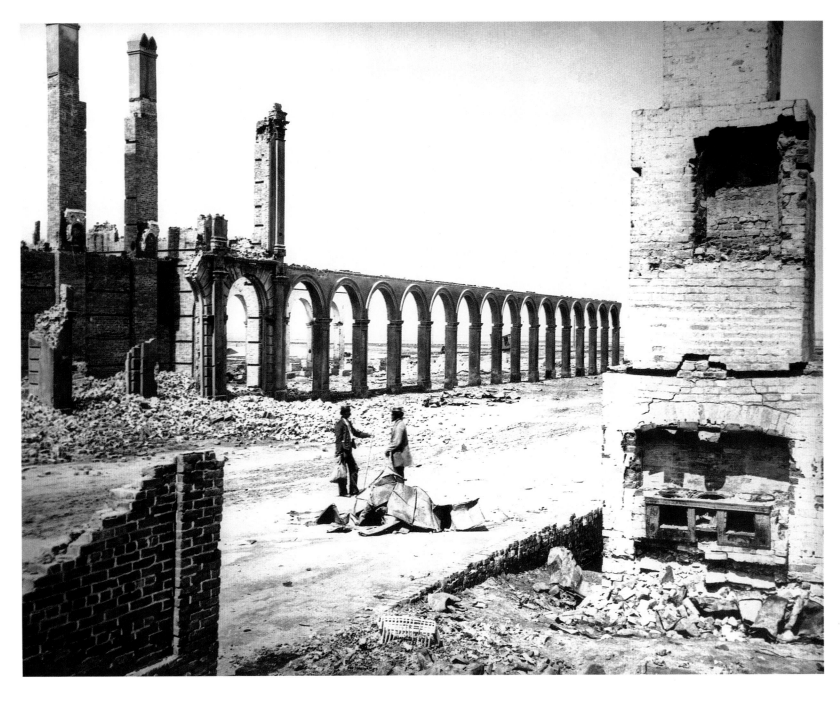

George N. Barnard. b New York (USA), 1819. **d** New York (USA), 1902. **Charleston Railway Depot**. 1866. Albumen print.

Basilico Gabriele

Le Tréport

Le Tréport is a small town on the Normandy coast of France, halfway between Dieppe and Abbeville. From this viewpoint you can pick out the principal features of the town and its hinterland: the port itself, the beach, church, suburbs and factories. Most of Basilico's pictures are inclusive. They are surveyor's pictures which ask audiences to take their time, to put two and two together, or to remark on relationships between structures, and between structures and landscape. Basilico's aesthetic endorses the whole rather than the fragment, and thus tries to transcend mere instances and the kind of small-scale evidence amongst which we usually live. Basilico trained as an architect, and then began to photograph architecture. Between 1984 and 1985 he worked for the admirable French DATAR project documenting coastal landscapes in the Nord-Pas-de-Calais and Normandy. *Porti di Mare* was an award-winning exhibition and book of 1990.

☛ R. Adams, Berry, Davies, Deal, Testino

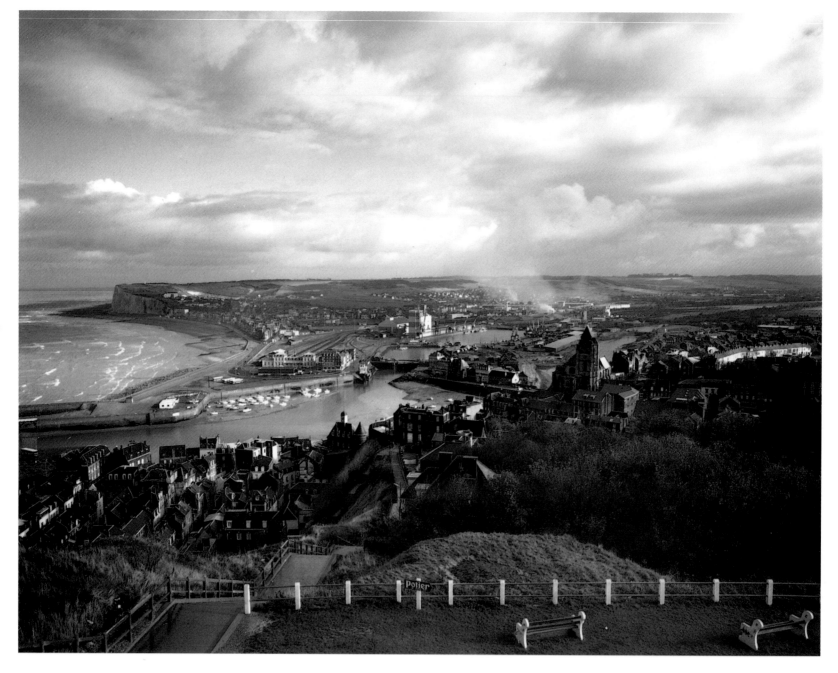

Gabriele Basilico. b Milan (IT), 1944. **Le Tréport**. 1985. Gelatin silver print.

Battaglia Letizia

The Murder of Judge Cesare Terranova

Judge Cesare Terranova has been shot dead by Mafia gunmen at the wheel of his car. This photograph, which is an example of pure reportage, has been taken from the point-of-view of the police or of a passer-by. Battaglia's purpose in the late 1970s and early 1980s, was to disclose the murderous work of the Mafia in Sicily. After experience as a journalist for the daily newspaper *L'Ora*, she took up photography in 1974. In 1977, with Franco Zecchin, she founded a cultural centre for photography in Palermo and worked at the Sicilian documentation centre, Giuseppe Impastato, named after a young Mafia victim. In 1986 she set up, with Valeria Ayovalosit, the publishing house, La Luna, dedicated to the promotion of women's literature. In 1985 she was awarded the W. Eugene Smith prize for social reportage. Instances of her photography appear in *Chroniques Siciliennes*, introduced by Marcelle Padovani and published in 1989.

☛ **Eppridge, Gardner, McCullin, Silk, Zecchin**

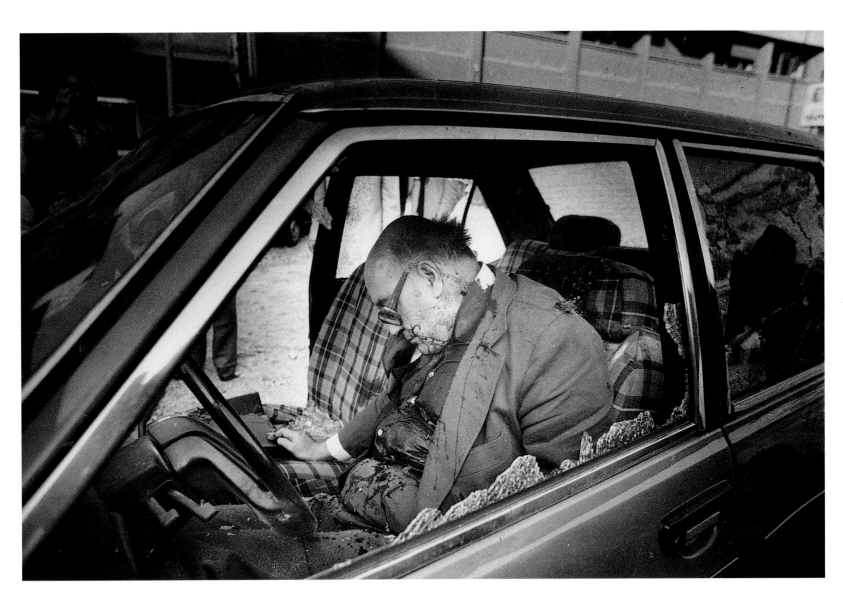

Letizia Battaglia. b Palermo (IT), 1935. **The Murder of Judge Cesare Terranova**. 1979. Gelatin silver print.

Bayard Hippolyte

The Drowned Man

The subject – according to a long inscription on the back of the print – is Bayard himself, appearing as a drowned man in his own composition. His closed eyes are explained by the length of time needed for the exposure. The straw hat was probably included to fill the dark space on the left, and maybe even to allude to the sun and to the tanned face and hands of the artist

and the pallor of his body. Bayard was always most careful and poetic in his arrangement of pictures, all of which require a degree of interpretation. This is the first fictional image in photography, and was apparently devised as a protest against official indifference to his discovery in 1839 of a direct positive process for use on paper. Government support and recognition

had gone instead to Louis-Jacques Daguerre, who simultaneously announced a way of fixing direct positive images on treated metal surfaces (the daguerreotype).

☛ Daguerre, Hurn, Jokela, Kalvar, Luskačová, L. Miller

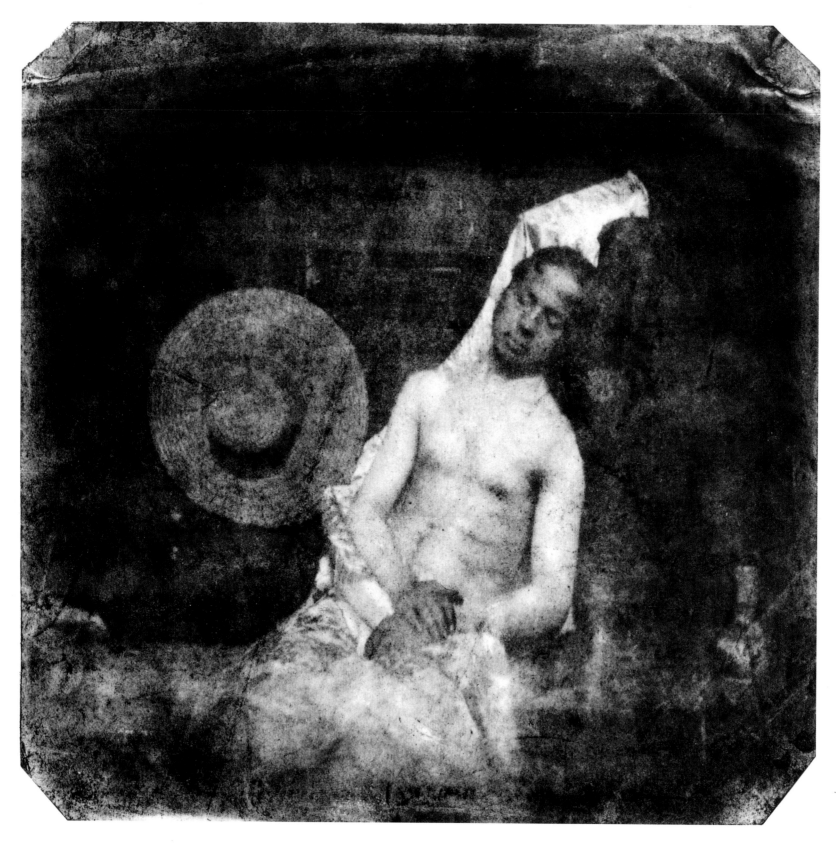

Hippolyte Bayard. b Breteuil-sur-Noye (FR), 1801. d Nemours (FR), 1887. **The Drowned Man**. 1840. Direct positive print.

Beato Felice A.

The Pei-t'ang Fort

The British army are shown relaxing at their new headquarters at Pei-t'ang Fort following its capture from the Chinese on 2 August 1860. In bright sunlight and a stiff breeze, the British seem to be taking stock of their new premises, although the informal arrangement may have been deliberately managed by Beato to register the scale of the bastion. The debris includes a Chinese wooden cannon bound with leather. Beato, the first Western photographer to take pictures in China, was accompanying a British and French expeditionary force sent to conclude a treaty with the Manchu government in the north of the country. Beato worked originally with James Robertson, whom he met in Malta in 1850. Together they took pictures of the Fall of Sebastopol in the Crimean War of 1855, and then the aftermath of the Indian Mutiny in 1857–8. Robertson remained in India when Beato went on to China. Between 1862 and 1877 he worked in Japan.

☞ Chambi, Hurn, Marubi, O'Sullivan

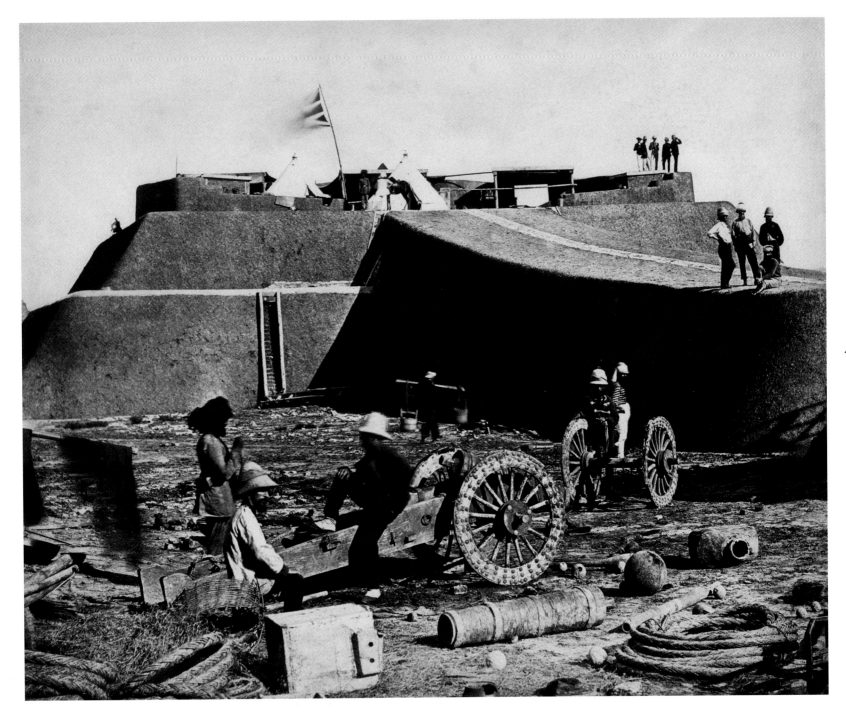

Felice A. Beato. b Venice (IT), c1830. d Mandalay (BUR), 1906. **The Pei-t'ang Fort**. 1860. Albumen print.

Beaton Cecil

Dame Edith Sitwell

Edith Sitwell was a notable society figure and poetess of the 1920s and after. She was a devotee of 'dressing-up' who thought of the literary life (in Kenneth Tynan's terms) 'as a sober, straight-faced charade' to participate in which she must disguise herself 'with heirlooms, with rattling beads or peacock's plumes'. Edith Sitwell worked in Hollywood in the early 1950s on a script for a film on the life of Elizabeth I. One of Cecil Beaton's very first pictures to be published, in *The Sketch* of November 1927, showed Edith Sitwell (described by Beaton as 'a tall graceful scarecrow'), lying in state as if dead between statues on a tiled floor. Beaton's fear, in a long life as a photographer and as a costume and set designer in the theatre, was of boredom and stagnation. Always a portraitist, he was also a fashion photographer of repute and a highly regarded stylist. His portraits appear most notably in *Persona Grata* (1953), with texts by the theatre critic Kenneth Tynan.

☞ Callahan, Lele, McDean, Ruff, Strömholm

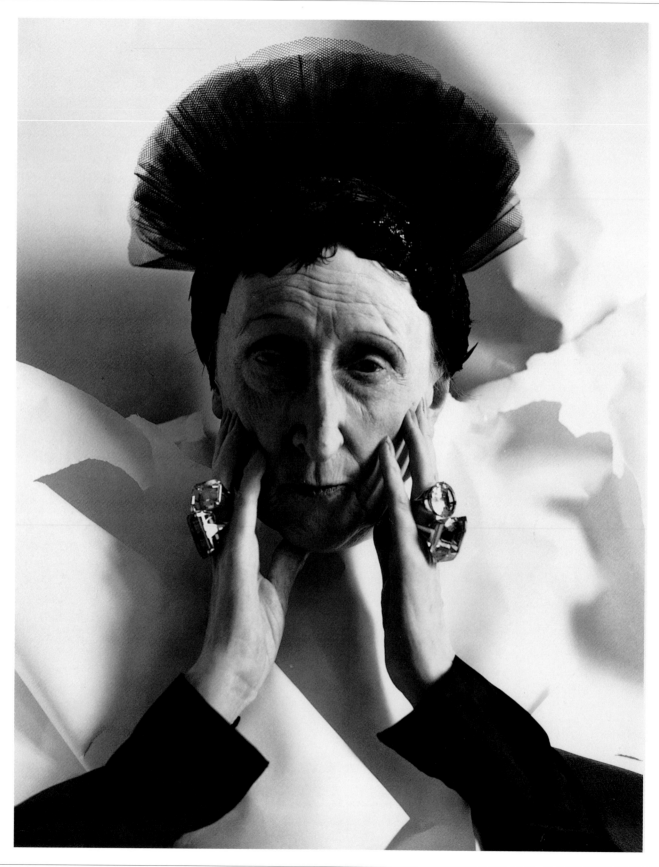

Cecil Beaton. b London (UK), 1904. d Broadchalke (UK), 1980. **Dame Edith Sitwell**. 1956. Gelatin silver print.

Becher Bernd & Hilla Industrial Facades #23

When the Bechers' pictures of industrial installations are shown together in groups, they invite comparison and study. The point at issue here seems to involve industrial facades and their decoration. Why should they be decorated at all, and if they are, why should they adopt particular styles, such as the Romanesque in these instances? The Bechers' first important book on

industrial building, *Anonymous Sculptures: A Typology of Technical Construction*, was published in 1970. Since then there have been many other books, including *Water Towers* in 1988 and *Blast Furnaces* in 1990. The Bechers like to draw attention to the grandeur of industrial buildings, but their chief aim is to invite audiences to pay close attention to the processes under

consideration – and to become aware of that often involuntary attention. During the 1970s Bernd Becher was an influential teacher of photography at the Art Academy in Düsseldorf, where his students included Andreas Gursky and Candida Höfer.

☞ Baldessari, Berman, Calle, Gursky, Höfer, Michals

 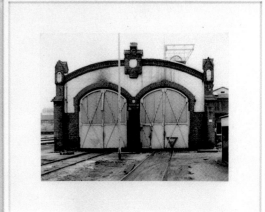

Bernd Becher. **b** Siegen (GER), 1931. **Hilla Becher**. **b** Potsdam (GER), 1934. **Industrial Facades #23**. c1980. Six gelatin silver prints. Each **h**94 × **w**173cm. **h**37 × **w**68 in.

Bellocq Ernest James Storyville Portrait

The woman is drawing a butterfly on a bare wall. In classical mythology butterflies stood for Psyche or the soul, especially in relation to its entombment in the body. The subject was a prostitute in the Storyville district of New Orleans, one of many photographed by E. J. Bellocq. On his death, eighty-nine glass plates containing portraits of Storyville prostitutes were discovered in his desk drawer. Some of their faces had been erased. Bellocq worked as a commercial photographer for the Foundation Shipbuilding Company, but devoted his spare time to composing portraits of prostitutes and of smokers in the opium dens of New Orleans. His plates were acquired by a gallery owner, and then bought by the photographer Lee Friedlander, who made positive prints on printing-out paper. As Friedlander suspected, the pictures turned out to be amongst the most sympathetic portraits ever taken – and they immediately entered the canon of the medium's great pictures.

☞ Cunningham, Friedlander, Horst, Roversi, Weston

46

Ernest James Bellocq. b New Orleans, LA (USA), 1873. **d** New Orleans, LA (USA), 1949. **Storyville Portrait**. c1912. Gold-toned print.

Berengo Gardin Gianni Gypsy Camp, Trento (Italy)

Gypsy musicians need to know how to present themselves for audiences, even if their rehearsal rooms are as improvised as this. The girl seems to be taking note and the youngsters are waiting their turn. Together the group seems quite unselfconscious and intent, as if acting out a scene agreed with the photographer. Gianni Berengo Gardin is one of the great generation of poetic

documentarists who like to compose with an idea in mind – in this instance the idea is that of rehearsal and the making of appearances. He was influenced, like every other major documentarist of the 1960s and after, by Henri Cartier-Bresson and the work of the American Farm Security Administration; and his sympathies have always been for those whose day-to-day

activities support the fabric of society: workers, doctors, priests and even itinerant musicians. A member of the influential La Gondola group in Venice in 1954, Gardin is a specialist in that city, and the first of his many books was *Venise des Saisons* (1965).

☛ **Allard, C. Capa, Cartier-Bresson, Hawarden, Shahn**

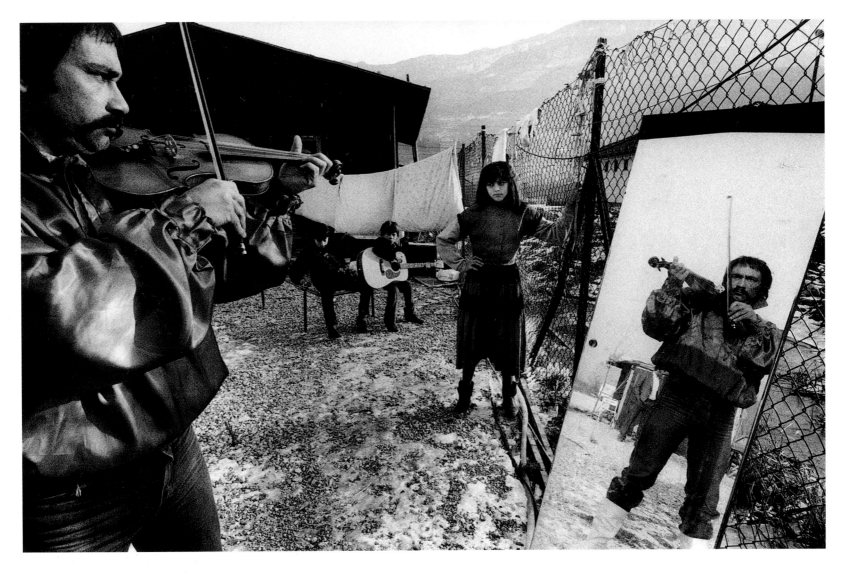

Gianni Berengo Gardin. b Santa Margherita Ligure (IT), 1930. **Gypsy Camp, Trento (Italy)**. 1985. Gelatin silver print.

Beresford G. C.

Leslie Stephen and his Daughter Virginia (Woolf)

Leslie Stephen, the editor of the British *Dictionary of National Biography*, is turning towards his daughter Virginia, the future Virginia Woolf. Soft focus was in fashion when this photograph was taken. Here it invests the young woman with an aura of the spiritual, in contrast to her father, who seems to be from the material world. Perhaps he is offering advice for the journey ahead, and the gravity of their demeanour suggests something like foreknowledge. Beresford had few subjects as rewarding as Leslie Stephen and his daughter. He was a portraitist primarily of the sensible middle classes and of military officers during World War I. Some of the giddier styles in British portraiture in the 1920s were partly a reaction to his sobriety. From 1902 to 1932 he had a portrait studio in Yeoman's Row, off the Brompton Road in London. Beresford is said to have been the model for M'Turk, a senior schoolboy in Rudyard Kipling's *Stalky & Co.* of 1899 who specialized in 'affairs of art'.

☛ **Disfarmer, van der Keuken, W. Miller, Vishniac**

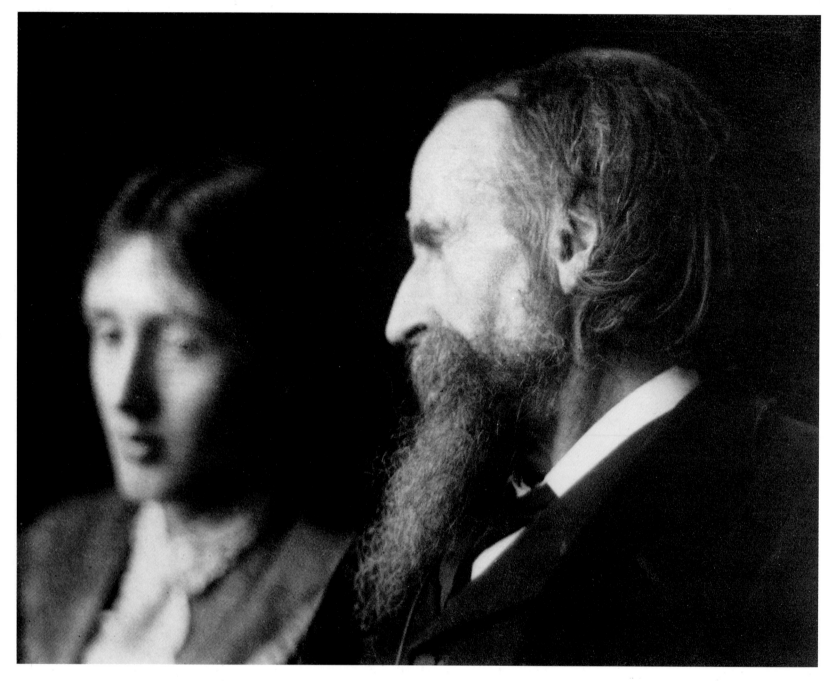

48

G. C. Beresford. b Ireland (UK), 1864. **d** Brighton (UK), 1938. **Leslie Stephen and his Daughter Virginia (Woolf)**, c1902. Gelatin silver print.

Berman Wallace

Untitled (A1-Cross)

The basis of all Berman's collages, which he began work on in 1964, is a picture of a hand-held transistor radio. Onto this he would place verifaxed images taken from popular culture and the natural world – a snake and a mushroom in this case. Verifax was an early photocopying process and Berman sometimes enhanced the results with hand-colouring. His art was premised – like that of Andy Warhol in New York – on the idea of a national consciousness somehow held together by representative popular imagery. Warhol magnified Presley, Monroe and all the other icons, as if they belonged to a world apart and beyond reach. Berman's proposal, on the other hand, was that there exists an image-bank of minor motifs under the control of a public which can choose and re-combine these images for itself. Berman, who was the publisher of the art and poetry journal *Semina* between 1955 and 1964, was a major influence on the developing art of Los Angeles during the 1960s.

☞ Becher, Calle, Heinecken, Warhol

Wallace Berman. b Staten Island, NY (USA), 1926. d Topanga, CA (USA), 1976. **Untitled (A1-Cross)**. 1970. Verifax collage. **h**35½ × **w**33 cm. **h**14 × **w**13 in.

Berry Ian

Whitby, Yorkshire

Berry's subjects, although ostensibly watching yachts race in the harbour at Whitby, seem wrapped up in their own thoughts or – like the younger man in the front – simply content to take in the sun. This picture introduces *The English*, Ian Berry's book of 1978. Having worked as a photojournalist in South Africa during the 1950s and lived in France in the early 1960s,

Berry was in a position to look at England from the outside. Whitby, a port in north Yorkshire, is important in photographic history as the home town of Frank Meadow Sutcliffe, a renowned photographer of the 1880s and 1890s, whose name was often cited during the revival of British photography in the 1970s. Famous then as now for its ancient abbey, Whitby was,

in Sutcliffe's day, an active port and market town. Berry's loyalties as a reporter in the news zones – especially in South Africa in the 1980s – have always been to presence and self-possession of the kind on show here.

☛ **Basilico, Hurn, Oorthuys, Sutcliffe**

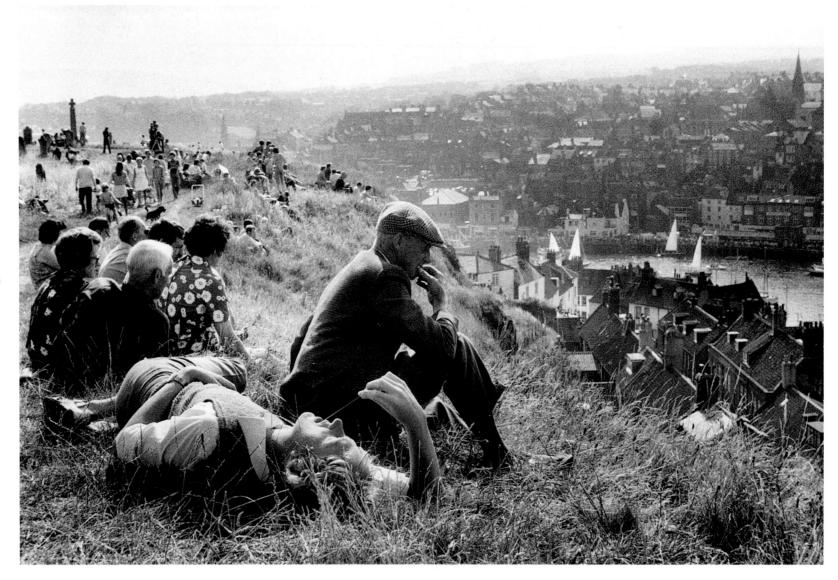

Ian Berry. b Preston (UK), 1934. **Whitby, Yorkshire**. 1978. Gelatin silver print.

Besnyö Eva

Starnberger Street

Starnberger Street appears to be nowhere in particular, nothing more than a transit zone peopled by a few pedestrians. A taxi has just drawn up, next to an advertising column on the pavement. Beyond there is a relatively ordinary café; very long shadows are being cast everywhere, suggesting that it may be late in the afternoon. In other words, everything here points elsewhere: the pedestrians and the taxi are en route; whatever is advertised is not visible; with the sun in that position the street will soon be dark. Photographers in 1931 were fascinated by the idea that the instant could be savoured and that it was ripe with other succeeding moments. This aesthetic reflected the adventurous circumstances of the time and the sense of anticipation. In the autumn of 1932 political pressures forced Besnyö to move from her native Hungary to Amsterdam, where she still remains, active mainly as an architectural photographer and reporter.

☞ **Abbott, Atget, Daguerre, Gruyaert**

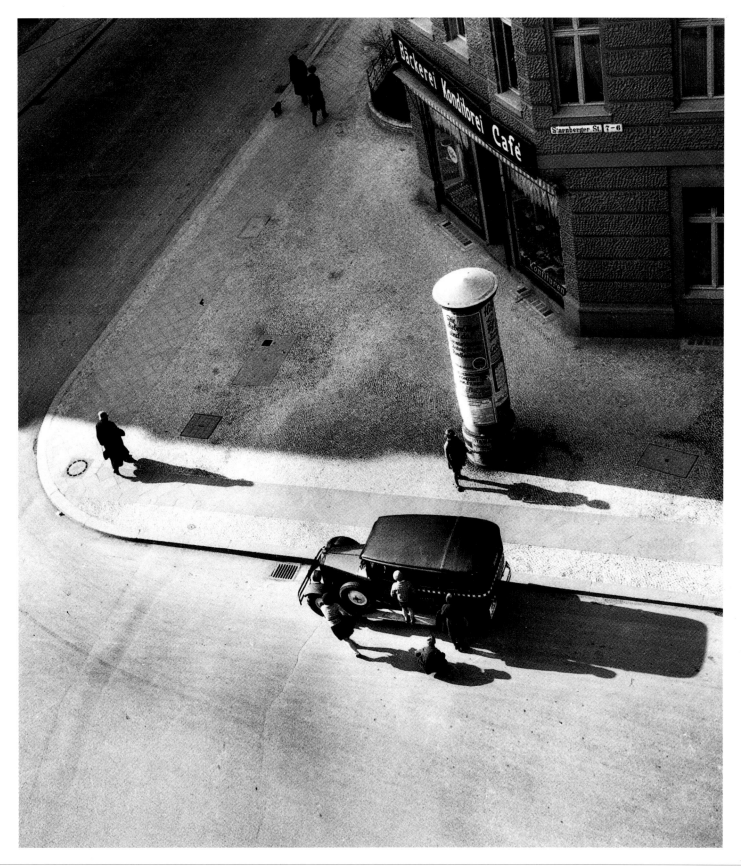

Eva Besnyö. **b** Budapest (HUN), 1910. **Starnberger Street**. 1931. Gelatin silver print.

Bevilacqua Carlo Catari

The shimmering dress of the older girl gives voice to the group's exuberance. Bevilacqua, who became one of Italy's most distinguished photographers in the 1950s, only turned to photography in 1942, and he remained an amateur. He worked all his life in his family's textile business in Cormons in Friuli in the north-east of Italy, and took up photography as a result of deafness which barred him from more sociable and collective activities. Bevilacqua was interested in photography as an art, at a time when reportage and documentary were in the ascendant. In 1951 he joined a photographic group centred on Venice and called La Gondola and then in 1955 he enrolled in The Friulian Group for a New Photography, an organization dedicated to 'a poetic documentation' of the people of Friuli. Although his pictures are of working people, his tendency was always to symbolize conditions and states of mind: Youth and Age, for example, or Love and Envy.

☞ **Barbey, Brandt, Konttinen, Levitt, Parkinson**

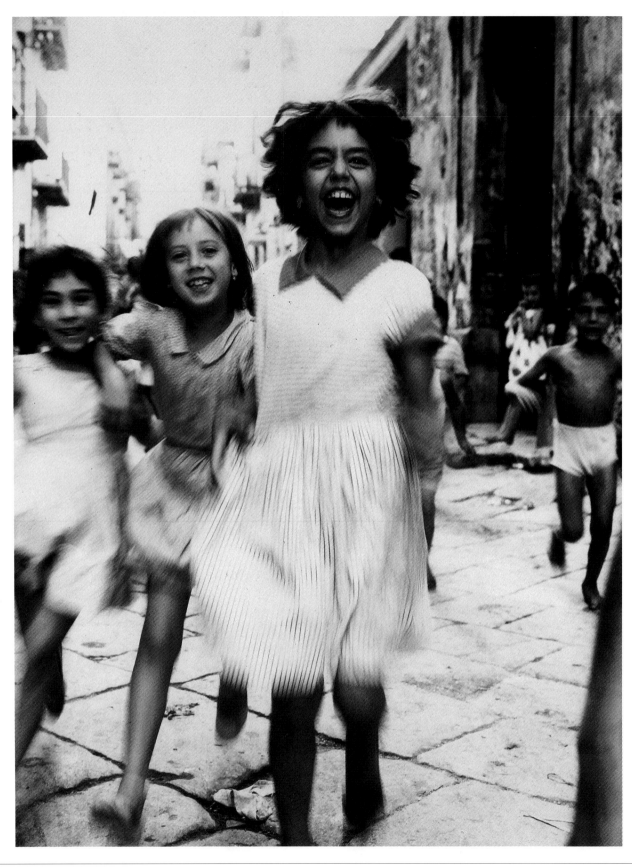

Carlo Bevilacqua. b Cormons (IT), 1900. d Cormons (IT), 1987. **Catari**. 1960. Gelatin silver print.

Billingham Richard Untitled

The broken patterns on the woman's dress echo the complexity of the jigsaw puzzle in front of her. Eventually the pieces will fit together to make a completed figure, which will be as clearly identifiable as the word SKY on the blue cigarette packet. The idea may be that the puzzle-solving stands for mending lives broken into pieces. This is Elizabeth, the photographer's mother, who appears in Billingham's celebrated family album of 1996 called *Ray's a Laugh*, a title from a bygone radio comedy programme. The point about the Billingham family is that it survives against the odds, with a father who is a chronic alcoholic and a mother who copes and smokes. Billingham's study is a corrective to the melodramatic but well-turned out soap operas on British television. His tactic is to go in close enough to ornaments, wallpaper and skin texture to bring the milieu to believable life; his intention is to acknowledge and not to sit in judgement.

☛ Andriesse, Dührkoop, Pécsi, Wilding

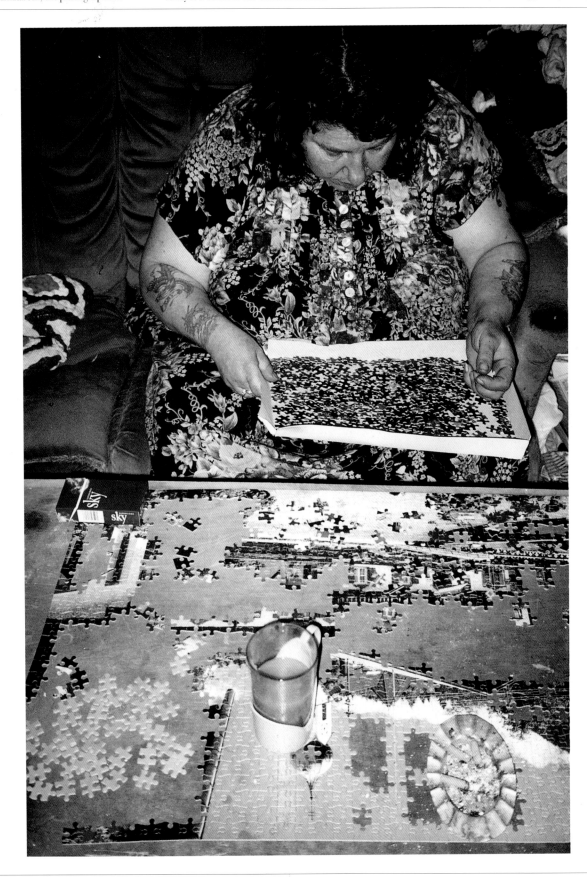

Richard Billingham. b Birmingham (UK), 1970. **Untitled**. 1995. C-type print.

Bischof Werner

Andean Boy, Cuzco

In an idyllic scene a boy plays his pipe as he walks along a mountain road on the way to Cuzco, Peru. Bischof, who was an international photojournalist, took many affecting pictures of children as symbols of a better future. A visionary, he wanted to see the world re-civilized and he believed that photography could demonstrate how this might be achieved. Although he covered both the Korean and Indo-China Wars, family and social life were his preferred topics because they spoke of continuity, rather than the wholesale renovation favoured by the totalitarians. Many of his pictures are of musicians, dancers and the cultural life of tradition-conscious communities. He found an exemplary world in traditional Japan, which he made the subject of an important book published in 1954. In the same year Bischof was killed in a car accident in the Andes, shortly after this picture was taken.

☛ Alpert, Arbus, Lengyel, Shahn

54

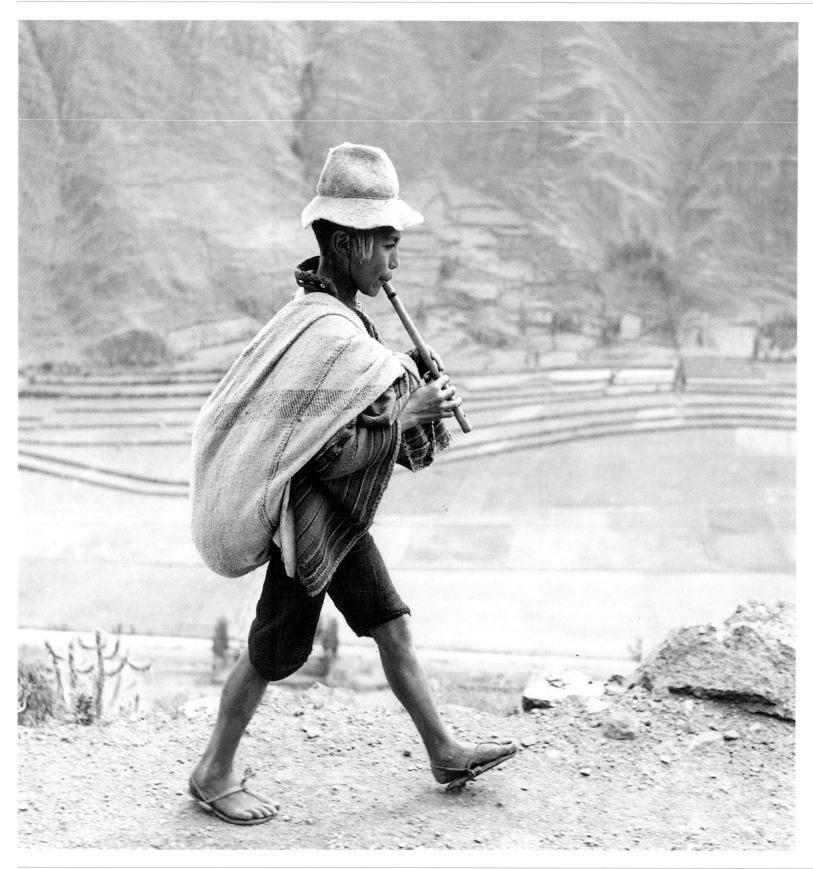

Werner Bischof. b Zurich (SW), 1916. **d** Andes (PER), 1954. **Andean Boy, Cuzco**. 1954. Gelatin silver print.

Bisson Louis-Auguste & Auguste-Rosalie Saint-Ursin, Bourges

This picture of a figure gazing up at the portal and tympanum of the Church of Saint-Ursin at Bourges is other than it seems. In reality, it would be almost impossible to see those carved fables and labours of the months from such a close vantage point and yet if he were to tilt his head further back, his hat would fall off and if he were to step back, he would be too close to the camera. What emerges, then, is a tableau devoted to the concept of seeing. Without that spectator, it would merely be a picture of a famous portal; with the spectator, it becomes a representation of the act of viewing the portal and thus of interest to a generation brought up on the pleasures of Conceptual Art. This is Plate 23 in a series of 201 plates taken by the Bisson brothers to show highlights of French architecture and sculpture from the Middle Ages to the Renaissance. Established in a fashionable quarter of Paris, the studio of 'Bisson Frères' opened in 1841.

☛ Dupain, F. H. Evans, W. Evans, Johnston, Yavno

Louis-Auguste Bisson. b Paris (FR), 1814. **d** Paris (FR), 1876. **Auguste-Rosalie Bisson. b** Paris (FR), 1826. **d** Paris (FR), 1900. **Saint-Ursin, Bourges**. 1853. Albumen print.

Blossfeldt Karl Oriental Poppy

The seed pod of an oriental poppy has been magnified five times and printed in monochrome. This process has created a sculptural effect and made the poppy head look like a cast-iron ornamental feature. Blossfeldt began to take his photographs of living plants at the beginning of the century and many of his details of buds, stems and leaves recall the Art Nouveau metalwork of the time. The pictures were originally taken to provide no more than easily accessible material to be copied by Blossfeldt's students at the Arts and Crafts College in Berlin. In 1928 the images were published in *Urformen der Kunst* (translated as *Art Forms in Nature*). The book was successful amongst artists, and was seen as supporting the new 'straight' photography of the 1920s. It is also possible that the pictures were admired as fetishes, outlandish elements in keeping with the Surrealist spirit of the late 1920s.

☞ de Meyer, Modotti, Parker, Penn, Tosani

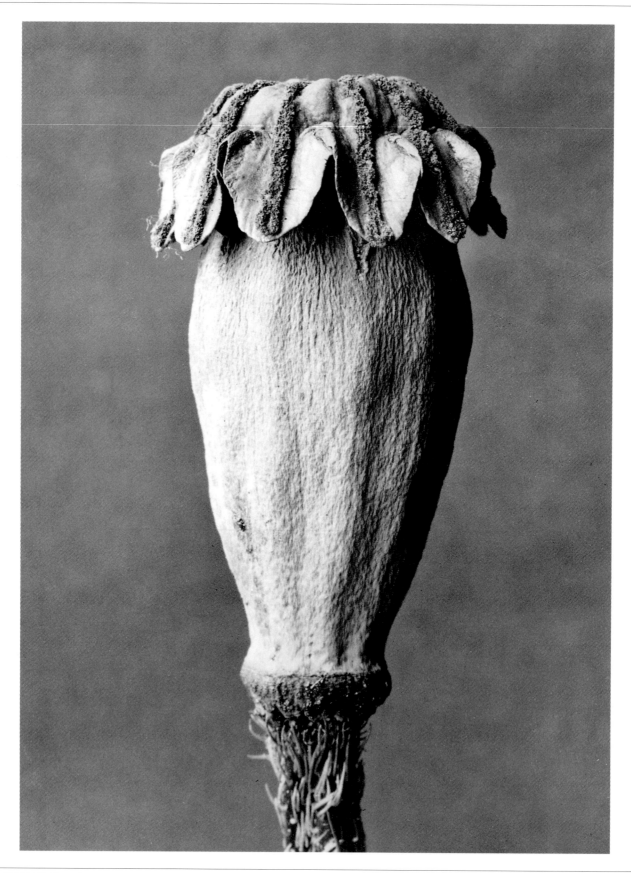

Karl Blossfeldt. b Schielo (GER), 1865. **d** Berlin (GER), 1932. **Oriental Poppy**. c1920. Gelatin silver print.

Blume Anna & Bernhard Transcendental Constructivism

Anna Blume looks astonished at the sight of a white Suprematist square hovering above her kitchen table. The vision seems to have shaken her to her foundations. This pair of pictures is part of a series in which the photographers appear as 'mediums and victims of involuntary constructs'. In this picture, artistic creativity – as represented by a work of art by the Russian painter Kasimir Malevich – has surprised a housewife in the thick of ordinary life. Since the 1970s the Blumes have been taking staged photographs in which they present themselves as very ordinary citizens confronted by large-scale social and aesthetic questions. The world, as they see it, has got out of hand, and they can do no more than serve as stunned witnesses. In doing this they are continuing a German tradition of staged photo-narratives which dates back to the 1920s and early 1930s, the heyday of the illustrated press.

☞ Boubat, van Elk, Newman, Silverstone

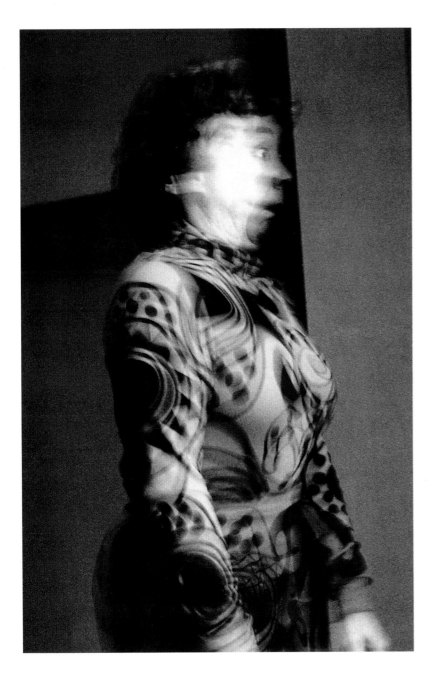

Anna Blume. b Bork (GER), 1937. **Bernhard Blume**. b Dortmund (GER), 1937. **Transcendental Constructivism**. c1993. Two gelatin silver prints. Each **h**126 × **w**81 cm. **h**49½ × **w**31¼ in.

Blumenfeld Erwin

Lisa Fonssagrives

Standing amongst the girders of the Eiffel Tower, Lisa Fonssagrives is modelling a dress by Lucian Lelong. Blumenfeld's pictures of her appeared in the May 1939 issue of French *Vogue*, as part of a twenty-page portfolio marking the fiftieth anniversary of the construction of the Eiffel Tower. Reportage, as it developed from the late 1920s onwards,

ventured out-of-doors into the real and often dangerous world – and fashion soon followed. Blumenfeld became a noted exponent of the heroic, handsome style in fashion photography which was especially associated with *Harper's Bazaar*, where he worked from the summer of 1939. A Berliner, Blumenfeld served as an ambulance driver during World War II, before

setting up a leather goods business in Amsterdam. Bankruptcy forced him into photography, which was at first no more than a hobby. In 1941 he emigrated to New York, and in 1944 he returned to *Vogue* on a lucrative contract.

☛ Bailey, Dahl-Wolfe, Frissell, Gimpel, Teller, Testino

58

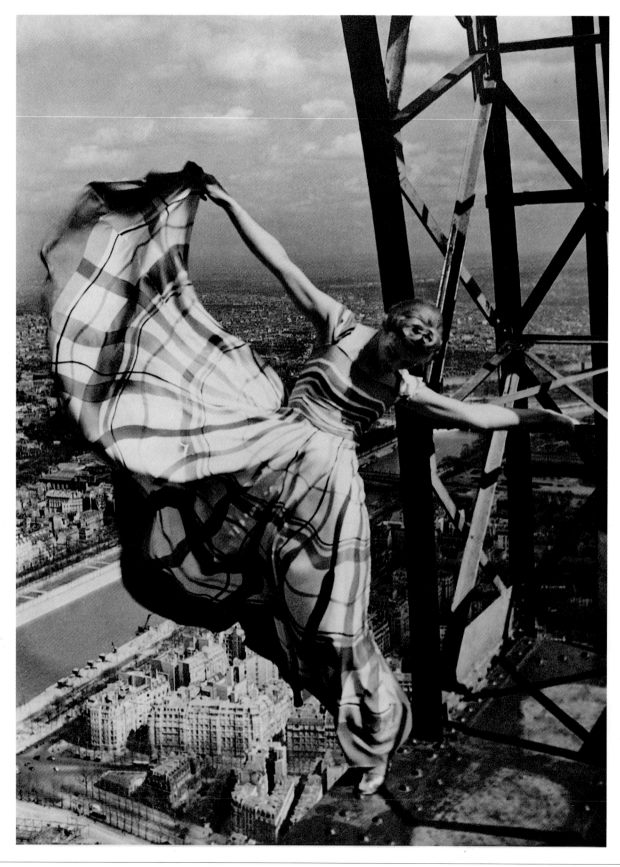

Erwin Blumenfeld. **b** Berlin (GER), 1897. **d** Rome (IT), 1969. **Lisa Fonssagrives**. 1939. Gelatin silver print.

Boonstra Rommert

Untitled

Cones or chimneys from an old industrial world order fragment and topple against a misty background of crumpled paper. A flame gutters, and an eagle stretches its wings. Boonstra, an exponent in the 1980s of staged photography which made use of painted models and back-projections, liked to imagine the last days of civilizations abandoned and swept by storm and fire. Staging allowed him to call up memories of the Lost City of Atlantis and the Tower of Babel, producing pictures which had a dramatic sense of catastrophe. Boonstra was one of a new wave of Rotterdam artists who established that city as the capital of Dutch photography as well as an Amusement Park for Culture. He participated in the very important 'Fotografia Buffa' exhibition of constructed photography in Groningen in 1986 – an exhibition which summed up the achievements of Dutch installation photography in the 1980s.

☛ Bourdin, Fontcuberta, Lanting, Mylayne

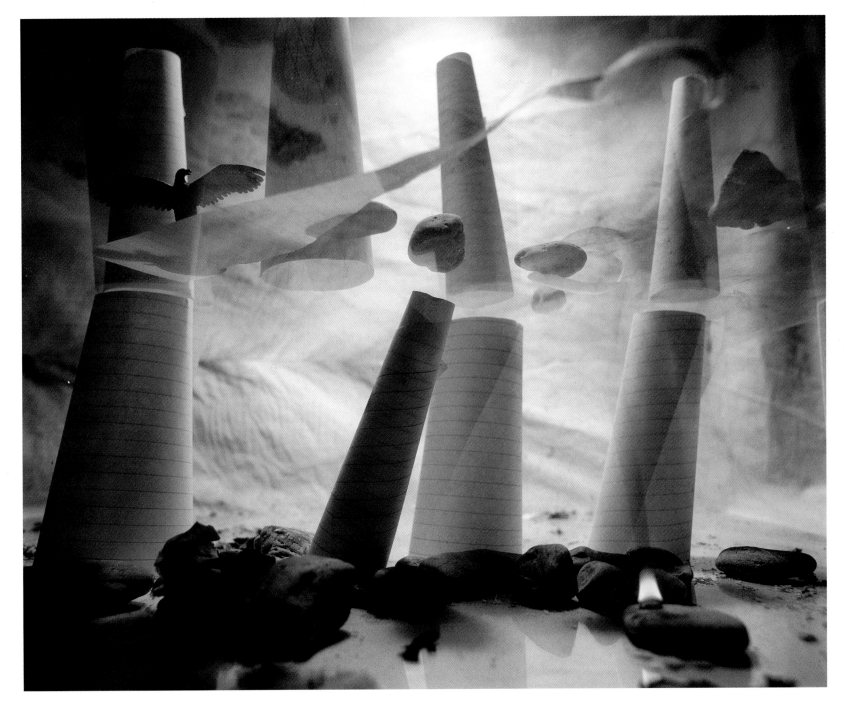

Rommert Boonstra. b Groningen (NL), 1942. **Untitled**. 1984. Cibachrome. **h**50 × **w**60 cm. **h**19½ × **w**23½ in.

Bosshard Walter Portrait of Mao Tse-Tung

A Chinese man in a worker's cotton jacket is gazing into the distance, looking more thoughtful than heroic. This is a picture of the formidable Mao Tse-Tung, the future founder of the People's Republic of China. At this point he has everything still ahead of him, including the Long March and the Cultural Revolution. Bosshard was one of the major photo-reporters in Europe in the 1920s. He was an indefatigable writer and traveller, visiting India, Indonesia and China, and at first using photographs simply as a supplement to his notes. In 1929–30 he was commissioned by the *Münchner Illustrierte* newspaper to report on India – and on Mahatma Gandhi in particular. The Ullstein press organization in Berlin then sent him to China and to Mongolia. In the summer of 1932 Bosshard made an Arctic flight aboard the airship *Graf Zeppelin* for the *Berliner Illustrierte* newspaper. He lived in Peking until the Communist victory in 1949.

☞ **Aigner, Bourke-White, Brady, Karsh, Reed, Salomon**

60

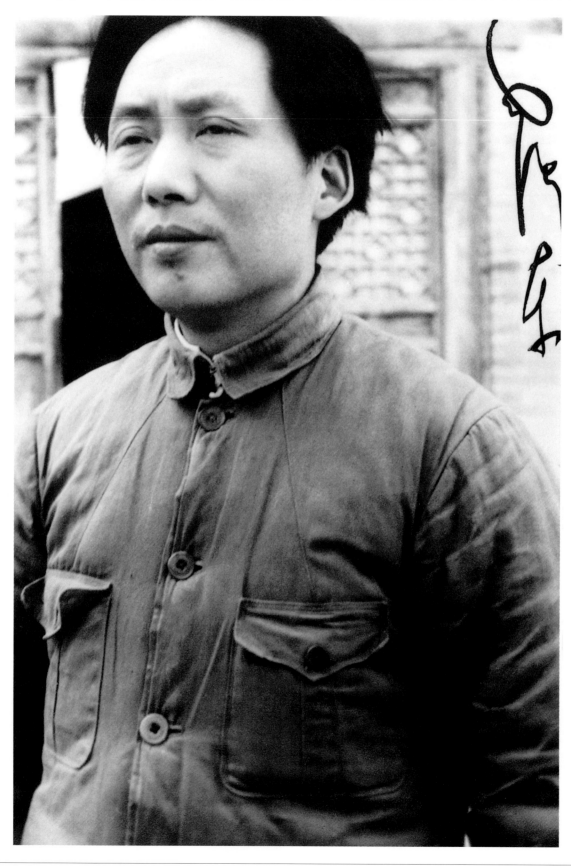

Walter Bosshard. b Samstagem (SW), 1892. **d** Ronda (SP), 1975. **Portrait of Mao Tse-Tung.** 1938. Gelatin silver print.

Boubat Édouard

Lella, Brittany

Lella was one of the photographer's sister's friends. In an interview Boubat described these friends, who were among his earliest photographic subjects, as being each one more beautiful than the rest. Here he may be proposing that Lella is some handsome epitome of France resurgent, for the war was not long over. The face in the background, by contrast, looks older and anxious, as if to confirm Lella in her beauty. Boubat, who studied photogravure at the Ecole Estienne in Paris during the war, admits to being self-taught in photography itself. Nevertheless, his ability to make an art out of 'instants in which nothing happens' was in keeping with a post-war ethos which stressed respect for others. His approach to his subjects was companionable and conversational. Boubat's first exhibition was at La Hune bookshop on the Left Bank and was prompted by Robert Delpire, who would become the most influential publisher of new photography in the 1950s.

☞ **Cameron, Furuya, Newman, Sieff, Southworth & Hawes**

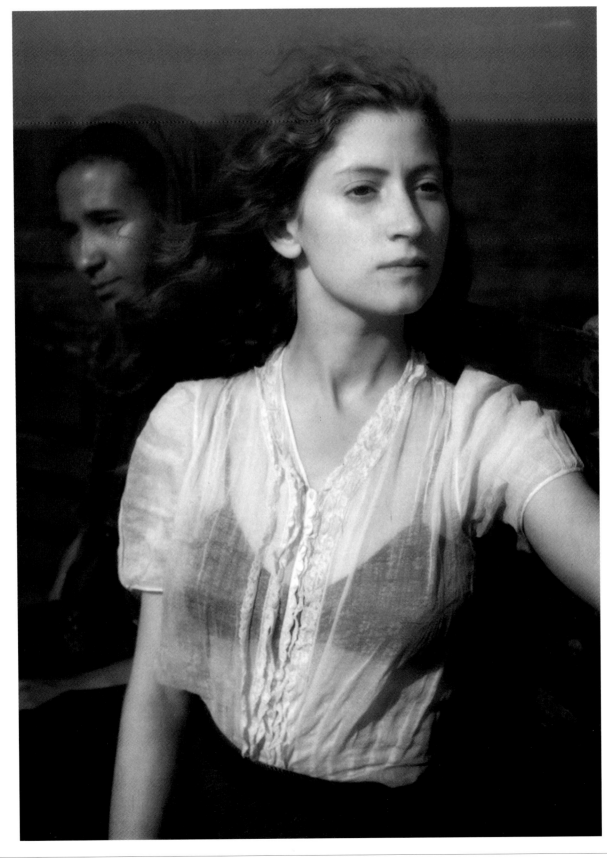

Édouard Boubat. b Paris (FR), 1923. **Lella, Brittany.** 1947. Gelatin silver print.

Bourdin Guy Untitled

Rocks signify nature and the longer stretches of geological time. Packaging, on the other hand, points to culture and a transient state of affairs. The red shoes, too, look completely out of place amongst the tumbled stones. Do they imply cataclysmic and misguided shopping, or a collection assembled by aliens? Bourdin, whose images are often mysterious, said: 'For me photography is a means of expressing my wonderment at objects or certain people, a way of celebrating the poetry of nature or the melancholy of passing time…' He began to work as a painter and photographer in Paris in 1952, and in 1955 became a professional fashion and advertising photographer. He broke with tradition in that he remained above all an artist and inventor, somewhat in the manner of Man Ray whom he admired. He associated fashion – Charles Jourdain shoes, in this case – with the radical styles of vanguard art in the 1960s.

☛ Boonstra, Connor, den Hollander, Man Ray, Watkins

62

Guy Bourdin. b Paris (FR), 1928. **d** Paris (FR), 1991. **Untitled**. c1978. C-type print.

Bourke-White Margaret Mahatma Gandhi

Gandhi adopted the *charka*, a primitive spinning wheel, as a symbol of India's struggle for independence. Before they would allow Bourke-White to photograph him, Gandhi's secretaries made sure she learnt how to use the spinning wheel and they restricted her to three flash bulbs because he was troubled by bright lights. Bourke-White went to India in early 1946 on assignment from *Life* magazine and she covered events on the sub-continent for the next two years. Gandhi symbolized hopes for a peaceful, civilized future but was assassinated in 1948, not long after being interviewed by Bourke-White. A classic reporter in the great age of photojournalism, she first came to notice in 1931 with a report from the USSR, *Eyes on Russia*. She is best known, however, for her two books on the USA in economic crisis, both of which had texts prepared by her husband, the writer Erskine Caldwell. Their titles were *You Have Seen Their Faces* (1937) and *Say, Is This the USA* (1941).

☛ Aigner, Bosshard, Karsh, Salomon

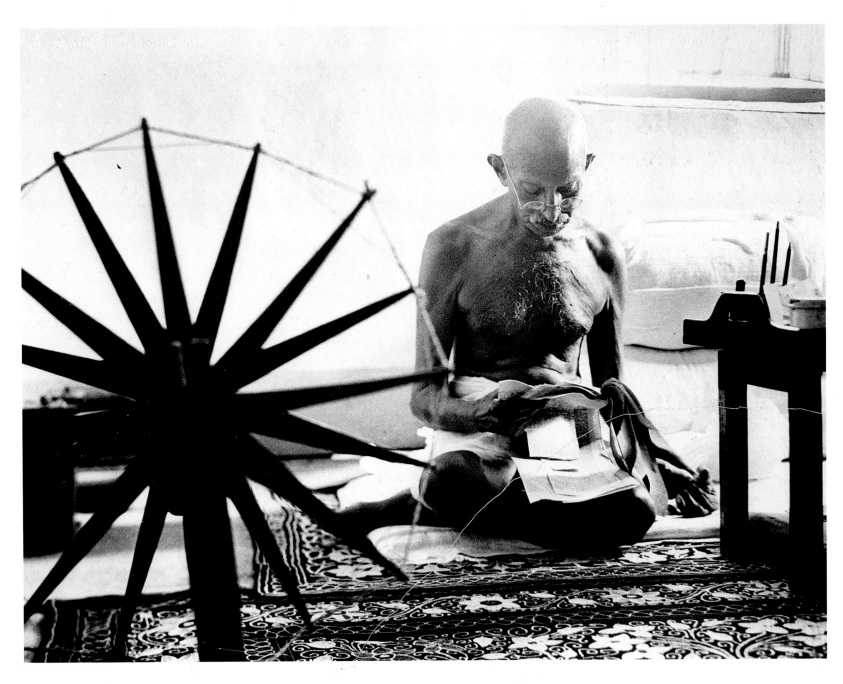

Margaret Bourke-White. b New York (USA), 1904. d Stamford, CT (USA), 1971. **Mahatma Gandhi**. 1946. Gelatin silver print.

Bradshaw Ian

Streaker

The elegant nude – an Australian accountant called Michael O'Brien – has just run naked past the crowded stands at a Twickenham rugby match. He looks as if he was intending to audition for the part of Christ at the Deposition. The bareheaded policeman, meanwhile, who sports the long sideburns so fashionable in the 1970s, seems to have the Judas role in mind. His helmet is doubling as a giant codpiece, an echo of the style of Henry VIII. The gent with the coat – a committee man by the look of him, and an epitome of the supervising classes – is arriving too late to save the day for decency, but makes the scene more of a pantomime than it already was. The policeman's lot, in this instance, is a happy one. British press photographers, from the 1930s onwards, have always been aware of the national narrative: a farce enacted by archaic types in the Punch and Judy tradition.

☛ Coplans, García Rodero, von Gloeden, Koppitz, Samaras

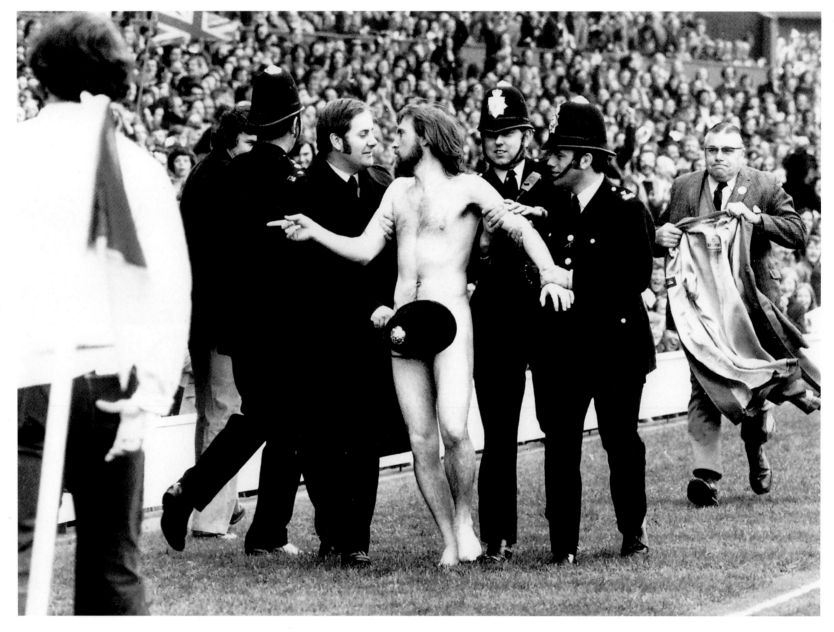

Ian Bradshaw. b Salisbury (UK), 1943. **Streaker**. 1975. Gelatin silver print.

Brady Mathew B.

General William Tecumseh Sherman

The stern-faced General Sherman. a principal figure in the Unionist campaign against the Confederacy in the American Civil War. is wearing a black sash on his left arm – a gesture required of all military men during the six weeks' mourning period for the assassinated President Abraham Lincoln. Sherman's unkempt hair and badly arranged collar and tie

testify to his hasty nature. Brady, under whose aegis this portrait was taken. was for many years virtually the photographer-laureate of the USA. In 1844 he opened a daguerreotype studio in New York, where he soon became the leading portraitist of his day, known as 'Brady of Broadway'. In 1861 Brady organized a corps of photographers (amongst

them Timothy O'Sullivan) to cover the Civil War, and he was the first to publish war images in sets and series. The war brought new men to the fore, as well as new energetic personal styles of the kind exemplified by General Sherman.

☛ Bosshard, Burke, Carjat, Hoppé, Nadar, Strand

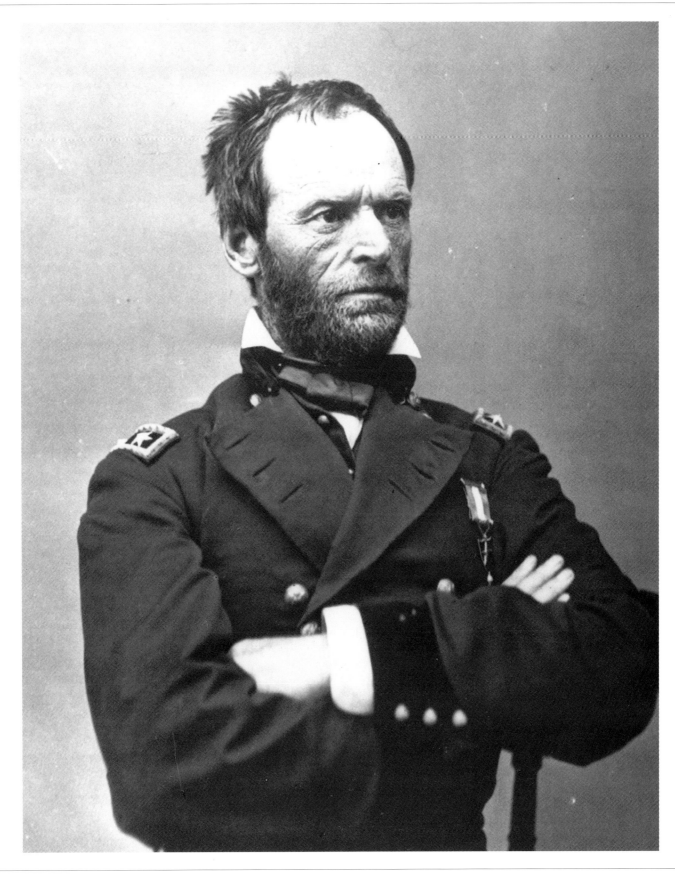

Mathew B. Brady. **b** Warren County, NY (USA), c1823. **d** New York (USA), 1896. **General William Tecumseh Sherman**. 1865. Albumen print.

Bragaglia Anton Giulio & Arturo Photodynamic Typewriter

A prolonged exposure in front of a dark ground has resulted in an impression rather than a description of typewriting. Photography's frozen moments tend to give a poor account of actions that take place over the course of time, and the Bragaglia brothers aimed to put that right through the development of what they called photodynamism. They were committed to an idea of movement as continuous or as part of a trajectory, and sceptical of the experiments of Eadweard Muybridge, who represented movement analytically, seeing it as made up of successive phases. The Bragaglia brothers began their experiments with photodynamism in 1911, and in 1913 made contact with the Futurist painters. In June 1913 Anton Bragaglia published a book entitled *Fotodinamismo Futurista*, but shortly afterwards the pair broke with the painters, who favoured the analytical approach. Anton later turned to film production.

☛ **Muybridge, Mylayne, Steinert, Wells**

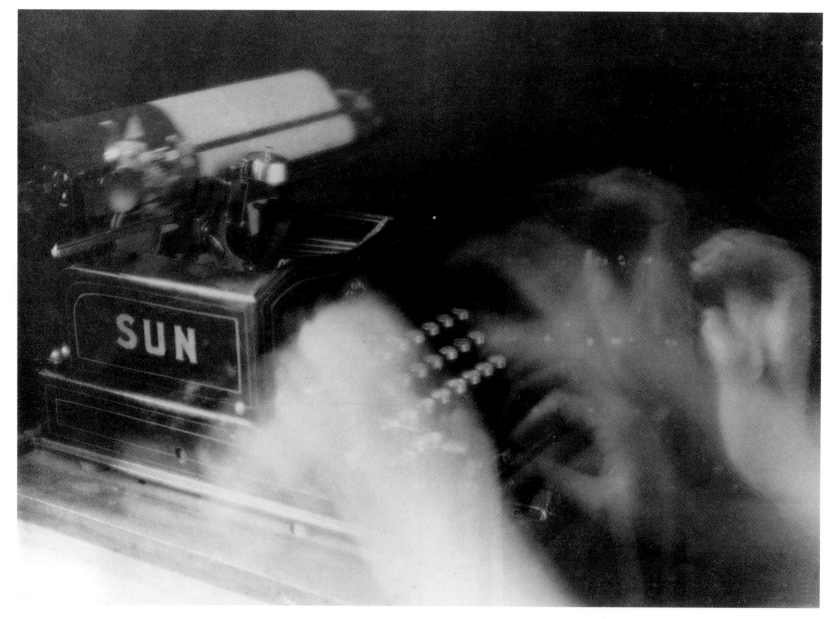

Anton Giulio Bragaglia. b Rome (IT), 1890. **d** Rome (IT), 1960. **Arturo Bragaglia. b** Rome (IT), 1893. **d** Rome (IT), 1962. **Photodynamic Typewriter**. 1911. Gelatin silver print.

Brandt Bill

The Lambeth Walk

The girl lived in Bethnal Green, in the East End of London. At the photographer's request she is dancing the Lambeth Walk, a dance made famous in the 1930s. Although dressed in an ill-fitting assortment of clothes, she performs with elegance and self-possession. The picture was taken for *Picture Post*, the illustrated weekly for which Brandt worked from its foundation in 1938 until the late 1940s. Brandt, one of the great artists in the medium and a strong influence on young photographers in the 1940s and 1950s, studied in Man Ray's studio in Paris in the late 1920s, travelled in Spain and Hungary, and settled in Britain. Like the many German photojournalists of the late 1920s whose example he followed, he preferred pre-arranged to candid pictures. From 1938 he worked regularly both for *Picture Post* and for the monthly *Lilliput*. As a romantic landscapist in the 1940s and then as a portraitist and photographer of nudes during the 1950s, Brandt had no equal.

☛ Barbey, Bevilacqua, Doisneau, Konttinen, Man Ray, Mayne

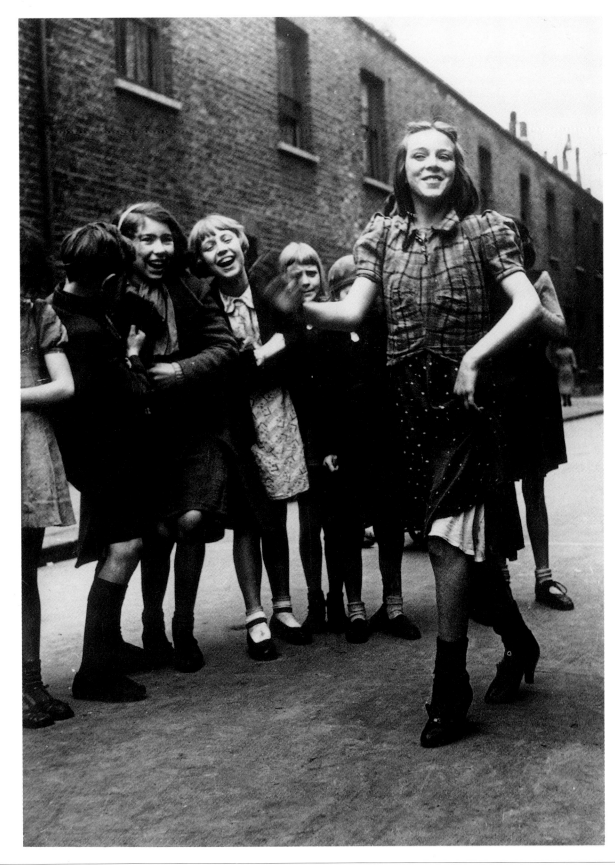

Bill Brandt. b Hamburg (GER), 1904. d London (UK), 1983. **The Lambeth Walk**. 1936. Gelatin silver print.

67

Brassaï

Lovers in a Café

The lovers might be posing for the benefit of an audience. Mirrored cafés of this sort presuppose a high degree of self-consciousness, and give credence to the idea that life is an act. When Brassaï took this photograph, and many others showing café clientele, he was preparing what was to become one of the best-known books in the history of the medium, *Paris de nuit*

(1933). He kept such pictures as this in reserve, however, partly because they were of identifiable figures. *Paris de nuit* shows the city as a melancholic place peopled by night-workers and beggars, and seen at a distance as if by a lonely insomniac. It established Brassaï as the great interpreter of romantic Paris, and during the rest of the 1930s and through the war years his

images of the city by night appeared in illustrated magazines throughout the world. Between 1936 and 1963 he also photographed for *Harper's Bazaar*, taking pictures of the Parisian artists with whom he associated.

☛ Eisenstaedt, Goldin, Lichfield, G. Smith, Wellington

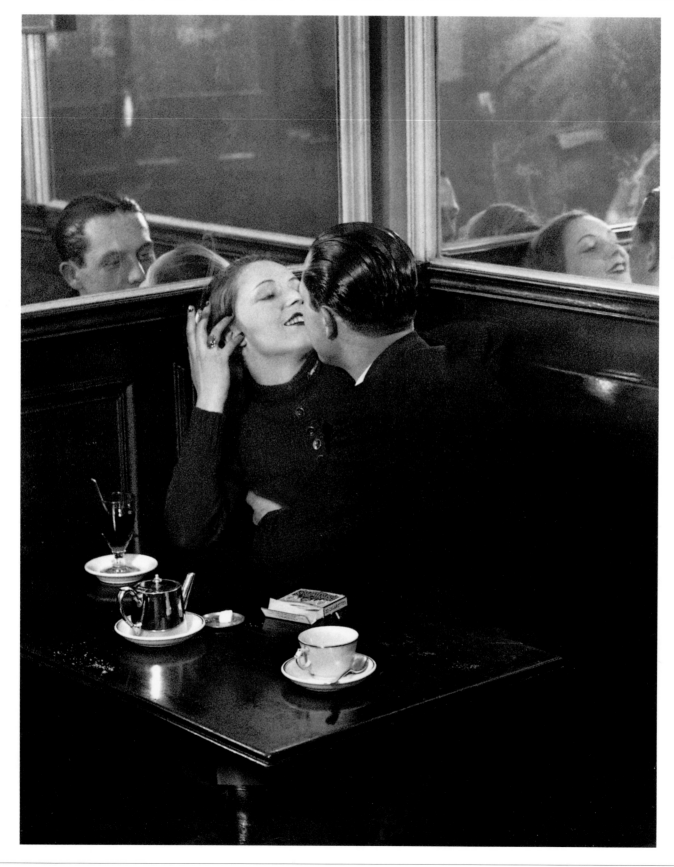

68

Brassaï (Gyula Halász). b Brasso (HUN), 1899. d Beaulieu-sur-Mer (FR), 1984. **Lovers in a Café**. 1932. Gelatin silver print.

Brigman Anne W. The Soul of the Blasted Pine

She is probably a hamadryad or classical tree nymph who is suffering the bad fortunes of her host in the mountains of California. According to the old stories, hamadryads were tree spirits and they died when their trees decayed. Brigman took many pictures of this kind in the Donner Lake area in the Sierras of California, using her friends, sister and mother as models. She described the trees of the Sierras as 'squat giants twisted and torn with the sweep of the prevailing winds' and remembered how she had been so transfixed and possessed by the spirit of the place that she could visualize 'the human form as a part of tree and rock rhythms'. What gives particular conviction to a body of work which might otherwise look contrived is a powerful sense of mortality. In 1909–10 Brigman was welcomed into the Alfred Stieglitz circle in New York, in part because of her 'strange, foreign' Californian tone.

☛ Barbieri, Holland Day, Kinsey, Stieglitz, Tillmans, Uelsmann

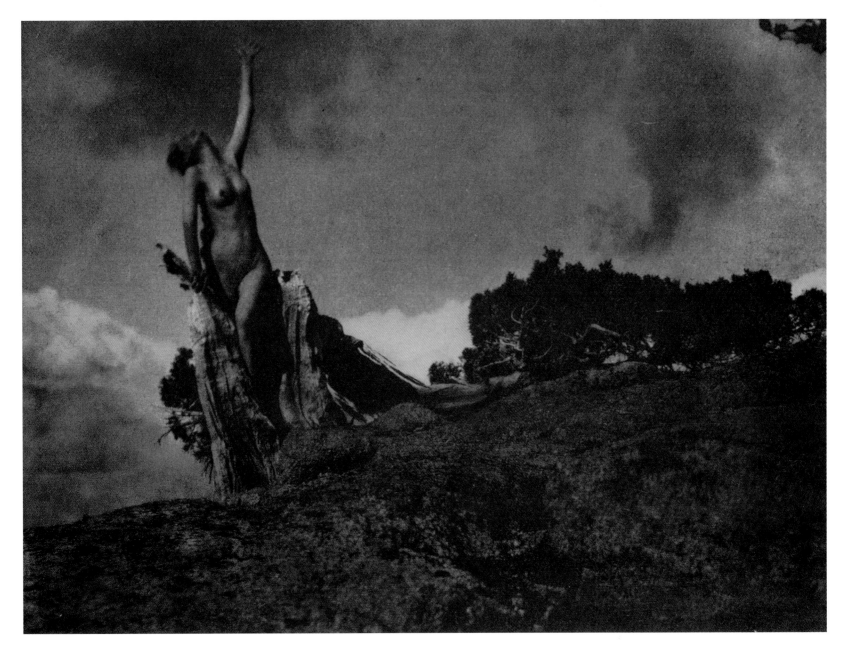

69

Anne W. Brigman. b Honolulu (HAW), 1869. d Oakland, CA (USA), 1950. **The Soul of the Blasted Pine**. 1907. Photogravure.

Brus Günter

Self-Portrait

The artist has covered himself with a white paste, and then marked with a brush what might be a line of dark stitches leading from his scalp to his neck. It looks as if his head has been opened up and then put together again. The work was a performance closely allied to photography, and was intended to show a self-inflicted savagery aimed at taking the sins of the world on his own shoulders. Brus was originally an informal or action painter, from which it was an easy transition into performance art of the kind which needed to be completed by a photographic record. Between 1964 and 1970 he carried out forty performances, all of which contained elements of drawing and writing. All were characterized by self-mutilation, either symbolic or real. Brus was a founder member of the Wiener Aktionismus group of performance artists in 1964. His art had an influence on the radically objective portrait styles of the European avant-garde in the 1980s and 1990s.

☞ **Nauman, Rainer, Warhol, Witkiewcz, Wulz**

Günter Brus. b Ardning (AUS), 1938. **Self-Portrait**. 1964. Gelatin silver print. **h**50 × **w**40 cm. **h**19½ × **w**15¾ in.

Bubley Esther

Greyhound Bus Terminal, New York City

Although waiting in New York's Greyhound Bus Terminal, the two men present themselves with impressive elegance – as you might expect of men conscious of a young woman with a camera. Despite the work of Dorothea Lange and Margaret Bourke-White, Bubley was really the first American documentarist to look at life in the USA quite deliberately from a woman's point of view – and also the first to present that life as thoroughly theatrical. Men quite clearly like to perform for her, perhaps as beaux or as grizzled cowhands or as heroes saluting the flag. Women, on the other hand, act too, but in altogether more subtle roles, and apparently in collusion with the photographer. Bubley was one of the last photographers to be taken on by the Farm Security Administration in Washington. Thereafter she was employed by Roy Stryker at Standard Oil, and then by *Life* magazine in the late 1940s.

☞ Bourke-White, Hoppé, Lange, Sander, Weber

71

Esther Bubley. b Superior, WI (USA), 1922. d New York (USA), 1998. **Greyhound Bus Terminal, New York City**. 1947. Gelatin silver print.

Bull Clarence Sinclair

Greta Garbo

The actress Greta Garbo plays the part of Mata Hari, the Dutch spy, in the film of that title. Presented as impassively as this, Garbo looks like a Berlin modernist of the 1920s or a product of Man Ray's Parisian studio. Bull went to Hollywood in 1918, and worked originally as an assistant cameraman at Metro Pictures. Later in 1918 he moved to Goldwyn Studios. In 1924

Goldwyn and Metro merged and he became head of stills at MGM, where he remained until his retirement in 1961. In 1929 he began to take pictures of Garbo, who had arrived in Hollywood in 1925, and he continued to be her photographer until 1941. He said that she was 'the easiest of all stars to photograph … having no bad side and no bad angles'. Jean

Harlow and Clark Gable were among his other subjects. In the 1950s he collaborated with the scientist Harold Edgerton on the introduction of strobe lighting into colour photography.

☛ **Edgerton, Harcourt, Henri, Lerski, McDean, Stock**

Clarence Sinclair Bull. **b** Sun River, MT (USA), 1896. **d** Hollywood, CA (USA), 1979. **Greta Garbo**. 1931. Bromide print.

Bullock Wynn

Tide Pool

What look like the heavens' embroidered cloths are actually no more than marks on the surface of a tide pool. Only seconds after the photograph was taken, the scene had completely disappeared in the wind. Bullock took an epic view of landscape, seeing it as made up of transient effects playing over enduring sub-structures. In the beginning there were rocks, themselves subject to long-term change and contrasting with a fluctuating present defined by the action of light on vapour and liquid. In this instance, the momentary display is made up of a crust of salt on water held within a basin; in later pictures Bullock found evidence of the organic within the veins and folds of stone itself. He always composed with reference to contrasts: rocks in relation to mist, water on stone or a small child in the wilderness. Bullock began in music and then spent years as a commercial photographer before turning to 'straight' photography in the late 1940s.

☞ Cooper, Hannappel, Le Gray, Régnault, Silvy

Wynn Bullock. b Chicago, IL (USA), 1902. **d** Monterey, CA (USA), 1975. **Tide Pool**. 1957. Gelatin silver print.

Burke Bill

Reverend William Beegle, Bellaire, Ohio

The Reverend William Beegle shows himself to be a major presence, outlined against the darkness of his porch. There is something of the minister about the set of his head and the gesture of his right hand. His belt may be buckled to the side for greater ease when seated. The picture is a Polaroid and was taken in the course of a survey sponsored by the Kentucky

Bicentennial Documentary Photography Project, and it is as impressive a male portrait as has ever been taken. Burke, who has worked extensively as a documentarist in Southeast Asia, thought that he should make pictures where he didn't know the rules, where he would be off balance – or sufficiently so to make pictures like this, which look as if they have been granted by the

subject rather than imposed by the photographer. Burke's importance in the 1970s lay in his denial of the idea that people were wholly defined by material circumstances and role-playing learned from television.

☛ **Brady, Carjat, Nadar, W. E. Smith, Strand, Weber**

74

Bill Burke. **b** Derby, CT (USA), 1943. **Reverend William Beegle, Bellaire, Ohio**. 1979. Polaroid.

Burnett David

A Cambodian Woman Cradles her Child

The tiny feet caught by the light reveal that the woman is holding a child. She looks remarkably impassive and seems to be waiting in the half-light. A Cambodian, she is from one of the trouble spots of the 1970s. In December 1978 the country had been invaded by Vietnamese forces intent on bringing order or on controlling the extremist Khmer Rouge. The Cambodian Communists were supported by China, and the Vietnamese by Russia; and the woman could be forgiven for thinking that she had been caught up in something far greater than any mere individual could comprehend. Concerned reportage in the 1970s was less optimistic than at any time in the past. In the 1950s, for instance, photo-reporters believed in the emergence of a better world order and in the unbreakable vivacity of the people. In the 1970s, by contrast, recent experiences, of the sort on which this woman may be reflecting, suggested that waiting was the only answer to present problems.

☛ **Arnatt, Curtis, Lange, Lyon, Seymour**

David Burnett. b Salt Lake City, UT (USA), 1946. **A Cambodian Woman Cradles her Child**. 1979. C-type print.

Burri René

São Paulo, Brazil

Below, pedestrians throng the pavements of São Paulo, while above a group of four men occupies the sunlight on that rooftop. Burri's preference, from the outset, was for depicting humanity going about its business come what may, absorbed in the moment, as these men appear to be. It was, and remains, a photography of daily life, sceptical of the inhumanity of the kind of systems expressed in such architecture as this. Burri was known during the 1960s for a set of eighty pictures on German life, which were taken on magazine assignments during 1956–62. His Germany is seen mostly from the point of view of figures in the street – tram-passengers, doormen and porters – and was published in 1962 as *Die Deutschen*. Burri's bias towards the uncompleted and transient marked an important development in the 1950s and 1960s since in his pictures the reporter appeared as a fellow-traveller, or someone who was in no way superior to his subjects.

☞ Abbott, Krull, Munkacsi, Ruscha

René Burri. b Zurich (SW), 1933. **São Paulo, Brazil**. 1960. Gelatin silver print.

76

Burrows Larry

South of the DMZ, South Vietnam

The black soldier with his bandaged head scarcely knows where he is going, which is why the doctor in spectacles is trying to guide him away from the figure outstretched on the mud. Recently caught up in violent action, the soldiers seem shocked and distracted. This is one of Vietnam's most noted pictures, partly because of its echoes of religious art: a crucifixion or deposition in the foreground, with a recognition scene suggested by those outstretched arms. Burrows also finds a contrast between the earthy tones of the fallen soldier and the emblematic blood on the bandaged man. One of the longest-serving of the Vietnam photographers, Burrows first went there in 1962, and was killed in Langvie in 1971. Originally a supporter of Western intervention, he began to develop doubts which he made public in his *Life* photo-essay of 19 September 1969, 'A Degree of Disillusion'. Time-Life honoured him in 1972 in *Larry Burrows: Compassionate Photographer*.

☛ Baltermants, Faucon, Gardner, Griffiths, Wall

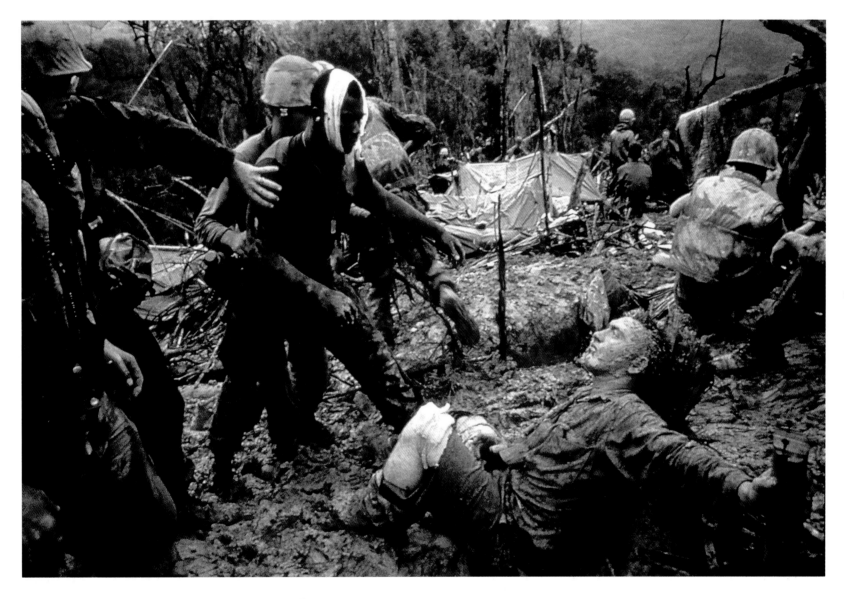

Larry Burrows. b London (UK), 1926. **d** Langvie (VIET), 1971. **South of the DMZ, South Vietnam**. 1966. C-type print.

Callahan Harry Eleanor

Eleanor Callahan, the photographer's wife, is looking straight at the camera. The portrait's refined outlines and pale tonalities recall the purist style of the 'straight' photography of the 1930s. 'Straight' photography, however, was impersonal, and its subjects never responded with this kind of self-possession. In all of Callahan's portraits and street pictures the people are similarly self-possessed and even heroic. His many landscapes, too, feature a world made up of discrete items and flattened spaces, as if he wanted to grant everything its due and not to show it subordinated. This disinterested style of surfaces means that his photography is organized along lines very close to those followed in painting by his contemporary Jackson Pollock.

When Callahan took this picture he was working as an instructor at Chicago's Institute of Design, where he remained for fifteen years after his appointment in 1946 by Arthur Siegel and László Moholy-Nagy.

☛ Beaton, Lele, Man Ray, Ohara, Ruff, Sherman

Harry Callahan. **b** Detroit, MI (USA), 1912. **d** Atlanta, GA (USA), 1999. **Eleanor**. c1947. Gelatin silver print.

Calle Sophie

The Hotel, Room 44

These photographs, which were taken in a Venetian hotel room in February 1983, are record pictures and intended to be exhibited in a group. They show disturbed beds, half-unpacked luggage and drying washing: the average contents of anonymous rooms. Calle had herself hired as a temporary chambermaid and for three weeks she was in charge of twelve bedrooms on the fourth floor. During that time she took pictures and made notes on the habits of the guests. The results, which amounted to secret surveillance, were published and exhibited. She was careful not to follow through on her enquiries, which meant that the occupants of the rooms remain unidentifiable. The importance of Calle's art has been to raise questions about just what it is that interests us: the ordinary fabric of others' lives, for example. Her dispassionate, objective procedures have been of great influence in the gallery photography of the 1980s.

☞ Baldessari, Becher, Berman, Hammerstiel, Tomaszewski

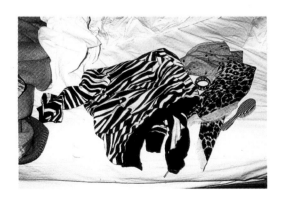

Sophie Calle. b Paris (FR), 1953. **The Hotel, Room 44**. 1983. Nine gelatin silver prints. **h** 102 × **w** 142 cm. **h** 40¼ × **w** 56 in.

Cameron Julia Margaret 'Call I Follow, I Follow; Let Me Die'

This photograph is of Mary Hillier, Cameron's maid, photographic assistant and favourite model. The title comes from Alfred Lord Tennyson's *Idylls of the King*, and refers to a woman's choice of love or death – one of Mrs Cameron's habitual themes. The woman might be a saint or a sinner, or something of both, and this ambiguity is typical of Mrs

Cameron's art. She believed in a history of types, or in the kind of recurrence which would make it possible to find among her circle of acquaintances people who in some way epitomized major figures from the remote past. Believing this, she had no option but to present her subjects in the most general terms possible, and free from contemporary trappings. She was

almost fifty when she took up photography seriously in 1863, by which time she had acquired a considerable body of knowledge and doctrine.

☞ Boubat, Hawarden, Muray, Newman, Ritts, Silverstone

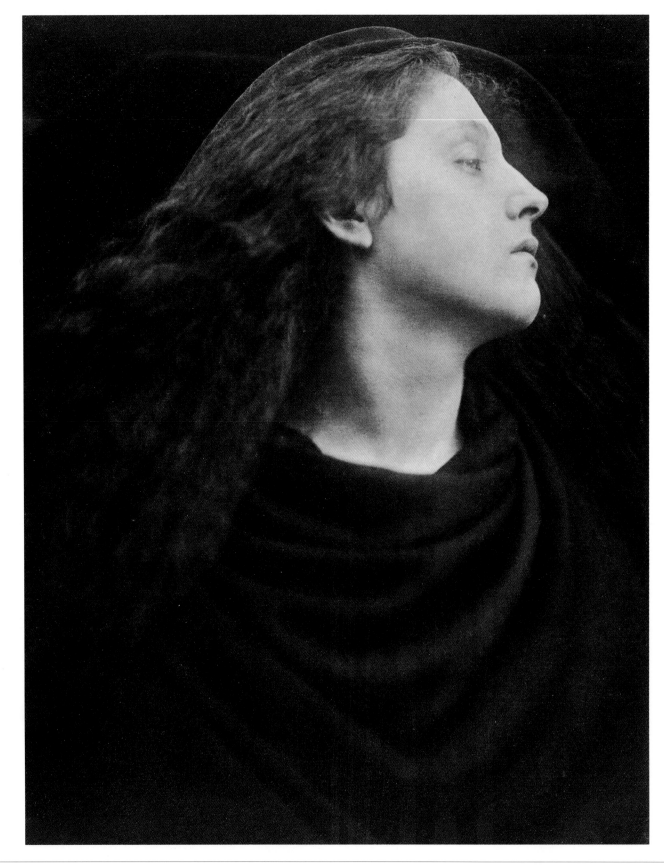

Julia Margaret Cameron. **b** Calcutta (IN), 1815. **d** Kalutara (CEY), 1879. **'Call I Follow, I Follow; Let Me Die'**. c1867. Carbon print.

Du Camp Maxime Abu Simbel

This photograph of a man in a headdress sitting atop a blank-eyed statue was taken at Abu Simbel during Du Camp's special mission to document certain sites in Egypt and the near East. It has figured constantly in histories of the medium, perhaps because it can be read as symbolizing the triumph of photography. Traditionally, the medium has been associated with transient moments, whereas art proper has kept company with eternity. Thus photography's representative in this case is the impudent human figure and art's the blind giant specially unearthed for the occasion. Du Camp took lessons in photography from Gustave Le Gray before setting off on his mission. He was accompanied by the writer Gustave Flaubert who confessed himself to be profoundly bored by Egyptian temples. The 200 photographs which Du Camp took in Egypt, Nubia, Palestine and Syria constituted the first important photographic body of work to be published in France.

☛ Ghirri, Holland Day, Le Gray, Michals, Paneth, Steichen

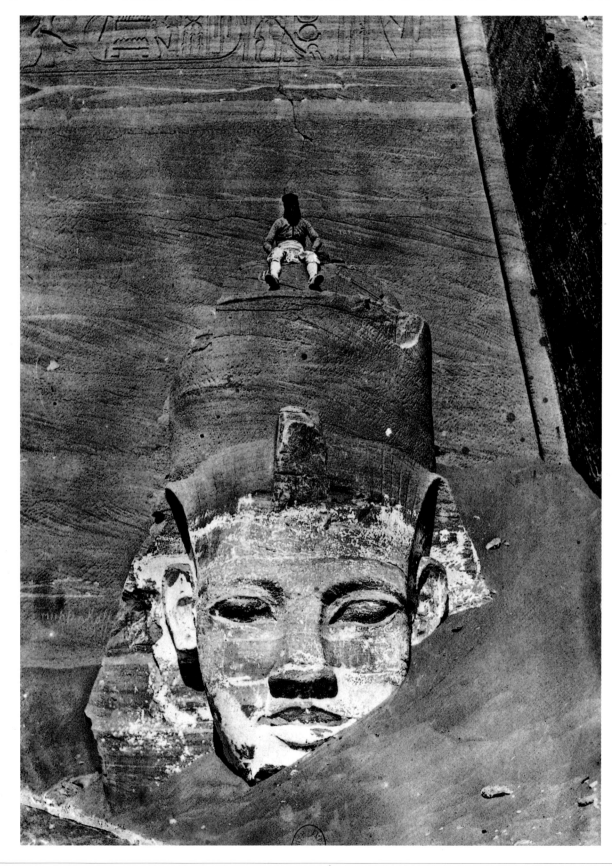

Maxime Du Camp. b Paris (FR), 1822. **d** Baden-Baden (GER), 1894. **Abu Simbel.** c1850. Albumen print.

Capa Cornell

Bolshoi Ballet School, Moscow

In this picture of beauty, grace, light and elegance, Cornell Capa has captured the essence of ballet. Ironically for a photographer whose work is usually devoted to social reform, this is his best-known image. Its interest lies in the juxtaposition of the reality of each ballerina's hard work with the mirrored illusion of effortlessness. Cornell Capa became a *Life* staff photographer in 1946, and only joined Magnum Photos in 1954 on the death of his brother Robert. An all-round photo-reporter, he covered American politics in the 1950s and 1960s, as well as life on Wall Street and in the Third World, and especially in Latin America, the subject of his *Margin of Life* (1974). Other books include *Farewell to Eden* (1964) and *The Concerned Photographer* (1968). In 1974 he founded the influential International Center of Photography (ICP) in New York and in 1978 he received the Award of Honor from the Mayor of the City of New York.

☞ Berengo Gardin, R. Capa, Haas, Hawarden, Kollar, Morgan

82

Cornell Capa. b Budapest (HUN), 1918. **Bolshoi Ballet School, Moscow**. 1958. Gelatin silver print.

Capa Robert

Death of a Loyalist Soldier

The Loyalist soldier in his white shirt (now known to be Federico Borrell) must have made a tempting target for enemy riflemen on the Córdoba Front in September 1936. The Spanish Civil War, which was fought out between a left-wing government and right-wing insurgents, had just begun that summer. Capa had taken pictures amongst demonstrators in Paris earlier in 1936, and after Spain he would report on the Sino-Japanese war and then on Europe in 1939–45. His Spanish pictures were published in 1936–7 in various magazines: *VU* and *Regards* in France, *Life* in the USA and *Picture Post* in England. His book on Spain, *Death in the Making*, appeared in 1938 and several others followed, including *Robert Capa: War Photographs* (1950). Gerda Taro, his companion in Spain, was killed during the retreat of 1937 and Capa himself died after stepping on a landmine while taking photographs for *Life* in Indochina in 1954.

☛ **E. Adams, Eppridge, Gardner, Jackson, McCullin**

Robert Capa. b Budapest (HUN), 1913. d Thai-Binh (VIET), 1954. **Death of a Loyalist Soldier**. 1936. Gelatin silver print.

Caponigro Paul

County Wicklow, Ireland

The deer look ghostly running through the shadows under a screen of beech trees in County Wicklow. The invitation is to follow their flow as if it were a stream of light. Yet because the picture has been taken in a fraction of a second, their legs can be seen with clarity in contact with the grass underfoot. The result is a depiction of movement punctuated, and that has always been Caponigro's subject in a long career in landscape photography. Whenever he photographs river scenes, for instance, it is for the sake of the swirls and eddies shaped by projecting stones. He refers to himself as trying 'to express and make visible the forces moving in and through nature', and of gaining contact 'with the greater dimension – the landscape behind the landscape'. During the late 1960s and early 1970s he took many pictures in Ireland and England, often of standing stones on ancient sites. Like his precursor Ansel Adams, Caponigro originally trained as a pianist.

☛ A. Adams, Cranham, Iwago, Le Querrec, Muybridge

84

Paul Caponigro. b Boston, MA (USA), 1932. **County Wicklow, Ireland**. 1967. Gelatin silver print.

Carjat Étienne

Charles Baudelaire

The poet Charles Baudelaire seems sad and preoccupied in this relatively late portrait by Carjat. As a young man Baudelaire had been a dandy with curling, shoulder-length black hair. Something of his early dandyism survives here, but Baudelaire's health had begun to decline in 1864 and by 1866 he was paralysed and unable to speak. In 1857 his famous book of poems *Les Fleurs du Mal* had been legally condemned after being seized by the police. When it was published in 1878 in Carjat's *Galerie Contemporaine*, this portrait must have looked like an awful warning about the consequences of dissipation. Carjat himself was a draughtsman, journalist, dramatist and finally a professional photographer who opened his first studio in Paris in 1860. He was noted, like his more successful contemporary Gaspar Felix Nadar, for expressive portraiture which concentrated on the subject unsupported by accessories.

☛ **Brady, Burke, Hoppé, Nadar, Strand, Weber**

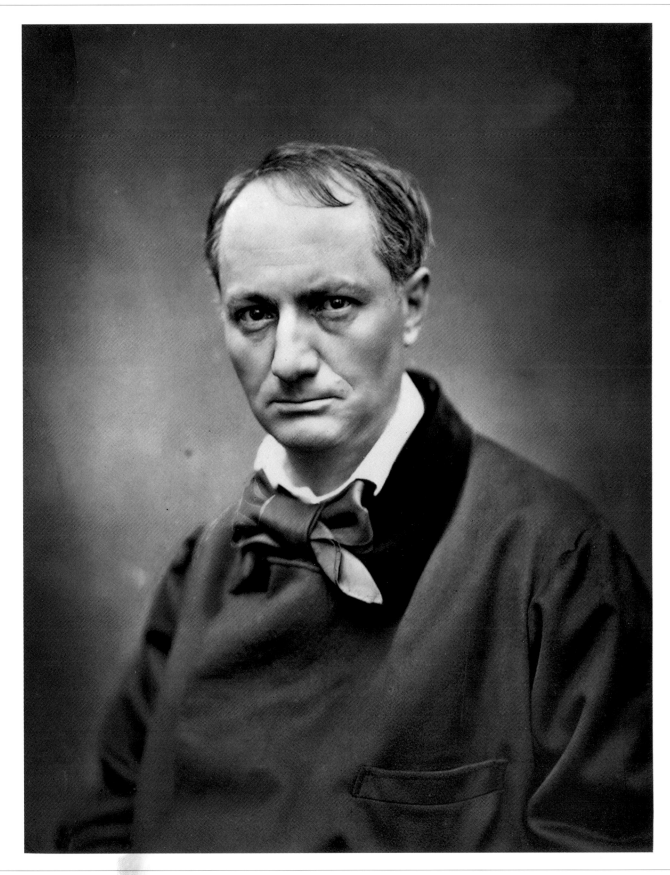

85

Étienne Carjat. b Fareins (FR), 1828. d Paris (FR), 1906. **Charles Baudelaire**. 1878. Woodburytype.

Caron Gilles

The Student Revolution in Paris, May 1968

This dramatic photograph was taken in Paris during the student riots of May 1968. The pursuing policeman seems to have violence in mind and that even looks like blood on the pavement. Caron has singled out an emblematic moment, the kind of moment on which he built his reputation as one of the virtuoso reporters of the 1960s. In 1965 he joined Apis, a Parisian agency, and in January 1967 was one of the co-founders of the important Gamma agency. On 4 April 1970 he disappeared in Cambodia, presumed killed, on route No. 1, not far from Phnom Penh. The late 1960s was an era rich in spectacular news, much of it covered by Caron: the Six-Day War in the Middle East in 1967, and the battle of Dak To in Vietnam in the same year; the Biafran War in Nigeria, and the May student uprising in Paris in 1968; the 'troubles' in Northern Ireland in 1969; insurgency in Chad in the 1970s, and finally the war in Cambodia.

☞ **Atget, Doisneau**

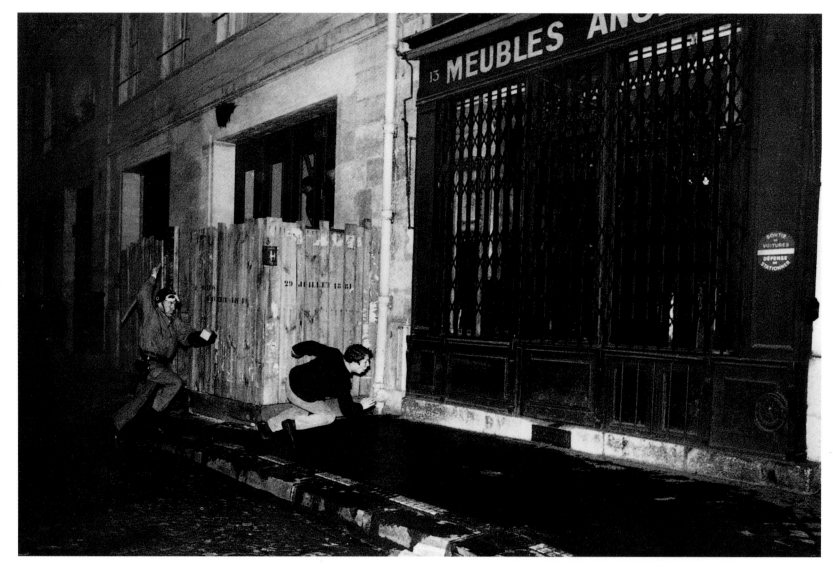

86

Gilles Caron. b Neuilly-sur-Seine (FR), 1939. d Phnom Penh (CAM), 1970. **The Student Revolution in Paris, May 1968**. 1968. Gelatin silver print.

Carroll Lewis

Mary Millais

Mary Millais was the daughter of the painter John Everett Millais and Effie Gray, the former wife of John Ruskin. She has signed the picture herself. Carroll, who wrote *Alice's Adventures in Wonderland* and *Alice Through the Looking Glass*, was a clergyman and mathematician who taught at Christ Church in Oxford. He took up photography in 1855 and made many pictures of children, especially girls, in his rooms at Christ Church and in the gardens of friends. They were often photographed nude or in costume and were specially posed. Helmut Gernsheim, the celebrated historian of photography who first published the pictures, preferred the early images, such as this, from the 1860s. Carroll also took pictures of celebrities, including the actress Ellen Terry and the poet Alfred Lord Tennyson. Children featured greatly in the art of Pre-Raphaelite painters such as Millais, often with respect to harsh and tragic times ahead: illness and the torments of love.

☛ Alvarez Bravo, Erfurth, Mark, Seeberger, Sommer

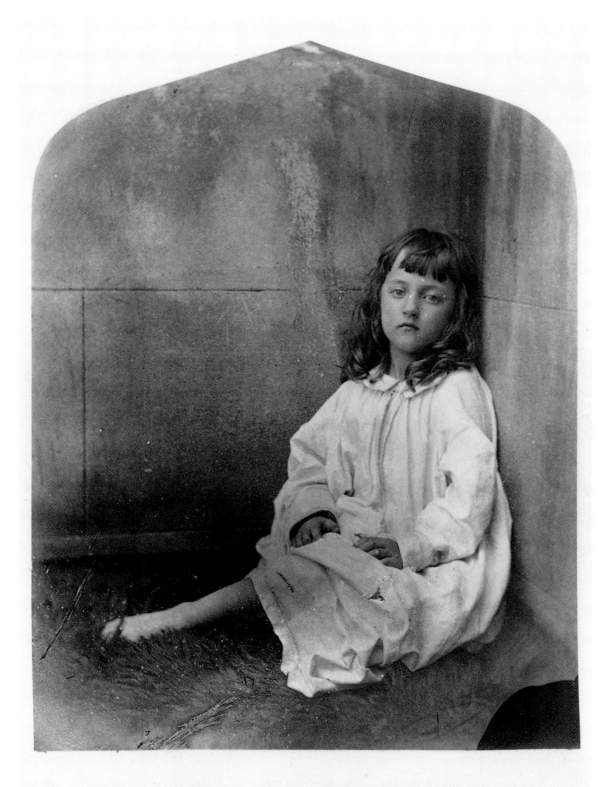

Mary Millais.

Lewis Carroll (Charles Lutwidge Dodgson). b Daresbury (UK), 1832. d Guildford (UK), 1898. **Mary Millais**. c1860. Albumen print.

Cartier-Bresson Henri Place de l'Europe

A man attempting to leap a large puddle is captured by the photographer in mid-air. His streamlined shape is mirrored in the water and in the ballet poster behind him. He has gone as far as ingenuity will take him and yet – in the circumstances – it is not far enough. Cartier-Bresson is known, above all, for his identification of the 'decisive moment', which was also the title of his first important book, published in 1952. This picture is an example of just such a minor but thoroughly revealing instant of decision. The orderly architectural setting is also a common characteristic of Cartier-Bresson's work, serving as a foil against which human vitality can be seen to advantage. His interest lies in actual life as carried out among the potholes of the real city. Henri Cartier-Bresson, together with Robert Capa, David 'Chim' Seymour and George Rodger, was a co-founder of the influential photographers' co-operative Magnum in 1947.

☛ R. Capa, A. Klein, Lartigue, Rodger, Seidenstücker, Seymour

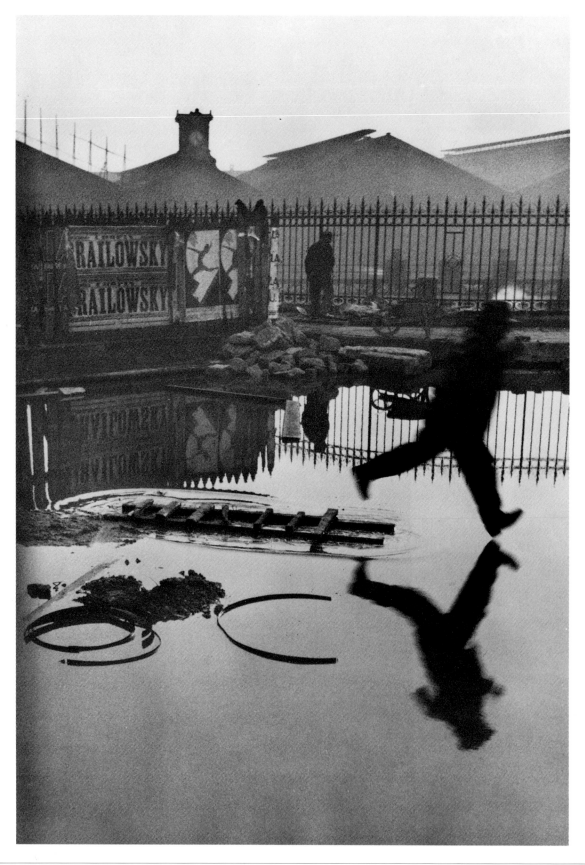

Henri Cartier-Bresson. b Chanteloup (FR), 1908. **Place de l'Europe**. 1932. Gelatin silver print.

Chaldej Jewgeni

On the Reichstag, 4 May 1945

It looks as though the battle is all but over, since there are figures roaming heedlessly in the street below the Reichstag. And you could be forgiven for wondering just what exactly is going on, for surely it would be impossible to attach a flagstaff to that finial, shaped as it is; even if the attempt were successful, the flag would be almost illegible to those below.

On the other hand, the soldiers in their precarious way do rhyme very nicely with the bold statuary further along the cornice, and the flag – from our viewpoint at least – is so clearly visible as to suggest that the event was staged only for the camera's benefit. Apparently this is exactly what happened. Chaldej improvised the flag from several red tablecloths and

flew to Berlin with it, planning to show it being raised on the Reichstag. He was inspired by Joe Rosenthal's famous picture of the American marines raising the Stars and Stripes on top of Mount Suribachi on the island of Iwo Jima.

☛ **Frank, Kawada, Rosenthal**

Jewgeni Chaldej, b Juzovka (UKR), 1917. **On the Reichstag, 4 May 1945**. 1945. Gelatin silver print.

Chambi Martin

Crowd at the High Court in Cuzco

Six *campesinos* (peasants) are waiting to give evidence in the High Court in Cuzco. Understandably, they seem cowed by an experience which must have been alien to them – witness those bare feet on the floral carpet. A question sometimes asked about Chambi, who was himself an Indian and of *campesino* origin, is whether or not he intended his pictures to be critical – for Peru at the time was an exploitative and stratified society, with its Indian aboriginals at the bottom of the pile. On the evidence of the photographs, it looks as if he had no option but to take account of hierarchies, since his Peruvian clients seem themselves to have asked for collective portraits. At the same time it is clear that, once out of the city, he idealized the Indians of the highlands. As the leading professional photographer in Cuzco and a portraitist of notables, it seems likely that he felt duty-bound to record as much of Peruvian life, landscape and architecture as possible.

☛ Gichigi, Marubi, O'Sullivan, Rejlander, Tsuchida

90

Martin Chambi. **b** Coaza (PER), 1891. **d** Cuzco (PER), 1973. **Crowd at the High Court in Cuzco**. 1929. Gelatin silver print.

Charbonnier Jean-Philippe Backstage at the Folies Bergères, Paris

Three colleagues talk together behind the scenes at the Folies Bergères. They look as if nakedness is no impediment to day-to-day discourse. The welling clouds behind the dancer and the prancing horse are, of course, signs of the kinds of volcanic passions to which such nudity might give rise… but for the moment these three are simply co-workers. Classic documentarists and reporters in the 1930s liked to take their audiences backstage, and this picture is the consummation of that tradition. The idea was to disclose just how things really are, and to strip the world of its falsity. We should emerge from the experience of any Charbonnier picture with our understanding enhanced. Although a specialist in the fabric of French life, Charbonnier, like the great reporters of his era, has photographed all over the world. In 1950 he joined the French monthly magazine *Réalités*, for which he continued to work until 1974.

☞ Abbe, Kollar, Koppitz, Newton, Rheims

Jean-Philippe Charbonnier. b Paris (FR), 1921. **Backstage at the Folies Bergères, Paris**. 1960. Gelatin silver print.

Christenberry William Coleman's Café, Greensboro, Alabama

Coleman's Café, the notice says, and it looks decrepit. In 1936, the year of Christenberry's birth in Tuscaloosa, Alabama, the great Walker Evans was taking photographs in that county and even in Greensboro itself. Evans's black-and-white photographs show almost exactly the same buildings as those captured by Christenberry, although in 1936 they were in better repair. The difference between the two is that Evans intended his buildings to be both evidence of rural joinery and construction techniques, and primitive commercial collages, whereas Christenberry shows them, as here, set within landscapes and touched by weather and the seasons. Christenberry's sense, that is to say, is a sense of place above all. Originally a painter, Christenberry taught at the Corcoran School of Art in Washington, DC. He took up photography as an *aide-memoire* and thus his home state remains an area of special interest for him.

☛ Abell, W. Evans, Magubane, Meyerowitz, Morris, Sternfeld

92

William Christenberry. b Tuscaloosa, AL (USA), 1936. **Coleman's Café, Greensboro, Alabama**. 1971. C-type print.

Clark Larry Untitled

In Tulsa, Oklahoma, a young man is casually taking aim beneath the stars and stripes of the American flag. Ever since Gene Pitney's chart-topping song from 1960, '24 Hours from Tulsa', the town had stood for young love and family values. This comfortable image changed with the appearance in 1971 of Larry Clark's *Tulsa* (published by Ralph Gibson's trend-setting Lustrum Press), which presented a new and unexpected version of the town as home to drugs and guns, although never unspeakably violent and degraded. Clark's own targets, then and in *Teenage Lust* (1983) and *Perfect Childhood* (1995), were complacent ideologies of the kind which held that American childhood in the 1960s and afterwards was a time of innocence. His quarrel has always been with purveyors of false consciousness and media claims that all is well. Clark has worked mainly in New York since being banned from Oklahoma for a shooting offence in 1976.

☛ **E. Adams, Gaumy, Jackson, Nachtwey**

Larry Clark. b Tulsa, OK (USA), 1943. **Untitled**. 1971. Gelatin silver print.

Clifford Charles

The Bridge at Martorell

Martorell, the site of the bridge, lies just to the north-west of Barcelona, and the figure standing on the river bank is probably Jane Clifford, the photographer's wife. The bridge was said to have been built by Hannibal in honour of Amilcar. This best known of Clifford's pictures is no. 155 in the author's book *A Photographic Scramble through Spain*, which was published in the 1860s. At the time Clifford thought of it as no more than another picture from Spain, for he had been taking pictures there regularly throughout the 1850s. His pictures, like those of his contemporary Francis Frith, were meant to be looked at in conjunction with their commentaries, person-to-person accounts of the difficulties and pleasures of travel in a country not yet homogenized by the railroad. In 1861 Clifford was commissioned by Queen Victoria 'to produce an album of some 600 plates representing the principal monuments of Spain'.

☛ **Aarsman, Baldus, Barnard, Coburn, Frith, Silvy**

94

Charles Clifford. b London (UK), 1800. **d** Madrid (SP), 1863. **The Bridge at Martorell**. c1858. Albumen print.

Coburn Alvin Langdon Williamsburg Bridge

The three hesitant men are crossing the Williamsburg Bridge in New York on foot at such different speeds that they prompt thoughts of old humanity at a loss within the modern environment. Coburn was a Symbolist and a self-confident new photographer and artist. What distinguished him from other urban photographers of the period was an arrogance of viewpoint whereby he placed himself with the engineers and planners, and at a remove from the figure in the street. In 1910 he described the engineers of 'those magnificent Martian-like monsters' (the bridges) as doing similar work to himself. This photogravure appeared in his *New York* of 1910, a book in which H. G. Wells thought that it was 'the machine and enterprise that prevail'. Coburn remained committed to innovation, and in 1917 produced his famous vortographs, abstract pictures of crystals taken through a triangular tunnel of mirrors called a Vortoscope.

☛ **Aarsman, Baldus, Barnard, Clifford, Frith, Nègre, Sander**

Alvin Langdon Coburn. b Boston, MA (USA), 1882. **d** Colwyn Bay (UK), 1966. **Williamsburg Bridge**. 1909. Photogravure.

Collins Hannah Untitled (Snails in a Bag)

A net full of live snails is hanging from a meat hook in a Spanish market. Some of the snails have managed to escape through the mesh and for them freedom is in sight. Others have deposited a trail of mucus, making mirrors in the upper part of the net where it narrows. Any description of this work soon expands to take account of freedom (the escapees) and art (the mirrors). The whole picture is slow-moving, visceral and organic, and imposes its own rhythm, the more so because the original is very large for no obvious reason. It is the kind of photograph which has to be physically approached and assessed, as if it were a piece of nature in its own right. Most of Collins's photo-installations and large-scale single images project presence and comparative stillness in the style of this one. A student at the Slade School of Art in London in the 1970s, Collins now lives and works in Barcelona, the subject of *Shopping* (1996).

☞ **Bar-Am, Renger-Patzsch**

96

Hannah Collins. **b** London (UK), 1956. **Untitled (Snails in a Bag)**. 1990. C-type print. **h**220 × **w**190 cm. **h**86½ × **w**75 in.

Connor Linda

Petroglyph and Star Trails, Sonora, Mexico

The earth, represented by shrubs and outcroppings, looks as though it is turning beneath a night sky. The star trails show that the exposure was made over several hours, or long enough to register degrees of light in the heavens. What emerges are intensities of light and a suggestion that the purpose of the petroglyphs was to register the response of various textures to starlight – and to highlight the rock itself. One of Connor's recurring subjects has been illumination, and her pictures show light from the sun, windows and lamps transforming stone, gauze, water and other substances. In the introduction to her book *Solos* (1979) she remarks that creative energy is an elusive force which it is her privilege to 'serve and transform'. Between 1972 and 1977 she used an antique, large-scale view camera with a soft-focus lens and she continues to use large-format cameras today. Her prints are sun exposures made by contacting negatives on printing-out paper, which provides great detail and tonal range.

☛ Gilpin, den Hollander, Mili, Watkins, M. White

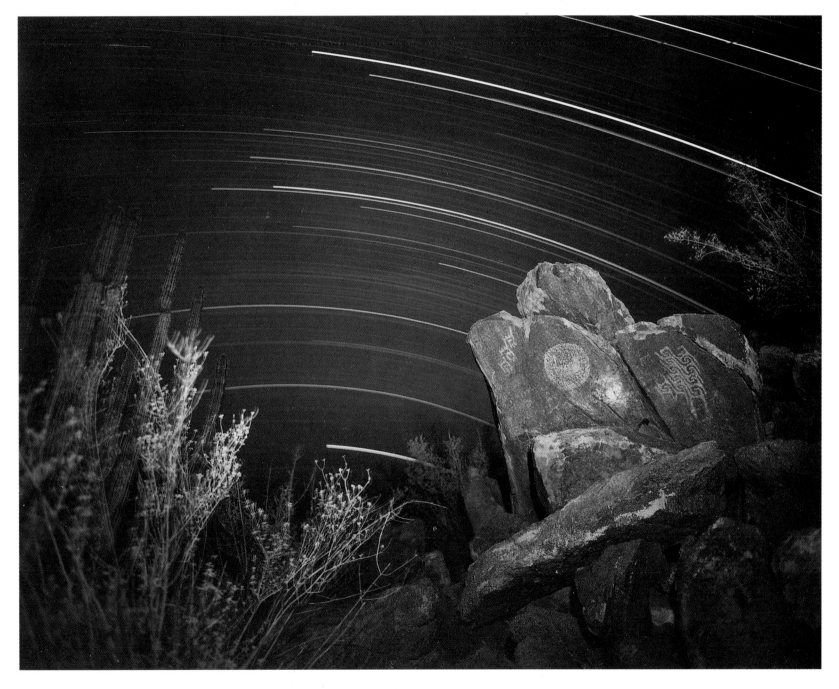

97

Linda Connor. b New York (USA), 1944. **Petroglyph and Star Trails, Sonora, Mexico**. 1991. Gelatin silver print.

Cooper Thomas Joshua

West (The Furthest Point), The Atlantic Ocean

The sea seethes, evaporates and appears to generate its own light. A reader can find consolation in the name, Point Ardnamurchan (a place on the west coast of Scotland), but the sea cannot easily be read by non-specialists, and can principally be remembered or sensed by means of sound and rhythm – eventually reminding you of your own breathing or the pounding of your heart. Romantically, Cooper's many seascapes from the 1980s and 1990s propose a relationship between human beings and Nature's movements and stirrings. Even in his landscapes of rocks, hillsides, grass and vegetation, he discovers Nature as a living, breathing existence. Cooper trained as a photographer in California and New Mexico, but has spent most of his working life as a teacher and artist in England and Scotland. His landscape art was surveyed in a book of 1988 entitled *Dreaming the Gokstadt*, and a catalogue of 1995 called *Simply Counting Waves*.

☞ **Bullock, Hannappel, Le Gray, Mahr, Watkins**

98

Thomas Joshua Cooper. b San Francisco, CA (USA), 1946. **West (The Furthest Point), The Atlantic Ocean**. 1990. Gelatin silver print.

Coplans John Self Portrait (Upside Down No. 7)

Coplans has a hairy body, and that thickening of the skin which seems to develop with age. Seen upside-down, this picture reminds us of St Peter, who was crucified upside-down, and of the martyred saints and apostles who appear in the paintings of the seventeenth-century Baroque artist Caravaggio. Coplans's work prompts memories of Baroque painting and its acute consciousness of the body as a weighty encumbrance. His pictures are made against neutral backgrounds and they are not portrayals, even if they do show the artist's body. This means that they can refer far and wide, to personal experience, classical statuary and Baroque matryrdoms. Above all, though, they divert attention from the social and the personal. Coplans trained as a painter in London and co-founded the influential magazine *Artforum* in San Francisco in 1962. In 1980 he moved to New York, where he took up photography, embarking on his series of *Self Portraits* in 1984.

☛ **Bradshaw, Durieu, García Rodero, von Gloeden, Samaras**

John Coplans. **b** London (UK), 1920. **Self Portrait (Upside Down No. 7)**, 1992. Gelatin silver print.

Cosindas Marie

Sailors, Key West

Marie Cosindas met the two sailors by chance in Key West, Florida. They look, in the context of the worn carpet and the still-life of flowers, like actors in a pre-war drama. Cosindas's male contemporaries in the 1960s were specialists in the social landscape, a tough locale poorly behaved. She, on the other hand, liked to imagine the world re-made tenderly, finely coloured and furnished. Originally a painter and a student of fashion design, she left Boston for California in 1961 to study photography with Ansel Adams. In 1962 she was asked by the Polaroid Company to test Polacolor, a colour film about to be launched. The new medium suited her, and she became an expert after experimenting with a variety of filters and with varied exposure and development times. Her early pictures of flowers, fashion designers and the dandies of the day were published in 1978 in *Color Photographs*, which was introduced by Tom Wolfe, one of her subjects.

☛ A. Adams, Eisenstaedt, Hill & Adamson, Samaras

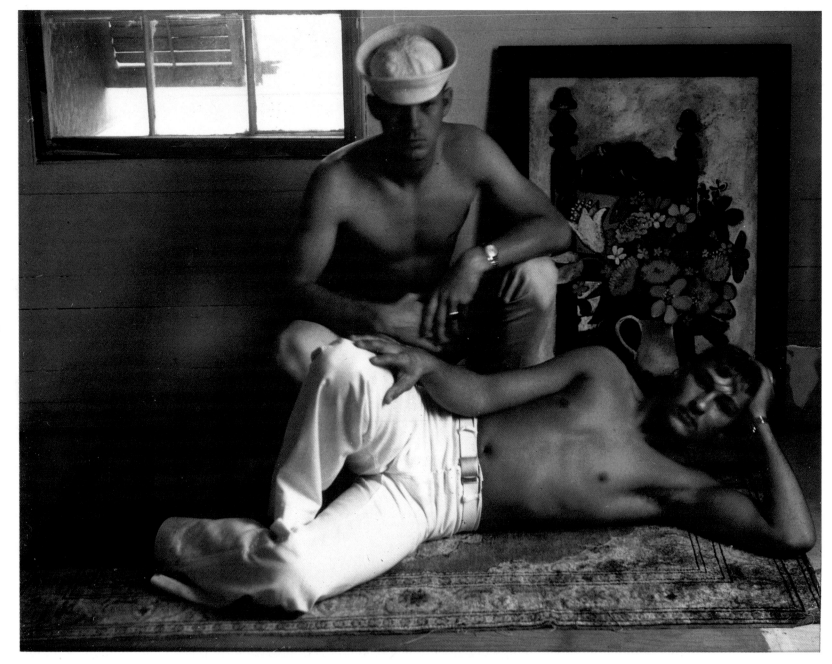

100

Marie Cosindas. **b** Boston, MA (USA), 1925. **Sailors, Key West**. 1966. Polaroid.

Cranham Gerry

Happy Valley Racing, Hong Kong

In this photograph of a race meeting at Hong Kong's famous Happy Valley everything contradicts the established images of horse racing. It is traditionally a daytime occupation, set in the English, French or American countryside, but this event takes place at night in an urban setting on a surface of raked sand. Whereas an English race meeting is just that, a meeting point for the classes fascinated by racing, this scene shows the spectators penned in behind railings, virtually invisible, and backed by racing details in neon – as opposed to the old-fashioned letters and boards typical of English venues. Thus, in a single image, Gerry Cranham has encapsulated many of racing's primary elements, negatively from the point of view of English expectations but in a way which brings them to our attention. This was the keynote image in *The World of Flat Racing*, a collection of his photographs published in 1987.

☛ Caponigro, Le Querrec, Liebling, Muybridge, Prince

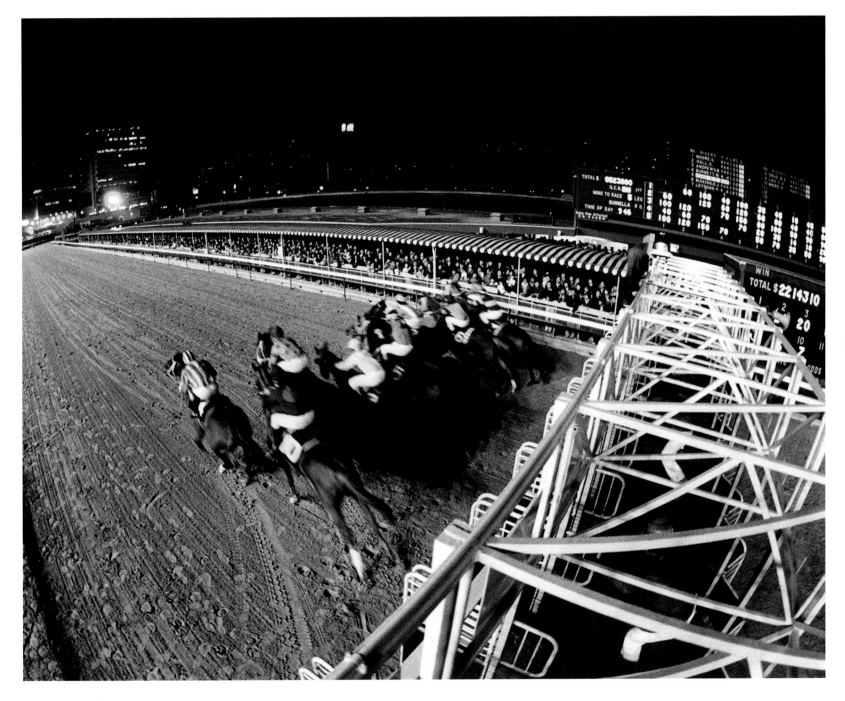

Gerry Cranham. b Famborough (UK), 1962. **Happy Valley Racing, Hong Kong**. 1980. Gelatin silver print.

Cumming Donigan April 27, 1991

Nettie Harris is resting in the foetal position on a stained mattress. She is surrounded by seemingly casually arranged signs from the past. The picture's title is a date, which is the photographer's way of referring to his subject's mortality. Nettie Harris, who died in 1993 at the age of eighty-one, had been a journalist and then a movie extra before she began to model for

Donigan Cumming in 1982. Her first appearance was in a series of arranged photographs called *The Mirror, The Hammer and The Stage*, pictures which initially look as if they are concerned with deprivation and despair, the traditional preoccupations of documentary photographers. Nettie Harris plays a leading role in *Pretty Ribbons*, a remarkable picture book of 1996.

Throughout the series she enacts any number of roles: coquette, odalisque, femme fatale, celebrity and specimen. *Pretty Ribbons* (where this photograph appears) amounts to an act of defiant exuberance in the face of death's solemnity.

☞ Cunningham, Hockney, Kaila, Riis, Weegee, Weston

102

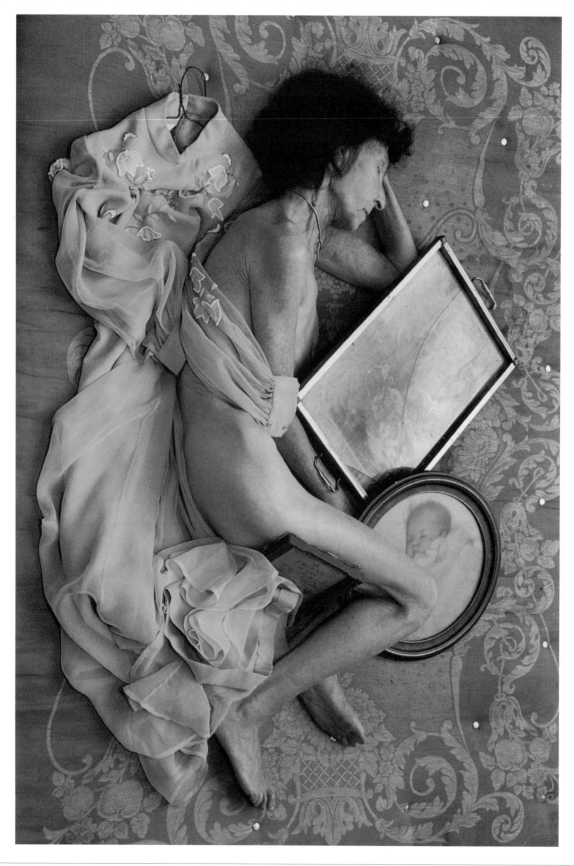

Donigan Cumming. b Danville, VA (USA), 1947. **April 27, 1991**. 1991. Colour coupler print. **h**112 x **w**76 cm. **h**44 x **w**30 in.

Cunningham Imogen Nude

Imagine the photographed space as a shallow box to be occupied by a form held close to the picture surface, and thus both substantial and decorative. The form might be almost anything with pronounced surface continuities: a human body or a boulder or the leaves of a plant. Imogen Cunningham is often associated with such 'straight' photographers of the 1920s and 1930s as Ansel Adams and Edward Weston for, like them, she was a founder member of the Californian Group f.64 in 1932. Her many pictures of buds, stamens and pistils, usually taken among the succulents, flowers and cacti of her own garden, suggest that she regarded fertility as an important theme. She worked as a photographer from around 1901, sometimes in association with Edward S. Curtis, but she found her own aesthetic and topics early in the 1920s. Cunningham cited Gertrude Käsebier as an influence, together with Utamaro, the Japanese printmaker.

☛ **A. Adams, Bellocq, Cumming, Curtis, Käsebier, Weston**

103

Imogen Cunningham. b Portland, OR (USA), 1883. d San Francisco, CA (USA), 1976. **Nude**. 1932. Gelatin silver print.

Curtis Edward Sheriff

Mother and Child

The native Indian woman pauses for her portrait. An Indian interpreter once said to Curtis, 'You are trying to get what does not exist'; nonetheless, his huge ethnographic survey of *The North American Indian* (1907–30), taking in all the tribes west of the Mississippi, is one of the most ambitious and admirable enterprises in the history of the medium. The idea came to Curtis, a photographer from Seattle, when he was on an expedition to the coast of Alaska. In 1906, with the support of President Theodore Roosevelt and the financial backing of J. Pierpont Morgan, he began work in earnest. The twentieth and last volume in the series was published in 1930, along with 2,200 photographs in separate folios. Although meant as a record of 'all features of the Indian life and environment' the pictures have often been accepted as works of an imagination devoted to the idea of life lived in harmony with tradition and nature.

☛ Burnett, Davidson, Lange, O'Sullivan, Stoddart

Edward Sheriff Curtis. **b** White Water, WI (USA), 1868. **d** Los Angeles, CA (USA), 1952. **Mother and Child**. c1909. Photogravure.

Daguerre Louis-Jacques Mandé Boulevard du Temple

The Boulevard du Temple was a haunt of Parisian lowlife in 1838, when this very early photograph was taken. Along it were many theatres showing horror plays, which resulted in its nickname, Boulevard du Crime. Daguerre, inventor of the diorama and of the daguerreotype, had worked here in the Théâtre Ambigu-Comique as a stage designer in 1827.

Photography, that is to say, was born out of such low haunts, and amongst people who scarcely mattered. The quacks and entertainers who peopled the boulevard are not even visible in this picture, apart from a blurred shoe-shiner and his static patron, both of whom must have been on the spot for the several minutes required for an exposure. This photograph was

soon known throughout the world through descriptions in the press marvelling at the kind of details on show: cracked plaster and distant commercial inscriptions. Daguerre gave away many of his early pictures in order to publicize the process.

☛ Atget, Besnyö, Gruyaert

Louis-Jacques Mandé Daguerre. b Cormeilles (FR), 1787. d Bry-sur-Marne (FR), 1851. **Boulevard du Temple**. 1838. Daguerreotype.

Dahl-Wolfe Louise Lauren Bacall

Lauren Bacall seems to be reflecting on all those serving their country overseas. When this picture was taken in 1943, she was no more than Betty Bacall, a young model at the beginning of her career; this appearance took her to Hollywood and to stardom. Dahl-Wolfe began to work for *Harper's Bazaar* in 1936, and continued to do so for the next twenty-two years;

during that time her pictures were used on eighty-six of the magazine's covers. It is no wonder that Dahl-Wolfe's photograph launched Bacall's screen career since her trademark was fashion as drama. She chose to imagine her models en route and reflective, pausing momentarily in the middle of a train of thought. Dahl-Wolfe was one of the first to

take fashion pictures in natural light. She retired in the late 1950s, realizing that 'the coming world of technology – the machine age, a commercial age' was on the horizon.

☛ Bailey, Blumenfeld, Frissell, Sieff, Teller

Louise Dahl-Wolfe. **b** Alameda, CA (USA), 1895. **d** New York (USA), 1989. **Lauren Bacall**. 1943. C-type print.

Dalton Stephen

A Leopard Frog

A North American leopard frog is diving into deep water in search of security. Perhaps, like many of Dalton's animals, it fears humanity, which has been responsible for the destruction of its habitats. Nature pictures from the 1940s often had a metaphoric element: they tended to symbolize cruelty or the fight of one against all. In the 1980s, however, nature's inhabitants – seen in full colour – came to stand for a beautiful world apart, which we might identify with and understand, had we the patience and the sympathy. Dalton began to take pictures of birds and insects in flight during the 1960s. His photography is technically intricate, making use of flash units capable of exposures of 1/25,000th of a second attached to light beams and photo-cells. Dalton's career, with its varied cast of bats, rats, snakes and frogs, is recounted in his book of 1988 entitled *Secret Lives*.

☛ Doubilet, Drtikol, Frissell, Sammallahti, Wegman

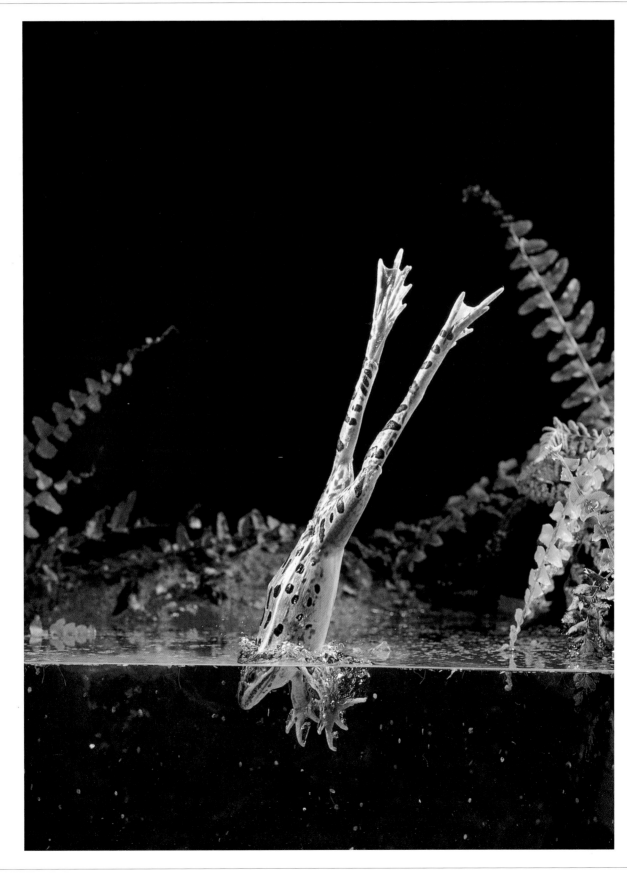

Stephen Dalton. b Kingswood (UK), 1937. **A Leopard Frog**. 1988. C-type print.

Dater Judy

Ms. Cling-Free

Ms. Cling-Free, a picture for which Judy Dater posed in person, represents the oppressions of domesticity. In another photograph in the same series entitled *Death by Ironing* she appears with the cord of the iron twisted around her neck. This perfunctory stage also sees her as *Queen of the Night*, *Elephant Woman*, *Spider Woman* and *The Magician*. Judy Dater's is a notably personal and autobiographical art, seemingly made for the attention of those of her friends who appear in it. You are invited in, but on condition that you go along with its combination of fantasy and intimacy. It is art in the tradition of the Californian avant-garde as shaped in the 1920s, an art devised amongst close associates. In 1978 Judy Dater completed a book on the photographer Imogen Cunningham, one of her great Californian precursors. Her own books include *Women and Other Visions* (1975), *Body & Soul* (1988) and *Cycles* (1994).

☛ Cunningham, Hammerstiel, Minkkinen, Morimura, Wulz

108

Judy Dater. b Hollywood, CA (USA), 1941. **Ms. Cling-Free**. 1982. Cibachrome.

Davidson Bruce — Mother and Child

Together they make an entwined figure on the white bedspread. A mother with child endure the bare walls and dim room of a narrow tenement apartment. This pair appear towards the beginning of Davidson's *East 100th Street* (1970), which is one of photography's major works. Davidson photographed on this street in East Harlem for two years in the mid-1960s, documenting and giving prints to his subjects. In an eye-to-eye relationship with the people, he expressed both dignity and despair with compassion. These intimate images made in homes, on rooftops and in the street are testimony to the vitality of the community. Davidson began his career in humanistic documentary photography in the late 1950s with a series on a youth gang in Brooklyn. He tends to see life on the fringe and is often an insider looking out. He uncovers meaning with a visual vitality that is uncanny.

☞ S. L. Adams, Curtis, Lange, Lyon, Mydans, Nixon, Seymour

Bruce Davidson. b Oak Park, IL (USA), 1933. **Mother and Child**. c1967. Gelatin silver print.

Davies John

Allotments Overlooking Easington, County Durham

Beyond the improvised fences in the foreground are the allotment gardens used by the coalminers living in the pit town of Easington. The chimneys of the town stretch back into the smoky distance. In all of his pictures of Britain, which were published in 1987 in *A Green & Pleasant Land*, Davies gives a panoramic account of landscape together with explanatory comments. Like many landscapists of the period, and especially those in Germany, Davies's interests lie in incorporating small-scale historical and incidental details into a larger whole. Thus, in this case, the line of re-used doors to the left recalls the ordinary traffic of our lives, an idea which is taken up more uniformly by the smoking chimneys and finally lost sight of as the town recedes towards the skyline. Davies was one of the first British landscapists to use panoramic formats in the style of the New Topography as practised in Europe in the early 1980s.

☞ A. Adams, R. Adams, Basilico, Deal, Hannappel

110

John Davies. b Sedgefield (UK), 1949. **Allotments Overlooking Easington, County Durham**. 1983. Gelatin silver print.

Davison George

The Onion Field

This tranquil scene of an onion field, taken in the early summer of 1889 at the village of Gomshall in Surrey, is the first successful Impressionist photograph in the history of the medium. Made with a pin-hole camera requiring a long exposure time, it is the work of an artist convinced that the kind of sharp focus practised in the 1880s was unnatural. Soft focus led to what Davison called 'diffusion' and meant that a scene could be read quickly and for its overall feeling. His intentions were as much social as aesthetic, for the response he most wanted to elicit was one of sympathy for working people. In 1892 he was a co-founder of the important Linked Ring exhibiting society, and he was a great influence in art photography throughout the 1890s. From 1889 he was associated with the Kodak company, but his commitment to radical political causes eventually led to his withdrawal from that association in 1907.

☞ **Deal, Demachy, Hofmeister**

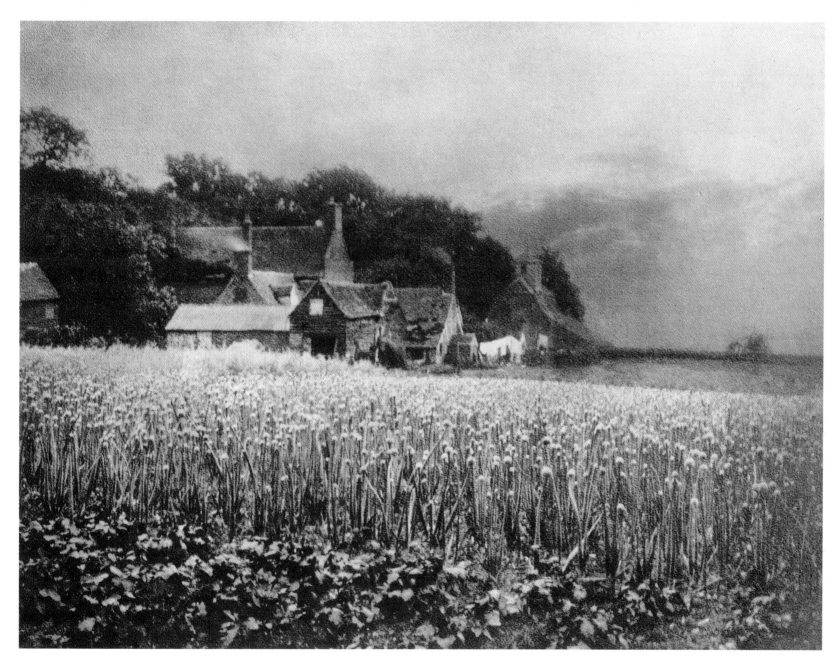

III

George Davison. **b** Lowestoft (UK), 1854. **d** Antibes (FR), 1930. **The Onion Field**. 1889. Photogravure.

Deal Joe

Colton, California

The land beyond in the sunlight looks well maintained and part of the ordinary world, and those houses to the right seem settled and protected in the lee of the hill. The foreground, however, with its scattered rocks remains part of the wilderness, and the title of the series, *The Fault Zone*, refers to earthquakes and danger. Deal's is a landscape art based on such distinctions: wilderness and culture, private and public. In addition, he likes to distinguish between foreground zones of things which come to hand – material pieces strewn on hillsides and in yards – and a world beyond which can mainly be seen and understood as an idea. His analytical turn of mind has presented him with material everywhere, but principally in California and in and around Los Angeles. Although his pictures always invite analysis, they stop short of criticism. One of the earliest of the New Topographers, Deal is well-known for survey work undertaken for the bicentennial of the city of Los Angeles in 1980.

☛ **A. Adams, R. Adams, Davies, Davison, Gerster**

Joe Deal. b Topeka, KS (USA), 1947. **Colton, California**. 1978. Gelatin silver print.

Delahaye Luc

Kosevo Hospital, Sarajevo

The soldier Remzija Aljukic was shot on the front line near Sarajevo in July 1993. Taken to the emergency ward of Kosevo Hospital by his two brothers, who were fighting at the same place, he died a moment later. Delahaye took several pictures of the event, of which this is the most comprehensive. Wars, Delahaye says, allow for 'a sort of cool indifference to myself which lets me have a cold sensibility to the world'. He compensates for the fierce reality of war zones by working on portraits in his home city of Paris. His first book, *Portraits/1*, is made up of eighteen portraits of homeless people, taken in photo booths. His second book, *Mémo*, is of identity pictures of people who died in the Bosnian war, and his third is of stolen photographs of passengers on the Paris *métro*. These works are based on the absence of the photographer and the negation of his relation to the subject, allowing the subjects to reveal their true nature.

☞ Eppridge, Gardner, McCullin, L. Miller, Silk

113

Luc Delahaye. b Tours (FR), 1962. **Kosevo Hospital, Sarajevo.** 1993. Gelatin silver print.

Delano Jack

Interior of a Rural Home, Green County, Georgia

A girl is standing in a doorway with another figure behind her halfway down the hall, and beyond him the girl's grandmother sitting facing the back steps. Delano liked this picture. He said that despite its being carefully composed and formal, it was also documentary and very direct. It looks as if it might have been put together with reference to the painting of the seventeenth century, and like that genre of painting it appreciates cultural and temporal continuities. Delano proposes a world carefully assembled and in touch with the past, and in this respect his photography is far more history-conscious than that of, for example, Walker Evans and Ben Shahn, who preceded him in the documentary section of the American Farm Security Administration. Delano, one of the last photographers to be employed by the FSA, replaced Arthur Rothstein in 1940. In 1941–2 he settled in Puerto Rico, where he continued to work as a photographer and a composer of music.

☛ W. Evans, Mark, Rothstein, Shahn, Tripe

114

Jack Delano. b Kiev (RUS), 1914. **Interior of a Rural Home, Green County, Georgia**. 1941. Gelatin silver print.

Demachy Robert

In the Grass

Dressed in white, the girl lies reading in a meadow. It is important that she is reading, for that signals spirit and a sense of introspection. It is easy, looking at her, to imagine what it might be like to lie like this in the country, amongst flowers, grasses, scents and breezes. Demachy's tendency was to fuse figure and ground, to show his subjects made – or so it seems – out of the very stuff of nature. He took many pictures of women in landscapes, and of country life in Brittany. Whatever the topic, his figures always begin to merge with the atmosphere surrounding them. Between 1900 and 1905 Demachy was France's leading art photographer, having already built up an international reputation as a printer and specialist in the gumbichromate process. From 1904 he began to make oil prints. For Demachy the negative was no more than a starting-point, and each print was unique. He was constantly attacked by purists, and withdrew from photography in 1914.

☛ **Davison, Erfurth, Hofmeister, Patellani**

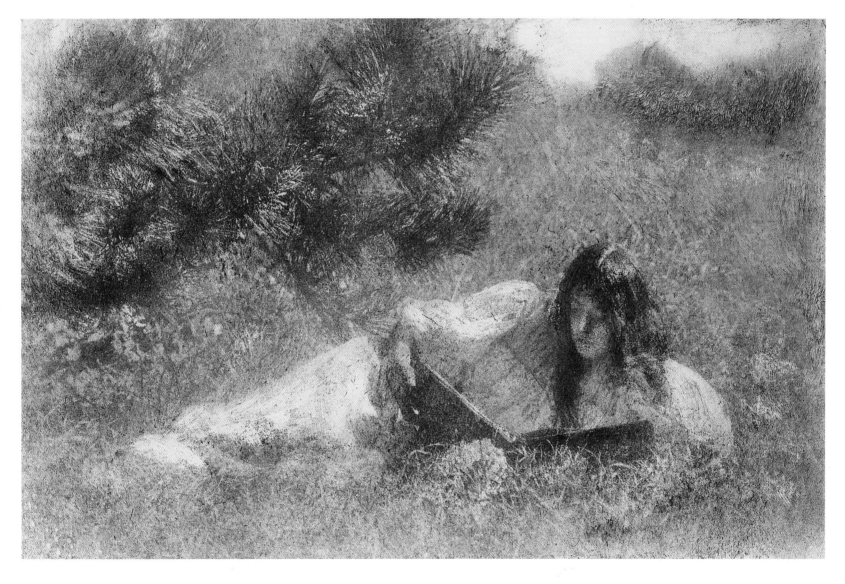

115

Robert Demachy. b Saint-Germain-en-Laye (FR), 1859. **d** Hennequeville (FR), 1936. **In the Grass**. 1902. Oil print.

Depardon Raymond Chile

In order to read his newspaper in a room without electric lighting, the man is sitting with his back to the window. Coping with a young child, his wife approaches, while an elder daughter gazes at the camera – as if the photographer wanted to admit to his own presence within the group. Perhaps it is the end of the working day, for the man's hair seems peculiarly shaped, as if by the pressure of a hat. The picture has no obvious meaning, but Depardon's intention has always been to detain and to draw his readers in until they understand the picture for themselves. The fact that Depardon has evidently arranged the scene, for example, raises questions of candour. Is it more just to admit to one's own intervention? As you might expect from a photographer wary of simplification, much of his work is provisional and diaristic. It includes projects entitled *Notes* (1979), *Correspondence new-yorkaise* (1981) and *Le Desert americain* (1983).

☛ **S. L. Adams, Faigenbaum, Lange, Lyon, Owens, Seymour**

116

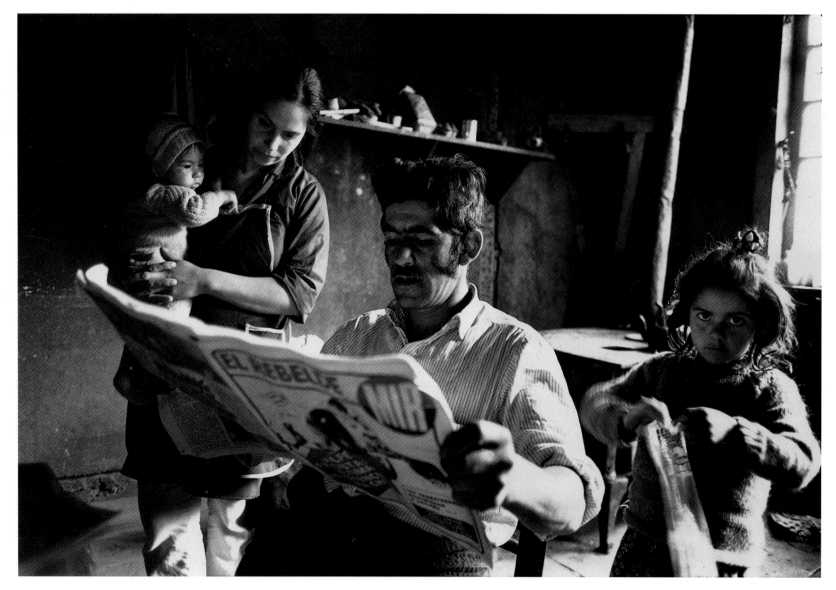

Raymond Depardon. b Villefranche-sur-Saône (FR), 1942. **Chile**. 1971. Gelatin silver print.

DiCorcia Philip-Lorca Eddie Anderson; 21 Years Old; Houston, Texas; 20 Dollars

This might be a film still, for the young man seems beautifully and intentionally side-lit by the rays of the setting sun. Eddie Anderson was paid twenty dollars for this appearance, which suggests that the picture is somehow staged – or more so, at least, than most street photography. Evidently it is a picture about communication, for not only is there a telephone to the right but the whole photograph is traversed by an inscription on the glass which reads PEACE ON EARTH. Perhaps, then, it is the season of goodwill. The photographer's intention seems to have been to set up groups of signs which offer mutual confirmation. If the young man, for example, looks archaic, that suggestion is taken up by the classical facade printed on the beaker – just as his hunger finds its sign in the shape of that hamburger. The picture belongs to diCorcia's *Hollywood* series, a reference less to the place than to the directorial mode.

☛ Lee, Marlow, Parks, Riboud, Singh, Zachmann

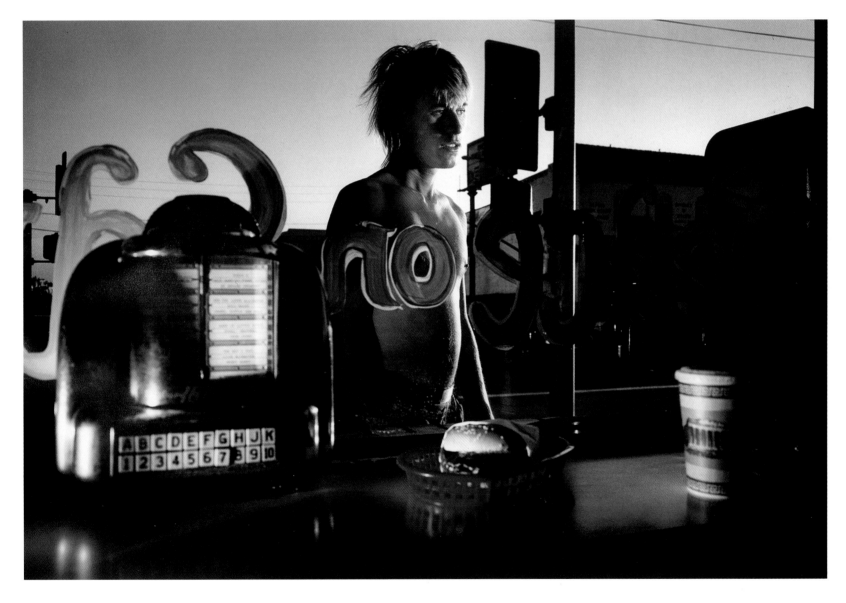

Philip-Lorca diCorcia. b Hartford, CT (USA), 1953. **Eddie Anderson; 21 Years Old; Houston, Texas; 20 Dollars**. c1991. Ektacolor print.

Dijkstra Rineke

Hilton Head Island

The girl is standing – somewhat anxiously – on a beach at Hilton Head Island, South Carolina. She might be posing in recollection of Botticelli's Venus emerging from the foam, although here the surf is far away and placid. This photograph is characteristic of the many beach portraits made by Dijkstra in the late 1980s and 1990s, in which her subjects stand against a neatly proportioned background of sea and sky. Dijkstra's people co-exist awkwardly with such harmony in nature as if unaware of the exact rules, just as they are not quite certain of the etiquette of self-presentation on such exposed sites. The point of such portraits is to show character in formation and human vulnerability, and although they may be appreciated in isolation, they may also be understood as part of a challenge to the lethal self-confidence of many of the news and history makers of the day. Dijkstra trained at the influential Gerrit Rietveld Academie in Amsterdam.

☛ Gibson, Goldblatt, Hoyningen-Huene, Model, Ross

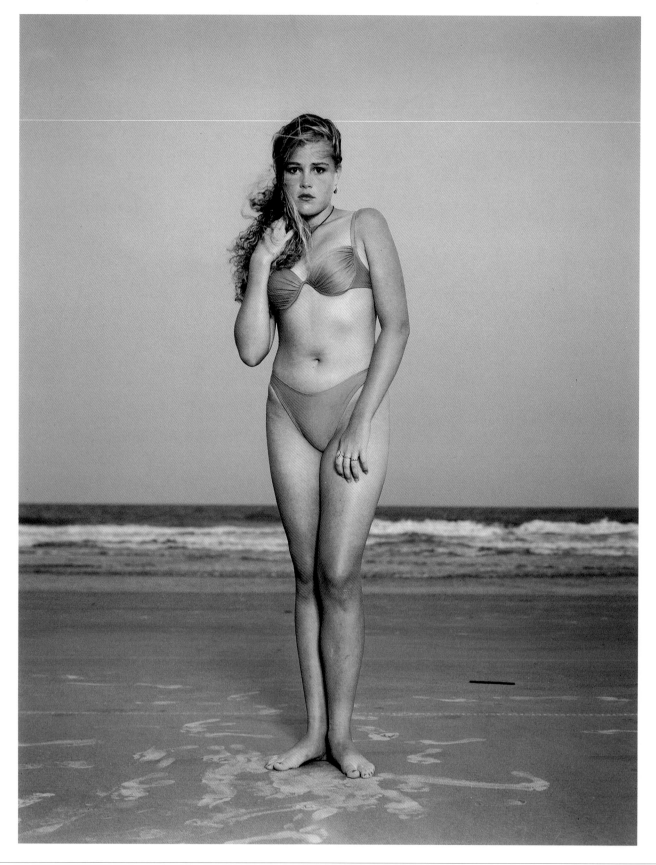

Rineke Dijkstra. b Sittard (NL), 1959. **Hilton Head Island**. 1993. C-type print. **h** 154 × **w** 130 cm. **h** 60½ × **w** 51¼ in.

Disfarmer Mike

Mr and Mrs Barger

This picture was taken to be sent to the Bargers' son who was convalescing in New York after being wounded in the war in Europe. Like many other photographs by Disfarmer, this portrait acted as a substitute for the subject. Photography is almost always assumed to be meant for a distant audience, but Disfarmer's clients – who came from the small town of Heber

Springs in Arkansas – usually had their portraits made for friends and relatives. Disfarmer's portraits carry a conviction hardly matched in the history of the medium. This may be because his subjects did not believe in posturing or posing, wanting to show more than just one aspect of themselves. It is likely, too, that many of his subjects from Heber Springs had

never had the leisure to envisage themselves from others' viewpoints. Born Mike Meyer, Disfarmer took up commercial portraiture sometime in the 1920s.

☛ Durieu, van der Elsken, van der Keuken, W. Miller, Vishniac

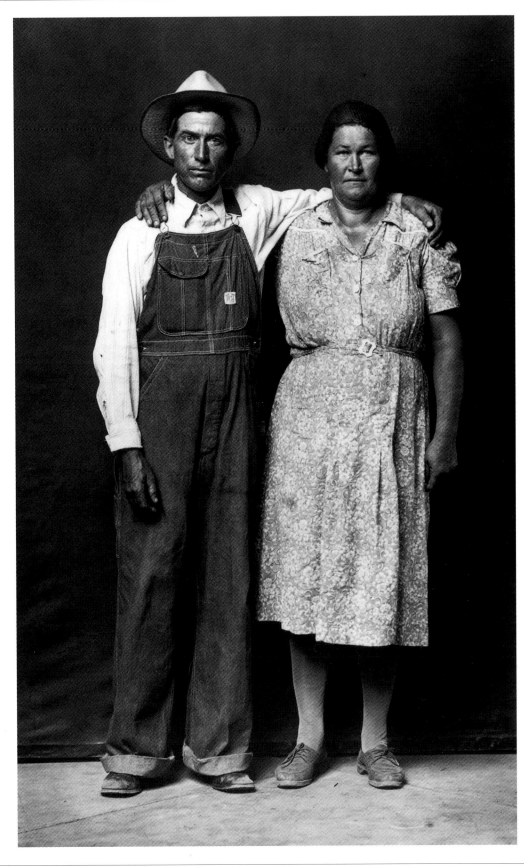

Mike Disfarmer (Mike Meyer). b Heber Springs, AR (USA), 1884. d Heber Springs, AR (USA), 1959. Mr and Mrs Barger. c1943. Gelatin silver print.

Doisneau Robert

The Kids in Place Hébert

Maybe the elder girl just wanted the child in the apron to pose properly, because cameramen must have been rarities in Place Hébert, up in the north of Paris near to the Porte de la Chapelle. She seems to be addressing herself directly to Doisneau, and to be completely unaware of the running figure behind her and the youth idling by the telephone and looking for all the world like a pimp in training. What distinguishes Doisneau's street photography of the 1940s and 1950s is a capacity for narrative. There was also some point in photographing the unwashed real life of Place Hébert, because it was a way of toying with the romantic images of the city which were then very much in vogue. Doisneau came to photography by way of the studio of André Vigneau and (from 1935–9) the publicity department of Renault at Billancourt, which he described as 'a hard school'. In 1949 he signed a contract with *Vogue*, but it is for his 'street photographs' of Paris that Doisneau is best known today.

☛ **Barbey, Brandt, Caron, Käsebier, Levitt**

120

Robert Doisneau. b Gentilly (FR), 1912. **d** Paris (FR), 1994. **The Kids in Place Hébert**. 1957. Gelatin silver print.

Doubilet David

Diver and Cardinal Fish in Wire Coral Forest

The swirling shape in the blue overhead is made up of a shoal of cardinal fish, and the thicket in the foreground is black wire coral. The picture was taken at 55m (180ft), a depth at which nitrogen accumulates in the bloodstream and produces a narcotic effect. Doubilet recounted feeling like a lost child in a fairy tale, 'roaming through a witch's scalp'. The photographer,

who took this picture in Suruga Bay off the coast of Japan, published his first pictures in *National Geographic* in 1972 and has continued to do so regularly since then, reporting eventually on most of the world's oceans. Although some of his pictures are of weird beasts of the deep and of vegetation glowing vividly under artificial light, an equal number are of

underwater landscapes in which opaque blue distances come to the kind of shadowy life on show here. This is an alternative world in which Man is neither the measure nor the master, but rather an encumbered intruder.

☞ Dalton, van Elk, Frissell, List, Mahr, Tomatsu

David Doubilet. b New York (USA), 1946. **Diver and Cardinal Fish in Wire Coral Forest**. 1989. C-type print.

Drtikol František

The Soul

A figure cut from cardboard but representing the soul dives through an atmospheric spiral from darkness into the bright light of understanding. Drtikol gave no explanations with his later pictures, which always feature such sprightly figures cut from board, and their meanings can only be surmised from a knowledge of his interest in Theosophy and Buddhism in the 1920s and after. Perhaps it is important that the figure curves in sympathy with the descending spiral, and also that its limbs are so accentuated. Drtikol was in touch with Rudolf Steiner, the founder of Anthroposophy, who taught that the soul begins to sing when the limbs carry out the harmonious cosmic movements of the universe. Through the limbs, according to Steiner, we absorb the movement of the world into ourselves, which he calls the Spirit. Drtikol only undertook this theological photography in the 1930s, having worked as a successful portraitist in Prague from 1910 onwards.

☛ Dalton, Funke, A. Klein, Moholy-Nagy, Sorgi

122

František Drtikol. b Pribram (CZ), 1883. **d** Prague (CZ), 1961. **The Soul**. 1930. Chlorobromide print.

Dührkoop Rudolph Clotilde von Derp

The heart-shaped motifs on the woman's dress make a beautiful floating pattern which catches and holds the eye. The photographer has used a very narrow depth of field which helps to make us aware of this as a pose held for no more than a moment. By 1913, when this picture was taken, photographers were becoming increasingly conscious of time and mortality.

Dührkoop came to photography relatively late in life. He started work as a retail tradesman and served in the army during the Franco-Prussian War of 1870–1. In the 1880s he opened a portrait studio and became interested in what could be learned from Hamburg's thriving art world. He was one of the first portraitists to abandon the studio for the kind of

familiar and domestic settings implied in this picture. In 1901 he travelled to London, and in 1904 to the USA, where he met Gertrude Käsebier. He was partnered by his daughter Minya, who may have been involved in taking this picture.

☞ **Billingham, Hurrell, Käsebier, Knight, Pécsi, Wilding**

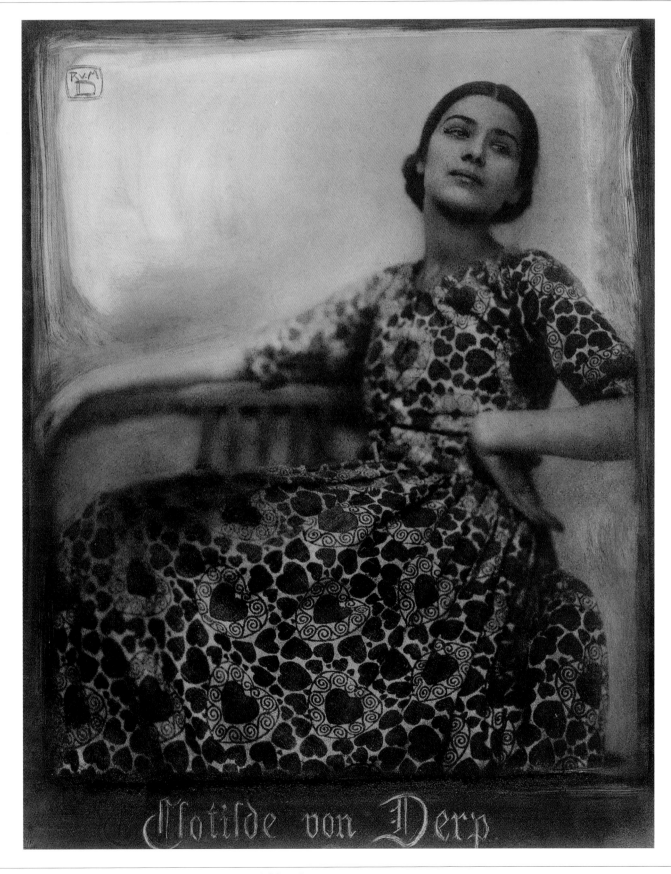

Rudolph Dührkoop. b Hamburg (GER), 1848. d Hamburg (GER), 1918. **Clotilde von Derp**. 1913. Bromoil.

Duncan David Douglas

Freezing Marine

This American soldier is in retreat in intensely cold weather and Duncan meant to show exactly what it was like. The occasion was the campaigns of the American Marine Divisions in Korea during the war of 1950. The war had gone well until the winter, when General MacArthur's forces over-extended themselves as they advanced into the north and were taken by surprise by Chinese reinforcements. The withdrawal was made famous by General Smith's remark: 'Retreat, hell! We're just fighting in another direction.' Duncan himself had been a Marine during World War II, which meant that in Korea he took the soldier's part and reported from ground level without indulging in the kind of partisanship and special effects commonplace in the reporting of the war. The pictures of Korea appeared in 1951 in *This is War!* Contemporaries thought that 'the intimate, naked look of the subjects photographed in Korea was largely due to the choice of the miniature camera for most of their work'.

☛ **Carjat, Echagüe, Meatyard**

David Douglas Duncan. b Kansas City, MO (USA), 1916. **Freezing Marine**. 1950. Gelatin silver print.

Dupain Max

Bondi

The man and woman standing on Bondi Beach represent something approximating to physical perfection, but to stop them becoming mere emblems the photographer has actualized both: the man's thumb puckers the small of his back, and the woman is reaching to empty sand from her bathing costume. Thus this photograph can be seen as the epitome of a 'modern' picture for the way in which it relates ideas to the senses. Both figures appear to be reflecting on the ocean, but at the same time they might just be absorbed in whatever their neighbours are doing, in line with the figure on the right looking across the picture. *Bondi*, which was one of several notable beach pictures taken by Dupain in the 1930s, was sufficiently admired to be reproduced on a forty-three-cent Australian postage stamp in the 1990s. Like others at the time, Dupain worked primarily in advertising and promotion, achieving recognition as a photographic artist only in the 1970s.

☛ Bellocq, Horst, Hoyningen-Huene, Moriyama, Yavno

Max Dupain. b Sydney (ASL), 1911. **d** Sydney (ASL), 1992. **Bondi**. 1939. Gelatin silver print.

Durieu Jean-Louis-Marie-Eugène Nude Study

There is no narrative involved here, merely a complex spatial relationship between two figures placed around an upended box and a bench. There is a clear invitation to calculate just where heads, hands and limbs are positioned in relationship to each other and to the simple furniture. The picture, which is one of a set, was taken by Durieu in collaboration with the painter Eugène Delacroix. Delacroix preferred photographic studies because of their animation, which was unattainable in the normal course of studio modelling, and which transferred readily into the sort of vivacious history painting for which he was celebrated. Durieu was an administrator in charge of religious architecture in France. His work meant that he was interested in photography as a means of documentation: but in addition he made a series of nude studies for the use of artists. It is likely that in this particular case he worked under Delacroix's instruction.

☛ Disfarmer, Goldin, Samaras, Saudek

Jean-Louis-Marie-Eugène Durieu. b Nîmes (FR), 1800. **d** Paris (FR), 1874. **Nude Study.** 1854. Albumen print.

Van Dyke Willard

Funnels

Van Dyke's composition asks its audience to map a space which at first sight looks straightforward enough. The funnel to the left appears to stand closer to us than the capped tube to the right, but it is impossible to be sure because of the lack of a ground-plan or any contextual details. Van Dyke, and his American precursors such as Paul Strand in the 1920s, liked to withhold co-ordinates in pictures of machinery like this, so that the viewer has no option but to become a surveyor of abstract surfaces, and thus involved with facts rather than sentiments. Van Dyke was a founder member, in 1932, of the legendary Group f.64, which advocated 'straight' photography in opposition to the 'devitalized' pictorialism which was then the norm in California. As the 1930s progressed, however, Van Dyke turned his attention increasingly to the soup lines of the Depression, and late in the decade he switched to film-making.

☞ **Baltz, Sheeler, Strand**

127

Willard Van Dyke. **b** Denver, CO (USA), 1906. **d** Jackson, TN (USA), 1986. **Funnels**. 1932. Gelatin silver print.

Dyviniak William W. Automobile Accident

The best reportage pictures are opportunistic, although in this case the photographer may have arrived with the rescue services. The accident took place near Cheektowaga, New York. How the dead motorist ended up among those telephone wires is beyond explanation. The police officers seem engrossed by the wreckage, and the citizens confounded by what has happened. Car accidents were part of the stock in trade of American reporters in 1945 and they continued to be so long afterwards. In 1950, for instance, there were 34,000 fatalities on American roads, and in 1969 around 56,000. (For the artist Andy Warhol in the 1960s car accidents were a recurring topic.) Reportage consists of such genres as the accident picture; from time to time, and sometimes by virtue of the photographer's talent, a genre can be made to transcend itself, as here, in what looks like a stunned re-enactment of the Crucifixion on a provincial road.

☛ Heinecken, Lévy & Sons, Silk, Warhol, Weiner

William W. Dyviniak. Active 1940s (USA). **Automobile Accident**. 1945. Gelatin silver print.

Eakins Thomas

Wrestlers

A shadowy figure, slightly out of focus, watches the wrestlers. They were Eakins's students, and the picture was probably taken during a modelling session for a painting of 1883, *The Swimming Hole*. Eakins, one of the major artists of the nineteenth century, had studied in Paris, before returning to Philadelphia in 1870. He associated form with motion, and wrote in a letter of 1867, 'Form was made by modelling and is seen by running the attention around it'. In this picture his idea may have been to show the same event unfolding from right to left as the wrestlers approach each other, grapple and fall to the ground. Painting did not allow for such experiments with lapsed time and with multiple exposures. Eakins took up photography in the 1870s, originally to take pictures of his family and friends, but he soon found that his interests coincided with the instantaneous picture-taking of Eadweard Muybridge, whom he first met in Philadelphia in 1883.

☛ Hoff, Levinthal, Muybridge, Riefenstahl, Rodger

Thomas Eakins. b Philadelphia, PA (USA), 1844. **d** Philadelphia, PA (USA), 1916. **Wrestlers**. c1883. Platinum print.

Echagüe José Ortiz The White Monk

The white monk is standing as if he is a statue illuminated in a niche. He is holding a book open and at such an angle that it is easier for the viewer to read than for him. Many of Echagüe's pictures look like photographic versions of Spanish paintings from the seventeenth century. He was dedicated to the idea of Spain, to its spirituality as well as its anthropology, and from 1911 onwards undertook an extensive documentary survey of the land and its people. He set up his own publishing company, in order to maintain a high standard of reproduction, and went on to publish four major books, the first of which – *Tipos y Trajas* (on local people and costume) – came out in 1930. A national figure in Spain, Echagüe was by training a military engineer. He was given his first camera in 1898, and from 1906 he experimented with pigment printing processes. In later life he held important positions in Spain's aeronautical and automobile industries.

☛ Duncan, Meatyard, Nadar, W. Smith

José Ortiz Echagüe. b Guadalajara (SP), 1886. **d** Madrid (SP), 1980. **The White Monk.** Date unknown. Fresson print.

Economopoulos Nikos　Nomads by the Side of the Road

The dog appears to have sprung from the mountains and even to stand as a giant monument to wilderness, while the windswept children below keep their eyes on the road. Economopoulos's vision, as expressed in his many pictures of the Balkans taken in the late 1980s and beyond, is of a society sufficiently de-regulated to reveal the kind of raw energies on show here. Once upon a time – or in post-war Europe – photographers had had access to this kind of quick existence, but affluence soon changed all that. The collapse of Communism put it on show once again, and Economopoulos has seized his opportunity. His book of 1995, *In the Balkans* (to which this picture serves as an introduction), ranges widely and asserts cultural continuities across national boundaries. It is, in this respect, another of photography's gallant interventions on behalf of the family of man in its struggle with social norms, however enforced.

☛ **Erwitt, Killip, Maspons, Wegman**

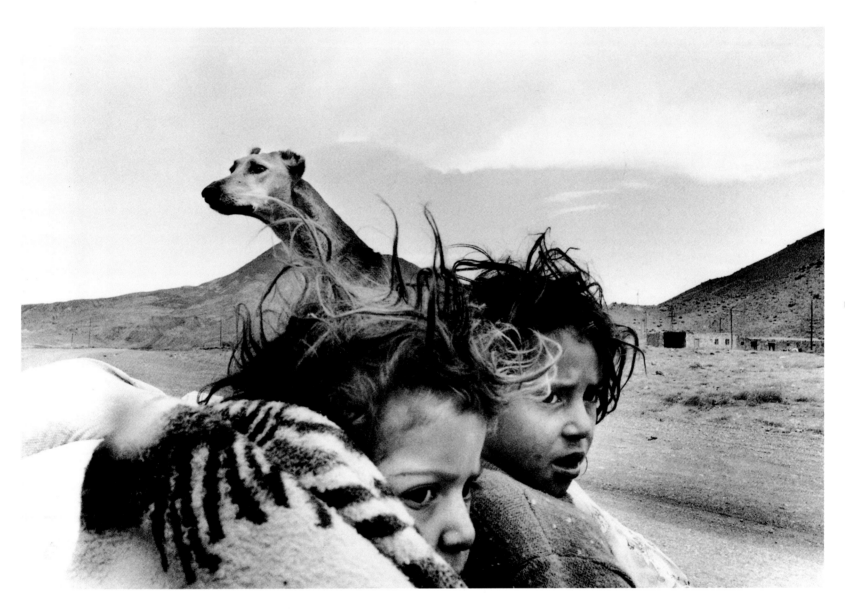

131

Nikos Economopoulos. b Kalamata (GR), 1953. **Nomads by the Side of the Road**. 1989. Gelatin silver print.

Edgerton Harold E.

Milk Drop Coronet

A drop of milk falling onto a thin layer of milk on a plate makes a nearly symmetrical splash. Edgerton, who worked as an electrical engineer at the Massachusetts Institute of Technology, began experimenting with this particular figure in the early 1930s in the hope that he might achieve a perfect coronet. In 1931 Edgerton introduced the stroboscope, a device able to produce quick bursts of intense light. The stroboscope made it possible to create instantaneous pictures of, for example, bullets in flight. Edgerton's experiments and invention coincided with Cartier-Bresson's idea of 'the decisive moment' in photo-reportage. Edgerton's pictures, for which he won many awards, were wonders of science and aesthetic curiosities which seemed to prove that time could be brought to a standstill. Pictures of bullets exiting from soft materials – balloons, apples, lemons – also made a point, even if under cover of science, about violence against the person.

☛ Aeby, Cartier-Bresson, Dalton

Harold E. Edgerton. b Fremont, NE (USA), 1903. d Cambridge, MA (USA), 1990. **Milk Drop Coronet**. 1957. Dye transfer print.

Eggleston William Untitled

The plane looks as if it has been bleeding onto the tarmac on which it stands. The man might be offering consolation, or perhaps he is just curious about what sort of material it is made from. The fence and searchlights also speak of danger; even the name of the town, Huntsville, confirms the notion. Eggleston has been one of the most admired colour photographers in the history of the medium, ever since the publication of *William Eggleston's Guide* in 1976. But a guide to what? Eggleston's tactic was to let himself be captivated by whatever capacity an event had to tell a story of whatever kind. Previously, photography had claimed a higher significance for itself, bearing on the state of nations and humanity, and had never dared to admit to such fanciful notions as Eggleston liked to entertain. His pictures look like images from the tall tales which might originate in such potentially legendary sites as Memphis, Eggleston's home town.

☛ **Appelt, Muray, Patellani**

133

William Eggleston. b Memphis, TN (USA), 1939. **Untitled**. 1972. C-type print.

Eisenstaedt Alfred — V-J Day in Times Square

A sailor is kissing a nurse in Times Square, New York, in celebration of the absolute end of World War II. The picture appeared in *Life* magazine, and came to epitomize the relief and joy felt on the ending of that war. It was, of course, a contrived rather than a candid picture, but Eisenstaedt came from a tradition in German reportage which thought in terms of staged events. In 1930 he worked for the Pacific & Atlantic Agency in Berlin, specializing in metropolitan subjects and in life around the great hotels and resorts. He travelled in the Balkans with the King of Sweden, toured the Middle East, reported on the Abyssinian court, and circled the globe on the *Hindenburg* airship, before quitting Germany for the USA in 1934. A founder member of the Pix Agency, he became a leading Time-Life photographer, and is remembered for his sense of enterprise even in a profession where that sense was usually taken for granted.

☛ **Brassaï, Cosindas, Goldin, Lichfield, Staub**

134

Alfred Eisenstaedt. **b** Dierschau (PRU), 1898. **d** Oak Bluffs, MA (USA), 1996. **V-J Day in Times Square**. 1945. Gelatin silver print.

Van Elk Ger

The Discovery of the Sardines

Are they the same sardines? When you glance from one picture to the other, it looks as though they are, which might explain why van Elk has called this piece a 'discovery'. Or has he imagined the earth springing a leak, and the sea being about to burst through? But why is the piece in two parts? The second situates the artist's rather poetic idea in the context of ordinary life, represented by a passing car. In a moment or two, if the road is busy, the discovered sardines will be pulped into the road and disappear – and with them will go the evidence of van Elk's bright idea. Photography is perfectly fitted to remark on such transient art and to hold onto it precariously for perpetuity. Van Elk's tragi-comic staged photographs were influential throughout the 1970s, especially in encouraging and furthering the development of the important Dutch Fotografia Buffa movement.

☛ Blume, Doubilet, List, Mahr, Michals, Tomatsu

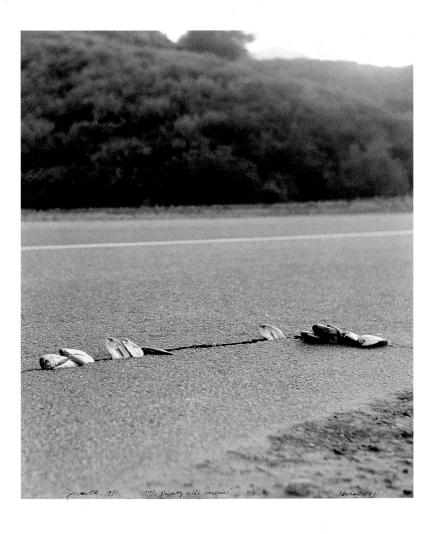
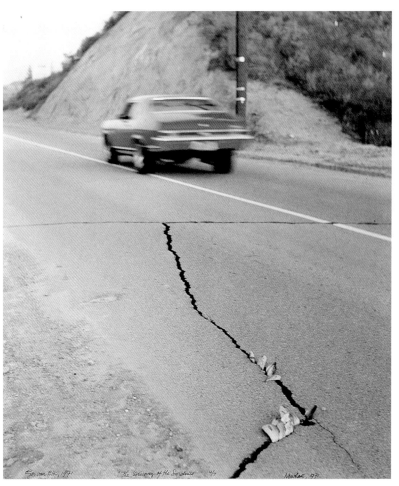

Ger van Elk. b Amsterdam (NL), 1941. **The Discovery of the Sardines.** 1971. Two C-type prints.

Van der Elsken Ed Love on the Left Bank

The woman in the centre is an Australian dancer called Vali Myers and the man beside her is her young Mexican lover. Geri, the figure on the left, is a friend and witness. These are the main characters in *Love on the Left Bank*, a book of photographs by van der Elsken published in 1956. It tells the tale of how the Mexican is wrongly convicted and imprisoned in the Santé gaol, but the real point of the book is its pictures of Parisian life amongst bohemians subject to inertia, doubt and melancholy. Reluctant to tell the story in detail, van der Elsken relies on introverted portraits suggestive of states of mind. He was especially interested in the staging of women in positive roles. His men, by contrast, are either luckless – as in the case of the shortly-to-be-imprisoned Mexican lead – or destructive. Van der Elsken was also a film-maker of some renown. His work in photography is surveyed in a retrospective appreciation entitled *Once Upon a Time* (1991).

☛ **Beresford, Disfarmer, van der Keuken, Vishniac**

Ed van der Elsken. b Amsterdam (NL), 1925. **d** Edam (NL), 1990. **Love on the Left Bank**. 1956. Gelatin silver print.

Emerson Peter Henry

Buckenham Ferry, Norfolk

The cart is waiting at Buckenham Ferry in Norfolk on a misty morning. The bell hanging in the frame on the left is used to summon the ferryman from the other side of the river, and memories of sound are also implicit in the rims of the wooden cartwheels on the stony road and those rattling milk churns. Emerson began to take pictures in the early 1880s, and made his first visit to East Anglia in 1883. It was there that he took most of his pictures in a quite short but influential career in photography. He believed in fidelity to nature, by which he meant that the picture should give a full account of the depth and density of space, of sounds and of atmosphere. His pictures were printed as photogravures and published with his own texts in such books as *On English Lagoons* (1893) and *Marsh Leaves* (1895). In 1886 he published a book entitled *Life and Landscape of the Norfolk Broads*, which was the result of a collaboration with the landscape painter T. F. Goodall.

☞ Annan, Howlett, Manos, Morath

137

Peter Henry Emerson. b La Palma (CU), 1856. **d** Falmouth (UK), 1936. **Buckenham Ferry, Norfolk**. 1893. Platinum print.

Eppridge Bill

Robert F. Kennedy Shot

On 5 June 1968 Senator Robert F. Kennedy was assassinated by Sirhan Sirhan with two shots from a .22 calibre pistol in the corridor of the Ambassador Hotel in Los Angeles. Just minutes before, the Senator had been thanking supporters who had helped him to win the crucial 1968 primary election in California. For Eppridge, a *Life* photographer, this must have

been a routine political assignment, but he happened to be on hand when the deed was done. This is the second in a set of six pictures of the mortally wounded Senator. The final picture is a turmoil of interventions, but at this instant, immediately after the shooting, it looks as if the presence of death has imposed its own decorum. The light, in particular, appears to be a religious

light of revelation and martyrdom. It also introduces that oddly symbolic hand in the background, which looks like a sign connected with the supportive hand of the man in white and the outspread, martyred arm of the dying man.

☛ Battaglia, Delahaye, Gardner, McCullin, Silk

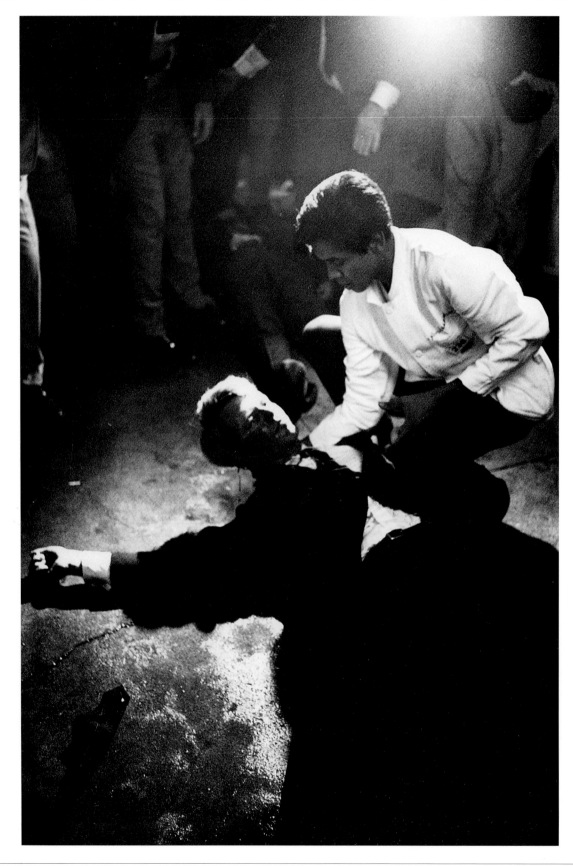

Bill Eppridge. b (USA), 1938. **Robert F. Kennedy Shot**. 1968. Gelatin silver print.

Erfurth Hugo

Girl

This picture of a girl may look at first sight like an exercise in the Art Nouveau style of 1900, but although Erfurth could replicate that elegant manner it is as if he never quite believed in it. A pioneer of the impersonal style of the New Objectivity of the 1920s, Erfurth was troubled by the idea that the design of a picture might be somehow expressive of a state of mind, or that such a state might be intimated in any way at all in an image. Thus where many contemporaries might have turned the girl's head away, to show her deep in thought, Erfurth was content to stage her as a presence, free-standing in a landscape which is no more than a setting. The wide-brimmed hat held by her left side could almost be a sign of the obscurity which she has put aside for the clearer light of day. Erfurth went on during the 1920s and 1930s to become a leading portraitist of German cultural notables as formidable creatures, implacably envisaged.

☞ Carroll, Demachy, Hofmeister, Lee, Mark, Sommer

139

Hugo Erfurth. b Halle (GER), 1874. **d** Gaienhofen (GER), 1948. **Girl.** 1910. Carbon print.

Erwitt Elliot

New York City

The occasion was an advertisement for boots, and the Great Dane and the Chihuahua were on hire from an agency. Erwitt, the most famous dog photographer in the history of the medium, remarked on the advantages of dog models, saying that they were cheaper than hired humans, often more attractive, more distinctive than humans and indifferent to fashion trends. Dogs, too, are ideal for shoe adverts because they take the eye down to where it matters. In other more philosophical work in which dogs and humans appear together, Erwitt points both to the animality of humans and to the humanity evident in animals. Like them we eat, scratch and guard our privacy. The purpose of almost all of his pictures, with or without dogs, is to elicit commentary and captioning: in this case bearing on the large and the small. A multi-faceted photographer from his teens, Erwitt's books include *Observations on American Architecture* (1972).

☛ **Economopoulos, Hurn, Maspons, Wegman**

Elliot Erwitt. b Paris (FR), 1928. **New York City**. 1974. Gelatin silver print.

Escher Károly

Bank Manager at the Public Baths

Even though seen at a disadvantage floating in the public baths, the bank manager still keeps something of his official aura. It ought to be remembered that many photo-reportage pictures from the 1930s were meant – as here – either to inspire comic titling or to be viewed together to make an amusing point. Escher's bank manager, for instance, might have been intended to appear next to a seal or a hippo. Readers, as understood from the Hungarian standpoint, looked for amusement and were ever ready to make remarks. This Austro-Hungarian vogue flourished during the 1930s, and was eagerly taken up in Britain, then greatly under the influence of Hungarian editors and photographers. The war of 1939–45 did much, however, to bring a new sobriety to photo-reportage. The most popular photojournalist in Hungary, Escher only became a full-time reporter in 1928 after a decade working as a movie cameraman.

☞ Dupain, Hoyningen-Huene, Le Secq, Yavno

Károly Escher. **b** Szekszárd (HUN), 1890. **d** Budapest (HUN), 1966. **Bank Manager at the Public Baths**. 1938. Gelatin silver print.

Evans Frederick H.

A Sea of Steps

This picture, of the stairs leading to the Chapter House in Wells Cathedral, was always meant to be understood in terms other than purely architectural ones. The steps themselves ripple and look increasingly like waves building in an ocean as they mount towards the lighted space beyond. The stairs seen rising to the right could be a great wave on the point of breaking, thus representing a danger to the traveller or pilgrim. In the middle is a cut block of stone, symbolizing a steadfast soul put in place by the Divine Architect. The point, though, is not just that the steps look oceanic but that they have been worn that way by generations of use, until their significance had been inscribed into the very fabric of the building. Evans's tendency was always to look for a meaning already present, making him very respectful of appearances as given and thus an early advocate of 'straight' photography. Originally a bookseller, he took up photography when he retired in 1898.

☛ Bisson, Ghirri, Johnston, Kales, Larrain

142

Frederick H. Evans. b London (UK), 1853. d London (UK), 1943. **A Sea of Steps**. 1903. Platinotype.

Evans Walker

Washroom in the Dog Run of Floyd Burroughs's Home, Hale County, Alabama

A bench, bucket, bowl, towel and mirror make a washroom, or a studio of sorts in which an appearance can be put to rights. Evans was an admirer of the painter Degas, who was interested in the art of staging oneself: rehearsals, dressing-up, washing and generally getting ready. Beyond the threshold lies the dining room, a sacramental zone of ritual. In the summer of 1936 Evans took other pictures of this house and the Burroughs family: Allie Mae and the children Lucille, Charles and Squeakie, the youngest. Evans, one of photography's outstanding artists, worked for the Farm Security Administration in the USA between 1935 and 1937. A perfectionist who used an 8 x 10-inch view camera, Evans was one of that organization's least productive photographers. Like Ben Shahn, his contemporary and friend, he envisaged his subjects as vernacular artists whose unselfconscious works are honoured in his own very attentive compositions.

☛ Bisson, Delano, Shahn, Tomaszewski

Walker Evans. b St Louis, MO (USA), 1903. d New Haven, CT (USA), 1975. **Washroom in the Dog Run of Floyd Burroughs's Home, Hale County, Alabama**. 1936. Gelatin silver print.

Faas Horst

A Father's Tragic Burden

In this, one of the most terrible war pictures ever, it is apparent that the man's pleading will be to no avail, even though perhaps all he really wanted was a witness to his grief. However, this picture shows more than just an encounter between hurt individuals and a juggernaut. The man on the ground seems to have made contact in his sorrow with that hatless corporal, whose relatively compassionate gesture provokes reactions in the rest of the soldiers. Altogether, Faas has caught or created an instant of interaction, for the men on the juggernaut are responsive to the force field of the man with his dead child. The small homestead in the background, around which the action pivots, also plays its part. Faas's Vietnam war photographs won him a Pulitzer Prize for news photography. A Berliner brought up during World War II, Faas went to work at the age of twenty-three for the agency Associated Press, reporting on action in the Congo and in Algeria before working in Vietnam.

☛ **E. Adams, Burrows, Griffiths, Ut, Veder**

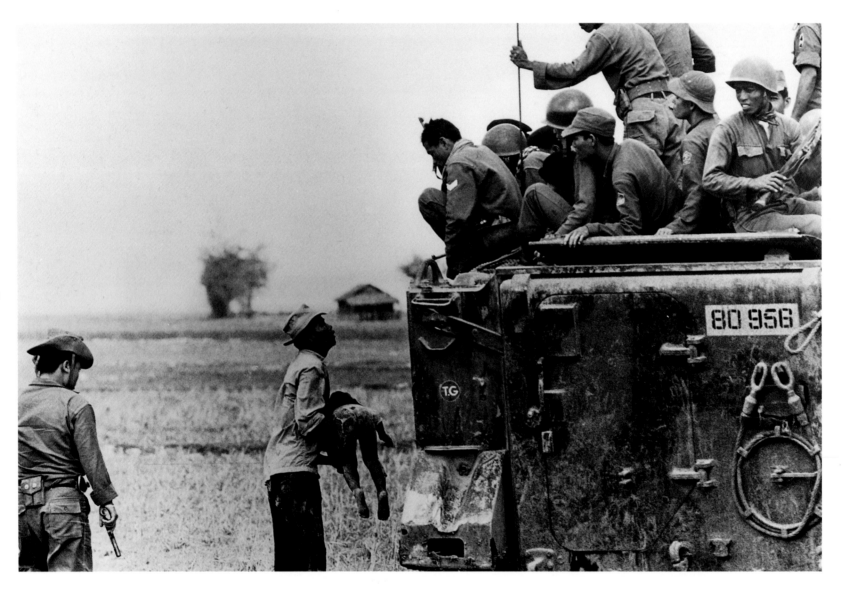

Horst Faas. b Berlin (GER), 1933. **A Father's Tragic Burden**. 1964. Gelatin silver print.

Faigenbaum Patrick

The Colonna di Paliano Family, Naples

Members of the Colonna di Paliano family from Naples are posing in the light beyond the archway, leaving the foreground to darkness and an incidental table holding a selection of bottles. Faigenbaum, one of the most notable portraitists of the 1980s, always ensures that his subjects are either sufficiently distant or obscured to make it necessary to look closely into the picture. He invests his subjects with a sense of mystery, not because they are necessarily mysterious in themselves but because of actual conditions. We are more likely to meet people, he suggests, in the shadows or at long range than in the clarity of the studio. He has taken pictures in Italy, among the noble families of Florence, Rome and Naples – among people, that is, to whom deportment comes as second nature. He admits to having been influenced in 1976 by Bill Brandt, who advised him to make portraits in the decor and surroundings of everyday life.

☛ **S. L. Adams, Brandt, Depardon, Owens**

Patrick Faigenbaum. b Paris (FR), 1954. **The Colonna di Paliano Family, Naples**. 1991. Gelatin silver print. **h**81 × **w**79 cm. **h**31¾ × **w**31 in.

Faucon Bernard

The Battlefield

The young boy and the flames dotted around the edge of the field are real enough, but the casualties are dummies dressed up as soldiers. This scene is part of a series put together in the late 1970s and published as *Les grandes vacances* in 1979. Faucon's procedure was to use shop window dummies and children together in staged tableaux of scenes from an idyllic childhood. Faucon's 'children' sail home-made boats, fly kites and celebrate in beautiful landscapes, and seem untroubled by older generations. Yet these pictures are not entirely innocent but rather show an adult's games played around the idea of a perfect childhood. In this case, for instance, the young boy is reporting to the camera apprehensively, almost as if he has just returned from an actual battle. The invitation, as in so much of the photography which followed in the 1980s, is to reflect on just what it is like to be faced by such combinations of the real and the fictive.

☛ **Baltermants, Burrows, Gardner, Simmons, Wall**

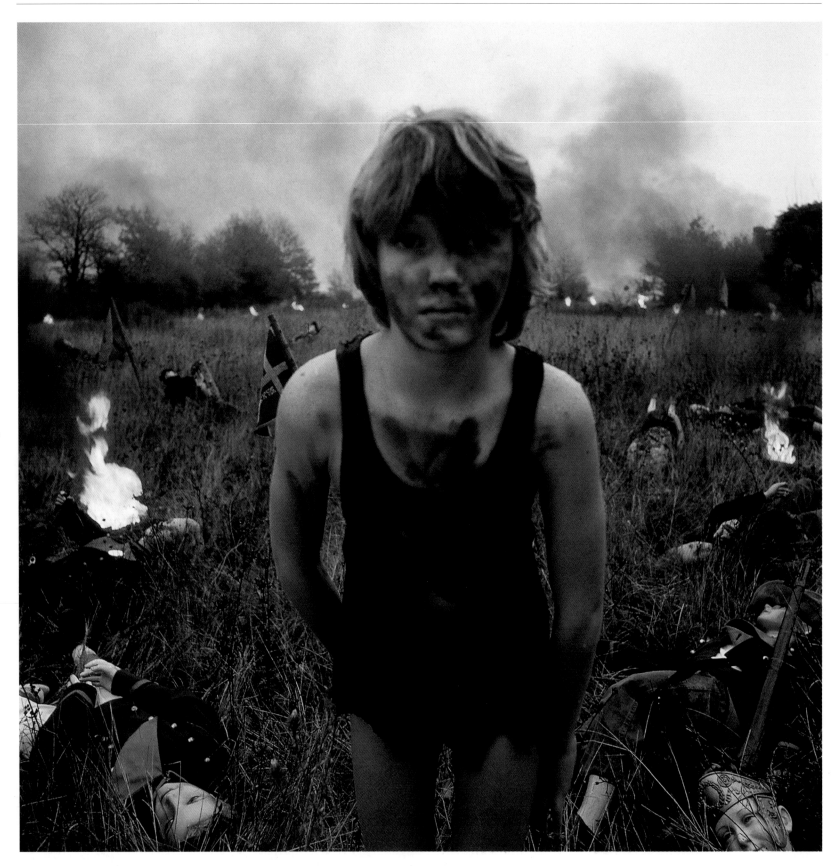

Bernard Faucon. **b** Apt-en-Provence (FR), 1951. **The Battlefield**. 1978. Ektachrome. **h**60 x **w**60 cm. **h**23½ x **w**23½ in.

146

Feininger Andreas

The Photojournalist

Dennis Stock, the face behind the camera, went on to become a leading photojournalist with Magnum Photos. When this picture was taken in 1955 Stock had just won *Life* magazine's Young Photographers Contest. By 1955 photojournalism was increasing in status, and its leading names were becoming widely credited and known. This melodramatic staging of the young cameraman as a mechanized insect owes much to the expressionist aesthetics of the 1920s, when photojournalism first emerged as a profession in Germany. Feininger himself was part of that formative generation, having studied architecture at the Bauhaus in Weimar. He went on to practise as an architect and in 1932 served in Le Corbusier's studio in Paris. In 1939 he moved to New York and began to work full-time in photography. He worked for *Life* between 1941 and 1942, and is known for his urban and architectural photography.

☞ Hubmann, Lendvai-Dircksen, Ohara, Özkök

Andreas Feininger. b Paris (FR), 1906. **d** New York (USA), 1999. **The Photojournalist**. 1955. Gelatin silver print.

Fenton Roger

Valley of the Shadow of Death

Although it shows nothing more than a track across a barren landscape in the Crimea, this is one of the most famous of war pictures – and one of the earliest. Its title is taken from the 23rd Psalm, which is equally well known for its mentions of 'green pastures', 'still waters' and 'the paths of righteousness'. The positive, redemptive aspects of the psalm must always have formed part of the picture's meaning. Contemporaries also saw the cannonballs lying like stones in the hollows of the ground as being rather like the debris left behind by glaciers, thus prompting them to think of war as a natural as well as a man-made catastrophe. Fenton made around 300 pictures of the Crimean War, which met with a lukewarm response when they went on sale in 1856. Originally a painter, he trained in London and also in Paris in the studio of the artist Paul Delaroche. In 1853 he was one of the founders of the London Photographic Society, later the Royal Photographic Society.

☞ Gardner, Hannappel, Hütte, Shore

Roger Fenton. b Heywood (UK), 1819. d London (UK), 1869. **Valley of the Shadow of Death**. 1855. Salted-paper print.

Ferrato Donna

Lisa – Moments After her Husband Beat her

This is the keynote picture at the beginning of Ferrato's book of 1991. Entitled *Living with the Enemy*, it deals with the subject of domestic violence against women in the USA. Ferrato came upon this subject by chance in 1982 when she was on assignment to do a story on a highly successful and seemingly contented family. She was living with the family when she was awakened one night by the sound of blows and shouting and found the wife, Lisa, being attacked by her husband. Ferrato determined to follow up on a topic which she felt was obscured by public platitudes, and the result is a series of all-too believable case studies taken in a harsh, intimate monochrome and accompanied by full supporting texts and interviews.

The difficulty facing concerned photography in the 1980s was that the public seemed to be engrossed by surface appearances. Audiences had to be forced to face reality by means of direct testimony, a photographic style which spoke person to person.

☛ Boubat, Furuya, Man Ray, Stoddart

Donna Ferrato. b Waltham, MA (USA), 1949. **Lisa – Moments After her Husband Beat her**. 1982. Gelatin silver print.

Fink Larry

Pat Sabatine's Eighth Birthday Party, Martin's Creek, Pennsylvania

The woman is concentrating hard with good reason. Whatever is happening behind the door could put an abrupt end to her task. There is plenty in the picture to empathize with: her fingers on the dish, that elegantly extended arm above her head, the emphatic gestures of the boy and of the girl beside him. When Fink took this photograph (which appeared on the cover of his 1984 book *Social Graces*), he was still at work on what he called his 'black tie' series, portraits of high and fashionable society at Studio 54, Club Cornich and gallery events in New York. Like the great Weegee, his precursor in New York in the early 1940s, Fink savours the social scene for its ambiguities and its sensuousness. Like Weegee, too, he takes pictures with ethics in mind. If the 'black tie' circuit was marked by 'abuses, voluptuous folds, and unfulfilled lives' (his words), its counter-example must be the Sabatine household of Martin's Creek, Pennsylvania.

☞ S. L. Adams, Arbus, W. Klein, Levitt, Weegee

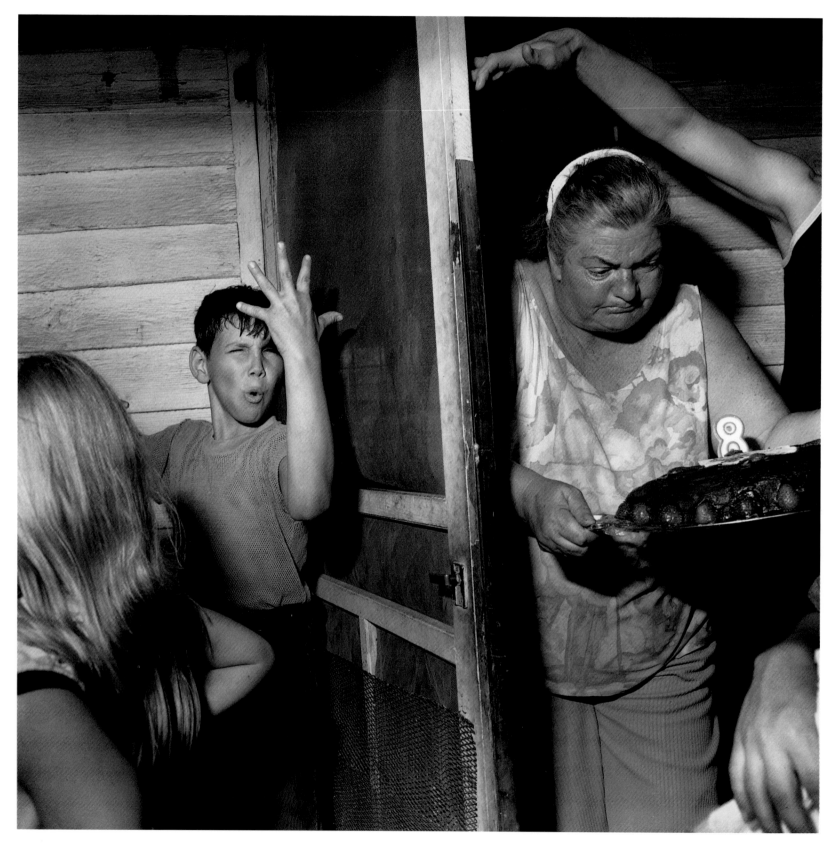

150

Larry Fink. b Brooklyn, NY (USA), 1941. **Pat Sabatine's Eighth Birthday Party, Martin's Creek, Pennsylvania**. 1977. Gelatin silver print.

Florschuetz Thomas Triptych #77

The nostrils are not symmetrical, nor are the lips. The subject seems to be sweating, through that day-old growth of hair. The invitation is to examine the compelling forensic evidence on show, and in the process to focus on lips, nostrils, skin, hair and breath. The feet look as though they have moved outwards suddenly, perhaps in reaction to the voice crying out.

Florschuetz's colour prints of the late 1980s and 1990s are large-scale and show isolated body fragments and other mysterious close-ups which are usually more difficult to identify than these. Florschuetz's aim is to draw attention to the sort of things which are easily taken for granted: physical processes, for example, and life itself. Like many of his

contemporaries in the 1990s, Florschuetz has been anxious to avoid the easy meanings attainable in documentary photography. His pictures are intended to be shown in gallery spaces, and to challenge audience responses.

☞ Arnatt, Burnett, Hubmann, Ohara, Sherman

151

Thomas Florschuetz. b Zwickau (GER), 1957. **Triptych #77**. c1993. Three C-type prints. **h**150 × **w**300 cm. **h**59 × **w**118 in.

Fontcuberta Joan

Cercopithecus Icarocurnu

The original *Cercopithecus icarocurnu* was a type of long-tailed ape, but this one has developed owl's wings and a narwhal's tusk. The picture belongs to the series *Fauna*, which was completed by Fontcuberta and the writer Pere Formiguera between 1985 and 1990. Each entry in their fantastic bestiary is made up of one major 'record' photograph, such as this one, along with invented field notes and drawings. According to the notes, this flying monkey (which was actually assembled from a collection of negatives) was sighted in the Amazon jungle in the spring of 1944, and was regarded as semi-divine by the Nygala-Tebo tribe. Fontcuberta has produced many such series, as if intent on inventing an alternative culture complete enough to constitute a world. His pictures, which are a mine of misleading information beautifully realized, can be thought of as entertainments conceived in opposition to the sobriety of much of the new art of the 1970s and 1980s.

☛ **Boonstra, Hosking, Lanting, Mylayne, Vilariño**

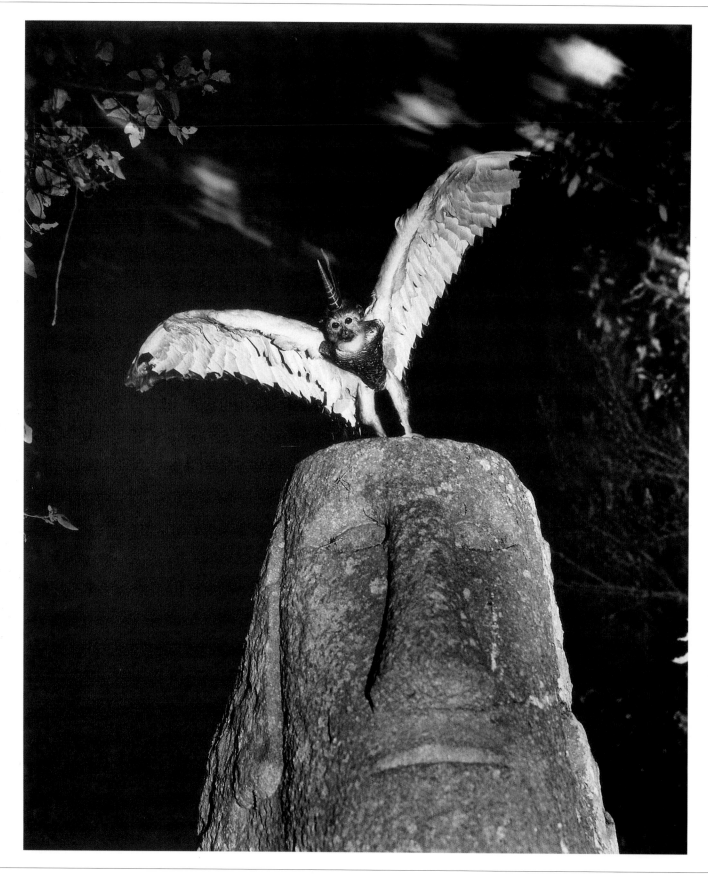

Joan Fontcuberta. b Barcelona (SP), 1955. **Cercopithecus Icarocurnu**. 1986. Toned and tinted gelatin silver print. **h**50 × **w**40 cm. **h**19½ × **w**15¾ in.

Fox Talbot William Henry The Haystack

This looks like a well-built, thatched haystack and the season – to judge from the trees in leaf – is either late summer or early autumn. This would eventually become one of the most famous photographs in the history of the medium, but *The Haystack* was introduced by its creator in *The Pencil of Nature* (1844–6) simply as a demonstration of photography's capacity to disclose 'a multitude of minute details which add to the truths and reality of the representation, but which no artist would take the trouble to copy faithfully from nature'. The ladder and hay-knife may both indicate the presence of man. Fox Talbot's images of such humble objects always promise some hidden meanings and took on a special significance for the art audiences of the 1980s. Fox Talbot began photographic experiments in 1834, and made his first negative in 1835. In 1841 he patented what he called the calotype process (from the Greek word *kalos*, meaning beautiful).

☛ Aarsman, Baltz, Turner

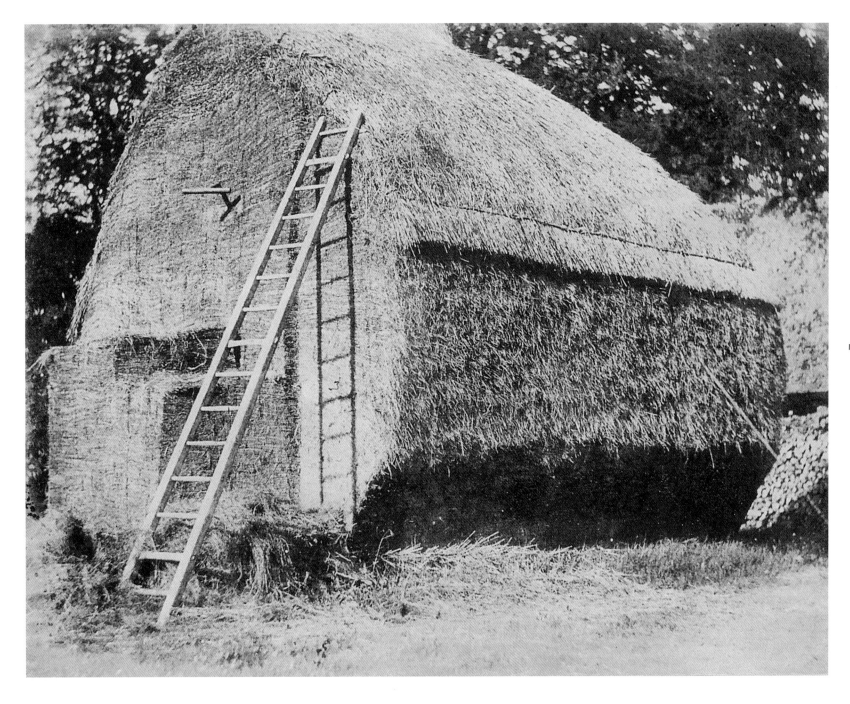

153

William Henry Fox Talbot. b Melbury (UK), 1800. d Lacock (UK), 1877. **The Haystack**. 1844. Salted-paper print.

Franck Martine

Le Brusc, South of France

In this very scrupulously composed picture, it looks as if the setting has been manufactured specifically to contain and to do justice to the human body, showing it off to advantage. The action consists of random waiting and exercising, with a potentially disruptive sub-text in which the boy idly watches the woman who in turn idly watches the man. Although taken at Le Brusc in the south of France in 1976, this picture encapsulates the utopian aesthetics and social vision of the modernist designers of the 1920s, and then makes one wonder whether this was the sort of leisure-based outcome intended. It is typical of Franck to invoke the idea of a perfected world and then to undermine its reassurances. In her pictures from China in the 1960s and of Vietnamese boat people in the 1980s, she shows family life and the generations disrupted. One of her best-known books, *Le Temps de vieillir*, is on the theme of ageing and was published in 1980.

☛ Hopkins, Hurn, Steele-Perkins

154

Martine Franck. b Antwerp (BEL). **Le Brusc, South of France**. 1976. Gelatin silver print.

Frank Robert

Parade, Hoboken, New Jersey

The wind is blowing the flag out taut, and in the process obscuring the eyes of one of the women at the window. National emblems may provide a focus, but they also stand in the way of seeing. The women were watching a procession when they first caught Robert Frank's eye. They appear in *Les Americains*, his survey of the USA which was published by Robert Delpire in Paris in 1958 and then republished in the USA with an introduction by Jack Kerouac as *The Americans* in 1959. This book of eighty-three pictures, although it was badly received to begin with, eventually became one of the major books of the era (in any medium), and a landmark in the history of photography. Frank's memories of his life, and of his life in photography, came out under the title *The Lines of My Hand*, a picture-book which was first published in Japan in 1972. His gift has always been an ability to invest the seemingly commonplace with supplementary qualities, romantic or religious and always mysterious.

☛ **Chaldej, Clark, Meatyard, René-Jacques, Rosenthal**

Robert Frank. b Zurich (SW), 1924. **Parade, Hoboken, New Jersey.** 1955. Gelatin silver print.

Franklin Stuart

The Potato Farmer

A peasant farmer is carrying a sack of potatoes along a track near Cajamarca in the Peruvian Andes. Potatoes are a traditional crop in the area, hand-cultivated on ancestral terraces; the man himself is a speaker of Quechua, the language of the Inca. For the moment, though, he is struggling under a heavy load and seems to be more labourer than representative of an ancient culture. Franklin's strategy has been to re-introduce evidence of materiality into his pictures, and to show more than just surfaces. In the early 1980s he undertook an extensive survey of British society affected by economic depression, and he has remained a concerned photographer. Following his work in Britain, he reported on the effects of military actions in Honduras and Afghanistan, and – most notably – on confrontations between man and machine in Tiananmen Square in Peking in 1989. In the 1990s much of his documentation has been of South and Central America.

☞ Nègre, Rai, Ronis

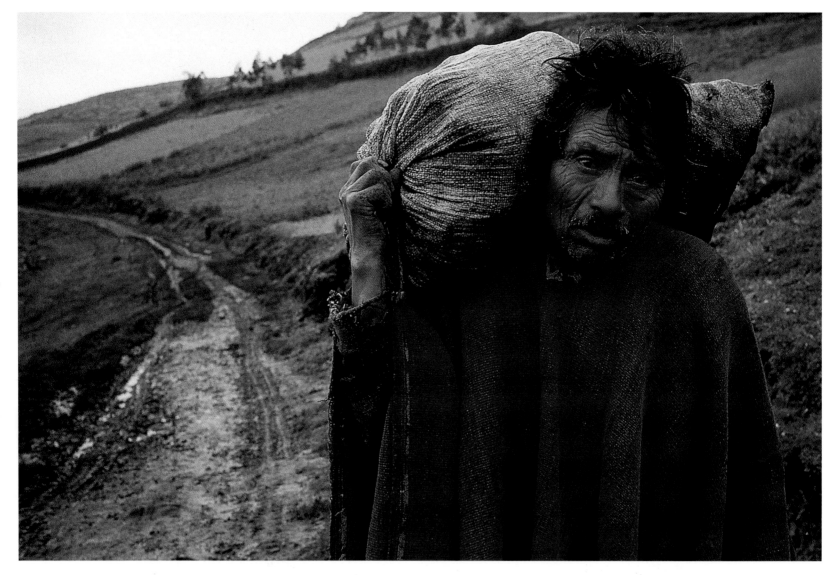

Stuart Franklin. b London (UK), 1956. The Potato Farmer. 1991. C-type print.

Freed Leonard

Suspect in Police Car, New York

The veins in the prisoner's hands are beginning to swell from the pressure of the manacles. He appears in *Police Work*, Freed's famous account of the policing of New York, which was published in 1980. *Police Work* invites its audience into the thick of the action, relayed in pictures and reported speech. From the 1960s onwards, Freed set himself the task of creating a reportage strong enough to make itself heard, and his tactic was to accompany his pictures with vivid commentaries and fragments of recorded dialogue. In this respect he was continuing a tradition established by Margaret Bourke-White in the 1930s, and showing the way to such successors as Eugene Richards in the 1980s. Freed is a concerned photographer and epitomizes the outlook of Magnum Photos, the co-operative with which he has been associated since the mid-1950s. He is perhaps best known for *Black in White America*, published in 1969, and for *Made in Germany* (1970).

☛ Bar-Am, Bourke-White, Koudelka, Richards

157

Leonard Freed. b Brooklyn, NY (USA), 1929. **Suspect in Police Car, New York**. 1978. Gelatin silver print.

Freund Gisèle

Walter Benjamin

Twice a week in the mid-1930s Gisèle Freund used to meet the writer Walter Benjamin on the upper floor of a café in the Boulevard Saint-Germain to play chess. Both were then working in the Bibliothèque Nationale in Paris: Benjamin on a study of Baudelaire, and Freund on early French photography. Her pioneering book (entitled *Photography in France in the*

Nineteenth Century) was published in 1936. Benjamin's own essay, 'A Short History of Photography' (which concentrated mainly on Eugène Atget and August Sander), had been published in 1931 and became in the 1960s the most celebrated and quoted text on the history of the medium. Freund moved from Berlin to Paris after the Nazi takeover in 1933. Interested

in social issues, she photographed the effects of the Depression in England in 1936 for *Life* magazine. However, she is best known for her portraits of the intelligentsia at home and preoccupied – as Benjamin was – by intractable issues of the day.

☛ Atget, Hubmann, Moholy, Özkök, Rodchenko, Sander

158

Gisèle Freund. b Schönenberg (GER), 1908. **Walter Benjamin**. 1938. C-type print.

Friedlander Lee

New York

The blurred public telephone in the foreground, just as much as the automobile which fills the background, stands for elsewhere and for the present as a staging point between destinations. Friedlander's subject has always been the present as a predicament, as incomplete or even unreadable in itself. The problem with clarity and fixity, it was felt in the 1960s, was that they represented a status quo and were thus at odds with a reality which a new generation knew to be in flux. The lived present could only be grasped with difficulty, imperfectly refracted or reflected in windows and mirrors. One of the defining new documentarists in the USA in the 1960s, Friedlander starred in 1966 – together with Bruce Davidson, Garry Winogrand, Danny Lyon and Duane Michals – in Nathan Lyons's influential exhibition 'Toward a Social Landscape', which took place at the George Eastman House, Rochester, New York.

☛ Davidson, Lyon, Michals, Winogrand

159

Frissell Toni

Underwater Model

The elegant model is drifting gracefully downwards through the water, a trail of bubbles rising from her. The new fashion photographers of the 1930s vied with each other to choose the most adventurous settings. Earlier in 1939 (also for *Vogue*) Erwin Blumenfeld had photographed Lisa Fonssagrives elegantly placed on the upper girders of the Eiffel Tower. The intention of fashion photographers was to extend the moment, to keep it from being dismissed, which explains the lingering ambiguities in a pose which both soars and settles. Toni Frissell worked for *Vogue* through much of the 1930s, originally as a caption writer. She subsequently claimed to have been the first to take fashion pictures on location. In the early 1950s she gave up fashion to concentrate on hunting, shooting and fishing subjects for Time-Life's *Sports Illustrated*. During the war she photographed in Europe for the US Armed Services and for the American Red Cross.

☛ Bailey, Blumenfeld, Doubilet, Krause, Teller

160

Toni (Antoinette) Frissell. b New York (USA), 1907. **d** New York (USA), 1988. **Underwater Model**. 1939. Gelatin silver print.

Frith Francis

Delhi Railway Bridge

The photographer contrasts a wonder of Victorian engineering with several fragile local shelters on the river bank. Although the sweeping railway bridge takes the River Jumna in its stride and seems to belittle those incidental figures in the process, its qualities could hardly be appreciated without them. Frith was as attentive to specifics as he was to the major monuments which were his ostensible topic. In his first book, *Egypt and Palestine Photographed and Described* – made up from pictures taken during a tour of 1857 – his own commentaries show him fascinated by the contingencies of travel: the dust, the heat and the casual encounters with guides and camel-drivers. Originally a grocer in Liverpool, Frith undertook three major tours of the Middle East in the late 1850s, which helped him establish himself as Britain's principal topographic photographer. He set up his own publishing company in Reigate, Surrey, in 1859.

☞ **Aarsman, Baldus, Barnard, Clifford, Coburn**

161

Francis Frith. **b** Devon (UK), 1822. **d** Reigate (UK), 1898. **Delhi Railway Bridge**. c1860. Albumen print.

Funke Jaromír Untitled

Of the three projected images, the one furthest away has priority because it is overlapped by the central figure, which in turn is cut into by the triangular motif in the foreground. Although it may be incorrect to think of priorities with respect to overlapping brightness, there is a kind of progression from the clearly described bottle in the background to the cursory shadow near at hand, as if the picture is progressing towards abstraction. The bottles, too, suggest humanity, or maybe just a man in a hat. Funke, in this as in many of his pictures from the 1920s, is deliberately testing the viewer's perception, as if he is playing a game with photography – on the priority of shadows, for example. His pictures ask to be worked out, stage by stage – as if he wanted his audiences to understand exactly what was implied by the new vision of that era. In the 1930s, whilst teaching photography in Bratislava, he was a member of the radical group Sociofoto.

☛ **Drtikol, Moholy-Nagy**

162

Jaromír Funke. **b** Skuteč (HUN), 1896. **d** Prague (CZ), 1945. **Untitled**. c1927. Gelatin silver print. **h**29.2 × **w**23.5 cm. **h**11½ × **w**9¼ in.

Furuya Seichi

Izu (Japan)

The photographer's wife, Christine Gossler, is holding herself for the camera as if she were a heroic labourer from the 1930s. This picture introduces Furuya's *Mémoires* of 1989, a book devised in memory of his wife, who died in 1985. There is a recent scar on her neck, as if from an operation, and as the book progresses the scar heals, although it is often obscured by shadow. However, as the scar heals, Christine's health deteriorates and her features appear more and more drawn and wasted. We may think that we have no right to watch her decline so painfully, but Furuya is undeterred. The passage towards death is interspersed with snapshot incidents and motifs from their life together. The importance of *Mémoires*, which was published in Austria where the couple lived for most of their lives, was that it took the rhetoric of performance art and invested it with actualities sometimes too affecting to bear.

☞ Boubat, Cameron, Muray, Newman, Sieff, Silverstone

163

Seichi Furuya. b Izu (JAP), 1950. **Izu (Japan)**. 1978. Gelatin silver print.

Fusco Paul

Finca el Encanto, Mexico

This looks, apart from a scrap of litter in the foreground, like an idyll from the New World, and it is except that the settlers are Indians (the original Aztecs) who have come back to reclaim their land, now cleared and in the hands of cattle ranchers. Driven from the jungle territory which once sustained them, the original inhabitants were forced to work on the *fincas* for the very people who stole their lands with government collusion. The picture was taken in 1994 in the Mexican state of Chiapas, not longer after the start of the insurgency on 1 January by the Zapatista National Liberation Army. Fusco emphasizes the fragility of the settlers' camp, established in full view on a hilltop. These few elements, in the presence of the rising sun, epitomize the people and their aspirations. Fusco has been responsive to myth and heroism; one of his stories from the late 1960s concerned the California Grape Strike and its mythic leader, Cesar Chavez: it appeared as *La Causa* in 1970.

☛ Abell, Christenberry, Sternfeld

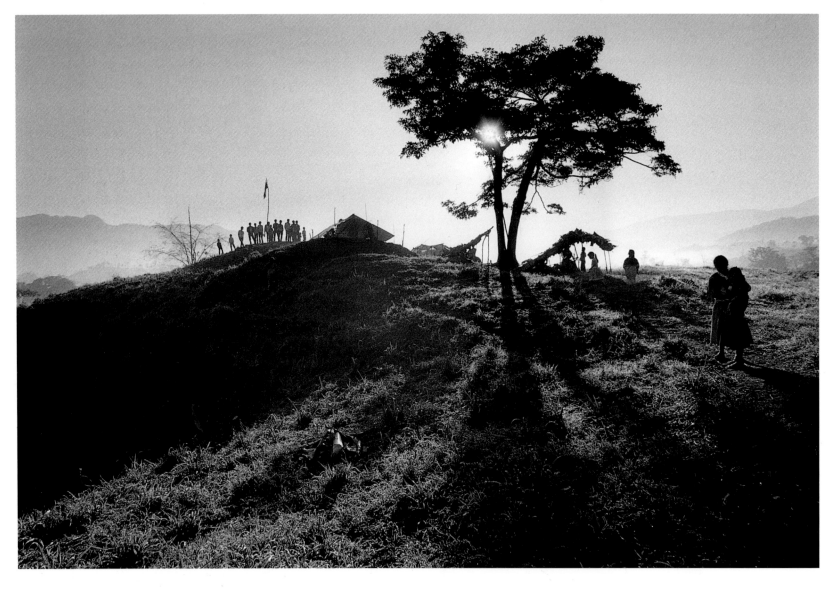

164

Paul Fusco. b Leominster, MA (USA), 1930. **Finca el Encanto, Mexico**. 1994. Gelatin silver print.

Fuss Adam

Lovers

This could be a picture of Apollo in pursuit of Daphne in a classical collection somewhere. According to the myth, she refused his advances and so he turned her into the tree which bears her name (the daphne or laurel). This is one of Fuss's many pictures of classical statuary. His use of a pin-hole camera to take it resulted in the 'distortion' which you see here.

In conventional, corrected photography the object takes its place within an orderly space, whereas the pin-hole process, by contrast, dynamizes and blends the figures with their spaces. Even the stoniest figures loom and retreat to a degree which brings them dramatically to life. In Fuss's own words, the pin-hole camera made it possible 'to create or recreate a

photographic space in which the sculptures could "breathe"'. Having worked as a commercial photographer in New York's art world, he is very conscious of what he calls 'the pervasive technological-consumerist photographic culture'.

☞ Kertész, Pécsi, Pierre et Gilles, Steichen, Tingaud

165

Adam Fuss. b London (UK), 1961. **Lovers**. 1985. Gelatin silver print.

García Rodero Cristina The Naked Woman

The beribboned children, brightly decked out in their carnival best, are posing uninhibitedly with this brazenly reclining nude in a street procession in Ciudad Real, García Rodero's native city. The subject of the carnival matters less to them than the fact of being portrayed, and García Rodero has always been interested in such differences, especially between the bright

surfaces of religious ceremonials and the piety of the participants. This scene appears in *España, fiestas y ritos*, a survey of Spanish folk-life published in 1993. García Rodero first considered the idea of a documentary study of the popular festivals and traditions of Spain while studying in Italy in 1971, having originally trained in Spain as a painter. Her intention

was to focus on events in rural areas most vulnerable to the dangers of modernization. Her reflections on archaic life, and particularly its religious elements, were published in black and white in *España oculta* in 1989.

☛ Coplans, Cumming, von Gloeden, Samaras

166

Cristina García Rodero. b Ciudad Real (SP), 1949. **The Naked Woman**. 1992. C-type print.

Gardner Alexander Home of a Rebel Sharpshooter, Gettysburg

A sharpshooter has come to grief in a rocky gully. His eyes are closed and his belongings scattered; someone has propped his gun against the stones of the embrasure, as a sign of his trade. There is strong evidence to suggest that this picture was staged. Its content is heavy with meaning – sharpshooters representing sight and the rocks symbolizing nature in the raw. Gardner originally joined the army to take pictures of maps and charts for the Secret Service, but from 1860 he worked as a field photographer for Mathew Brady's Washington, DC studio. In November 1862 he set up his own organization to photograph the American Civil War, taking with him many of Brady's photographers, including Timothy O'Sullivan. In 1865–6 Gardner's *Photographic Sketchbook of the War* was published in two volumes. The cumbersome wet-plate process made war photography very difficult and all the major pictures were taken after the events of the battlefield.

☛ Baltermants, Brady, Burrows, Faucon, McCullin, O'Sullivan

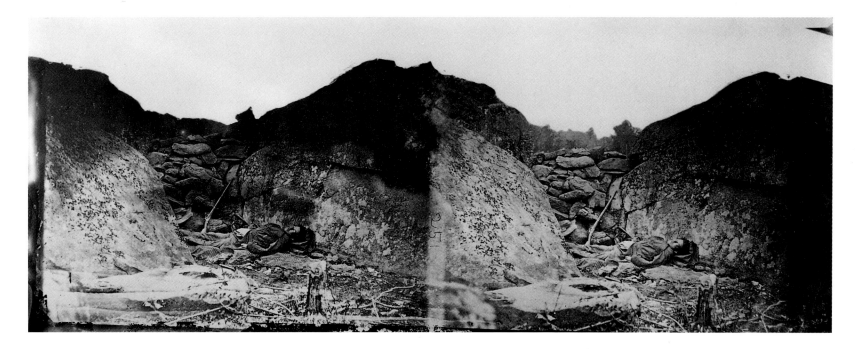

Alexander Gardner. b Paisley (UK), 1821. d Washington, DC (USA), 1882. **Home of a Rebel Sharpshooter, Gettysburg**. 1863. Albumen print.

Gaumy Jean

Iran's Chadored Warriors

Women in the Iranian home guard, wearing black chadors, practise with pistols at a training camp on the north-eastern outskirts of Teheran. The year is 1986 – seven years after the Iranian Revolution. In other pictures from the same series they appear training with a variety of weapons, including rocket launchers. Gaumy, who was a relative latecomer to Iran, seems to have been interested in the way in which national life had been choreographed and the Revolution itself encapsulated for local consumption in a few well-chosen images of falling columns and toppled statues. Thus these women ought to be seen less as a report drawn from Iranian actuality than as a tableau shaped by the revolutionary imagination for use in its own drama. Such a stylized and stage-managed image was at odds with advanced reportage in the mid-1980s which favoured informalism. Gaumy, a student of extreme situations, was the first photographer – in the late 1970s – to be allowed to document French prison life.

☛ E. Adams, Clark, Jackson, McCurry, Nachtwey

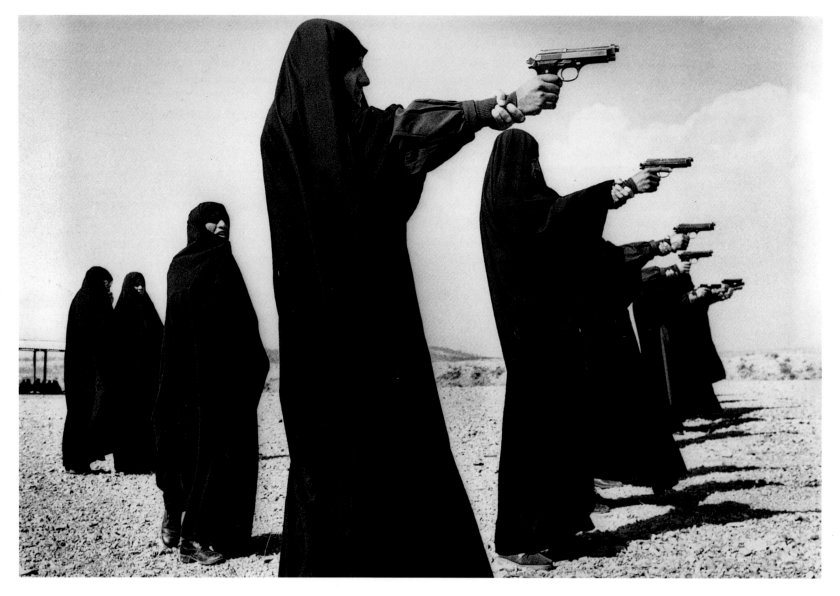

Jean Gaumy. b Royan (FR), 1948. **Iran's Chadored Warriors**. 1986. Gelatin silver print.

Genthe Arnold

Street of the Gamblers

This picture was taken in San Francisco's Chinatown, where Genthe was working as a private tutor. He originally started taking photographs for his relatives and friends back in Berlin, but the project escalated and became of special interest after 1906, when the old Chinatown was destroyed by an earthquake and fire. The pictures were published in 1908 and again in 1913 in *Old Chinatown*. Genthe worked secretly, since his models were very 'shy and superstitious' and wary of his camera. His imagination was caught by the idea of a community which kept to the shadows, and he regretted the 'new City, cleaner, better, brighter' which arose after the earthquake. Although the pictures may look like nothing more than documents from a forgotten time, they are important in the history of the medium because they are premised on the idea of concealment, in contrast to documentary photography's subsequent presumptions regarding disclosure and dominance.

☞ **Levitt, Riboud, Zachmann**

Arnold Genthe. b Berlin (GER), 1869. **d** New Milford, CT (USA), 1942. **Street of the Gamblers**. 1896. Gelatin silver print.

169

Gerster Georg

Labbézanga, Mali

The mud huts of the Malian village of Labbézanga look like strings of carefully arranged wooden beads when viewed from a low-flying plane. Georg Gerster, a specialist aerial photographer, was on a reconnaisance flight along the bend in the Niger River when he spotted a village that looked to him more beautiful than any other he had seen in Africa. It took him several days to locate the village on the ground but when he did he discovered that it was receiving close scrutiny from the government who wanted to move it to a more convenient site. As a result of Gerster's photograph of 'the most beautiful village in Africa', the resettlement plans were dropped. In the mid-1980s, sponsored by civil authorities impressed by the beauty of his pictures, Gerster undertook an aerial survey of China. He travelled in balloons, fixed-wing aircraft and helicopters over 'mountains transfigured into man-made sculptures by terracing' and across landscapes of 'wheat and barley in a seamless tapestry of human triumph over nature'.

☛ Krull, Munkacsi, Ruscha

170

Georg Gerster. b Winterthur (SW), 1928. **Labbézanga, Mali**. 1972. C-type print.

Ghirri Luigi

Capri (Italy)

The stone animal is either gazing out to sea or towards the horizon. The viewer, on the other hand, may focus on that complex and ambiguous architectural arrangement on the left. Ghirri was a metaphysical photographer interested in the difference between ideas and things, or between the horizon and those finely graded and calculable surfaces. In general, he envisaged Europe as a glamorous urban stage nostalgic for the infinite; and his precursors are the Italian Metaphysical painters of the 1920s, Giorgio di Chirico and Carlo Carrà. His proposal is that Europe might be a site for the imagination, and that its spaces might – as here – be swept free of sociological clutter. As a teacher of photography at the University of Parma, he exercised a formative influence on a new generation of Italian photographers, many of whom experimented with broad-format photography – a format for which Italy was especially well known in the 1980s.

☛ Abbott, Du Camp, Steichen, Tingaud

171

Luigi Ghirri. b Scandiano (IT), 1943. **d** Scandiano (IT), 1992. **Capri (Italy)**, 1981. C-type print.

Giacomelli Mario I Have No Hands to Caress my Face

A group of trainee priests is dancing together in the courtyard of a seminary in Senigallia, on the Adriatic coast of Italy. Giacomelli, who took this photograph secretly from a roof, spent a year at the seminary, where he produced some of his most celebrated pictures. Others show the same priests involved in snowball fights and enjoying cigarettes, which Giacomelli himself had provided. The cigarettes incident ensured that he was banned from the seminary. Giacomelli is known for this sort of contrasted printing which makes a figure of the ground and a symbol of the whole. He began to photograph seriously in 1955, creating sombre portraits in natural settings. He was also attentive to scenes of suffering and made exceptional studies of the mentally handicapped and of crippled pilgrims at Lourdes. This humanist trend in his art culminated in 1974 in pictures of the famine in Ethiopia. The bulk of Giacomelli's work, however, depicts the people of Italy and their way of life.

☛ Burke, W. Klein, Morgan, Siskind

Mario Giacomelli. b Senigallia (IT), 1925. **I Have No Hands to Caress my Face**. c1962. Gelatin silver print.

Gibson Ralph

Untitled

Objectively this is a picture of a reclining female nude wearing a knitted bikini. Seen in another way, however, it is a typical Gibson still-life of the early 1970s, arranged to register both the fall of sunlight on surfaces and the properties of those surfaces themselves. The sun is Gibson's subject, but the sun is beyond any artist's scope, and can best be established as an absence and in terms of its effects: light, shadow and the idea of warmth. Thus the hand carefully suspended in front of the hip functions as the vane on a sundial. As for the qualities of the objects, these are just as carefully expressed. The breast, for instance, without its knitted cover, would be no more than an abstract shape, but the jagged shadow thrown by the edge of the fabric both marks out the form below and contrasts with the purity of the shadowed edge. Gibson's pictures have appeared in *The Somnambulist* (1970), *Deja-Vu* (1973) and *Days at Sea* (1974), all of them published by his own Lustrum Press.

☛ Dijkstra, Hoyningen-Huene, Model, Ross

173

Ralph Gibson. b Los Angeles, CA (USA), 1939. **Untitled**. 1972. Gelatin silver print.

Gichigi John

Eubank Roadshow

Chris Eubank, a world champion at super-middleweight, makes his entrance into the arena to defend his title against the challenger Sammy Storey in Cardiff. Sport in the 1990s means spectacle. This picture was highly commended in the 1994 Nikon Awards because of the way in which it stages the pageant of boxing: the charismatic performer, his minders, trainers and publicists in a throng of gesticulating fans. Until recently it was the contestants who figured in sports photography, but increasingly interest has shifted to the making and the staging of the star. Sport has become a commercial and promotional drama in which those formerly behind the scenes have begun to emerge as actors in their own right. After studying photography at the University of Westminster, John Gichigi worked as a freelance photographer until 1979, when he joined the Allsport agency. A specialist in boxing images, he has covered the full range of sports in the course of his career and has won various awards.

☞ Chambi, Hoff, O'Sullivan, Rejlander, Rio Branco

174

John Gichigi. **b** Thika (KEN), 1954. **Eubank Roadshow**. 1994. R-type print.

Gilpin Laura

Changing Woman

This picture shows Changing Woman, an ancestor of the Navaho people of Arizona and New Mexico. She is holding an ear of corn in her right hand, and in her left a corn tassel containing pollen. Around her neck (although it is hard to make it out) is a rainbow necklace made from stones from the four sacred mountains of the Navaho – white shell, turquoise, coral and jet. According to Indian mythology, she was impregnated by a ray of light from the sun, passing through drops of water from a waterfall. Her children slew monsters and made the earth safe for human habitation. This is a keynote image in Laura Gilpin's book of 1968, *The Enduring Navaho*, which was the outcome of over thirty years of work on Navaho culture. It is a conceptual picture, dependent on extraneous knowledge, and typical of a photographer who always seems to have been conscious of the inadequacies of pure documentary. Gilpin trained at the Clarence White School in New York.

☛ **Connor, Godwin, Gutmann, Hannappel, C. White**

Laura Gilpin. b Colorado Springs, CO (USA), 1891. **d** Santa Fe, NM (USA), 1979. **Changing Woman**. 1959. Gelatin silver print.

Gimpel Léon

The Flying Club Cup

Crowds have gathered to one side of a display of hot air balloons set in a picture-postcard view of Paris. In 1904 Gimpel went to work for the French periodical *L'Illustration*, where he became the first reporter to make colour pictures on a regular basis. In 1907 it was Gimpel who organized the public seminar in Paris at which Louis Lumière presented the details of his newly developed autochrome colour process. Lumière's process turned out to be at least thirty years ahead of its time, since in 1907 it was thought that colour gave an unacceptable bias to reportage. Black and white dramatized events and made them susceptible to analysis, while colour made objects look opulent and encouraged people to focus on appearance rather than reality. Autochrome's suggestion was that we were luxuriant materialists, and not the sort of people who could easily be mobilized on behalf of the national interest, or for any other abstract cause.

☞ **Blumenfeld, Marville, Sternfeld, Warburg**

176

Léon Gimpel. b Paris (FR), 1878. **d** Paris (FR), 1948. **The Flying Club Cup**. c1910. Autochrome.

Glinn Burt

Moscow School

An image of Lenin in severe monochrome is looking out over a line of singing children. The cluster of stars on the wall traversed by a flight of rockets heading into the light refers to the Soviet space programme spectacularly announced by the launch of Sputnik in 1957. The picture comes from Glinn's first major book, *A Portrait of all the Russias*, published in 1967.

Glinn has singled out three outstanding aspects of Soviet culture: authoritative and benignly intended leadership, scientific achievement, and regard for posterity. Even though Lenin looks as formidable as ever, this is not an image taken from an adversarial point of view. What it is, though, is a composition which clearly articulates a series of opposites: the

past in relation to the future, adulthood with respect to childhood, large and small, leader and people. As an adept political portraitist and reporter during the 1950s and 1960s, Glinn spent much time face-to-face with history.

☛ Hamaya, Mark, Munkacsi, Snowdon, Sommer, Tmej

177

Burt Glinn. b Pittsburgh, PA (USA), 1925. **Moscow School**. 1963. C-type print.

Von Gloeden Baron Wilhelm　Untitled

The young man is sleeping. Von Gloeden has been careful to align his upper hip bone with the angle of the wall. The leopard skin on which he is lying sprawls down towards a jug and a canister, one white and one black. If the figure had been standing up, he might have looked like a male Venus born out of the foam. Originally because of his health, von Gloeden left Germany and moved to Taormina in Sicily, where he took up photography in 1889 when money from his family was discontinued. His pictures, which sold well, are not all of homoerotic subjects. He was attracted by paradox, and many of his child subjects act the part of streetwise adults, just as his men pose as women might have done for Parisian painters of the 1880s. In 1936 his studio was raided by government or Fascist party agents who impounded and destroyed many of his glass-plate negatives.

☛ Bradshaw, Coplans, Durieu, García Rodero, Samaras

178

Baron Wilhelm von Gloeden. b Wismar (GER), 1856. **d** Taormina (IT), 1931. **Untitled.** c1890. Albumen print.

Godwin Fay

Untitled

That could be a landscape in the background, taken through the greenish deposits on the surface. Those uprights might be signposts or even headstones. The mossed or dusty surface near to hand looks almost like a weather system registered by satellite, although it is also interrupted by scratched initials and the tracks of children's fingers or snails. Fay Godwin's subject here, and in all of her colour pictures taken in the 1990s, is a larger biological history, mixing this year's spring with last year's autumn, with such vulnerable human interventions as you see here. In some instances these pictures include the stems and veins of plants, a poignant suggestion that the landscape too lives and breathes. Fay Godwin, a major British landscapist, began to take photographs – principally for walkers' guidebooks – in the 1970s. In 1985 her work was surveyed in the retrospective *Land*. The despoliation of Britain was her subject in *Our Forbidden Land* (1990).

☛ **Barbieri, Gilpin, Hannappel, Shore, Tomatsu**

179

Fay Godwin. b Berlin (GER), 1931. **Untitled.** 1990. C-type print. **h**51 x **w**61 cm. **h**20 x **w**24 in.

Goldberg Jim

Tweeky Dave

Tweeky Dave is the hero of Goldberg's tragi-comic *Raised by Wolves*, a story of street children in Hollywood. On the title page, Dave promises that it is only a story, with a happy ending, but at the end he dies, as a result of hepatitis B, C and D. The book, a phenomenon in photography, was begun in 1985 and completed in 1995, and its 320 pages contain on-site photographs, dramatized interviews and handwritten inscriptions pertinent to the lives of Dave, Echo, Cookie, Nikki, The Magician and any number of others living in and around Plummer Park, Oasis Alley and elsewhere. Goldberg recognizes the tragedy of lives blighted by drugs and prostitution, but is non-judgemental and even sympathetic to the romantic longings with which all these stories start off. The book centres on Dave's love for Echo, a runaway who eventually returns to the suburbs – the dull ground where all their troubles began. *Raised by Wolves* both looks and reads like an illustrated script for a complex TV epic.

☛ **Barbieri, Joseph, Nauman, Sims**

Jim Goldberg. b New Haven, CT (USA), 1953. **Tweeky Dave**. 1995. Gelatin silver print with ink and tape.

180

Goldblatt David

Miss Lovely Legs Competition

This event could be taking place anywhere in the developed or merchandising world. And just who was the winner? The picture was published in Goldblatt's book of 1982, *In Boksburg*, a collection of photographs taken in the autumn and winter of 1979 and 1980. Goldblatt chose Boksburg, in the East Rand, since he saw it as an epitome of a small town 'shaped by white

dreams and white properties'. He remarks, in the introduction, on the white values prevalent there: 'Blacks are not of this town. They serve it, trade with it, receive charity from it and are ruled, rewarded and punished by its precepts. Some, on occasion, are its privileged guests. But all who go there, do so by permit or invitation, never by right'. Yet Goldblatt himself is enough of a

documentarist to register the place without bias, seeing it as both 'nondescript and elusive', and open to analysis. Goldblatt's first book, *On the Mines* (1973), was on gold-mining in the same East Rand area of South Africa.

☛ Dijkstra, Model, Ross

181

David Goldblatt. b Randfontein (SA), 1930. **Miss Lovely Legs Competition**, 1979. Gelatin silver print.

Goldin Nan

Teri Toye and Patrick Fox on their Wedding Night

Outlined and gilded by artificial lighting, and pictured on their wedding night, this couple represent an idealized union; yet at the same time there is something contrived about their pose, and she is turning her face away. In the introduction to her book of 1987, *The Ballad of Sexual Dependency*, Goldin remarks on 'how the mythology of romance contradicts the reality of coupling and perpetuates a definition of love that creates dangerous expectations'. In actuality, many of the men in her book respond impassively to her camera, as if wrapped up in themselves and happy to leave consciousness and suffering to the women who keep them company. Goldin explained that she took up photography in the early 1970s so that she could remember the details of her life, and that later she came to realize that she also wanted to create and to sustain a sense of her own identity, an identity threatened by the fact that her sister had committed suicide in 1965.

☞ Abbe, Brassaï, Durieu, Eisenstaedt, Nixon, Saudek, Wojnarowicz

Nan Goldin. **b** Washington, DC (USA), 1953. **Teri Toye and Patrick Fox on their Wedding Night**. 1987. C-type print.

Gowin Emmet

Edith and Berry Necklace

Edith, the photographer's wife, is standing in the corner of a garden in Danville. With her necklace of berries she might be intended to represent Pomona, the Roman goddess of fruit trees. Those details of foliage in the foreground establish the viewer as another creature of nature and the seasons. Since the late 1960s, Gowin – a student of Harry Callahan and Aaron Siskind – has focused mainly on photographing his own family in living rooms, backyards and gardens such as this. He was the first photographer in the USA to see home life as a world in itself, which could represent the greater family of man, myths and ancestors. In particular he pointed to the small events, pleasures and even irritations of home life as being engrossing in their own right. In the visual culture of the early 1970s Gowin's cast of familiars stood as a corrective to the blighted landscapes of the New Topographers and to the commercial and metropolitan culture celebrated by Andy Warhol.

☞ **Araki, Callahan, Charbonnier, Siskind, Tillmans, Warhol**

Emmet Gowin. **b** Danville, VA (USA), 1941. **Edith and Berry Necklace**. 1971. Gelatin silver print.

Graham Paul

Franco's Head on Coins, Vigo, Spain

On the evidence available, this must be a picture of a bench near a public telephone in Spain. Smokers, preoccupied by the problems of dialling and inserting coins, have left their cigarettes to burn out on the painted surface. Although it may be no more than a commonplace site, the abused surface touches on the question of character, focusing on the difference for instance between those who would place a burning cigarette on the edge of a bench and others who might be less careful of the consequences. And just as the burn marks indicate character, so the coins, with their inscriptions and civic portraits, refer in their own understated way to history, which is Graham's constant subject. Photojournalism has always been premised on the idea of significant events; Graham, though, has always chosen to work with symptoms and with scarcely inscribed evidence such as this which, if carefully considered, will tell another story bearing on life beyond the headlines.

☛ Friedlander, Groover, Penn, Tosani

184

Paul Graham. b Harlow (UK), 1956. **Franco's Head on Coins, Vigo, Spain**. 1988. C-type print. **h**203 × **w**152 cm. **h**80 × **w**60 in.

Griffiths Philip Jones　　Civilian Victim, Vietnam

The label reads VNC, meaning Vietnamese civilian. In a caption supplied in *Dark Odyssey*, his career survey of 1996, Griffiths notes that it would have been more usual to tag the woman VCS, or Vietcong suspect. The entry must have been made by a sympathetic corpsman. Griffiths has always been attentive to the finer points of language in his reportage, and his text for *Vietnam Inc.*, his in-depth survey of the Vietnam war and of Vietnamese society, is informative throughout. He saw Vietnam as a traditional and well-balanced culture disrupted by futuristic apparatus and by the ethics of the control room. His argument was largely with the dehumanizing powers of technology and with its bureaucratic apologists, and his sympathies were with the peasant victims of the war. *Vietnam Inc.*, published in 1971, was the outcome of three years of reporting. Griffiths voiced Western misgivings about that war, and helped bring it to an end.

☛ E. Adams, Burrows, Faas, Ut

185

Philip Jones Griffiths. **b** Rhuddlan (UK), 1936. **Civilian Victim, Vietnam**. 1967. Gelatin silver print.

Groover Jan

Tybee Forks and Starts (K)

The prongs of a fork and the blade of a knife speak immediately of touch and pressure. All the rest is merely reflected in their surfaces and exists elsewhere as colour and light, so that the picture is a point of intersection and reference. The difference between this and the kind of light-flooded abstract photographs made in the 1920s is that here Groover is presenting only fragments, such as knives and forks with their handles beyond the frame. Thus she is insisting on the picture as an arrangement, as having been contrived and not part of some universal right order buried deep in transactions between humanity and nature. The photographer herself has written: 'I think it's lovely that a knife can be pink. Its shape can be moulded by light, the silver surface picks up and reflects bits of colour – it's all very liquid.' Originally an abstract painter, Groover began to take photographs in 1970 and to specialize in studio work from 1977. This series was made in the kitchen sink.

☛ Graham, Modotti, Moholy-Nagy, Parker, Penn, Tosani

Jan Groover. b Plainfield, NJ (USA), 1943. **Tybee Forks and Starts (K)**. 1978. C-type print.

Gruyaert Harry

Ouarzazate, Morocco

A man in a short coat on a Moroccan pavement passes out of the shadow into a patch of pale sunlight. Further away a cyclist begins to enter another palely sunlit zone on a wide street marked by an electrically lit crown turned off. Almost nothing happens in most of Gruyaert's pictures, but almost nothing is still significant and Gruyaert manages whatever it is so consummately – as in this picture – that it becomes compelling. In ravaged urban settings of the 1970s photographers often associated inertia with victimhood, but Gruyaert holds back from judgement and remarks instead on how it is to crouch, stoop or just pass by in conditions where no one pays attention. His proposition is that states of being matter as parts of the scene, and that distance, depth and absence must somehow be acknowledged. Many of Gruyaert's best pictures come from Morocco, which is one of his preferred sites and the subject of a major book of 1990.

☛ **Atget, Besnyö, Daguerre**

Harry Gruyaert. b Antwerp (BEL), 1941. **Ouarzazate, Morocco**. 1985. C-type print.

Gursky Andreas

Siemens, Karlsruhe

This is the assembly room of an electrical goods factory in Karlsruhe, Germany. The wheeled trolleys are individually numbered and the racks carry all sorts of labelled materials. You could, if you were sufficiently interested, piece together the processes from the evidence available, as you could in many of Gursky's large-scale pictures of manufacturing. But would you really care to implicate yourself in all that complexity, even if it does involve other people's lives? Gursky's subject is not so much the world out there as an autonomous system in itself, as our reading of this world. His suggestion is not that working life is deplorable and that we must sympathize with its participants, but that we are in no position to come to any conclusions whatever, that we lack analytical capacity even when the evidence is as thick on the ground as it is here. Gursky was a student of Bernd Becher, whose images of industrial sites raise very similar questions.

☛ Becher, Hine, Kubota, Man, Tomaszewski

188

Andreas Gursky. b Leipzig (GER), 1955. **Siemens, Karlsruhe**. 1990. C-type print.

Gutmann John

The Artist Lives Dangerously

This picture looks very American – the noonday sun, a daring boy, a Red Indian in outline and an automobile. In this case, John Gutmann was interested in the action of the scene, but he generally reported on things writ as large and intact as that passing car. He was also interested in signs or in symbols like the Native American – the kind of motifs through which the USA was defined. Gutmann, who trained as a painter in Berlin, watched the coming of the Nazis with alarm and decided in 1933 to move to America, where he found work as a photojournalist with the agency Presse-Photo. Although conscious of the Depression, Gutmann enjoyed American life and was entranced by its brand names and emblems and by the graffiti and announcements he saw written in and on the street. His vision of the USA as being made up of pictures, inscriptions and advertisements was unparalleled at the time, but very much in line with the conceptual art of the 1970s and 1980s.

☛ Gilpin, Johns, de Keyzer, VanDerZee

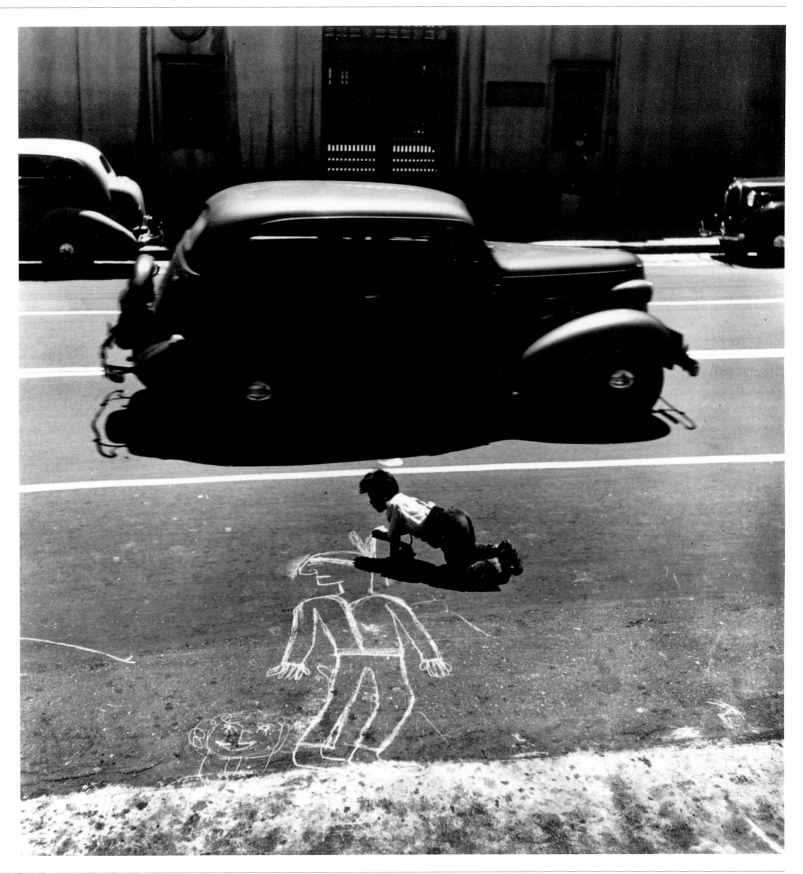

John Gutmann. b Breslau (GER), 1905. **The Artist Lives Dangerously**. 1938. Gelatin silver print.

Haas Ernst

London

The mirrors on the wall hang at different angles and because of that, some of the participants in 'PERFECT' reappear in the panorama above. The man in the cap and spectacles (which underline the idea of seeing) looks wary enough to be a custodian or even a voyeur. This is one of the most tantalizing of reportage pictures, because of what it might mean. Are the subjects intended to be, or even just readable as, 'the people' under surveillance, as if Haas – who had survived the war in Europe with difficulty – was recalling that earlier supervised existence? Haas's reputation was made in 1947, when he was working for the Vienna magazine *Heute*, and was founded on a series of pictures of Austrian prisoners of war returning to Vienna from camps in Eastern Europe. Haas was attracted to London in the 1950s because of its thriving street life and the opportunities it provided for reportage.

☛ Allard, Berengo Gardin, C. Capa, Hawarden, Riboud

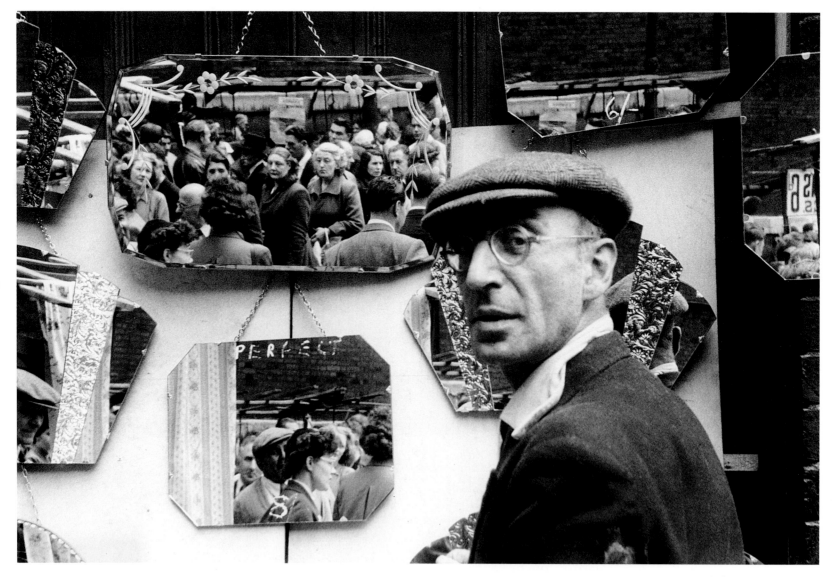

190

Ernst Haas. **b** Vienna (AUS), 1921. **d** New York (USA), 1986. **London**. 1951. Gelatin silver print.

Hajek-Halke Heinz Home of the Sailors

The sailors have made their marks on the wall and some have added dates. Hajek-Halke has overlaid the whole with the contents of their dreams, and for good measure he has made those windows into blank eyes. This picture, which is one of several related to the theme of the home of the sailors, is difficult to make out, and may have been printed from three or four negatives: one each for the wall, the initials and the nudes. Scratched and chalked inscriptions were important in the iconography of photography as signs of transience and vulnerability. The wavering uncertainty of the bodies suggests that this picture was intended to represent a dream. Hajek-Halke, who trained as a painter, came to prominence as a photographer during the 1920s. Under the influence of the Surrealist painters, he tried to invest his photographs with psychological meanings. In 1951 he began to teach photography at the Hochschule für Bildende Kunst in Berlin.

☞ Frank, Heinecken, Laughlin, Schmidt

191

Heinz Hajek-Halke. b Berlin (GER), 1898. **d** Berlin (GER), 1983. **Home of the Sailors**. c1928. Gelatin silver print.

Halsman Philippe

Dali Atomicus

On the count of 'four' Salvador Dali leapt and Halsman's assistants threw three cats and a bucket of water across the scene, whilst the photographer's wife held up the chair on the left. It took twenty-six attempts and five hours before Halsman had the result he wanted. The picture was entitled *Dali Atomicus* after *Leda Atomica*, Dali's picture of his wife as Leda – a copy of which appears here behind the flying cats to the right. The intention in both the painting and the photograph was that everything should be in suspension, as in the atom – for 1948 was well into the atomic era. Halsman and Dali forged a unique creative collaboration that spanned more than forty years and produced many other memorable images, including the thirty-two photographs for the book *Dali's Moustache*. Halsman is best known as one of the finest portraitists of his time; he had more than one hundred *Life* covers to his credit, a record.

☛ **Cartier-Bresson, Lartigue, Longo, Richards, Seidenstücker**

192

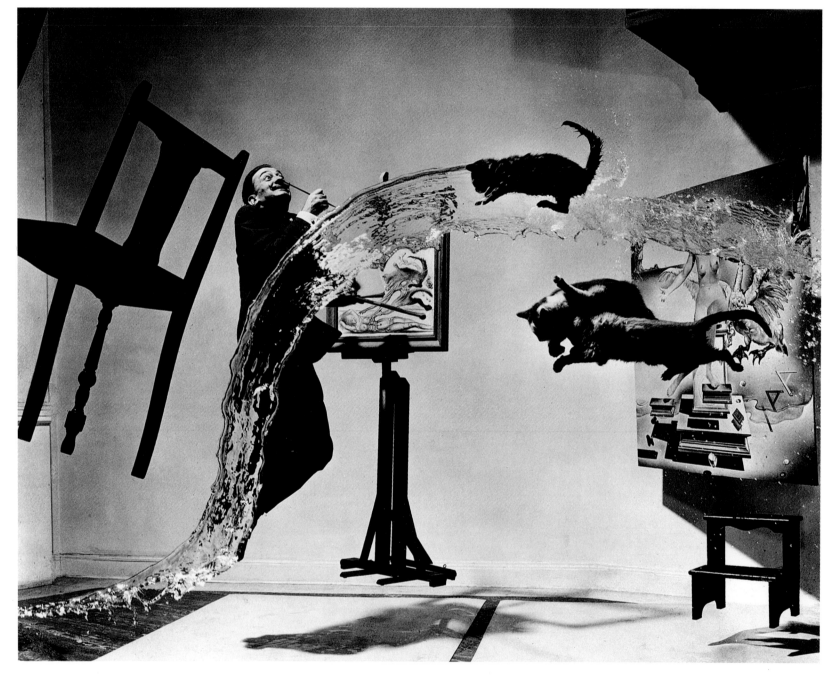

Philippe Halsman. b Riga (LAT), 1906. **d** New York (USA), 1979. **Dali Atomicus**. 1948. Gelatin silver print.

Hamaya Hiroshi

Boys in Niigata, Japan

The boys in this procession are singing songs to drive away noxious birds. Although the drummer at the front is visible, both the songs and the birds have to be imagined. The only other feature in the flash-lit snow scene is a white track which implies that someone has left the path, circled around and then returned to the security of the road. In Hamaya's poetics, events involving exposure to noise, frost and water, for example, are pictured in such a way as to invite an imagined re-enactment – as here, when one follows the varying steps of the boys as they negotiate the snow in darkness. Hamaya is best known for his series of pictures (of which this is one) made in the northern areas of Japan from 1939 onwards and published in 1956 as *Snow Land*. Like Cartier-Bresson he reported on the establishment of Communist China in the late 1940s, an account published in *Red China I Saw* in the late 1940s.

☛ **Cartier-Bresson, Hurley, Plossu, Sella, Vachon**

Hiroshi Hamaya. b Tokyo (JAP), 1915. **d** Kanagawa Prefecture (JAP), 1999. **Boys in Niigata, Japan.** c1942. Gelatin silver print.

Hammerstiel Robert F. make it up

Dolls' outfits packaged in transparent plastic are part of everyday commercial reality. They introduce children to adult patterns of consumption. Hammerstiel's tactic is to photograph and reproduce such miniatures on a scale large enough to make them objects for thought. His strategy in general is to show how what we think of as reality is produced, and to demonstrate that there is little which is natural about it – hence his interest in the presentation of goods, as well as in the goods themselves. In the *make it up* series, to which this photograph belongs, he includes portraits of dolls variously made up, as well as studies of packaged outfits. In earlier series, such as *Grüne Heimat* (1988–90), he pictures pieces of domesticated nature; in the series *Mittagsporträts* (1989–90), he features place settings presented together for comparison. His subject in *Public Intimacy* (1990–1) is designated meeting points or arrangements of tables and chairs in architectural settings.

☛ Calle, Dater

Robert F. Hammerstiel. b Pottschach (AUS), 1957. **make it up**. c1994. C-type print. **h** 122.5 × **w** 110 cm. **h** 48¼ × **w** 43¼ in.

Hannappel Werner Norway

A foreground of rock and lichen dips towards a shoreline littered with pools and boulders. It looks like low tide on a quiet day, disturbed only by a breeze blowing onto the shore. Pale veins in the nearby rock floor may be ice or quartz. The bleached sticks may have been arranged to make a pattern – or perhaps they were there anyway. All of Hannappel's landscapes are of such sites taken at a distance which prevents them being seen either as particular places or as mere samples of geology. One of his subjects is the kind of attention and language which we bring to our understanding of the world. The ocean, too, present in most of his pictures, hints at infinity and the dissolution of all specifics. Hannappel studied photography at the Folkwang Schule in Essen with Otto Steinert, and he began to exhibit and to publish regularly in the early 1980s: landscapes from northern Europe, Iceland, Ireland, Scotland, Norway and France.

☛ R. Adams, Bullock, Cooper, Gilpin, Godwin, Shore, Steinert

Werner Hannappel. b Essen (GER), 1949. **Norway.** 1988. Gelatin silver print.

Harcourt Cosette

Edith Piaf

Although this is actually a portrait of the French singer Edith Piaf, it could equally be a picture of one of the women at the foot of the Cross or of a saint enduring in expectation of Paradise. Piaf is usually represented, in reportage and performance in the 1940s, as a woman of this world rather than in this heavily retouched, other-worldly guise. The pose and its treatment imply sin and redemption. This is the most extravagantly 'religious' rendering of any French star of the period, suggesting that Piaf alone had the charisma to keep company with legends and national icons. In 1934 Harcourt went to work for the brothers Lacroix, who were successful publishers and confident enough to set up a photographic studio during the recession. The success of the Studio Harcourt was phenomenal, and in 1957 the French writer and critic Roland Barthes remarked that to be recognized as an actor it was necessary to have been photographed by Harcourt.

☛ Bull, Callahan, Henri, Lele, Lerski, McDean, Ruff

Cosette Harcourt. b Paris (FR), 1900. d Paris (FR), 1976. **Edith Piaf**. 1946. Gelatin silver print.

Hardy Bert

The Inchon Landings

This is the most remarkable picture in Hardy's award-winning series for *Picture Post* on the Inchon landings in south Korea. On 15 September 1950 the UN forces landed at Inchon and went on to liberate Seoul. In the original caption the scene was introduced as a tragic charade from a world turned upside-down: 'Its old ones caper round like crazy goats, its young ones put out more flags in a confused desire to please, its crazy infants surrender in advance…humanity…can stand no more liberations like this.' Hardy set great store by a peaceful, community-based culture, and this event by a Korean roadside encapsulated everything he dreaded. Vietnam, in the late 1960s, would be interpreted in a similar way by Philip Jones Griffiths, another British war reporter, as a culture and community under attack. Hardy began his life in photography as a darkroom assistant and printer, but in 1940 he was taken on by *Picture Post* as a photographer.

☞ **Griffiths, Hamaya, D. Martin, Ut**

Bert Hardy. b London (UK), 1913. **d** Limpsfield Chart (UK), 1995. **The Inchon Landings**. 1950. Gelatin silver print.

Hawarden Clementina

Young Girl with Mirror Reflection

The young woman, who is Lady Hawarden's daughter Clementina, might just have been disturbed during some reverie by the mirror. But to judge from her posture and the placing of her left wrist on the pivot of the mirror, it seems more likely that she has been placed there for the sake of her reflection. This full-length swivelling mirror often appears in Lady Hawarden's pictures. It was a piece of furniture known at the time as 'a psyche', and its name provides an insight into the artist's intentions. According to Greek mythology, Psyche was a beautiful girl to whom Eros, the personification of passion and physical love, played court. Psyche herself became the personification of the soul or the spiritual side of the body. Thus Clementina's beauty and her melancholy are both explained by her being staged as body and soul seen both together and apart. Lady Hawarden only took up photography in 1858, when she was thirty-six.

☛ Allard, Berengo Gardin, C. Capa, Haas

198

Clementina Hawarden. b Glasgow (UK), 1822; **d** London (UK), 1865. **Young Girl with Mirror Reflection**. 1860s. Albumen print.

Heinecken Robert Costume for Feb '68

This picture is an example of the tendency common among American cultural commentators in the 1960s to remark on the conjunction between sex and violence. The rose is part of the iconography of advertising, as is the swathe of blond hair. The car headlights, placed as breasts, are probably meant to pick up on men's vernacular; the death scene is a typical news item from that era. This collage has been achieved by projecting negatives onto a collection of pictures mounted on a wall. Heinecken worked with juxtapositions which were as abrupt and brutal as the news events to which they referred. Other inventions by him from the 1960s refer to the Kennedy assassination in Dallas and to atrocities in Vietnam. Heinecken, who studied in California in the 1950s, became an important innovator and influence in the Los Angeles area. Constructed photography, of the sort developed by him in the 1960s and 1970s, began to oust 'straight' photography during the 1980s.

☞ Berman, Dyviniak, Hajek-Halke, Modotti

199

Robert Heinecken. b Denver, CO (USA), 1931. **Costume for Feb '68**. 1968. Black-and-white film transparency over collage. **h**23 × **w**13 cm. **h**9 × **w**5 in.

Henri Florence

Woman with Cards

Side-lighting shows up the pores on the subject's skin, so that there can be no doubt as to her reality beyond those made-up eyes and lips. Presumably she is dreaming of what life holds in store, even if those scattered cards imply that her future is in the hands of providence. In about 1930 Florence Henri epitomized Modernism, both in her life and in her pictures –

which were mainly portraits. She and her generation were objectivists who liked to admit to the merely physical, expressed here in those skin textures and sensibly trimmed fingernails. At the same time they were dreamers, but always within the kind of practical limits suggested by a pack of cards, cheap music and the iconography of advertising (much of

which they devised themselves). Schooled in France, England and Italy, Florence Henri set out to be a pianist, but became a painter and then turned to photography around 1928.

☛ Bull, Harcourt, Lerski, Yevonde

200

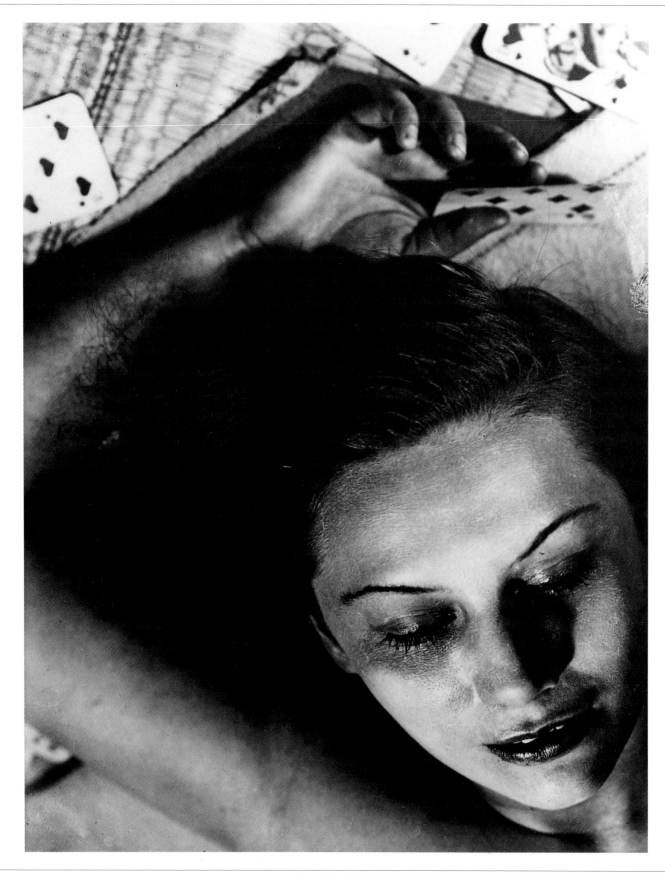

Florence Henri. **b** New York (USA), 1893. **d** Compiègne (FR), 1982. **Woman with Cards**. 1930. Gelatin silver print.

Hill & Adamson

Alexander Rutherford, William Ramsay and John Liston

In this scene Hill and Adamson have succeeded in registering sharp tonal contrasts: the tanned faces of the men, for example, stand out against the brightness of the sky. The very earliest photographers were interested in exploring the capabilities of their medium. These are amongst the earliest documentary photographs ever taken, and it is possible that they were made as part of a fund-raising project to pay for the decking of the fishermen's boats and the well-being of their families. Hill, a painter, and Adamson, a calotypist, began their collaboration in 1843, largely in order to make preliminary studies of a group of 400 priests who had just broken with the Church of Scotland. Adamson, who was always in poor health, died in 1848, but by then they had produced around 3,000 paper negatives between them. Their very great reputation was made posthumously, after the discovery and publication of their work in the 1890s by the Scottish photographer James Craig Annan.

☛ Annan, Cosindas, Eisenstaedt, Nègre, Sander

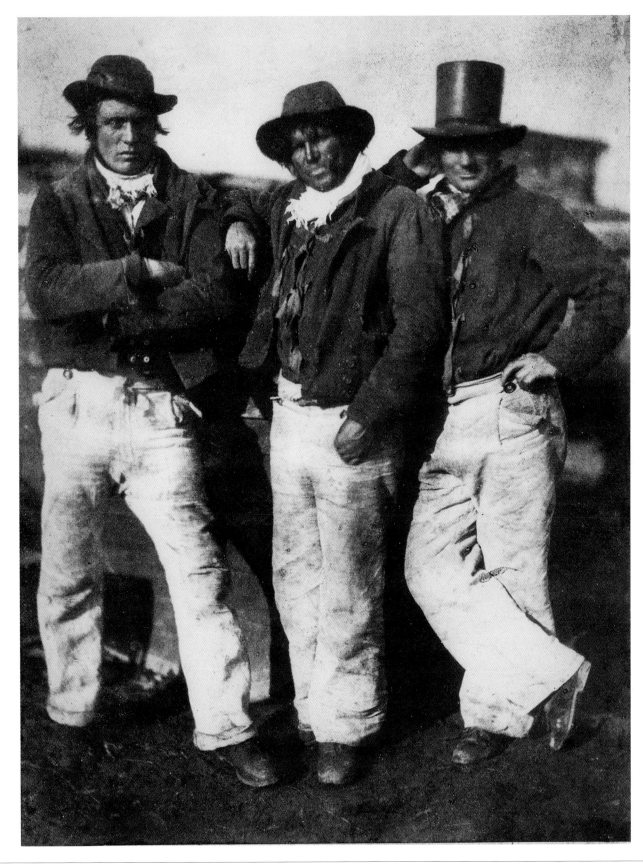

David Octavius Hill. b Perth (UK), 1802. d Edinburgh (UK), 1870. **Robert Adamson**. b Berunside (UK), 1821. d St Andrews (UK), 1848. **Alexander Rutherford, William Ramsay and John Liston**. c1846. Salted-paper print.

Hilliard John X

This set of pictures was arranged to be explained or spoken into existence over a finite moment or two. In the first picture a man and a woman face each other in a darkened room, each holding a lighted torch. The man, who is opening a door, appears reflected in a mirror. The second pairing is of the same two seen over a longer time span which allows you to follow their responses. She, for instance, appears to have lowered her arm but she is still focusing on the man's spectacled face, while his torch beam has moved down her exposed body. Was the move instinctive, or has it been choreographed? The picture is called *X* after the fall of the light on the first pairing. The pattern it makes is point, line, line, point or dot, dash, dash, dot – X in Morse code. After all, this is photography and photography originally meant writing with light – and writing entails spelling, too. Hilliard's pieces set the tone and standard for much of the constructed photography of the 1980s and later.

☛ **Durieu, Goldin, Mili**

John Hilliard. b Lancaster (UK), 1945. **X**. 1982. Gelatin silver print. **h**183 × **w**427 cm. **h**72 × **w**168 in.

Hine Lewis W.

Steamfitter

The steamfitter has been asked to hold that spanner at an angle so that he fits within the circle, making a completed figure of Labour. Hine's idea in 1920 was to show that men, rather than machines, produce industrial wealth. This icon of work anticipates Soviet pictorial types during the 1920s and 1930s, and indeed is echoed in Hine's own book *Men at Work* (1932), which focuses on the construction of the Empire State Building. Between 1907 and 1918 he worked for the National Child Labor Committee, an organization set up to publicize abuses. He took pictures in mines, factories and mills, and has subsequently been admired for his ability to make portraits of those whom others would have seen only as representatives. His respect for the individual, who was often maimed, exploited and oppressed, established him as an embodiment of American values. However, by 1920 he was beginning to alter course and to move towards this kind of positive, representative imagery.

☞ **Gursky, Kubota, Man, Salgado**

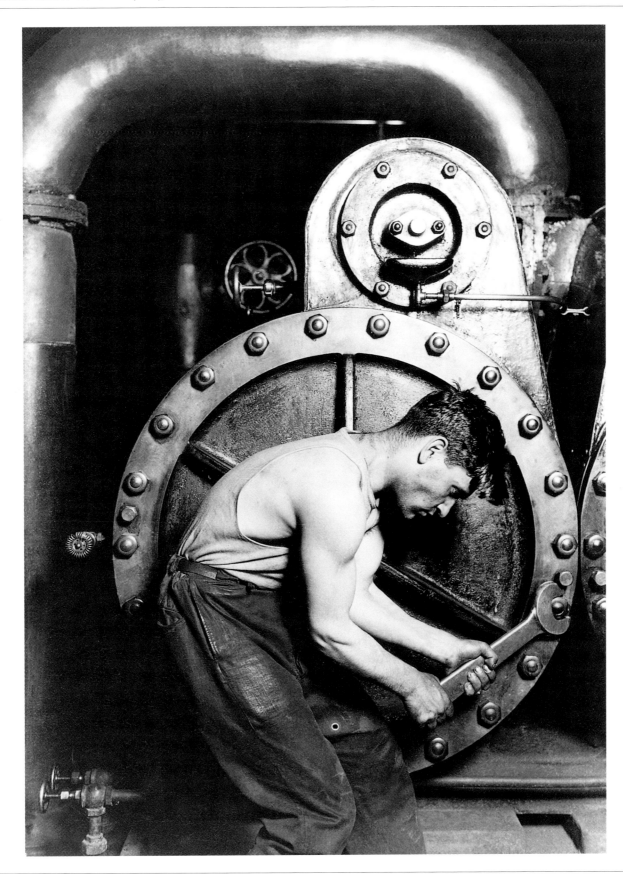

Lewis W. Hine. **b** Oshkosh, WI (USA), 1874. **d** New York (USA), 1940. **Steamfitter**. 1920. Gelatin silver print.

Hockney David

My Mother, Bolton Abbey, Yorkshire

She is reflecting, her surroundings seem to imply, on death. At the same time, though, and judging from her clothes and her posture, she might just be oppressed by the weather which is shrouding the noted beauty spot in gloom. Venerable graveyards like this were established as prime sites by such neo-romantic photographers as Bill Brandt and Edwin Smith in the 1940s; they were haunted again in the 1970s by a new generation of British photographers – including Martin Parr, who took fine early pictures at this very abbey. This peculiarly dislocated form, assembled from a series of single pictures, re-introduces into picture-making some of the formality not present in the snapshot. It is possible to imagine her asking if he's finished yet, and if she can move now. Likewise the work has a handmade quality and is thus quite at odds with the heavily technical and expert feel of professional photography.

☛ Brandt, Cumming, Parr, Riis, Rodchenko, E. Smith, Weegee

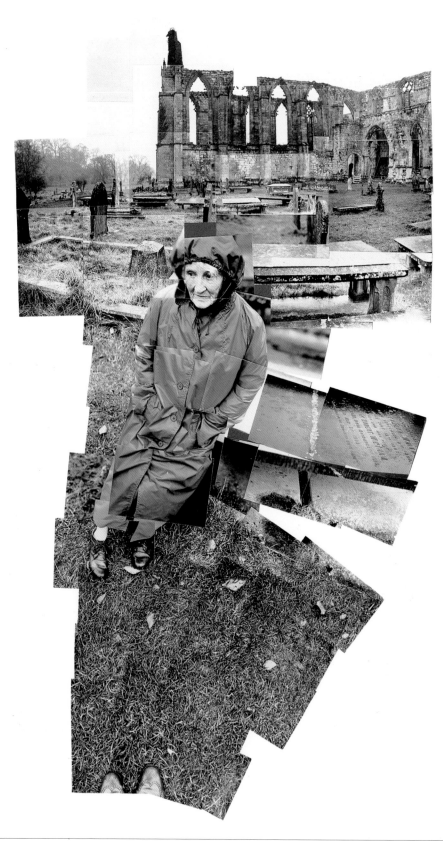

David Hockney. b Bradford (UK), 1937. **My Mother, Bolton Abbey, Yorkshire**. 1982. Photographic collage. **h**74.9 × **w**27.5 cm. **h**29½ × **w**10¼ in.

Hocks Teun

To and Fro

The lone figure, wearing pyjamas and a raincoat, is battling with the elements. He has just lost his hat and his scarf flies upwards. Yet despite the storm, that candle-flame remains unmoved. Is he travelling, using a very circuitous route, from one house to another? Is he Hercules at the crossroads wondering what the future holds in store? Hocks's photo-narratives of the 1980s tell other unfathomable stories in which trees might be buried and the moon attached to a string. Although this is an invented and capricious photography which makes references to the dream-like and yet realistic Surrealist paintings from the 1930s, especially those of René Magritte, it is humanitarian in that it asks for identification with such figures as this barefoot wanderer. Hocks is a leading representative in Europe of staged photography and known for his participation in the landmark exhibition 'Fotografia Buffa', which took place in Groningen in 1986.

☞ Misrach, Moon, Rothstein, Towell, Tress

205

Teun Hocks. b Leiden (NL), 1947. **To and Fro**. 1986. Painted gelatin silver print. **h**122 × **w**158 cm. **h**48 × **w**62¼ in.

Hoepker Thomas Marine Recruits

The lower lip of the black recruit is just touching the back of the white man. Both feature in Hoepker's startling report from the US Marines' boot camp at Parris Island, Georgia, which was supervised by sadists in uniform. Hoepker's preferred subject area then, and often afterwards in the course of a long career, was physiognomy. Many of his subjects are the bearers of what might be terrible knowledge – of intimidation in the case of the men of Parris Island, but sometimes only of the legacy of long experience. He is, though, always careful to give some account of what lies behind appearances, as if a look might be explained by events. The importance of Hoepker's portraiture in the history of the 1960s is that it tried to contend with the idea of portrayal as mere spectacle. Hoepker's subjects – even if demeaned to the level of automata at Parris Island – still belong to history and can be made sense of and understood through its events.

☛ Hubmann, Krause, Ohara, Weber

206

Thomas Hoepker. b Munich (GER), 1936. **Marine Recruits**. 1970. Gelatin silver print.

Höfer Candida

Karlsruhe Zoo I

A giraffe is walking across a grassed paddock in Karlsruhe Zoo – in a very normal-looking picture. That must be the giraffe house beyond, with its variety of meshed gates and tiled panels. Oddly, the tiling on the wall seems to be compatible with some of the mesh on the gates, which makes it difficult to determine exactly what stands where. Maybe all that spatial complexity accounts for the giraffe's look of puzzlement, and it makes it easy to put oneself in the animal's position. This is the cover picture from Höfer's book of 1993 entitled *Zoologische Gärten*, in which you are variously invited to see the world from the points of view of polar bears, crocodiles, elephants and tigers. In *Spaces* (1992) her theme was deserted meeting places, such as galleries, restaurants and conference rooms, in which events could be imagined from the placing of chairs, lecterns and glasses of water. One of many distinguished students of Bernd Becher. Höfer studied at the Kunstakademie in Düsseldorf.

☛ Becher, de Montizon, Stern, B. Webb

Candida Höfer. b Eberswalde (GER), 1944. **Karlsruhe Zoo I**. 1992. C-type print. **h**26 × **w**45 cm. **h**10¼ × **w**17¾ in.

Hoff Charles

Ezzard Charles and Rocky Marciano

Boxing matches are often a continuum of indecisive moments, of holding and clinching, and it was the photographer's job to find such iconic pictures as this which might show the whole fight in a heroic light. The American Marciano was world heavyweight champion between 1952 and 1956. Fight photographers composed with reference to picture pages which would usually be headed by a statuesque tableau presenting the boxers in their entirety, as identifiable individuals; then, in support of such a defining picture, one would find – at least in the heyday of boxing, which lasted from the 1930s through to the 1950s – sets of fragments taken from the action at large: grimaces, moments of impact, bleeding and gasping. But at about the time this picture was taken, and in response to an appetite for thrills generated by televised boxing, a new generation of cameramen began to concentrate on faces in close-up and under all sorts of duress.

☛ Eakins, Levinthal, Riefenstahl, Rio Branco, Rodger

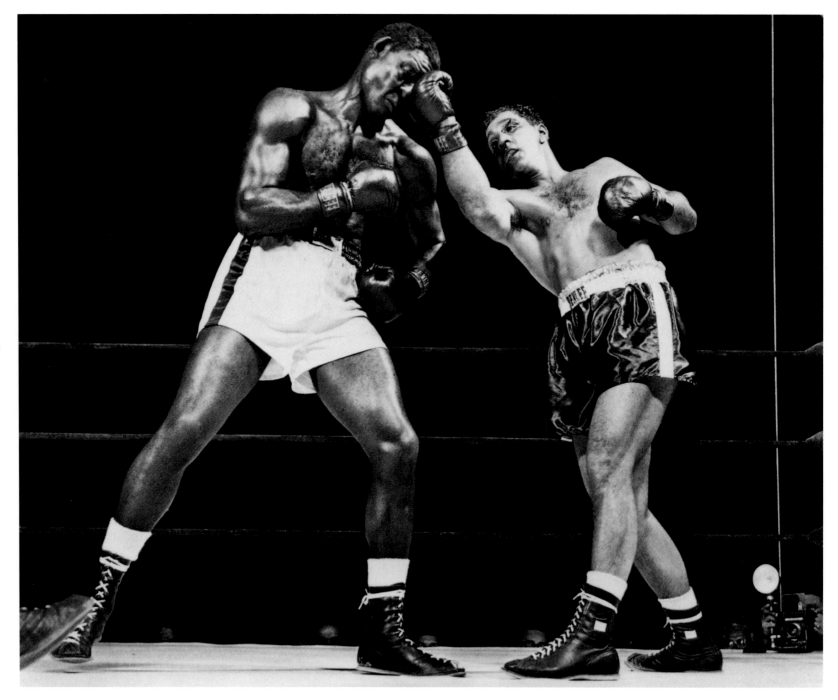

208

Charles Hoff. b Coney Island, NY (USA), 1920. **d** Hollandale, FL (USA), 1975. **Ezzard Charles and Rocky Marciano**. 1954. Gelatin silver print.

Hofmeister Theodor & Oscar The Haymaker

The girl returning from the fields at the end of the day is a descendant of Jean-François Millet's country people of the 1860s. There is a difference, however, in that she appears to be lost in thought to a degree which would have been unthinkable earlier. The picture is in part about labour, for she is wearing protective headgear and special sleeves cover the arms of her blouse, but the real subject is hidden from our gaze: her state of mind. Although she might be thinking or dreaming of anything, the Hofmeisters' implication – expressed in the shape of that landscape background – is one of a consciousness stretching from here to infinity. Their habit, in outdoor subjects, was always to show an unbroken continuity starting from a foreground marked by flowers, for instance, and moving rapidly towards a very distant, open horizon. The gum printing technique they used allowed them to soften naturalistic detail and evoke atmosphere and mood.

☛ **Davison, Demachy, Erfurth**

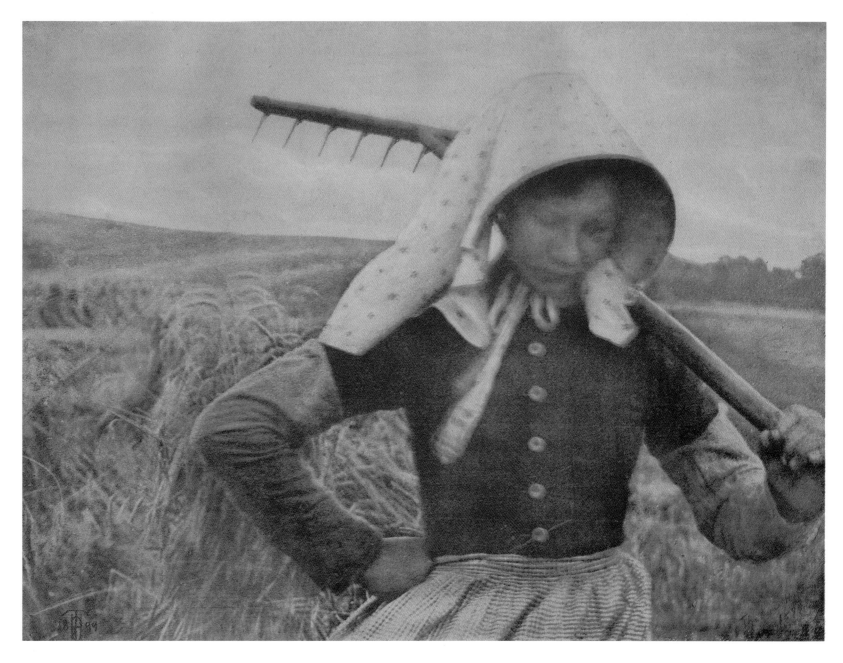

Theodor Hofmeister. b Hamburg (GER), 1863. d Icenhausen (GER), 1943. Oscar Hofmeister. b Hamburg (GER), 1871. d Hamburg (GER), 1937. The Haymaker. 1899. Gum bichromate print.

Holland Day Fred Untitled

The figure coming to consciousness at the mouth of the cave might be the first man stirring or an early version of the god Pan who loved mountains, caves and lonely places and was especially associated with sleep and with dreams. Whoever he is, Holland Day has portrayed him not as a real person but as a state of mind, as expressed in that sorrowful profile emerging from the hillside. Holland Day's ability, unmatched in the history of the medium, lay in retelling old stories with conviction. Since he chose not to identify his subjects, his photographs have a timelessness and a sense of originating at a time when the myths were in formation. Holland Day was devoted to the poetry of John Keats and his photographs often have a Keatsian dreaminess and an almost overpowering sensation of the scents and tastes of nature. In 1904 Holland Day's studio and its contents were destroyed by fire.

☞ Appelt, Brigman, Du Camp

Fred Holland Day. b Norwood, MA (USA), 1864. d Norwood, MA (USA), 1933. **Untitled**. 1907. Platinum print.

Den Hollander Paul Untitled

The snake appears to caress and even to shape the stone on which it moves. Although the snakes make engrossing subjects in themselves, den Hollander's real topic here is the perception of time. Partly because of the way in which the serpent's head has been integrated, the viewer has no option but to trace the flow of its body across the undulating rock and to relate the patterned surface to the ground. Both shapes appear to taper and even to vanish into folds in the rock, meaning that every bit of the scene is open to a probing examination. By comparison, the segment of rope strung across the foreground stands for another, more abstract way of understanding space. In den Hollander's first major book, *Moments of Time* (published in 1982), he deals much more with social time in a series of photographs often taken on the Belgian seacoast in which heavy figures stand poised in expectation or recollection.

☛ **Bourdin, Connor, Misrach, Watkins**

211

Paul den Hollander. **b** Breda (NL), 1950. **Untitled**. 1984. Cibachrome. **h** 48 × **w** 48 cm. **h** 18¼ × **w** 18¼ in.

Hopkins Thurston — On the South Bay Beach

Thousands crowd the sands at Scarborough, the popular Yorkshire seaside resort. In the background is the Grand, one of the famous luxury hotels. In the foreground, the masses separate out into individual family, play and conversation groups. This picture marked an important moment in British photography because it demonstrates Hopkins's appreciation of commonplace events. In the 1940s the people had often been seen in ones and twos and given representative status as heroes and heroines, survivors of the recent troubles. By 1952, however, Hopkins felt free to present the nation more informally, glad that there was no longer any need for collective endeavour. This vision of crowds as being made up of individuals occupied with conversation and family matters informed the new British documentary of the 1970s and influenced the work of Ian Berry and David Hurn. Hopkins, who was one of the principal documentarists of post-war Britain, began to work for *Picture Post* in the very early 1950s.

☛ Hurn, Kühn, P. Martin, R. Moore, Steele-Perkins

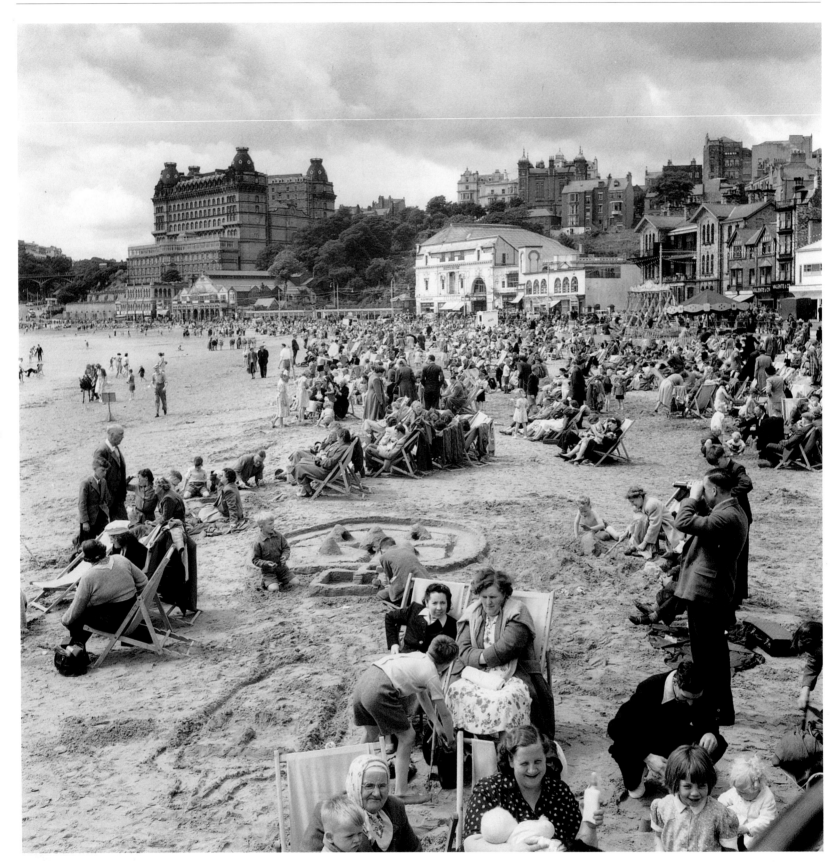

Thurston Hopkins. b London (UK), 1913. **On the South Bay Beach**. 1952. Gelatin silver print.

Hoppé Emil Otto

Portrait of A.P. Allinson

Looking completely impassive, the painter A.P. Allinson is posing in front of one of his own creations, which is slightly out of focus. His monocle, together with the blurred painting behind him, suggest that the act of seeing is part of the portrait's subject. Allinson's remarkable lack of expression anticipates new German styles of portraiture in the 1920s.

Educated in Vienna, Hoppé was originally destined for a career in banking, but on the first stage of a journey to China in 1900 he stopped off in London, where he remained for the rest of his days. He took up photography as a full-time occupation in 1907, and by 1913 had established himself as one of London's leading portraitists. In the 1920s he turned to documentary and travel photography, publishing a book on Romania in 1924 and another on Australia in 1931. In 1945 Hoppé, who was one of the most over-productive of all photographers, wrote an autobiography called *100,000 Exposures*.

☛ Leibovitz, Nadar, Newman, Sander, Snowdon, Tmej

213

Emil Otto Hoppé. **b** Munich (GER), 1878; **d** London (UK), 1972. **Portrait of A.P. Allinson**. c1909. Chlorobromide print.

Horst Horst P.

Mainbocher's Pink Satin Corset

This is a fashion picture influenced by Surrealism. The model, in her pink satin corset, is staged fetishistically, as an object rather than as a character. Her actions, which have been dictated by the photographer, seem designed to deprive her of expressive capacities of her own and to draw attention to the lacing of the corset and those tapes spread out on the bench.

New photographers between the wars liked to think of themselves as engineers and even as artisans, making work which related primarily to the sense of touch. In this case, for instance, Horst alludes to the tightening of the corset, and makes a point of contrasting the tautness of the plaited lacing with the languor of the unused tape. Horst originally went to

Paris to study architecture with Le Corbusier and must have been well aware of modern design issues. In 1934 he succeeded George Hoyningen-Huene as the *Vogue* fashion photographer.

☞ Bellocq, Cunningham, Hoyningen-Huene, Moriyama, Weston

214

Horst P. Horst. b Weissenfels (GER), 1906. **Mainbocher's Pink Satin Corset**. 1939. Gelatin silver print.

Hosking Eric

Barn Owl

Hosking believed this to be the first-ever flashlit picture of an owl with its prey – a young rat. In 1936 night-time photography of birds was a novelty and an adventure, and Hosking likened the feeling to 'standing on the threshold of some vast uncharted realm'. In his book *Birds of the Night*, published in 1945, Hosking described the excitement of his investigation, and the difficulties of watching for his subject in the darkness. *Birds of the Night*, with its studies of snowy, tawny, long-eared, short-eared and barn owls, was important in the history of ornithology, but it was influential too in the larger history of culture, for it introduced nature in surprisingly savage terms to readers more used to affable illustrations in children's books. Hosking's owls may look suave, but most of them stand with dead rodents at the entrance to improvised nests. The artist Francis Bacon owned Hosking's books on British birds and used them in his work.

☛ Fontcuberta, Lanting, Mylayne, Vilariño

Eric Hosking. b London (UK), 1909. d London (UK), 1991. **Barn Owl**. 1936. Gelatin silver print.

Hosoe Eikoh Kama-itachi #34

The figure, a dancer called Tatsumi Hijikata, seems to be stirring among grasses and webs. *Kama-itachi*, the title of the series, means 'weasel's sickle', and refers to a sharp cut caused by a small but powerful cyclone. Here a connection is being made with the pangs of memory. Hosoe's idea was that if he returned with the dancer to the area of Honshu, which both of them remembered from childhood, it would somehow be possible for them to re-enact the past and to bring back their unconscious memories. Hosoe sees photographs as scores or texts, which are there to be read with reference to the senses. In this case there is a clear invitation to replay the gestures of the dancer's hands, and to wonder from the reduced information given in the silhouette just how they might be held in relation to the head. Earlier series, in which body parts are aligned and manipulated, also invite the viewer to see through the picture to the point of physical re-enactment.

☞ **Alvarez Bravo, Fink, W. Klein, Renger-Patzsch**

Eikoh Hosoe. b Yamagata (JAP), 1933. **Kama-itachi #34**. 1968. Gelatin silver print.

Howlett Robert

The Valley of the Mole

Why should someone, at a time when photography was a cumbersome procedure, bother to take several pictures of a cart left standing on the edge of a river? Some aspect of the scene must have caught Howlett's eye. Perhaps he was interested in the manufacture of the cart itself, and in particular in its tipping mechanisms. Or maybe he was intrigued by the figure of the wheel, as a found version of the wheel of fortune; or possibly he identified the cart in the river as a re-enactment of Constable's *Hay Wain* of 1821, in which a harvest cart has been led into river water to keep its wooden wheels and spokes from shrinking. Howlett's intentions may be forever obscure, even if they were straightforward in the first place; but in the 1980s, when this picture began to be widely exhibited, audiences were becoming familiar with photographs in which interpretation was both invited and forever delayed.

☛ Annan, Emerson, Killip, Manos, Morath

Robert Howlett. b London (UK), 1831. d London (UK), 1858. **The Valley of the Mole**. 1855. Albumen print.

Hoyningen-Huene George Bathing Suits by Izod

The pair look as though they might gaze out to sea for ever. In 1930 high-divers epitomized perfection, for they were the most self-possessed of all performers. Hoyningen-Huene's models may be advertising nothing more than swimwear, but the context is the world of athletics. Hoyningen-Huene inaugurated the heroic phase in fashion photography in the late 1920s. In both his fashion and travel photography he tried to present mankind in a dignified light, as sculptural and heroic. He appreciated what he called 'naturalness of form and movement' and deplored 'organized artificiality'. Both phrases are taken from *African Mirage*, his travel book of 1938. He undertook fashion photography for *Vogue* in 1926, moved to *Harper's* *Bazaar* in 1936, and in 1943 published eloquent picture books on Egypt and Greece. In 1946 he moved to Hollywood and became a portrait photographer of movie stars.

☞ Dupain, Escher, Horst, Keetman, Yavno

George Hoyningen-Huene. b St Petersburg (RUS), 1900. **d** Los Angeles, CA (USA), 1968. **Bathing Suits by Izod.** 1930. Gelatin silver print.

Hubmann Franz

Alberto Giacometti

The face of the sculptor Alberto Giacometti was one of the most photographed of the post-war era. Together with Samuel Beckett he represented experience, just as Picasso stood for creativity as inventiveness. Artists had featured in Europe's pantheon before, but never to this degree. They stepped into the place recently vacated by the political leaders of the 1930s, and promised a new kind of society open to personal values. Yet there is a paradox in this close-up of the sculptor's face, for he was associated – especially in the 1940s – with spindly figures which appeared only to exist at a distance. Giacometti had, it seems, no wish to violate his subjects' privacy. If this is the case, Hubmann's portrait looks very much like a violation, for the photographer is close enough to pick out every line and wrinkle. Both Giacometti and Beckett, however, were masters of impassivity, whose faces could be understood merely as external facades to be worked on by time, weather or natural forces.

☛ Florschuetz, Freund, Lendvai-Dircksen, Nadar, Ohara, Özkök

219

Franz Hubmann. b Freden (AUS), 1910. **Alberto Giacometti**. c1951. Gelatin silver print.

Hurley Frank

The Endurance by Night

Sir Ernest Shackleton's ship, *The Endurance*, is trapped in pack ice in the Weddell Sea during an Antarctic expedition of 1914–17. Taken by the light of a magnesium flash, this is a picture of transformations, of a solidified sea appearing to move under an ice ship which looks like a ghost in the darkness. The picture could almost be a photographic negative, and suggests that Surrealism's interest, in the 1920s, in shimmering mirages and deceptions could have originated in the Antarctic in the age of exploration. Hurley set out to take documentary photographs of ice in formation and in action, but the most striking pictures he obtained were of the spectre ship. Altogether he took pictures on five Antarctic expeditions, and is remembered for his book of 1925 entitled *Argonauts of the South*. A commercial photographer with an interest in topical subjects, Hurley went straight from the Antarctic to photograph events in the battle zones of Europe.

☛ Arbuthnot, Hamaya, Mortimer, Oorthuys, Sutcliffe

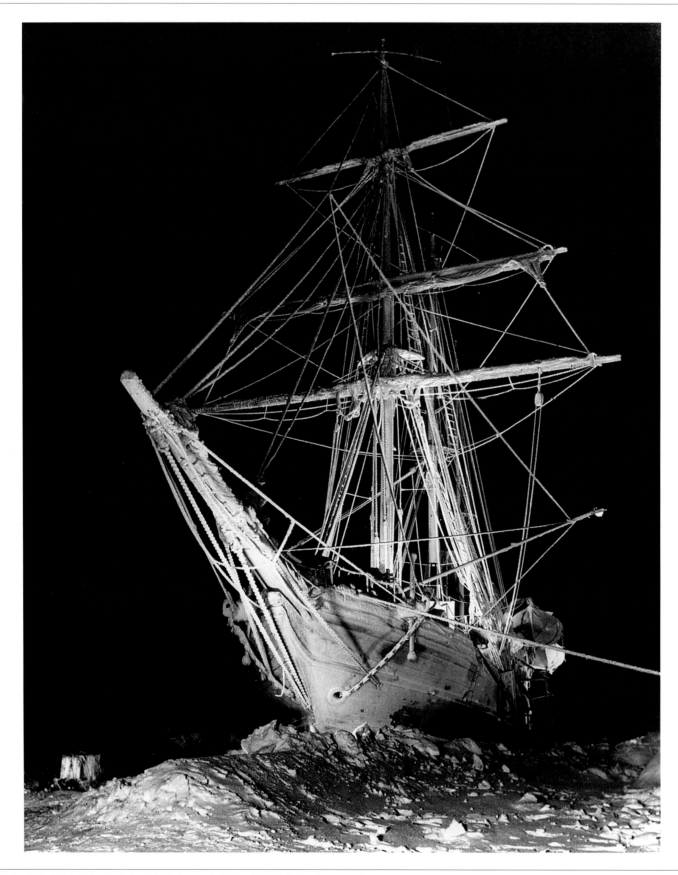

Frank Hurley. b Sydney (ASL), 1885. **d** Auckland (NZ), 1962. **The Endurance by Night**. c1915. Gelatin silver print.

Hurn David

Day Trip to Aberavon Beach

Although the older man and the dog are resting contentedly and even carelessly, the others still attend to whatever the situation is – and it can be imagined from any of the various points of view on offer here. The assembly, with its carefully differentiated and paired subjects, represents a body of reportage which concerned itself with people and the generations. This is what you might expect of a photographer whose career began in 1956 when the great 'Family of Man' exhibition was beginning its travels. The generations, according to the orthodoxy of that period, constituted one great family, but Hurn's interest in the family and its rituals was rather as a format against which eccentricity could be registered. In this case on the Welsh coast, the wayward child, the beautiful girls and the blithely sleeping elder suggest an idea of the family disrupted by either accident or wilfulness.

☛ Beato, Berry, Jokela, Kalvar, Luskačová, de Montizon

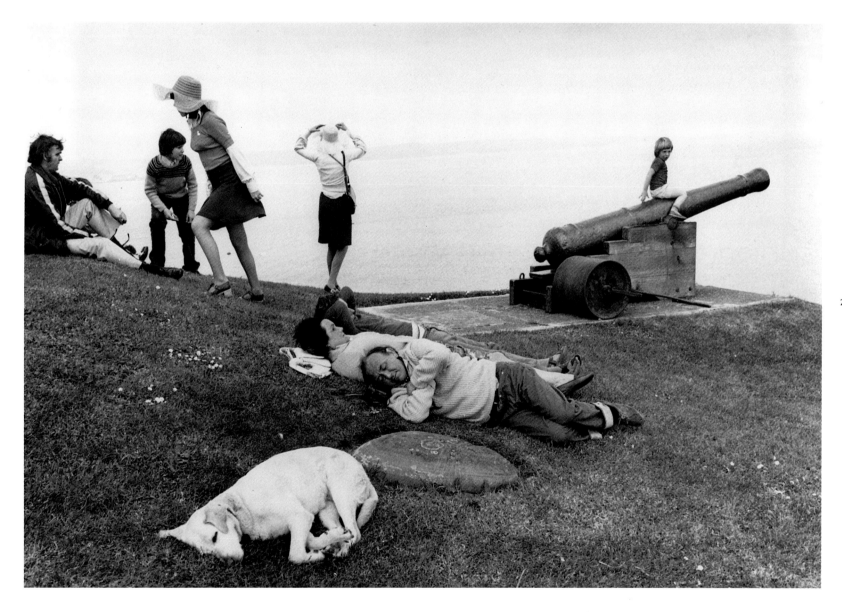

David Hurn. b Redhill (UK), 1934. **Day Trip to Aberavon Beach**. 1974. Gelatin silver print.

Hurrell George

Marlene Dietrich

Marlene Dietrich had stubby fingers, but here they have been retouched to their advantage. Hurrell's tendency in the 1930s was to use dramatic lighting from a single source in order to dramatize his Hollywood celebrities, and to make them expressionist and modern in the style of the German 1920s. The alternative style – as demonstrated by Clarence Sinclair Bull, in particular – was atmospheric and dreamy. Hurrell trained in Chicago, and moved to Laguna Beach in 1925. He worked for MGM in the late 1930s, and set up his own studio in 1932 in Sunset Strip. In the mid-1930s he accepted assignments from Twentieth-Century Fox, and between 1935 and 1938 was on contract to Warner Brothers. After serving as Staff Photographer at the Pentagon during the war he returned to Hollywood, where he was hired by Columbia Pictures. In the 1960s he entered television and shot *Gunsmoke*, *Star Trek* and *M.A.S.H*. As a portraitist he photographed everyone who was anyone in the major studios.

☛ Bull, Dührkoop, Harcourt, Kirkland, Pécsi

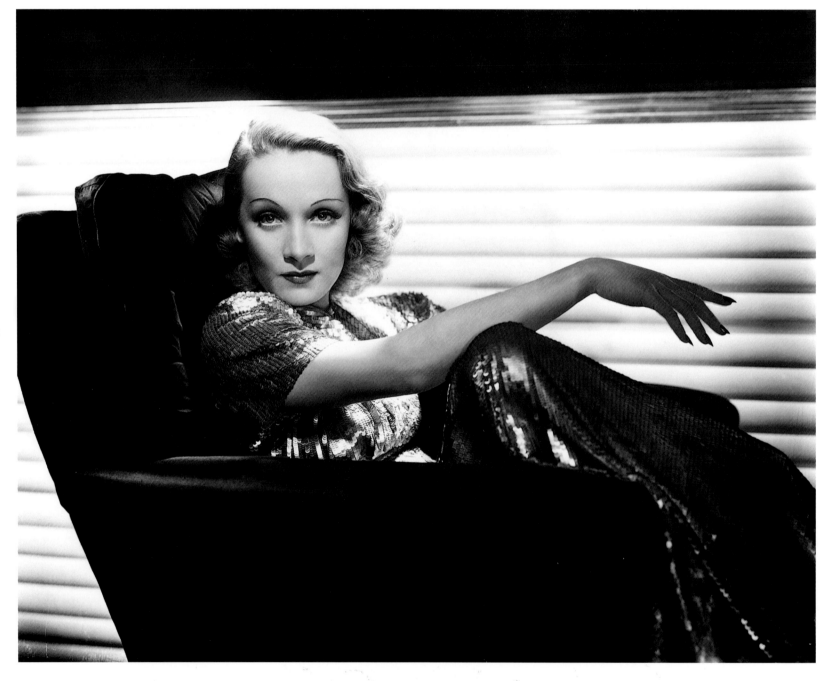

222

George Hurrell. b Cincinatti, OH (USA), 1904. d Los Angeles, CA (USA), 1992. Marlene Dietrich. 1938. Gelatin silver print.

Hütte Axel Fuhra

The surviving trace of snow in the gully suggests that this picture was taken in the late springtime – for everything else looks very green. Perhaps the gully lies just deep enough to keep out the sunlight, although it is hard to tell from the evidence available. Nor is it absolutely clear why we should take a keen interest in what looks like a landscape detail seen in passing. Hütte likes to raise questions concerning landscape and identity. Here he seems to be asking how it is possible to think of a mountain pass as a place with its own separate identity. Surely a mountain pass is simply a transit zone, somewhere passed through en route? Most of Hütte's landscapes feature places which are loosely named. They are either sites like this, which are part of a continuum, or views seen through or beyond foreground details, which are always far more immediate than the prospect beyond.

☞ **Fenton, Godwin, Sella, Shore, M. White**

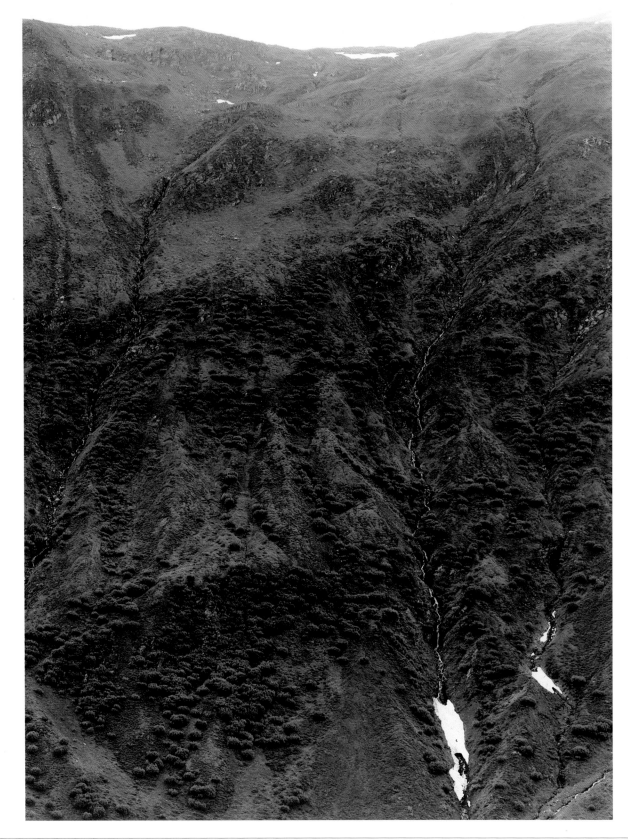

223

Axel Hütte. b Essen (GER), 1951. **Fuhra**. 1996. C-type print.

Iturbide Graciela Our Lady of the Iguanas

This woman with iguanas in her hair appears on the cover of Iturbide's extraordinary book of 1989 entitled *Juchitán de las mujeres* (Juchitán, Town of Women). Juchitán, in the far south of Mexico, has a remarkable Zapotec-influenced culture. Lizards, associated with the old gods, are still venerated, and the sacred furnishings of the Church are known as 'the Lizard's instruments'. Iturbide, in conjunction with the book's writer Elena Poniatowska, envisages the area as 'a mythical space where man finds his origins and woman her deepest essence'. Iturbide's women are strong-willed, large-bodied and dominant in a matriarchal community. Her intention seems to have been partly to explain religious and sexual practices in Juchitán, and partly to challenge a stereotype of 'self-sacrificing Mexican mothers drowned in tears' (in Poniatowska's words). Iturbide, whose previous book was *Paper Dreams*, took up still photography in 1974.

☛ Furuya, Lele, Muray, Strömholm, Yevonde

224

Graciela Iturbide. **b** Mexico City (MEX), 1942. **Our Lady of the Iguanas**. 1979. Gelatin silver print.

Iwago Mitsuaki

Horned Avalanche

A herd of wildebeest is migrating across a river in the Serengeti National Park in Tanzania. When this picture was taken in the mid-1980s, there were over a million and a half of these animals in the park, and in events such as this hundreds drowned. Iwago's study of the Serengeti, which was published in May 1986 in *National Geographic*, took eighteen months to complete, and this was one of its most successful pictures. The crossing, lost in dust, might have looked like a mass of confusion had it not been for that leaping figure in profile in the foreground which expresses the leap itself and links the animals above and below. Iwago is a virtuoso of the decisive moment as applied to migration and the seasonal life of animals. This and other pictures subsequently appeared in *Serengeti: Natural Order on the African Plain*, which was published in 1987. Iwago has photographed wildlife subjects all over the world, travelling from the Arctic to the Antarctic.

☞ Caponigro, Cartier-Bresson, Le Querrec, Muybridge

Mitsuaki Iwago. **b** Tokyo (JAP), 1950. **Horned Avalanche**. 1986. C-type print.

Izis

The Trône Fair

The tranquillity of the shining face of the woman above the beam contrasts beautifully with the brutish scene depicted below. Izis noticed that the staccato line of nailheads established a noisy relationship between the two caricatures. In the 1930s, when photographers began to plan their pictures around contrasts between the artificial and the actual, the actual was usually disadvantaged, and often represented – especially in Parisian streets – by outcasts asleep. Izis's tactic, however, was to reverse that priority on behalf of humanity. Together with Willy Ronis and Robert Doisneau, he was one of the great poetic photographers of the post-war years. His memorials are the books *Paris des rêves* of 1949 and *Le grand bal du printemps* of 1951. What marked Izis out from the others was an enhanced sense of dangers recently undergone. Here, for instance, the quick-fire orator on the left in Roman armour brings to mind Mussolini making a speech.

☛ **Doisneau, P. Martin, Peress, Ronis, Walker, Zachmann**

Izis **(Izis Bidermanas)**. **b** Mariampole (LIT), 1911. **d** Paris (FR), 1980. **The Trône Fair**. 1950. Gelatin silver print.

Jackson Robert

The Murder of Lee Harvey Oswald

On the day before John F. Kennedy's funeral, a Dallas nightclub owner called Jack Ruby shot and killed the President's accused assassin as he was being transferred from the Dallas city jail to the county jail. Public events in the USA in the 1950s and 1960s often featured a host of local functionaries, and the pictures tended to look like portrait galleries – none more so than this one. This picture lodged itself in the imagination of the American humorist and genius Lenny Bruce, whose routine ran: 'I was just thinking of that picture of Oswald, you know, when he got shot? That's Lyndon Johnson's relation face – you know, that guy with the hat on, the big Texan.' Elsewhere Bruce (who specialized in Jewish jokes) remembered Ruby as seen here: 'Yeah. Even the shot was Jewish – the way he held the gun. It was a dopey Jewish way.' Jackson, a photographer for the Dallas *Times-Herald*, won the 1964 Pulitzer Prize for this picture, as well as a place in the American imagination.

☛ E. Adams, R. Capa, Clark, Gaumy, Nachtwey

227

Robert Jackson. b Dallas, TX (USA), 1934. **The Murder of Lee Harvey Oswald**. 1963. Gelatin silver print.

Johns Chris

John and Josie Adams

John Adams of Dunster in British Columbia is caring for his mother, Josie. Adams remarked that their hilltop theatre, which had been chosen for the excellence of its TV reception, also proved attractive to wolves, moose and bears. The improvising Adams family must have been the answer to a documentarist's prayer. Once upon a time, North American society had been renowned for its mobility, with the car as its emblem. In the pioneering days, too, people had been in contact with the fabric of their surroundings and with the earth and the weather. Here, on the Fraser River, the old lady epitomizes the past, as does the car with its promise of mobility. Television, on the other hand, stands for a future in which movement is no longer required. *National* *Geographic*, where this photograph appeared, became more and more alert during the 1980s to the kind of ecological issues so deftly identified here by Johns, one of their regular contributors on the North American scene.

☛ **Abell, Gutmann, de Keyzer, Link, VanDerZee**

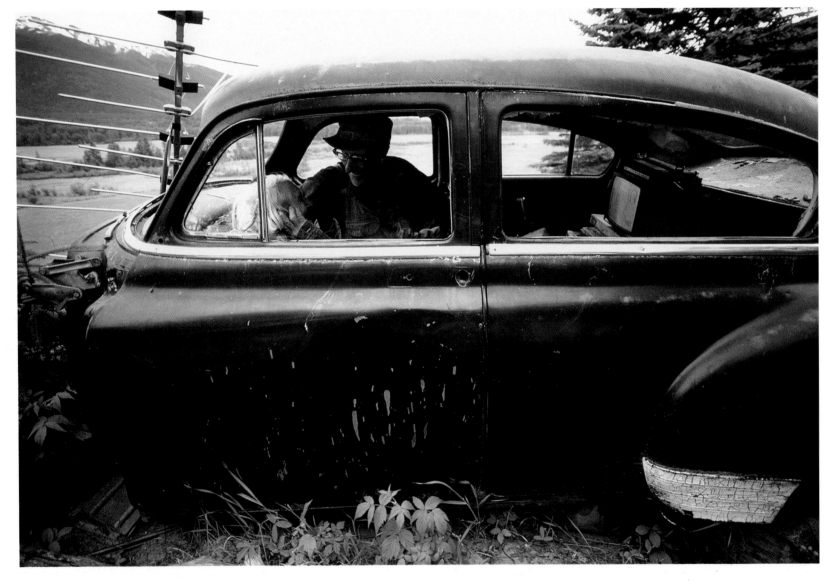

228

Chris Johns. b Medford, OR (USA), 1951. **John and Josie Adams**. 1986. C-type print.

Johnston Frances Benjamin Arithmetic, Measuring and Pacing

Against the background of what could be a Romanesque church, but is actually the Hampton Institute in Virginia, four women make measurements on the grass with tapes and rulers while others look on. This photograph was taken as part of a documentation of *Contemporary Negro Life in America* for the Paris Exposition of 1900. In the rest of the series similar groups carry out other instructive tasks at the same archaic pace. In an interview of 1895 Johnston spoke of her ambition 'by care of detail, a study of arrangement and lighting, to make not only photographs but *pictures...*' Her reputation since the 1970s has been based mainly on the album of photographs she took at Hampton which is seen as the epitome of control and mastery.

After studying painting in Paris at the Académie Julian in the 1880s, she took up magazine photography before becoming a very successful portrait photographer in Washington.

☛ Bisson, F. H. Evans, Laughlin, Marubi, O'Sullivan

Frances Benjamin Johnston. **b** Grafton, WVA (USA), 1864. **d** New Orleans, LA (USA), 1952. **Arithmetic, Measuring and Pacing**. c1900. Gelatin silver print.

Jokela Markus

InterRail Travellers, Yugoslavia

These youths are probably Scandinavians, and the fragment of landscape beyond the window is Yugoslavia. In 1990 InterRail travellers were a familiar sight all over Europe. Jokela, a documentarist for the Finnish illustrated periodical *Helsingin Sanomat*, specializes in images of contemporary leisure and consumerism: beach and pizza culture, Christmas trade, shopping, begging, packaging and waste. His gift lies in his identification of new cultural phenomena such as InterRail and in the registering of actualities: heat, boredom, fatigue and discomfort in this case. This new kind of reportage documents and appreciates banalities such as shoe styles and fast food wrapping. It suggests that the significance lies in the details and can only be remarked on close to by fellow materialists sweltering and hungering. In 1990 Jokela was also working on a series entitled *War Veterans*, portraits of the incapacitated brutally realized.

☛ Hurn, Kaila, Kalvar, Luskačová

230

Markus Jokela. b Helsinki (FIN), 1952. **InterRail Travellers, Yugoslavia**. 1990. Chromogenic colour print.

Joseph Benny Felton Turner

Felton Turner looks detached, perhaps because this is less a portrait than a record of his body as a document inscribed. An unemployed awning installer, Turner had participated in a sit-in in March 1960 with Texas Southern University students in Houston. Four masked white youths followed him home and abducted him at gunpoint before tying him to a tree, beating him with chains and carving two sets of the initials KKK (Ku Klux Klan) on his abdomen. Joseph, a Houston photographer who worked for black civil rights attorneys and for the *Houston Informer*, took this picture in Turner's home shortly after the incident, to judge from those surgical dressings. Presented intimately like this, Turner's image exists in sharp contrast to the bulk of civil rights shots taken during the 1960s in the USA. Whereas mainstream reportage had become familiar and public, this image deals incontrovertibly with human presence. Joseph was also known for his portraits of the major blues and gospel singers of the era.

☛ Goldberg, Mapplethorpe, Mather, Sims

Benny Joseph. b Lake Charles, LA (USA), 1924. **Felton Turner**. 1960. Gelatin silver print.

Kaila Jan

Untitled

The model Elis Sinistö looks peaceful lying beneath a blanket of daisies in the sunlight. Elsewhere in Jan Kaila's pictures Sinistö meets himself as an angel on a frozen lake, plays chess with a magpie, stands in a lily pond and comes across a brightly coloured globe suspended in nature. The old man stars in Kaila's book of 1992, *Elis Sinistö*, sometimes as an allegorical figure like this, and at other times acting expressively in response to Kaila's prompting: 'greedy', 'proud' and so on. Sinistö, an acrobat, dancer and magician, was born in Lapland and lived in Paris before returning to a village west of Helsinki where he built a miniature village and playground. Kaila remembered him from his own childhood and returned in the 1980s to make a collaborative artwork improvised from material to hand. Sinistö acts the utopian part of Everyman as a universal artist.

☛ **Cumming, Hurn, Jokela, Kalvar, Luskačová**

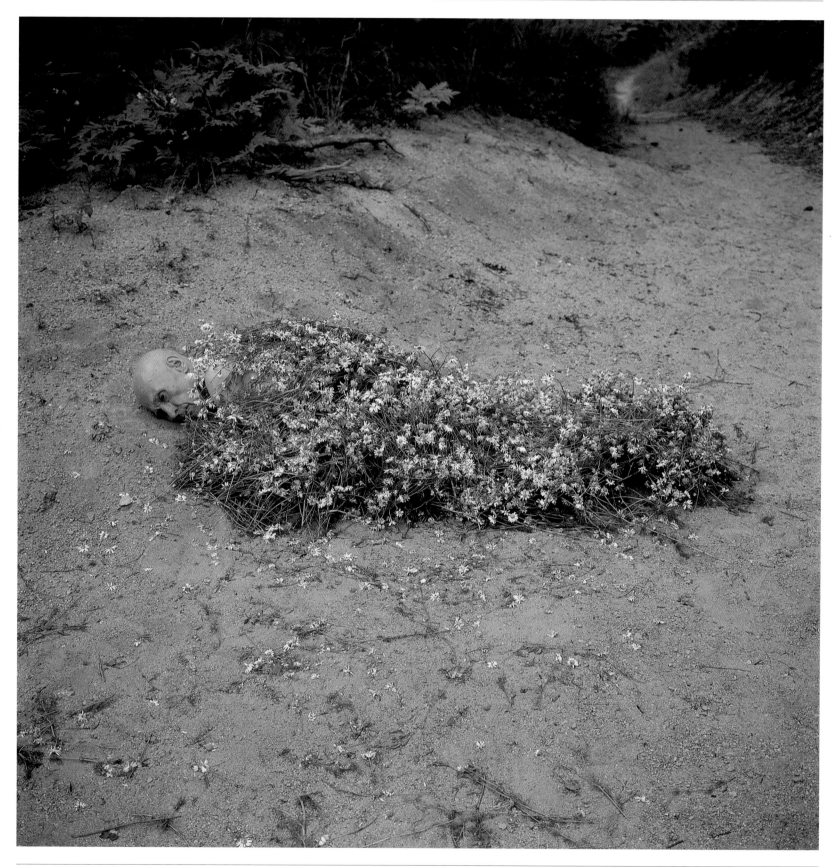

232

Jan Kaila. **b** Åland Islands (FIN), 1957. **Untitled.** 1991. Cibachrome. **h**120 × **w**115 cm. **h**47¼ × **w**45¼ in.

Kales Arthur F.

The Thirty-Nine Steps

Despite the title (which mirrors that of John Buchan's book of 1915), there are fewer than thirty-nine steps – at least on show – but they do ask to be counted: not only does the counting take time but it also involves sustained eye contact with those textured surfaces and an appreciation of the roundness of the tower. In a typical piece by Kales the subject is reaching out, as if to confirm by touch the evidence of her eyes. Kales's bromoils usually feature women in dreamlike (Freudian) contexts like this and with their eyes averted, in a way which gives the viewer unimpeded access to the fabric of the picture. Kales was a specialist in bromoil printing, a process which allowed for considerable inflections of tone and texture. In 1928 he exhibited fifty prints at the Smithsonian Institution in Washington, DC, but by then 'straight' photography was beginning to define bromoil as an archaic process.

☞ F. H. Evans, Larrain, Paneth

Arthur F. Kales. b Phoenix, AZ (USA), 1882. d Los Angeles, FL (USA), 1936. The Thirty-Nine Steps. 1922. Fresson print.

Kalvar Richard

Twenty-Four-Hour Automobile Race, Le Mans, France

The scene is a very ordinary bar frontage at Le Mans in north-west France. Clients and staff are minding their own business, seemingly indifferent to the prone figure in the foreground. Is he drunk, or just resting? His folded arms suggest that he might just be taking a nap. Kalvar's topic, succinctly expressed here, has always been single-mindedness. In any well-regulated society we like to get involved on behalf of good order, but Kalvar's personnel, who are intent on their own purposes, prefer to leave well alone. So, if the ex-client is not actually impeding access to the bar, what is the point of troubling him? Kalvar's sympathies lie with those who are outsiders and any argument he has is with the view that society and the environment give us no room for manoeuvre. Although his cast includes many loners and eccentrics going about their affairs in the shadow of the silent majorities, he also stages everyman and woman in unguarded and expressive moments.

☞ Bayard, Hurn, Jokela, Kaïla, Luskačová, Robinson

234

Richard Kalvar. b New York (USA), 1944. **Twenty-Four-Hour Automobile Race, Le Mans, France**. 1972. Gelatin silver print.

Karsh Yousuf

Winston Churchill

According to one story, Karsh was irritated by Churchill's cigar smoking and removed the cigar from the Prime Minister's hand. This photograph was taken in Ottawa in December 1941, just after Churchill's speech to the Canadian parliament promising that Britain would fight on. In a portrait by Cecil Beaton, Churchill, who is wearing what looks like the same spotted bow tie, appears to be much more at ease with a cigar in his hand. The photographer's task was to provide a contrast to the portraits of Hitler and Mussolini, dictators who were associated with violent gesturing and military paraphernalia. Churchill, on the other hand, preferred to present himself as a resolute chairman or manager, head of a civilian enterprise which granted interviews face-to-face. Karsh, the greatest portraitist of political and cultural notables in the 1940s and 1950s, remarks on the 'internal strength of his subjects', who included Jawaharlal Nehru and George Bernard Shaw.

☛ Aigner, Beaton, Bosshard, Bourke-White, Lessing, Salomon

Yousuf Karsh. b Mardin (ARM), 1908. **Winston Churchill**. 1941. Gelatin silver print.

Käsebier Gertrude Blessed Art Thou among Women

Supervised by an older woman, the girl in black appears to be on the point of crossing a threshold. The title suggests that she is Mary, the future mother of Christ, and this idea is supported by what looks like a picture of the Visitation in the background. In the Visitation, a familiar subject in Christian art, Elizabeth, mother of John the Baptist, shares with Mary her knowledge of the divine pregnancy. Why should Käsebier set up a picture so permeated with Christian symbolism and meaning at a time when many of her contemporaries were turning to urban themes of the moment? She was consistently interested in the business of growing up as it affected women, and many of her pictures are of girls making preparations, learning to read, write and dance, or experiencing such significant moments as this child does at the threshold. Echoes of the Christian tradition, with its stress on sacrifice and hardship, enabled the photographer to invest her theme appropriately.

☛ **Doisneau, Lange, Larrain, Mydans, Ueda**

Gertrude Käsebier. **b** Des Moines, IA (USA), 1852. **d** New York (USA), 1934. **Blessed Art Thou among Women**. 1899. Platinum print.

Kawada Kikuji

The Japanese National Flag

A crumpled and sodden Japanese flag seems to be on the point of merging into its background. Generally flags are seen fluttering in the wind, proud symbols of countries, companies or administration areas. This flag, by contrast, no longer represents the risen sun of Japan. It has become instead merely a piece of submerged drapery, reclaimed by nature. The flag appeared originally in Kawada's important book of 1965, *The Map*, where it kept company with other examples of embedded and eroded surfaces: scraps and shavings, caps and discarded bottles. Kawada's suggestion in *The Map* is that with respect to geological time all things are equal, a point made all too clearly by the atomic explosions which had flattened several Japanese cities in 1945. In *The Map* Kawada explores the Japanese heritage from this other long-term point of view. Kawada became a freelance photographer in 1959, the year of 'The Sun', his first one-man exhibition.

☛ Chaldej, Frank, Rosenthal, Tsuchida

237

Kikuji Kawada. b Ibaragi (JAP), 1933. **The Japanese National Flag**. c1963. Gelatin silver print.

Keetman Peter Highboard

Not one of the nineteen bathers taking part seems very committed. Diving in the 1930s stood for purposeful activity, but post-war aesthetics liked to grant time and space to individuals to be themselves. In Keetman's experimental pictures of water drops taken in the 1950s, there is a similar invitation to remark on modules which may look similar at first sight but which turn out to be quite distinctive on inspection. Keetman, who was seriously wounded during the war, was a founder member in 1949 of the group Fotoform, which was described by Robert d'Hooghe in the *Frankfurter Allgemeine Zeitung* as 'an atom bomb in the dung heap of German photography'. One of the new subjective photographers, Keetman was determined to invest his pictures with the kind of poetic and personal elements which were excluded in the normal range of documentary picture-making. These experimental photographs succeeded in establishing his international reputation.

☞ Escher, Hoyningen-Huene, LaChapelle, Le Secq

Peter Keetman. b Wuppertal-Elberfeld (GER), 1916. **Highboard**. 1957. Gelatin silver print.

Keita Seydou

Untitled

These two young women from Bamako in western Mali are wearing dresses known as *dyakaase*, a name which derives from the city of Dakar in nearby Senegal. Their golden rosettes are *sanu koloni*, while those larger pendants are *doola*. They also wear collars of pearls set in cornelian (a sort of reddish quartz) called *tyaaka*. All of Seydou Keita's portraits can be admired for their surface appearance, but if they are to be fully appreciated, the various elements must also be spelled out and even said aloud. Such elaborately patterned costumes and such differing kinds of jewellery ask to be identified, and this invitation was taken up by Youssouf Tata Cissé, who introduced Keita's pictures when they were first published in large numbers in 1995. There is no other body of portrait photography so heavily involved with the sound of language as this. Keita began to take portraits in 1945, established himself during the later 1940s and flourished in the 1950s.

☛ **Atwood, Disfarmer, Meisel, Molenhuis, Weber**

239

Seydou Keita. b Bamako (MA), 1923. **Untitled**. 1949. Gelatin silver print.

Kertész André

The Satiric Dancer

Magda, a dancer with pointed elbows, is acting the part of an odalisque on a scuffed couch. The setting looks like the uncarpeted corner of a studio, and she must have Art Deco statuary in mind – of the kind on show on the left. The style of the 1920s was streamlined, athletic and in low-relief – or, in photographic terms, imagined in a narrow depth of field. Thus, Magda's limbs lie almost entirely on the same plane. In 1926 Kertész, who had served in the Austro-Hungarian army during World War I, had only recently arrived in Paris, which was then a magnet for all the world's aspiring artists. One of the most inventive and playful of photographers, Kertész worked in Paris between 1925 and 1935, and was closely associated from 1928 with the illustrated magazine *VU*, for which he undertook documentary projects. *Paris vu par André Kertész*, which came out in 1934, was his first major publication. In 1936 he moved to New York, where he soon found work with *Vogue* and *Harper's Bazaar*.

☛ Fuss, Pécsi, Pierre et Gilles, Steichen, Tingaud

240

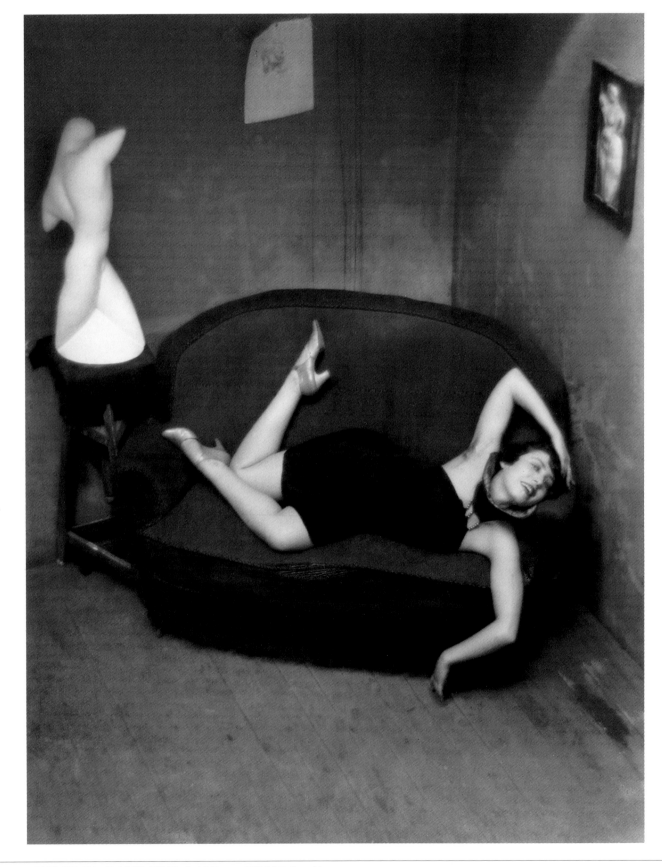

André Kertész. b Budapest (HUN), 1894. **d** New York (USA), 1985. **The Satiric Dancer**. 1926. Gelatin silver print.

Van der Keuken Johan Selling Lilies-of-the-Vaiiey

This couple, selling lilies-of-the-valley in a Parisian street on May Day sometime in the late 1950s, do not look quite like street traders. Both might be dreaming of a career in films, or of better times on the Riviera – if conclusions are to be drawn from his medallion and her wealth of jewellery. While he looks out along the street, she is altogether more aware of the camera.

Both, by the look of them, have histories, secrets and aspirations still to be met. Either could, without too much difficulty, be imagined in the movies of the period, as participants in some desperate and fatal romance. Through portrayals of this kind, van der Keuken provides evidence of depth of character and proposes that even ordinary lives are

imbued with drama. This particular image was published in *Paris mortel*, van der Keuken's book of Parisian street pictures published in 1963.

☛ Disfarmer, van der Elsken, Saudek, Vishniac

241

Johan van der Keuken. b Amsterdam (NL), 1938. **Selling Lilies-of-the-Valley**. 1958. Gelatin silver print.

De Keyzer Carl

Bombay

Grinning broadly, the occupants of the packed car are waving enthusiastically as it ploughs through the water. Do they know that there is deep trouble ahead, or are they simply optimistic? This picture from Delhi appeared on the cover of de Keyzer's *India* (1987) and displays his appreciation of the moment lived out intensely for its own sake. He seems to have rejected the continuities of history in favour of small events. History is still there, of course, and in his Indian photographs is often represented by film posters and famous buildings, but it takes place at a distance from people who are committed to the present. Life, he remarks, has to go on somehow despite ecological mismanagement, militancy and economic breakdown. In India, he finds, it goes on by leaps and bounds, heedless of the consequences. De Keyzer has also produced a book on the former USSR, entitled *Homo Sovieticus* (1989), and *East of Eden* (1996), on the people of Eastern Europe.

☛ **van Elk, Gutmann, Johns, Link, VanDerZee**

242

Carl de Keyzer. b Kortrijk (BEL), 1958. **Bombay**. 1985. Gelatin silver print.

Killip Chris

Rocker and Rosie Going Home

The pair have been collecting sea-coal with their horse and cart. The woman, in keeping with her maturity, looks thoughtful while the boy pays attention to the road ahead. Gathering fuel has been a subject of reportage photography since the turn of the century at least. It figures in German urban reports from the 1920s, and then, in a British context, in the work of Bill Brandt in the 1930s. The difference, though, between this image and its precursors is that this is more deliberated, with the facts of the situation brought vividly to life in such details as the bright nails on the boy's darkened hands. This pair feel the cold, just as they must feel the jolting of their cart on the stony shore. Like other documentarists of his generation, Killip chose to keep clear of the gentility of the Home Counties and to concentrate on the north-east of England. Many of Killip's north-eastern photographs, including this one, appear in his book *In Flagrante* of 1988.

☞ Brandt, Economopoulos, Emerson, Howlett

243

Chris Killip. b Douglas (UK), 1946. **Rocker and Rosie Going Home**. 1982. Gelatin silver print.

Kinsey Darius

Man Lying in a Twelve-Foot Cedar

The twelve-foot cedar will shortly become a trophy taken from Nature by these proud sawyers. Kinsey's picture demonstrates how the work will be completed, by using platforms let into the trunk of the tree. Darius Kinsey became an itinerant photographer in the state of Washington during the early 1890s. In 1897 he established a studio in Sedro-Woolley, Washington, in collaboration with his wife, Tabitha, who managed the darkroom. In 1906 they moved to Seattle, and Kinsey began to specialize in the logging industries and in scenic views of the Northwest. Pictures of logging operations were sent back to the camps and sold to loggers for between 50 cents and $1.50 a picture. Kinsey continued to work in this way until 1940, when a fall from a tree stump ended his career. In 1971 the Kinsey archive passed into the hands of Californian photographers Dave Bohn and Rodolfo Petschek, and in 1975 they published a book entitled *Kinsey: Photographer*.

☞ Brigman, Steinert, Uelsmann, C. White

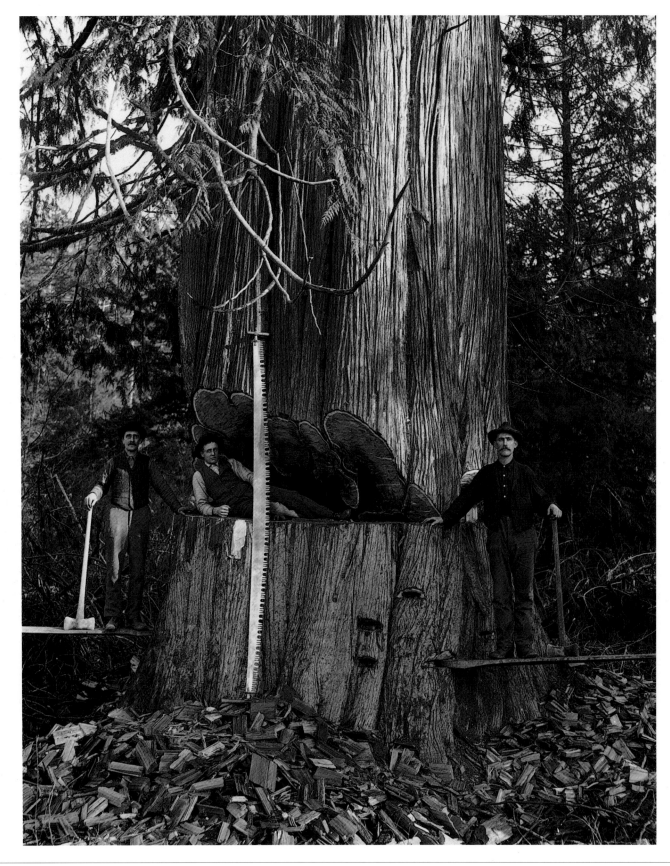

244

Darius Kinsey. b Maryville, MO (USA), 1869. **d** Seattle, WA (USA), 1945. **Man Lying in a Twelve-Foot Cedar**. 1906. Gelatin silver print.

Kirkland Douglas

Brigitte Nielsen, Hollywood

'She was pleasant and businesslike. We met in a parking lot, took her stretch limo into the Hollywood Hills, and under a Kodachrome blue sky she posed for what is essentially a little private spoof on the idea of glamour that she herself embodies.' In the age of Garbo glamour was innate, but by the 1980s it could be appreciated as a contrivance. Major stars, of the sort photographed by Kirkland from the 1960s onwards, acted out roles devised by and borrowed from great precursors. Kirkland's innovation was to take celebrity portraiture out of the studio and into the photojournalistic mode in which his subjects could improvise and extend their public identities. In the 1960s Brigitte Bardot, Marilyn Monroe and Elizabeth Taylor featured in his photo-essays. In the 1970s they were succeeded by Jessica Lange, Cher and Sophia Loren, and in the 1980s by Jessica Grey and Debra Winger. Kirland's career, with comments and memoirs, is surveyed in *Light Years* (1989).

☛ Hurrell, Knight, Pécsi, Southworth & Hawes

Douglas Kirkland. b Toronto (CAN), 1934. **Brigitte Nielsen, Hollywood**. 1986. C-type print.

Klein Astrid Night Matter I

The figure jumps or floats into what might be a void, across what looks like an embossed and engraved surface ready for printing. German artists in the 1980s were often obsessed by claustrophobia, as epitomized by the Berlin Wall but also implicit in the alienating architecture of the New Europe. The point about photograms, a form of printing that displays the negative, is that the certainties of 'normal' space are destroyed, and the readers are left to pick their way through airless shallow surfaces. In front of these large-scale photo-works you are no longer a privileged onlooker, but more of a passive searcher, negotiating by touch. In pictures in later series the interiors of rooms can often look like keyboards inviting exploration by hand, while other pictures include printed inscriptions, many of them half lost in shadow. One of these series is called *Verführung – Sklaverei* (Seduction – Slavery), even the title evoking the idea of a primitive state of entrapment.

☞ **Cartier-Bresson, Drtikol, Lartigue, Seidenstücker**

246

Astrid Klein. b Cologne (GER), 1951. **Night Matter I**. 1985. Gelatin silver print. **h**245 × **w**428 cm. **h**96½ × **w**168½ in.

Klein William

Dance in Brooklyn

They're dancing and hamming it up for the photographer, but she also looks like the Angel of the Annunciation half transubstantiated by blur. In three months Klein, who had scarcely photographed before, took the pictures which went to make up one of the most celebrated photo-books of the 1950s: *Life is Good and Good for You in New York: Trance Witness*

Revels. In 1981 he recalled that he had intended the book 'as a monster big-city *Daily Bugle* with its scandals and scoops that you'd find blowing in the streets at three in the morning'. In 1956 Klein had just returned from Paris, where he had been a student of the painter Fernand Léger, who had urged his students 'to get out of studios into the streets…to be

monumental'. Klein's is just such a monumental street art and has nothing to do with documentation as practised in the 1950s. In 1958 Klein turned from taking photographs to making films, creating a film called *Broadway by Light*.

☞ **Bevilacqua, Fink, Giacomelli, Hosoe, Siskind**

William Klein. b New York (USA), 1928. **Dance in Brooklyn**. 1954. Gelatin silver print.

Knight Nick

Susie Smoking

To judge from the cigarette smoke rising above, she must have held that awkward pose for a moment or two. This dramatic photograph, which is one of Nick Knight's best known, shows the model Susie Bick. It was taken for the fashion designer Yohji Yamamoto in 1986. In 1995 Nick Knight was judged by the *Face* magazine to be the 'most influential fashion photographer in the world'. The style which made him so is in general dramatic, involving heavy shadows and the sort of sublime space implicit in this background. His first book, completed whilst he was still a student, was *Skinheads* (1982), on the extremes of vernacular fashion. In early 1990 he was commissioning picture editor of *i-D* magazine, and in 1994 a retrospective of twelve years of his work was published by Schirmer Mosel, *NICKNIGHT*. He has been under contract to American *Vogue* and has worked for a wide range of international magazines including *Vanity Fair*, *The Face*, *Arena* and *Interview*.

☞ Kirkland, Southworth & Hawes, Wilding, Zecchin

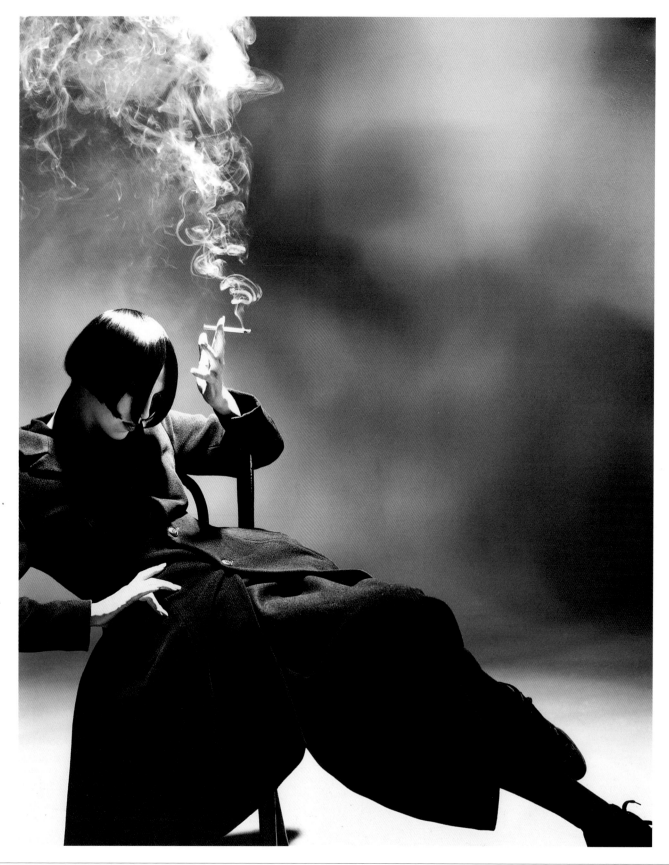

Nick Knight. b London (UK), 1958. Susie Smoking. 1988. C-type print.

Kollar François

A Dancer of the Monte Carlo Ballet

Standing backstage, this dancer of the Monte Carlo Ballet is practising her steps. We are shown a very workaday view of the ballet, reinforced by the roughly cut timber boards. The subject has been envisaged less as an entertainer than as a worker in dancing, which is a predictable angle for Kollar to take. In 1931 Kollar agreed to provide pictures for *La France travaille*

(France at Work), which became one of the great documentary projects of the 1930s. The enterprise, which took him into all walks of life and all over France, was completed in 1934 and established him as a major name in French photography. Like many other professional photographers in the 1930s, Kollar was active in publicity and fashion, and worked for *Harper's*

Bazaar from 1933 until 1949. Although French by adoption, he was born and brought up in Czechoslovakia, moving to Paris only in 1924. There he worked initially as a metalworker in the Renault car factories.

☞ C. Capa, Charbonnier, Koppitz, Morgan, Morimura

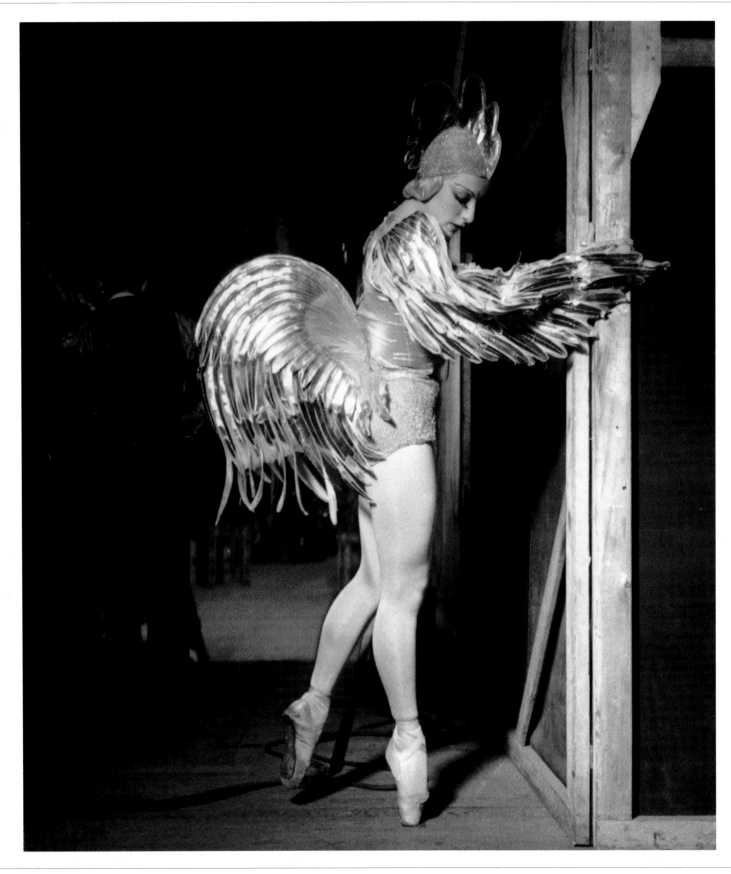

François Kollar. b Senec (CZ), 1904. **d** Creteil (FR), 1979. **A Dancer of the Monte Carlo Ballet**. c1937. Gelatin silver print.

Konttinen Sirrka-Liisa Girl on a 'Spacehopper'

A child wearing a sequined dress and mounted on a 'Spacehopper' is making the most of the streets of Byker, an ageing and shortly to be demolished working-class area in Newcastle in the north-east corner of England. Sparkling and tousled, the child rises above her surroundings. She looks or refers back to the animated style of the 1940s and 1950s when active children stood for Europe's future. In this case, however, in the 1970s, she stands rather for utopia lost, for the Byker community is about to be moved to apartment blocks elsewhere. Thus, although she may be jumping for joy, she does so in a deserted street. *Byker*, Konttinen's book of 1983, surveys the streets and houses of the doomed area along with their people, many of whom are interviewed to provide a text which turns the book into their story. Taken over an eleven-year period beginning in 1970, the Byker pictures are a defining example of community photography.

☞ **Bevilacqua, Brandt, Levitt, Mayne**

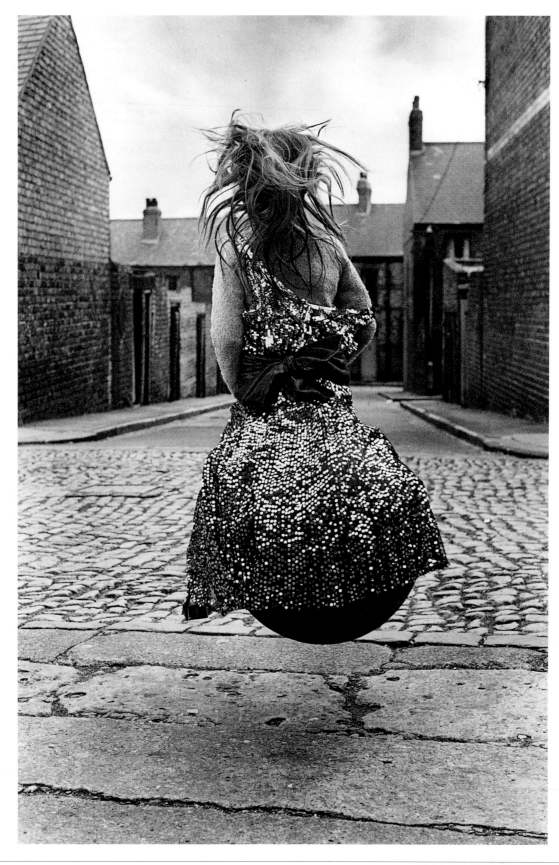

250

Sirrka-Liisa Konttinen. **b** Myllykoski (FIN), 1948. **Girl on a 'Spacehopper'**. 1971. Gelatin silver print.

Koppitz Rudolf

Movement Study

The dancer Claudia Issatschenko plays the central role in this very famous picture. Its meaning is obscure, for it was never explained by Koppitz, but the naked dancer may in some way represent death, or even a fatal moment – she gives the impression of having been struck down as she was advancing. Either that, or she is on the point of coming back to life. Her three attendants, too, seem to be rehearsing either a revival or a loss of consciousness. The implication of this, and of a number of other such groupings of naked and draped dancers undertaken in the mid-1920s, is that Koppitz's subject was the stirring of the spirit in relation to the physical body. Figures on the point of dying or reviving can even be understood as metaphors for the work of art in which material is invested with a spirit of its own. In the 1930s Koppitz turned increasingly to the documentation of country life and landscape in Austria.

☛ Bradshaw, Charbonnier, Kollar, Newton, Rheims

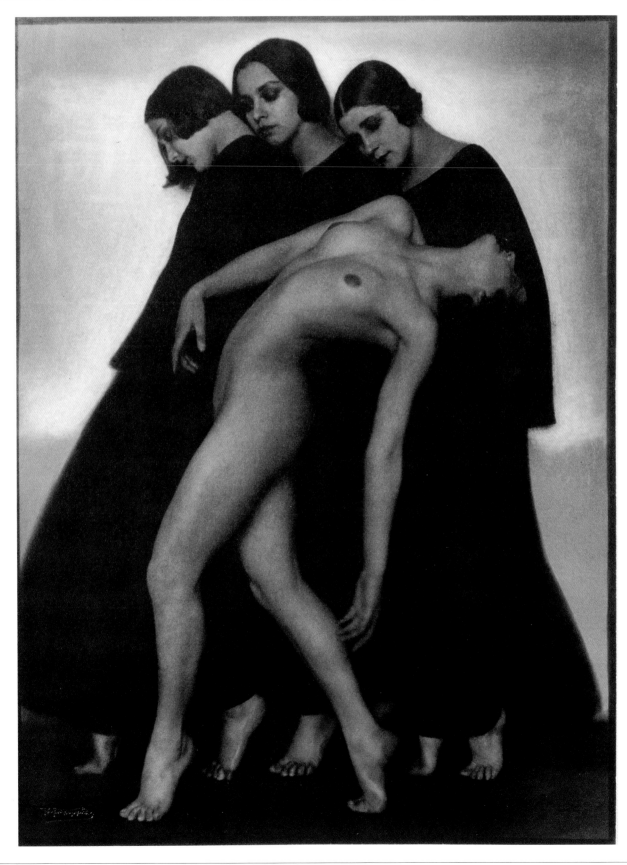

Rudolf Koppitz. b Schreiberseifen (POL), 1884. **d** Vienna (AUS), 1936. **Movement Study**. 1926. Carbon print.

Koudelka Josef

Jarabina

In this famous picture a handcuffed Gypsy is being led to a reconstruction of a murder. In the background a policeman prepares a camera to take a picture of the event, and a small crowd keeps its distance. In his pictures of Gypsy settlements taken in Eastern Slovakia between 1962 and 1968, Koudelka depicts a landscape which has deteriorated into mud and darkness and is almost at the end of the world. Radical poverty has caused the near-breakdown of any sense of community. Many of his subjects, both in Slovakia and later on in Spain, present themselves to the camera in poses seemingly half-remembered or poorly learned from another more formal culture now apparently vanished. He was one of the first photographers in Europe to tackle the notion of cultural breakdown, and his *Gypsies*, published in 1975, establishes a mood increasingly expressed in the documentary photography of the 1980s.

☛ **Bar-Am, Freed, Unknown, Weiner**

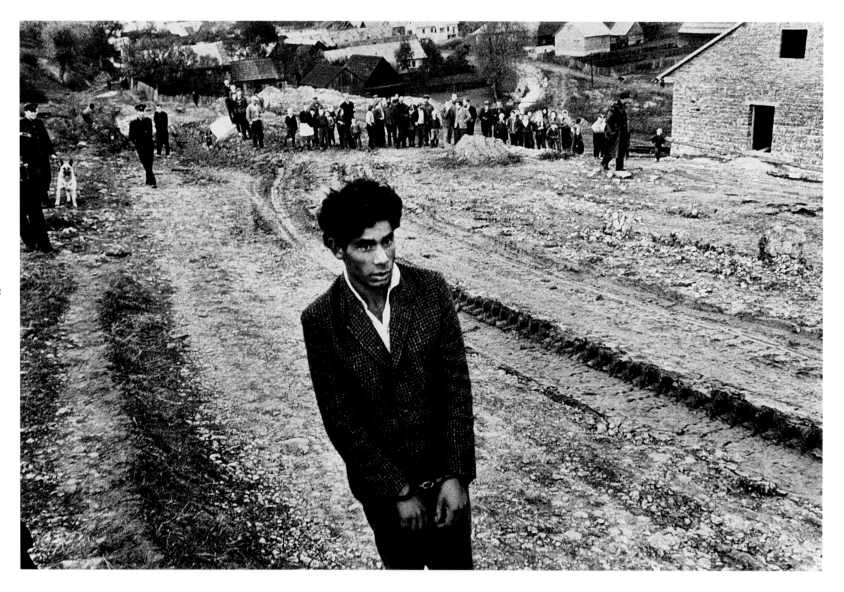

252

Josef Koudelka. b Boskovice (CZ), 1938. **Jarabina.** 1963. Gelatin silver print.

Krause George Fountainhead

A skein of water like a veil seems to shape the boy's head sculpturally, as if he were a figure on a fountain. He is, as it were, coming to life, emerging from the picture seeing and breathing. This image was commissioned for use on a bicentennial poster but was rejected on the grounds that it might be read as a death mask. Krause is a symbolist in photography, noticing motifs which have the power to intimate meanings far beyond themselves. His declared intention is 'to leave an after-image, something that you can't quite get out of your mind'. He graduated from the Philadelphia Museum School in the 1950s, and developed his style in the course of the 1960s through travel in the USA, Mexico, South America, Greece and Spain. Mortality has always been his subject, and many of his pictures show the suffering of sculpted martyrs and the distress of the survivors.

☛ Bayard, Hoepker, Lendvai-Dircksen, L. Miller, Nauman

George Krause. b Philadelphia, PA (USA), 1937. **Fountainhead**. 1970. Gelatin silver print.

Krims Les

Stilted

This picture, which has been assembled from several different images, centres on a vision of America as a carnival to be read and enjoyed. Taken from the series *The Decline of the Left*, it shows the hammer and sickle fading into the blue skies above and leaving the sidewalks free for a group of girls to have fun. Echoes of the past are still present, however, in the vintage images appearing at the corners. The woman on stilts in the top right is the photographer's mother and the star of several of his picture series from the 1970s and 1980s. Krims has always been an exuberant inventor in photography and impatient of the status quo. In 1971, for example, he published *The Little People of America*, a portfolio of twenty-four pictures of dwarfs, all of whom appeared happy and none of whom fitted into the kind of melancholic social landscapes then frequented by American documentarists.

☛ Abell, Johnston, Levitt

Les Krims. **b** New York (USA), 1943. **Stilted**. 1996. Iris print.

Krull Germaine

Pont Transbordeur, Marseille

The transporter bridge in Marseille excited photographers in the late 1920s because it allowed them to take aerial views of a working port, almost as if it were a board game. Germaine Krull's book *Marseille* was published in 1935, but her interest in industrial sites such as this can be traced back to her days working in Amsterdam in the early 1920s. In 1924 she moved to Paris, where she established herself as an all-round photographer. Her first book, *Metall*, took as its subject the structural uses of iron. Krull worked as a photo-reporter for the famous Parisian weekly *Vu* from its foundation in 1927, and soon developed a reputation for her pictures of depressed areas on the outskirts of Paris. In the early 1930s she made a pioneering study of unemployment blackspots in Britain, for *Weekly Illustrated*. Most of her ground-breaking reportage work from the early 1930s remains immured in press archives, and she has never received the credit which is her due.

☞ Abbott, Gerster, Munkacsi, Ruscha

Germaine Krull. **b** Wilda-Posen (POL), 1897. **d** Wetzlar (GER), 1983. **Pont Transbordeur, Marseille**. 1926. Gelatin silver print.

Kubota Hiroji

Turpan, China

This photograph was taken in Turpan, north-western China. Water there is scarce, and so wells have to be dug very deep – which accounts for the long rope with its attendant men and the donkey in the distance. Typically, Kubota makes it possible not merely to understand life in the desert but almost to re-enact that life by means of the kind of details which invoke labour and texture. The piece of winching apparatus, for instance, is depicted clearly enough to invite an examination of its structure. Why should the axle be of different thicknesses on either side of the pulley wheel? And what is it that the man is reaching for in the dust? Kubota's procedure in his documentary mode is to establish an overriding idea of the place itself and then to complement that idea by including the kind of items which we might handle in daily life. His comprehensive *China*, photographed during forty visits, was published in 1985.

☞ **Gursky, Hine, McCurry, Salgado**

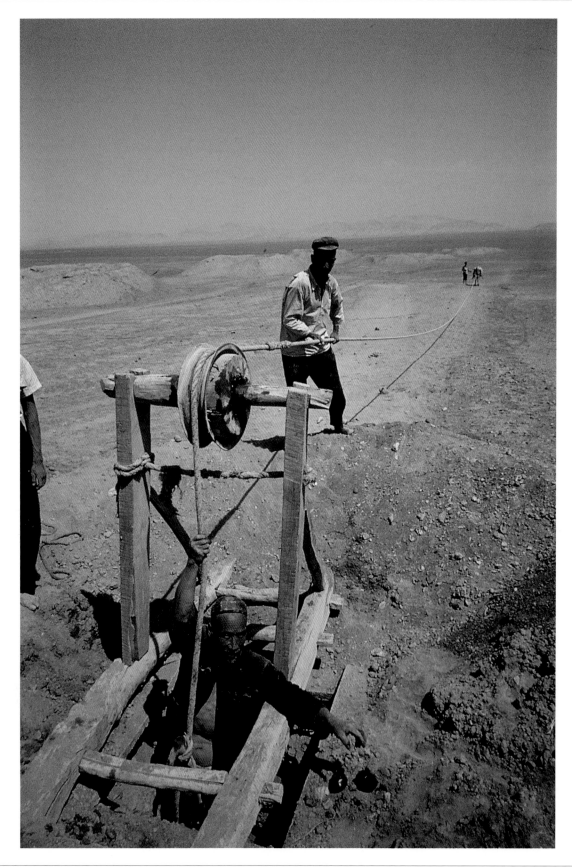

Hiroji Kubota. b Tokyo (JAP), 1939. **Turpan, China**. 1985. C-type print.

Kühn Heinrich

The Artist's Umbrella

Beneath the shade of a large umbrella, an artist is working – probably on a portrait of the two boys at the upper left of the photograph. A third boy is watching the work in progress. A member of the Vienna Camera Club, Kühn was one of Europe's leading specialists in gum bichromate printing. During the 1890s he made a name for himself as a landscapist, depicting woods and waters, for example, heavily invested with shadows. From 1894 onwards he worked in an organization called Kleeblatt (Cloverleaf) which broke up in 1903. Kühn's wife died in 1905, and he seems as a consequence to have turned towards the kind of private and domestic idioms for which he is now best known. His four young children became his preferred models, and this beach scene may include two of his sons. He took up the colour autochrome process when it first appeared in 1907. The influential American photographer Alfred Stieglitz published several of his pictures in *Camera Work*.

☛ Hopkins, Lartigue, R. Moore, Steele-Perkins, Stieglitz

Heinrich Kühn. b Dresden (GER), 1866. **d** Birgitz (GER), 1944. **The Artist's Umbrella**. 1908. Photogravure.

LaChapelle David

Body Building, Cape Canaveral, Florida

The perfectly formed bodybuilder is as faultlessly presentable as the spacecraft behind him. All the others, though, have a long way to go, and seem to have been asked to show their muscles in any way they could. LaChapelle's documentary studies are choreographed, but only up to a point, for he likes incidentals to enter in – such as the yawn on the right. A great fashion and advertising photographer, LaChapelle is interested in the everyday less because of anthropology than because it is inescapable and because 'good taste is the death of art' (Truman Capote). His formative years were spent as a busboy in Studio 54 in New York, and then working in the office of Andy Warhol's *Interview*. His idea is that his pictures are 'a small intermission, a break of beauty'. His first real progress as a photographer was made when *Details* magazine gave him licence to invent and to fantasize. Since then the magazines have allowed him 'to go completely crazy'.

☛ Keetman, Lengyel, Warhol, Yavno

258

David LaChapelle. b Hartford, CT (USA), 1963. **Body Building, Cape Canaveral, Florida**. 1993. C-type print.

Lange Dorothea

Migrant Mother, Nipomo, California

The subject was discovered by Lange at an iced-up pea-pickers' camp in the Nipomo Valley in California at the end of the photographer's extensive journey through southern California, New Mexico and Arizona. The woman, whose name Lange did not take, was thirty-two and living in a lean-to tent with her children. She had just sold the tyres from her car to buy food, and admitted that her family was living on frozen vegetables from the fields and on birds killed by the children. This is one of the most famous of all photographs. It belongs to a set of six taken in March 1936 which became well known almost immediately. Roy Stryker, who organized the documentary work of the Farm Security Administration, thought of it as the organizations's ultimate image. Here, as elsewhere, Lange shows herself to be a realist, holding to the idea that one understands and sympathizes with other people more through physical contact than through analysis.

☛ **S. L. Adams, Curtis, Lyon, Mydans, Owens, Seymour**

Dorothea Lange. b Hoboken, NJ (USA), 1895. **d** San Francisco, CA (USA), 1965. **Migrant Mother, Nipomo, California**. 1936. Gelatin silver print.

Lanting Frans

Macaws, Manu, Peru

A group of watchful macaws is eating clay on a river bank in the Peruvian rainforest. They are especially likely to do this in the late summer when food scarcities force them to eat seeds that are more bitter and toxic than usual. The clay, it seems, helps in detoxification. Macaws are unusually long-lived and astute and, like all bright and attractive things in nature, they live under constant threat from misguided human interests. Photography, of the kind practised to perfection by Lanting, both represents and realizes nature's objects in a way which answers to and deflects our need to possess. Thus, having once seen these wary birds eating their way through a drying river bank, it will be hard to imagine them as having an independent existence away from their habitat. Lanting's idea, as stated in *National Geographic*, where his work often appears, is: 'To turn wild creatures into ambassadors for whole ecosystems.'

☛ **Fontcuberta, Hosking, Mylayne, Roversi, Vilariño**

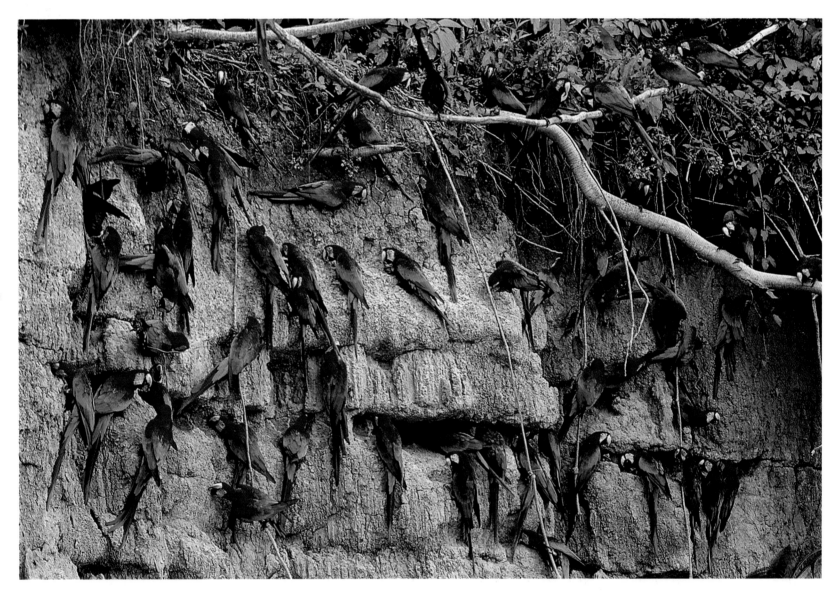

Frans Lanting. b Rotterdam (NL), 1951. **Macaws, Manu, Peru**. 1992. C-type print.

Larrain Sergio

Valparaiso, Chile

The two girls, one in shadow and one in sunlight, look similar enough to be the same person separated by an interval of a few seconds. Presumably the nearer figure in shadow is also walking into the picture space, although that has to be confirmed because she exists mainly in silhouette. The girl descending the staircase just comes into contact with the long diagonal shadow, almost as if the picture had been deliberately composed. It may be near midday in Santiago in 1954, but Larrain seems to have been less interested in the moment as unique than as somehow extended and reversible. He may have been prompted to make such pictures by the nature of Chilean cities which, with their staircases and passageways, look – in Larrain's art at least – vaguely Surrealistic. During the 1960s Larrain took photographs in Iran and the USA, but it is his late Surrealism of the 1950s that established him as one of the great poetic photographers.

☛ Kales, Käsebier, Ueda

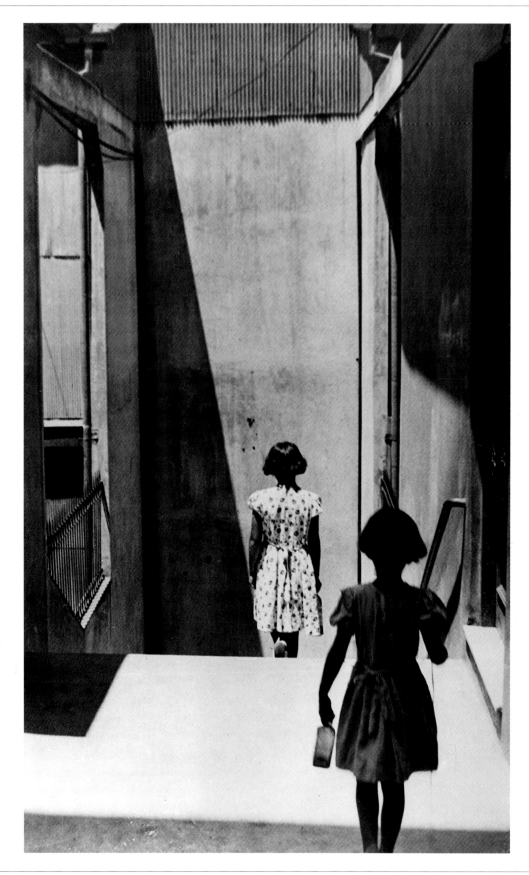

Sergio Larrain. b Santiago (CH), 1931. **Valparaiso, Chile**. 1957. Gelatin silver print.

Lartigue Jacques-Henri

Gerard Willemetz and Dani

The king of the castle is leaping for joy, or to impress a younger audience. Lartigue began to take photographs and to accumulate them in albums while still a child, and he continued to do so for the rest of his life. Like many others from privileged backgrounds he studied painting at the Académie Julian in Paris, but his true success came through photography, partly because he was working from within the society which was his subject, but also because of his unerring eye for small events: walking in the rain, boarding a car, saying farewell. He was particularly intrigued by the possibility of capturing frozen motion in a photograph, as he has done here. Lartigue's project as a photographic chronicler of society and cultural life may have been designed to recall that Belle Epoque which appeared to have been destroyed in 1914–18. His work was honoured with a large solo exhibition at New York's Museum of Modern Art in 1963.

☞ **Cartier-Bresson, Halsman, A. Klein, Kühn, Seidenstücker**

Jacques-Henri Lartigue. b Courbevoie (FR), 1894. **d** Nice (FR), 1986. **Gerard Willemetz and Dani**. 1926. Gelatin silver print.

Laughlin Clarence John Elegy for the Old South, Number Six

The Woodlawn Plantation, in the Lafourche country of Louisiana, was a splendid house, the only plantation house in Louisiana with Ionic capitals carved from stone. In 1946 it was demolished, and remains strewn about the site. Laughlin remarked of this double exposure that the pattern on the necking of the capitals repeated the anthemion motif found on the Erectheum in Athens. Laughlin looked at the old plantation houses with 'sorrow and recollection' and tried through his photographs and writings to keep their memory alive. This picture appeared in his principal book *Ghosts Along The Mississippi* (1948). Laughlin developed his eccentric photography in New Orleans during the 1930s when working for the US Engineers. In 1939 he began a series of staged pictures called 'The Burning Cities of Our Time'. He saw himself in the 1940s as introducing 'The Third World of Photography: Poetic, Surrealist and Transcendental'. *New Orleans: A Vanishing Magic*, came out in 1983.

☛ Hajek-Halke, Johnston, Tripe

Clarence John Laughlin. b Lake Charles, LA (USA), 1905. d New Orleans, LA (USA), 1985. **Elegy for the Old South, Number Six**. 1946. Photoprint.

Lee Russell

Migrant Child Returning Home from Fields, Prague, Oklahoma

Together, the sidelong glance of the child worker and the punctured glass act as disturbing elements in what might otherwise appear to be a picture of an idealized pastoral America. This is among the most poetic of all the pictures taken for the American Farm Security Administration in the late 1930s. Russell Lee, during the period 1936–42 when he worked for the FSA, composed with great deliberation, preferring to use only a few significant items in pictures which were conceived almost as tableaux. The purpose of the FSA project was to document and to uncover shortcomings in the society of that time, and child labour was one of the abuses remarked on by the photographers. Lee's tendency was to overpower the ordinary, to show it radically disrupted. The returning child and her landscape might have been transported into the world of gangsters, for instance. Elsewhere, notably, he once found a church organ washed up in a flooded field.

☛ **diCorcia, Lange, Mark, Parks, Singh, Sommer**

264

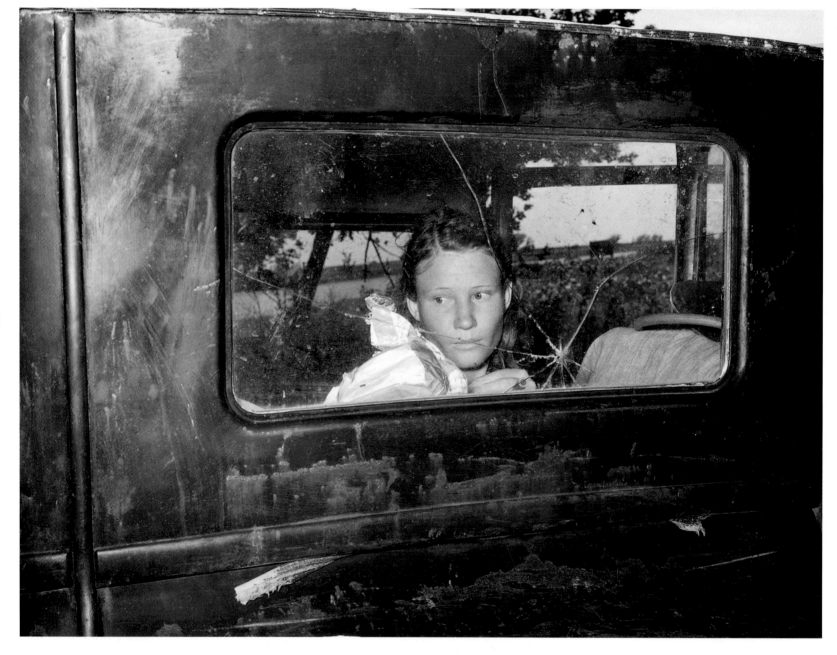

Russell Lee. b Ottawa, IL (USA), 1903. d Austin, TX (USA), 1986. **Migrant Child Returning Home from Fields, Prague, Oklahoma**. 1939. Gelatin silver print.

Le Gray Gustave

Sea and Sky

The vast expanse of the ocean is enhanced by the apocalyptic light of the sun breaking through the clouds. Le Gray solved the problem of photographing the sky by taking it on a different negative, exposed more briefly, and then printing from two negatives. Thus he was able to make pictures in which there appeared to be a relationship between earth and sky, rather than just two separate elements. Originally a painter, Le Gray opened a photography studio in Paris in 1848 and was among the first to claim that photographs should be thought of as artworks in themselves, and that they could have an intrinsic value. The first great teacher in the history of the medium, his students included Charles Nègre, Henri Le Secq and Maxime Du Camp. His interest in experimentation and high technical standards jeopardized his business, however, and in 1859 he left Paris for Sicily, Malta and eventually Cairo, where he ended his career as a teacher of drawing.

☛ Du Camp, Cooper, Le Secq, Mortimer, Nègre, Oorthuys, Silvy

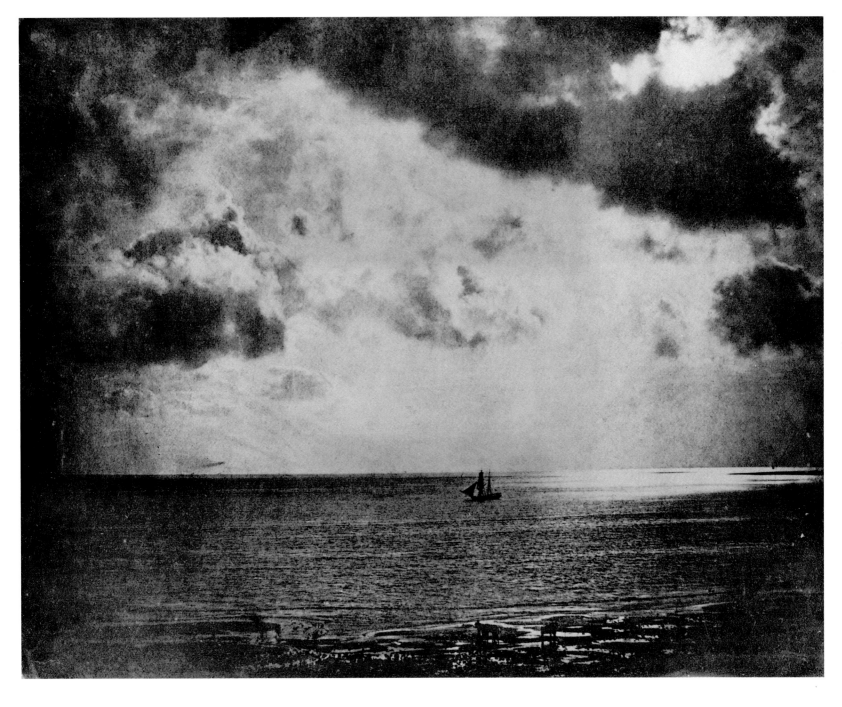

Gustave Le Gray. b Paris (FR), 1820. d Cairo (EG), 1882. **Sea and Sky.** 1856. Albumen print.

Leibovitz Annie

Keith Haring, New York City

The American painter Keith Haring poses as a camouflaged or naturalized element in one of his own painted environments. In the 1950s Picasso, Giacometti and their contemporaries would have been shown autonomously, apart from their creations. Their successors, though, often prefer to present themselves as part of the show – either because they consider their privacy to be off-limits, or as an admission that there can be no such thing as privacy in a culture of high publicity. Celebrity has always been Annie Leibovitz's subject. At first, when she began to take portraits of rock and pop music stars for *Rolling Stone* magazine in San Francisco in 1970 portraits still showed the subject as a personality. As the 1980s unwound, however, personality and celebrity drew further apart; and this process can be followed to perfection in Annie Leibovitz's art, published in two major collections in 1983 and 1991. She now works principally for *Vanity Fair*.

☞ Halsman, Hoppé, Mili

266

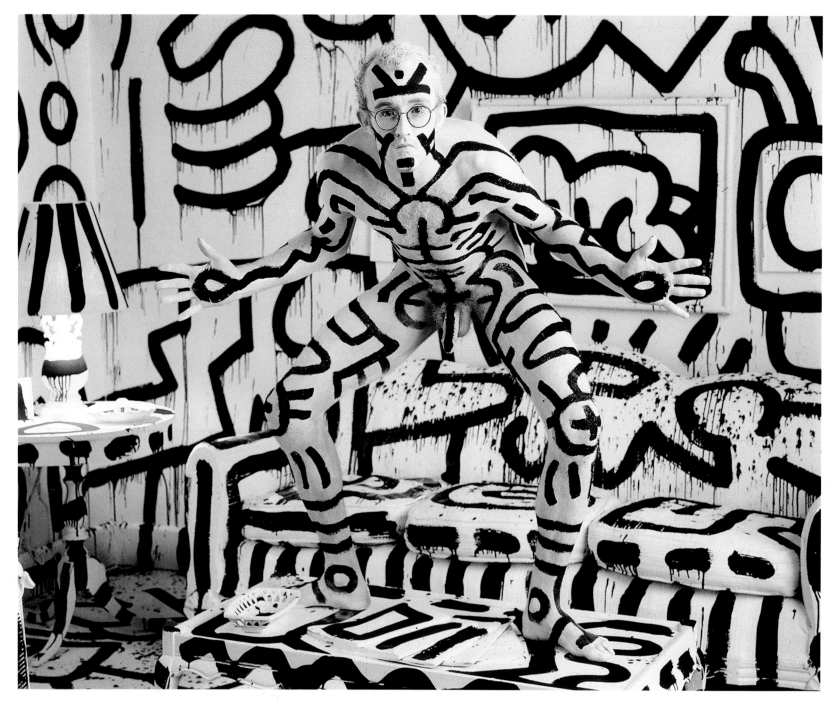

Annie Leibovitz. b Waterbury, CT (USA), 1949. **Keith Haring, New York City**. 1986. C-type print.

Lele Ouka

Lemons

This picture, with its surplus of lemons, is an allegory of taste. Ouka Lele takes black-and-white photographs and then hand-colours them, giving them vivid, saturated or unnatural backgrounds. The end results look like advertising images which have developed strenuous lives of their own, at the expense of some innocuous commercial subject – soft drinks, in this case.

This particular portrait belongs to the series *Peluqueria* through which Ouka Lele established her reputation in 1980 at the Galeria Redor in Madrid. *Peluqueria* is a series of portraits of people oddly coiffed with, for example, model aircraft, books, irons (domestic), with reference to the elaborated portrait styles of the eighteenth century. In the 1980s the scale of Lele's

pictures increased to include hand-coloured formal portraits in extended domestic settings across the social range: from palaces to backyards. Many of these later portraits are commissioned by their subjects, who are designers and artists.

☛ **Beaton, Iturbide, Lerski, Muray, Ruff**

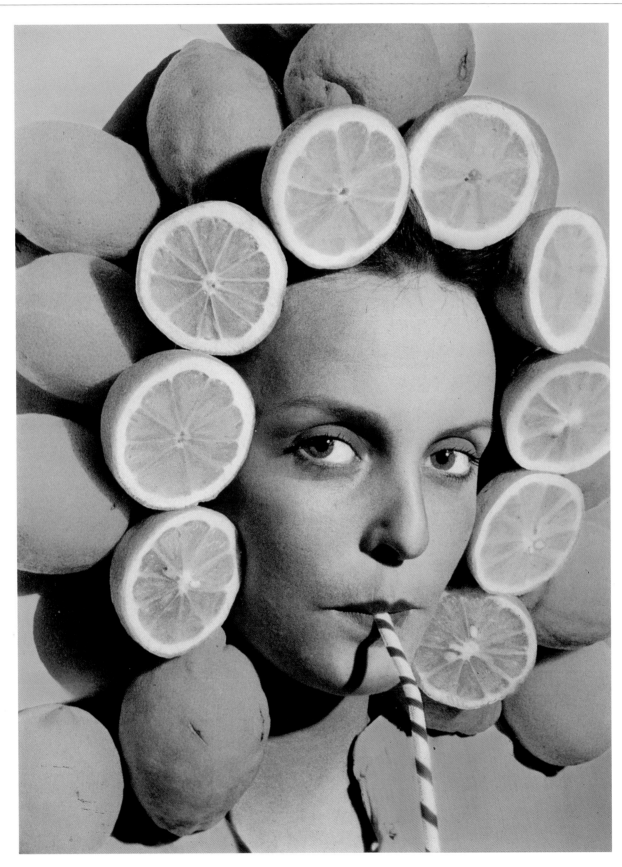

267

Ouka Lele (Barbara Allende). b Madrid (SP), 1957. **Lemons.** 1979. Painted gelatin silver print.

Lendvai-Dircksen Erna Head of a Child

He is a particular type of German child, although at such close range the picture becomes a portrayal of emotion rather than character – and a very affecting one, too. When the new German photographers of the 1920s made portraits, they liked to think of the face as an assemblage of parts which had nothing much to do with the human spirit. During the 1930s, however, Lendvai-Dircksen reversed this emphasis, giving priority to the soul, or to whatever feeling might be expressed in a gaze like this. Yet it is not so much the child's spirit which looks out here as the spirit of a people. Lendvai-Dircksen was one of the most successful photographers of the 1930s in Germany, where her soulful, national bias was in tune with the ideology of the National Socialist government. In 1932 the first of the seven volumes of her survey of the German people entitled *Das Deutsche Volksgesicht* (Face of the German People) appeared.

☛ Arbus, Hubmann, Krause, Ohara, Ruff

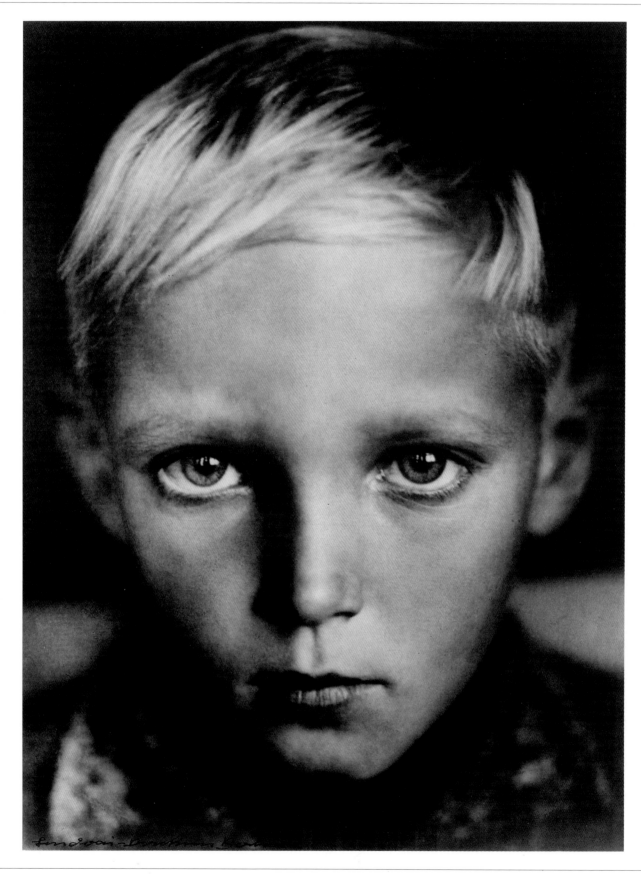

Erna Lendvai-Dircksen. b Wetterburg (GER), 1883. d Coburg (GER), 1962. **Head of a Child**. 1938. Bromide print.

Lengyel Lajos

Pebble Throwers

To judge from the braces which hold up his trousers, the younger boy comes from a prudent home. The gawkier figure, though, poses like a sportsman attentive to the outcome of his action. On the face of it there is nothing exceptional about a couple of boys skimming pebbles on the edge of a shallow lake, but in 1934 in Europe almost any event had ideological potential: grown men carrying coal, for instance, would be seen as standing for the urban proletariat, just as peasants in traditional dress would represent the spirit of the nation. Children such as these stood, by and large, for the future considered in utopian terms, as free from all those inherited cultural constraints which disfigured the present. Lengyel was what the Hungarians call a socio-photographer. Brought up in the south Hungarian town of Makó, he had been a locksmith and then a printer before taking up photography in the 1930s.

☛ **Arbus, Kühn, LaChapelle, Levitt, Schuh**

Lajos Lengyel. **b** Makó (HUN), 1904. **d** Budapest (HUN), 1978. **Pebble Throwers**. 1934. Gelatin silver print.

Le Querrec Guy

Big Foot Memorial Ride

It is the eleventh day of a commemorative journey undertaken by a group of Sioux to the site of the Battle of Wounded Knee. Here the riders are crossing Big Foot Pass into the Badlands of South Dakota. It looks very much like a scene from an epic Western, and the invitation is to follow the riders as they cross the horizon and bunch together on the lower slopes. There is nothing much to be learned about the Sioux or the landscape from this picture, but the stream of riders does pace itself variably and sometimes in relation to the ground. The musicality of this image is typical of Le Querrec's photography in which the sun's rays, for example, across the murky light of a café might just as well be read as a cry or trumpet call. Known for his photographs of jazz musicians, Le Querrec took his first such picture in 1962 and became a full-time professional photographer in 1968.

☛ Alpert, Caponigro, Liebling, Muybridge, Prince

270

Guy Le Querrec. b Paris (FR), 1941. **Big Foot Memorial Ride.** 1990. Gelatin silver print.

Lerski Helmar

The Couturière

Lerski has achieved the dramatic effect in this close-up portrait of a dressmaker by placing the source of light behind the subject's head and then using mirrors to create certain emphases. The subjects for his famous *Köpfe des Alltags* (Everyday Faces) of 1931 were beggars, street sweepers, hawkers, washerwomen and servants recruited from employment exchanges in Germany during the economic depression. A Svengali among portraitists, Lerski was fascinated by photography's power to transform routine appearance into something exceptional. Although he intended only to make objective character studies, his photographs looked to contemporaries like a throw-back to the demonic days of German film-making in the mid-1920s. Lerski's aesthetic sprang from his early days as an actor in the American theatre. In 1911 he turned to theatre photography and then worked as a film cameraman in Berlin for fourteen years.

☞ Harcourt, Henri, Lele, McDean, Rodchenko, Umbo

Helmar Lerski. **b** Strasbourg (FR), 1871. **d** Zurich (SW), 1956. **The Couturière**. 1929. Gelatin silver print.

Le Secq Henri

The Public Baths, Paris

The man in the pool seems to be deliberately standing still at the bottom of the steps – for any movement would have resulted in an unsightly blur, so extended were exposure times in the early 1850s. The other three figures might have been asked to represent further stages in the process of bathing, or maybe they were there to register how the light would fall on white towelling and shadowed skin. Early photographic processes had such limitations that artists became acutely conscious of motifs such as staircases and ladders which would allow them to calibrate space. In fact a veritable aesthetic grew up around these shortcomings, with Le Secq as its virtuoso and with this photograph as one of its masterworks. Trained as a painter in the studio of Paul Delaroche in Paris in the early 1840s, with Roger Fenton as one of his fellow students. Le Secq was introduced to photography by Gustave Le Gray, who was another Delaroche student.

☛ Escher, Fenton, Keetman, Le Gray

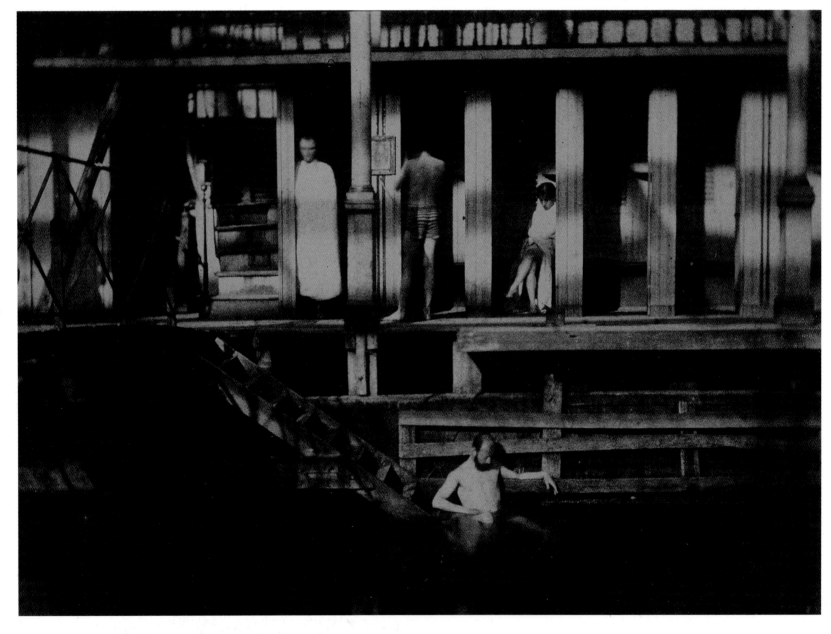

272

Henri Le Secq. b Paris (FR), 1818. d Paris (FR), 1882. **The Public Baths, Paris**. 1853. Salted-paper print.

Lessing Erich

Dwight Eisenhower

Dwight Eisenhower, the American President, is arriving for a summit at Geneva in 1955. Caught by the light, he raises his hat in acknowledgement of the crowds, who are there by implication in Lessing's picture. However, the scene is driven less by Eisenhower than by the Swiss President Max Petitpierre, who is just behind him and who might even be seen as the dark side of the President's nature. The lit and shadowed faces in line, the raised and lowered hats, the smile and the frown: photographers lived in hope of capturing such moments. Lessing, brought up in Vienna in the 1930s and in Israel during the war, was conscious – as few other reporters were – of the discrepancies in politics between image and actuality, between the public face of the President, for instance, and the more serious business of the summit. Despite success in reportage in the 1950s, he began to concentrate on cultural and historical photography around 1960.

☛ **Aigner, Bosshard, Karsh, Reed, Salomon**

Erich Lessing b Vienna (AUS), 1923. **Dwight Eisenhower**. 1955. Gelatin silver print.

Levinthal David Untitled

This picture of a fierce fight between a cowboy and an Indian is taken from Levinthal's Wild West series, begun in 1986. The other tableaux in the series feature gunfighters, cowhands, pioneer matrons and Red Indian warriors – figures from Hollywood's epic of the West. The pictures were taken on a Polaroid 20 x 24-inch Land camera, one of five built in 1977–8.

Levinthal's aesthetic strategy is to generalize his images so that the audience is forced to reflect on the idea: heroism, struggle, action, catastrophe. In the preface to his book *The Wild West* (1993) he explains the difficulties of making a properly iconic image from appropriate toys and models, and a minimum of lighting and background. His first success, produced in

collaboration with the cartoonist Garry Trudeau, was *Hitler Moves East: A Graphic Chronicle, 1941–43*, published in 1977. More recent books include *American Beauties* (1990), in which he explores the 1950s, and *Desire* (1991).

☛ Eakins, Hoff, Simmons, Skoglund

274

David Levinthal. b San Francisco, CA (USA), 1949. **Untitled**. 1988. Polaroid.

Levitt Helen

New York

The mirror has been broken, and two of the more responsible members of the group are picking up the pieces. Others look on, just as their elders would do at the scene of a crime. Meanwhile the rest of the world (including an oddly entranced figure in white in the middle distance) goes about its business. This is the fourteenth in a set of sixty-eight street pictures which was published in 1981 as *A Way of Seeing*, one of photography's most impressive sequences. Its theme is society in formation, moving from infancy into adolescence. All Levitt's sympathies lie with the creative exuberance of children experiencing the world for the first time, mainly on the streets of East Harlem in New York. Levitt became interested in photography in the late 1930s after seeing pictures by Henri Cartier-Bresson and Walker Evans. In 1943 she had her first show at the Museum of Modern Art in New York. In the late 1940s she turned to documentary film-making, and then to colour photography in 1959–60.

☛ Cartier-Bresson, Doisneau, W. Evans, Genthe, Lengyel, Winogrand

275

Helen Levitt. b New York (USA), 1913. **New York**. c1945. Gelatin silver print.

Lévy & Sons

The Accident at the Gare Montparnasse

This dramatic scene looks like a failed re-enactment of a railway tableau by the painter Giorgio de Chirico, right down to the station clock registering business as usual above. The event was newsworthy at the time and retained its cachet into the Surrealist period, when it exemplified real life gone terribly wrong. Being able to capture it on film was something of a coup since the early reportage photographers were usually dependent on predictable events with curiosity value, such as the departure of airships and hot air balloons. French photographers and collectors were always very appreciative of photographic curiosities and their representation of a subversive or alternative national history, carried out as a charade by enthusiastic amateur players. This very famous photograph is part of the collection of Lévy & Sons, a photographic studio which became part of the Agence Roger Viollet in 1970.

☛ Dyviniak, Link, Vink

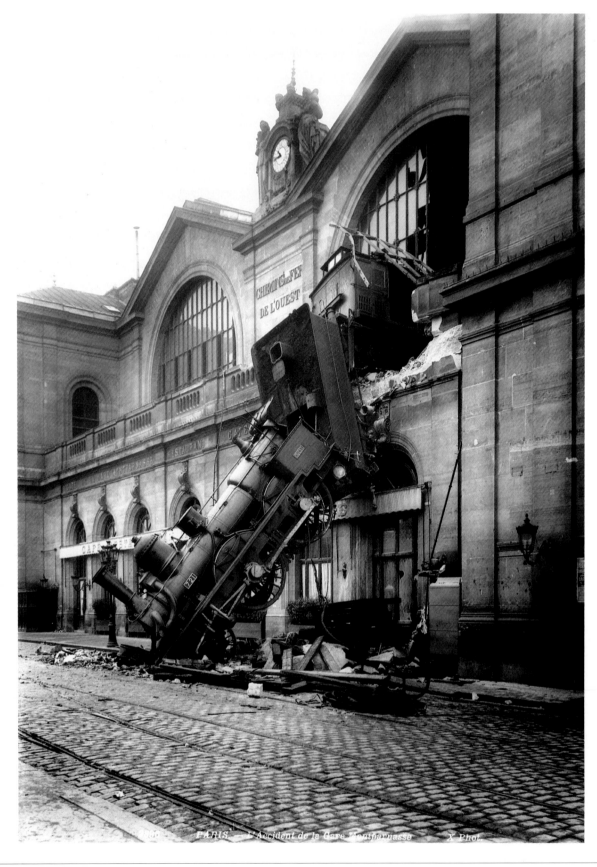

PARIS — L'Accident de la Gare Montparnasse X Phot.

Lévy & Sons. Active 1890s. **The Accident at the Gare Montparnasse.** 1897. Albumen print.

Lichfield Patrick

The Royal Wedding

The Prince and the Princess met, fell in love and married. Like any other newly married couple, they had to pose for the camera. The intention was to dwell on that moment of affection, hence the movement of the picture across the spreading folds of her dress towards their approaching profiles. One awkwardness, registered in passing, was that the dress which epitomized the fairy tale also served as a hindrance to their coming together. A fraction further forward and his foot will be off the ground. The slight awkwardness on show is a mark both of innocence and of the difficulty of maintaining the idyll or its appearance. Official and royal portraiture as it existed in the 1930s and 1940s was seamless and iconic. By 1981, though, Western culture was far more appreciative of events in the making and of the hazards involved in putting on a show, rather than of the show itself. The Earl of Lichfield was the official photographer for the royal wedding. His books include *The Most Beautiful Women* (1981).

☛ Brassaï, Eisenstaedt, Goldin, Saudek, Staub

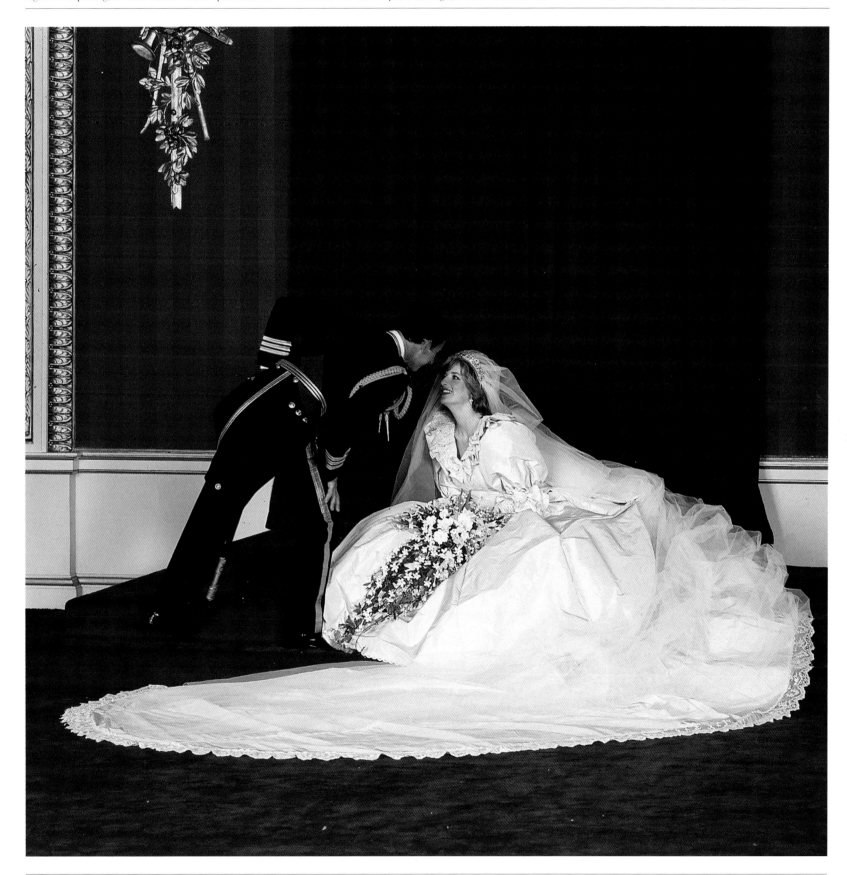

Patrick Lichfield. b London (UK), 1939. **The Royal Wedding.** 1981. C-type print.

Liebling Jerome

Browning, Montana

The American West is not supposed to look as practical and down-to-earth as this. Even the dogs are aware of their best interests and shelter from the sun in the shadow cast by the horse. Grey horses, too, notoriously suffer from sunburn, which explains that fringed muzzle. Liebling, who took up photography in the late 1940s, has always chosen to remark on the kind of realities itemized here, and on the gap between rhetoric and actuality – between the practicalities of cow-herding, for example, and Hollywood's vision of Montana. In 1947 Liebling became an executive officer in the Photo League, a reformist organization dedicated to social documentary. He went on to study film-making at the New School of Social Research in New York, and has devoted much of his working life to teaching. He was a founding member of the Society of Photographic Education.

☛ Allard, Le Querrec, Muybridge, Prince, E. Smith

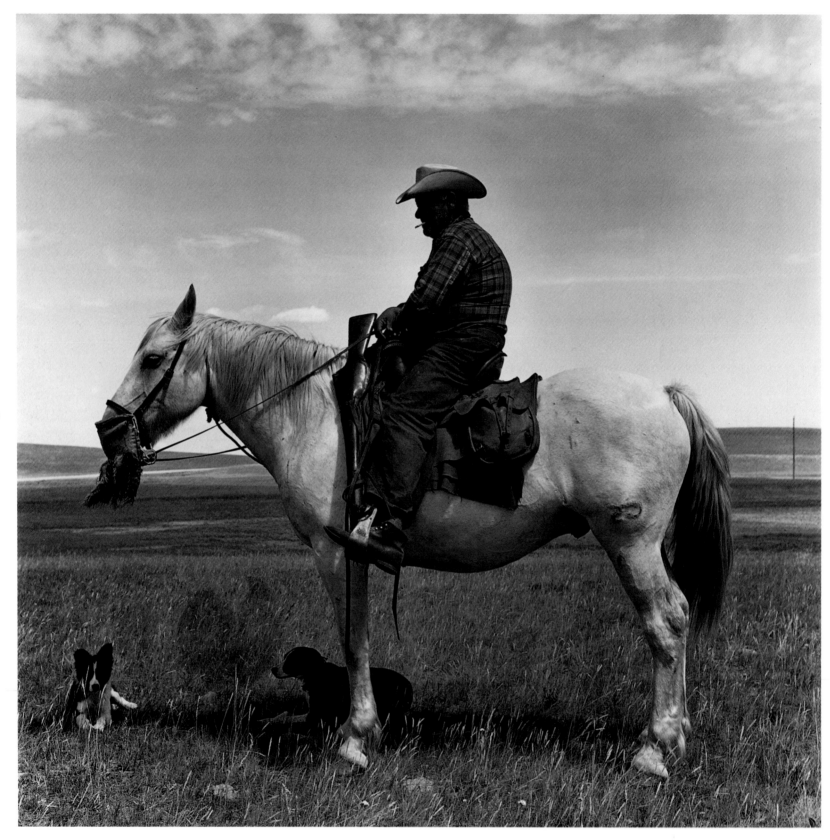

278

Jerome Liebling. b New York (USA), 1924. **Browning, Montana**. 1962. Gelatin silver print.

Link Winston O.

Hot Shot Eastbound, Iaeger, West Virginia

A steam locomotive from the Norfolk and Western Railway is moving past a drive-in movie site at which the audience is watching a USAF Sabre airplane. The lovers in the foreground seem secure in each other's company, and pay no heed to the iron monster sweeping across the embankment. That familiar relationship between humanity and the locomotive is typical of Link's art, much of which is devoted to portraying the last days of steam trains on this line and the people whose lives they enter. Link was a railway enthusiast devoted to the age of steam. He began the documentation in 1955, and took around 2,200 images, completing most of them by 1957. They were mostly, as in this instance, elaborately staged, often using as many as fifteen flash units for one exposure. Link was originally a civil engineer, and from 1946 he worked in New York as an industrial and commercial photographer.

☛ Abell, Baldus, Johns, Lévy & Sons, Sugimoto, VanDerZee

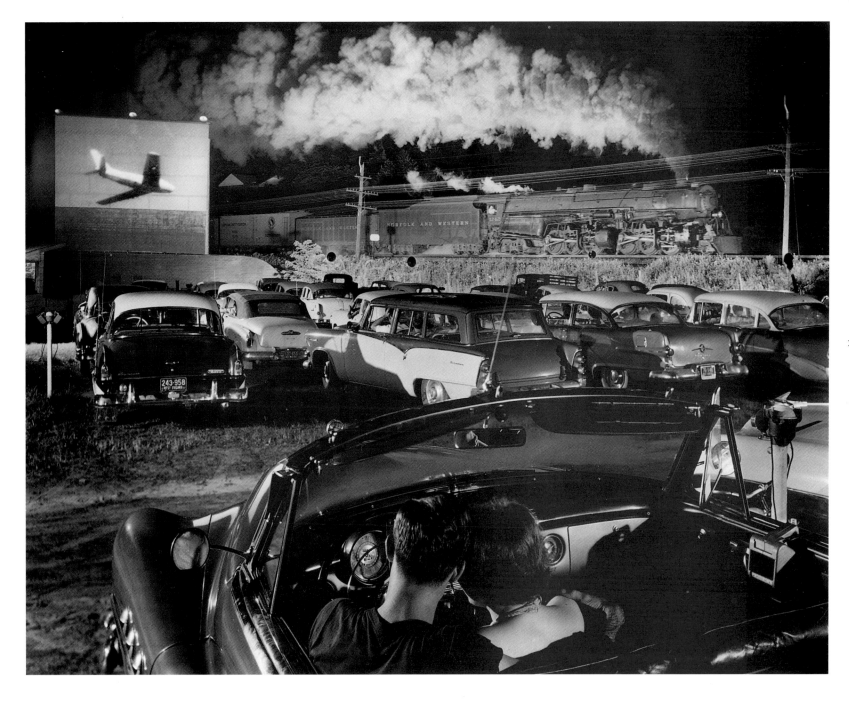

279

Winston O. Link. b Brooklyn, NY (USA), 1914. **Hot Shot Eastbound, Iaeger, West Virginia**, 1956. Gelatin silver print.

Lissitzky El

The Constructor

The artist – who was also a designer and an architect – is looking out from the shadows. A creative hand holding compasses is drawing a circle which doubles as a halo and symbolizes the designer's god-like potential in the Soviet Union at that time. El Lissitzky, who was a Russian cultural representative in the West during the winter of 1921–2, may have learned of photomontage from the Berlin Dadaists, who had developed the technique in 1918. It was a useful medium for a designer such as El Lissitzky who was called on at short notice to imagine the furnishings of the new society then being devised. During the 1920s he designed Russian exhibitions abroad. One of his most significant projects was the frieze of assembled newspaper clippings and photographs for the Soviet Pavilion at Cologne in 1928. A leading promoter of the Soviet Union, he became art editor of the propaganda monthly *USSR in Construction* in 1932.

☞ **Nauman, Rainer, Warhol, Witkiewcz**

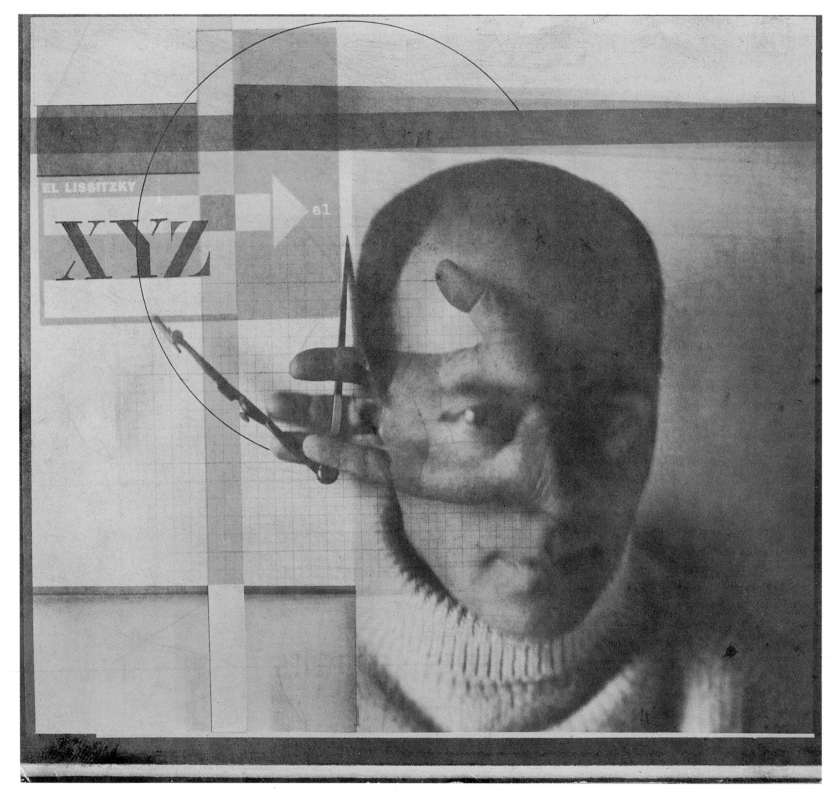

El Lissitzky (Lazar Markovich Lisitsky). **b** Polschlinok (RUS), 1890. **d** Moscow (RUS), 1941. **The Constructor**. 1924. Gelatin silver print.

List Herbert

Goldfish Glass

A goldfish is swimming in a glass bowl. In the background the sun is setting across the sea. The setting is the Greek island of Santorini. According to List, the fish in the bowl symbolizes the human spirit trapped within the material world. It cannot escape from that setting into whatever lies beyond, which is represented here by light playing on the distant water. This very famous picture expresses the new romantic spirit abroad in European art in the mid-1930s. It was a spirit marked by melancholy and acutely conscious of human vulnerability and isolation. List began his working life as a specialist importer and taster in the family coffee business in Hamburg. He was a member of a bohemian society called Children of the Sun and interested in the theatre. A Jew, List had to leave Germany for London in 1936 and from there he moved to Paris, where he made his living as a fashion photographer for *Vogue* and for *Harper's Bazaar*.

☛ Doubilet, van Elk, Mahr, Tomatsu

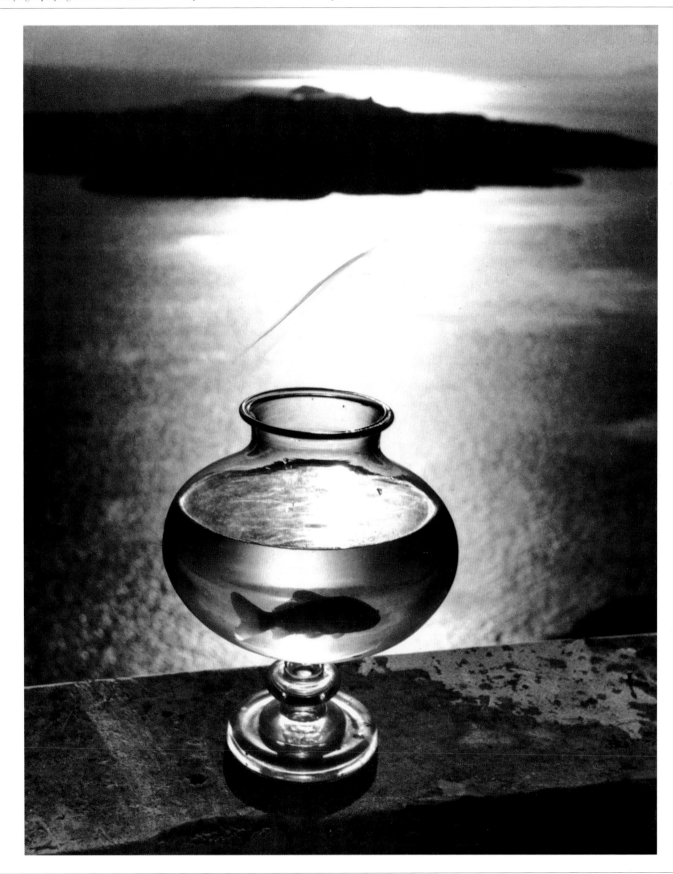

Herbert List. b Hamburg (GER), 1903. d Munich (GER), 1975. **Goldfish Glass**. 1937. Gelatin silver print.

Longo Robert

Untitled

He is performing for the artist's camera on a studio rooftop in New York. Later the picture was projected and drawn on a large scale for incorporation into Longo's series of 1981–87 entitled *Men in the Cities*. Is the intention to give the impression that the man has been shot or hanged, or caught in the grip of some impersonal force such as an electro-magnetic field? Whatever the cause, Longo's figures suffer disruption and pain. In particular, he shows them cut off from reality and their surroundings and often taking leave of their senses. Reportage photographers have always been attentive to such vivid gestures, but have usually tried to contain them within a recognizable social setting. Longo, by contrast, likes to think of them as signs without interpretation – and thus as a torment to audiences looking for a message. Longo said that he took his cue from a gestural style current in the movies and music of the early 1980s.

☞ Halsman, Meyerowitz, Parkinson

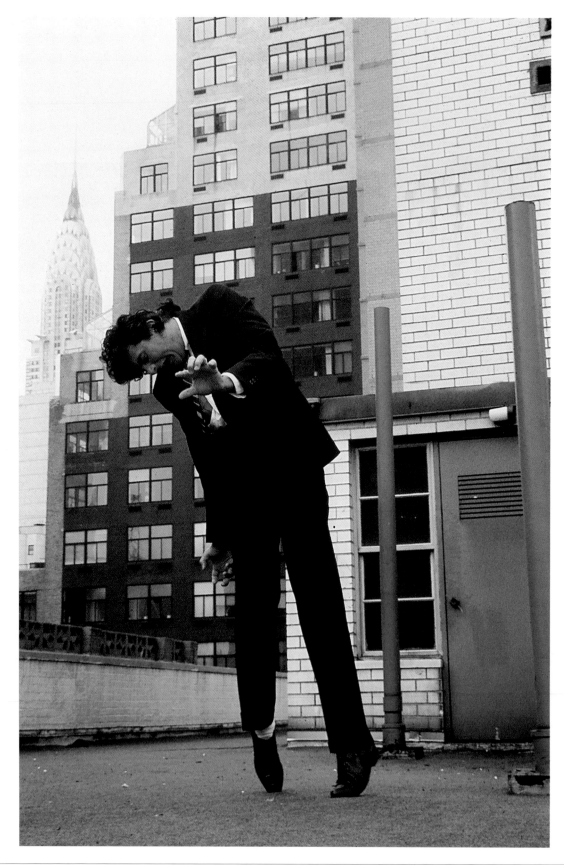

282

Robert Longo. b New York (USA), 1953. **Untitled**. c1984. C-type print.

Luskačová Markéta Sleeping Pilgrim

Levoča, where the man lies asleep, is a centre of pilgrimage in Slovakia. Its main festival is on 4 July, followed by a summer season of minor events, many of which were recorded by Luskačová in a series of visits between 1967 and 1974. This picture seems to want to register the here-and-now, established by means of a number of evocative details. The pilgrim's buttoned jacket, for example, and the string over his shoulder refer us to our sense of touch, as does the placing of his hands. Luskačová's tactic in *Pilgrims*, her book of 1983 in which this picture appears, was to invoke the weight of the earthly condition to such a degree that thinking on the spiritual became unavoidable. Born and educated in Prague, Luskačová specialized in Slovakian religious topics in the late 1960s before travelling in Ireland and then settling in London in 1975. Her first British exhibition was of beach scenes in the north-east of England in 1978.

☛ Bayard, Hurn, Jokela, Kaila, Kalvar, Robinson

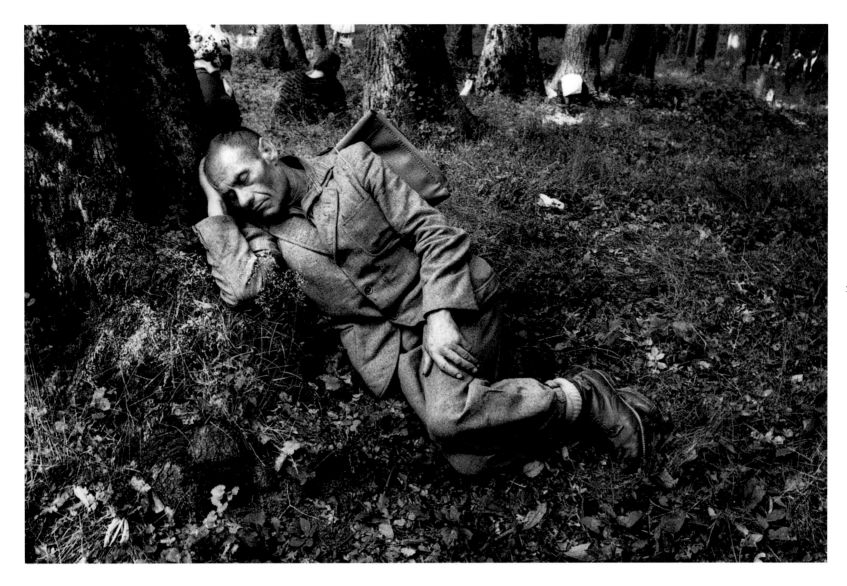

283

Markéta Luskačová. b Prague (CZ), 1944. **Sleeping Pilgrim**. 1968. Bromide print.

Lyon Danny

Mother with her Child, San Cristóbal de las Casas, Chiapas, Mexico

The younger child knows no better than to respond to the camera. The elder boy and the mother have less time for distractions. This picture presents a mother and child group but with a working rather than a suffering, iconic mother: it even looks as though it might have been taken as a family record. Lyon's implication is that ordinary life goes on, even in an area wracked by civil conflict, as the Chiapas region has been since 1994. Since at least the early 1980s Lyon's photography has been family-conscious and comparatively informal – truer to actualities than the heroic documentary manner prevalent in the USA in the 1960s. *The Paper Negative* (1980), set in New Mexico, relates a family story in words and pictures. Lyon's pictures first appeared in *The Movement* (1964), a documentary of the Southern civil rights movement. *The Bikeriders* was published in 1967 and *Conversations with the Dead*, a report on life in a Texan prison, in 1971.

☛ Curtis, Davidson, Lange, Mydans, Seymour, Stoddart

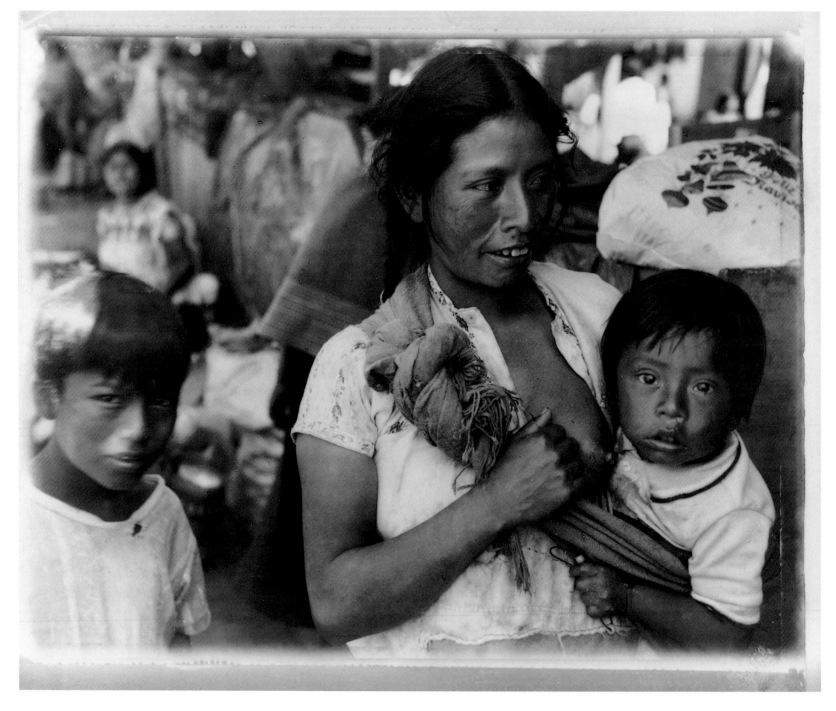

284

Danny Lyon. b Brooklyn, NY (USA), 1942. **Woman with her Child, San Cristóbal de las Casas, Chiapas, Mexico**. 1995. Gelatin silver print.

Maar Dora

Untitled

This picture may have no title, but it is begging for an interpretation. The figure in the background is warlike Athena, who is also the goddess of wisdom, even though in this instance she has been cut from a postcard. Athena was born fully armed from the head of Zeus, which made her a half-sister to the Dioscuri, the twins Castor and Pollux. When Castor was killed,

Zeus granted them both immortality but on alternate days. It may be that here the two boys stand for the self in its conscious and unconscious aspects; for the supporting figure looks alert, while his double, placed like that, has phallic possibilities. Or the picture may just be intended as a premonition of war and its consequences – in 1937, Picasso, with whom Maar was living at

the time, was painting *Guernica*. Maar was herself a signed-up Surrealist, and had been friendly with André Breton and Man Ray since 1934, and so perhaps this picture is a response to Surrealism's interest in a collective mythology.

☛ Man Ray, Rheims, Rodger

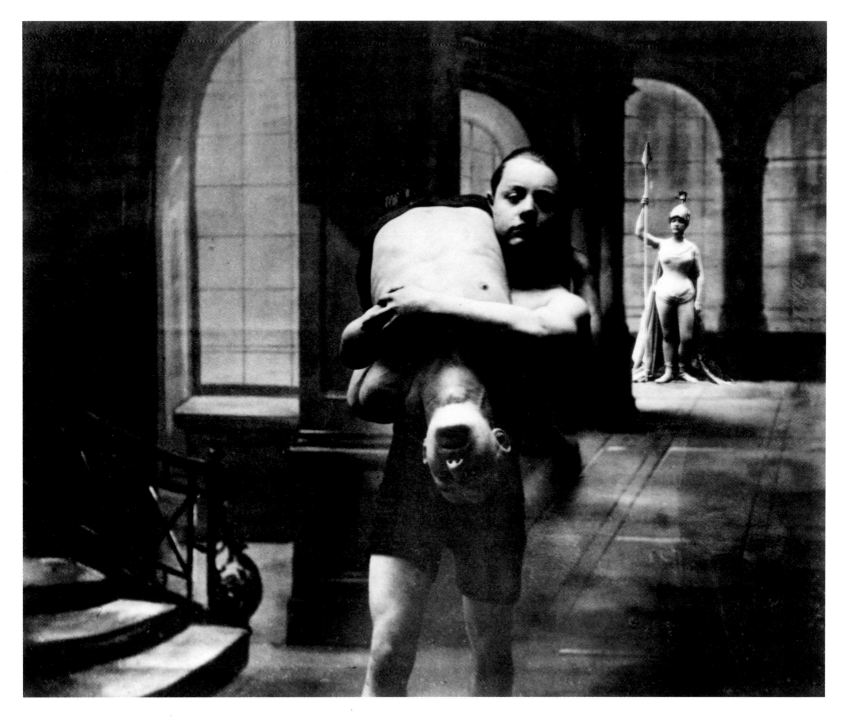

Dora Maar. b Paris (FR), 1907. **d** Paris (FR), 1997. **Untitled**. 1937. Gelatin silver print.

McBean Angus

The Beatles

The Beatles are looking out of the kind of modernist perspective you find in Bauhaus photography of the 1920s, in another era when all the world was a stage. It is as if they are setting sail on some giant transatlantic liner, or bidding farewell on a Liverpool quayside – as, in a sense, they were in the early 1960s. From the 1930s McBean was a specialist in theatre photography and style management. Initially he made masks and theatre scenery and took portraits for a living, working for a famous society portraitist called Hugh Cecil. By 1937 he had become court portraitist to London's theatreland and he grew famous for his fantasy portraits staged in surrealist settings. In 1940, however, he overstepped the mark when he published a picture of the disembodied head of Diana Churchill under a kitchen chair. Intended as an example both of Surrealism and of glamour, the picture offered succour to enemy propagandists, and McBean was imprisoned for two and a half years. On his release, he returned to theatre photography.

☛ van Manen, Sander, A. Webb, Weber

Angus McBean. b Newbridge (UK), 1904. **d** Ipswich (UK), 1990. **The Beatles**. 1963. C-type print.

McCullin Don

Hue, Vietnam

The man – a North Vietnamese soldier – lies dead, with the contents of his pockets and a bag of ammunition strewn before him, signs respectively of his home life and his trade. It is, of course, a picture with an obvious bearing on the horrors of war, but beyond that it sets death in relation to life for there is a contest between the face of the dead soldier and that of the still-living girl in the photograph. Each makes demands of a different kind, and those made by the girl take precedence, both because she still lives (even if only in this shadowy form) and because she represents something of the vision the soldier was fighting for. McCullin is recognized as one of the greatest of war photographers, although that assessment proposes far more than it seems to, for to comprehend war means also to comprehend its opposite, represented poignantly here by those scattered snapshots.

☛ Battaglia, Eppridge, Gardner, Meiselas, L. Miller, Silk

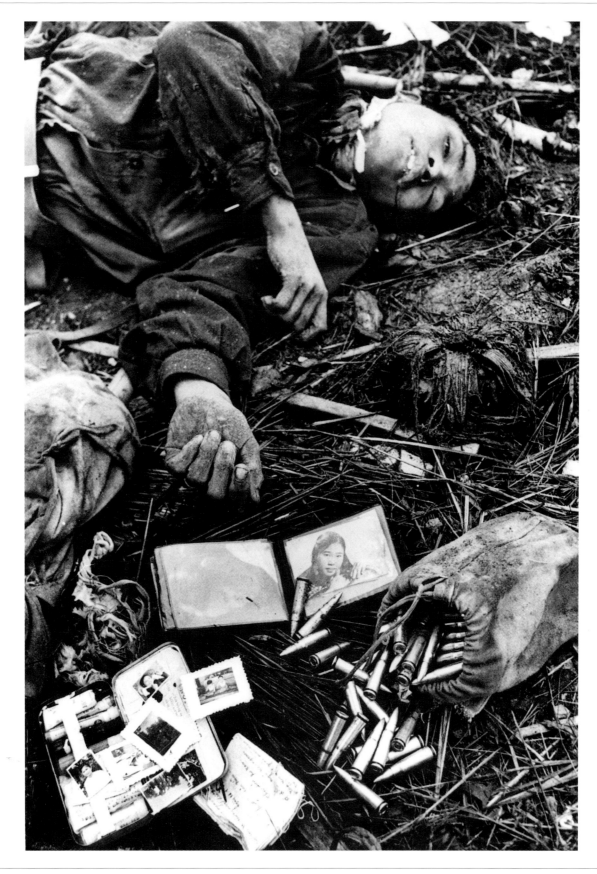

Don McCullin. b London (UK), 1935. **Hue, Vietnam**. 1968. Gelatin silver print.

McCurry Steve

Afghanistan

A group of nomads in the desert near Qandahar face west towards Mecca to offer the fourth of five daily Muslim prayers. This picture was published in October 1993 in 'Afghanistan's Uneasy Peace', an article prepared by Steve McCurry and the writer Richard Mackenzie for *National Geographic*. McCurry is a specialist in Afghan geography and history and at the time

this article was published had made seventeen trips to the country. He is known for his book *Monsoon* (1986), which focuses on weather, society and agriculture in Southeast Asia. He has worked for *National Geographic* since the early 1980s, principally in areas (such as the Philippines and Sri Lanka) affected by social unrest. Part-reporter and part-

documentarist, his surveys take into account topography, culture, tradition and news as it unfolds. In this moment in the desert he establishes the religious background to Afghanistan's turbulent recent history.

☛ **Gaumy, Plossu, Ueda, Xiao-Ming**

288

Steve McCurry. b Philadelphia, PA (USA), 1950. **Afghanistan**. 1993. R-type print.

McDean Craig

Guinevere

McDean's androgynous Guinevere looks preoccupied and equivocal. She is as much a symbol of the unattainable as the women who feature in the photographs of Julia Margaret Cameron and Lady Hawarden, women who stand as romantic symbols and animate stories from the past. Yet Guinevere is very much a figure of the 1990s, a supermodel who features here in the fashion designer Jil Sander's 1996 campaign. Craig McDean, a British fashion photographer of international repute, first studied photography at Mid Cheshire College between 1987 and 1989. He completed his training at Blackpool College and was taken on as an assistant to Nick Knight, who was by then well established in the field. Two years later McDean set up on his own. His many commissions have included work for *Harper's Bazaar*, *Rolling Stone* and *Arena* magazines. He has also worked for several advertising agencies, shooting campaigns for Calvin Klein and Lancôme, amongst others.

☛ Bull, Cameron, Harcourt, Hawarden, Henri, Knight, Lerski

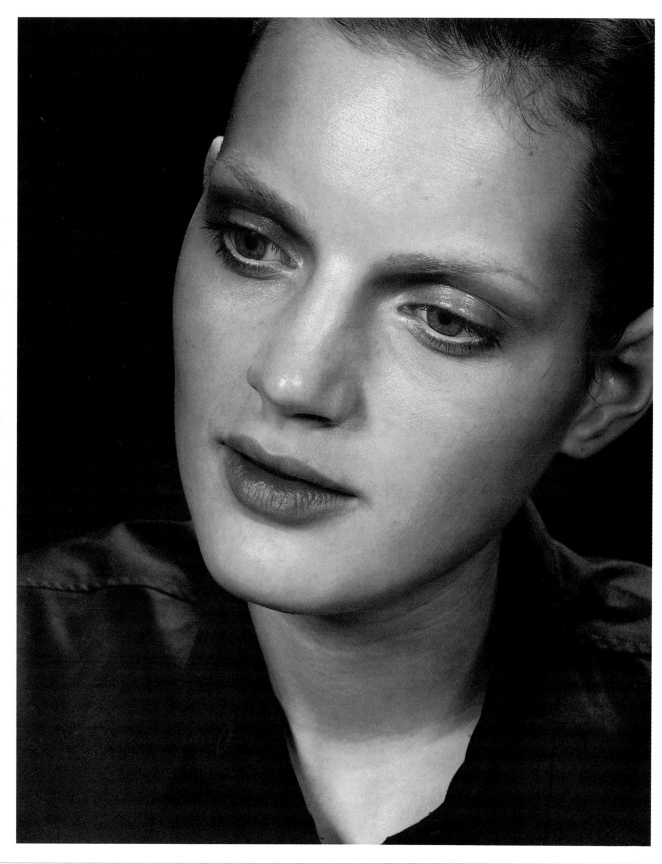

289

Craig McDean. b Nantwich (UK), 1964. **Guinevere**. 1996. C-type print.

Magubane Peter

Ndebele Home

This picture appears to stand for a traditional way of life threatened by industrialization. The promise of danger takes the shape of the dog advancing towards the hen and her brood. The Ndebele people live in the north-east of South Africa, within commuting distance of Johannesburg. They are known for their personal decoration and their painted architecture.

This house, which was decorated freehand by Danisile Ndimande, attracted Magubane's attention when he was visiting the area in 1985. The assignment – which was undertaken for *National Geographic* – turned out to be a difficult one for, while covering a funeral in a township, Magubane was hit in the legs and feet by shotgun pellets fired

by police trying to disperse a crowd. In 1969–70 he had spent 586 days in solitary confinement. He was then subject to internal 'banning' within South Africa for five years, and detained once again in 1976.

☛ Abell, Christenberry, Post Wolcott, Sternfeld

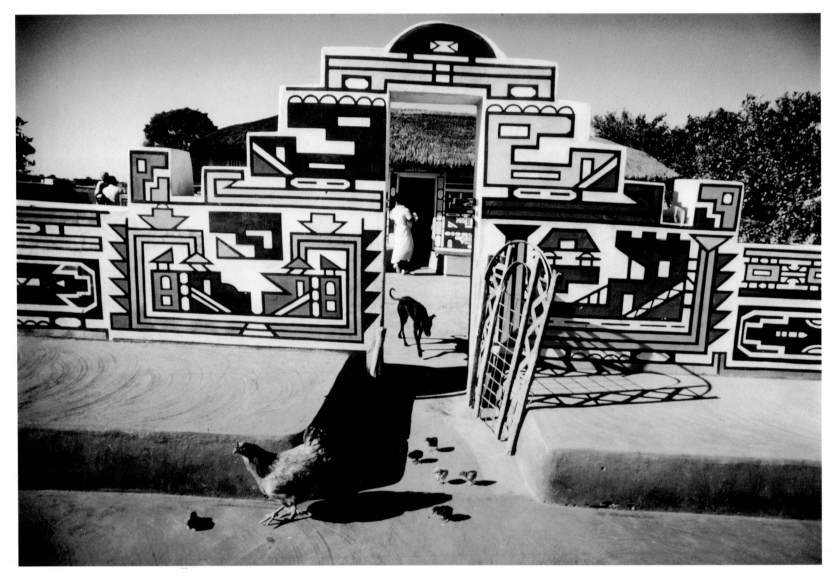

290

Peter Magubane. b Vrededorp (SA), 1932. **Ndebele Home**. 1985. C-type print.

Mahr Mari

A Time in the South Pacific/1

This mapped land with its mountains represents an island in the Pacific, and the six fish which hold it down against that background of surf bring to mind a sense of touch and taste. Mari Mahr's usual procedure, in her extended series of pictures which are meant for exhibition, is to combine photographic backgrounds with separate items photographed and incorporated into the picture. The result is that her ensembles also function as physical mementoes or as keepsakes from a long time ago. The series are given such names as *A Few Days in Geneva* and *Once Upon a Time There Was a Soldier*, both of which date from 1985. This picture, which is part of a set called *A Time in the South Pacific*, relates to the island of Rarotonga.

A Chilean, Mari Mahr studied in Budapest in the 1960s and then in London in the 1970s, and her work reflects on the position of an expatriate in Europe.

☞ Cooper, Doubilet, van Elk, List, Tomatsu

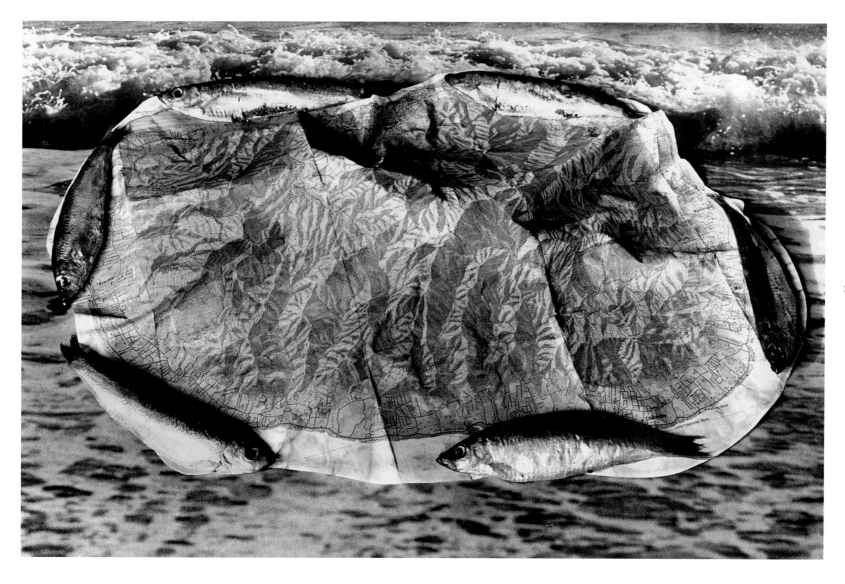

Mari Mahr. b Santiago (CH), 1941. **A Time in the South Pacific/1**. 1988. Gelatin silver print. **h** 61 × **w** 91 cm. **h** 24 × **w** 36 in.

Man Felix H. Steelworks

Two figures in long protective coats are crossing an inspection bridge in a steelworks. This may be an example of industrial reportage in the style of the 1920s, but it is more expressive than descriptive. The pair look like demagogues haranguing a crowd in a hellish metropolitan underworld. Man's reportage pictures, even when taken in such ordinary workplaces as this, were imagined in terms of European political extremism. Man was one of the great photojournalists of his era. He started out working as a magazine illustrator in Berlin in 1926 but soon switched to photography. Between 1929 and 1931 he completed over eighty interviews, illustrated with his own photographs, for the principal illustrated weeklies of Berlin and Munich. In 1934 he emigrated to England, where he was employed as a reporter on *Weekly Illustrated*. From 1938 until 1945 he worked for *Picture Post*, which published between 150 and 200 of his photographic articles.

☛ Gursky, Hine, Shere

292

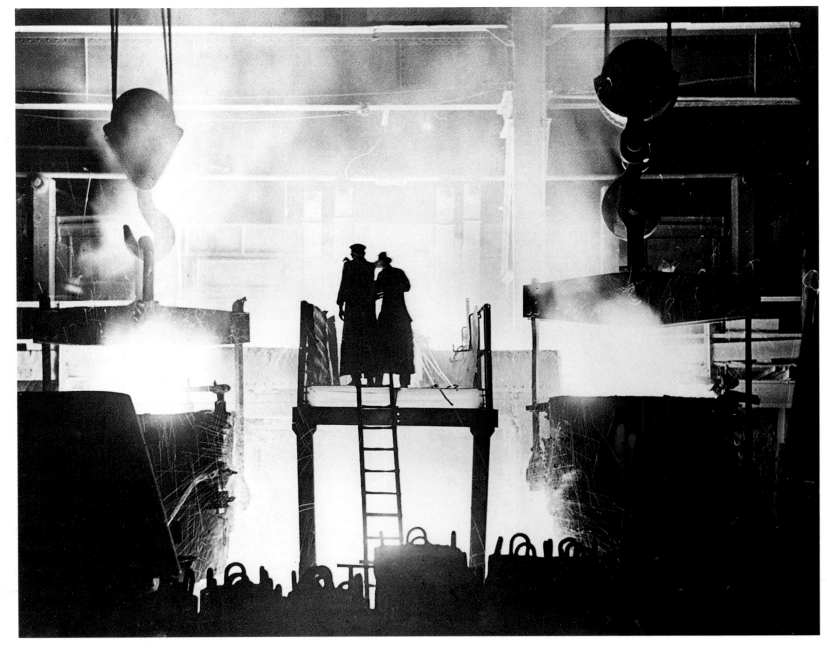

Felix H. Man (Hans Felix Siegismund Bauman). b Freiburg im Breisgau (GER), 1893. **d** London (UK), 1985. **Steelworks**. 1930. Gelatin silver print.

Van Manen Bertien Tbilisi, Georgia

Three men stand casually around a table. Is this an innocent get-together or a highly secret meeting? Caught unawares by the photographer, the two men on the left have glanced up as the picture is taken while the moustached figure on the right is handing over a cup of coffee. We know nothing about these men or their surroundings, although it is possible to make out a large oval mirror in the background and a marble female statue topped by a pillow. This photograph is from a book published in 1994 called *A hundred summers, a hundred winters* which is made up of seventy-three pictures from Siberia, Georgia, Moldavia and the Ukraine. Van Manen's portraits are, in fact, records of encounters with people who are not well known by the photographer, who are more or less at home in their own settings and who cannot readily be interpreted or set up as representatives of post-Communism. Van Manen's idea of the photographer is of someone as apprehensive of the world as any of the rest of us.

☞ McBean, Pinkhassov, Sander, W. E. Smith, A. Webb, Zecchin

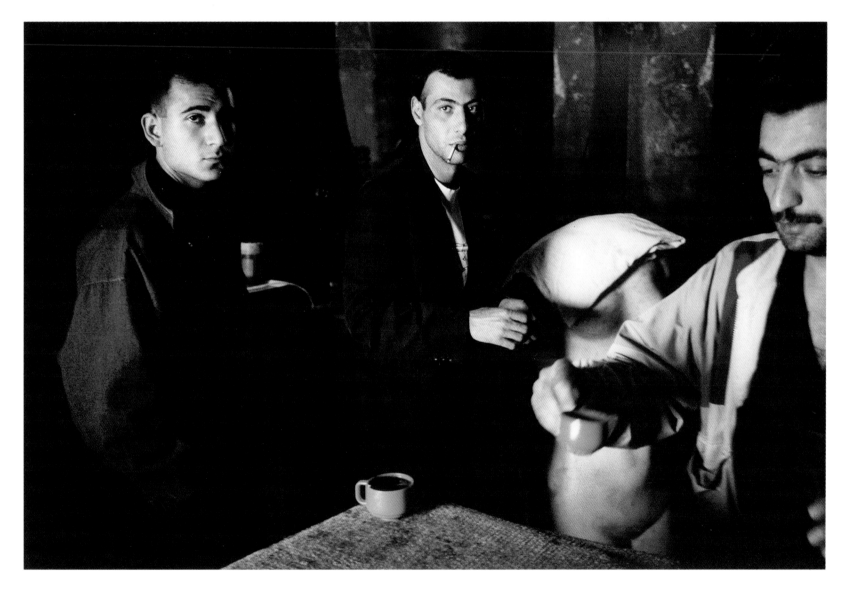

293

Bertien van Manen. b The Hague (NL). **Tbilisi, Georgia**. 1993. C-type print.

Mann Sally

Emmet, Jessie and Virginia

In this identity parade of adult attitudes we are confronted by two sirens and a bruiser in friendship bracelets. Each child rehearses adult poses, as if such poses were inherent rather than picked up from the culture at large. In Sally Mann's explorations of family life she often seems to come across evidence of early maturity such as this. Her findings seem to deny childhood innocence and the idea that humanity is somehow ruined by environmental pressures and adult example. We were not, that is to say, born pure as we would like to imagine, but – instead – we enter life ready for the streets. If we are fallen virtually from birth, the implication may be that that is how we naturally are and that we may be in no need of salvation. All of Sally Mann's controversial pictures of her children growing up make this largely unacceptable suggestion. Her family portraits are collected in *Immediate Family* (1992).

☛ **Mark, Ross, Seeberger, Sommer**

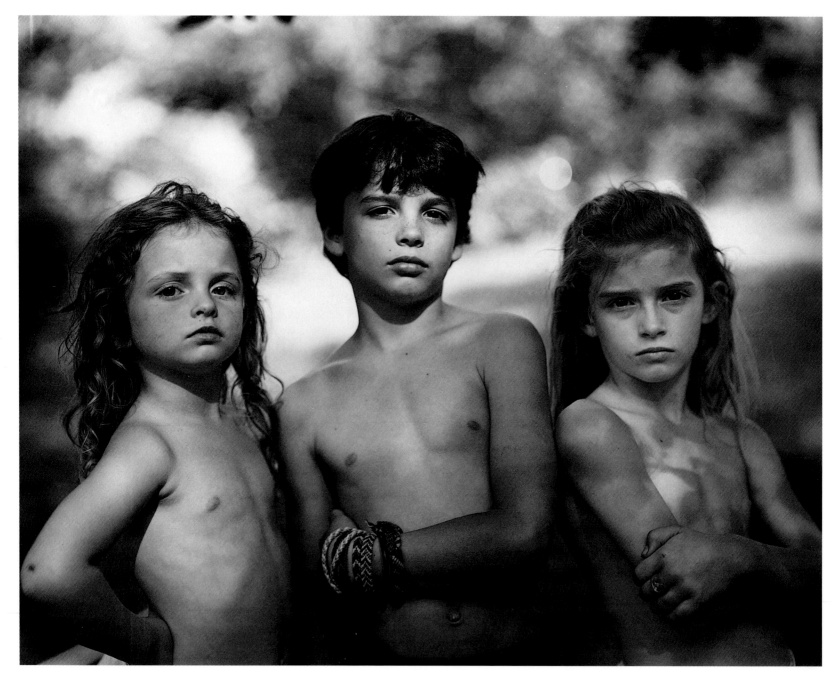

Sally Mann. **b** Lexington, VA (USA), 1951. **Emmet, Jessie and Virginia**. 1989. Gelatin silver print.

Manos Constantine

Dufusque Island, South Carolina

Judging by the shadows, it must be the end of a working day. Certainly whatever was going on has reached a pause. The mule droops rather, and the three men are concentrating on their own preoccupations. A drum and a barrel stand by the water's edge, several boats are either moored or drawn up on the shore, and the front wheels of that spring cart are turned slightly towards us. Manos's idea, like that of several of his contemporaries in the 1950s, was to present both people and things distinctly in a continuous space so that they might be appreciated at leisure and for themselves. A respectful art of this kind could never countenance action, for in action things and people are narrowly defined in terms of the moment. Thus most of his cast, whether here in South Carolina or in Greece during the 1960s, do little more than these three figures in their corner of paradise.

☞ Annan, Emerson, Howlett, Morath, Muybridge

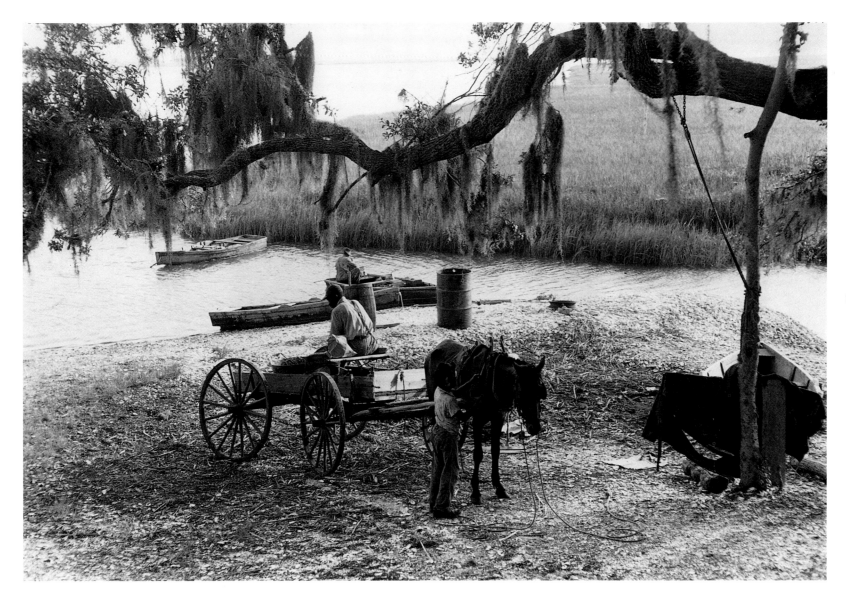

295

Constantine Manos. b Columbia, SC (USA), 1934. **Dufusque Island, South Carolina.** 1952. Gelatin silver print.

Man Ray

Tears

If real tears are an incontrovertible sign of grief, then glass tears could possibly be the mark of insincerity. Man Ray, like the vanguard artists with whom he associated in Paris in the 1920s, was attentive to signs and fragments: lips, eyes and profiles. Man Ray trained as a painter and sculptor in New York, became interested in photography in 1915, and in 1917 was a co-founder of the New York Dada group. In 1921 he went to Paris, where he became acquainted with the Surrealists. In the early 1920s he began his experiments with photograms, which he called 'Rayographs'. However, he is best known for his heavily stylized and impassive portraits of such Parisian notables as the Countess Casati and Kiki de Montparnasse.

Man Ray remained a leading fashion photographer until the 1930s, and acted as a major international influence, disseminating his ideas through the publication of such picture books as *Man Ray* (1924).

☛ **Callahan, Ferrato, Sherman, Stoddart**

296

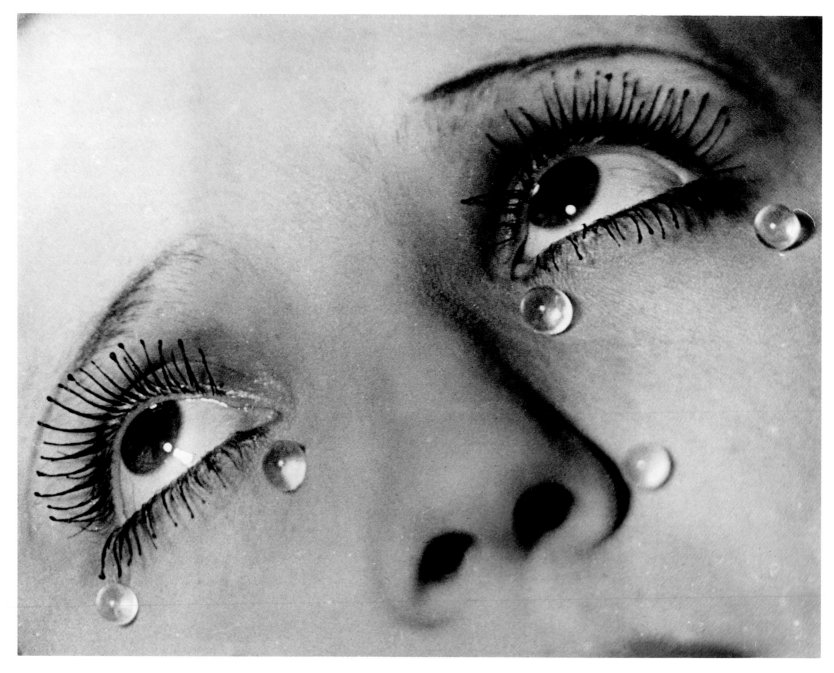

Man Ray (Emmanuel Rudnitsky). b Philadelphia, PA (USA), 1890. d Paris (FR), 1976. **Tears**. c1930. Gelatin silver print.

Mapplethorpe Robert Derrick Cross

At first sight, this looks like no more than a picture of a black male torso with the musculature clearly defined. Yet Mapplethorpe was known as an iconographer who was preoccupied by the construction and interpretation of his pictures. In this case the subject's nipples and navel suggest that the torso might also be a face. Carefully lighted from either side, the middle of the body contains another shadowy figure rising across the pelvic muscles and into the chest and looking, with its slightly dipped head and raised right arm, like the raised fist Black Power symbol of the 1960s. Alternately, the raised figure in shadow might be meant as an erect phallus, but presented as an idea or as a figure in thought. Mapplethorpe's aim was to show photography as an art that could itself appeal simultaneously to the mind and to the senses. He preferred to photograph classical themes but made his name through his homoerotic images.

☛ Joseph, Mather, Outerbridge

Robert Mapplethorpe. b New York (USA), 1946. **d** New York (USA), 1989. **Derrick Cross**. 1983. Gelatin silver print.

Mark Mary Ellen

Street Child, Trabzon, Turkey

This portrait of a young girl posing in a Turkish street is regarded by Mary Ellen Mark as being her first successful picture. She comments: 'For me, this picture says all those things that come into our minds when we think about a young girl becoming a woman.' Neither spoke the other's language, but the girl 'just stood there'. The picture was taken when Mark was a Fulbright Scholar in Turkey. Her life in photography has been devoted to 'the nonfamous', because she believes them to be more worthy, 'more deserving to be photographed'. She has always acted within the American tradition of concerned photography, and her work includes projects on the mentally ill and prostitutes in Falkland Road in Bombay. Conditions in India have interested her, and in 1985 her *Photographs of Mother Teresa's Missions of Charity in Calcutta* was published, followed in 1990 by a book on life in Indian circuses. In 1981 she co-founded the co-operative agency Archive Pictures.

☛ Erfurth, Hofmeister, Lee, Mann, Seeberger, Sommer

298

Mary Ellen Mark. b Philadelphia, PA (USA), 1940. **Street Child, Trabzon, Turkey**. 1965. Gelatin silver print.

Marlow Peter

Dungeness

A wide, flat space such as this, under an average sky, can only be articulated by an imposed format of the kind made possible by the panelled glazing. Not only do the vertical subdivisions frame and thus raise the status of the landscape's desultory objects, but they also provide a near foreground to complement the far horizon. Since the 1970s at least, new generations of photographers have been attracted by the idea of measured space, partly because of its arbitrariness. If the landscape's rocks, stones and trees cannot be made to fit the format naturally then there is no alternative but to set up provisional arrangements such as this. The culture and the ethics of the 'transit zone' have been Marlow's subjects since the late 1980s when he undertook a major study of Liverpool, a city notoriously in transition. The Dungeness pictures were published in the *Independent* newspaper in April 1996, under the heading 'World's End'.

☛ diCorcia, Riboud, Singh, Sinsabaugh, Sudek

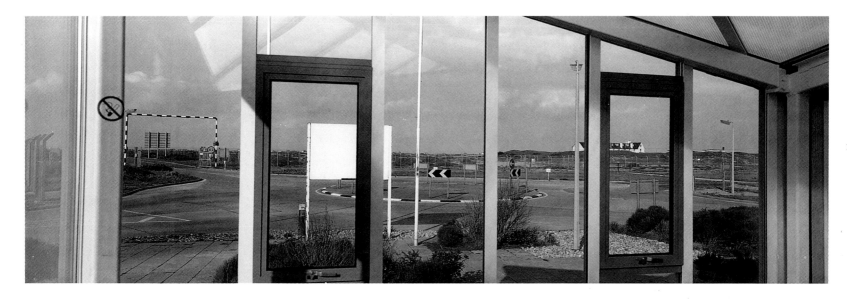

299

Peter Marlow. b Kenilworth (UK), 1952. **Dungeness**. 1996. Gelatin silver print.

Martin Douglas

Dorothy Courts Enters a Newly Desegregated School

Youths are mocking Dorothy Courts, a black girl who has just enrolled at the high school in recently desegregated Little Rock, Arkansas. The revolt against racial inequality in the USA began in Montgomery, Alabama, with a bus boycott in 1955. The Rev. Martin Luther King Jr., then a minister in Montgomery, became the leader of the movement, and was unchallenged until 1960, when his commitment to non-violence was questioned by a new generation of activists. This image commemorates that early era of passive resistance. In part the change came about because of the distribution of such pictures in which defenders of the old injustices presented themselves as self-confident bigots. Dorothy's two civic escorts, one scarcely older than her tormentors, seem like two halves of the American psyche, caught somewhere between a reluctant admiration and a grim determination to carry out an unpalatable duty.

☛ Hardy, C. Moore, Unknown

300

Douglas Martin. Active 1950s. **Dorothy Courts Enters a Newly Desegregated School**. 1957. Gelatin silver print.

Martin Paul

You Dirty Boy!

The board, with its inscription, was part of the equipment of a resident seaside photographer in the 1890s. The official photographer would just have taken straight pictures of the installation. Martin, on the other hand, was a visitor and was armed with a new 'Facile' camera which allowed him to take candid pictures behind the scenes. He was, in fact, one of the first reporters, although in the late 1880s, when he began working, he thought of reportage only as entertainment. A wood engraver by trade, he was employed by the *Illustrated London News*. Photography was his hobby, and he was ingenious enough to adapt his Facile detective camera to make it properly effective in the street. He experimented with Kodak roll film in the early 1890s, and later became a professional photographer concentrating on funerals, parades and other major state occasions. He is remembered for his early informal pictures which anticipated British photojournalism of the 1930s.

☛ Izis, Peress, Walker, Yavno, Zachmann

Paul Martin. b Herbeuville (FR), 1864. **d** London (UK), 1944. **You Dirty Boy!** 1892. Gelatin silver print.

Marubi Kel

Captain Mark Raka with the Head of the Shala Clan

This complex event centres on the old man in traditional Albanian dress – the head of the Shala clan. He grasps a reversed rifle held by a seated soldier in uniform and at the same time appears to read from a document presented by a man of the town in a dark suit. Another seated figure in a traditional outfit looks towards the old chieftain, and in the shadows a soldier takes notes, overseen by a standing figure in a fez. The mood seems cordial, to judge from the number of hands on neighbouring shoulders. What exactly is going on can no longer be identified with certainty, and in this respect Kel Marubi's tableau belongs with any number of vintage pictures which cite forgotten cultural codes (the reversed rifle, for example) and events beyond conclusive analysis. Kel Marubi, born Kel Kodheli, was the successor to an Italian photographer named Pjeter Marubi, who opened Albania's first photo studio.

☛ Beato, Chambi, O'Sullivan, Rejlander, Tsuchida

Kel Marubi (Kel Kodheli). b Shkodër (ALB), 1870. d Tirana (ALB), 1949. **Captain Mark Raka with the Head of the Shala Clan**. 1922. Gelatin silver print.

Marville Charles

Château de l'Ambigu

This photograph, relatively well-known in the history of the medium, shows a six-berth public urinal or *vespasienne (Système Jennings)*, a concessionary kiosk over on the left, and a Morris advertising column nearer to the centre. It was taken at some time in the mid-1870s by a photographer who specialized in the architecture of Paris. In the 1860s Marville took pictures in the old streets of central Paris before their demolition by the city planner Baron Haussmann. During the 1870s he seems to have been asked to make a record of street furniture and of amenities such as gas lighting appliances, kiosks and public toilets. At the time, Marville's pictures were used in albums and in exhibitions devised by planning departments, and had no more than a functional value. However, a hundred years later the pared-down aesthetic sense of landscape photographers brought Marville's pictures under consideration as art.

☞ Atget, Blumenfeld, Doisneau, Gimpel, Ronis

Charles Marville. b Paris (FR), 1816. **d** Paris (FR), 1879. **Château de l'Ambigu**. c1875. Albumen print.

Maspons Oriol Two Dogs

In post-war photography in Europe, bad dogs stood for barbarism and for all those savage forces which the optimists in the 1930s had so disastrously ignored. By using metaphors like this, the photographer could reflect on and express the overall state of the times, whereas documentary pictures simply gave objective reports and refrained from commitment. European photography in the 1950s was a contest between the documentarists and those who, like Maspons, took a more subjective line. This, for instance, is a successful picture in subjective terms not only because of its choice of message but also because the two dogs make a rhythmic figure which is expressive in its own right. Maspons was a member of the Photographic Association of Almeria (AFAL) founded in 1950. AFAL favoured subjective photography, and was regarded by the authorities as radical and subversive since it was felt that the strong emphasis it placed on art threatened the state's institutions.

☛ Economomopoulos, Erwitt, Hurn, Wegman

Oriol Maspons. b Barcelona (SP), 1928. **Two Dogs**. 1958. Gelatin silver print.

Mather Margrethe

Semi-Nude Male

The man, who was a painter and designer and a frequent collaborator of Mather's, is William Justema. He is wearing a black and white kimono – his favourite, according to a memoir. Mather must have arranged his hands so that they kept the kimono in place and charted the shape of the body, but without impressing on it. One of the heroines of photography, Mather

began life as an orphan in Utah before becoming a teenage streetwalker in San Francisco. Supported and brought out into the world of arts and letters by a lesbian known as Beau, she took up photography in her early twenties and met Edward Weston, then a portrait photographer. Weston fell in love with her, but who influenced whom artistically has never been settled.

The relationship, which was said to be 'semi-platonic', lasted until around 1923, when Weston went to Mexico with Tina Modotti. Established in Weston's studio in Tropico (Glendale), California, Mather worked as a portrait photographer.

☞ Mapplethorpe, Modotti, Outerbridge, Weston

Margrethe Mather. b Salt Lake City, UT (USA), c1885. d Glendale, CA (USA), 1952. **Semi-Nude Male**. c1925. Gelatin silver print.

Mayne Roger

Child About to Do a Handstand, Kensal Road

The girl is about to do a handstand on the pavement, like many other children playing in front of photographers in the 1940s and 1950s. The street is her gymnasium, and Mayne shows it measured out by paving stones and grids. Her hands, strongly emphasized, will soon come into contact with the gritty surface of the road. Altogether, she makes a strong figure or inscription against that pale background, as if the human form was able to express its own significance. Mayne is known for his pictures of children and adolescents at play in the streets of London. He was representative of a generation which believed in humanity's capacity to re-make itself out of its own resources and energies. Self-taught in photography after studying chemistry, Mayne first exhibited his street pictures in 1956 at the influential Institute of Contemporary Arts in London and then at the Victoria and Albert Museum in 1994.

☞ Brandt, Doisneau, Konttinen, Levitt, Schuh

306

Roger Mayne. b Cambridge (UK), 1929. **Child About to Do a Handstand, Kensal Road**. 1957. Gelatin silver print.

Meatyard Ralph Eugene Untitled

In the darkness of the interior he or she seems to have seen the light and to have been dazzled, whereas the hooded figure looking in appears to be oblivious to whatever epiphany is taking place across the cracked floor. The children and the setting fulfil whatever scheme the artist had in mind. All of Meatyard's visionary art takes place in such manifestly ordinary and even abandoned places – as if he wanted to point out that revelation does not depend on sight. Perhaps the unseeing watcher at the window stands for disinterest, or indifference. Whatever Meatyard's intention, there is an invitation to compare and contrast, and even to imagine oneself to be one or the other of those diametrically opposed figures.

Born, oddly enough, in the town of Normal in Illinois, Meatyard spent all his working life as an optician in Lexington, Kentucky. He took around 18,000 pictures of the locality, often featuring his own family as participants in such dramas as this.

☛ Duncan, Echagüe, Frank, René-Jacques

Ralph Eugene Meatyard. b Normal, IL (USA), 1925. d Lexington, KY (USA), 1972. **Untitled.** 1962. Gelatin silver print.

Meisel Steven

Untitled

Two elegant women in cloche hats sit at a table in a carefully composed scene. Meisel's references are all to modernism. His colour, pastel and grainy, recalls the autochrome process of the early years of this century, and the colour photography of Jacques-Henri Lartigue. The plain furniture, too, is modernist as is the architectural backdrop. Taken for Italian *Vogue* and published in October 1996 in connection with a story called 'Neo-Fashion', the picture is meant to invoke a range of modernist styles – for the sake of the pleasures of recognition. Fashion entails a consciousness of styles revived knowingly or not. Meisel asks his audiences to think of themselves as learned and sophisticated. Meisel came into fashion photography after working as an illustrator for *Women's Wear Daily*. His pictures appear regularly in American and Italian *Vogue* and he has worked on various advertising campaigns, including those for Versace and Valentino.

☞ Atwood, Keita, Lartigue

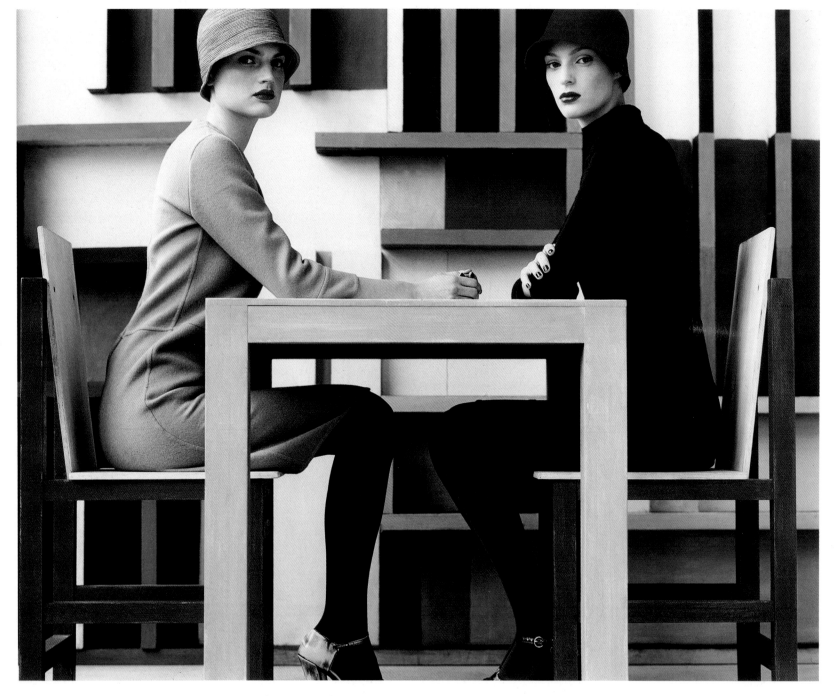

Steven Meisel. b New York (USA). **Untitled**. 1996. C-type print.

Meiselas Susan Cuesta del Plomo

Human remains are a staple of war photography, but in this case they have been pictured within a beautiful extended landscape, symbolic of peace and the real world. This picture appears in *Nicaragua*, Meiselas's outstanding war report of 1981. She photographed in Nicaragua in the summer of 1978, during the struggle between the Somoza dictatorship and the Sandinista opposition, and the book which finally emerged is rich in historical and geographical information. It is as if Meiselas wanted her readers to understand the country and even to take the part of the ordinary people who went to Cuesta del Plomo daily to look for missing persons, aware that it was the site for many assassinations by the National Guard. Physical vulnerability has always been her subject, and her first book of 1975 was entitled *Carnival Strippers*. In the late 1980s Meiselas began to photograph the Mexican migrants arrested on the US border, another group subject to arbitrary violence like the Nicaraguans.

☛ Battaglia, Eppridge, McCullin, L. Miller, Wall

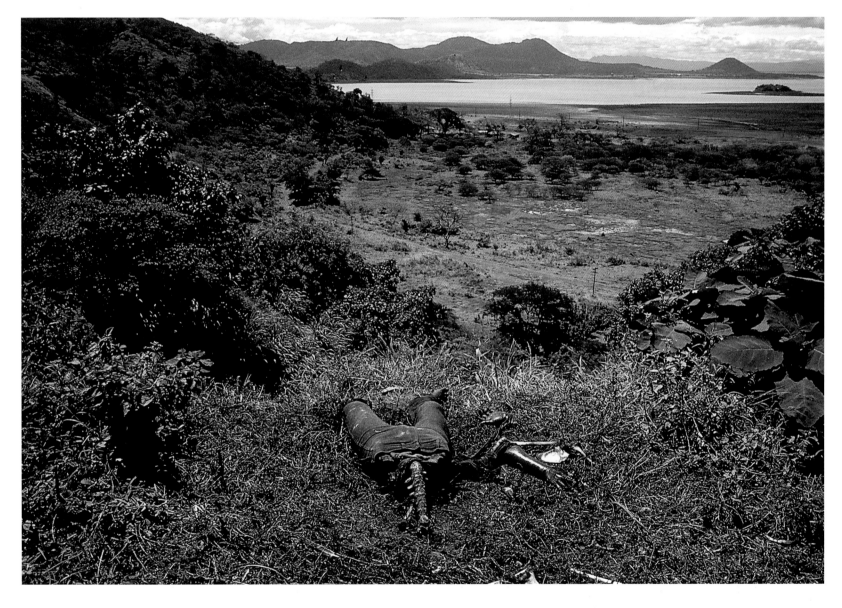

309

Susan Meiselas. b Baltimore, MD (USA), 1948. **Cuesta del Plomo**. 1978. C-type print.

De Meyer Baron Adolph Hydrangea

Those cut flower stems look real enough as they touch the sides and the rim of the glass, but everything else in the picture is suffused by light. De Meyer's art dealt in visual impressions, presenting a world which could be sensed but hardly touched. De Meyer is seen by many as the founder of fashion photography. In 1899 he married Olga Caracciolo, a professional beauty who was said to be the illegitimate daughter of Edward VII. Through her de Meyer was introduced to the highest in the land and was able to take portraits of many of the celebrities. His work was published in Alfred Stieglitz's *Camera Work* in 1908 and in 1911 he took pictures of the dancer Nijinsky, who was performing in London. In 1914 he became principal photographer for Condé Nast and *Vogue* magazine in New York. In 1923 he left *Vogue* for *Harper's Bazaar*, where he remained until 1935, by which time his delicate symbolist manner was beginning to look old-fashioned.

☛ Blossfeldt, Modotti, Parker, Sougez, Stieglitz

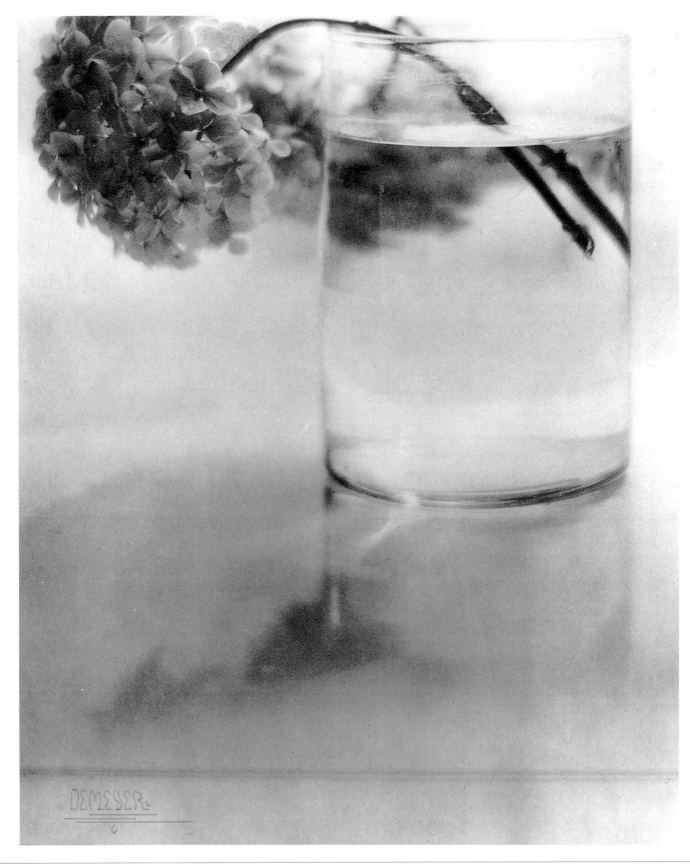

310

Baron Adolph de Meyer. b Paris (FR), 1868. d Hollywood, CA (USA), 1946. **Hydrangea**. c1908. Photogravure.

Meyerowitz Joel 12th Avenue between 34th and 35th Streets

Meyerowitz said of this picture that the Empire State Building still took him by surprise, and also constituted a starting-point from which he could see 'the counterpoints between architectural styles': the terminal and the warehouse, the diner and the brownstone. Nonetheless, it is the adjacent building which catches the light and establishes the kind of epiphany or revelation for which Meyerowitz looked during the 1970s. By 1978, when this picture was taken, the banalities of the street had become a challenge in photography, and Meyerowitz's response was to create an art around a divergence: drabness and light. The greater the divergence the more effective the picture, and in this blue-painted diner he found an epitome of the unpretentious, an elemental shelter to stand against that vivid moment in the blue morning light. In his book of 1980, *St. Louis and the Arch*, the transcendental role is taken by Eero Saarinen's free-standing arch.

☞ Christenberry, Longo, Morris, Parkinson

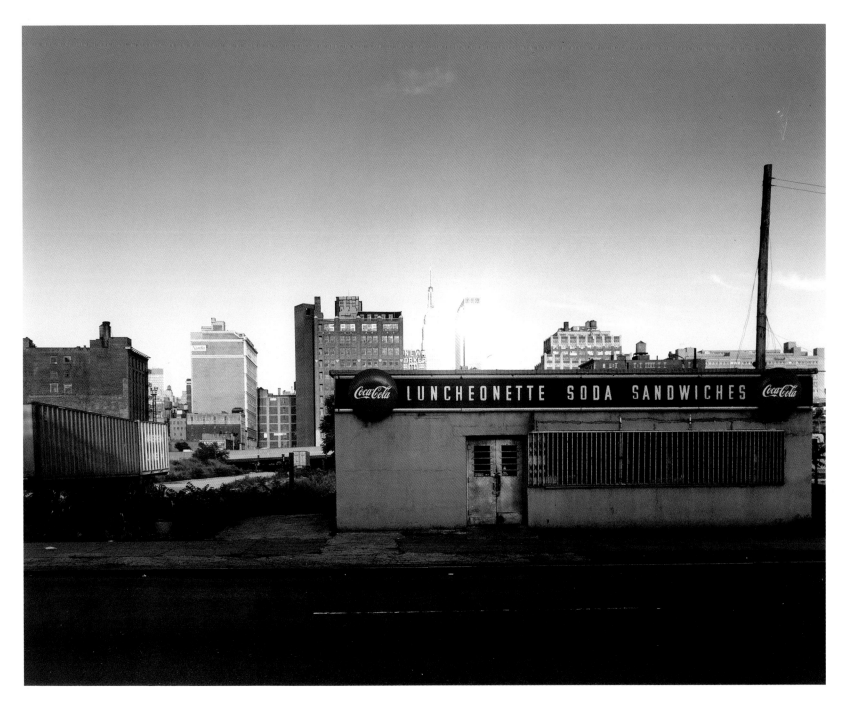

Joel Meyerowitz. b New York (USA), 1938. **12th Avenue between 34th and 35th Streets**. 1978. C-type print.

Michals Duane I Build a Pyramid

Michals wrote that there were two difficulties in building your own pyramid: the first was getting to the site early enough in the morning to have it to yourself; the second was selecting sufficiently good stones. Some pre-planning has gone into the construction of this pyramid, for the sixth and final picture shows an edifice which complements the angles of the major structures beyond. Michals is here making his own mark in the face of the kind of timelessness represented by the ancient pyramids. His photographs, which are often put together in sets like this, have human fragility for their subject: people seem to disappear in them, leaving the room or place unmarked. Michals began to take photographs whilst on a trip to Russia as a tourist in 1958, and by the mid-1960s had established himself as one of the most assured of a new generation of social landscapists. He began to make sequences in the late 1960s, accompanying some of them with a handwritten narrative.

☞ Baldessari, Becher, Du Camp, van Elk, Paneth

Duane Michals. b McKeesport, PA (USA), 1932. **I Build a Pyramid**. 1978. Six gelatin silver prints.

Mihailov Boris Untitled

A civic father on a pedestal blends into the winter sky. The setting is Kharkov in the old Soviet Union and the poster and statue in the background are typical of Soviet settings in the late 1980s. Mihailov's worker, however, is atypical, being a trader in pastries and snacks, whose posture rhymes with that of the striding athlete on the left. Mihailov has taken this black-and-white picture of an ordinary street scene and painted over selected details. This is a procedure he has been carrying out since the 1970s in a series of pictures which he called *Luriki*, after the Russian habit of hand-tinting portraits of the deceased to bring them to life. He called these portraits 'society pictures'. Mihailov is a phenomenon: a whole photo-culture in himself. and an adept with many styles and cameras. After completing the tinted society pictures, he began a series called *U Zemli* (On the Ground), panoramic pictures of pure documentation showing ordinary moments on the streets of Kharkov.

☛ **Cartier-Bresson, Sternfeld, Thomson, Warburg**

Boris Mihailov. b Kharkov (UKR), 1938. **Untitled**, c1980. Painted gelatin silver print. **h**50 × **w**60 cm. **h**19 ½ × **w**23 ½ in.

Mili Gjon

Picasso

In the 1950s the Spanish painter and sculptor Pablo Picasso represented creativity under its Mediterranean and classical heading. Playfully, he reiterated the art of the Greeks and Cretans. In this instance, at his pottery at Vallauris in southern France, Picasso has just drawn a centaur in the air, using a flashlight in the dark. The same audiences which appreciated creativity also enjoyed the new-fangled and anything which told of technological wizardry. Mili was a specialist in new techniques in photography. On graduating from the Massachusetts Institute of Technology he became a lighting engineer at Westinghouse, and then in 1937 heard Professor Harold Edgerton lecture about a new stroboscopic lamp which produced a flash lasting only 1,100,000th of a second. Intrigued, Mili put this knowledge to use in sports, theatre and dance photography.

☛ **Connor, Edgerton, Hilliard, Leibovitz**

314

Gjon Mili. b Kerce (ALB), 1904. **d** Stamford, CT (USA), 1984. **Picasso**. 1949. Gelatin silver print.

Miller Lee

Dead German Guard in Canal, Dachau

Apparently sleeping peacefully, this soldier figures in one of the most terrible of war pictures. An accredited US war correspondent in 1944–5, Lee Miller took some of the most affecting pictures to come from the war. Amongst them are shots of corpses at Dachau and a poignant picture of the daughter of the burgomaster of Leipzig, a girl 'with exceptionally pretty teeth', who had killed herself. Originally a model in New York in the late 1920s, Miller was photographed by Edward Steichen, Horst P. Horst and George Hoyningen-Huene. In 1929 she moved to Paris and became the lover, technical collaborator and model of Man Ray. Familiarity with Surrealism informed her war pictures: in 1933, for example, she experimented with the floating head of a woman. In 1935 she moved to Cairo, but, wearying of the steady city life, she turned increasingly to travel and adventure photography in the late 1930s. In 1947 she married the English artist Roland Penrose and settled in Sussex.

☛ Bayard, Horst, Hoyningen-Huene, Krause, Man Ray, Steichen

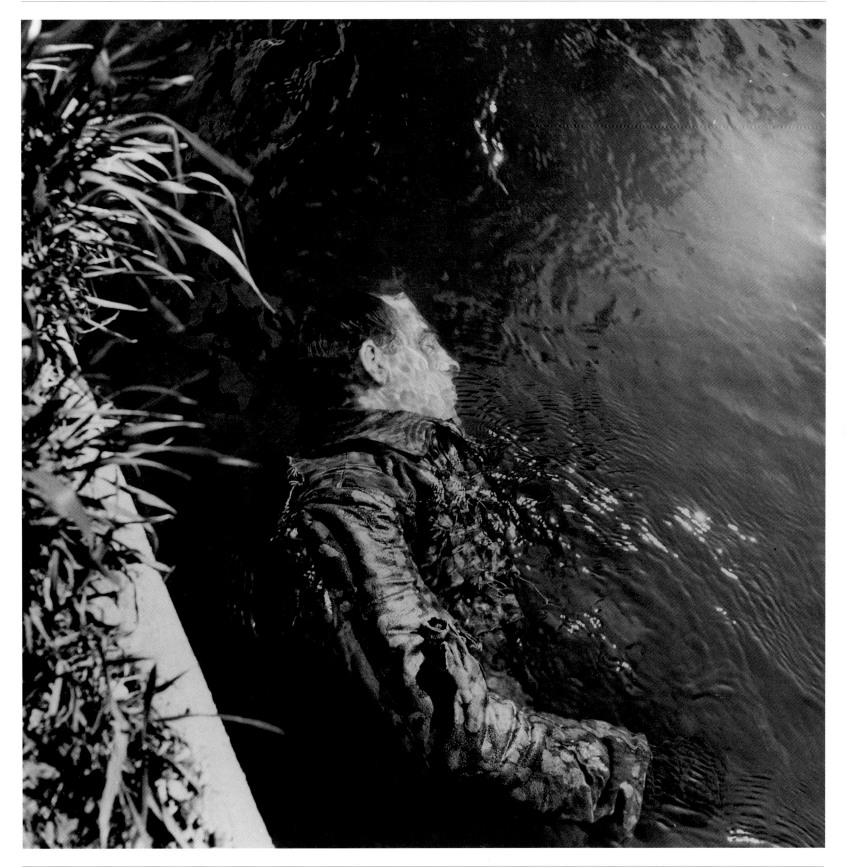

315

Lee Miller. b Poughkeepsie, NY (USA), 1907. d Chiddingly (UK), 1977. **Dead German Guard in Canal, Dachau**. 1945. Gelatin silver print.

Miller Wayne

The Cotton Picker

Wayne Miller comments on this picture thus: 'The cotton picker works all day but doesn't even have enough money for glasses. While his wife entertains other men in his absence and is bored with him.' The story is supplemented by their gestures: his defeated look, and her apparent attention to her fingernails. The picture appeared in 'Family of Man', the exhibition of

1955 for which Miller acted as assistant to the director, Edward Steichen. Miller served in the US Navy from 1942 to 1946, and was assigned to Steichen's Naval Aviation Unit. In 1946 he began to work as a freelance photographer in Chicago, and he photographed blacks in the northern states on two consecutive Guggenheim fellowships (1946–8). In 1949 he moved to

Orinda, California, and began to work for *Life*, continuing to do so until 1953. A member of Magnum Photos from 1958, he withdrew from photography in 1975 to concentrate on farming, forestry and conservation.

☛ **Beresford, Disfarmer, Steichen, Vishniac**

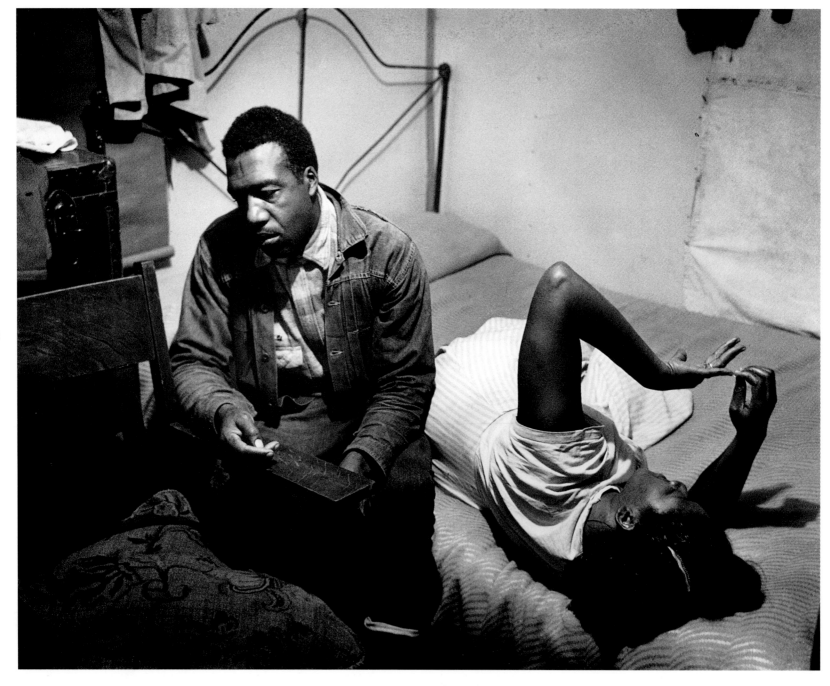

Wayne Miller. b Chicago, IL (USA), 1918. **The Cotton Picker**. 1950. Gelatin silver print.

Minkkinen Arno Rafael Self-Portrait, Helsinki

The photographer has crouched and stooped in front of the camera. The picture asks you to surmise the distance between his elbows and the wall; and it is hard to tell just what the gap might be. Something of the same spatial difficulty is reiterated in the door with its two sets of nailheads, the upper set implying falsely that the door stands open. Arno Minkkinen was a student of both Harry Callahan and of Aaron Siskind at the Rhode Island School of Design, and he has inherited their interest in the representation of space. In the 1940s and 1950s Callahan and Siskind would have been content to chart a shallow space filled with pale surfaces – skin or bark, for instance. Minkkinen, by contrast, chooses to project the same aesthetic concerns onto larger, even panoramic spaces, and to make the work of dechiperment as tantalising as possible. He is the principal actor in his own compositions, many of which are published in *Waterline* (1993).

☛ Callahan, Dater, Morimura, Nauman, Nixon, Siskind, Wulz

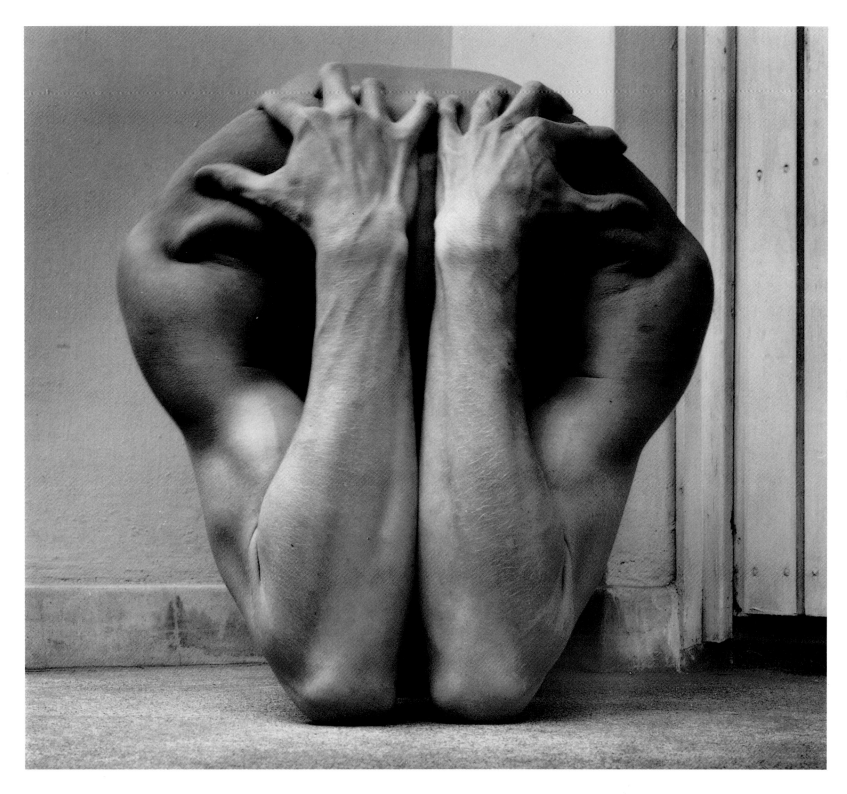

317

Arno Rafael Minkkinen. b Helsinki (FIN), 1945. **Self-Portrait, Helsinki**. 1976. Gelatin silver print.

Misrach Richard

Diorama (Rattlesnake), Palm Springs Desert Museum

A giant moth flutters in a bush and a preserved rattlesnake skirts the rocks of a painted landscape in the Palm Springs Desert Museum. Misrach often remarks on just how artificial nature can look, especially when lit by flash. This picture appears as one of the endpapers to *Desert Cantos*, a catalogue of 1987 introduced by the architectural historian Rayner

Banham. That book of pictures from 1983–5 shows the desert parched and generally trashed. *Desert Cantos*, and much of Misrach's western landscape art, looks like a corrective to the great Time-Life series of the late 1970s, *The World's Wild Places*, in which Mexico's Baja California, for instance, and the Grand Canyon (photographed by Jay Maisel and Ernst Haas

respectively) appear unspoiled, beautifully pure and original. Misrach's suggestions are that although we might have ruined the place we have also brought it within the scope of art, fancy and imagination.

☛ **Alinari, Hocks, den Hollander, Moon, Parr, Tress**

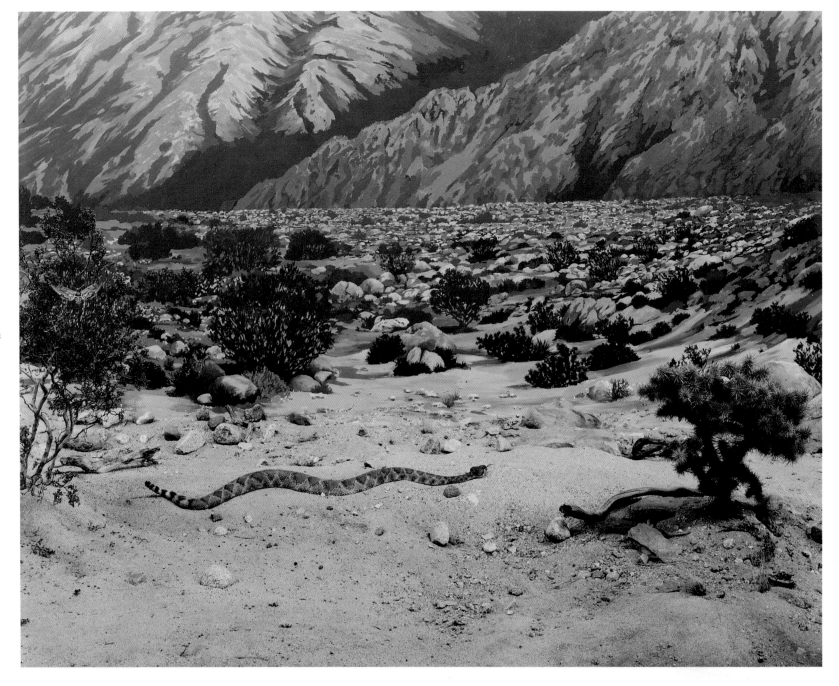

318

Richard Misrach. **b** Los Angeles, CA (USA), 1949. **Diorama (Rattlesnake), Palm Springs Desert Museum**. 1983. Dye coupler print. **h** 102 × **w** 127 cm. **h** 40¼ × **w** 50 in.

Model Lisette

Coney Island Bather, New York

A big woman is acting exuberantly on the seashore at Coney Island, New York. Model was one of the first documentarists to value people for their substance and sheer presence, making no allowances for ideal form. She was not a satirist, or at odds with society, and in a rare statement of 1965 insisted that glamour was her subject and that she meant 'to photograph America's self portrait a million times projected and reflected, to make the image of our image'. She believed that people took what lay in front of them too much for granted, and that her task was to celebrate the disregarded – in this case, material woman on a commonplace beach. In doing this she was rejecting the cultivated idea of glamour and distinction which held sway among most documentarists. Model was an influential teacher of photography in New York in the 1950s, when Diane Arbus was her finest student. Trained in music, Model studied with the composer Arnold Schoenberg in Vienna.

☛ Arbus, Dijkstra, Dupain, Gibson, Goldblatt, Ross

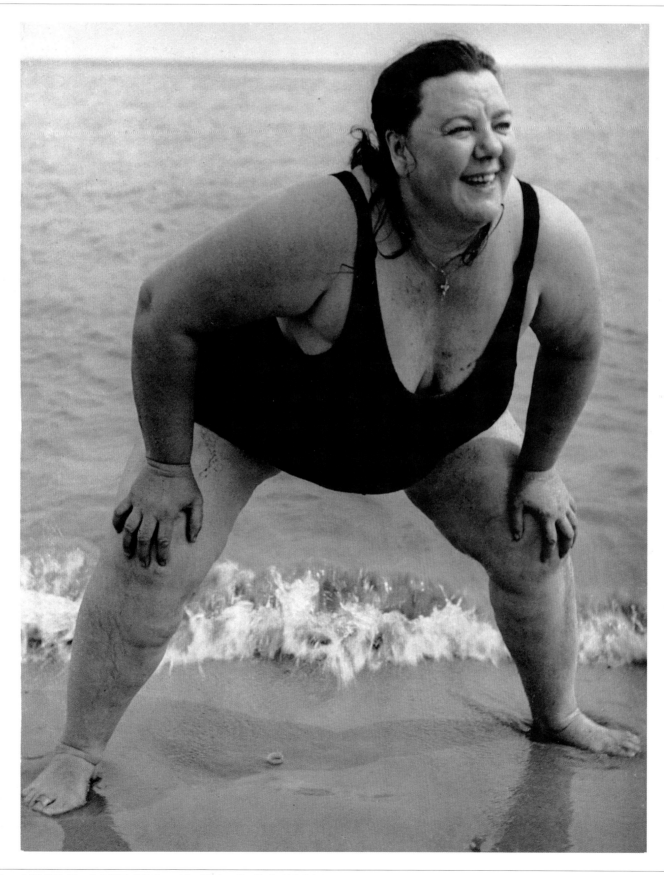

Lisette Model. b Vienna (AUS), 1906. **d** New York (USA), 1983. **Coney Island Bather, New York**. c1940. Gelatin silver print.

Modotti Tina

Roses, Mexico

The four roses sculpt the shallow space of the photograph. This is a typical purist picture of the 1920s which asks its viewers to chart its delicate tones with care. Modotti took this photograph while she was working in Mexico under the influence of her lover, the Californian photographer Edward Weston. Modotti's family moved from Friuli to San Francisco in 1913. After a period working in films in Hollywood around 1920, she went to Mexico with Weston and soon became involved in left-wing agitation there. Weston returned to the USA and Modotti was expelled from Mexico in 1930. With another lover, the activist Vittorio Vidali, she settled in Moscow for a while before embarking on a three-year period with the republican forces in the Spanish Civil War. On Franco's victory in Spain she was advised by sympathisers in Moscow to return to America under an assumed name. On 6 January 1942 Modotti, a notably beautiful figure and an icon of the Left, was assassinated in Mexico City.

☛ **Blossfeldt, Groover, Heinecken, de Meyer, Tosani, Weston**

Tina Modotti. **b** Udine (IT), 1896. **d** Mexico City (MEX), 1942. **Roses, Mexico**. 1924. Platinum print.

Moholy Lucia

Franz Roh

Dazzled, perhaps, by the setting sun, Franz Roh is closing his eyes and showing himself to be either deep in thought or, much more likely, somehow absent from his own portrait. Roh was a critic, art historian and experimental photographer and had been an assistant to the art historian Heinrich Wölfflin. Both he and Moholy had experimented since the early 1920s with photograms, in which an image – rather in the manner of Roh's face here – was constructed by the action of sunlight on objects placed on print-out photographic paper. Lucia married László Moholy-Nagy in 1921 and in 1923 they moved to Weimar, where László had been appointed to the Bauhaus. Together, Lucia and László had begun to make photograms in 1922, and they continued their collaboration in photography until their separation in 1929. Franz Roh went on to organize the notable 'film und foto' exhibition in Stuttgart in 1929, and in 1939 Moholy's book *A Hundred Years of Photography* was published.

☞ Freund, Hubmann, Moholy-Nagy, Özkök, Rodchenko

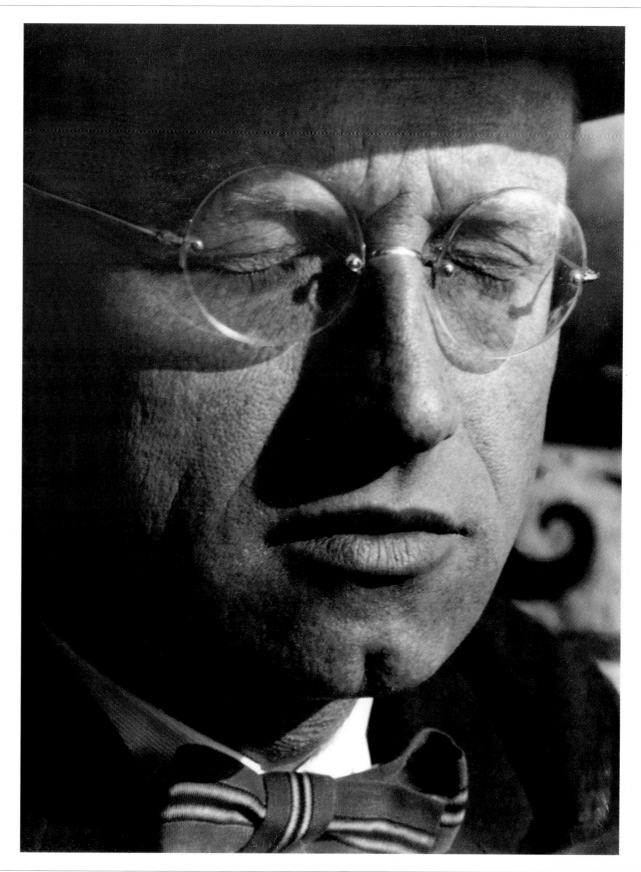

321

Lucia Moholy. b Karolinenthal (CZ), 1894. **d** Zollikon (CZ), 1989. **Franz Roh**. 1926. Gelatin silver print.

Moholy-Nagy László Photogram

Even without much experience of the development of images on print-out paper, a viewer would think it possible to identify various stages in the making of this photogram as the items were introduced and withdrawn from the light. The process might be confusing to re-trace, but the invitation is there to work it out and to put yourself in the position of the artist watching as the design took shape. Modern artists in the 1920s were fascinated by this process. The uniqueness of photograms also drew attention to the moment of origination, whereas the reproducibility of photography in general devalued the instant. Moholy-Nagy trained originally as a lawyer and moved to Berlin, where he met and married Lucia Moholy. In 1923 he was appointed head of the Weimar Bauhaus. In 1925 his important book, *Painting, Photography, Motion Pictures*, was published, in which he tried to clarify the relationship between painting and photography.

☛ **Funke, Groover, Moholy**

322

László Moholy-Nagy. b Bácsborsod (HUN), 1895. d Chicago, IL (USA), 1946. **Photogram**. 1926. Photogram.

Molenhuis Jacob

Villagers

Molenhuis's villagers are inhabitants of a state of mind unfamiliar with visual stereotypes, and thus virtually unequipped to wear any sort of a complaisant public face. In front of such portrayals, successors have no choice but to see themselves as the mannered constructs of Hollywood and the advertising industry. From time to time such formidable portraits as this one come to light. At the time of origination (unknown in this case) such pictures may have been of little interest to anyone other than the portraitist and his subjects, but over the years they begin to look exceptional – because they come to represent a culture and state of being almost unimaginable to later generations. Molenhuis himself kept a bicycle shop and ran a small photo-studio in the village of Kruisweg in North Groningen in Holland. He was the only professional photographer in the area, and left behind him 6,000 negatives of various sizes.

☛ **Disfarmer, Keita, Weber**

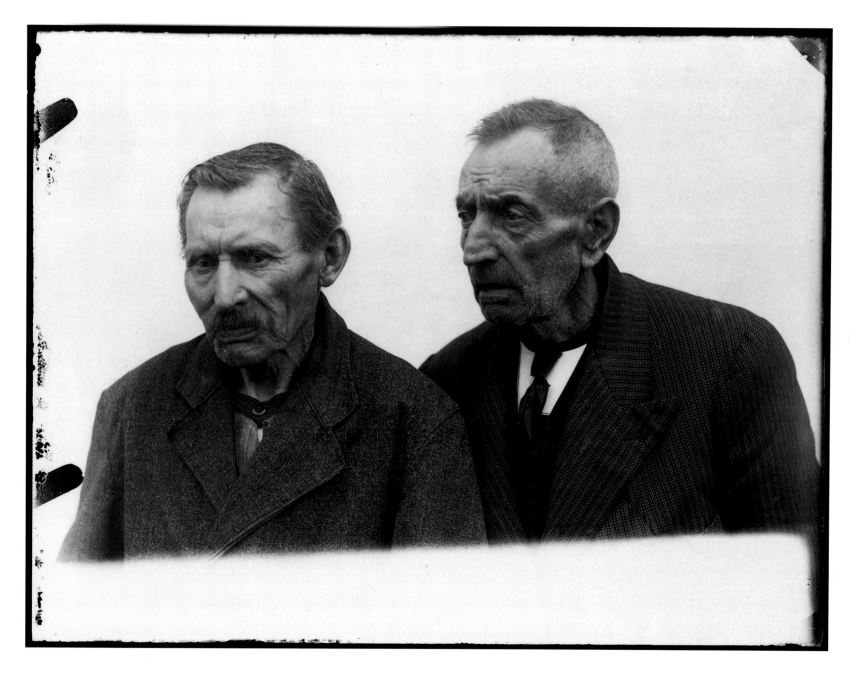

Jacob Molenhuis, **b** Kloosterburen (NL), 1894. **d** Kloosterburen (NL), 1987. **Villagers**. Date unknown. Gelatin silver print.

De Montizon Count

The Hippopotamus at the Zoological Gardens, Regent's Park

This most complacent animal is resting contentedly, secure in the belief that mankind is safely behind bars. It seems likely that the Count de Montizon intended this picture to be no more than a representation of an exotic beast which was at the time an object of great excitement in London's Zoological Gardens in Regent's Park – having been captured in August 1849 on the banks of the White Nile and sent by the Pasha of Egypt as a present to Queen Victoria. The Count de Montizon, who was a nephew of Ferdinando VII of Spain, contributed the picture to *The Photographic Album for the Year 1855*, a publication of the Royal Photographic Society's Photographic Exchange Club, and thereby secured himself an unshakeable place in the history of the medium. The Count, who was also known as Prince Juan de Borbón, moved to England permanently in 1833 following his father's unsuccessful attempt to secure the Spanish succession.

☛ Bar-Am, Höfer, Hurn

324

Count de Montizon (Juan Carlos Maria Isidro de Borbón). b Madrid (SP), 1822. d London (UK), 1887. **The Hippopotamus at the Zoological Gardens, Regent's Park**. 1852. Salted-paper print.

Moon Sarah

Morgan

Morgan Le Fay was a sorceress. According to Arthurian legend, she was Arthur's sister and spirited him away after the fatal battle of Camelot. Here, in a picture taken from Sarah Moon's book *Red Riding Hood*, she appears as a creature in a dream briefly maintained against a backdrop in a shabby street. She sustains her imaginary role in a very everyday setting. In the introduction to *Vrais Semblants*, a catalogue of 1991, Sarah Moon describes her difficult strategy, which is to start from nothing, to make up a story which is not explained and to imagine a situation which hardly exists. She wonders if she can enchant the world, even if just for a moment. In her introduction to *Unlikeness* (1991), she notes the difficulties of making pictures of 'privilege, illusion, evanescence, unlikeness and beauty; then I seek for emotion, an even more hopeless quest'. *Souvenirs Improbables* surveys her work in fashion photography up to 1981.

☞ **Alinari, Hocks, Misrach, Parr, Tress**

Sarah Moon. b Paris (FR), 1941. **Morgan.** 1985. Gelatin silver print.

Moore Charles

Birmingham

The jet of the water-cannon probes and compresses its black subjects between two white rectangles in a picture which stands as an emblem of the black/white divide at issue in Civil Rights agitation in the 1960s. Charles Moore concentrated on the Civil Rights struggle in the USA between 1958 and 1965. His first major assignment for *Life* magazine in September 1962 was on violent events surrounding the admission of the first black student, James Meredith, to the University of Mississippi under the protection of US Federal marshalls. His Civil Rights pictures are collected in *Powerful Days*, published in 1991. Moore, working mainly for *Life*, photographed the civil war in the Dominican Republic as well as political violence in Venezuela and Haiti. He covered the Vietnam War for *Life*, *Saturday Evening Post* and *Fortune* magazines. Much of his subsequent travel and documentary picture-making features Southeast Asia: Burma, Bali, Sumatra and Singapore.

☛ Halsman, D. Martin, Nauman, Richards

Charles Moore. b Tuscumbia, AL (USA), 1931. **Birmingham**. 1963. Gelatin silver print.

Moore Raymond

Pembrokeshire

Hopscotch, perhaps, on a beach in Pembrokeshire? Whatever game this chart was intended for, the right-hand side has been used less than the left. In fact, no. 1 has been almost entirely obliterated. Moore's invitation is for the viewer to imagine what it might be like to walk or hop from panel to panel, with the sea lapping indifferently in the background. All of Moore's landscapes from the 1960s and 1970s invite this sort of imagined re-enactment, as if the photographer wants to remind us of the things we tend to overlook in passing and in the spaces between the significant moments. Moore took his photographs on the outskirts of small towns or on the coastline, preferring to work in snow and mist. His pictures, like poetry, were always meant to be open to interpretation. Moore trained as a painter in the 1950s and was an especially influential teacher of photography in the 1970s.

☛ Hopkins, Kühn, Lartigue, Steele-Perkins, Vachon

Raymond Moore. b Wallasey (UK), 1920. **d** Canonbie (UK), 1987. **Pembrokeshire**. 1967. Gelatin silver print.

Morath Inge

Ox Shoeing

The ox, which looks enormous, has somehow been manoeuvred into the pen and then hoisted by means of pulleys. The site appears well used, for the tree trunk by the animal's head is rubbed free of bark. In the foreground, to judge from those iron wheels, that must be the blacksmith's handcart. If you wanted to know how to shoe an ox, or even just how they were shod in about 1950, this picture would give you a good idea, for the parts are very distinctly on display. The ox, too, shows exemplary patience, which is only matched by the indifference of the spare helper on the left. Morath's subject in the 1950s was the private realm as a site of small pleasures, encounters and tasks, all of which might be completed comfortably and quickly. Her commitment was to ordinary life – at least as it was expressed in archaic cultures – in preference to the strong political and ideological messages of the 1930s.

☛ Annan, Emerson, Howlett, Manos, Rai, Ray-Jones

Inge Morath. b Graz (AUS), 1923. **Ox Shoeing**. 1953. Gelatin silver print.

Morgan Barbara

Martha Graham: 'Letter to the World' (Kick)

'Letter to the World' was created by the dancer and choreographer Martha Graham in 1940, and it was first performed at Bennington College in Vermont, where Graham taught. Graham's radical idea about dancing was that it should return to basics and relate in particular to the ground, which classical dance had sought to transcend. Movement should take place – as here – around the centre of the body, in a series of contractions and releases. Graham's intention was to renew dancing and to make it both relevant and palatable to contemporaries. Her first masterwork was *Primitive Mysteries* (1931). She choreographed American subjects in *Frontier* (1935) and *Appalachian Spring* (1944). Barbara Morgan, who had trained as a painter, photographed Graham from the late 1930s onwards, and Graham's original world is now most widely known through Morgan's records and interpretations.

☛ C. Capa, Giacomelli, Kollar, Schuh, Siskind

329

Barbara Morgan. b Buffalo, KS (USA), 1900. d Tarrytown, NY (USA), 1992. **Martha Graham: 'Letter to the World' (Kick)**. 1940. Gelatin silver print.

Morimura Yasumasa 'Doublannage' (Dancer I)

This is a self-portrait of the photographer, who has dressed up as Nijinsky in a costume designed by Léon Bakst at the beginning of the century. The gilded training shoes are an obvious anachronism and indicate that this picture is not only about dressing-up. Morimura's subject is cultural integration, a key issue at a time when people were increasingly aware of other cultures as lifestyles to be imitated. Morimura, by imitating Manet's *Olympia*, for example, or Marcel Duchamp's alter ego Rrose Sélavy, shows that he has been culturally colonized and yet remains unmistakably Japanese and contemporary. His theme is that culture itself is hybridization, for his own imitations point to an element of imitation in the 'original'. Morimura's interests in culture as a construction were shared in Europe in the late 1980s by Joan Fontcuberta and the Dutch Fotografia Buffa artists. Morimura began to exhibit in Japan in 1983.

☞ **Dater, Fontcuberta, Kollar, Nauman, Rainer, Warhol, Wulz**

Yasumasa Morimura. b Osaka (JAP), 1951. **'Doublannage' (Dancer I)**. 1989. Mixed media. **h**240 × **w**120 cm. **h**94½ × **w**47¼ in.

Moriyama Daido Woman, Yokosuka

She is said to be a whore, as if that fact has some bearing on her predicament. She has been caught barefoot by the photographer's flash as she picks her way through the jagged debris lying in an alley. The importance of Japanese photography in the 1970s – and of Moriyama's in particular – is that it sketched out a future improvised by unidentified personnel among the ruins of a civilization. Although Moriyama's sites belong nowhere and his events crop up and are gone, his is still an ethical art, for his pictures are staged as encounters. In this case we are with the hunter, and thus implicated in whatever dark and personal work is involved. When Western photographers explored such issues as this in the 1970s they stopped short of reality, preferring to see the cataclysm as a stage play gone badly wrong. This picture originally appeared in *A Hunter*, Moriyama's book of 1972.

☛ Bellocq, Dupain, Horst, Yavno

331

Daido Moriyama. b Osaka (JAP), 1938. **Woman, Yokosuka**. 1970. Gelatin silver print. **h**34.5 × **w**26 cm. **h**13½ × **w**10¼ in.

Morley Lewis

Christine Keeler

Christine Keeler is sitting astride Arne Jacobsen's four-legged Ant Chair in a very famous image from 1963. A former model and showgirl, Keeler was involved in the Profumo affair of the same year (which nearly brought down the Conservative government). Lewis Morley, who is regarded by some to be the key photographer of the Swinging Sixties, made his name with his pictures of Christine Keeler and Joe Orton. The son of English and Chinese parents, Morley was born in Hong Kong and interned during the Japanese occupation between 1941 and 1945. The family moved to the UK after the war and Morley trained as an artist at Twickenham Art School. His first published photograph appeared in *Photography Magazine* in 1957 and he began working as a photojournalist for *Tatler* in 1958. He continued to photograph London's *beau monde* throughout the 1960s and his work appeared in a National Portrait Gallery exhibition in 1989. He now lives in Australia.

☞ Abbe, Arnold, Willoughby

332

Lewis Morley. b Hong Kong, 1925. **Christine Keeler**. 1963. Gelatin silver print.

Morris Wright

Powerhouse and Palm Tree, near Lordsburg, New Mexico

This picture is so deliberately composed that it might have been staged. Comparisons are invited between the plucked and plumed palm tree, which surely represents nature, and the blackened chimney of the powerhouse. If the tree represents nature, it also represents time, for it takes and diffuses the light by degrees. The building too, with its slats, boards and panels, functions altogether like a sundial telling the hour via cast shadows. Morris said of such pictures that they were of 'the representative structure that would speak for the numberless variations'. During 1939–40 Morris travelled 10,000 miles across the USA photographing vernacular buildings of this kind, a journey which he resumed in 1942. The result was a book of images accompanied by Morris's own texts, published as *The Inhabitants* in 1946. The fact that the pictures were meant to support commentary might explain the clarity of a composition like this.

☛ Christenberry, Meyerowitz, Ristelhueber, Scianna

Wright Morris. b Central City, NE (USA), 1910. **Powerhouse and Palm Tree, near Lordsburg, New Mexico**. 1940. Gelatin silver print.

Mortimer Francis James The Wreck (of the Arden Craig), St Agnes, Scilly

This picture of the shipwreck of the sailing vessel *Arden Craig* was taken as the grain ship went down on its way from Glasgow to Australia. Mortimer's underlying interest was in the hostile and destabilizing elements which might be countered symbolically by the figure of a lighthouse or a warship or – as here – by the composed presence of the

watchful sailor to the left of this group of survivors. Mortimer printed such pictures as this from a combination of negatives accumulated over years as a marine photographer. Much of his time was spent on editorial work for the *British Journal of Photography* (from 1904), *Amateur Photographer* (from 1908) and *Photograms of the Year* (from 1912). The Royal

Photographic Society awarded him its Progress Medal in 1944, which was also the year of his death. He was fatally injured by a German V-1 flying bomb which destroyed the London bus on which he was a passenger.

☛ Arbuthnot, Hurley, Le Gray, Oorthuys, Ulmann

334

Francis James Mortimer. b Portsea (UK), 1874. **d** London (UK), 1944. **The Wreck (of the Arden Craig), St Agnes, Scilly**. 1911. Chlorobromide print.

Munkacsi Martin

Children at Kissingen, Germany

These children at a kindergarten in Kissingen seem, from the look of them, to be aware of the photographer. They are enjoying the sun with their teachers, some of whom can be glimpsed beyond the wires. In 1937 Munkacsi explained why he considered this to be his best photograph. He thought that it depicted the 'hopeless fate of human beings: their similarity to the fate of herrings, pressed into a barrel, or pressed in a city, minus air, with no horizon – freedom on paper only, and not in fact – with duties made by themselves, or imposed by leaders, to hold them in a certain manner'. Looking back, Munkacsi regarded his picture, which was originally published in the *Berliner Illustrierte Zeitung*, as a premonition of totalitarian Europe. Munkacsi left Budapest for Berlin in 1927 and soon established himself as an energetic stylist who liked to work from such acute angles as this. Between 1933 and 1940 he worked for *Harper's Bazaar* in New York.

☛ **Arbus, Gerster, Glinn, Krull, Ruscha, Salgado**

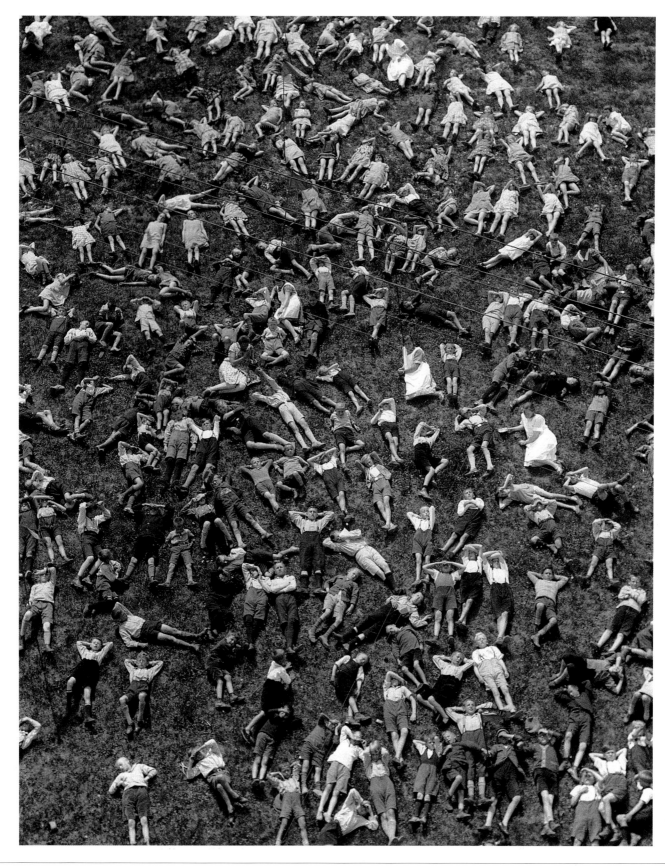

Martin Munkacsi. b Cluj (ROM), 1896. **d** New York (USA), 1963. **Children at Kissingen, Germany**. 1929. Gelatin silver print.

Muray Nickolas

Soldiers of the Sky

The girl's vivid lipstick is necessary as a signal of her femininity. Aviators' outfits in the 1930s isolated the face and could sometimes give an ambiguous impression. Another problem at the time was that such heroic imagery, designed to exhort the people, was associated with totalitarian regimes in Russia, Germany and Italy. Cosmetics, though, introduced a saving glamour and linked war service with Hollywood. By the time he took this photograph, Muray was the best-known celebrity portraitist in the USA. He had originally trained as an engraver in Hungary before moving to America in 1913. In 1921 he began to take portraits for *Harper's Bazaar*, and by 1925 he was famous. He was known as a master of the colour carbro process – as used here. Glamorous himself, he won the US National Sabre Championship in 1927, and represented that country at the Olympics. During the war Muray served as a flight lieutenant in the Civil Air Patrol.

☞ Eggleston, Iturbide, Lele, Patellani, Yevonde

336

Nickolas Muray. b Szeged (HUN), 1892. d New York (USA), 1965. **Soldiers of the Sky**. 1940. Colour carbro print.

Muybridge Eadweard J. Attitudes of Animals in Motion, Horses, Trotting, Edginton, No. 34

As the horse moved forward, it broke taut threads which activated the shutters of twelve cameras placed 53 cm (21 in) apart. The horse was travelling at 131.25 m (40 ft) per second in front of a segmented, numbered screen, and the exposures were taken in less than half a second. To photograph a horse in motion had been an ambition in photography, and it was successfully accomplished by Muybridge in conjunction with Leland Stanford, the railroad magnate, at Palo Alto in California in the late 1870s. Muybridge worked at Palo Alto between 1878 and 1880, photographing animals and then human beings in motion. The next step was to use such pictures to make a moving image, and Muybridge experimented along those lines in the 1880s with a device he called a zoopraxiscope, but he left the development of that idea to Thomas Edison, the inventor of the phonograph. In 1884 Muybridge began to work under the aegis of the University of Pennsylvania.

☛ Bragaglia, Caponigro, Le Querrec, Manos, E. Smith

Eadweard J. Muybridge (Edward James Muggeridge). b Kingston-on-Thames (UK), 1830. d Kingston-on-Thames (UK), 1904. **Attitudes of Animals in Motion, Horses, Trotting, Edginton, No. 34**. 1879. Photoprint.

Mydans Carl

Mother and Children

The barefoot mother is attending to her younger child, whilst the children – more easily distracted and responsive to the instant – look towards the cameraman. They are living in a one-room hut on an abandoned Ford chassis on US Highway No. 70 in Tennessee. Mydans took this picture while working for the documentary project set up in 1935 for the Resettlement Administration in the US Department of Agriculture. In 1936 he left to join the newly established *Life* magazine. Mydans's outlook – very evident here – was that of a reporter rather than a documentarist. He was interested, that is to say, in the passage of time and in time's events, even if they were quite small events such as this one. What makes this into an exceptional image is the correspondence between the careworn face of the mother and her son's calm expression. Between the one pristine state and the other stand all those anxieties represented in the figure of that agitated child.

☛ **Lange, Lyon, Owens, Seymour, Stoddart**

338

Carl Mydans. b Boston, MA (USA), 1907. **Mother and Children**. 1936. Gelatin silver print.

Mylayne Jean Luc

A swallow, caught very briefly in passing, has just left its nest. Mylayne has focused on the farm landscape beyond, and registered the bird almost as an emblem of flight, oddly striated in the sunlight. Mylayne's interest is less in Nature's residents for their own sakes than in how they might be perceived from a human standpoint. A swallow on the wing, for instance, epitomizes haste. Taken in any other way the bird would look unnatural, like a taxidermist's specimen. The result, in this case, is an image of a startled moment, barely noticed but true to perception. Mylayne's pictures are referred in general terms to the time of year, August-September in this case, because his intention is also to evoke a seasonal feeling: the stillness of a hot summer's day, for example, on a quiet farm shaded by trees. The bird complements and even completes a mood implicit in the landscape beyond.

☞ Fontcuberta, Hosking, Lanting, Vilariño

339

Jean Luc Mylayne. b (FR), 1946. august-september. 1992. C-type print. h100 × w100 cm. h39½ × w39½ in.

Nachtwey James

A Croat Soldier Fires from an Abandoned and Destroyed Apartment

A Croatian soldier is firing on Muslim positions from the window of an abandoned apartment in Mostar. Mindful of the domestic values under assault in wartime, Nachtwey has set the scene in a deserted bedroom. The whole ensemble, with its focus on the fussy, technical lines of the light fitting outlined against the ceiling, and in the wider context of that darkening space, stages the gunman's focused vision and its fatal consequences. Nachtwey, whose work was collected in 1989 to great effect in *Deeds of War*, is the most expert of war reporters and probably one of the few ever to have been interested in war itself, or in those fundamental moments when aim is taken, as here, and consciousness lost. Nachtwey has received such honours as the Robert Capa Gold Medal (four times) for his war reporting, much of it carried out in the most dangerous news zones: Afghanistan, Lebanon, Nicaragua, Northern Ireland, El Salvador, Sri Lanka and Chechnya.

☛ E. Adams, Clark, Gaumy, Jackson

340

James Nachtwey. b New York (USA), 1948. **A Croat Soldier Fires from an Abandoned and Destroyed Apartment**. 1993. Gelatin silver print.

Nadar

Jean-François Millet

Nadar praised Millet as being 'one of the most sincere talents of the French school', and portrayed the painter thus – as Jove in a frock coat. Nadar's importance can hardly be over-estimated, for in an outstanding series of portraits made between the mid-1850s and the 1870s he put on record an image of French cultural nobility to which the nation continued to turn for

assurance. Working without props in natural light inflected by mirrors and screens, Nadar allowed his subjects to act as they saw fit – which was most often with the kind of romantic *gravitas* seen here. Described in a police dossier as 'one of those dangerous characters who spread highly subversive doctrines in the Latin Quarter'. Nadar served as a journalist and kept

bohemian company in the 1840s. Baudelaire, Daumier and Jules Verne were among his many friends. In the 1860s and 1870s he gained even greater renown as a balloonist and advocate of 'Heavier-than-Air Machines'.

☞ Brady, Burke, Carjat, Hoppé, Hubmann, Strand

Nadar (Gaspard Félix Tournachon), b Paris (FR), 1820. d Paris (FR), 1910. **Jean-François Millet**. c1860. Salted-paper print.

Nauman Bruce

Self-Portrait as a Fountain

The photographer, who imagines himself to be a figure on a fountain, is projecting a thin jet of water towards the camera. Nauman's ambition, formed early on in his career, was to make things charged with personal meaning, which literally meant using his own body in photographically recorded performances. *Self-Portrait as a Fountain* is one in a series of eleven colour photographs dating from 1966–7. The others illustrate puns and clichés such as *Feet of Clay* (feet daubed with clay) and *Eating My Words* (edible letters on a plate). Nauman was fascinated by the straightforward objects and ideas which might be exhibited and even accepted as art. He forswore sophistication, although there is an echo in this piece of Marcel Duchamp's famous exhibited urinal of 1917 which was entitled *Fountain*. It was during the 1960s, and partly because of Nauman's example, that photography and sculpture began to draw closer together.

☛ **Morimura, Rainer, Richards, Warhol, Witkiewcz, Wulz**

342

Bruce Nauman. **b** Fort Worth, IN (USA), 1941. **Self-Portrait as a Fountain**. c1966. C-type print.

Nègre Charles

Chimney-Sweeps Walking

Chimney-sweeps, who advertised their services with a monotonous cry, were a distinctive feature of autumn in the city. This scene – which looks so authentic, until you check on the steps taken by the trio – was arranged and photographed in 1851 on the Quai Bourbon in Paris, where Nègre had a studio just around the corner from that of Honoré Daumier. Even though a picture like this might have been intended simply as a study for a painting, it is nonetheless important in the history of the medium – principally because it seems to announce photography's long-standing preoccupation with the capturing of movement in an instant. Like several of the pioneer photographers, Nègre had trained as a painter in the studio of Paul Delaroche. He took up photography in the late 1840s, and in 1854 his photographic study of the Midi was published. In 1861 he retired to Nice, where he spent his time making portraits and views for holidaymakers.

☛ Coburn, Franklin, Ronis, Sander

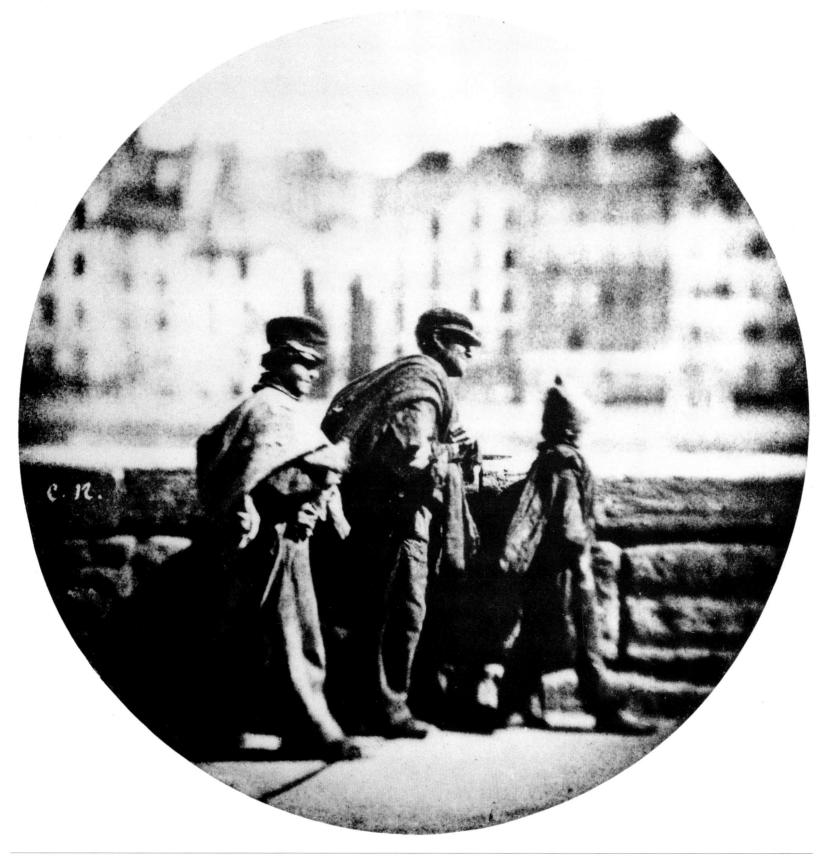

343

Charles Nègre. b Grasse (FR), 1820. **d** Grasse (FR), 1880. **Chimney-Sweeps Walking**. 1851. Albumen print.

Newman Arnold

Georgia O'Keeffe, Ghost Ranch, New Mexico

The skull and horns of the bighorn sheep above were among the painter Georgia O'Keeffe's favourite motifs; the sky, too, with its pure clouds and resonant distances recalls the blue distances in her pictures. O'Keeffe herself, seen in profile against an empty canvas, even looks like a figure in one of her own compositions. Any American artist such as Newman setting out in the 1940s must have been well aware of such authoritative and legendary careers as that of Georgia O'Keeffe, a major symbolist and even a former lover of Alfred Stieglitz, the great prophet in art photography. Newman, who trained in Philadelphia, responded to art's prestige by portraying artists in context, with reference to careers accomplished and marked out by a style and an iconography. In 1946 he moved from Philadelphia to New York, where he continued to specialize in artists' portraits and to work for the major magazines, including *Life* and *Harper's Bazaar*.

☛ Blume, Cameron, Furuya, Hoppé, Stieglitz

Arnold Newman. b New York (USA), 1918. **Georgia O'Keeffe, Ghost Ranch, New Mexico**. 1968. Gelatin silver print.

Newton Helmut They are Coming

The title, *Sie kommen*, sounds portentous in German, as if these girls are vanguard elements in an invading army. They wear their skin as if it is a costume to which they are more or less indifferent. Having absented themselves as personalities, their portraits become specimen pictures, anthropological and anatomical studies. The problem faced by performers and

major public artists in the 1970s and 1980s was that of appearing in public without being used up by the event. Thus Newton's major models put themselves on show as impassively as if they were, for instance, posing for Andy Warhol, who was also a Newton subject in 1976. Newton's interest in masking and in acting recalls the ways of Berlin photography in the

1920s. Brought up in Berlin. Newton trained in a portrait studio there before going to Australia in 1940. In 1956 he began to work for English *Vogue*, and since the 1960s he has been recognized as one of the world's leading fashion photographers.

☞ Abbe, Koppitz, Rheims, Warhol

345

Helmut Newton. b Berlin (GER), 1920. **They are Coming.** 1981. Gelatin silver print.

Nichols Michael 'Nick' Mr Jiggs

Mr Jiggs, got up in a wristwatch and braces, is performing for a slightly apprehensive public at a Fireman's Ball. Mr Jiggs (who is actually a female) is billed as 'the world's smartest chimp', and when the picture was taken had been with her owner, Ronny Winters, for twenty-seven years. She lived uncaged in her owner's house, with her own bedroom and refrigerator. Mr Jiggs

was the only adult performing chimp ever encountered by Nichols, a specialist photographer of wildlife. His projects reflect the disruption of the natural order and the loss of something precious. In 1988 he produced *Gorilla: Struggle for Survival in the Virungas*, on a nearly extinct species of mountain gorillas living on the borders of Rwanda and Zaire. In 1993 *The Great*

Apes: Between Two Worlds appeared, on the relationship between man and the great apes. In 1996 Nichols published *Keepers of the Kingdom*, on the revolution in America's zoos. Since 1996 he has been a staff photographer with *National Geographic*.

☛ Ray-Jones, Skoglund, Stern, Wegman

346

Michael 'Nick' Nichols. b Florence, AL (USA), 1952. **Mr Jiggs**. 1991. C-type print.

Nilsson Lennart

A Human Foetus at Three Months

A human foetus in its early stages occupies its placenta against a background which seems to have been drawn from Creation in the galaxies. Birth and childhood figured in the 'Family of Man' exhibition of 1955, but at that time they were seen as preliminaries to adult life. Nilsson's pictures from the womb, which he began to take in the early 1960s, situate life on a

grander scale altogether, and suggest that humanity should think of a new destiny among the stars. In the 1940s and 1950s, Nilsson worked as a reporter for the Swedish magazine *Se* and for the Black Star agency. Even then he was attentive to life as biology. Around 1960 he determined to record the human embryo in its stages of development. The project, with

the help of *Life* magazine, took four years to complete, and the results were published to worldwide astonishment in that magazine and in the Swedish *Idun* in the summer of 1965.

☛ Arnatt, Wojnarowicz

Lennart Nilsson. b Strängnäs (SWE), 1922. **A Human Foetus at Three Months**. 1973. C-type print.

Nixon Nicholas

Sam with Bebe

This is a picture of an affectionate gesture. The arms are those of Bebe Nixon and the face that of Samuel Hunter Nixon, who was born in November 1983. The picture vouchsafes intimate knowledge: her skin texture, for example, and the brace on his teeth. The viewpoint is the son's, whose response is that of a delighted child. Photography usually keeps an objective distance, for the sake of analysis. Pictures taken at a more intimate range ask us to put ourselves in another's position and to be, rather than simply to understand, the other. This has been Nixon's practice as a documentary portraitist since the early 1980s and is seen in his close-ups of ageing people and of family members. His art of the 1980s and 1990s reflects a feeling that established styles of documentary have become complacent and even remote. In 1975 he participated in the important 'New Topographics' exhibition at George Eastman House in Rochester, New York.

☞ Davidson, Goldin, Minkkinen

348

Nicholas Nixon. **b** Detroit, MI (USA), 1947. **Sam with Bebe**. 1996. Gelatin silver print.

Notman William

Campfire Scene

This picture was taken in a studio in Montreal, and is one of the series of photographs of Canadian outdoor activities with which Notman made his name. The light of the campfire came from a magnesium flare, and the snow in the foreground was most likely salt. Notman explained how his pictures of Canadian life were contrived in his studio on an old carpet on which he could pile timber, build cottages, spread sandy beaches with boats drawn up, erect tents, plant trees and simulate snowy plains, frozen lakes and icebound rivers. Although Notman made any number of portraits of notables and of ambitious architecture, he is celebrated because of the challenge to perception embodied in pictures such as this one – pictures in which the illusion asks to be tested, and quickly reveals itself for what it is. He moved from studio installations in the 1860s to elaborate composite photography in the 1870s and 1880s. In 1861 Queen Victoria named him 'Photographer of the Year'.

☛ Abbas, O'Sullivan, Tsuchida

349

William Notman. b Paisley (UK), 1826. **d** Montreal (CAN), 1891. **Campfire Scene**. 1866. Albumen print.

Oddner Georg

Meal Time

A boy is guiding a blind beggar across the cobbled stones of a courtyard in Peru. He may be leading him towards the photographer, for the beggar is carrying his hat in front of him in readiness. The event, which Oddner made into one of the most complex of all concerned photographs in the 1950s, has any number of biblical connotations. The meal in the background could suggest the Last Supper or the marriage feast at Cana in Galilee, when Christ turned water into wine. The beggar, one might say, is making his approach in the hope of some small miracle, and the ladder propped against the wall makes an allusion of sorts to the Crucifixion. European reporters in the years after World War II were easily reminded of the road to Golgotha, and Oddner found his source of such reminders in underdeveloped South America. Having worked as a jazz musician between 1946 and 1949, Oddner became a freelance photographer in 1951.

☞ **Atwood, Barbey, Scianna, Shahn**

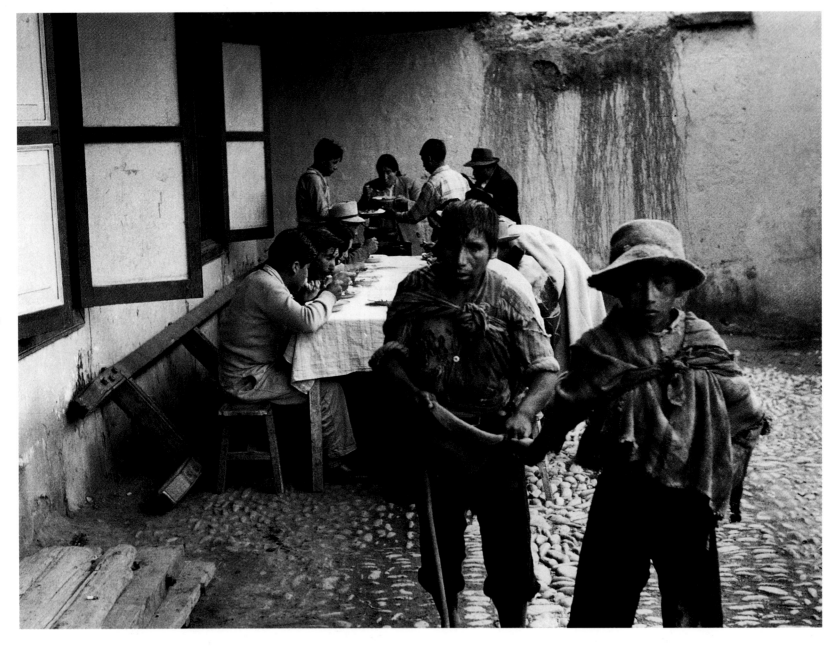

350

Georg Oddner. b Stockholm (SWE), 1923. **Meal Time.** 1955. Gelatin silver print.

Ohara Ken

One

How do you or can you respond to this kind of portrait? It shows eyes, eyebrows, nose and lips. Other people deserve privacy, or are given the chance to appear even slightly civilized beneath styled hair or above a shirt collar. Basic features soon make the individual into a type, and ask the viewer to do no more than make classifications. This picture appeared in 1970, in *One*, Ohara's famous book of close-up portraits, all of them done to this strict format. There are in fact hundreds of such pictures in *One*, each occupying a full page. In his introduction Ohara declares: 'I want people to get bored looking at it. When people get bored that's when the essential comes in.' The essential would involve wondering about one's responses to such inexpressive pictures. Ohara showed the way to a new generation of photographers worried about the way in which humanist photography in the 1940s and 1950s was based on compassion.

☛ Callahan, Florschuetz, Hubmann, Lendvai-Dircksen, Sherman

351

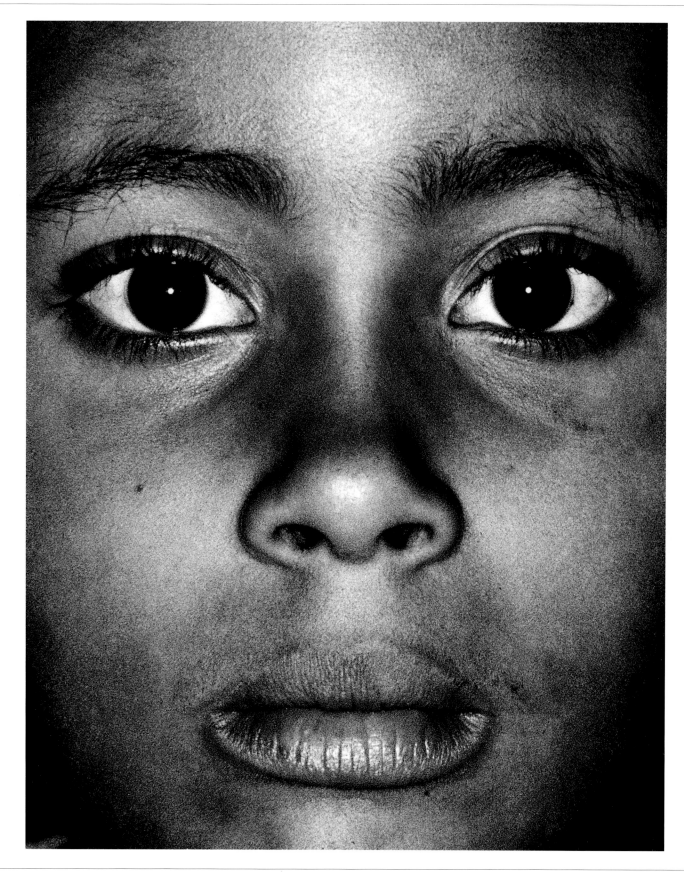

Ken Ohara. b Tokyo (JAP), 1942. **One**. 1970. Gelatin silver print.

Oorthuys Cas

Rotterdam Harbour

Smoke and steam mingle, drift and disperse across the busy skyline of Rotterdam harbour. Big ships lie moored by the quayside and in the middle the tug *Europa* and a companion begin to ease a cargo boat from her berth. In the foreground a launch passes across the scene, making waves and spray. Oorthuys, who was the most prolific of all Dutch photo-reporters in the 1940s and 1950s, was doing no more than taking a picture to commemorate one of the last missions of an archaic steam tugboat, but in the process he succeeded in expressing the varied dynamics of a complex industrial site. The picture asks for involvement, in response to the different kinds of energy and movement represented. Oorthuys's subject, in a long career, was energy as expressed on the streets and in the workplace, as you might expect of a photographer active during the 1930s in Arfots, the Dutch Association of Worker Photographers.

☛ Berry, Le Gray, Mortimer, Sutcliffe

352

Cas Oorthuys. b Leiden (NL), 1908. **d** Amsterdam (NL), 1975. **Rotterdam Harbour**. 1952. Gelatin silver print.

O'Sullivan Timothy H. Shoshoni

This group of Shoshoni Indians, who look as though they are wearing bartered outfits, seems unsure of the event which is taking place and its significance. The scene could even be an extract from a diorama of the kind which used to be made up to celebrate major national events. Not far beyond the group, the landscape, which is noticeably out of focus, begins to look like a painted backdrop. In addition, the shadow of the photographer, with his right arm raised as though he is conducting events, enhances the feeling of contrivance. Even so, things have not gone quite according to plan, for the wind has shaken and blurred the flags, as if to represent the impact of the adventitious in history. O'Sullivan, who had spent five years working for Mathew Brady's studio and taking photographs near the front during the American Civil War, took this picture while working on a subsequent geological survey of the American West.

☞ **Brady, Chambi, Curtis, Gutmann, Marubi, Notman, Rejlander**

Timothy H. O'Sullivan. b New York (USA), 1840. **d** Staten Island, NY (USA), 1882. **Shoshoni.** c1870. Gelatin silver print.

Outerbridge Paul Nude Woman Wearing Meat Packer's Gloves

This picture looks like an obscenity, with those cruel spikes in contact with the woman's exposed flesh. Certainly it is a perverse picture, but mainly because of the way in which Outerbridge has infiltrated technicalities into an ostensibly Surrealist subject. The fingers in both gloves are evenly spread and straight, which means that they are only laid on her skin.

Thus the two central spikes impact on the breast in such a way as to show its curvature, and so one breast is realized whereas its counterpart is simply represented. In the same way the points on the other glove accentuate the curvature of the waist which is given more abstractly in outline on the right. This is a laborious way of reflecting on form, but since 1925 Outerbridge

had been working in Paris in close association with Marcel Duchamp, Man Ray and others in the avant-garde movement and so he was well aware of everything Surrealism meant. He enjoyed a long, varied and successful photographic career.

☞ Man Ray, Mapplethorpe, Mather

354

Paul Outerbridge. b New York (USA), 1896. d Laguna Beach, CA (USA), 1958. **Nude Woman Wearing Meat Packer's Gloves**. 1937. Three-colour carbro print. **h**39 x **w**25 cm. **h**15 ¼ x **w**9 ¾ in.

Owens Bill

We're really happy. Our kids are healthy, we eat good food and we have a nice home.

There is no reason to disbelieve these people's statement or to imagine that the photographer has taken them at anything other than face value. This family appeared in Bill Owens's *Suburbia* (1972), a watershed publication and the first of a four-part project set primarily in the Alameda County area of California. The other books are *Our Kind of People* (1975), *Working [I Do it for the Money]* (1977), and the yet-to-be-published *Leisure*. Documentarists had previously taken it for granted that they should report on marginals and others difficult of access. Owens, however, decided to report on the middle classes and to encourage them to comment in their own words. The pictures were disturbing, leaving critics and audiences unsure of their reactions. *The Los Angeles Times* commented that the work 'rouses pity, contempt, laughter and self-recognition'. Owens's influence was immense during the 1970s, especially with respect to the kind of portraiture-by-agreement on show here.

☞ Depardon, Lange, Mydans, Seymour

355

Bill Owens. b San Jose, CA (USA), 1938. **We're really happy. Our kids are healthy, we eat good food and we have a nice home.** 1972. Gelatin silver print.

Özkök Lütfi

Portrait of Samuel Beckett

Beckett's is one of the best-known faces in culture. Mapped thus, it stands for experience. A cigarette might have tipped the balance towards worldliness, but spectacles stand for judgement and analysis. Özkök came to photography out of necessity. While working as a literary translator in Stockholm, he was asked to provide pictures with his translations and he found that the only way to obtain them was to take them himself. His cast eventually came to include most of the great writers of the Beckett era, including Char, Duras, Milosz and Neruda. A poet himself, Özkök got to know Beckett well. In interviews Özkök speaks appreciatively of work in the darkroom 'dans la solitude et la silence'. Colour photography he dismisses, saying '...la photo en couleur c'est du caramel'. Marriage to a Swedish woman first took him to Stockholm in 1950, where he has remained. His wife says of him that he cannot act, adding, 'That is why the writers like him'.

☞ Feininger, Freund, Hubmann, Moholy, Rodchenko

Lütfi Özkök. b Istanbul (TUR), 1923. **Portrait of Samuel Beckett.** 1966. Gelatin silver print.

Paneth Friedrich Adolf Pyramid Entrance

The woman, who is most likely Paneth's wife Elsa Hartmann, is a European on tour in Egypt, and thus appears isolated in her own space. The Egyptian guide, on the other hand, belongs to that place, and shows himself to the camera as an anthropological specimen. Together, the two figures constitute a human measure against which the scale of the Pyramids can be estimated. Paneth, an amateur photographer, is much better known as the Director of the Max-Planck Institute for Chemistry in Mainz during the 1950s. A radiochemist, Paneth was working in Vienna and Glasgow just before World War I broke out – at around the time when this picture was taken. He was involved in geo-chemical studies of the upper atmosphere, cosmo-chemistry and nuclear physics. During the 1920s he made important researches into the age of meteorites. He left Germany for England in 1933.

☛ Du Camp, van der Elsken, Kales, Michals, Saudek

Friedrich Adolf Paneth. b Vienna (AUS), 1887; **d** Mainz (GER), 1958; **Pyramid Entrance**. c1914. Autochrome.

Parker Olivia

Pods of Chance

'A row of peapods, alike in structure but alive in their variation, fascinates me. A row of plastic flowers identical in their structure but dead in their sameness would hold little appeal – unless they had been chewed by my dog, varied, altered by living energy.' Thus Olivia Parker introduced her book *Signs of Life* in 1978. The still lifes for which she is famous were made with a view camera, contact printed on silver chloride paper and toned in selenium, so that they look like old pictures which have been subjected to the attentions of time. The guiding idea of this most philosophical of artists is that pictures should be made which represent reality's transitions in a world made up 'of fine balances and thin edges: small variation within fragile structure, delicate membranes, narrow temperature and pressure tolerances'. Parker studied Art History at Wellesley College in Massachusetts, graduating in 1963.

☛ Blossfeldt, Groover, Penn, Sougez, Tosani

Olivia Parker. b Boston, MA (USA), 1941. **Pods of Chance**. 1977. Selenium-toned silver contact print. **h** 18 × **w** 13 cm. **h** 7 × **w** 5 in.

Parkinson Norman

New York, New York

This exuberant couple express the vitality and energy of New York City, which was on its way to becoming a Mecca for photographers in 1955. One of the most famous fashion photographers, Parkinson began his career as an apprentice to the court photographers Speaight and Sons. In 1934 he opened his own studio in London and by 1935 he was working for

Harper's Bazaar. He was amongst the first fashion photographers to start taking fashion shots out of doors in the 1930s and he remained a realist throughout his career, saying: 'My women behaved differently ... my women went shopping, drove cars, had children, kicked the dog.' Employed mainly by *Vogue* after 1945 Parkinson developed his and the world's taste

for outdoor and location fashion pictures. He kept pace with the growing post-war interest in travel and adventure photography. He also pioneered the use of colour in fashion photography in the 1940s.

☛ Bevilacqua, Longo, Meyerowitz, Towell, Veder

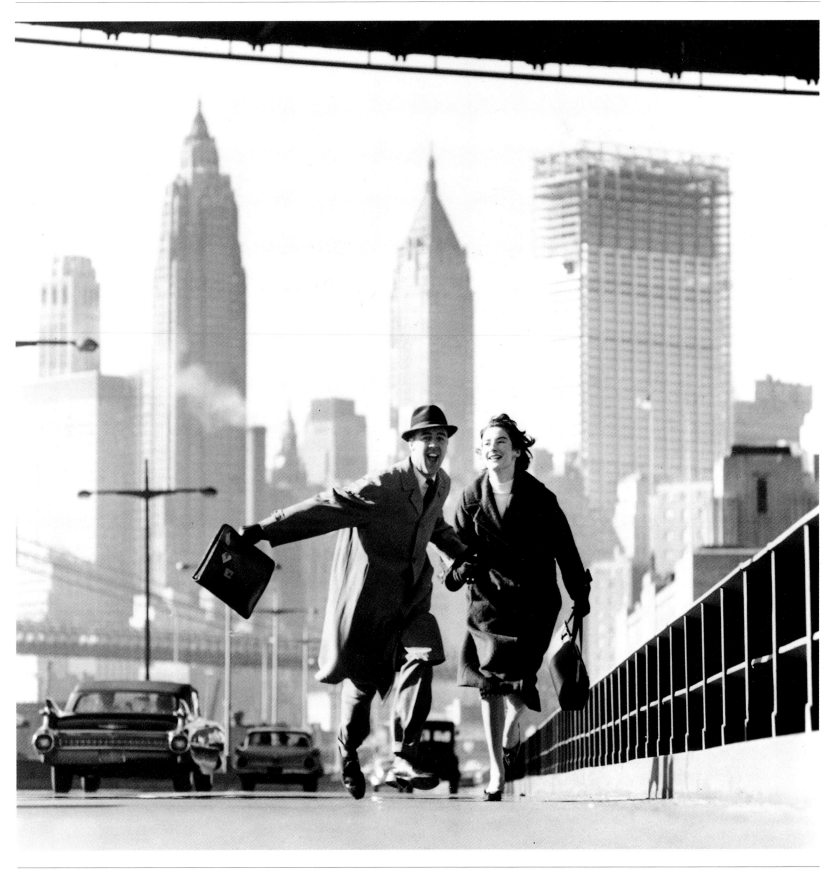

Norman Parkinson. b London (UK), 1913. **d** Tobago (WIN), 1990. **New York, New York**. 1955. Gelatin silver print.

Parks Gordon

Red Jackson in The Harlem Gang Story

The shattered window pane on the right reflects Red Jackson's state of mind. Jackson, the star of the film *The Harlem Gang Story*, was a Harlem gangleader and part of a violent culture, even though he is looking oppressed and thoughtful here. Social disadvantage was an important subject for Parks, who – as a black man making his way in a white man's profession – had experience of hardship and discrimination. After beginning his career as a nightclub pianist, semi-professional basketball player and railroad waiter, he took up photography in 1937 before being accepted by the Farm Security Administration documentary project in 1942. In 1944 he went to work as a documentarist for Standard Oil, which was a major patron of photographers at that time. Parks flourished and was taken on as a staff photographer for *Life* magazine in 1948. He went on to become a successful film director, his most notable film being *Shaft* of 1971.

☛ **diCorcia, Lee, W. E. Smith, A. Webb**

Gordon Parks. b Fort Scott, KS (USA), 1912. **Red Jackson in The Harlem Gang Story**. 1948. Gelatin silver print.

Parr Martin

Bethlehem, Israel

The three kings or wise men are processing across a bare landscape interrupted only by an electric socket. The site is a restaurant waiting for customers, and the place is Bethlehem in about 1990. The picture first appeared in a collection of 1995 entitled *Small World: A Global Photographic Project, 1987–1994*, which was devoted to the phenomenon of world tourism at such major venues as the Pyramids in Egypt. Parr has been preoccupied throughout the 1980s and 1990s with the establishment of an international language of consumption: palm trees on tee-shirts, soft drinks motifs, airline logos and the rest. Whereas in Bethlehem the painter was familiar with the look of camels and desert vegetation, for the most part Parr's icons of tourism are studio-based inventions which have been repeated and generalized for everyday use everywhere. His perception is that the spread of this code of clichés has such an impetus as to be irresistible.

☛ **Misrach, Moon, Tress**

361

Martin Parr. b Epsom (UK), 1952. **Bethlehem, Israel**. c1990. R-type print.

Patellani Federico

The Lazio Plain

The war is over, and this elegantly dressed young woman seems to be reflecting on whatever the impressive airplane wreckage might represent of brave days and lost men. Between the wars Italy exemplified modernity and dynamism, which suggests that Patellani's choice of a gutted plane and a woman reclining on ragged stubble is meant to signify a cancellation of that old pictorial order. When he took this picture Patellani was on the staff of the *Corriere Lombardo*. In 1946 he returned to *Tempo*, an illustrated magazine which had been founded in 1939 by the Mondadori family. In his reports for *Tempo* Patellani re-visualized Italian life along the kind of archaic lines denied in the modern era. In this rediscovered country peasants and priests took the places once occupied by athletes and aviators, and its celebrities were no longer the politicians and military men of the 1930s but instead the producers, directors and writers of the new age.

☛ **Appelt, Demachy, Eggleston, Muray**

362

Federico Patellani. b Monza (IT), 1911. **d** Milan (IT), 1977. **The Lazio Plain**. 1945. Gelatin silver print.

Pécsi József

Avant-Garde

Two impassive figures, of the kind often found in the new photography of the late 1920s, are confronting each other across a darkened space. Pécsi's suggestion is that it may only be one figure gazing into a mirror, but a comparison soon disposes of that idea. His leading lady hams it up for the camera as she ducks down to make space for the avant-garde drama behind her. The new style – already very familiar by 1932 – can be put on, as in a game. Pécsi, however, was from an older and deeper school and had grown up with the sombre intent style of portraiture typical of that era. The problem with the objective modern manner, as expressed and parodied here, was that it belonged to a new generation and deliberately made no allowances for inwardness and spiritual values. Nevertheless, Pécsi did become an important practitioner and teacher of all the new styles which emerged between the wars.

☛ Dührkoop, Fuss, Kertész, Pierre et Gilles, Tingaud, Willoughby

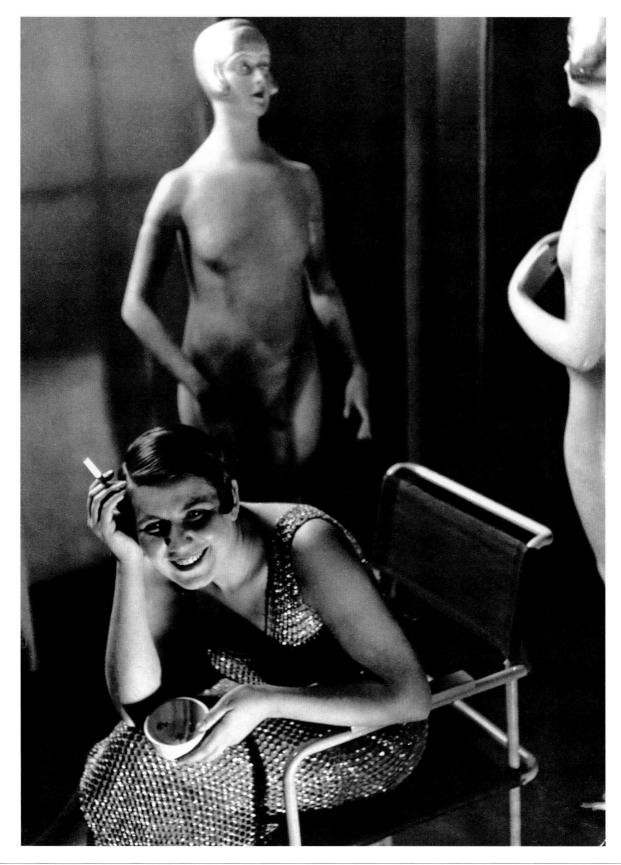

József Pécsi. b Budapest (HUN), 1889. **d** Budapest (HUN), 1956. **Avant-Garde**. 1932. Gelatin silver print.

Penn Irving

Cigarette No. 17

In reality half-smoked and discarded cigarettes would smell terrible. Here, though, they begin to seem both more and less like themselves. Penn, well known as a fashion photographer since at least 1943 when he began to work for *Vogue*, has always been attracted to points of interchange, where due to a switch of context the prosaic begins to appear glamorous and vice versa. The other-worldliness of high fashion, for example, is made strange by being shown in the street, as strange as street life might be if it were brought into the studio. In 1951, for example, *Vogue* published his *New York Small Trades* portraits, which show longshoremen and others from an unsavoury side of the city seen in isolation in natural light against plain studio backdrops. His interest in vernacular motifs and their context was shared by the Pop artists of the 1960s. In the series of cigarette pictures his strategy of creating strange images is taken to an extreme.

☛ **Blossfeldt, Groover, Parker, Tosani**

Irving Penn. b Plainfield, NJ (USA), 1917. **Cigarette No. 17**. 1972. Platinum print.

Peress Gilles

Tabriz, Iran

The event, a demonstration on behalf of the Ayatollah depicted on the placard, is just getting underway and the demonstrators have no proper focus for their attention. They look here and there, talk amongst themselves or merely wait. Peress's celebrated pictures from Iran, published as *Telex Persan* in 1984, are those of a witness reporting primarily on his own experiences of an event centred elsewhere. History was in the making, but his own encounters were often with such people as these, people who made up the numbers or acted small parts in the great event. He remarks on commemorative portraits and inscriptions, on the kind of details which say something about the consciousness of Iranians caught up in affairs which are as mythic as they are actual. Peress's other preferred site has been Belfast. His report on the ethnic cleansing in Bosnia was published as *Farewell to Bosnia* in 1994 and on the genocide in Rwanda in the early 1990s as *The Silence* in 1995.

☞ Izis, P. Martin, Walker

Gilles Peress. b Neuilly-sur-Seine (FR), 1946. **Tabriz, Iran**. 1980. Gelatin silver print.

Pierre et Gilles

The Devil (Marc Almond)

The devil, played by the British pop singer Marc Almond, is gesturing modestly in response to the putto's advice. Pierre takes the photographs and these are then enhanced by Gilles, originally a painter and collagist. Marc Almond, who has been their subject several times, describes it as 'a theatrical experience involving props, sets, costumes, make-up,

performance and attitude'. Recognizing the world at large to be brutish, Pierre et Gilles have set themselves the task of creating an alternative universe, beautifully transformed, in which the devil himself is easily abashed and even overcome by good conscience. The reduction of their identities to Christian names has prompted the suggestion that they see themselves as

magicians. Their sources lie in popular religious imagery and in the vernacular art of India. In the 1980s they produced album sleeves, for Boy George among others.

☛ **Fuss, Kertész, Pécsi, Steichen**

Pierre et Gilles. Met in 1976. **The Devil (Marc Almond)**. 1989. Painted photograph.

Pinkhassov Gueorgui Tokyo, Japan

Men in Japan inhabit a room dappled with shadow. What they are doing cannot be determined, and it is hard even to distinguish substance from shadow. Pinkhassov is in the forefront of reportage in the 1990s, because of an approach which is engrossed by the idea of impediments to clarity. His portraits, made for editorial use in periodicals, are almost always interrupted by shadow. Sites no longer make spatial or thematic sense as they once did; people come and go in his pictures but for no good or discernible reason in social settings difficult to determine. His first reports in the early 1990s were on the dissolution of the USSR, on tanks in Vilnius and on voting in Russia. He continued to report on Russia's post-communal world, and it is that failure to make sense which has coloured his subsequent style. He has been attracted to cultures in transition and to cities remarkable for their sub-cultures: Moscow in the early 1990s, then Prague, and Shanghai and Tokyo in 1996.

☞ van Manen, A. Webb

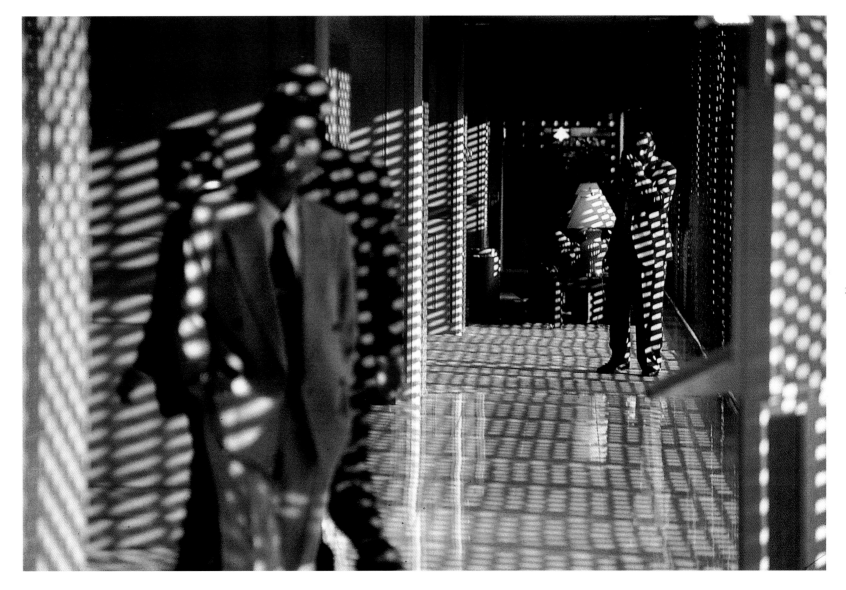

Gueorgui Pinkhassov. b Moscow (RUS), 1952. **Tokyo, Japan.** 1997. C-type print.

Plossu Bernard

Egypt

Two women, seen from an approaching car window, are walking along a road on the way to market on a misty morning. Like many of Plossu's images taken on the road, this is a very precise evocation of an event met with in passing which arouses a certain amount of curiosity, but which will soon fade into oblivion. Otherwise he remarks on encounters with people at crossroads, bus stops and in villages, or in the kinds of places where there are sufficiently few people to make the meeting noteworthy, even if it will never produce anything like a decisive moment. In an anthology of 1986 he gave prominence to a quotation by Malcolm Lowry: 'I'll never forget that day, though the photographs didn't come out' – as if his own pictures were mere accompaniments to travel, establishment images and no more. Plossu is the author of *Le Voyage Mexicain 1965–1966* (1979) and *Voiles d'Afrique* (1984).

☛ Hamaya, McCurry, Sella, Vachon

Bernard Plossu. b Dalat (VIET), 1946. **Egypt**. 1977. Gelatin silver print.

Post Wolcott Marion Mrs Lloyd and Miss Nettie Lloyd

The younger woman, Miss Nettie Lloyd, is a pellagra victim. She is seen sitting in the company of her ninety-one-year-old mother, who had been resident in the house since her marriage sixty-nine years before. Pellagra stems from vitamin deficiency and can result in insanity. Post Wolcott, one of the most scrupulous and tender of the documentarists to work for the American Farm Security Administration, asks her audience in this – as in many of her pictures – to attend closely to particular rather than to representative lives. Everything about the picture keeps the lives of the two women before us. Scattered leaves and a turkey feather might invoke an airy lightness, but those heavy stones at the door and the planks put down against the mud of autumn enact more awkward physical difficulties – as do her subjects' muddied shoes. Post Wolcott withdrew from photography in 1942 because of commitments to her children.

☛ Lange, Lee, Magubane, Rothstein, Vachon, Weegee

369

Marion Post Wolcott. b Montclair, NJ (USA), 1910. **d** Santa Barbara, CA (USA), 1990. **Mrs Lloyd and Miss Nettie Lloyd**. 1939. Gelatin silver print.

Prince Richard Untitled (Cowboy)

A cowboy is riding through a Wild West landscape, probably as part of an advertisement for a cigarette company. This figure appears in *Spiritual America*, Prince's book of American icons which was published in 1989. Prince's originals are Ektacolor photographs taken from posters, magazine illustrations and television screens. His extracts from popular culture are presented without comment and often include cartoons with their captions, as well as news items. Altogether Prince reconstructs an idealized American consciousness fixated on advertising imagery, to the point at which 'reality' seems to disappear completely. Many of his pictures appear blurred and out of register, which is a way of showing that they have been taken in through the air and in passing – as if they belong to an actual landscape affected by the weather. He is careful to stress that his America is haphazardly remarked on, although he likes its wilder extremes, as represented by the bikers who are the subject of his 1993 book, *Girlfriends*.

☞ Allard, Cranham, Le Querrec, Liebling, E. Smith

370

Richard Prince. b Panama Canal Zone (USA), 1949. **Untitled (Cowboy)**. c1982. Ektacolor print. **h**69 × **w**102 cm. **h**27¼ × **w**40¼ in.

Rai Raghu

Chhota Udaipur in Gujarat State

The man in white standing on the left is Ranchod Patel, one of ten sons who inherited a share of a forty-acre farm – on which Ranchód was supporting a family of seven. The caption in *National Geographic* raises questions about Indian farming – for there are more than four acres under continuous cultivation here. But Rai's interests are theoretical as well as practical, and have as much to do with registering human importance as with farming. Without the two stabilizing and inactive figures in white on either side of the picture, those working the land would feature only irregularly in relation to each other. Rai's response to the problem of picturing India has been to situate its distances and numbers within such measures as these two men. The result is that his subjects, including even the least significant stone gatherers, appear to take their places on a known scale of things.

☛ Franklin, Morath, Salgado, Ueda

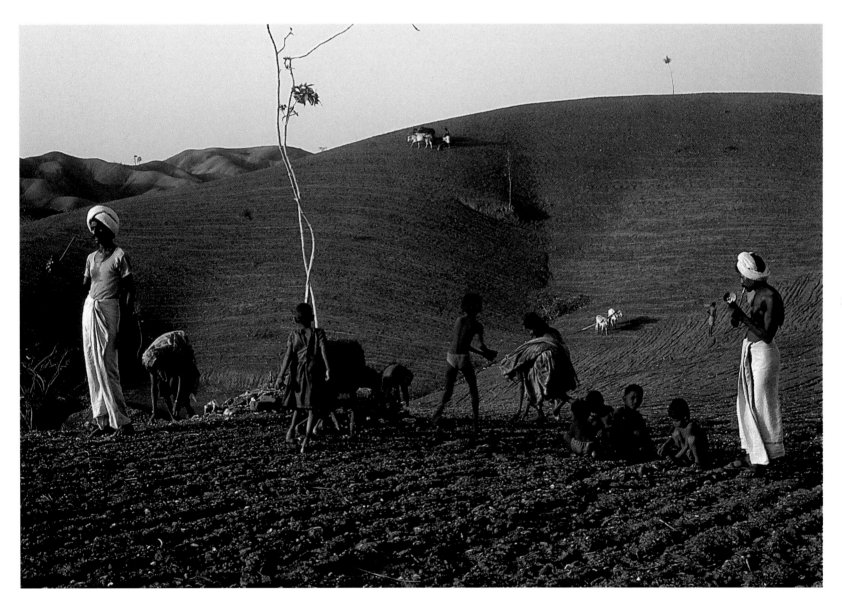

Raghu Rai. b Jhang (PAK), 1942. **Chhota Udaipur in Gujarat State**. 1988. C-type print.

Rainer Arnulf

Angst (Portrait of the Artist)

Rainer, his head thrown back, is grimacing for the camera. Rainer's main subject has always been himself, seen as an actor in extreme situations, comic or tragic. His first photographic self-portraits were made in a passport photo-booth in Vienna's main railway station in 1968–9. His idea was that acting in front of the camera would call up 'dormant, or psychopathic, reserves of energy'. Then in the 1970s he began to supplement the photographs with violent over-drawing, to reveal new and unexpected personages within himself. In the 1970s he called the portraits *face-farces*. The grimaces in these portraits are projected outwards, and they are affronts meant both to engross and to keep others at a distance. Even though they are expressionist in appearance, Rainer's photographs also recall European art in the 1920s, when the face was often imagined as a mask rather than a window onto the soul.

☛ Morimura, Nauman, Warhol, Witkiewicz, Wulz

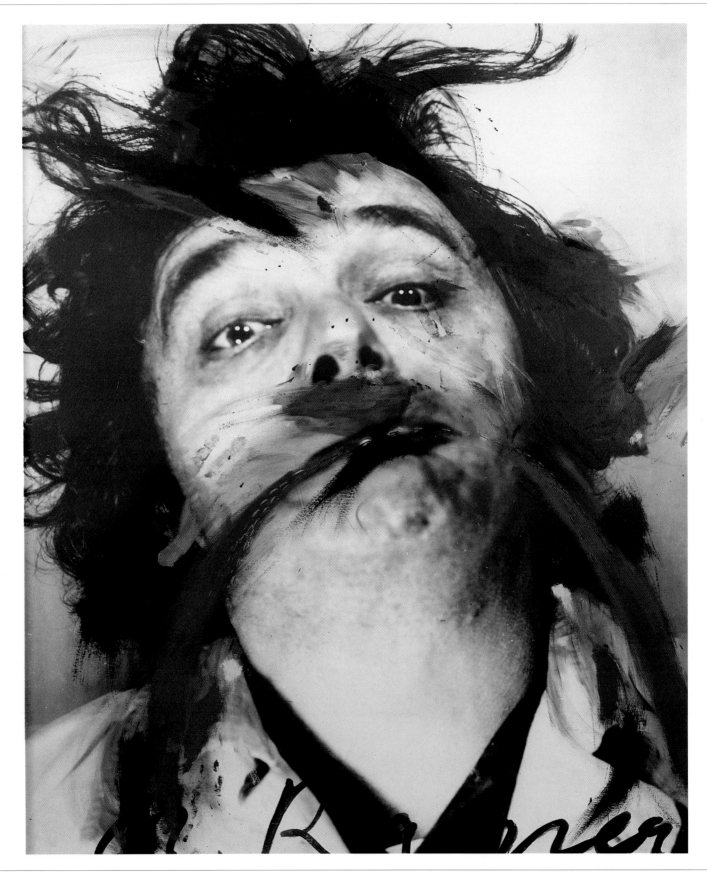

Arnulf Rainer. b Baden bei Wien (AUS), 1929. **Angst (Portrait of the Artist)**, c1971. Oil paint on photograph. **h**120 × **w**88 cm. **h**47¼ × **w**34½ in.

372

Ray-Jones Tony Glyndebourne

A ha-ha, or grass ditch, separates the picnickers from the field of cows beyond. This photograph was taken at Glyndebourne, the English opera house set in the Sussex countryside, and it testifies to an English predisposition for making arrangements. It also speaks of insularity, or of introverted, self-contained lives in contrast, for example, to the far more expressive world of the cattle. English life was Ray-Jones's subject during the 1960s, seen to some degree as it might have been by the *Picture Post* photographers of the 1940s. He had trained in the USA with the very influential Alexey Brodovitch and, partly because of that background, envisaged English life less in terms of action than as a series of stilled tableaux. There was also less pressure on young British photographers in the 1960s to report affirmatively on the state of the nation, and correspondingly more space to reflect on society, to look beyond its surfaces and into the kind of structures revealed here.

☛ Morath, Nichols, Skoglund

373

Tony Ray-Jones. b Wells (UK), 1941. **d** London (UK), 1972. **Glyndebourne**. 1967. Gelatin silver print.

Reed Eli

Marion Barry with Dick Gregory

In what is one of the USA's most suggestive political portraits, Marion Barry, then a Washington, DC councilman, is shown in conversation with Dick Gregory, the comedian and political activist. There are other shadowy parties out of the frame. At the time the picture was taken, Barry was making a political comeback. He had formerly been Mayor of Washington but was filmed smoking crack cocaine in January 1990 and sentenced to a year's imprisonment. Presumably Reed had something of this melodramatic history in mind when he took this picture. Not only does Gregory, looking like the Ancient Mariner, have an urgent case to put, but the third party too, gesturing eloquently off screen, seems convincing – and all the more so in that ghostly form. Principally a reporter, Reed is best known for his books *Beirut: City of Regrets* (1988), based on time spent in that city in 1983–4 and 1987, and *Black in America* (1997).

☛ Aigner, Bosshard, Karsh, Lessing, Salomon

374

Eli Reed. b Linden, NJ (USA), 1946. **Marion Barry with Dick Gregory**. 1993. Gelatin silver print.

Régnault Henri-Victor The Banks of the Seine Near Meudon

With its marked sense of calm, this picture looks English – or at least Turneresque – and may possibly reflect Régnault's interest in the pioneering methods of English photographers. The long exposure time has made the river look immobile and even conceptual, which may be why it is paralleled by the broad path to the left, its surface marked by dappled light and gradients.

Not only do the familiar frontages of the houses recall humans, but those planks (so conspicuously placed) and the moored barge in the foreground carry their own implications of labour and create a dichotomy in the picture between the world of dreams and the real world. Régnault was a physicist and a chemist by profession and a professor in the Collège de France.

Between 1852 and 1871 he was director of porcelain manufacturing at the Sèvres factory. His interest in photography dated from its earliest days and he exhibited at the London Society of Arts in 1851.

☛ **Oorthuys, Silvy, Sutcliffe**

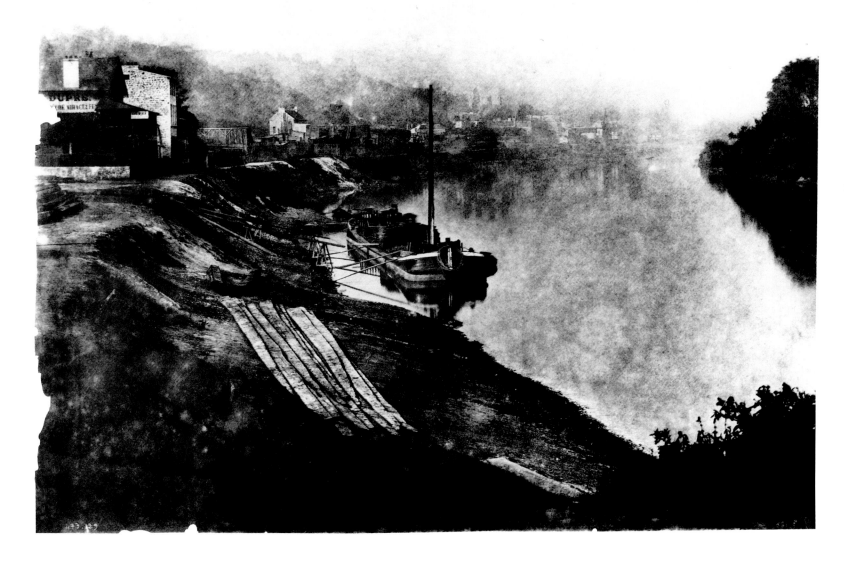

Henri-Victor Régnault. **b** Aix-La-Chapelle (FR), 1810. **d** Paris (FR), 1878. **The Banks of the Seine Near Meudon**. 1850. Calotype.

Rejlander Oscar Gustav The Two Ways of Life

The elderly gentleman in the centre is serving as an arbitrator or guide to the young man, who is faced by two ways of life, one virtuous and one vicious. The youth is listening out for the siren song of vice, while also approaching virtue with his eyes closed. This picture was made in 1857 using thirty-two wet collodion negatives, and its composition was borrowed from Raphael's

The School of Athens, in which the painter contrasted Science with Philosophy. Rejlander had worked as a portrait painter in the 1840s in Rome, where he had copied the Old Masters. On setting up in England, he thought that something similar could be achieved in photography. For this picture he used models from a group known as the Pose Plastique Troupe, who were

used to staging *tableau-vivant* versions of statues and groups from paintings. Queen Victoria bought one of the very few copies printed. However, the picture caused much controversy because of Rejlander's assemblage techniques and use of nudes.

☛ Chambi, Marubi, O'Sullivan, Tsuchida

376

Oscar Gustav Rejlander. b (SWE), 1813. d London (UK), 1875. **The Two Ways of Life**. 1857. Brown carbon print. **h**40.9 × **w**76.8 cm. **h**16 × **w**30¼ in.

René-Jacques

Madame Rayda

Perhaps Madame Rayda's claim to be able to interpret photographs attracted René-Jacques. The scene is rich in matter for interpretation and was discovered in the Rue Vilin, in the old-fashioned Belleville-Ménilmontant area to the north-east of Paris where Willy Ronis was also taking pictures in the late 1940s. Ronis's vision, however, was altogether more genial than that of René-Jacques, who liked to envisage Paris as an uncanny environment of dark and usually empty streets inhabited at best by such people as the watchful Madame Rayda. His disillusioned style and taste for deep, impersonal spaces evolved during the 1930s, when he was commissioned to take photographs to illustrate Francis Carco's text.

Envoûtement de Paris (Spell of Paris), published in 1938. René-Jacques's romantic style, with its intimations of solitude, abandonment and yearning, stood in sharp contrast to the sociable documentary which was the norm in post-war France.

☛ **Frank, Meatyard, Ronis**

René-Jacques (René Giton). b Phnom Penh (CAM), 1908. **Madame Rayda**. c1945. Gelatin silver print.

Renger-Patzsch Albert Crab Fisherwoman

This fisherwoman made an interesting photographic subject because she holds a net whose meshes calibrate the space around her figure. The net, its mesh distorted by various forces, invites a very deliberative scan, as if one were a scientist taking readings. Thus the artist has tried to force the viewer into a slow, scientific way of seeing, at odds with the instant gratifications of the new

culture of publicity. Renger-Patzsch was especially attracted by patterned surfaces in nature and in culture, by anything linked, scaled or meshed, and saw enough affinities between human artefacts and nature's products to suggest that the two creative processes had a common root. He came to fame largely because of his book of 1928 entitled *Die Welt ist schön* (The World is

Beautiful), a book whose optimism regarding craftsmen has continued to influence German photographers. Renger-Patzsch was a leading light in the Neue Sachlichkeit (New Objectivity) movement of the 1920s and early 1930s.

☛ **Bar-Am, Collins, Hosoe**

Albert Renger-Patzsch. b Würzburg (GER), 1897. d Wamel bei Soest (GER), 1966. **Crab Fisherwoman**. 1924. Gelatin silver print.

378

Rheims Bettina Acrobats II

The acrobat, who almost looks as though she is supporting her own lower limbs, is watching the camera attentively as if to check that this is the required pose, and thus the picture stands mainly as a record of an event and an encounter. It comes from the series which established Rheims as a portraitist. The actress Catherine Deneuve, another of Rheims's subjects, writing in the introduction to *Female Trouble* of 1991, describes 'a remarkable atmosphere of confidence' and tells how the subject's eye maintains 'its own expression, its freedom, its own life'. One difficulty with nude photography is that personality tends to be degraded in the presence of nakedness. Rheims's nudes and other figures seem, by contrast, to be so absorbed in such games as this that their nudity becomes incidental. Her portraits are of people in control. If we are to participate in their world it is by invitation and under sufferance, or on the understanding that it does not belong to us.

☛ Charbonnier, Koppitz, Maar, Newton, Rodger

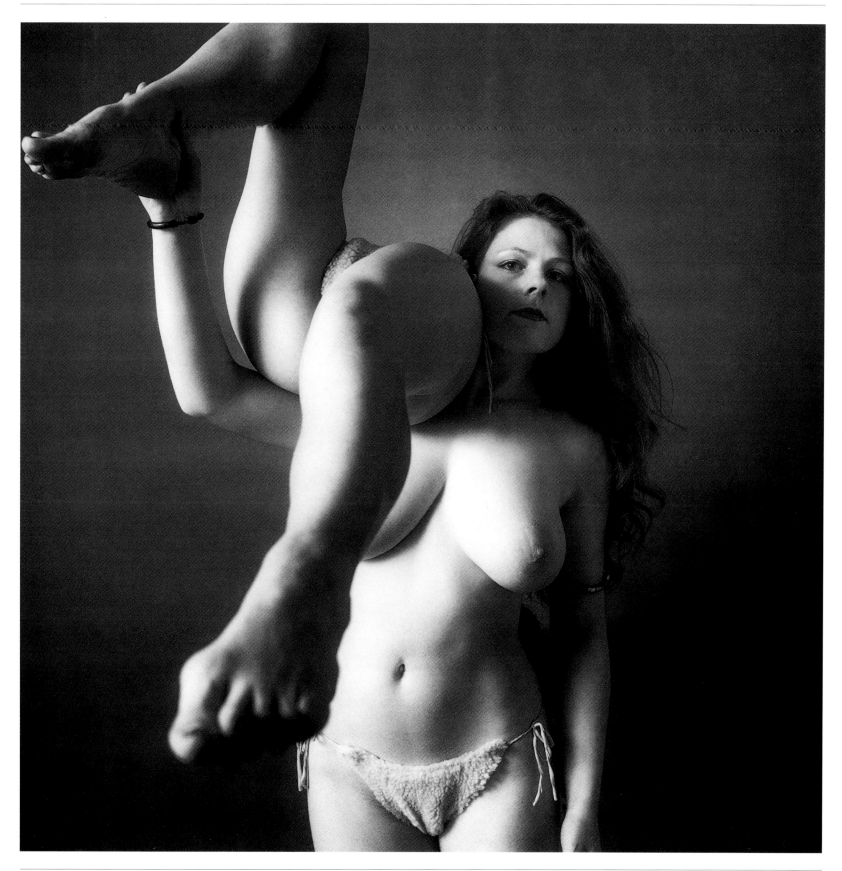

Bettina Rheims. b Paris (FR), 1952. **Acrobats II**. 1981. Gelatin silver print.

Riboud Marc

A Street in Old Beijing

In a street of antique shops called Liu Li Chang the gilded inscription to the left reads 'Prosperity'. It is the sign for a state art business which sold precious stones, tapestry and porcelain. Riboud recalled that in the crowded streets it was difficult to take pictures without attracting attention, which explains why he has hidden himself away. Yet passers-by still seem aware of him, at least those not wrapped up in family affairs. The outcome of this varying awareness, and of the division of the picture into a of six framed scenes, is that the people of Liu Li Chang emerge as individuals in a series of informal portraits. Riboud held to the view that individuality in China survived the persistence of ideology, and showed itself in the kind of glances and small transactions carried out here. He photographed at length in China, returning on several occasions. Several important books resulted, including *Capital of Heaven* (1990) and *Forty Years of Photography in China* (1997).

☞ **diCorcia, Genthe, Haas, Marlow, Zachmann**

Marc Riboud. b Lyons (FR), 1923. **A Street in Old Beijing**. 1965. Gelatin silver print.

Richards Eugene

Grandmother, Brooklyn

This photograph of a Hispanic grandmother at play was taken on a street running beneath the Manhattan Bridge – the bridge that connects Manhattan to the borough of Brooklyn. It was a white hot summer's day; the family was seeking relief from the heat. Originally Richards passed by, feeling like an intruder, then he returned. When the girl poured water on him he felt at home, part of things. Richards said it was a relief to photograph joy, rather than the sorrow witnessed so often. One of photography's most single-minded documentarists, Richards has always aimed for immediate access to victimized individuals, pictured and interviewed in such books as *Below the Line: Living Poor in America* (1987) and *Cocaine True Cocaine Blue* (1994)

– the latter on the crack cocaine epidemic in New York and Philadelphia. His first book was *Few Comforts or Surprises: The Arkansas Delta* (1973) and amongst his other publications is *The Knife and Gun Club: Scenes from an Emergency Room* (1989).

☛ Halsmann, C. Moore, Nauman

Eugene Richards. b Boston, MA (USA), 1944. **Grandmother, Brooklyn**. 1986. Gelatin silver print.

Riefenstahl Leni

Two Wrestlers

Two Nuban wrestlers are dusting themselves with ash, or *weega* in their language. The white ash, made from burnt twigs, is said to invest its wearers with strength and good health, and it also helps protect the skin from insects and vermin. These men appear in *The Last of the Nuba*, which was first published in 1976 with extensive texts by Leni Riefenstahl herself. Between 1962 and 1969 she made many visits to Nuban tribes in central Sudan, prompted in part by George Rodger's famous picture of Nuban wrestlers. Her study of these Mesakin Nuba people takes in most aspects of their culture: agricultural, dietary and religious. Intentionally or not, she succeeds in creating a picture of lives lived in harmony with nature and according to long-established traditions. One of photography's authentic celebrities, Leni Riefenstahl starred in several major German films in the late 1920s and early 1930s. In 1934 she directed *The Triumph of the Will*, a nationalist classic.

☛ Eakins, Hoff, Rio Branco, Rodger

Leni Riefenstahl. b Berlin (GER), 1902. **Two Wrestlers**. 1962. C-type print.

Riis Jacob

An Ancient Lodger in Eldridge Street with the Plank on which she Slept

The woman stands with her eyes closed, perhaps out of shame but more probably as a defence against the flashlight powder which Riis used when taking his photographs in the slums and cellars of New York City. The subject matters less as a personality than as an example, together with the board and the damaged wall. It was especially disgraceful that a woman, the symbol of family values, should have been so reduced that she was living a miserable existence in a cellar. Riis emigrated to New York in 1870 and in 1877 he became a police reporter for the New York *Tribune*. He became aware of the terrible conditions facing immigrants and decided to devote himself to reform. The invention of flashlight photography in 1887 made it possible for him to record the darker corners of the slums and to work at night. His book, *How the Other Half Lives* (1890), was the first book of its kind to be illustrated with photographs.

☛ **Cumming, Hockney, Rodchenko, Weegee**

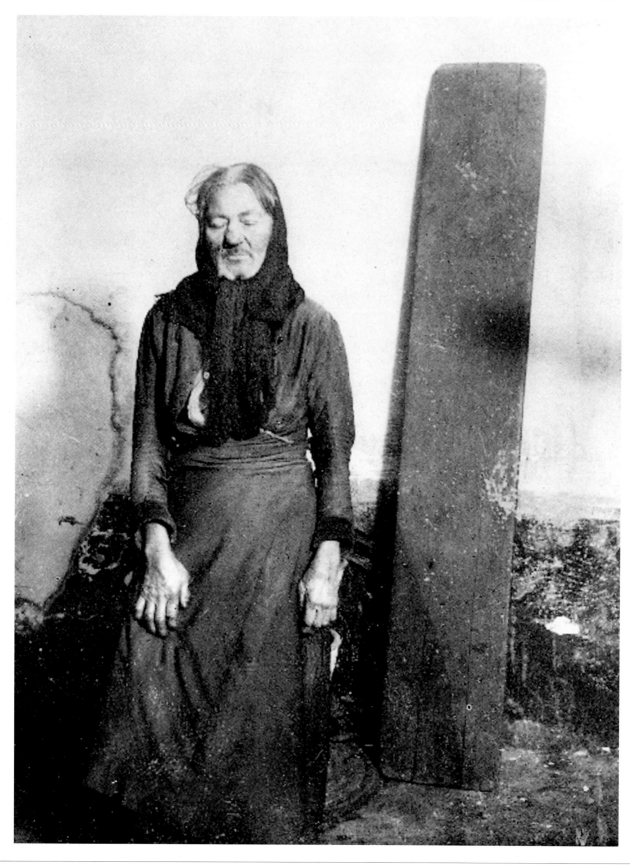

Jacob Riis. b Ribe (DK), 1849. **d** Barre, MA (USA), 1914. **An Ancient Lodger in Eldridge Street with the Plank on which she Slept.** c1890. Gelatin silver print.

Rio Branco Miguel

Academia Santa Rosa Boxing Club

Silhouetted against the sky blue wall, the boxer looks like an outlined emblem of boxing. His right hand, rather than making a fist, encircles the blue of the background and rhymes with the white light framed by the mirror, as if the photographer meant to play with the elements at his disposal. The most obvious symbol of bulk – although it also rhymes with the mirror and the hand – is that discarded truck tyre dumped in the centre of an otherwise elegant environment. Rio Branco's colour photography – as perfectly exemplified here – proposes that the world's savoury raw material, if attractively coloured and textured, can be saved for art by fastidious inscriptions and gestures of the kind performed by the fingers of the boxer's right hand. A film-maker and painter, as well as a still photographer, Rio Branco became an influence in colour photography following the publication in 1985 of eighty of his photographs in *Dulce Sudor Amargo*.

☞ Eakins, Gichigi, Hoff, Riefenstahl, Rodger

384

Miguel Rio Branco. b Las Palmas (SP), 1946. **Academia Santa Rosa Boxing Club**. 1993. C-type print.

Ristelhueber Sophie The Equator

This is a picture of an idea. The equator may be no more than a concept learned from a globe in the classroom, but concepts guide perception and here on the terrace of an abandoned café on the island of Sao Tomé in the Gulf of Guinea, it is as if the idea of the equator has determined the appearance of the site. It looks as though the line of the equator has been drawn in and put to use on that rusting furniture: perhaps those diving platforms and the lights were erected to help in the search for the elusive line. Landscape photography, with which Ristelhueber has been associated since the late 1970s, is a contentious subject. On the one hand, there are those who assume that photography is capable of objective impersonal records and is inhospitable to the imagination, and then there are others who assume the opposite: that it provides just another opportunity for imaginations well-stocked in advance with such irresistible ideas as that of the equator.

☛ Morris, Scianna

385

Sophie Ristelhueber. b Paris (FR), 1949. **The Equator**. c1992. C-type print. **h**100 × **w**130 cm. **h**39¼ × **w**51¼ in.

Ritts Herb

Madonna

Madonna looks like an animated version of Marilyn Monroe, and dresses in this picture as if James Dean were her boyfriend. The habit of posing against pale, flat backgrounds had been established in the 1950s and 1960s by Irving Penn and by Richard Avedon, and it often stood for victimhood. The subject had nowhere to go and had to make do with whatever resources of spirit the moment had to offer. Madonna's acting is a response to that format, and an assertion that she is equal to the moment. The Warhol response of the 1970s had been one of impassivity, but Madonna – representative of a new aesthetic – took a different approach, adapting and changing with the occasion. Herb Ritts, one of the best-known celebrity portraitists of the 1980s and 1990s, is especially associated with the magazine *Rolling Stone*, in which this portrait originally appeared. His major book on *Africa* was published to critical acclaim in 1994.

☛ Avedon, Cameron, Penn, Silverstone, Warhol, Yevonde

Herb Ritts. b Los Angeles, CA (USA), 1952. **Madonna**. 1987. Gelatin silver print.

Robinson Henry Peach　　The Lady of Shalott

Dying or perhaps already dead, the Lady of Shalott is drifting downstream towards Camelot. The photograph is based on Alfred Lord Tennyson's poem of the same title in which the lady is confined to a tower where she lives in seclusion. She has been condemned to see life only as reflected in her mirror but when she catches sight of the splendid Sir Lancelot going past on horseback, she loses control and whirls around to face reality. The result is her instant death. The theme, of contact with the world through pictures, would have been absorbing for any picture-maker and was much favoured by the Pre-Raphaelite Brotherhood, including Millais. This is a composite image and has been printed from two negatives. Exposure times in 1861 could not be adjusted to make such relatively complex scenes on a single plate. Robinson began to make composite prints in 1858, under the tuition of Oscar Rejlander, and soon established himself as Britain's leading art photographer.

☛ Bayard, Kalvar, Luskačová, Rejlander

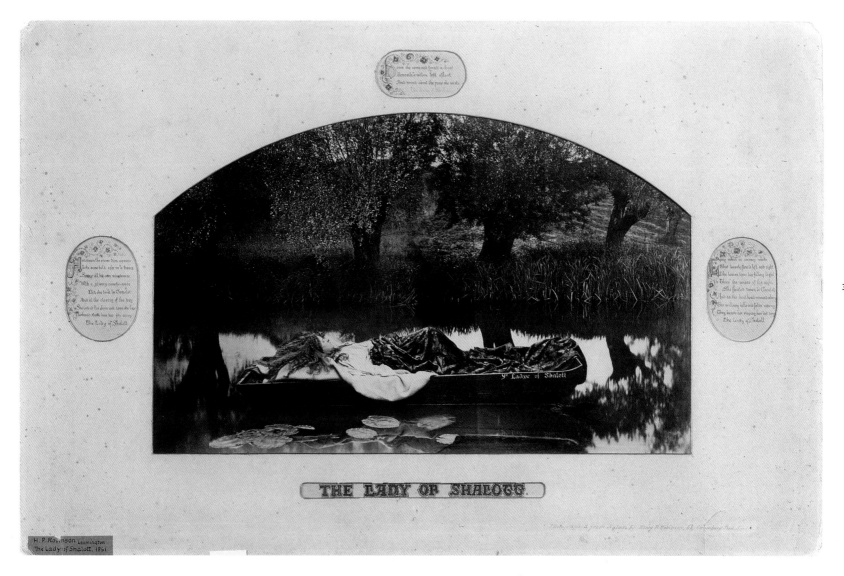

Henry Peach Robinson. b Ludlow (UK), 1830. **d** Tunbridge Wells (UK), 1901. **The Lady of Shalott.** 1861. Albumen print.

Rodchenko Alexander Portrait of Mother

How has she arranged the wire handles of her spectacles? They must have been twisted oddly to look like that. If she had been merely wearing them, this would have been no more than a picture of an elderly woman in glasses, but arranged thus it is a photograph of a woman with a lens, and even a picture of 'sight'. That impression is further heightened by the dotted fabric of her headscarf, which begins to look like a screen for an eye test. Rodchenko was one of the cleverest of photographers, and an adept at spatial play: views down and across ambiguous patterned surfaces, steps and paving stones. Originally a painter and designer, he began to take photographs in 1924, after working on Dziga Vertov's weekly newsreel *Ciné Eye*.

Between 1923 and 1928 he worked on the magazine *Lef* (Left). Although his dynamic style fell into disfavour in the late 1920s, he was employed on reportage projects for the influential periodical *USSR in Construction* from 1933 onwards.

☛ Beaton, Hockney, Lerski, Moholy, Riis

Alexander Rodchenko. **b** St Petersburg (RUS), 1891. **d** Moscow (RUS), 1956. **Portrait of Mother**. 1924. Gelatin silver print.

Rodger George

Korongo Nuba Wrestlers of Kordofan, South Sudan

The victor, dusted with ceremonial wood ash, is riding in dignified triumph on the shoulders of a burly companion. This pair appear in *Le Village des Noubas* (1955), Rodger's account in words and pictures of a journey through Kordofan. Rodger's was a new and influential vision of African life, which had never before been projected by any western photographer in such heroic terms. The village Nubans were dwellers in a cultural paradise of the kind cherished by European documentarists after the traumas of the war. Rodger also broke away from the agrarian and feminine stereotypes usual in African reporting. A co-founder of the influential Magnum Photos in 1947, Rodger was an official war correspondent with *Life* magazine. He recounted the war in *Desert Journey* and in *Red Moon Rising*, both from 1943, and on campaigns in North Africa and Burma. His career in photography was surveyed in *Humanity and Inhumanity* in 1995.

☞ Eakins, Hoff, Rheims, Riefenstahl

George Rodger. b Hale (UK), 1908. d Smarden (UK), 1995. **Korongo Nuba Wrestlers of Kordofan, South Sudan**. 1949. Gelatin silver print.

Ronis Willy

Rue Laurence Savart

The point, discreetly made in this picture, is that the glazier is carrying transparency on his back up the Rue Laurence Savart, and even that transparency casts a shadow. But Ronis does not insist on clever turns of phrase, for they would detract from the tranquillity of the street and the glazier's concentration on the task in hand. This picture was taken between 1947 and 1951 and published in Ronis's 1954 *Belleville-Ménilmontant*, the most genial topographic survey in the history of the medium. Ronis's topic was an old-fashioned working-class area in the north-east of Paris, and his subject the habitation of sympathetic urban spaces, courtyards and alleyways. In the style of Eugène Atget, who was the lodestar of Parisian documentarists in the 1940s, little happens beyond the daily round, but after the excessive action of 1939–45 that was only to be relished. In 1948 Ronis joined the Parisian Groupe des XV, set up in 1946 by René-Jacques, among others.

☞ **Atget, Franklin, Nègre, René-Jacques**

390

Willy Ronis. b Paris (FR), 1910. **Rue Laurence Savart**. c1949. Gelatin silver print.

Rosenthal Joe

Iwo Jima

A group of American marines – larger than you might think necessary for such a slender flagstaff – is raising the national colours on Mount Suribachi on the island of Iwo Jima, towards the end of World War II. With their faces turned away, the men have become, in effect, unknown soldiers, and thus representative figures. This picture is a national icon, and has inspired a famous statue now standing in Arlington Cemetery, Washington DC. However, the photograph has also caused some controversy since the moment captured is actually the second time the flag was raised. The first occasion took place ninety minutes previously but those watching considered the flag used to be too small and demanded a replay. Luckily for Joe Rosenthal he was present the second time round and captured this image, which won him a Pulitzer prize and has since appeared on stamps and posters everywhere.

☛ **Allard, Chaldej, Clark, Frank, Kawada**

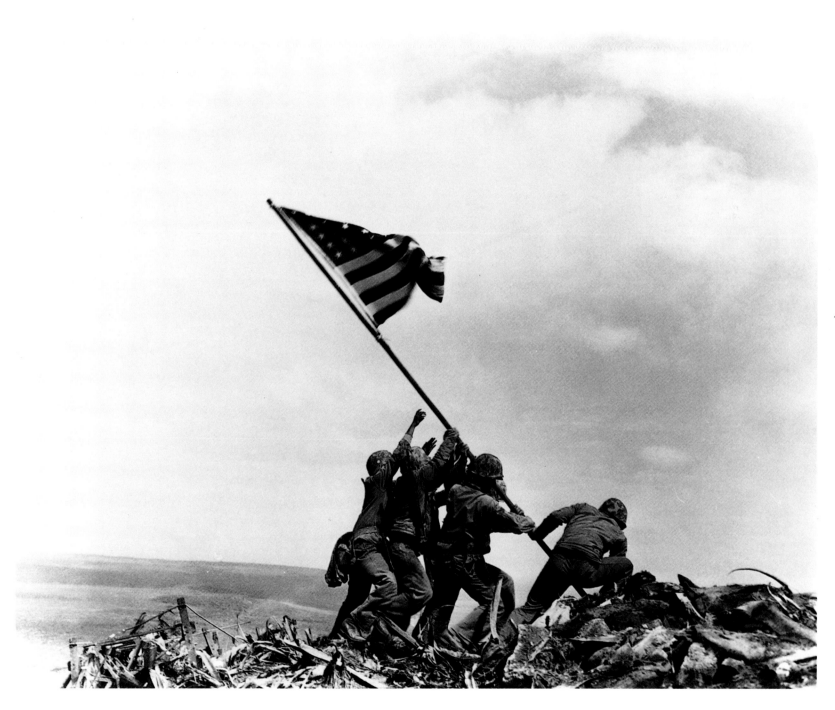

Joe Rosenthal. **b** Washington, DC (USA), 1911. **Iwo Jima**. 1945. Gelatin silver print.

ROSS Judith Joy

Untitled

The invitation in this portrait is to make comparisons, and to wonder why, for example, the two girls on the left have such a regard for modesty and symmetry. A portrait pure and simple would present the figures objectively, but Ross's tactic is to stage the event in such a way that what emerges is less a likeness than a response to the idea of being portrayed. In this case that aspect of the portrait is narrated by the obscured and curious figure in the background, the epitome of audiences everywhere. The virtue of such portraiture is that it deflects attention from mere appearance and focuses it on the minds which govern appearance. Like her precursors, such as August Sander from fifty years or more before, Ross uses an 8 x 10-inch view camera which makes the act of portraiture into an event for which the subject needs to carry out whatever preparations he or she sees fit.

☞ Dijkstra, Gibson, Goldblatt, Mann, Model, Sander, Seeberger

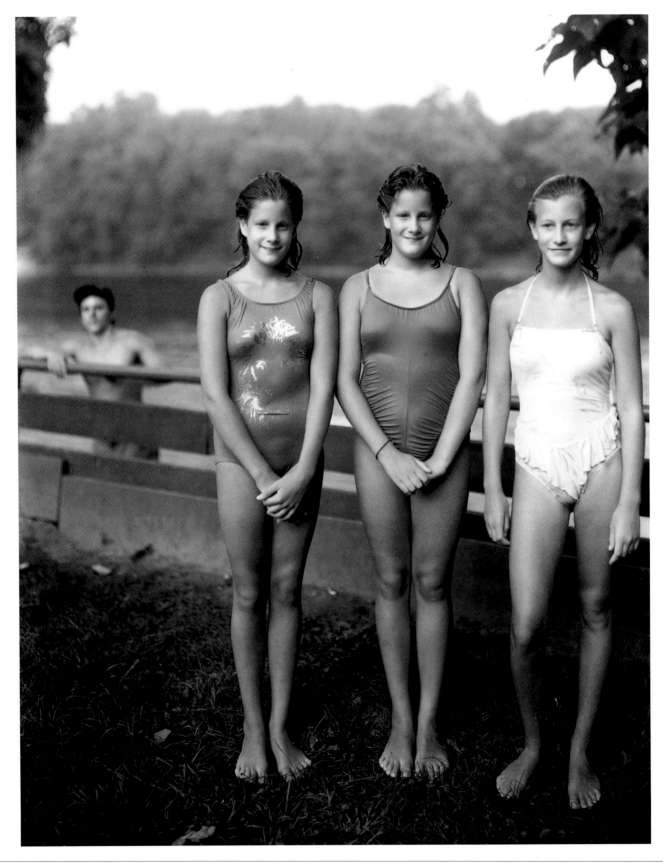

Judith Joy Ross. b Hazleton, PA (USA), 1946. **Untitled.** 1988. Gelatin silver print.

Rothstein Arthur Fleeing a Dust Storm

The farmer and his eldest son are pressing forward energetically into the wind, while the younger child – struggling to keep up – shields his eyes to protect them from the dust. The child's gesture is the key to this scene, for it makes sense of the abraded foreground and the bleak, dust-filled sky. Without that defensive gesture, the whole picture would amount to little more than a fragment of derelict countryside. Rothstein asks his audience not to stand back and analyze but to imagine in their bodies what it might actually feel like to live in such a pitiless landscape. The photographer himself suffered eye damage due to exposure to the dust of Oklahoma, an area badly affected by drought and dust storms. This picture, taken by Rothstein for the Resettlement Administration (an American government agency set up to cope with the impact of the Depression and later known as the Farm Security Administration), became an American icon and one of the great motifs of the 1930s.

☛ Hocks, Lange, Lee, Post Wolcott, Towell, Vachon

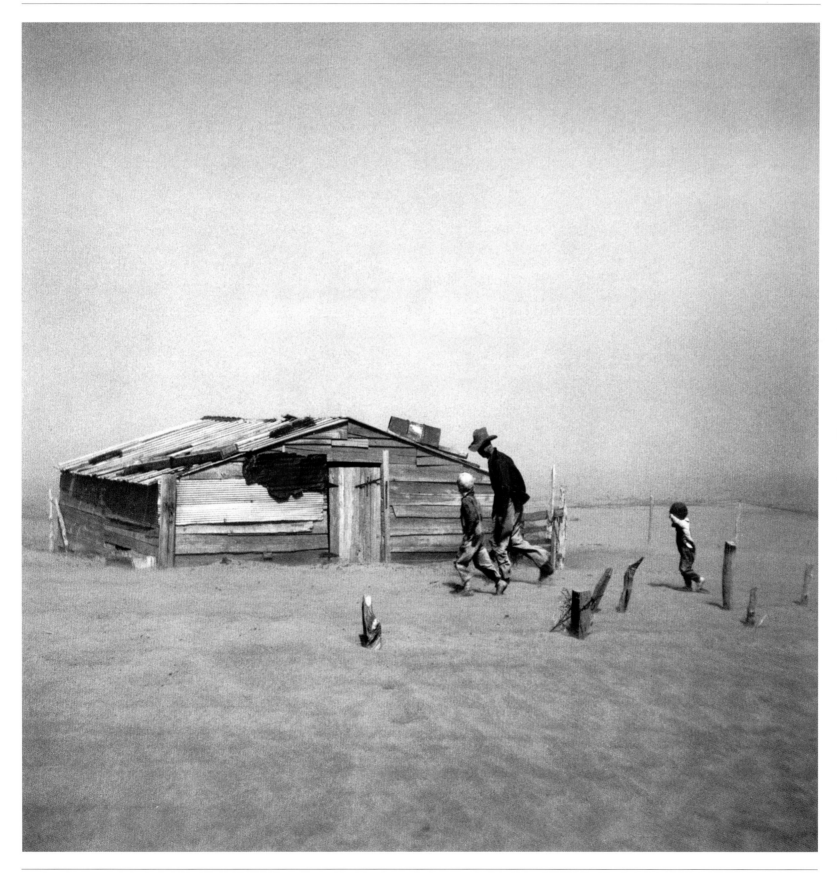

Arthur Rothstein. b New York (USA), 1914. d New Rochelle, NY (USA), 1985. **Fleeing a Dust Storm**. 1936. Gelatin silver print.

Roversi Paolo

Bird of Paradise

The figure, clad in vividly coloured feathers, seems fantastical. Fashion photography became athletic in the 1930s, and streetwise post-war and in the 1950s. Roversi took it out of the public domain and staged it as apparition…evanescent, here and gone in a moment. Roversi entered photography in 1967 as a reporter, interested mainly in portraiture. In Paris, where he has lived and worked since 1973, he turned increasingly to fashion, and his pictures have appeared in all of fashion's significant outlets: *Harper's Bazaar*, Italian *Vogue*, British *Vogue*, *Uomo Vogue*, *Arena*, *ID*, *Interview*, *W*, and *Marie Claire*. His autographed fashion campaigns include the following names: Givenchy, Cerruti 1881, Krizia, Yohji Yamamoto, Comme des Garcons, Valentino, Christian Dior, Yves Saint Laurent, Romeo Gigli and Cacharel. Among his monographs is *Paolo Roversi*, published by the Galérie Municipale du Chateau d'Eau, Toulouse, in 1994.

☛ Bellocq, Horst, Hoyningen-Huene, Lanting

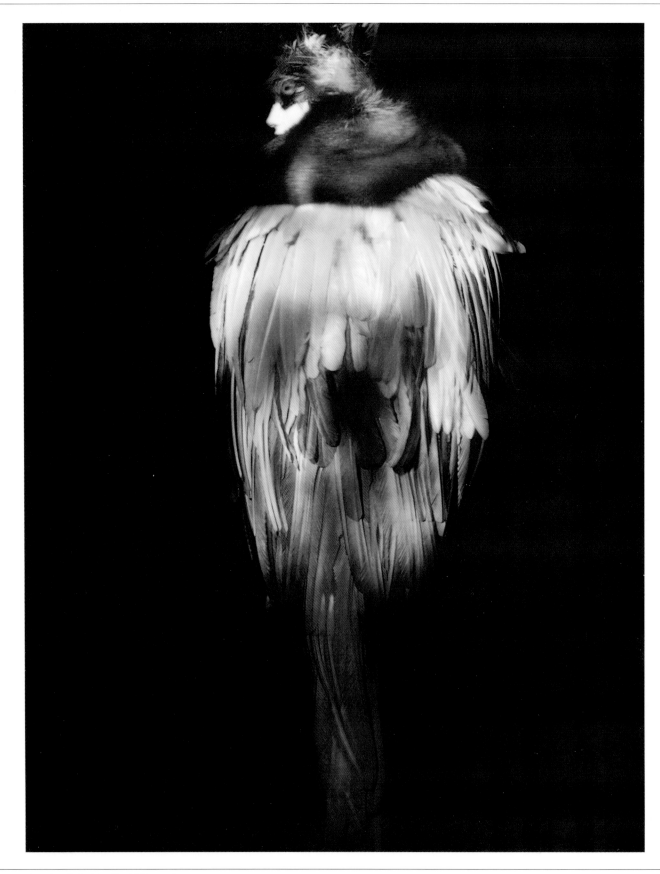

Paolo Roversi. b Ravenna (IT), 1947. **Bird of Paradise**. 1997. Polaroid.

Ruff Thomas Portrait 1987

Although this looks like an image made for official use, the intention was to print it larger than life-size and then exhibit it in a gallery. Like others in Ruff's cast of characters, the subject is neither well known nor even named. Why, in that case, should she be photographed and then put on public display? In the past, after all, there has always been a prima-facie case for exhibiting portrayals, for they were either of the famous or the typical. German photographers in the 1980s – and especially those who had been taught by the influential Bernd Becher – were preoccupied by just that sort of questioning, for it immediately involved audiences in matters of art and documentary. Here, for instance, there may be points of interest, such as the irregular cutting of her fringe, but in themselves they hardly justify the picture as art. In that case the picture's claim to attention must come from other qualities such as symmetry or a sense of calm.

☛ Beaton, Becher, Callahan, Harcourt, Lele, Lendvai-Dircksen

Thomas Ruff. b Zell am Hammersbach (GER), 1958. **Portrait 1987**. 1987. C-type print. **h**220 x **w**185 cm. **h**86½ x **w**72¼ in.

Ruscha Ed

State Board of Equalization, 14601 Sherman Way, Van Nuys

Such a picture might have been taken as part of a survey of land use in an urban area. Like the other pictures in the series *Thirty-four Parking Lots in Los Angeles*, this photograph is rich in evidence of a sort which might be interesting to urban planners, although not necessarily to anyone else. Such pictures raise questions about the nature of art. In what does their attraction lie? In his series of 1966 entitled *Every Building on the Sunset Strip* Ruscha appears to have found a natural limit for a photo-survey, but usually his work raises the question of arbitrariness, and of what might happen in the absence of an undeniable creative compulsion. Ruscha began to exhibit in 1963 in Los Angeles, and appears to be a successor to Andy Warhol, whose first one-man show of thirty-two paintings of Campbell's soup cans was staged in Los Angeles in 1962. Ruscha's European successors are Bernd and Hilla Becher, photographers of relics from the age of heavy industry.

☛ Baltz, Becher, Gerster, Krull, Munkacsi, Struth, Warhol

Ed Ruscha. b Omaha, NE (USA), 1937. **State Board of Equalization, 14601 Sherman Way, Van Nuys**. 1967. Gelatin silver print.

Salgado Sebastião

Serra Pelada Goldmine, Pará, Brazil

Manual labourers swarm through a goldmine in a scene reminiscent (but for one or two items of dress) of long ago or of a pre-industrial past. But for the figure in the foreground, it might be no more than a piece of documentary. Leaning like that, however, against the spar of wood and in the context of the ladders and baulks of timber beyond, he calls up a memory of the Crucifixion, and in particular of Tintoretto's famous *Raising of the Cross* in San Rocco in Venice. Salgado's documentary projects, many of them shot in South America, are greatly augmented and informed by Christian religious iconography, as if he understands contemporary labour in the Third World very much in terms of the life of Christ. Originally an economist, Salgado took his first photographs in the 1970s. His intention has always been to disclose the sufferings of the dispossessed or those without resources. In 1993 *Workers: an archaeology of the industrial age* was published to international acclaim.

☞ Alpert, Hine, Munkacsi, Rai

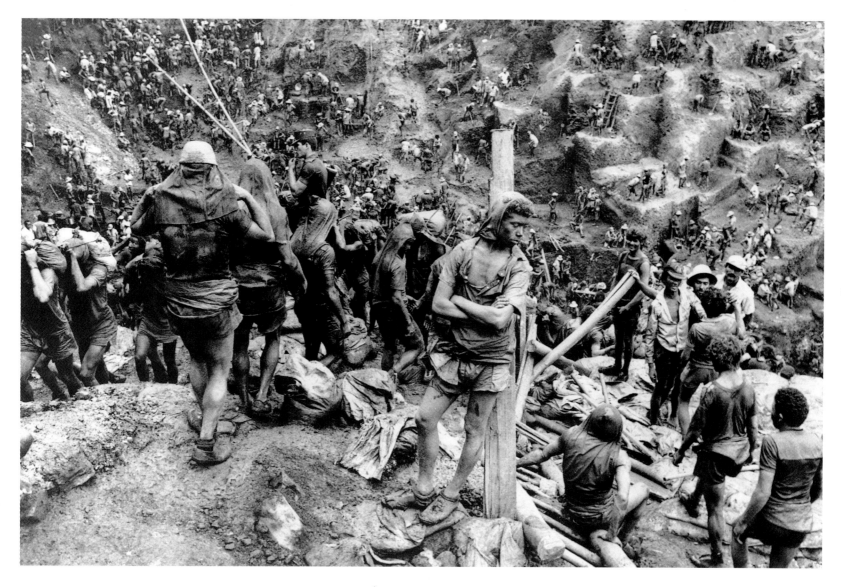

Sebastião Salgado. b Aimorés (BR), 1944. **Serra Pelada Goldmine, Pará, Brazil**. 1986. Gelatin silver print.

Salomon Erich

Diplomats

The balding man on the left is Heinrich Brüning, the Chancellor of Germany. He sits opposite the dark-haired Pierre Laval, Prime Minister of France, and the older Aristide Briand, Foreign Minister. The man in the hat on the couch is Hymans, the Belgian Foreign Secretary, who is talking to the sharp-eyed Dr Curtius. These men, who are on their way from Paris to London, are travelling in the Pullman car of the special train of the French government. Salomon's political reportage photographs, taken at the major conferences which were such a feature of the period, are from a culture of insider dealing which would last until Hitler's appointment in 1933. He began his career as a photo-reporter in 1928, with a report on a murder trial. Seen by some as the founder of modern political photojournalism, Salomon had a gift for taking intimate pictures secretly. The editor of the *Weekly Graphic* in London coined the phrase 'candid camera' to describe his pictures.

☛ **Aigner, Bosshard, Karsh, Lessing, Reed**

Erich Salomon. b Berlin (GER), 1886. d Auschwitz (POL), 1944. **Diplomats**. 1931. Gelatin silver print.

Samaras Lucas Sittings

The sitter seems – from the look on his face at least – to have been prepared for the session. The cherry-decorated backcloth, on the other hand, seems to belong to a kitchen – as does the chair. That is the photographer on the left, participating and even competing with the model, who could well have moved sideways in order to stay in the act. Samaras presents himself in *Sittings*, the series to which this picture belongs, as a would-be specialist in glamour who had neither the patience nor the taste to master the format, and anyway wanted to take pictures of himself in the directorial mode. Was it a craving for revenge? Did Samaras want to get the better of all those seamless modes on which the culture depended for a good opinion of itself? Certainly, he indulges in every garish ruse of lighting and staging ever frowned on in the manuals, and even confesses – as here – to a level of narcissism which would normally be regarded as unacceptable.

☛ Cosindas, Durieu, García Rodero, von Gloeden

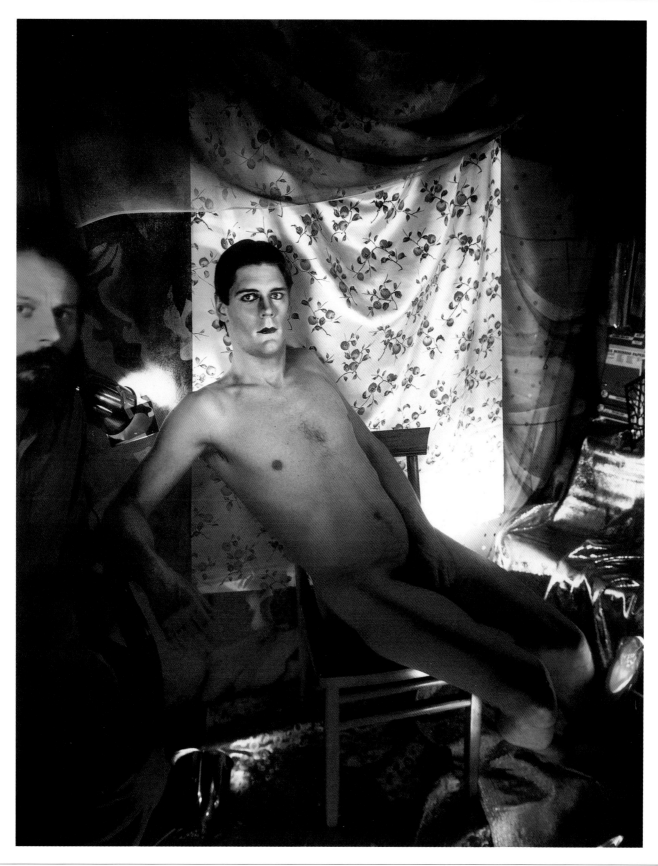

Lucas Samaras. b Kastoria (GR), 1936. **Sittings**. c1979. Polaroid.

Sammallahti Pentti Sandö, Dragsfjärd

This could be an incident from the beginning or the end of the world – at least as we know it. The frog, acting the part of a primaeval monster, is waiting for the sun to set, after which nature's more barbarous culture will come into its own. Photographers of nature and of traditional communities rarely propose, as Sammallahti does, that their subjects are indifferent to the camera and to the kind of civilization which it represents. Sammallahti's subject, presented in a series of portfolios begun in the late 1970s, is otherness. Gypsy life, for example, has interested him, mainly as a mysterious world apart, going about its own business. Hungarian Gypsies feature in a portfolio of 1987, *Honnos, My Fiddler*. Two earlier series, published in portfolios, are called *The Nordic Night* (1982 and 1983). Sammallahti has also photographed amongst shepherds and fishermen. He is currently working as a teacher at the University of Industrial Arts in Helsinki.

☛ **Dalton, E. Smith, Titov, Wegman, Wojnarowicz**

400

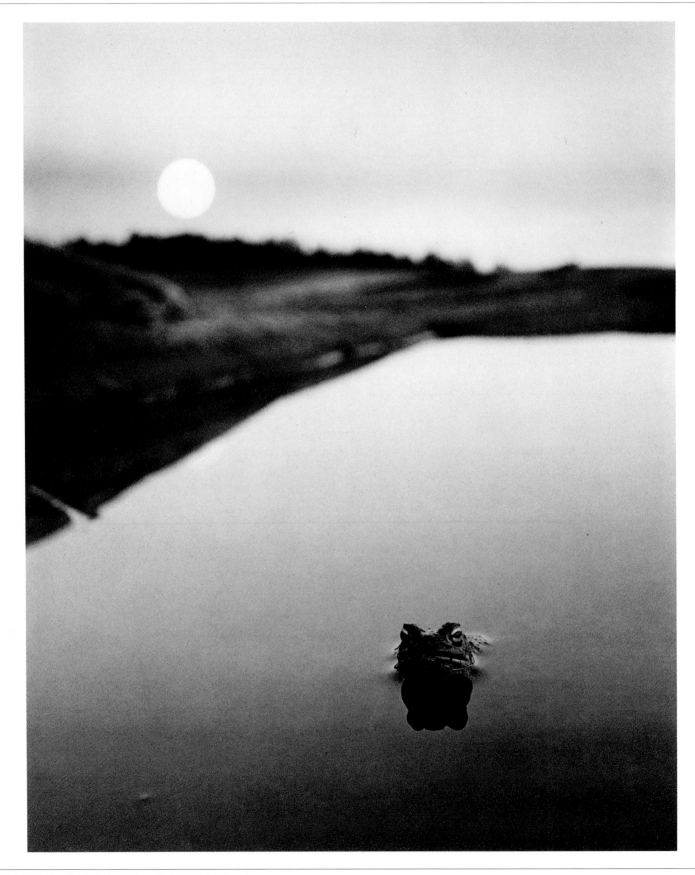

Pentti Sammallahti. b Helsinki (FIN), 1950. **Sandö, Dragsfjärd**. 1975. Gelatin silver print.

Sander August

Young Farmers in their Sunday Best

In this – one of the most famous portraits in the history of the medium – three young countrymen are posing for Sander's camera on their way to a dance. The leader may look like a model of probity, and that may be his brother next to him, but the third man is in every respect more raffish. Sander is known above all for his book of 1929 entitled *Antlitz der Zeit* (Face of Our Time), which he intended to be the first volume in a photographic project on *People of the Twentieth Century*. The sixty portraits in *Antlitz der Zeit* trace an ascent from the peasantry through various small-town and professional people upwards to artists, writers and musicians before descending into the ranks of casual labourers and the unemployed. The book was banned by the Nazis in 1934, possibly because it presented a vision of society which contradicted the official one. After the banning, Sander turned increasingly to landscape photography, concentrating on the Rhine area.

☛ Bubley, Hoppé, van Manen, Nègre, Ross, Weber

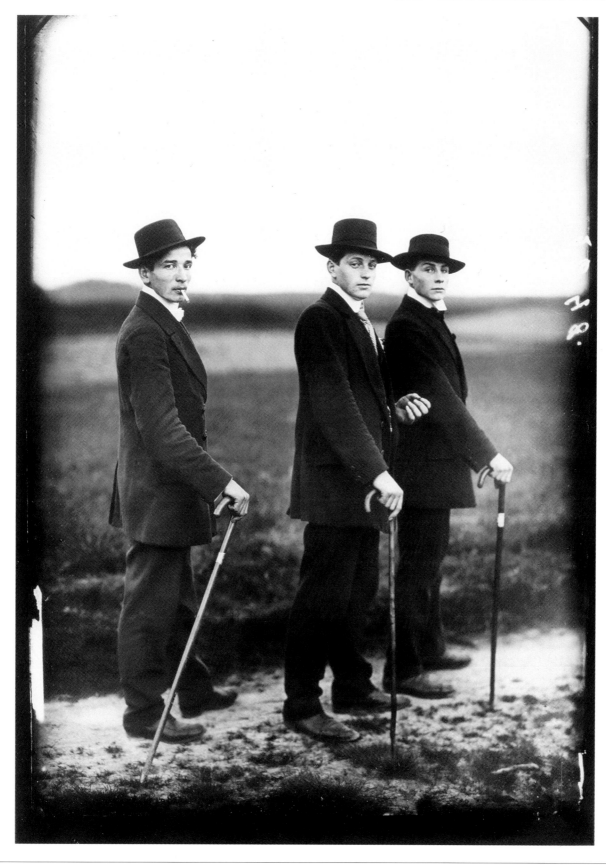

401

August Sander. **b** Herdorf (GER), 1876. **d** Cologne (GER), 1964. **Young Farmers in their Sunday Best**. 1914. Gelatin silver print.

Saudek Jan

With My Third Daughter from the Second Marriage

The couple swap roles. On the left he looks like a contemporary citizen wearing jeans and gloves. On the right, holding more or less the same position, he might be taken for a male model posing for an artist in the nineteenth century. Conversely, on the left she might be intended to be seen as Flora or Venus, whereas her second manifestation is as a peasant bride in an opera. The colouring suggests a postcard from the *belle époque*, or from the Prague of 1900. Saudek, who often uses pairings and sequences, likes to imagine the lady as a vamp and vice versa. In his sequences characters who enter in monochrome and fully clad often progress towards an exotic, polychrome nudity. Saudek's preferred site is his cellar studio in Prague. He studied at the School of Industrial Photography between 1950 and 1952 and then spent years doing enforced factory work. In 1984 he was finally given the right to practise as an artist by the Czech authorities.

☛ **Disfarmer, Durieu, Goldin, Lichfield, Tillmans**

402

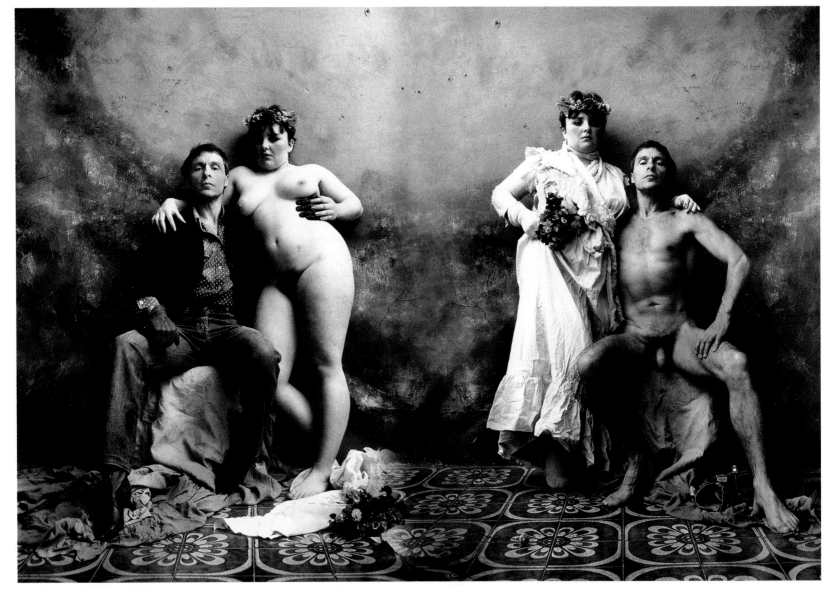

Jan Saudek. b Prague (CZ), 1935. **With My Third Daughter from the Second Marriage**. 1987. C-type print.

Schmidt Michael

The Berlin Wall

The Berlin Wall, Schmidt's topic here, stood for history obstructed. Its importance in German art should be recognized, for it associated the nation with impasse. This had consequences for social and national time which had once been marching forward but was henceforth little more than a space to be filled somehow. The contents of this new time came to rest, like detritus, on the Wall, the barrier against which time had come to a standstill. Many German artists in the 1980s responded to this sense of days robbed of their significance by making pictures of architecture and landscape from which everyday motifs had been expunged. Schmidt, however, took the opposite course, concentrating exclusively on the least significant of topical details. In *Waffenruhe* (Ceasefire), his study of Berlin prepared between 1985 and 1987, he presented the city on very average days and from unprivileged viewpoints.

☞ Hajek-Halke, Izis

Michael Schmidt. b Berlin (GER), 1945. **The Berlin Wall**. c1986. Gelatin silver print.

Schuh Gotthard　　Java

The boy seems to be playing marbles, or at least taking aim. Perhaps he is a dancer practising his moves on a marked surface; or is that just how Schuh chose to envisage him? Schuh's reputation was made in 1940 by a picture book on Bali entitled *Island of the Gods*. This book is remarkable for its finely composed pictures such as this one, many of them of dancers. At any other time in history such exquisitely judged moments might not have mattered, but they were seen as significant during and after the war of 1939–45 and quickly came to represent an ideal towards which humankind should start to aspire. This particular picture, which was regarded as an expression of human grace in ordinary circumstances, was one of the successes of 'Family of Man', the great humanist exhibition of 1955. A successful photojournalist in the 1930s, in 1941 Schuh became head of picture editing at the *Neue Zürcher Zeitung*, the leading Zurich newspaper.

☛ Lengyel, Mayne, Morgan

404

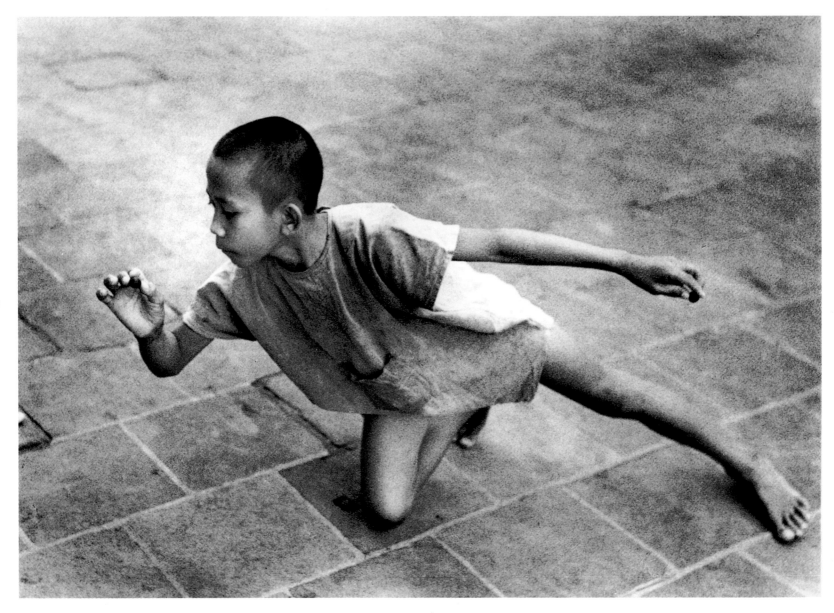

Gotthard Schuh. **b** Berlin-Schöneberg (GER), 1897. **d** Küssnacht (SW), 1969. **Java**. 1940. Gelatin silver print.

Scianna Ferdinando

Jorge Luis Borges, Palermo

The writer is sitting beyond the plate glass window of a café in Palermo. He grasps a walking stick with both hands, and the sunlight falls across his face. Borges's blindness is important in this picture because it raises the question of what it must be like to sit there and to feel the sunlight as warmth and the walking stick as material. Scianna's tendency is to compose his pictures with as few elements as possible and to arrange those elements so that they cannot be readily explained away as belonging to an incident. The palm tree reflected from the promenade beyond, for example, might be taken as symbolic of the author's imagination – since seen in silhouette like this it is no more than an idea of a tree. Likewise the darkness in the glass, with its distant hills, might be a landscape or a story in the making. The simpler the scene, that is, the greater the scope for poetics. This principle is seen to great effect in *Kami* (1988), Scianna's study of an ancient Bolivian mining community.

☛ Atwood, Morris, Oddner, Ristelhueber, Shahn

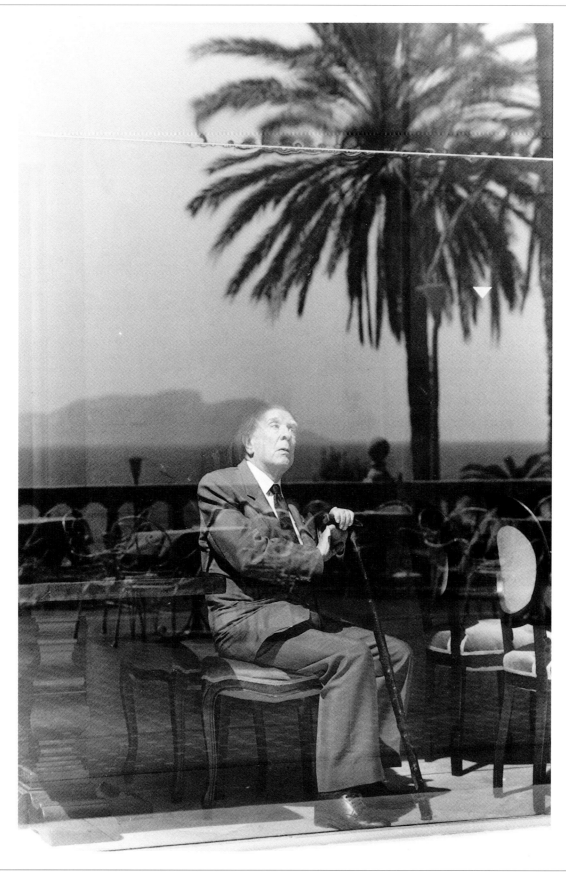

Ferdinando Scianna. b Bagheria (IT), 1943. **Jorge Luis Borges, Palermo**. 1984. Gelatin silver print.

Seeberger Jules Fairground, Paris

Three little fairground pigs are shown being managed by three sharply differentiated little girls. The story of the three pigs who built themselves three houses of straw, sticks and brick comes to mind. Seeberger, who was only just beginning his ultimately very successful career in photography in 1900, was well ahead of his time, since this kind of picture, which combined real and fictive elements, did not really establish itself in Paris until the 1930s. Trained as a draughtsman, Seeberger took up photography in the late 1890s and soon began to win competitions. Together with his brother Louis, he began to take photographs for postcards in 1904, and in 1906 a third brother, Henri, joined what was becoming a flourishing business. In 1909 they took up fashion photography and were very successful. The business survived World War I and in the 1920s they photographed famous and notorious Parisian sites for International Kinema Research of Hollywood.

☛ Mann, Mark, Ross, Sommer

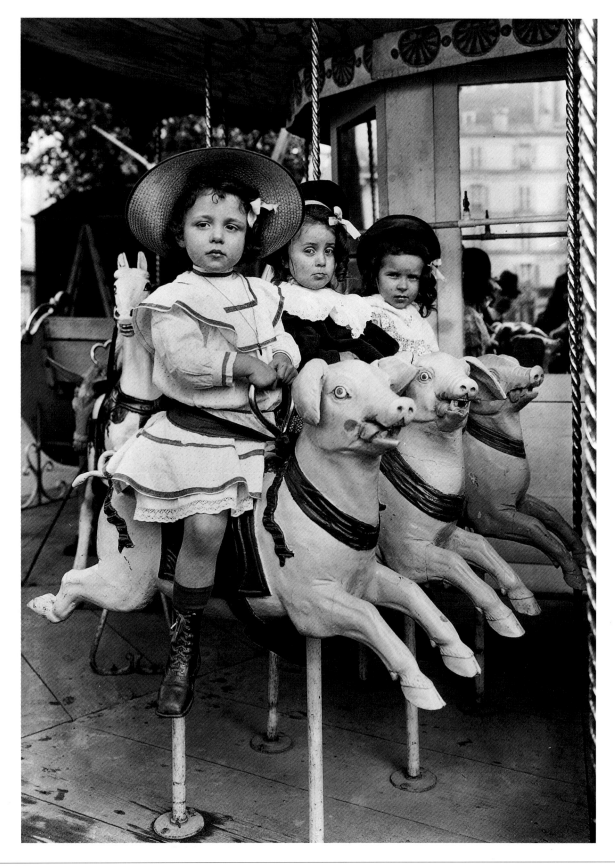

Jules Seeberger. b Vienna (AUS), 1872. **d** Paris (FR), 1932. **Fairground, Paris**. 1900. Gelatin silver print.

Seidenstücker Friedrich Leaping the Puddle

Will she make it to the other side, and what will happen if she does and sets foot on that slippery kerbstone? Seidenstücker's interests in the 1920s and 1930s in Berlin always lay in such minor moments. He was the first photographer to be thoroughly devoted to urban instances – rather than to the spirit of the city or to its people considered as types. And his were the commonplace events on which others built more intricately. For example, Henri Cartier-Bresson – of the irrefutable 'decisive moment' – would take this image of a figure jumping over a puddle and enlarge on it by including an ironical poster image of a leaping ballet dancer in the background. Seidenstücker, who trained and then practised as a sculptor until 1930, set down the most unadorned and durable images of Germany at work and then in depression. These images were sometimes used later in the decade to represent the old order in National Socialist publications.

☛ **Cartier-Bresson, Halsman, A. Klein, Lartigue**

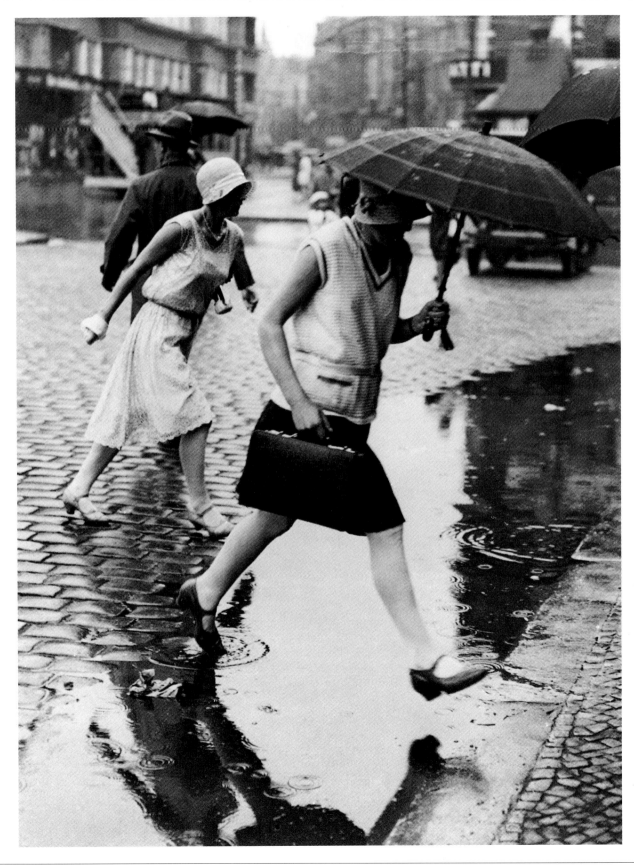

Friedrich Seidenstücker. b Unna (GER), 1882. d Berlin (GER), 1966. **Leaping the Puddle**. 1925. Gelatin silver print.

Sella Vittorio

On the Glacier Blanc

Climbers are approaching an Alpine crevasse in the Dauphiné region of France. Furrows in the snow show how the chasm has opened in what was once a continuous surface. How near the edge dare the leader go? Sella was the first specialist mountain photographer. He began by taking photographs in the early 1880s in the Italian Alps and then started to travel throughout the world, covering Russia, Alaska, Central Africa and the Himalayas. Sella was interested in the wilderness as a spectacle, as something noble and impressive in itself. Series of his pictures were bought by geographical societies such as the Sierra Club in California, where they proved to be an inspiration to the young Ansel Adams. Sella stopped travelling in 1909, choosing to spend his time printing and distributing his work, and making his house in his home town of Biella into a gallery.

☛ A. Adams, Hamaya, Hütte, Plossu, M. White

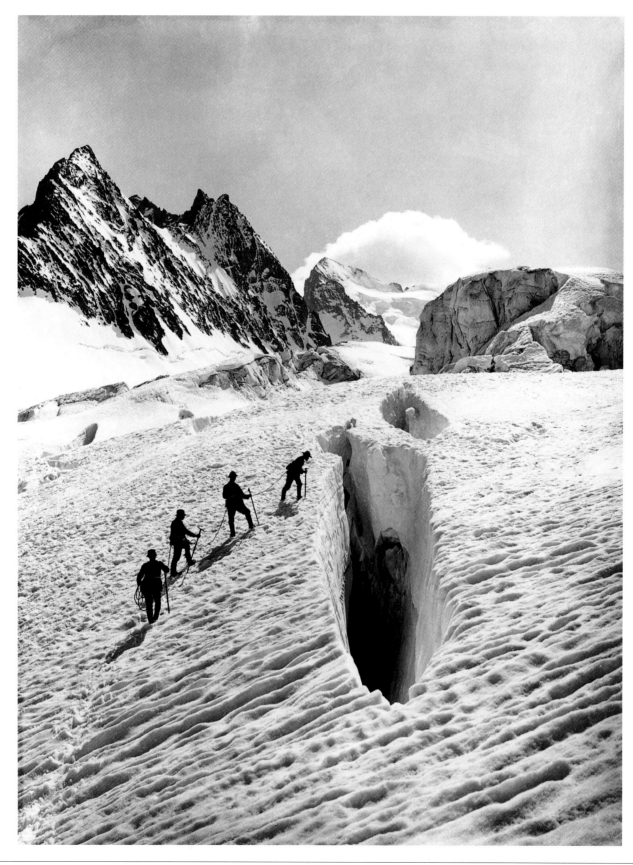

Vittorio Sella. b Biella (IT), 1859. d Biella (IT), 1943. **On the Glacier Blanc**. c1880s. Gelatin silver print.

Seymour David 'Chim' Land Reform Meeting, Estremadura

A nursing mother is looking up at a speaker who promises land to the peasants of her village, land which belongs to absentee landlords. The picture was published in May 1936, before the outbreak of the Spanish Civil War (July 1936), in *Régards* magazine, as part of a land reform story which Seymour photographed in Estremadura. This was a crucial issue, for the peasants were starving. Seymour was on assignment in Spain, and after the outbreak of war worked mainly from behind the lines. From 1934 to 1938 he reported under the byline CHIM on the Popular Front in France and on Republican Spain. With Henri Cartier-Bresson, Robert Capa and George Rodger he founded the agency Magnum Photos in 1947, and with them developed the documentary portrait as well as an informal (35mm) style of war reportage. Chim in particular associated the popular cause with humanitarian values. He was killed at Suez in 1956, just after the signing of an armistice.

☛ S. L. Adams, R. Capa, Cartier-Bresson, Lange, Lyon, Rodger

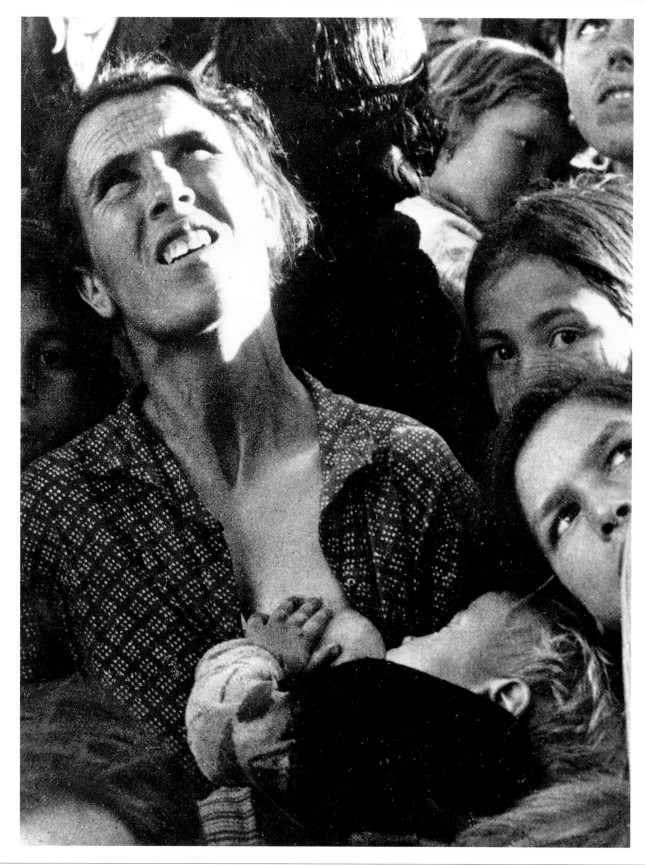

David 'Chim' Seymour. b Warsaw (POL), 1911. d Suez (EG), 1956. **Land Reform Meeting, Estremadura**. 1936. Gelatin silver print.

Shahn Ben

Blind Street Musician

In this picture, which was taken in the southern USA in the autumn of 1935, a blind street musician is playing 'River Stay Away From My Door' – a song with relevance in the Mississippi area. Many of Shahn's pictures were taken on the street like this and showed people who were only half-aware of the camera's presence. He used a right-angle viewfinder, in the interests of candid picture-taking, and went closer to his subjects than any of his colleagues. He also took many pictures from car windows with a small pocket Leica, and often caught people looking either puzzled or on the point of paying attention. Better known to history as a draughtsman and painter, he believed that humanity lived by and for Art – even on the meanest streets of the USA in the Depression. He was introduced to photography by Walker Evans and became a major influence amongst the documentarists of the Farm Security Administration, and one of that organization's most renowned photographers.

☛ **Atwood, Berengo Gardin, Bischof, W. Evans, Oddner, Scianna**

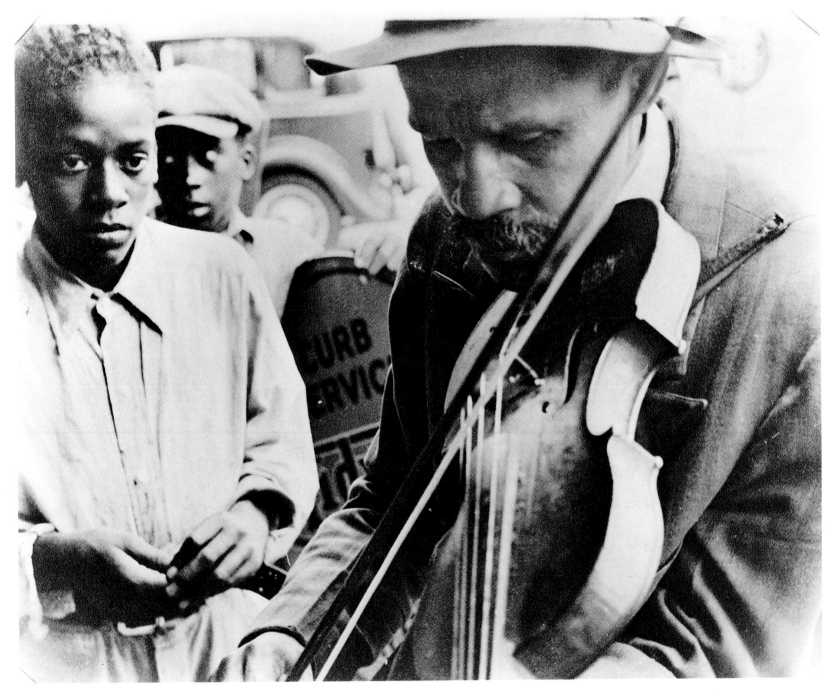

410

Ben Shahn. b Kovno (LIT), 1898. d New York (USA), 1969. **Blind Street Musician**. 1935. Gelatin silver print.

Sheeler Charles

Upper Deck

Taken on the S.S. *Majestic*, this photograph of electric motors and ventilation intakes and outlets served as the basis for Sheeler's painting of 1929, also entitled *Upper Deck*. It is true that he refers to the entity, the ship, by means of significant details, so that the whole can be imagined from its parts; but the picture has other and larger meanings written into its

iconography of vents and ducts. Sheeler, like many of his contemporaries in the 1920s, anticipated a new order which would be sharply distinguished from the sensuous world of heavy industry. The future, as displayed here, would be driven by invisible forces – electricity primarily – which might be calibrated and gauged, but not smelled and touched as in the

foundries of the Industrial Revolution. The inhabitants of this new environment would at last be released from contact with base materials, and free to enjoy an untroubled existence in the kind of crystalline light celebrated on the deck of the *Majestic*.

☛ Baltz, Van Dyke, Stieglitz

Charles Sheeler. b Philadelphia, PA (USA), 1883. **d** New York (USA), 1965. **Upper Deck**. 1928. Gelatin silver print.

Shere Sam

The Hindenburg Disaster

The *Hindenburg* airship burst into flames just as it was coming in to land at Lakehurst, New Jersey, in May 1937. This catastrophe was both a human tragedy and a blow to national prestige since the airship had been a potent symbol in the 1920s of a future in which time and space would be mastered effortlessly. Airships were also very important for the German national image in the 1930s. After the achievements of Baron von Richtofen and Franz Immelmann in World War I, Germans had begun to think of the air as their arena. In future they would rule the air as Britain had once ruled the sea, and the *Hindenburg* was their flagship. The event was graphically recorded by the twenty-two newsreel and still photographers who had turned up for the arrival. There was considerable irony in the fact that it was such a spectacular photo-opportunity, for airships had been used to carry photojournalists to exotic sites around the globe.

☛ Aeby, Man, Sternfeld

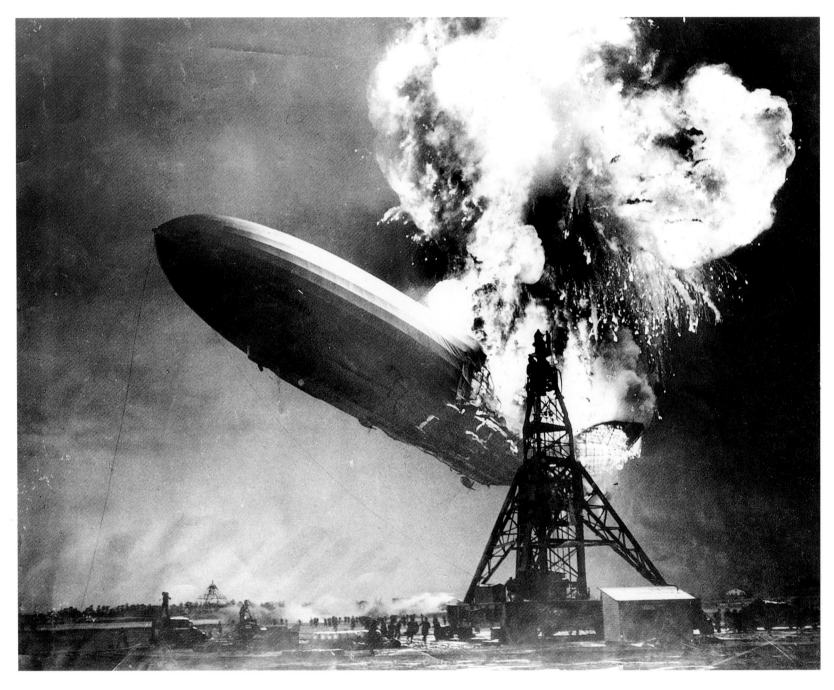

Sam Shere. b Minsk (RUS), 1904. **The Hindenburg Disaster**. 1937. Gelatin silver print.

Sherman Cindy

Untitled #180

At first sight this looks like a recent corpse, although it is actually no more than a tinted mask. Yet you still have to examine the eyes to be certain. Some sort of resinous fluid is oozing from the lips, and there is something which looks like grit or dried nasal mucus in the right nostril. But if it is only make-believe, how can it be truly repellent? In almost all of her photography Sherman asks you to go along with her, as if you are taking part in a charade. This means that you have to be aware of her intentions, to note that she means – as here – to provoke nausea or disgust, and that it is the idea which matters just as much as the first-hand experience. In this respect Sherman is, like most photographers who arrange and construct, a conceptual artist who believes that the evidence of the senses should be entertained in the company of words. This leads her to portray the idea of 'repulsion' or 'chaos' in mock portraits and elaborate stagings of melodramatic events.

☞ **Callahan, Florschuetz, Man Ray, Ohara, Strömholm, Umbo**

413

Cindy Sherman. b Glen Ridge, NJ (USA), 1954. **Untitled #180**. 1987. C-type print.

Shore Stephen

Uvalde, Texas

Over the course of time the wall built across the hillside has broken down and its stones have been scattered. In the background of the picture, footpaths fade into the landscape. In the foreground, tree roots poke through peppery gravel to emerge beside a rough surface in clay or concrete. This scene from Uvalde County gives away nothing which might interest a reporter, even if it does refer to events of a sort. In the 1970s and 1980s New Topography took many different forms, according to the aesthetic and outlook of its artists. Shore's preoccupations are with the longer reaches of geological and natural history or with change taking place across the millennia. His is an interesting history, for he was taught first of all by Minor White, a specialist in subjective landscape photography; and then went to work in New York at Andy Warhol's Factory. The impassive geological landscapes for which he is known are worlds apart from such starting points.

☛ Godwin, Hannappel, Hütte, Warhol, M. White

414

Stephen Shore. b New York (USA), 1947. **Uvalde, Texas**. 1987. Dye coupler print.

Sieff Jeanloup

Ina at East Hampton

Ina, a German model and the photographer's mistress in the early 1960s, is looking into the distance and into some inscrutable memory. The house, at East Hampton, New York, reminded Sieff of the house in *Psycho*, which he had photographed in 1962 with Hitchcock in Hollywood. The shadows under the eaves, an overcast sky and the sword-like leaves of the reeds all conspire to threaten Ina and her memories. Sieff's career began in the 1950s, under the influence of the romantic and individualistic aesthetics of the Parisian 'new wave' of film-makers, and in a very successful career for the major magazines he has remained a romantic and an artist of dark light and private spaces. In 1961 he moved from Paris to New York, then the world centre of photography. In the mid-1960s he returned to Europe and to what he called 'the only real values: warm water and unchanging sky'.

☞ Boubat, Furuya, Silverstone, Stock

Jeanloup Sieff. b Paris (FR), 1933. **Ina at East Hampton.** 1964. Gelatin silver print.

Silk George

The Law of the Gun

Albert Anastasia, one of five brothers and a famous gangland leader, has been shot and killed in the barber's shop of the Park Sheraton Hotel in New York. However, the underlying subject seems to be not so much the tragedy of death itself as how those in authority manage crises. Reassuringly, detectives are taking particulars. Anastasia had figured in American visual culture as one of the witnesses questioned in March 1952 by the Senate Crime Investigating Committee which, under the chairmanship of Estes Kefauver, held televised hearings in New York City. Television, which was then getting into its stride, had introduced a whole range of underworld figures, along with their accusers, to public attention as never before. Around 20 million people had seen and heard the Kefauver proceedings, and thus when Anastasia was assassinated in 1957, the event was important as a sequel. It marked the beginning of still photography's relationship with television.

☛ Battaglia, Delahaye, Dyviniak, Eppridge, Gardner, McCullin

416

George Silk. b Levin (NZ), 1916. **The Law of the Gun**. 1957. Gelatin silver print.

Silverstone Marilyn

Jacqueline Kennedy

Jackie Kennedy, who is on a tour of Rajasthan in northern India, is looking delightedly towards the people gathered on a parapet behind the viewer. She had been visiting a seventeenth-century palace on the lake, and wanted to land, but her bodyguards thought that the crush was too great. Silverstone's notes on the visit also hint at a possible need to escape from the kind of constraints signified by those white gloves and the fortified wall beyond. Subsequently, Andy Warhol would make Jackie Kennedy into a one-dimensional silkscreened icon, but here on the beautiful lake with those adoring people, she looks very real and human. This sympathetic interpretation of the First Lady is quite in keeping with Silverstone's aesthetic, which was premised on a dream of home and harmony, often symbolized by figures of domestic workers and of protected homesteads in Hungary, India or Iran. Her principal books are all on Indian subjects, and in 1977 she was ordained as a Buddhist nun.

☛ **Cameron, Ritts, Sieff, Southworth & Hawes, Warhol**

417

Marilyn Silverstone. b London (UK), 1929. **Jacqueline Kennedy.** 1962. Gelatin silver print.

Silvy Camille

Valley of the Huisne, France

The troubled sky, printed from a separate negative, extends beyond the superlatively placid river. There is little action in this very renowned early landscape, apart from a boatman preparing to set off and a group of bathers watching him from the bank. The scene is supervised by various clumps of trees, which are firmly silhouetted against the sky and dimly reflected in the river. Because of that sharp contrast between sky and water, Silvy's scene suggests a narration in moral terms, involving danger and assurance. Silvy was an aristocrat and a diplomat, whose interest in photography was initially that of an amateur. However, he became a professional portraitist in about 1858, starting off in Paris and then moving to London in 1859. As an exponent of *carte-de-visite* portraiture he was a great success, until the craze for these small-scale pictures waned in the late 1860s. His studio, in Porchester Terrace, was the most fashionable in London.

☛ Clifford, Régnault, Sutcliffe, Ulmann

418

Camille Silvy. Active 1856–69. **Valley of the Huisne, France**. 1858. Albumen print.

Simmons Laurie

Pink Stonehenge

Laurie Simmons's cast of model characters pose and appear to move against a back-projected view of a reddened Stonehenge, symbol of a timeless antiquity. This picture comes from her *Tourism* series of 1984. Models and figurines have attracted photographers since the 1920s at least, partly because they can be managed and made subject to the artist's intention. This troupe of four looks at a glance like a chorus line by Giacometti coming to life in the presence of an epitome of pre-history. Or they might represent a single figure in a time-lapse sequence turning and quitting the scene. Maybe they represent some kind of evolution, for the figure on the right looks like an ancient statue, in contrast to her companion on the left. In general, what Simmons has done is to quote an icon (Stonehenge) whose aura is recognizable and meaning more or less known in relation to a mystifying tableau of her own devising contrived out of disposables.

☛ **Faucon, Levinthal, Skoglund**

419

Laurie Simmons. **b** Long Island, NY (USA), 1949. **Pink Stonehenge**. 1984. Unique colour photograph. **h** 101.6 × **w** 152.4 cm. **h** 40 × **w** 60 in.

Sims David

Polish Prince

It might be an heroic pose remembered from the Communist era. He is called a Polish Prince, and the setting is workaday – a studio roof somewhere in London. The new fashion photography of the mid-1990s made a point of moving away from the high style of the 1980s. If fashion was determined at street level by people outside of any establishment that, then,

ought to be the starting-point; hence that topical haircut, the tattoos and the slate roof – the stuff of street-life. David Sims entered photography in 1985 and learned the business as a studio assistant. In 1986 he was commissioned by Phil Bicker, art director of *The Face* and then by Nick Knight, picture editor at *I.D.* In 1992 he was given a year's contract by Fabien Baron,

art director at *Harper's Bazaar*, who also commissioned him to shoot a Calvin Klein Jeans campaign. By 1994 he was established as 'Young Fashion Photographer' of the year at the Festival de la Mode, Paris.

☞ Goldberg, Joseph, Knight

David Sims. b Sheffield (UK), 1966. **Polish Prince**. 1996. Gelatin silver print.

Singh Raghubir

Sunday Market, Ahmedabad, India

The picture shows metal bowls, bins, a bicycle and a bat, seen through a car door and window on arrival at the market. Singh presents India not from some privileged viewpoint but from amongst its people and furnishings. It is an interrupted view of India in which the foreground counts: car doors, windows, doorways and the sort of frames through which we most often come on a place. A prolific reporter on Indian life, landscape and events, Singh's story is told in a foreword to *Rajasthan* (1981), a survey of his own home state in north-west India. Reflections on the kind of picaresque, incident-rich photography which he practised in the 1980s and 1990s appear in an extended conversation with the writer V.S. Naipaul, published in *Bombay* (1994), his survey of 'the contemporary elements of India'. In *The Grand Trunk Road* (1995) he remarked even more informally on the vernacular and the fabric of the country – from Calcutta to Amritsar, alongside the Ganges and Jumuna rivers.

☛ **Alinari, diCorcia, Friedlander, Lee, Marlow, Staub**

421

Raghubir Singh. b Jaipur (IN), 1942, d New York (USA), 1999. **Sunday Market, Ahmedabad, India**. 1997. C-type print.

Sinsabaugh Art

Chicago Landscape #117

Chicago's network of roads creates a complex and elegant figure. Seen like this, they seem principally to go round and round without ending. This picture was taken during a three-year documentation of the city of Chicago, which Sinsabaugh undertook in 1964. The landscape he remarks on is flat, without termini or emphases and with each element as interesting as the next one. His subject is less the horrors of an automated future than landscape as a continuum, punctuated by poles, posts and items of vernacular building. Sinsabaugh was one of the first photographers to insist, in advance of the New Topography of the 1970s, that landscape should be seen for what it was, or as an expanse haphazardly filled. His pictures, which are mainly of the American Mid-West, were often trimmed to emphasize horizontality. Sinsabaugh was a student of Harry Callahan at the Institute of Design in Chicago, to which he himself returned as a teacher.

☛ Callahan, Marlow, Ruscha, Struth, Sudek

422

Art Sinsabaugh. b Irvington, NJ (USA), 1924. d Chicago, IL (USA), 1983. **Chicago Landscape #117**. 1966. Gelatin silver print.

Siskind Aaron

Savoy Ballroom, New York

The dancers – in the Savoy Ballroom in Harlem, New York – make a fine pair in that dim light. It is as if Siskind wanted to stage their exuberance and to set it off against those steady markers which calibrate the ceiling. Siskind said that 'the so-called documentary picture left me wanting something', and indeed in the 1940s his photography became very subjective and abstract. In many of his early pictures made in Harlem in the 1930s, the urge to manage the picture and to make it expressive of a state of mind is already evident. This event, for instance, could almost symbolize dance and the feelings to which it gives rise. Siskind started out as a concerned socio-photographer working in the Photo League, but he left the organization in 1941. Many of his pictures of the 1940s, showing abraded and torn surfaces, can be thought of as works of art in the emerging Abstract Expressionist manner.

☛ C. Capa, Giacomelli, W. Klein, Morgan

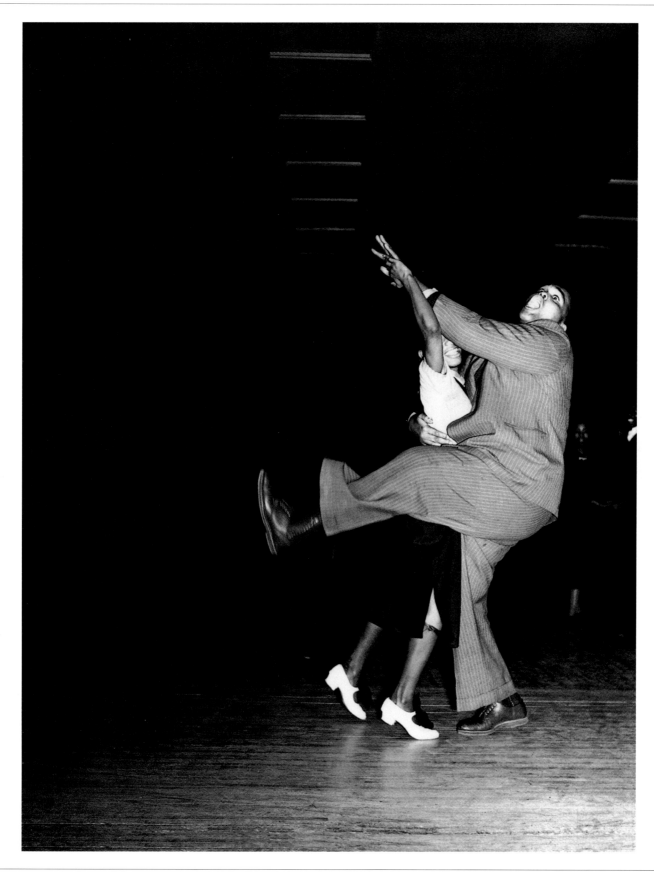

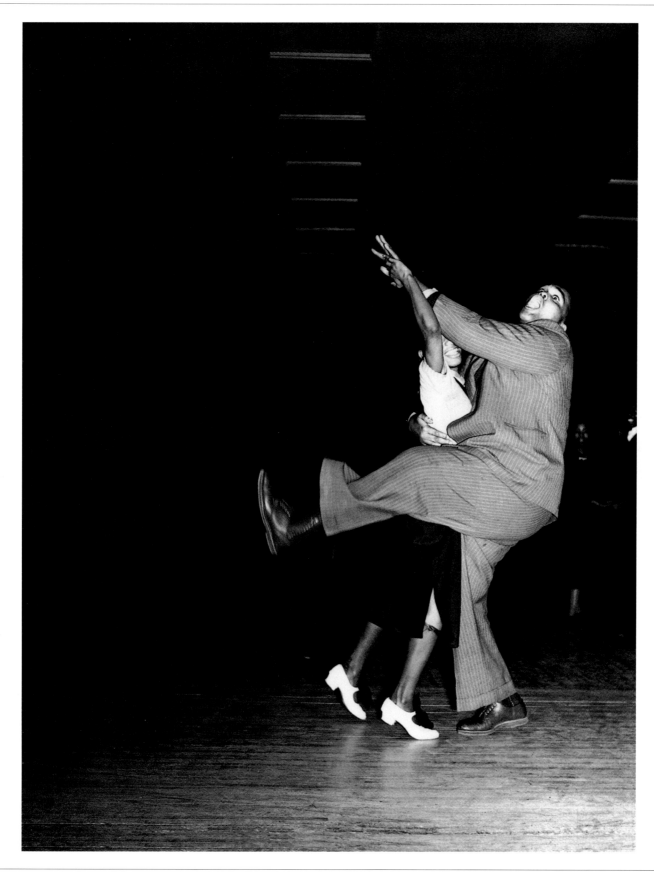423

Aaron Siskind. b New York (USA), 1903. d Rhode Island, NJ (USA), 1992. **Savoy Ballroom, New York**. c1936. Gelatin silver print.

Skoglund Sandy

Fox Games

Twenty-two red foxes clamber over the tables and chairs of a dining-room, playing, scratching, jumping and eating, as a waiter pours wine for a couple dressed in grey. A single grey fox, carrying a dead creature in its mouth, tiptoes cautiously across the floor. The arrangement looks flawless and not even the supports and wires are visible. The picture raises many questions. Firstly, has the scene been set up specifically to be photographed or is it a piece of installation art? Also, are the foxes off-the-shelf animals bought from a stockist or have they been modelled by the photographer? In this case there can be no escape from questions about art and its objects, even before you turn to the strangeness of the situation itself. Sandy Skoglund, a photographer who is also a set designer and sculptor, speaks of her tableaux as being a 'film in a frame'. She works very slowly on each one, producing no more than one or two in a year.

☛ Faucon, Ray-Jones, Simmons, B. Webb

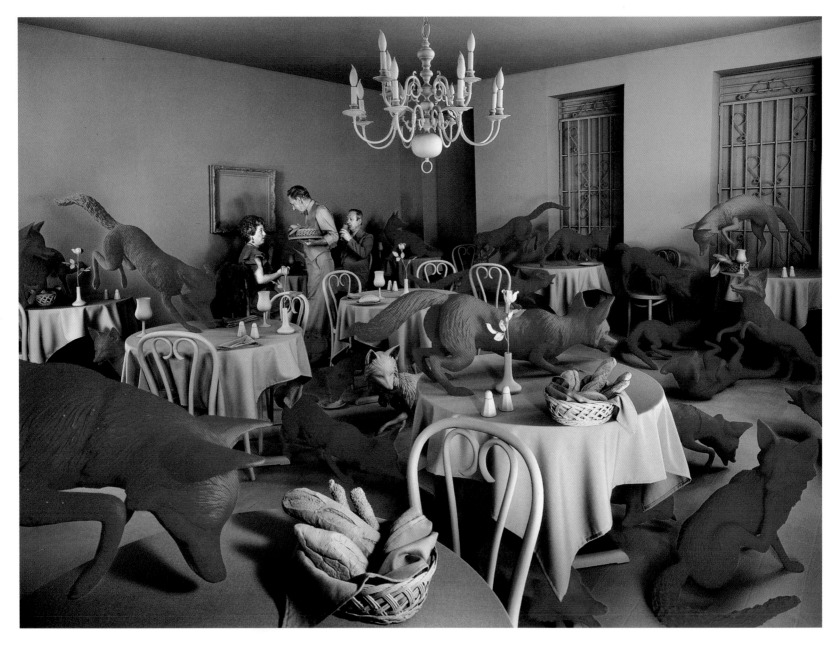

Sandy Skoglund. b Quincy, MA (USA), 1946. **Fox Games**. 1989. Cibachrome. **h**140 × **w**180 cm. **h**55 × **w**71 in.

Smith Edwin

Goldsborough Pasture, East Yorkshire

A grazing carthorse is looking towards the camera. Overhead a new moon makes a pale inscription in the sky. The field itself shows traces of ancient cultivation in those parallel ridges, or rigs, but it now seems to be grazed by sheep. This photograph may look like a fragment of agricultural landscape, but it contains elements symbolic of the culture and of traditional cultures everywhere, such as the horse and the moon and the field. Smith took up photography in the mid-1930s and concentrated at first on urban and social subjects. However, after the war he began to specialize in architectural photography and in British subjects, producing pictures of landscapes, gardens and interiors of farmhouses, churches and country cottages. He soon established himself as a virtuoso interpreter of the fabric of Britain. In 1950 he was commissioned to illustrate a series of books on the landscape and architecture of Britain. One of the most notable titles is *English Parish Churches* (1952).

☛ Liebling, Muybridge, Prince, Sammallahti

Edwin Smith. **b** London (UK), 1912. **d** Saffron Walden (UK), 1971. **Goldsborough Pasture, East Yorkshire**. 1956. Gelatin silver print.

Smith Graham

'The Zetland', Middlesborough

This photograph epitomizes Smith's statement that in the 1980s he worked mainly in Middlesborough pubs 'used by those who live on the edge, whose future is the next good time, the next good drink'. At that time the North-East was the British social landscape *par excellence*. Relatively free of the gentility which tainted the rest of the country, it kept Britain competitive – as a photographic site at least – with Joseph Koudelka's Slovakia and Bruce Davidson's New York. The problem, though, was how to treat such strong subject-matter. Documentarists had usually justified themselves on the grounds that they were doing good, and in the 1970s everyone knew about the important work undertaken by the Farm Security Administration photographers in the USA in the 1930s. Smith, who comes from Middlesborough, decided to turn down the part of social worker and instead to join in the fun and make a commentary on manners.

☛ Brassaï, Davidson, Koudelka, Wellington

Graham Smith. b Middlesborough (UK), 1947. **'The Zetland', Middlesborough**. 1982. Gelatin silver print.

Smith W. Eugene

The Country Doctor

Dr Ernest Ceriani is taking a break after performing an operation. In 1948 Smith was sent by *Life* magazine to Kremmling, Colorado, to photograph a country doctor at work. The results of the assignment constituted Smith's first major photo-story. He had served as a noted war photographer with the American forces in the Pacific theatre, and had been badly injured in 1945. In 1946 he returned to photojournalism with *Life* and although he worked on around fifty-eight assignments between then and 1954, he finally resigned due to disagreements with his editors. Smith's idea was that photography was 'a great power for betterment and understanding' if properly used. The photo-story, in his opinion, depended less on pre-existing arrangements than on images which could be read as excerpts from a continuum. Like Dr Ceriani, with his smoked cigarette and barely touched cup of coffee, Smith's personnel tend to exist between one moment and the next.

☛ van Manen, Parks, Southworth & Hawes, A. Webb

427

W. Eugene Smith. b Wichita, KS (USA), 1918. **d** Tucson, AZ (USA), 1978. **The Country Doctor**. 1948. Gelatin silver print.

Snowdon

Portrait

In the painting behind the dancer Rudolf Nureyev's head, Cupid and a protective goddess are shepherding their drowsy charge downhill towards his true love, asleep in the foreground. Putti shower the naked lover with their arrows, but to no avail. Nureyev, lavishly dressed in Chinese silk, seems to be enjoying the ironies of the situation: lascivious East and torpid, hesitant West, all mediated by an inscrutable globe. Both photographer and dancer came from a generation which appreciated ironies of this kind. In Snowdon's very first book, *London* (1958), there are many compositions structured around the differences between, for example, royalty and street markets, a Rolls Royce and back-street garage. *London*, mostly taken in passing, is an example of the informality practised by a new generation of Europeans, such as Robert Frank and René Burri. Snowdon's other principal interest is the theatre, where he has taken pictures and designed sets.

☛ Burri, Frank, Glinn, Hoppé, Tmej

428

Snowdon (Anthony Armstrong Jones). b London (UK), 1930. **Portrait**. 1986. C-type print.

Sommer Frederick

Livia

We expect portraits to be of well-established identities, and Livia seems to be one such identity, squarely placed in front of a weathered backdrop. Yet if this is meant to be a straightforward portrait, why has she been presented against such a complex screen of flaking veneer with its hints of anthropomorphic ears and eyes? At some points the tonalities of the screen match those of the child exactly, to the degree that there are parts of her neck, hair and arms which blend into the background completely. In a poem, Sommer wrote of physical indicators being present 'when something metaphysical is happening', as in the making of a portrait, he might have added. Thus Livia as an identity is shown by Sommer to be in the process of emerging from the physical circumstances which also lay claim to her. During the 1940s Sommer photographed dead creatures in the Arizona desert – dessicated creatures pictured merging into their backgrounds.

☛ Carroll, Erfurth, Glinn, Lee, Mann, Seeberger, Strand

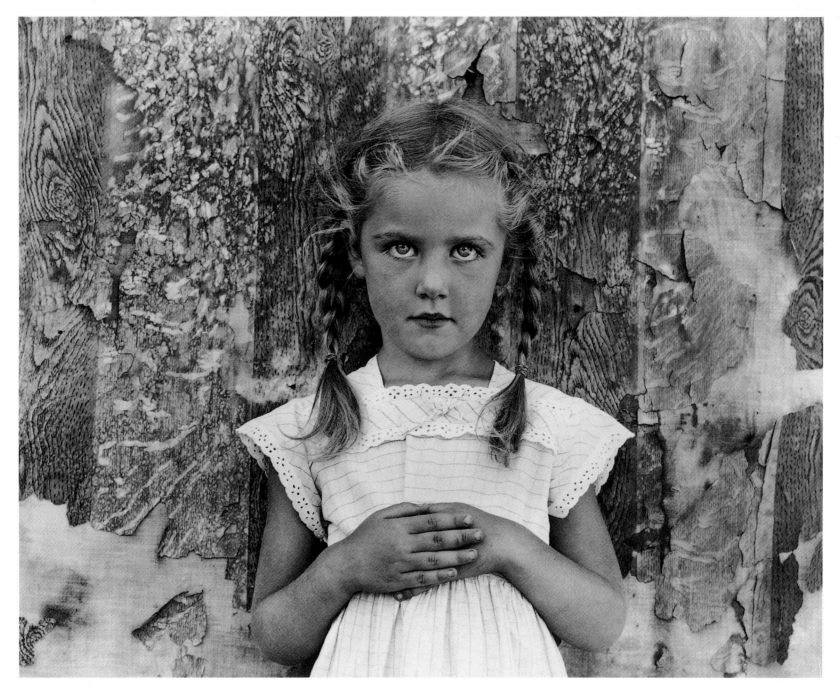

429

Frederick Sommer. b Angri (IT), 1905. Livia. 1948. Gelatin silver print.

Sorgi I. Russell · Suicide

The woman who has just jumped from the eighth-storey window ledge of the Genesee Hotel in Buffalo was a thirty-five-year-old divorcée. Sorgi, a news reporter with the Buffalo *Courier Express*, must have been tipped off that there was trouble at the hotel, although to judge from the body language of the other four participants, no-one expected quite this degree of melodrama. This picture of 1942 has forced its way into photography anthologies, partly because it is set in Main Street, which looks like a supervised, genial place. Up until around this time picture-makers had assumed that humanity was at home in the kind of space offered by the gloomy interior of the coffee-shop. Thus the suicide's indifference to such comforting paraphernalia as the patriotic poster and the barber-shop pole appeared shocking, a terrible reminder of real life, and an affront to the optimistic image-building with which American documentary had been associated in the 1930s.

☛ Dalton, Funke, A. Klein

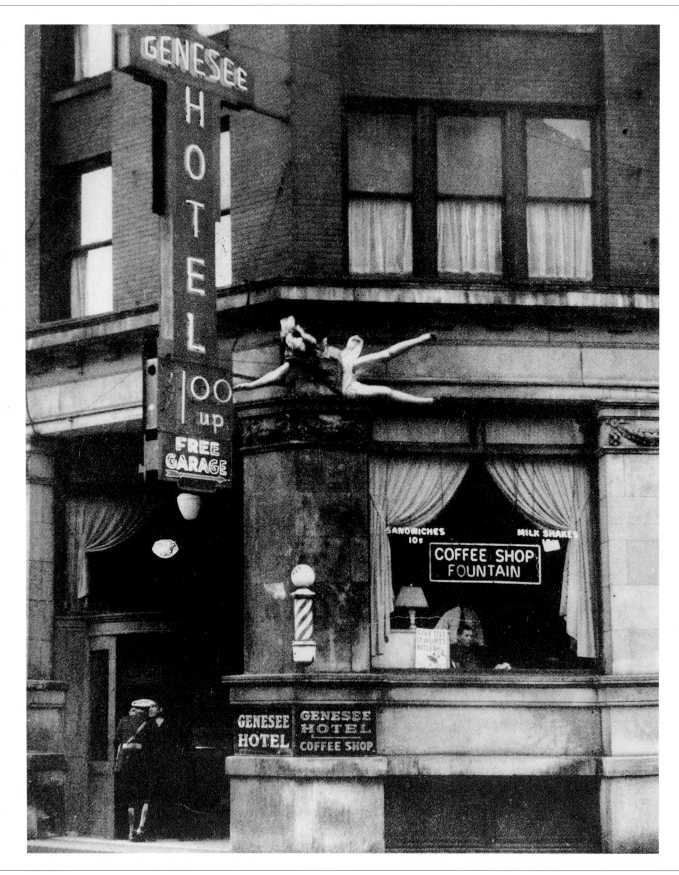

I. Russell Sorgi. b Buffalo, NY (USA), 1912. **d** Buffalo, NY (USA), 1995. **Suicide**. 1942. Gelatin silver print.

Sougez Emmanuel

Grapes

Grapes on a table would usually have no more than a commonplace significance, but here their textural and formal qualities begin to register in contrast to that spidery arrangement on the plate. Then the opacity of the plate contrasts with the transparency of the tumbler, until the whole begins to add up to a lesson in perception. This is the sort of composition which was valued in the 1930s because it heightened visual awareness in a culture becoming too open to political and commercial slogans. At the time he took this photograph Sougez was one of the most powerful influences in European photography, for in 1926 he had been asked to establish and to manage the photographic section of the review *L'Illustration* – where he was employed until the outbreak of the war. In the mid-1930s he set up the exhibiting society Le Rectangle and then in 1945 helped in the establishment of the Groupe des XV.

☛ de Meyer, Parker, Tomatsu, Wols

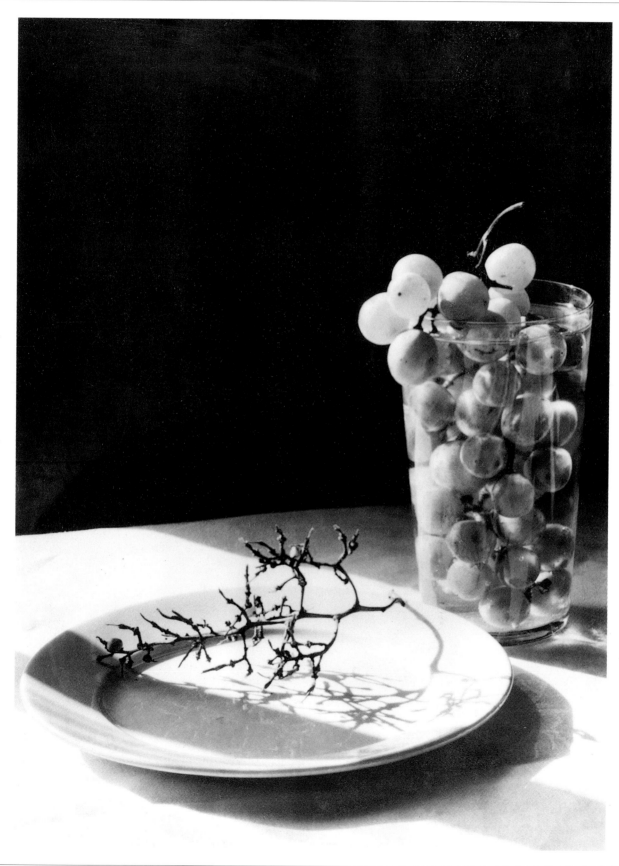

Emmanuel Sougez. b Bordeaux (FR), 1889. **d** Paris (FR), 1972. **Grapes**. 1934. Bromide print.

Southworth & Hawes

Lola Montez

In 1851, when this picture was taken, Lola Montez was the second most famous woman in the world after Queen Victoria. Born Eliza Gilbert in southern Ireland, she took the name Donna Maria Dolores de Porris y Montez in 1843 on her first stage appearance as a Spanish dancer. A series of controversial marriages and well-publicized affairs culminated in a liaison with Ludwig I of Bavaria which began in 1846 and contributed to his deposition in 1848. She went to America in 1851 to act in *Lola Montez in Bavaria*. The walking gloves and hand-rolled cigarette in this photograph are signs of an independent spirit, and her responsive glance beyond the viewer seems to indicate a strong character. Southworth, who had opened a daguerreotype studio in 1840, and Hawes, who had been a self-trained portrait painter, joined forces in 1843. They remained in business together until 1862 and succeeded by virtue of a remarkable combination of artistic and social gifts.

☛ Boubat, Kirkland, Knight, Silverstone, W. E. Smith

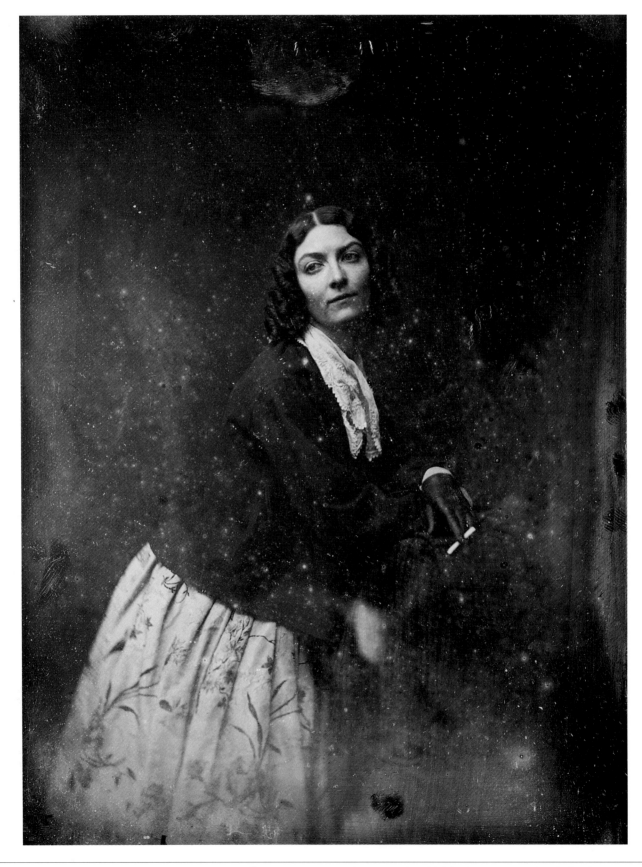

432

Albert Sands Southworth. b West Fairlee, VT (USA), 1811. d Charlesworth, MA (USA), 1894. **Josiah Johnson Hawes**. b East Sudbury, MA (USA), 1808. d Crawford's Notch, NH (USA), 1901. **Lola Montez**. 1851. Daguerreotype.

Staub Hans

In Front of the Kindergarten, Zurich

It is the moment of parting. Father and son have arrived at the gates of the kindergarten, and now it is time to say goodbye. The analytical manner in which the two figures are outlined so distinctly is typical of 1930, even if the subject anticipates the humanitarian tone of photography in the 1940s and later. Staub was a photo-reporter for the magazine *Zürcher Illustrirte*, and was able to turn his hand to anything, from fashion to school sports days. As a reporter he composed in terms of continuities in time: the journey to the gates, for instance, followed by farewells and then parting. The result was a photography of fragments and instances, expressive of societies on the move under the impact of economic hardship and political turmoil. Staub, who worked largely in the Zurich area, is a classic example of a regional reporter. He was the subject of an exemplary monograph of 1984 entitled *Schweizer Alltag: Eine Photochronik 1930–1945*.

☛ **Alinari, Eisenstaedt, Lichfield, Singh**

433

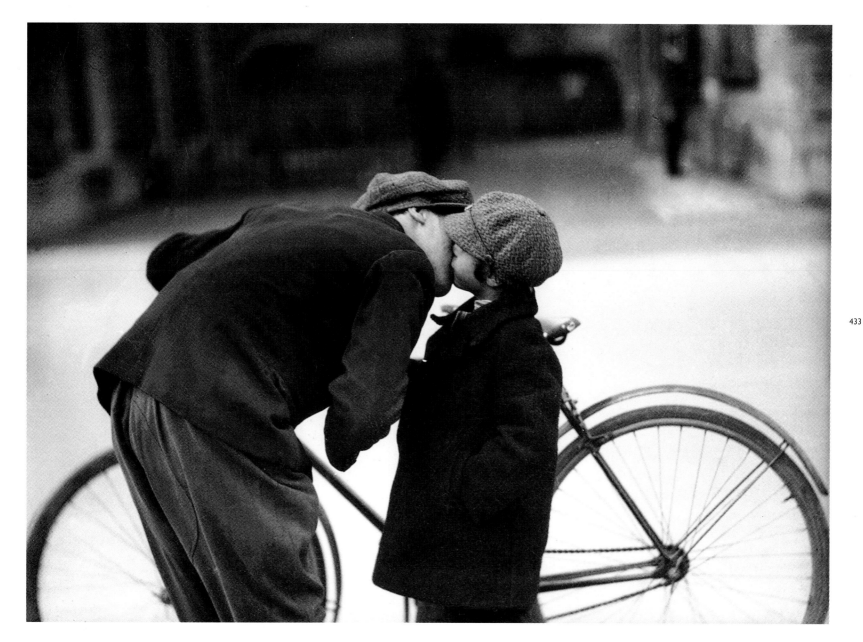

Hans Staub. **b** Wetzikon (SW), 1894. **d** Zurich (SW), 1990. **In Front of the Kindergarten, Zurich**. 1931. Gelatin silver print.

Steele-Perkins Chris Blackpool Beach in Summer

The dog's crime will soon be discovered. The donkeys, with their bells, will move away; the newspaper reader in his socks will be free to finish the crossword and enjoy his foil-wrapped sandwiches. This picture, which was taken on Blackpool beach in the north of England, presents a series of groups and individuals intent on such tasks as getting into that freezing water. At first glance it looks like a throwback to the 1950s when the idea of autonomy mattered to reporters who remembered the constraints of war-time. The difference, though, is that this much later event is considered with far more attention than before to an idea of the future. It is a future relatively open and worth waiting for, and its diverse freedoms stand in sharp contrast to many of the states of imprisonment, madness and death uncovered by Steele-Perkins in the news zones of the 1980s and 1990s. His book on Britain in the 1980s, *The Pleasure Principle*, was published in 1989.

☛ **Franck, Hopkins, Hurn, Kühn, R. Moore**

434

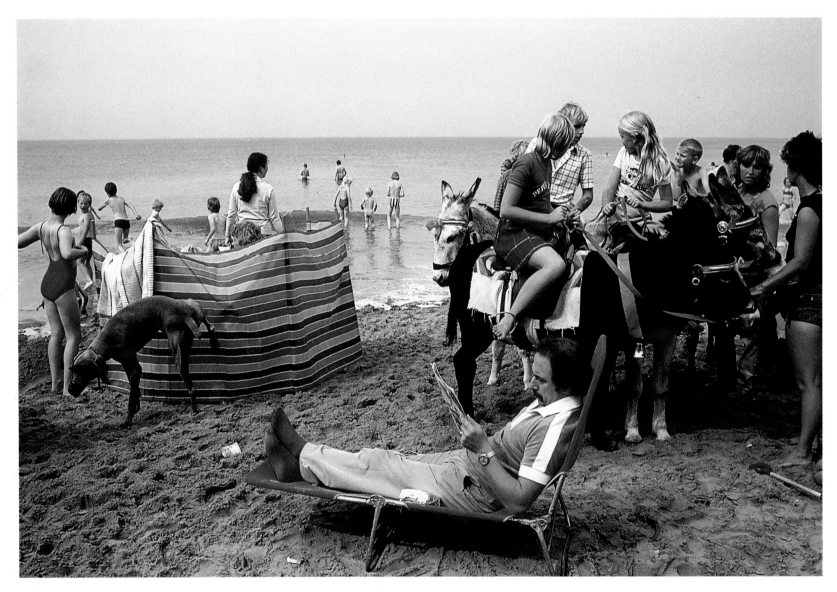

Chris Steele-Perkins. b Rangoon (BUR), 1947. **Blackpool Beach in Summer**. 1989. C-type print.

Steichen Edward

Rodin – Le Penseur

The sculptor Rodin is sitting lost in thought in the presence of the dark figure of *The Thinker* from his own *Gates of Hell*, and of a statue of Victor Hugo behind. All three represent genius as an affair of hand and head, light and darkness, and the struggle to transcend the problems of ordinary life in the material world. Steichen thought of himself as just such a genius, caught between the conflicting priorities of art and public service. Having originally trained as a painter, he believed in the role of the photographer as a creator, subject to inward visions. He was deeply influenced by Alfred Stieglitz in New York, and from 1900 onwards was active in the art world in Paris, where he was elected to the Linked Ring in 1901. In 1902 he was a co-founder of the Photo-Secession group. From 1923 he worked for *Vogue* and *Vanity Fair*, and in 1943 he became the director of photography at New York's Museum of Modern Art, where he organized the 'Family of Man' exhibition in 1955.

☞ Fuss, Kertész, Pierre et Gilles, Stieglitz, Tingaud

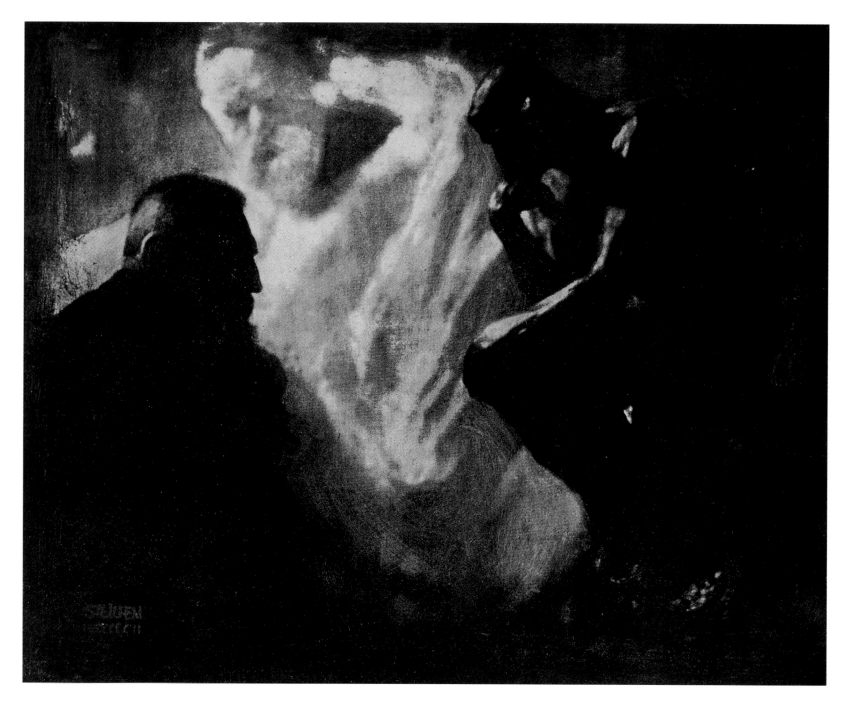

435

Edward Steichen. b Luxembourg (LUX), 1879. **d** West Redding, CT (USA), 1973. **Rodin – Le Penseur**. 1902. Photogravure.

Steinert Otto

Pedestrian's Foot

This is Steinert's most celebrated picture, even if it contains only one foot, a tree trunk and a stretch of pavement. Such a sparse composition may have been deliberate or perhaps Steinert just wanted to create an enigma. Even an enigma, however, would have tested and stimulated the imagination – thus fulfilling one of Steinert's ambitions for photography. In

1951 he launched the idea of *subjektive fotografie* in conjunction with an exhibition of that title which he organized in the Schule für Kunst und Handwerk in Saarbrücken. Steinert disliked what he called applied photography, by which he meant documentary and any other mode purely at the service of the motif. Instead he envisaged an expressive art of

photography in which the artist's creative intentions took precedence over the motif and whatever social meanings might attach to it. Steinert's influence was profound and – in the long run – decisive.

☛ Bragaglia, Kinsey, Tillmans, Uelsmann

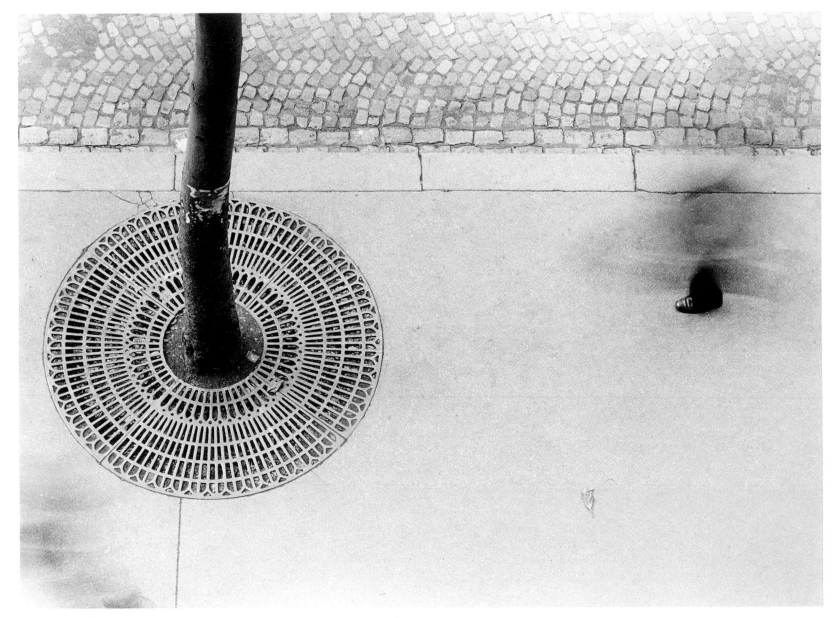

436

Otto Steinert. b Saarbrücken (GER), 1915. **d** Essen (GER), 1978. **Pedestrian's Foot**. 1950. Gelatin silver print.

Stoddart Tom

Young Mother and Child Awaiting Evacuation from Sarajevo

The small boy's eyes express innocence and apprehension, his mother's the desperation of a parent who fears she may not be able to take her child away from the constant threats and dangers of a town under siege. This picture is featured in 'Edge of Madness', an exhibition of photographs of the siege of Sarajevo taken by Tom Stoddart and Alastair Thain. Stoddart, who is a British photojournalist, spent four years documenting the daily lives of the citizens of Sarajevo. During that time he broke his ankle in six places and his shoulder while running from sniper fire, but he returned to Bosnia a year later, determined to complete what he regarded as unfinished business. The result is a collection of work which, as Martin Bell wrote in his introduction to the exhibition, 'demands attention and rewards reflection'. It stands as a monument to the dignity of people 'whose only task was survival and who would not let the war defeat them'. Stoddart recently photographed the Labour Prime Minister Tony Blair.

☛ Curtis, Ferrato, Lange, Lyon, Mydans, Seymour

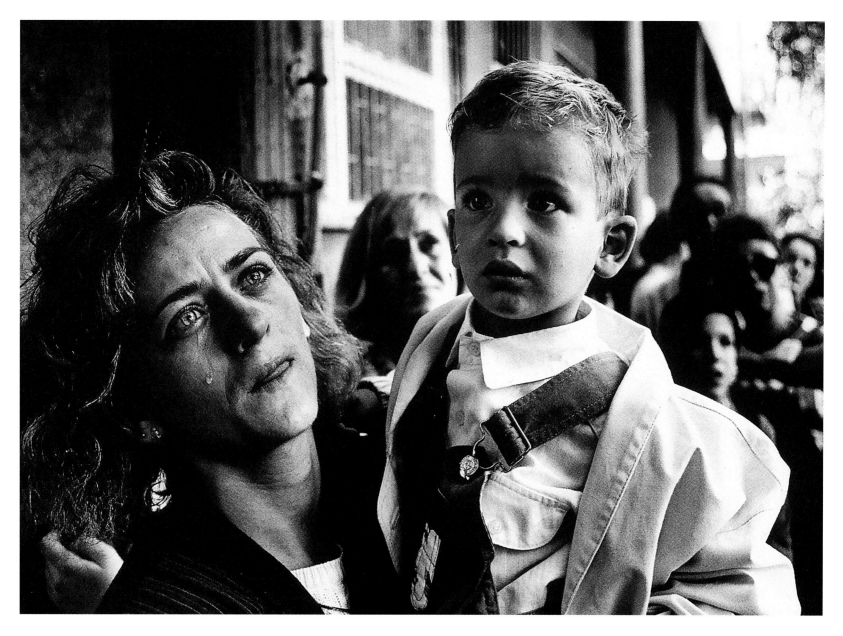

441

Tom Stoddart. b Morpeth (UK), 1953. **Young Mother and Child Awaiting Evacuation from Sarajevo**. 1992. Gelatin silver print.

Strand Paul

Young Boy, Gondeville, Charente, France

This boy represents youth, and may even be thought of as a torchbearer if you care to remark on the figure made by the light as it falls on the bridge of his nose and his forehead under the swirl of his hair. Little in Strand's pictures ought to be overlooked, and that peculiar silhouette of a door-latch by his right shoulder has a dressed-up look, as if in anticipation of the life ahead. For the moment, though, as you can tell from the intensity of his stare, the boy lives in the fullness of the here and now. This portrait was made for *La France de profil*, Strand's book of 1952, which he began work on in 1950. Other important projects include one on Italian life and another on the people of the Hebrides. First instructed in photography by the pioneer documentarist Lewis Hine, Strand became – and remained – a committed Socialist from the early 1930s, during which decade he worked as a film-maker for the Mexican Secretariat of Education. In 1950 he moved to France, where he died in 1976.

☛ Brady, Carjat, Hine, Nadar, Sommer

442

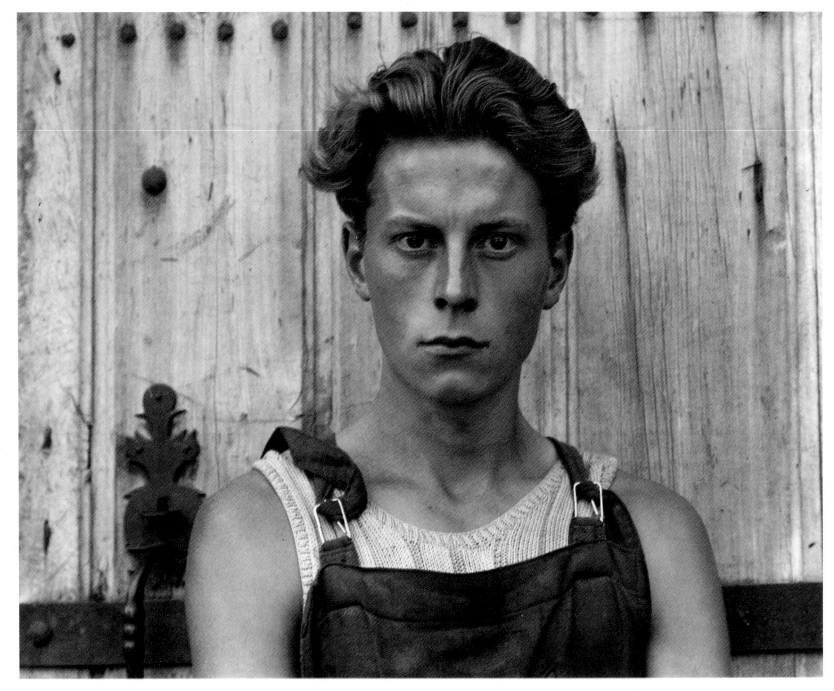

Paul Strand. b New York (USA), 1890. **d** Orgeval (FR), 1976. **Young Boy, Gondeville, Charente, France**. 1951. Gelatin silver print.

Strömholm Christer Barcelona (Portrait)

The man's hair, parted on the left, still has a masculine look, but it is his female gaze which counts. He poses as a woman who has had long experience of her own beauty and strangeness. She looks as though she has met you before, or many like you, and marked your response well enough to prepare this Mona Lisa face and a gaze both self-possessed and sad. With nothing to go on but the encounter itself, no contextual details in which to take refuge, you are left with the moment and an exchange of glances. Strömholm lived and worked between 1959 and 1962 among the demimonde in the Pigalle area of Paris. It was twenty years before his work was published in Sweden, and the series was called *Friends of the Place Blanche*. Originally a painter and graphic artist, Strömholm turned to photography in the early 1950s, and in 1962 he founded the Fotoskola at the University of Stockholm.

☞ Beaton, Iturbide, Ruff, Sherman

Christer Strömholm. b Stockholm (SWE), 1918. Barcelona (Portrait). 1959. Gelatin silver print.

Struth Thomas

Unconscious Places

Complicated architectural spaces, such as this one in the Shinjuku area of Tokyo, have to be read carefully using the ambiguous evidence available. Sometimes it is impossible to tell how things connect, especially when they are seen, as here, through a thicket of wires. Struth's pictures do, however, make the viewer aware that there is an urge towards clarity, a tendency to want to see just where things stand in relation to each other. They ask you both why it is that you look at pictures and just how far you are prepared to go for the sake of discernment. Struth's subject has always been an awareness of the act of seeing, which he experiments with in photographs of urban views. His earliest pictures were of street scenes in German cities, very plainly presented in the early morning light. Increasingly in the 1980s Struth began to take pictures of the kind of urban collage on show here. He was taught at the Kunstakademie in Düsseldorf by the photographer Bernd Becher.

☛ Baltz, Becher, Ruscha, Sinsabaugh, Sudek

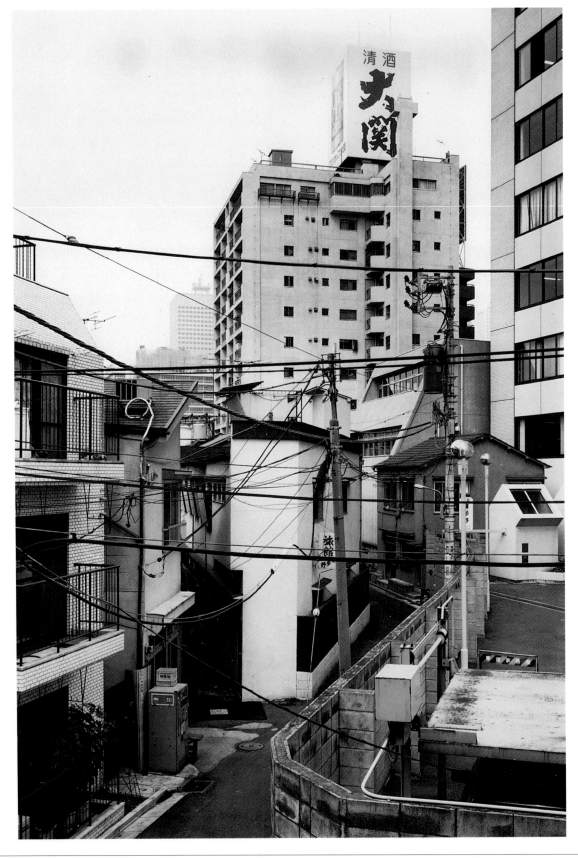

Thomas Struth. b Geldern (GER), 1954. **Unconscious Places**. 1986. Gelatin silver print.

Sudek Josef

Pankrác, on the Outskirts of Prague

Pankrác, situated in the south of Prague and to the east of the Vltava River, is an area which is more lived-in than visited. Sudek's requirement was that a site should show some signs of habitation such as a shed, a set of steps, a park bench or a tram stop. Sudek, who had been a photographer since the early 1920s, was one of a new generation of photographers and the

founder of the Czech Photographic Society in 1924. It was, however, not until much later that he became famous, when he was almost at the end of his career and still far from being a vanguard artist. In about 1950 he began to take pictures in and around Prague, using a Kodak panoramic camera, and it is to a large degree on these pictures – published in 1959 in *Praha*

Panoramatická – that his reputation rests. The panoramas were especially attuned to Prague, a city with broad squares and public parks, but principally they appealed because of their endorsement of the everyday.

☞ Marlow, Ruscha, Sinsabaugh, Struth

Josef Sudek. b Kolín (CZ), 1896. **d** Prague (CZ), 1976. **Pankrác, on the Outskirts of Prague**. 1959. Gelatin silver print.

Sugimoto Hiroshi

Cabot Street Cinema, Massachusetts

This picture was taken during a film shown at a packed cinema. The exposure lasted for around ninety minutes, or the length of the feature film on show, and was made with an 8 x 10-inch camera. Neither film nor audience can be seen, only the basic light effects used in the showing. The result is an idealized, abstract representation of the event, and one which denies all the incidentals of which it was actually made up. How, Sugimoto is asking, should we think of time? Most photography deals in the instant held still so that it might be analyzed, like a scientific specimen. Sugimoto, however, shows time stilled and seemingly sustained forever in pictures which record the essentials of a cinema light show. An earlier series displayed natural-history vitrines in museums in which moments from nature were stabilized for posterity's eyes. The sea, too, is another subject in which very long exposure times secure an abstract trace of something notoriously animated and restless.

☛ **Abell, Johns, Link**

446

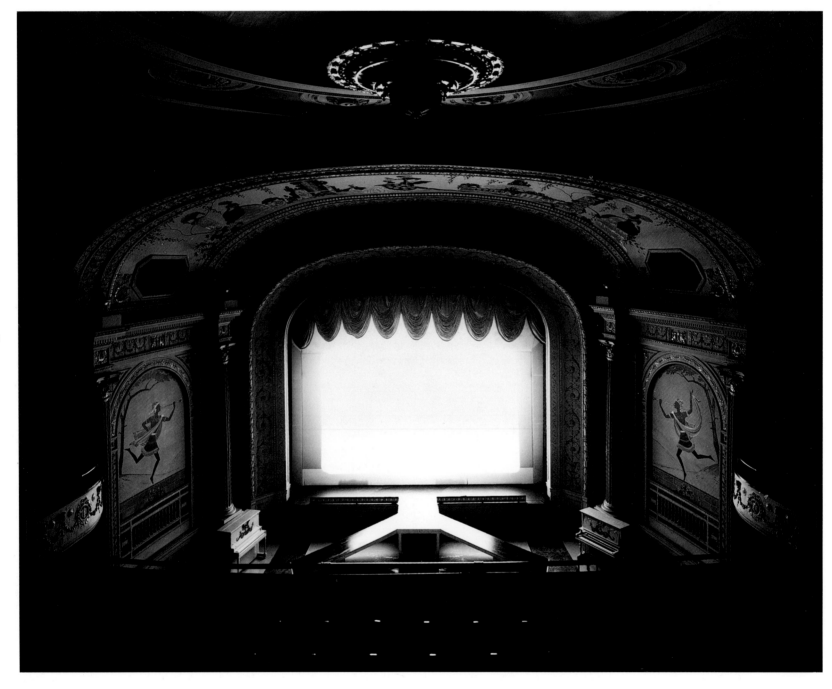

Hiroshi Sugimoto. b Tokyo (JAP), 1948. **Cabot Street Cinema, Massachusetts**. 1978. Gelatin silver print.

Sutcliffe Frank Meadow The Flying Spray of Glasgow

The Glasgow-registered paddle steamer *Flying Spray* is resting at low tide by the harbour wall at Coffee House Corner in Whitby, North Yorkshire. One of the smaller boats (known locally as cobles), second from the left and registered W3, belonged to Tom Cass, the pilot. The slats on the paddle casing rhyme with that flight of steps leading up to the Marine Hotel,

and the boats themselves sit contentedly on their reflections in the still water. Sutcliffe was known in the 1880s and 1890s for his portrayals of the fishing community in Whitby and for pictures of the town's ruined abbey and of the harbour with its bridges. But his underlying subject, quite apart from such ostensible topics as harbour traffic, was security. Sutcliffe's

ideal harbour is homely and reassuring, and like no other venue in the history of the medium. Here, for instance, the day's work is done and the doors of the Marine Hotel will soon be open.

☛ Basilico, Berry, Oorthuys, Régnault, Silvy

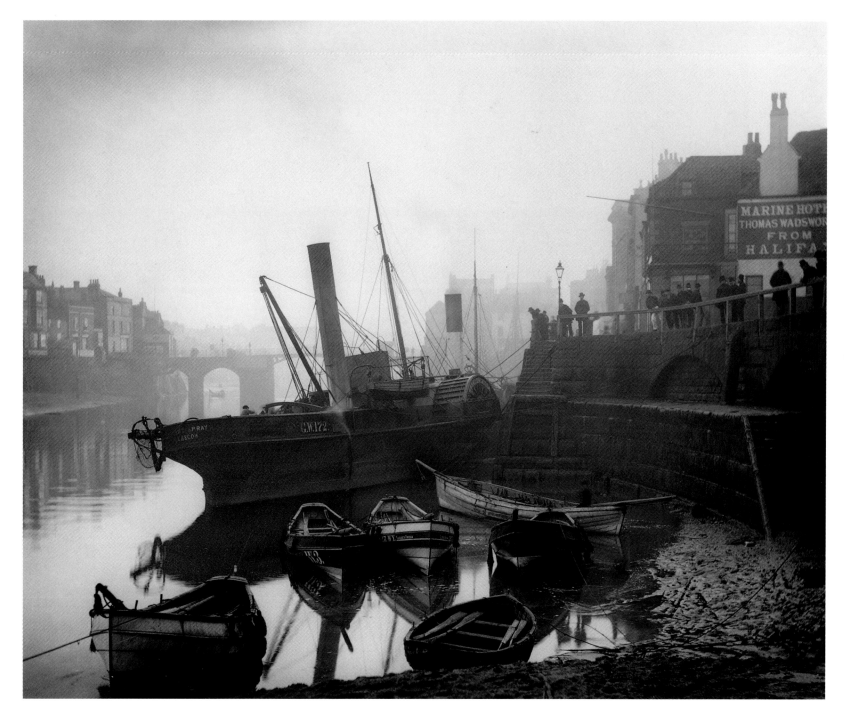

447

Frank Meadow Sutcliffe. b Headingley (UK), 1853. **d** Sleights (UK), 1941. **The Flying Spray of Glasgow**, c1895. Bromide print.

Teller Juergen

Kate Moss, Paris

The model Kate Moss raises one eyebrow, glances to the right, and half turns to the left. The question is, why has she arranged her mouth like that? Teller's pictures from the mid-1990s ask you to imagine what it might be like to be that model with that body in that place. How far, in this instance, has she turned her shoulders or raised that eyebrow? The idea underlying the new fashion photography of the 1990s is that we have to make do with a threatened physical existence, and that we are fragile. Teller's models are thinly clothed or nude, and slender to the point at which we become conscious of skin, bone and sinew – basic ingredients. Juergen Teller studied photography in Munich between 1984 and 1986 and immediately afterwards moved to London, where the photographer Nick Knight introduced him to record companies and magazines. He has been especially associated with such style publications as *i-D*, *The Face* and *Arena* and with a new generation of models.

☞ Bailey, Blumenfeld, Dahl-Wolfe, Knight

448

Juergen Teller. b Erlangen (GER), 1964. **Kate Moss, Paris**. 1994. C-type print.

Testino Mario

Untitled

Role reversal over Los Angeles, and an impending trial of strength? This photograph is an out-take from the Gucci perfume campaign which Mario Testino shot in Los Angeles in September 1996, and it features Georgina Grandville and Jason Fidelli. Testino remarks on the grace of young bodies, and on their fragility. He represents an elegant tendency in fashion photography at odds with the newest brutalism of the mid-1990s: 'This trend for hyper-realism and ugliness is exciting, but I don't think it's doing what it's supposed to do.' In the 1970s Testino read economics and law at the University of Lima, and then International Affairs in San Diego. In the late 1970s he studied photography in London, and began to work for British *Vogue* in 1980. He is credited with undermining the regime of the supermodel and all that entails of distance or withdrawal from the more vulnerable affairs of the world at large.

☛ Araki, Burri, Durieu, Goldin, Weston

449

Mario Testino. b Lima (PER), 1954. **Untitled.** 1996. Gelatin silver print.

Thomson John Street Doctor

This doctor, with his built-up shoe, seems to be having a hard job persuading the women to buy. Free hospitals in the 1870s meant that street doctors were beginning to become anachronisms on the streets of London. Street doctoring, known as 'crocussing', was thought to be a racket and it was one of a range of street trades pictured by John Thomson in 1876 and published in 1877–8 in a famous series, *Street-Life in London*. Each image was accompanied by an essay, written by either Thomson or Adolphe Smith, based on interviews with informants and rich in proper names, nicknames, street cries, anecdotes, local lore and trade argot, or 'patter'. The series is the first survey of a city's types in the history of the medium and it coloured the image of London until the 1950s at least. Thomson was almost as well known for his pioneering pictures of Chinese life and landscape taken between 1868 and 1872 and published in sets throughout the 1970s.

☛ Mihailov, Warburg

450

John Thomson. b Edinburgh (UK), 1837. **d** London (UK), 1921. **Street Doctor**. 1876. Albumen print.

Tillmans Wolfgang

Lutz and Alex Sitting in the Trees

A semi-naked man and woman photographed in the presence of trees might be intended to suggest the Garden of Eden, or just to portray dressing up in the woods. This idyllic image appears in several of Tillmans's photo-installations. It is usually printed big (at one of three specified sizes) and accompanied by pictures from street life. Tillmans's is a confessional art, centred around whatever catches his eye: dishes in a sink, fruit on a table-top, flowers, clichéd autumn foliage, airports, flyovers and the city seen from hotel windows. Like other European photographers in the 1980s and 1990s, he has dispensed with the idea that art should be taken from a special, privileged zone. The here and now has to be taken account of, even if it is shot through with contemporary gestures, expressions and motifs. Tillmans's career to date is summed up in *for when I'm weak I'm strong* (1996), a record of his travels, encounters and installations.

☛ Araki, Bailey, Brigman, Durieu, Saudek, Steinert

451

Wolfgang Tillmans. b Remscheid (GER), 1968. **Lutz and Alex Sitting in the Trees**. 1992. C-type print. **h**40 × **w**30 cm. **h**15¾ × **w**12 in. **h**60 × **w**50 cm. **h**23½ × **w**19½ in. **h**160 × **w**118 cm. **h**63 × **w**46½ in.

Tingaud Jean-Marc

Zagreb Interior

The lower photograph shows a line of cellists, men and women, playing in some bygone rehearsal staged for the camera. The all-male orchestra above is posing as a formal group. The sculpted figure below stretches luxuriantly, as if in appreciation of the light and music. She looks like a representative of an idealized modern world. This assembly appears in Tingaud's

Intérieurs of 1991, a collection of found arrangements taken against domestic backgrounds: walls, wallpaper, panelling. Tingaud's very poetic art depends on what he calls 'the patience of things', their ability in particular to invoke meaning if found in the right place and in the right light. His fear, outlined in a statement in *Intérieurs*, is of the abyss, a vast rupture of

memory and a situation in which objects no longer signify anything. His photographs look like the work of a collector displaying cherishable items which command attention and elicit meaning.

☛ **Fuss, Kertész, Pécsi, Steichen**

452

Jean-Marc Tingaud. b Saulieu (FR), 1947. **Zagreb Interior**. 1989. Dye transfer print.

Titov Gherman Vostok-2

The caption on this photograph reads: 'The first photograph of the Earth from space during the flight of Vostok-2 spacecraft on August 6–7, 1961. The photograph was made by a hand-held "Konvas" camera, 7 August 1961.' It was taken by Cosmonaut Gherman Titov during the second manned flight into space, which lasted twenty-five hours. During his time in orbit Titov was 'spacesick', but he managed to take some pictures, including this one, which can be seen as the equivalent to the pictures taken by explorers in the mid-nineteenth century to which details were sometimes added in pen. Titov's script authenticates the image and at the same time identifies the exploration of space as an adventure full of effort and risk.

Space travel had been imagined often enough in the 1950s by illustrators, but always more lucidly as part of a future which took no account of weather and handwriting.

☛ A. Adams, Armstrong, Sammallahti

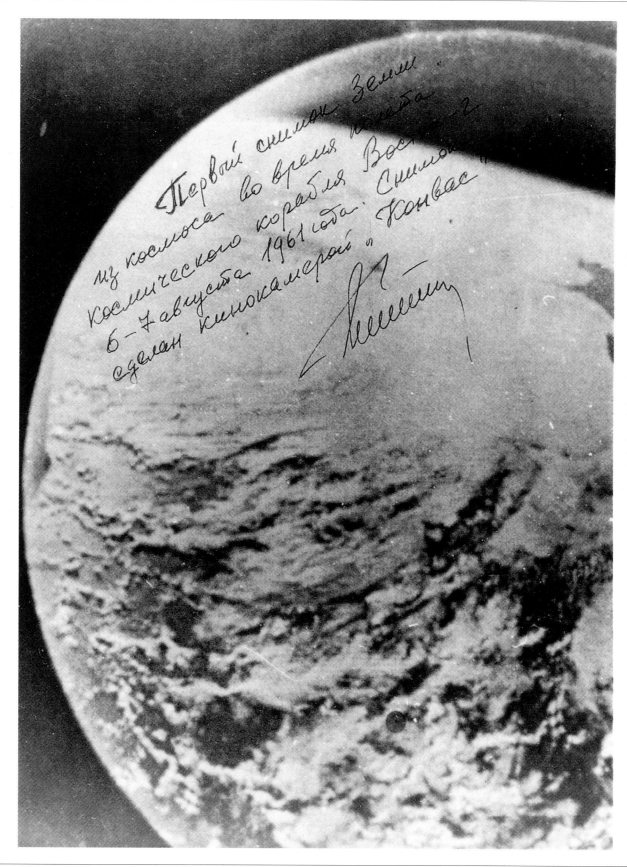

Gherman Titov. b Altaiski Krai (RUS), 1935. **Vostok-2**. 1961. Gelatin silver print.

Tmej Zdeněk

Czech Man Called up for Work in Germany, Breslau

Hitler, the epitome of the state's authority, is keeping a close eye on the Czech conscripts during a rest period in a hostel at Breslau. The man's obvious exhaustion is mocked by the exuberance of the ascending eagle on his cap-badge. In 1942 Tmej, who was already an established photographer in Prague, was called up to do forced labour for the German army at Breslau. He remained there until 1944 and took many illicit photographs showing the lives of conscript labourers, which were published at the end of 1945 as *Alphabet of Spiritual Emptiness*. His pictures present the conscripts playing cards, sleeping and resting, and on visits to brothels 'for foreigners only'. They were all taken indoors using available light, which emphasized tonal continuities and thus suggested the slow passage of time experienced by the conscripts. Subsequently Tmej worked as a photographer for the National Theatre in Prague, concentrating on ballet and folk dancing.

☛ Glinn, Halsman, Hoppé, Snowdon

454

Zdeněk Tmej. b Prague (CZ), 1920. **Czech Man Called up for Work in Germany, Breslau**. 1943. Gelatin silver print.

Tomaszewski Tomasz The Last Jews in Poland

The man's artificial leg is propped against the table, near to the kettle and the half-consumed jar of fruit. During World War II this man had been wounded and taken to a Soviet camp. After drinking a bottle of vodka, he let his cellmates amputate his damaged leg with a knife. When the war was over, he made a living by selling books from a baby carriage in the streets of Legnica in Poland and had occasional trouble with thieving boys. At home he spent his time either in bed or working out chess problems. His portrait first appeared in *National Geographic* in September 1986 together with an article carefully prepared over five years by the photographer's wife on the state of the last Jews in Poland. Tomaszewski's intention seems to have been to remark on people materially defined to such a degree that we have no option but to think of the spiritual and social life of Polish Jews as being of great importance.

☛ Calle, Gursky, Vishniac

Tomasz Tomaszewski. b Warsaw (POL), 1953. **The Last Jews in Poland**. 1993. C-type print.

Tomatsu Shomei

Ruinous Gardens

What is it exactly? Shrimps in profile suggest that the photograph has been taken underwater, but feathers, seeds and dried leaves bring autumn and air to mind. Tomatsu is hinting at the elements and the seasons, but he subordinates larger meanings to the feel of things and to the kind of time it might take to appreciate them. Tomatsu is one of Japan's leading photographers and is known for his books on major national themes, such as *Nippon* (1967), *Okinawa* (1969) and *Oh Shinjuku* (1969). He has also been associated, since the early 1960s, with reports on the effects on atomic radiation in Hiroshima and Nagasaki. Despite the significance of his subjects he has always been at pains to remark on such surfaces as this, articulated at random and inviting to the touch. His allegiances, that is to say, lie with the often disregarded fabric of things, and with the kind of decelerated time in which they might be taken in.

☛ Doubilet, Godwin, Mahr, Sougez

456

Shomei Tomatsu. b Nagoya-shi (JAP), 1930. **Ruinous Gardens.** 1964. C-type print. **h**56 × **w**46 cm. **h**22 × **w**18 in.

Tosani Patrick

Just what is the point of an image of the bowl of a spoon greatly magnified? On the face of it, the spoon – just like the cheque or the ice cube which also feature in Tosani's work – is purely practical, an object to be used and then discarded. Tosani's proposal, though, is that if you change the scale or context of an object it begins to become unusually interesting, despite your knowledge that it still remains the everyday item it always was. Museums, of course, are filled with such articles which once served in ceremonials now beyond recall. Thus Tosani is suggesting that we should look at the present, represented in its most typical objects, from a historical perspective, or from some point aeons away when spoons, for example, or cheques or ice cubes will have passed out of use. Either that or we should try to look at ordinary things somehow for their own sake, as sculptural pieces, rubbed, trimmed, burnished and deliberately put on display.

☞ **Blossfeldt, Groover, Modotti, Parker, Penn**

457

Patrick Tosani. b Boissy l'Aillerie (FR), 1954. **D**. 1988. Cibachrome. **h**182 × **w**120 cm. **h**71½ × **w**47¼ in.

Towell Larry

Dust Storm, Ourango Colony, Mexico

A group of girls is running before a dust cloud in Durango, Mexico. The picture looks as if it might have been taken in the early years of the century, since the girls are wearing traditional Mennonite dress. The Mennonites are a German sect, who emigrated to Russia and then to Canada in 1874. Later some of the strictest and most independent members moved to Mexico.

Towell, who is both a farmer and a travelling photographer, sympathizes with such agrarian communities as the Mennonites. Although as a reporter he visits combat zones such as Gaza and El Salvador, his abiding interests lie with the fabric and intimacies of communities which live close to subsistence levels, and with a respect for tradition. He likes his subjects to speak

for themselves. In 1994 he completed a book of photographs and interviews with relatives of people who had disappeared in Guatemala during the years of military oppression.

☛ Hocks, Parkinson, Rothstein

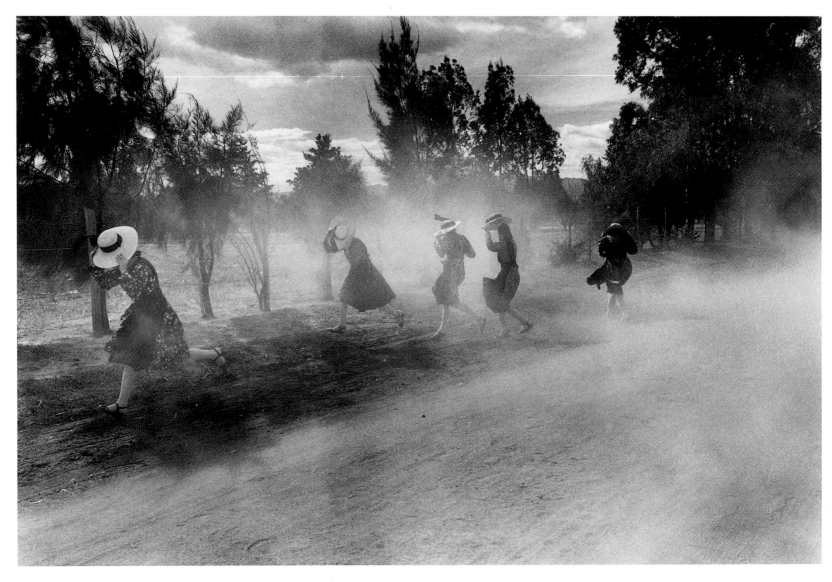

458

Larry Towell. b Chatham, ONT (CAN), 1953. **Dust Storm, Ourango Colony, Mexico.** 1994. Gelatin silver print.

Tress Arthur

Boy in Ruined Building, Newark, NJ

This photograph looks like a collage, for the window appears to have been pasted onto the wall, together with those four ragged fragments above. The boy has been deliberately placed to suggest that he is leaning against the painted couch. Tress found his subject in a burned-out store in the black section of Newark, New Jersey. The area had been devastated by riots two years before and was being used by local children as a playground. During the 1960s American documentarists concentrated on the social landscape, a grimly realistic zone in need of reform. Tress also reported on such subjects: harvest workers in California, for example, in 1969. Increasingly, however, he turned to what he dubbed 'social surrealism' in which the subject was manipulated in such a way that its authenticity was called into question. Tress was an originator who pointed the way towards the staged photography of the 1970s and after.

☛ **Alinari, Hocks, Misrach, Moon, Parr**

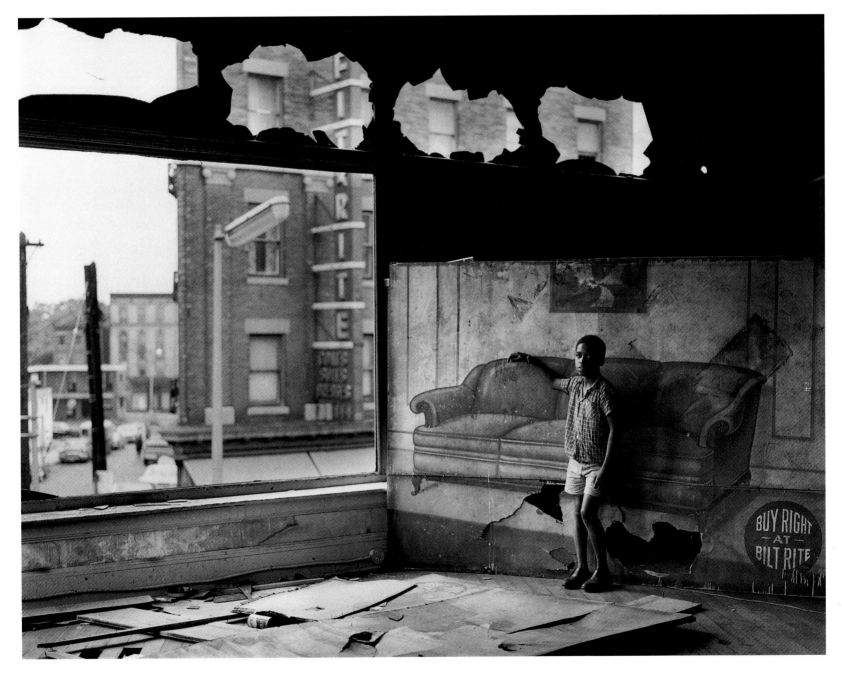

Arthur Tress. **b** Brooklyn, NY (USA), 1940. **Boy in Ruined Building, Newark, NJ**. 1967. Gelatin silver print.

Tripe Linnaeus

Aisle on the South Side of the Puthu Mundapum, Madura

Taken in a temple dating from 1623, this picture originally appeared in Tripe's *Photographic Views in Madura* in southern India where he had been asked to make photographic records of ancient architecture. The problem, in photographic terms, was one of extremes of contrast, for the users of the temple had painted the insides of the arcade white, for safety's sake at night. Thus it looks at first sight as if two intersecting sources of light are at work across the arcade. Likewise the whitening of the pillars made it difficult to read the ornaments which are only half-visible in the shadows above, meaning that there are several transactions in the piece between idea and actuality. It seems more than likely that Tripe himself was made aware as he photographed of those points at which the tangible shaded into the abstract or transcendental, for the bulk of his work had to do with sacred buildings and their contents, or with the physical as a mediation of the spiritual.

☛ Delano, Laughlin

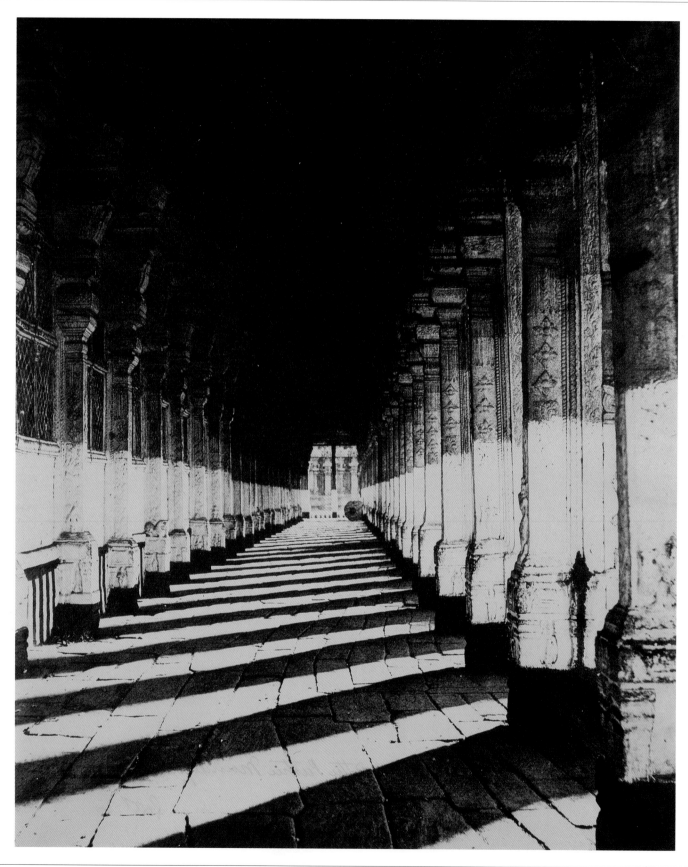

Linnaeus Tripe. b Devonport (UK), 1822. **d** Devonport (UK), 1902. **Aisle on the South Side of the Puthu Mundapum, Madura.** c1858. Albumenized salt print.

Tsuchida Hiromi

Workers Waiting in a Park for the Start of a May Day Demonstration

Small checks mingle with large checks under the supervision of a row of peaked caps. This picture appears in Tsuchida's book of 1990, *Counting Grains of Sand*, which contains a series of photographs taken between 1976 and 1989 focusing on the theme of the crowd. Tsuchida regards the masses as just another natural phenomenon to be analyzed from the evidence available:

hats and banners in this case. If mass existence is inevitable, he is saying, it ought simply to be remarked on. Tsuchida's attitude, evident here and in such earlier series as *Japanese Bondage* (1972), involves treating contentious issues as matters of fact. This disinterested view of things has distinguished Japanese photography since at least the 1970s, and has been widely

influential. After experience in advertising in the 1960s, Tsuchida became a freelance photographer in 1971, and was featured in 1974 in the influential exhibition 'New Japanese Photography' at the Museum of Modern Art, New York.

☛ Chambi, Marubi, Notman, O'Sullivan, Rejlander

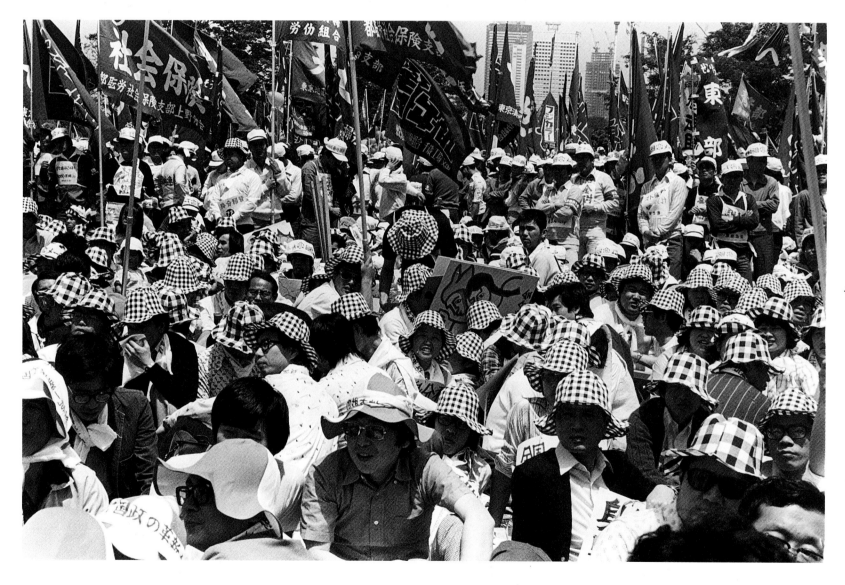

461

Hiromi Tsuchida. b Fukui (JAP), 1939. **Workers Waiting in a Park for the Start of a May Day Demonstration**. 1976. Gelatin silver print.

Turner Benjamin Brecknell At Compton, Surrey

This picture could have been intended as an inventory of English farming practices in the 1850s. It demonstrates the use of natural materials at a time when all materials were natural. The haystack to the left, for instance, stands on staddle stones to keep it from the damp, and its thatching has been finished – as has that of the adjacent barn and dovecote – with pegs and hazel lathes. The felled tree in the foreground and those bare branches beyond the far barn are signs of winter. Turner, who was a pioneer active in photography from the late 1840s, seems to have been interested in such well-stocked landscapes both as examples of building and for what they told about the working year. In other comparable pictures, for example, he shows stacks being used for winter feed and rooks preparing for a new season in the elms. Turner took his photographs (which also include portraits and architectural views) in between managing the family chandlery business in Haymarket, London.

☛ **Aarsman, Fox Talbot**

462

Benjamin Brecknell Turner. **b** London (UK), 1815. **d** London (UK), 1894. **At Compton, Surrey**. c1853. Albumenized print.

Ueda Shoji

Schoolgirls

The two girls on the left are looking towards the younger girl who is standing at the edge of the picture watching the camera. The girl in the centre is gazing into the eye of the camera, as if into a mirror, as she adjusts her headdress. Like many of Ueda's pictures, this was taken among the sand dunes at Tottori, the area of his birth. The white dunes provided an even ground easily calibrated by shadows. In this photograph Ueda is asking his audience to remark on just how far into the picture each child stands, and thus to judge the space around and above them. Ueda took up photography in 1931, at a time when the Japanese were becoming aware of the new German photography of the 1920s. His style, with its very distinct space construction, also depends on the Japanese pictorial tradition. After the war he took pictures for his own travel diaries, and did much to establish that autobiographical strand so characteristic of Japanese photography.

☛ Käsebier, Larrain, McCurry, Mark, Rai

463

Shoji Ueda. b Tottori Prefecture (JAP), 1913. **Schoolgirls**. 1945. Gelatin silver print.

Uelsmann Jerry N. Floating Tree

An island in a lake is home to a tree, which appears ready to drift off into the sky and away towards the mountains, just as its companion on the right has done. The idea of growth is sustained by the shadowy seed pod printed into the surface of the lake. Although this looks as though it is a unique view across a plain towards mountains, Uelsmann has, in fact, used one landscape on one side of the tree and its mirror image on the other, perhaps referring to the way in which seeds are often split down the middle. Uelsmann is an experimentalist whose work looks back to the photography of the Surrealists in the 1920s. In the 1950s, at a time when Americans were fascinated by the social landscape, Uelsmann's subject was humanity under constraint, in the shape of toys and manikins viewed in darkness. During the 1960s he began to take nature for his theme, and to represent growth and change across the seasons.

☛ Brigman, Steinert, Tillmans, C. White

464

Jerry N. Uelsmann. b Detroit, MI (USA), 1934. Floating Tree. 1969. Gelatin silver print.

Ulmann Doris

Man and Boy with Boat

The man and boy are posing as if they are about to shift their rowing boat. Doris Ulmann was interested in the poetics of labour and took pictures which made pictorial, as well as social, comments. A New Yorker, she was educated at the School of Ethical Culture and the Clarence White School of Photography. In the late 1920s she began work on a project to document the people of the American South. Working at her own expense, and sometimes in the company of the folk-song collector John Jacob Niles, she photographed in South Carolina (where this picture was taken), in Louisiana, in the Southern Appalachians and amongst the Mennonite and Shaker communities. She used archaic large-format cameras without shutters, which meant that exposures were made by raising and replacing the lens cap. Long exposure times also meant that her subjects had to act for the camera, as they do here. Ulmann's are among the most dignified and graceful documentary studies ever made.

☛ Mortimer, Silvy, Sutcliffe, C. White

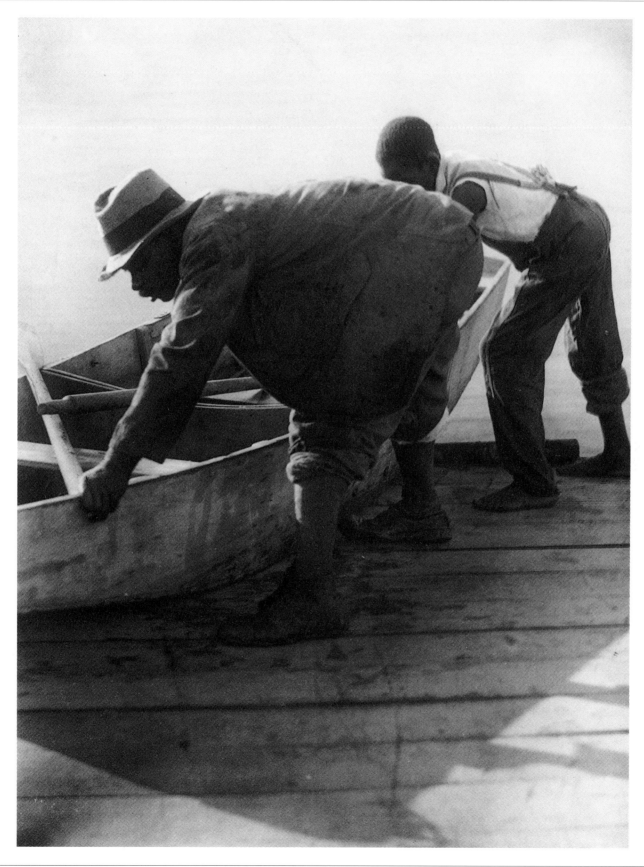

465

Doris Ulmann. **b** New York (USA), 1884. **d** New York (USA), 1934. **Man and Boy with Boat**. c1929. Gelatin silver print.

Umbo

Rut Landshoff

The face of the actress Rut Landshoff (who was Umbo's first model) looks like a mask seen in the act of turning out of the picture frame. In 1927, when this picture was taken, Umbo published a number of such mask-like close-ups in a Berlin newspaper called *Die Grüne Post*. His close-up portraits were the first to appear in print, and they were influential in portraiture and photojournalism. Umbo thought of photography as graphic art, to be bleached and manipulated for the sake of striking poster-like imagery. Expelled from the Bauhaus in 1923, he worked variously as a designer, clown and portraitist, and had a special interest in Berlin's nightlife and entertainment world. He also worked with the director Walter Ruttman on the documentary film *Berlin, die Sinfonie einer Grossstadt*. He was a friend of the Dadaist Paul Citröen, and in fact one of photography's links with the vivacity of Dada. His Berlin studio was bombed out during the war.

☞ Bull, Harcourt, Lele, Lerski, McDean, Sherman

Umbo (Otto Umbehr). b Düsseldorf (GER), 1902. d Hanover (GER), 1980. **Rut Landshoff**. 1927. Gelatin silver print.

Unknown

Persecution of Warsaw Jews, Warsaw Ghetto

Some members of the group are raising their hands, like military captives, while the family in the foreground has closed ranks and is thinking its own thoughts. This photograph was taken in 1944 during the destruction of the Warsaw Ghetto. By an unknown German photographer, it was shown at the Nuremberg War Crimes Trials in 1946, and then included in

'Family of Man', the great utopian exhibition of 1955, which was displayed around the world. For the soldier on the right the event is all in a day's work, and photography is just part of the official record. Yet for those under supervision, the camera – with its promise of posterity – belonged to a world now in the past. Those in the front rank are looking towards a future

which can hardly be imagined, of the sort expressed in the scratched darkness behind them. The theory of post-war photo-reportage in general was that the meaning of such a picture, with its horror and poignancy, would become self-evident.

☛ Alpert, Hamaya, Koudelka, D. Martin, Ut

467

Unknown German photographer. Active 1940s. **Persecution of Warsaw Jews, Warsaw Ghetto**. 1944. Gelatin silver print.

Ut Nick

Children Fleeing an American Napalm Strike

These frightened children helped to define the Vietnam War, and to solidify opposition in the USA. The photograph was taken just a year before the struggle was abandoned. Yet there is nothing in it to define the event as an atrocity, even though the older children are clearly distressed. The soldiers, for example, seem indifferent. If you were to wait for a moment or two, however, you would see that the naked girl has been badly burned down her back by the napalm which has produced that curtain of smoke. There were several photographers and film-cameramen present at the time; among them was Alan Downes of British Independent TV News, who recorded the event for television, showing how the badly burned girl already had rudimentary dressings on her back. This means that the still picture was less a full record of the event than a reminder of the drama as it unfolded in detail and in colour on television.

☞ E. Adams, Burrows, Faas, Griffiths, Hardy, Unknown

Nick (Huynh Cong) Ut. b Saigon (VIET), 1951. **Children Fleeing an American Napalm Strike**. 1972. Gelatin silver print.

Vachon John

Morton County, North Dakota

In this picture by Vachon (who is one of the most lyrical of the Farm Security Administration documentarists in the USA), children, whose sex is scarcely identifiable, are playing rudimentary games in front of a pair of cabins which also take up – very discreetly – that theme of the separation of the sexes. Children always matter to liberal and to utopian photographers because in their games and graffiti they reveal that humanity, from the outset, is expressive and artistic. Vachon came to photography by accident, like many photographers, and began as a filing clerk for the FSA in Washington, during which time he met Dorothea Lange, Ben Shahn and Walker Evans. Inspired by their example, he started to take photographs himself, and developed a style in which figures relate to the mood and light of their settings. By contrast, the documentary manner of the 1930s stressed legibility and analysis, appropriately for an art devoted to correcting present ills.

☛ W. Evans, Hamaya, Lange, Moore, Plossu, Sella, Shahn

469

John Vachon. b St Paul, MN (USA), 1914. **d** New York (USA), 1975. **Morton County, North Dakota**. 1942. Gelatin silver print.

Veder Sal

Lieutenant Colonel Robert Stirm Returns Home

Released after six years of captivity in North Vietnam, an American Air Force officer returns home to be greeted by his family on the runway. The two older children at the front must have clearer memories of their father than the other two. Returning prisoners and grief-stricken relatives waiting in vain were a staple in European reportage in 1945–7, but very rare in the American canon. Vietnam had been reported more candidly than any other war, and in that context of brutality this picture represents a return to the kind of normality familiar from the front cover of the *Saturday Evening Post* and a past golden age of family happiness. Veder's domestic drama points to a new direction in American documentary, which would increasingly take the family for its subject in the 1970s and 1980s. His successors, though, would have been interested less in the moment of homecoming than in whatever had changed in the intervening years.

☛ **E. Adams, Burrows, Faas, Parkinson, Ut**

470

Sal Veder. b Berkeley, CA (USA), 1926. **Lieutenant Colonel Robert Stirm Returns Home**. 1973. Gelatin silver print.

Vilariño Manuel

Sula Bassana

The spike of the hammer mimics the beak of the bird. Both are used for striking and piercing. The flat end of the hammer, on the other hand, could be seen as threatening the bird's extended neck. The bird is, of course, a taxidermist's relic and is long dead, but the hammer with its handle recalls the moment and the possibility of striking, the act of killing. This picture

appears in Vilariño's principal publication, *Bestias involuntarias* (1985), in which many other preserved specimens are placed with tools and equipment, prompting ideas of striking and cutting. Thus Vilariño brings into conjunction the fact and the idea of death, and makes it possible to approach the idea through a reality felt in the body.

Most of his pictures contain one or two items which have been carefully positioned and sharply differentiated, resulting in an art which is near to poetry.

☞ Fontcuberta, Hosking, Lanting, Mylayne

471

Manuel Vilariño. b La Coruña (SP), 1952. **Sula Bassana**. 1985. Gelatin silver print.

Vink John Hobo

The subject is Gypsie, a thirty-six-year-old hobo (or tramp) whose travels Vink documented in 1986. In this picture he was en route from Denver (Colorado) to Spokane (Washington), a journey which usually took between three and five days. It looks as if Vink has simply asked his companion to stand by the open door and gaze out into the passing landscape – just the sort of arrangement you would expect from two travellers with a camera. In general Vink's reportage makes a point of presenting the photographer as a credible witness to events which do not figure on the world's stage. His proposal is that even on a slow train to Spokane life carries on with attention to ordinary requirements. In the 1950s and 1960s photographers also took low roads of this sort, but then they liked to imagine themselves endangered. Vink rejects such melodramatic self-stagings and presents Gypsie, for example, not as a social problem, but as an experienced traveller.

☞ Lévy & Sons, Link

472

John Vink. b Ixelles (BEL), 1948. **Hobo**. 1986. Gelatin silver print.

Vishniac Roman

Grandfather and Granddaughter, Warsaw

Perhaps the old man has noteworthy or even terrible news to impart. His granddaughter certainly seems taken aback or distressed. At the time when it was taken, this photograph may have looked like nothing more than the record of an enigmatic encounter, neatly and symbolically staged against that tripartite background. However, the figures are Polish Jews living in Warsaw and they are destined to be murdered within a few years, together with most of Vishniac's other subjects. Originally from Russia, Vishniac determined to make a documentary survey of the Jews of Eastern Europe in 1938. He travelled 8,000 kilometres from the Baltic states to the Carpathians and took 16,000 pictures, of which some 2,000 have survived. His portraits, of traders, scholars and people on the street show a people in context, bent over texts and counters – and all unknowingly marked out by the kind of harsh destiny seemingly foretold in this encounter.

☛ Beresford, Disfarmer, van der Keuken, W. Miller, Tomaszewski

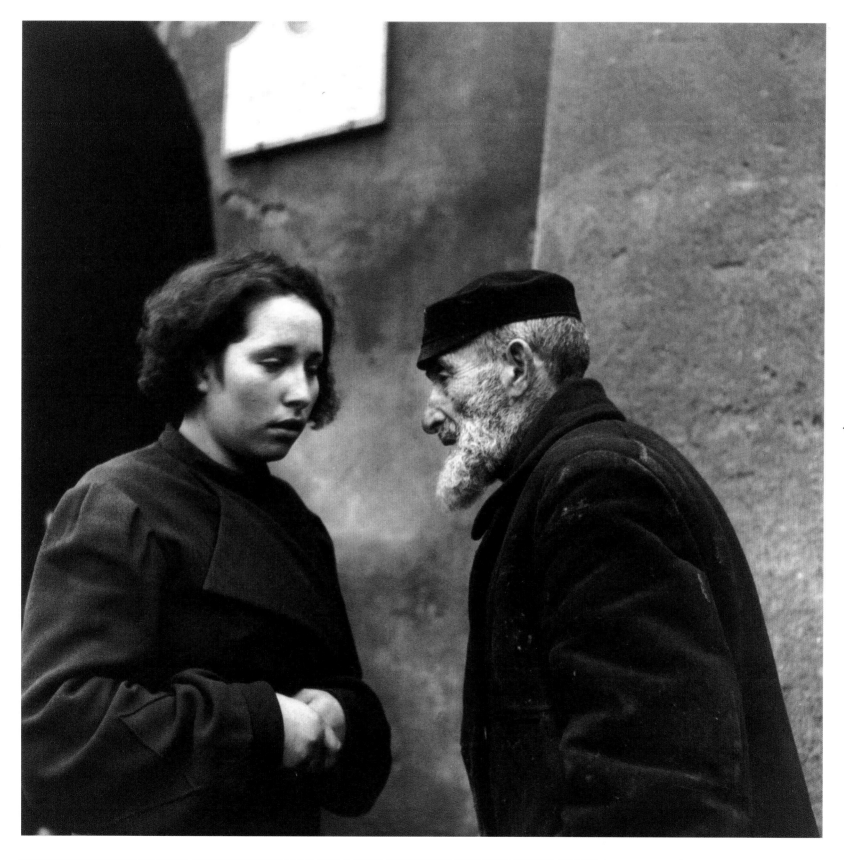

473

Roman Vishniac. b Pavlovsk (RUS), 1897. **d** New York (USA), 1990. **Grandfather and Granddaughter, Warsaw**. 1938. Gelatin silver print.

Walker Robert

Rue Ste-Catherine Est, Montreal

The designer of the 7-Up poster has even included a shadow for the paint roller. Altogether the painted scenery makes a merry commercial assemblage, entertainingly hard to unravel. The key to the story, however, lies in that dark and sinister figure on the left, who seems to be somehow associated with the work in progress in the foreground or perhaps a supervisor or even

Pascal, the owner of the van. Walker, in the tradition of street photography as evolved in Paris and Berlin in the 1920s and further evolved in New York, believes in the city, painted and placarded, as a source of destabilizing possibilities, capable of dissolving the horrors of suburban life. His first and major achievement was *New York Inside Out* (1984), which was

introduced by William Burroughs. As Walker himself says: 'In the jumbled chaos of New York City where I usually work, I like my pictures to have the crisp, clean colour, the choreography and humour of a Disney cartoon.'

☛ Izis, P. Martin, Peress

Robert Walker. b Montreal (CAN), 1945. **Rue Ste-Catherine Est, Montreal.** 1990. C-type print.

Wall Jeff

Dead Troops Talk

It is the winter of 1986 and the middle of the Soviet war in Afghanistan. Thirteen members of a Red Army patrol have been ambushed and killed in a ravine near a village. Yet somehow they have returned to life and are responding, each in his own way, to the catastrophe that has overtaken them. Two mujaheddin are attending to the confiscated weapons at the top of the path, and a teenage fighter is rooting through a soldier's knapsack. Jeff Wall's photograph is not a document but a staged construction, which was put together in a studio using many individual photographs. Displayed on a light box, *Dead Troops Talk* resembles the epic war paintings of the past, although it lacks any sense of the glory of battle and reflects on the fate of men fighting for an ambiguous purpose. The artist began to make staged, or 'performed', photographs in the 1970s and has worked in a variety of styles, ranging from the hallucinatory to the realistic.

☛ Baltermants, Burrows, Faucon, Gardner

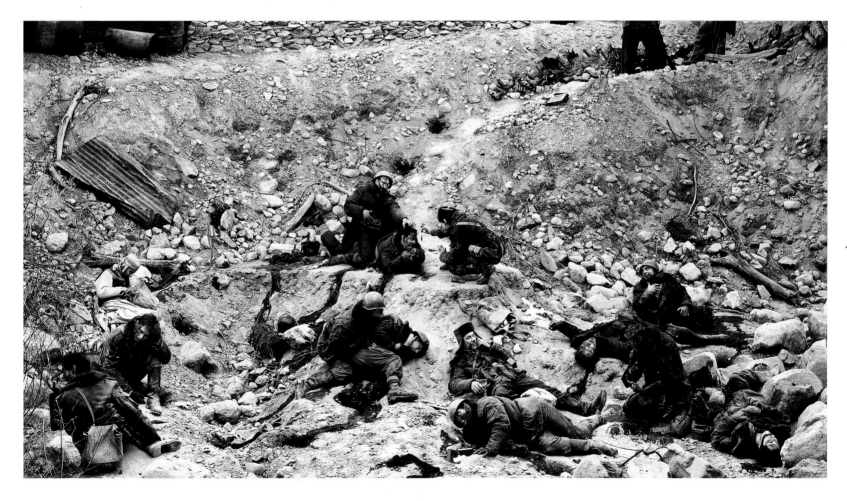

Jeff Wall. b Vancouver (CAN), 1946. **Dead Troops Talk: A Vision after an Ambush of a Red Army Patrol near Moquor, Afghanistan, Winter 1986**. 1992. Transparency in lightbox. **h**229 x **w**417 cm. **h**90¼ x **w**164 in.

Warburg John Cimon The Orange Stall

From the inscription 28959 NICE on the upturned box to the right, it looks as though Warburg took this autochrome in the south of France. It marks a radical departure from the delicate monochrome landscapes he was known for before since it is entirely devoted to the quality of particulars as they meet the eye and hand. The stall-holders, for instance, have obviously been asked to participate, or at least to act characteristically, and so she is laying her hand on the display of oranges while he is holding a box of fruit. Thus Warburg relates the details of his scene to our practical faculties, rather than to that inward sense of order which he might have invoked in monochrome in 1900. The autochrome colour process did not become commercially available until 1907. Warburg himself took up photography in 1880 and exhibited regularly until the 1920s, often under the aegis of the Royal Photographic Society in London.

☛ Gimpel, Mihailov, Thomson, Sternfeld

John Cimon Warburg. b London (UK), 1867. d London (UK), 1931. **The Orange Stall**. c1910. Autochrome.

476

Warhol Andy

Self-Portrait II

Whereas a single portrait can stand in for a character, a set of six identical pictures makes a pattern and challenges the idea of representation. Warhol was always interested in the thought of mere appearance, in the proposition that what you see is either sufficient or all that can be known. However, he also reflected on the depths beyond and thus this picture is at heart a romantic

and tragic image, deliberately moody. Its spiritual character is barely held in check by its format. Warhol's message was that life's hardships – manifest in personal and public catastrophes of all sorts – could best be handled formally, so that their unpalatable contents could be bracketed, or set aside for later consideration. In his studio, which he called 'The Factory', he

produced a constant flow of paintings, screenprints and sculptures. He also took photographs all the time and his book of New York portraits, entitled *Andy Warhol's Exposures*, caused a scandal when it was published in 1980.

☛ Becher, Morimura, Nauman, Rainer, Witkiewcz, Wulz

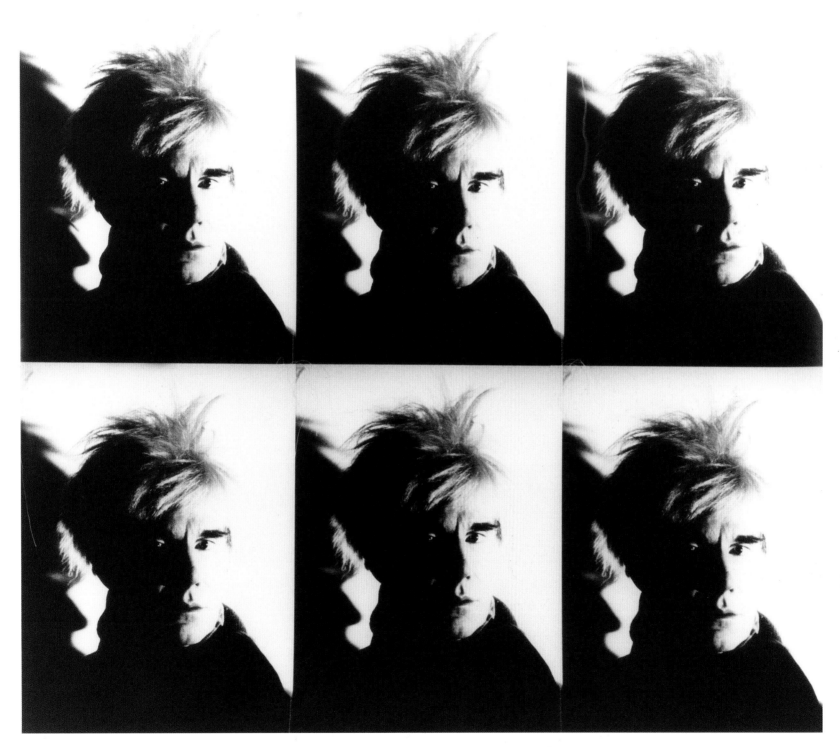

Andy Warhol. b Pittsburgh, PA (USA), 1928. **d** New York (USA), 1987. **Self-Portrait II**. 1986. Six gelatin silver prints stitched with thread. **h**54.6 × **w**69.9 cm. **h**21½ × **w**27 ½ in.

Watkins Carleton E. Sugar Loaf Islands, Farallons

This picture recalls the Creation: dry land appearing and primitive life (seals, in fact) emerging along the water line. The Farallons are rocky islands situated thirty miles west of San Francisco. By 1868–9, when this picture was taken, Watkins was known as a famous interpreter of the American wilderness. He used a specially constructed 18 x 22-inch camera, which was cumbersome to operate but appropriate to the sublime landscape of the western seaboard. He made his reputation in 1861 with a series of thirty large-scale plates and one hundred stereos taken in the Yosemite Valley. The Yosemite pictures were exhibited in New York in 1862, and were partly responsible for the 1864 legislation which declared the valley inviolate. Watkins was a technical virtuoso and an artist able (as here) to simplify and enhance landscape to the point at which it begins to read as symbol. The contents of his studio were destroyed in the San Francisco earthquake of 1906.

☛ Bourdin, Connor, Cooper, Hannappel, den Hollander

478

Carleton E. Watkins. b Oneonta, NY (USA), 1829. d San Francisco, CA (USA), 1916. Sugar Loaf Islands, Farallons. c1869. Albumen print.

Webb Alex

Grenada

There are three not very distinct ways of waiting on show here. The furthest man, head on hand, is indifferent to the photographer, and the nearest seems to be in a trance. The light at the windows implies strong sunlight and heat inside and out. These three figures appear in Webb's set of pictures from the Tropics entitled *Hot Light/Half-Made Worlds* (1986), which is introduced by a phrase from Carlos Fuentes on 'petrified desperation'. Webb's is a futuristic vision of intermediate states, of time passed in stifling heat among uncompleted buildings. His next book, a report on Haiti called *Under a Grudging Sun* (1989), also stands as a warning to those who do not make enough allowance for eroticism and violence. Webb's pictures are unquestionably beautiful, even opulent, but many of them host enormities. His Haitian book opens with a proverb from the area: 'Beyond mountains there are more mountains'. Webb is almost alone in using colour for ideological effect.

☛ van Manen, Parks, Pinkhassov, W. E. Smith, Wellington, Zecchin

479

Alex Webb. b San Francisco, CA (USA), 1952. **Grenada**. 1979. C-type print.

Webb Boyd Corral

A team of horizontal giraffes seems to be caring for the globe under circling foliage, which might be a sign of giraffe-habitat or a victor's wreath. They are, of course, toys arranged on plastic sheeting, but despite their artificiality they do indicate the kind of infinitude suggested by space photography from, for example, the Voyager space missions. Boyd Webb's photo-sculptures have always looked like extracts from tall stories in which giraffes might really be encountered in the outer reaches of space. From his beginnings in the 1970s he has subverted the commonplace in arrangements which have often featured actors moving as if among the planets or in the lower depths of the Pacific. His work is distinguished from that of other photo-inventors primarily by its scale and by his liking for the outer and lower reaches of science fiction. Born in New Zealand, Webb studied at the Royal College of Art in London between 1972 and 1975.

☞ Höfer, Skoglund, Stern

480

Boyd Webb. b Christchurch (NZ), 1947. **Corral**. 1989. Cibachrome. **h**158 × **w**123 cm. **h**62¼ × **w**48½ cm.

Weber Bruce

Twins in Pep Boys Tee-Shirts, Santa Barbara, CA

These two boys are twins. Male glamour has never developed anything like the formulae evolved by and for women. Because all the roles had been appropriated, men were left with that of simple appearance or being, without reference either to others or to events outside the frame. These two carry their own reading matter on their tee-shirts, but that title is part of the other social world which they have transcended. They appear in Weber's series on *Brothers*, published in his career survey of 1983 from the Twelvetrees Press, Los Angeles. Others who feature in this book are the actor Matt Dillon, lifeguards and various divers, all of them exponents of handsome impassivity. One of the best known of all fashion photographers, Weber is also the author of *No Valet Parking*, published in 1994. His credo, put down in a foreword to that book, centres on an idea of individual worth and distinction, free-standing and engrossed by the place and the moment.

☞ Brady, Carjat, Keita, Molenhuis, Nadar, Sander, Strand

481

Bruce Weber. b Greensburg, PA (USA), 1946. **Twins in Pep Boys Tee-Shirts, Santa Barbara, CA**. 1983. Gelatin silver print.

Weegee

The Critic (Opening Night at the Opera)

The two bejewelled ladies and the deranged bystander appear in 'The Opera', a section in Weegee's renowned book *Naked City* of 1945. He said: 'I couldn't see what I was snapping but could almost smell the smugness.' Someone stopped the pair in the foyer of the opera house and asked them if it was appropriate to wear so much jewellery 'in these critical times'.

The older woman apologized for wearing last year's jewels, and added that she wore them to help morale. As both a writer and a photographer, Weegee belonged to the hard-boiled school, but at the same time he had a heart of gold and an interest in the redemption of America. After ten years working in the darkroom at Acme newspapers, Weegee became a freelancer in around

1935, working mainly for *PM* on accidents, crime and mayhem. His nickname came from the Ouija board, for he was felt to have an uncanny knack of predicting photogenic events.

☞ Cumming, Hockney, Post Wolcott, Riis

482

Weegee (Arthur Fellig). b Zloczew (POL), 1899. d New York (USA), 1968. The Critic (Opening Night at the Opera). 1943. Gelatin silver print.

Wegman William — Frog

Man Ray, the photographer's Weimaraner, is posing for the camera in flippers and goggle eyes. The studio floor has been transformed into a lily pond, and a life-size frog sits on a lily leaf regarding its puzzling companion. Man Ray is present in many of Wegman's pictures between 1970 and 1982. Elsewhere he appears garlanded in tinsel, sprinkled with glitter, dressed in an evening gown and disguised as a racoon. In each case the artist's idea takes second place to Man Ray's presence, and even to the thought of just how the long-suffering model was persuaded to pose. In 1986 Fay Ray came into Wegman's life and prompted another famous collaboration. When Fay had a litter of puppies in 1989, Battina and Crooky joined the cast, soon followed by Chundo and Chip. Wegman's photographs, video tapes, paintings and drawings have been exhibited in museums and galleries all over the world. Currently involved in film-making, he has created a number of video segments for *Sesame Street*.

☛ Dalton, Erwitt, Maspons, Nichols, Sammallahti

William Wegman. **b** Holyoke, MA (USA), 1943. **Frog**. 1982. Polaroid. **h**61 x**w**50 cm. **h**24 x **w**19½ in.

Weiner Dan

New York City

Supervising a May Day Parade in New York City, the policemen look genial enough even if they do seem unduly conscious of the white gloves they are wearing in honour of the event. Weiner's implication – no more than that – is that the gloves are a cause of unease, and that both he and the policemen know that they are out of keeping with the business of law enforcement. Weiner was devoted to New York life, and in the 1950s was one of its most astute reporters. A member of the Photo League in New York in 1939–40, he came under the influence of Walker Evans, Dorothea Lange and Paul Strand and remained a humanitarian committed to themes from ordinary life. In 1954 he took the pictures for his only book, *South Africa in Transition*, the first in-depth report on racial troubles in that country. In 1959 he was killed in a plane crash near Versailles in Kentucky while travelling to another assignment.

☛ Bradshaw, Dyviniak, W. Evans, Koudelka, Lange, Strand

484

Dan Weiner. b New York (USA), 1919. **d** Versailles, KY (USA), 1959. **New York City**. 1948. Gelatin silver print.

Wellington James B. B. Refreshing Moments

While the gentleman is smoking a cigarette and holding a newspaper, his female companion is resting her arm elegantly on the awning and supporting a tray with glasses. The 1920s were – with respect to personal matters at least – a well-balanced era, when people were mindful of each others' spaces. In France, J. H. Lartigue was taking similar pictures of graceful small events like this one, although his pictures were far more informal than Wellington's. Although trained as an architect, Wellington was deeply implicated in the business of photography. Not only was he a regular exhibitor from the 1880s onwards and a member of the British secessionist Linked Ring organization, but from 1891 he was also the manager of the new Kodak works in England and he became a manufacturer of the fast fine-grain Iso-Wellington photographic plate. His company, Wellington and Ward Ltd, eventually merged with Ilford.

☞ Brassaï, Lartigue, G. Smith, A. Webb

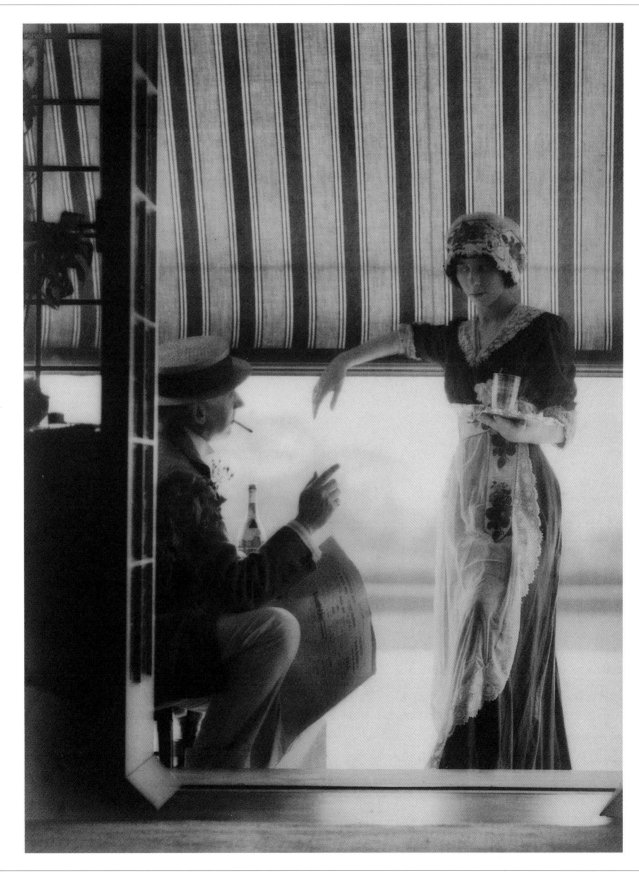

485

James B. B. Wellington. b Lansdowne (UK), 1858. d Elstree (UK), 1939. **Refreshing Moments**. c1925. Bromide print.

Wells Michael

Hands

The Ugandan child's hand, in contrast with that of the missionary, looks like the claw of an emaciated bird or something found on an archaeological site. This picture juxtaposes famine and the affluent West, even if the background hand is that of a well-meaning missionary who has contributed himself willingly. Ugandan and other African famines have been heavily reported in the Western press. There are many pictures of the dead, which raise questions about how the people died and how quickly they decay – on the practicalities of famine, that is to say. Texts on the question of Africa almost always raise intractable moral issues regarding the rights and wrongs of intervention. A picture such as this, which is more emblematic than explanatory, encapsulates the texts, capturing above all their element of guilt and self-accusation and the meaning of that well-fed and tended supporting hand.

☞ **Bragaglia**

486

Michael Wells. b Mtarfa (MAL), 1951. **Hands**. 1980. C-type print.

Weston Edward

Nude on Sand

Think of this as a very shallow space sculpted by the prone body of the woman. Light is falling directly from above, so that the shadows function as outlines, making it look as if she has been drawn onto the sand. One of the most committed artists in the history of the medium, Weston took time to establish himself. From around 1906 he was a door-to-door portraitist,

and then a pictorialist, making soft-focus pictures. In the mid-1920s he became a leading proponent of 'straight' photography, and in 1932 a founding member of the Californian Group f.64. The 'straight' aesthetic dispensed with impressions and ideas in favour of things which were scrupulously registered and yet always had enough formal

ambiguities to make them interesting. After returning from a period in Mexico, Weston lived between 1929 and 1934 at Carmel on the Pacific coast, where he made pictures based on the eroded rocks and weathered vegetation of the shoreline.

☛ Bellocq, Cunningham, Horst, Testino

Edward Weston. b Highland Park, IL (USA), 1886. **d** Carmel, CA (USA), 1958. **Nude on Sand**. 1936. Gelatin silver print.

White Clarence

The Orchard

The woman in the middle distance is reaching upwards, as if White had asked her to complement the stooping action of the figure in the foreground. Trees and fruit may superficially mean nothing more than Autumn and its harvests, but photographers at the turn of the century were conscious of more than mere documentary. Thus the figure in the foreground may well be intended to represent Mary Magdalene grieving at the Deposition, since she is reaching for a bruised fruit, one of the symbols of Christ's death. The virtue of White's work is that his staging is done with such discretion that it appears natural. Underlying the making of such a picture, with its references to the life of Christ, is an idea of recurrence, or history repeating itself in present space and atmosphere. White believed that art could be analyzed and taught, and turned increasingly to teaching from 1907, eventually founding his own school in 1914. A friend of Alfred Stieglitz, he taught both Margaret Bourke-White and Dorothea Lange.

☛ **Bourke-White, Lange, Stieglitz, Tillmans, Uelsmann**

Clarence White. b West Carlisle, OH (USA), 1871. **d** Mexico City (MEX), 1925. **The Orchard**. 1902. Platinum print.

White Minor

Yin and Yang

Yin and yang originally referred to the shady and the sunny side of a hill, and then came to be used with respect to contrast and difference. Minor White seems here to have returned to origins, to have discovered a hill in which features lost in the darkness can be read from what is visible in the light. White was always wary of photography's claims to represent the world objectively,

believing instead that one thing appeared only in relation to another. Equally, he took the view that photography was well suited to disclosing the artist's inner life – a life which looked for meanings behind ordinary appearances. In 1952 White was one of the founder members of *Aperture*, a quarterly publication of photography, and its first editor. White's

monument in his lifetime was *mirrors messages manifestations*, a monograph of 1969, in which several of his photographic sequences are published.

☛ **Hütte, Sella, Shore**

489

Minor White. **b** Minneapolis, MN (USA), 1908. **d** Boston, MA (USA), 1976. **Yin and Yang**. 1963. Gelatin silver print.

Wilding Dorothy

Mrs Helen Wills Moody

Mrs Helen Wills Moody was an American, and the most celebrated woman tennis player of the era. She is sitting on what looks like an improvised bench, which has been arranged principally to create that right angle beneath her left elbow. Wilding's intention was to make the bench serve as the basis for all the other deft angles and geometries in her composition. The narrow depth of field in which the subject's limbs are arranged is also characteristic of a period which liked the idea of limitation and control. Wilding opened her first studio in London in 1914 and went from strength to strength during the 1920s and 1930s, despite the ruination of the portrait business in general by the introduction of such automatic photographic techniques as the Photomaton in 1928 and the Polyfoto system in 1933. Wilding was an official photographer at the Coronation in 1937, the year in which she opened a second studio in New York.

☛ Arnold, Billingham, Dührkoop, Knight, Meisel, Pécsi

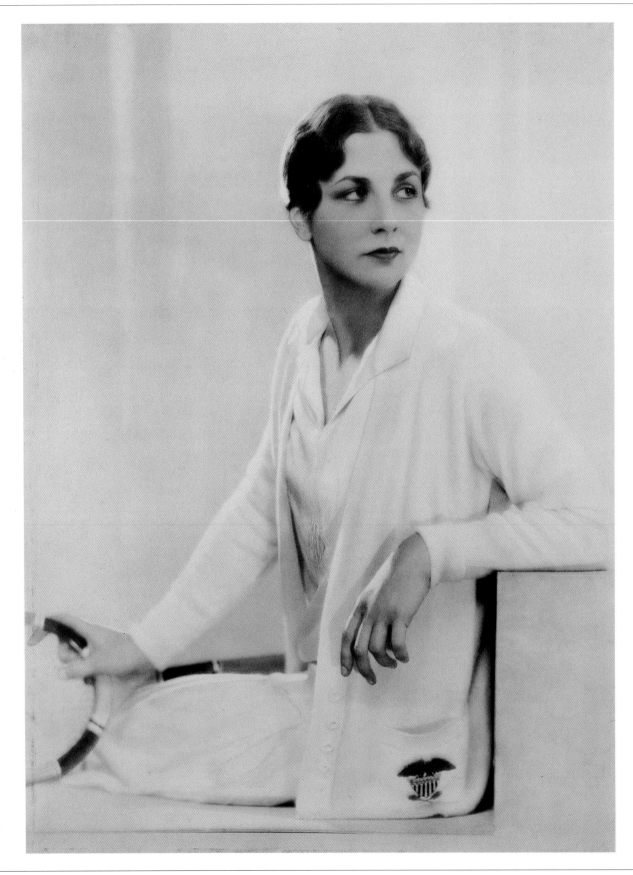

Dorothy Wilding. b London (UK), 1895. **d** London (UK), 1976. **Mrs Helen Wills Moody**. 1930. Chlorobromide print.

Willoughby Bob Marilyn Monroe

The chair on the right looks like a director's chair, and the room might be backstage somewhere. In company with the stacked chairs behind her, Marilyn Monroe seems to be waiting, and even acting the part of someone waiting and ready to oblige. She seems almost unaware of the camera, but perfectly composed. For reasons which have something to do with those ambiguities identified by Willoughby, Marilyn Monroe interested more artists and photographers during the 1950s and 1960s than almost any other American. She figured on nine *Life* covers, for example, and entered vanguard painting in 1954 when her lips starred in Willem de Kooning's *Marilyn Monroe*. In 1953 she was voted the year's most popular actress, but she always meant more than that. Perhaps what interested photographers was the fact that even her candid poses were schooled, meant to be activated by the camera, and thus not to be trusted.

☞ Arnold, Dührkoop, Pécsi, Post Wolcott, Wilding

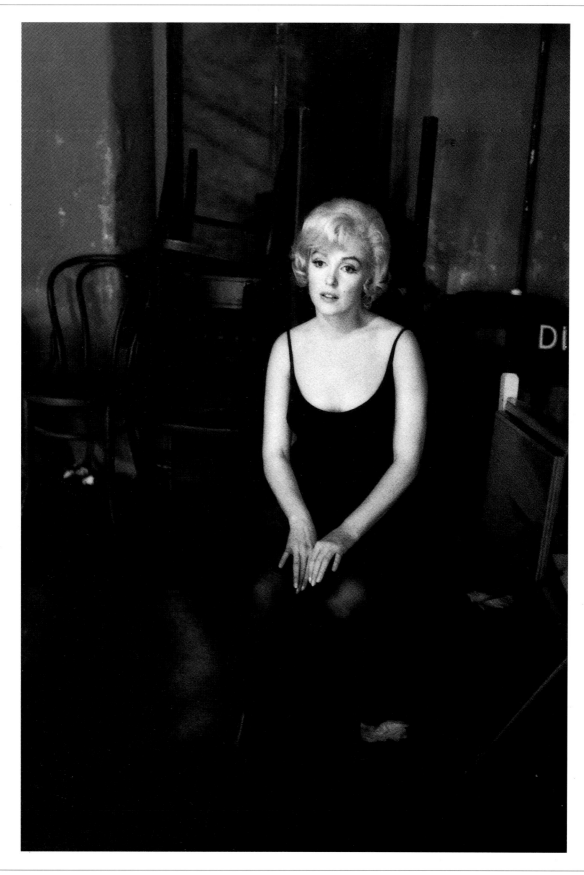

Bob Willoughby. b Los Angeles, CA (USA), 1927. **Marilyn Monroe.** 1960. Gelatin silver print.

Winogrand Garry

New Mexico

The scene, on the garage ramp of no. 1208, looks typically American, as does the surrounding landscape. Winogrand, however, seems to have hit on an odd time zone, for not only does suburbia stand incongruously in the wilderness, but local time – as manifest on the ramp, at least – appears to be running backwards from imminent catastrophe. The child, emerging from the darkness of the garage, may be entering a sunlit world as in the adverts, but it is rich in intimations of danger, signalled by the overturned tricycle and the approaching cloud. Winogrand's subject was always the maintenance of everyday American life in circumstances either so weird or so compelling that survival depended on their being overlooked. He began to take photographs in the late 1940s, after leaving the army, and studied for a while with the influential Alexey Brodovitch who stressed the importance of intuition in pursuit of a free-form version of Henri Cartier-Bresson's 'decisive moment'.

☛ **Cartier-Bresson, Glinn, Levitt**

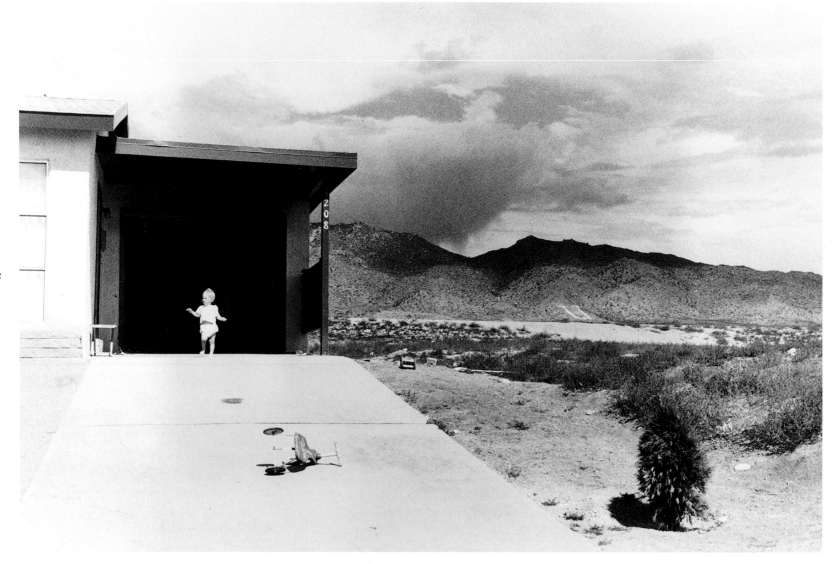

492

Garry Winogrand. b New York (USA), 1928. **d** Tijuana (MEX), 1984. **New Mexico**. 1957. Gelatin silver print.

Witkiewicz Stanislaw Ignacy Self-Portrait, with Lamp

His face stands out expressively in the darkness, like that of a visionary. Witkiewicz is said to be the only expressionist in photography, and his subject was usually himself exposed and over-wrought in such self-portraits as this. His style was that of the harsh woodcuts of the German painters Ernst Ludwig Kirchner and Emil Nolde transposed into photography.

Witkiewicz, who was better known as a painter and writer, ought to be thought of as one of the innovators in photography, for his was the style which was imitated and then adapted in the mask-like, close-up portraits of the 1920s made in Berlin and Paris. He later adopted the name Witkacy, to distinguish himself from a famous father who was also an artist and writer.

Having given up painting in 1921, Witkacy established the S. I. Witkiewicz Portrait Firm in 1924, making fantastical portraits of clients and of himself. After a life of crisis, he committed suicide on the eve of World War II.

☛ Feininger, Lissitzky, Nauman, Rainer, Warhol, Wulz

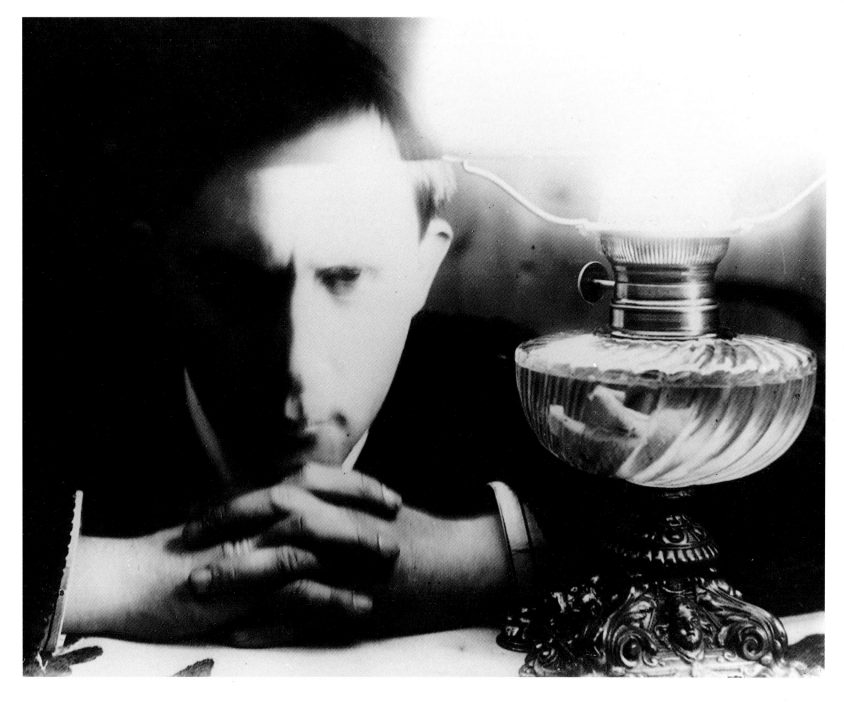

Stanislaw Ignacy Witkiewicz. b Warsaw (POL), 1885. **d** Jeziory (POL), 1939. **Self-Portrait, with Lamp**. 1913. Gelatin silver print.

Witkin Joel-Peter

Mandan

The figure supported by ropes lived in San Francisco. As a child he had begun to make holes in his pectoral muscles and he was eventually able to insert hooks into these holes and thus to suspend himself. The idea came from a ritual developed by Mandan tribespeople and documented in 1832 by the American painter George Catlin. Witkin, who took the picture in the man's garage, saw the ritual as part of an attempt 'to get closer to the origins of life'. Many of Witkin's arranged photographs are based on other artworks by such painters as Rubens and Goya. In his accounts of his pictures, Witkin shows himself to be searching for an understanding of physical experiences. After training as a sculptor, he served as a photographer in the US Army. From 1975 he studied photography at the University of New Mexico, where he began to develop the complex pictorial style for which he became famous in the 1980s.

☛ **Coplans, von Gloeden, Samaras**

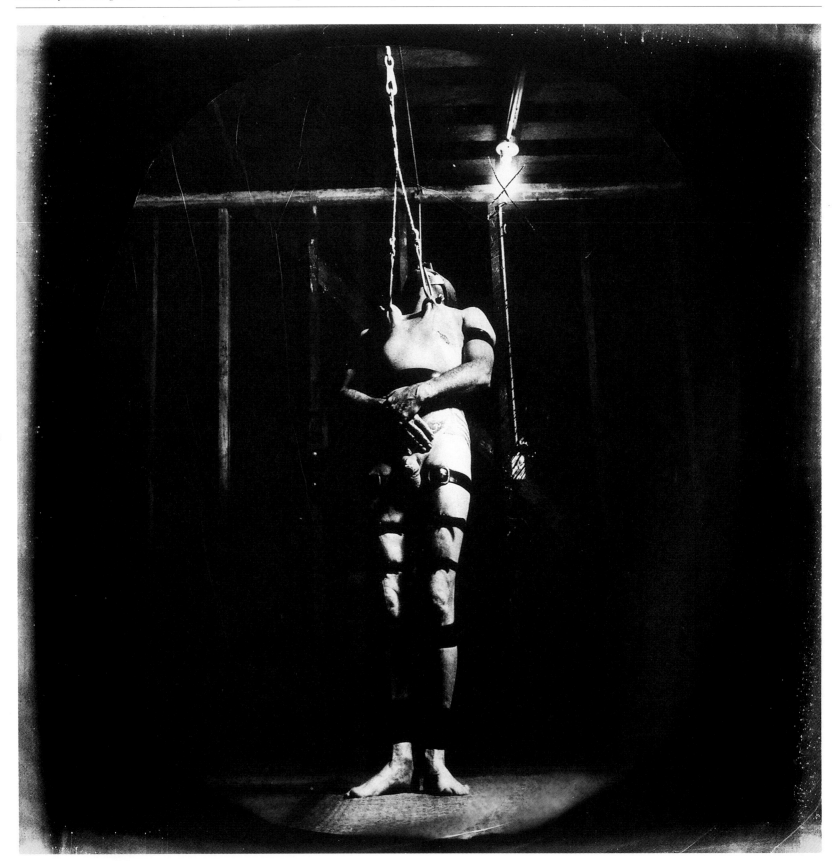

Joel-Peter Witkin. b Brooklyn, NY (USA), 1939. **Mandan.** 1981. Gelatin silver print.

Wojnarowicz David Sex Series (House)

Suspended in the black sky, like an imaged moon, is a sex scene, which was taken from the pornography collection of Peter Hujar, Wojnarowicz's companion and mentor in photography. The water tower he thought of as a sniper's nest, and the whole setting looks like the scene of a crime taken by a surveillance camera. One of eight images in Wojnarowicz's *Sex Series (For*

Marion Scemama), this is a photomontage enlarged from a colour slide and printed on black and white paper. Wojnarowicz was an allegorist who attributed meanings and values to the elements in his pictures: maps and carpets of dollar bills, for example, stood for law as oppression, and the white house and water tower here may be part of 'hell called the suburbs'. His

sympathies were for 'all the guys and girls future and past who give chaos reason and delight'. Author of *Close to the Knives: A Memoir of Disintegration* (published in 1991), Wojnarowicz died of AIDS in 1992.

☞ A. Adams, Goldin, Nilsson, Sammallahti

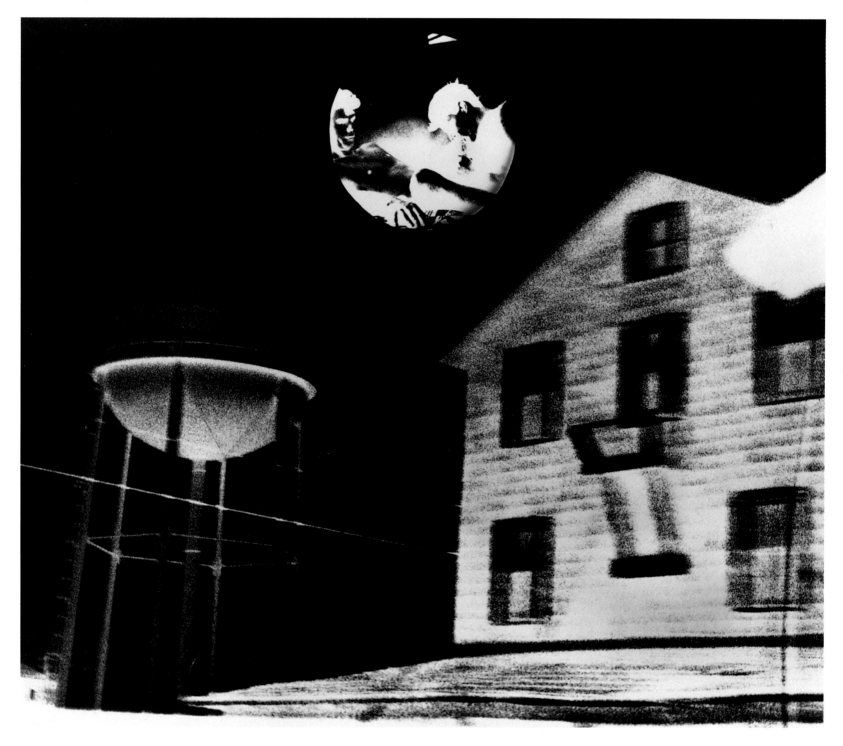

495

David Wojnarowicz. b Redbank, NJ (USA), 1954. **d** New York (USA), 1992. **Sex Series (House)**. c1988. Gelatin silver print.

Wols

Untitled

In what is meant as a portrait, the eyes are presented as voids and taste and smell signalled through cloves of garlic. Wols's tactic, in a series of photographs entitled *A Dark Family of Pictures*, was to make substitutions, to have a dark void stand for inwardness, for instance, or to signal the senses via an item of foodstuff. Contrived from scraps and everyday materials, the pictures seem modest, but his subjects were always ambitious: a life, for example, summed up in the spread-out contents of a pocket, or an idea of living represented in a handful of vegetables on a kitchen table. Wols worked in Paris during the 1930s as a painter and commercial photographer. After internment in France at the outset of the war, his art intensified and he became one of the most convincing of the existentialist artists of the 1940s. His successors were Joseph Beuys, Marcel Broodthaers and the Italian Arte Povera artists, all of whom were able to see a significance in humble materials.

☛ Ohara, Sherman, Sougez

Wols (Alfred Otto Wolfgang Schulze). **b** Berlin (GER), 1919. **d** Paris (FR), 1951. **Untitled**. 1951. Gelatin silver print.

Wulz Wanda I + cat

This combination of a self-portrait with the head of a cat has been achieved using multiple negatives which produce a complex, almost dreamlike effect. Although many European photographers used this technique as a matter of course in the 1930s, no-one else at the time had thought of anything so brilliantly compact. This is an example, that is to say, of a picture which had to bide its time, and whose place was prepared by the photo-sculptural work of Bruce Nauman in the 1960s and the *Face-farces* of Arnulf Rainer in the 1970s. Entitled *Io + gatto* (I + cat) it lives with words as positively as any of Nauman's single-act events. Likewise, Wulz's whiskers make her face into a kind of electrical mask, which is both an affront and a distraction to any viewer. Its topicality was strong enough to establish it as the leitmotiv of the photographic survey of 1989 completed by the Alinari Archive.

☛ Morimura, Nauman, Rainer, Warhol, Witkiewcz

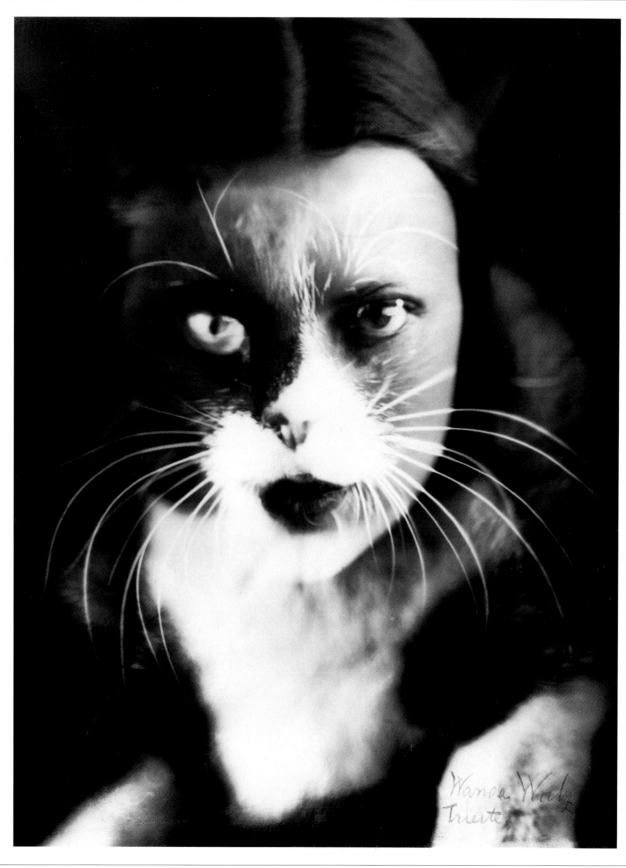

Wanda Wulz. b Trieste (IT), 1903. d Trieste (IT), 1984. **I + cat**. 1932. Gelatin silver print.

Xiao-Ming Li Funeral of a Child

The event is the funeral of a four-year-old Tibetan girl in Yunnan Province in China in 1993. The proportions of the grave point to it being that of a child. She had died of a sudden illness, and because her village was in the mountains and two and a half days' travel from the nearest hospital, emergency medical help was out of reach. The picture forms part of a documentary series on Roman Catholicism in China begun in the early 1980s at a time when the government was relaxing its attitude to religion. The apparent absence of a priest suggests that this might be a gathering of members of one of the unofficial churches, unapproved by the government and in direct contact with the Vatican. This is the purest kind of documentary photography in the sense that it puts on show a wide enough range of evidence to allow the structure and fabric of a society to emerge.

☛ A. Adams, McCurry

Li Xiao-Ming b Beijing (CHN), 1962. **Funeral of a Child**. 1993. Gelatin silver print.

Yavno Max

Muscle Beach

Yavno's proposal, to judge from the two major players standing in the foreground with their backs to the camera, is that this display on Los Angeles's Muscle Beach can be understood as a representation ready-made. Life, that is to say, is already capable of presenting itself as a tableau of how it ideally ought to be. Earlier and later documentarists might have stressed the darker side of Los Angeles life, especially if they came to it with Yavno's background in the left-wing and reformist Photo League of New York. For Yavno in the 1940s, however, the USA was for once in balance, at one with its self-image – as this picture so perfectly demonstrates. Yavno, whose picture of Muscle Beach appeared in 1950 in *The Los Angeles Book*.

thought ethically, or in terms of the whole of society, and even here young and old mingle in the presence of a choice of distractions: acrobatics and Jumbo Malts.

☛ Bellocq, Dupain, Hoyningen-Huene, LaChapelle

499

Max Yavno. b New York (USA), 1911. **d** San Francisco, CA (USA), 1985. **Muscle Beach**. 1949. Gelatin silver print.

Yevonde Madame Penthesilea

Penthesilea was the Queen of the Amazons. On the death of Hector, she came to the aid of the Trojans, but after some early success she was slain by Achilles, who mourned for her. Here, in the spring of 1935, she is being played by Lady Milbanke for a series of photographs called *Goddesses and Others*, which was exhibited in July in Madame Yevonde's Berkeley Square studio.

Yevonde's intention was to promote the artistic element in portraiture, then under threat following the development of 'do-it-yourself' photography and automatic systems. British socialites loved to dress up and to play charades, and Yevonde combined this tendency with her knowledge of the new Parisian portrait style of Man Ray. A campaigner for women's right to vote, Yevonde took up portrait photography just before World War II. She used the Vivex tri-colour process from its inception in 1928–9 until the closure of the Vivex factory in 1939.

☛ Cameron, Henri, Iturbide, Man Ray, Muray, Ritts

500

Madame Yevonde. **b** London (UK), 1893. **d** London (UK), 1975. **Penthesilea**. 1935. Vivex colour print.

Zachmann Patrick

A Hairdresser and Beauty Parlour in Wenzhou

The premises belong to Wendy, a hairdresser. The picture was taken in the state of Zhejiang, southern China, in the course of a journey made by the photographer. Zachmann spent eight years photographing in Chinese communities throughout the world. The result was a book of pictures and texts entitled *W. or the Eye of the Long Nose* (1995). In 1982 Zachmann was given permission to follow the homicide section of an anti-Mafia unit in the Naples police and this led to *Madonna!* (1983). Zachmann, a photographer with the agency Magnum Photos from 1985, is intrigued by communities lodged within larger cultures. In 1997 Editions Plume in Paris published his *Maliens ici et là-bas*, a comparative study of people from Mali in France and in their homeland. His second book, *Enquête d'Identité*, published by Contrejour in 1987, reflects on the question of the photographer's own identity through a seven-year photographic study of the Jewish community in France and his own family.

☛ diCorcia, Hurrell, Izis, Riboud

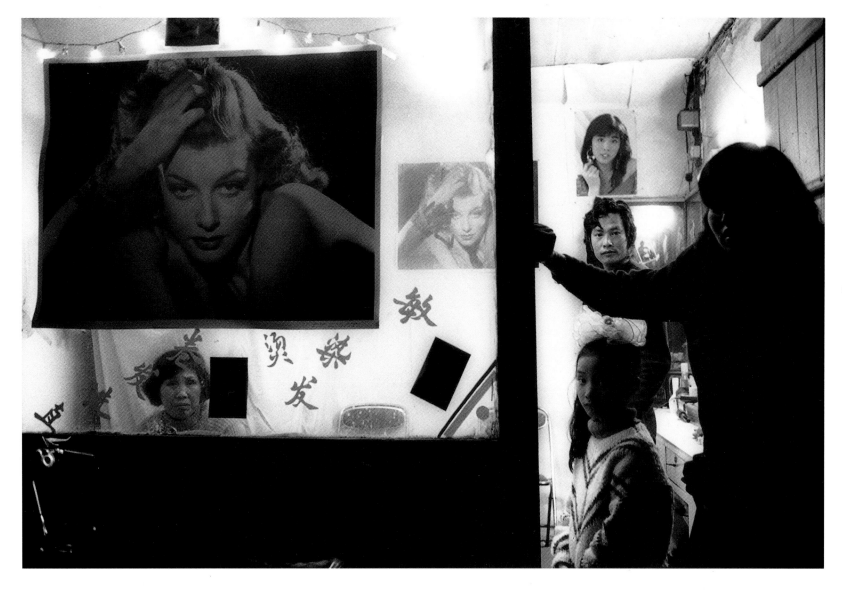

Patrick Zachmann. b Chasy le Roy (FR), 1955. **A Hairdresser and Beauty Parlour in Wenzhou**. 1991. Gelatin silver print.

Zecchin Franco

Masked Ball at Palermo

Whoever this figure is, he has not gone to much trouble to dress up beyond getting hold of that pendant earring and a mask more practical than decorative. Presumably he is standing like that with his head tilted back both to improve his line of vision and to keep the cigarette smoke from his nostrils. Is he some minor Mafioso who has hastily improvised this outfit for the evening in order to keep an eye on things? Zecchin's subject is the Mafia, and although he is known for his dramatic pictures of Sicilian society, carnivals and processions, he is even better known for horrifying pictures of murder victims, disposed of in cafés, small shops and cars. During the late 1970s Zecchin began to work for the Sicilian newspaper *L'Ora* and took it on himself to press for social reform. His analysis of Sicily's condition does, however, extend beyond the Mafia to reveal a culture of poverty and melodrama.

☛ Knight, van Manen, Parks, W. Smith, A. Webb

502

Franco Zecchin. b Milan (IT), 1953. **Masked Ball at Palermo**. 1980. Gelatin silver print.

VanDerZee James

Couple in Racoon Coats

The couple in their racoon coats have done well both financially and socially, and this was their way of making it known. James VanDerZee was Harlem's leading photographer from 1916 onwards when he opened the studio Guarantee Photos at 135th Street in Harlem, New York, with his friend and associate Eddie Elcha. From 1909 he had been a part-time portraitist and a musician with the celebrated Fletcher Henderson Orchestra. VanDerZee worked across the range: portraits, weddings, public events. He was no purist and readily used studio props, retouching and multiple printings and it was this hybrid style which attracted the attention of photographic audiences in the 1990s. His studio remained open until 1968, although by the 1950s it was ceasing to be fashionable. In 1969 his pictures featured in *Harlem on My Mind*, an important exhibition of Afro-American art assembled at the Metropolitan Museum of Art, New York.

☛ **Gutmann, Johns, de Keyzer, Link**

James VanDerZee. b Lenox, MA (USA), 1886. d New York (USA), 1983. **Couple in Racoon Coats**. 1932. Gelatin silver print.

Glossary of techniques and terms

Albumen print

Albumen printing paper was introduced by Louis-Désiré Blanquart-Evrard in a communication to the Académie des Sciences, Paris, on 27 May 1850, and it remained in general use until about 1895. It could be bought partly prepared, i.e. coated with a thin film of white of egg and was then sensitized with silver nitrate solution by the photographer. Toning with chloride of gold checked fading and produced a sepia effect (see Howlett), avoiding the unattractive reddening to which the paper was prone.

Ambrotype

The ambrotype process was patented in the USA by James Ambrose Cutting in 1854. The images obtained were known as collodion positives in the UK. The technique involved placing a glass collodion negative in front of a black background to produce a positive image.

Autochrome

The brand name of the first commercially marketed photographic colour process. Introduced in 1907 by the French inventors and manufacturers, Auguste and Louis Lumière, it was used until the early 1930s. In the autochrome process, starch grains dyed in the three additive primary colours (green, blue and red) were dusted onto a glass plate, flattened under pressure and coated with panchromatic emulsion. The coloured grains acted as filters, allowing some colours to be registered on the panchromatic film. After exposure, the film was developed as a black-and-white negative, and then treated chemically to produce a coloured positive. The image appeared to be in full colour when transmitted onto a screen or seen against the light. The network of starch grains in all autochromes ensured that the images looked grainy, like pointillist paintings (see Gimpel and Warburg).

Autotype see Carbon print

Blueprint see Cyanotype

Bromide print

Bromide paper (coated with a gelatin and silver bromide emulsion and silver iodide) superseded albumen paper; it was first introduced in the 1870s for both negatives and for positive copies. As negative paper it was cheaper than glass plates, and for positives it was a faster process altogether. It did not, however, become popular immediately on its introduction. It produced black and grey tones (see Bull and Sutcliffe).

Bromoil print

This technique depends on the fact that gelatin mixed with potassium bichromate (now called potassium dichromate) absorbs less water when exposed to light than when unexposed. Oil-based ink applied to this surface adheres better to the drier areas. The technique was perfected by G.F. Rawlings in 1904 and introduced to the public in 1907. Prepared gelatin emulsions were applied to silver bromide papers, and after exposure to the negative inks were applied using rollers and brushes. The photographer exercised control, both in terms of choice of pigments and of tones, and was thus able to manipulate the look of the print (see Dührkoop), to a degree which the 'straight' photographers of the 1920s found unacceptable.

Cabinet photograph

A standard size of photograph, almost always a portrait, which was popular from the mid-1860s to about 1900. Cabinet photographs were usually mounted on a piece of card embossed with the photographer's name and with an elaborately designed advertisement for his studio on the back.

Calotype

Also known as a Talbotype. The main advantage of William Fox Talbot's calotype process, which was patented in 1841, was that it allowed multiple prints to be taken from a single negative. The calotype negative was based on fine writing paper coated with a solution of silver nitrate and potassium iodide, which was dried and brushed with solutions of silver nitrate and gallic acid. The negative was developed in a solution of gallo-nitrate of silver, rinsed and fixed. The whole process had to be carried out on the same day. The negative was then waxed, for the sake of translucency and to reduce printing time (see Régnault). The principal improvement in this process was the **waxed-paper negative**.

Camera obscura

The precursor of the hand-held camera. A darkened room into which light is admitted through a convex lens set in a small aperture. Inverted images are projected onto a flat surface opposite the aperture.

Carbon print

Photography has always set its sights on permanence, and the carbon print (see Cameron and Rejlander) was an early answer to the problem. The process, introduced by Joseph Swan in 1864, made use of carbon tissue, which was a film of gelatin with finely powdered carbon. The tissue was sensitized with bichromate and exposed under a positive transparency. After development in water, the carbon tissue with its image was transferred onto a sheet of paper and the original backing removed. Positive carbon prints exhibited very few signs of aging and a delicate tonal range. They are also known as autotypes.

Carbro print

A subtractive colour process popular in the 1920s and 1930s (see Muray and Outerbridge) and similar to Vivex. Three negatives were exposed, to differentiate red (magenta), blue (cyan) and yellow. Exposures were made through an automatic repeating back camera, operated by clockwork. Negatives were exposed behind coloured filters.

Carte de visite

A type of print very popular in the 1860s until it was replaced by the larger **cabinet photograph**. *Cartes de visite* are about the same size as a visiting card and were the first mass-produced photographs of famous people. Large quantities showing such figures as Queen Victoria and Napoleon III were issued and collected in albums.

Chlorobromide print

Chlorobromide paper (paper coated with a gelatin emulsion containing silver bromide and silver chloride) was invented by Dr J.M. Eder of Vienna and announced in 1883. Faster than chloride paper, which was invented at the same time, it was used for contact copying under artificial light. Originally called 'gaslight' paper because it could be developed under gaslight in a darkroom, it was remarkably cheap. Its tones were warm black and brown (see Drtikol and Wilding).

Cibachrome

Cibachromes (see Boonstra and Kaila) are made from colour transparencies. The paper used has three silver-halide emulsion layers, each one of which is dedicated to one primary colour with its complementary. In the printing process, dyes are destroyed by chemical bleaching, leaving only those colours which make up the final image. Cibachrome is an Ilford product, marketed from 1963 onwards.

Collotype

Potassium bichromate loses its solubility in water in proportion to its exposure to light. The French inventor, Alphonse Louis Poitevin, noticed this property and put it to use in photographic printing for reproduction. In his collotype process, a sheet of stone or glass was coated with the bichromate, exposed under a positive transparency and washed in water. Areas exposed to light became hard. Thus, after washing and drying, the exposed plate could be inked like a lithographic surface.

Combination print

A print consisting of two or more images printed onto the same sheet of paper. The technique was widely used in the 1850s for adding details and building up images. Oscar Rejlander was a renowned exponent, sometimes using as many as thirty negatives to produce imaginary scenes.

C-type print

The C-type process was introduced in the 1950s for printing from colour negatives. C-type paper is coated with three emulsion layers sensitized to primary colours and protected by filters. The images are made from cyan, magenta and yellow dyes. C-type prints are also known as dye coupler prints.

Cyanotype

A photographic printing process based on iron salts which produces prints with a bright blue background. These prints are notable for being perhaps the most chemically stable of all early processes. Their chief commercial use has long been for engineers or architects.

Daguerreotype

This was the first commercial photographic process. It was made public by Louis-Jacques-Mandé Daguerre in 1839. Daguerreotypes were unique images fixed on silver-coated copper plates (see Daguerre and Southworth & Hawes). The silvered surface was treated with iodine and bromine vapours, to create a light-sensitive halide. After an exposure of several minutes' duration in a camera, the plate was developed over a dish of heated mercury, to bring out the latent image, which was then fixed in a bath of sodium thiosulfate. Daguerreotypes were reversed images. Positives, they could not be multiplied, and they also had to be protected by a cover glass from oxidation and abrasion. Early exposure times were of fifteen to twenty minutes, although that time was reduced in 1840-1 to make the process suitable for portraiture. The process was abandoned during the 1850s, with the introduction of the **wet-collodion process**, although it remained popular in the USA until the mid-1860s.

Diorama

A miniature three-dimensional scene reproduced with the aid of lights and colours.

Direct positive print

In 1840 Hippolyte Bayard announced his method for making direct positive images on paper to the Académie des Sciences in Paris. His technique involved taking silver chloride paper, blackening it in light, soaking it in potassium iodide and then exposing it in a **camera obscura**. The paper was then washed in hyposulfite of soda and dried. Bayard intended this process to be an alternative to Fox Talbot's negative process, but the images (like daguerreotypes) were unique and required exposures of around twelve minutes in the camera.

504

Duotone

A printing process in which a **halftone** image is passed through the press twice, often using black ink first and then another colour.

Dye coupler print see C-type print

Dye transfer print

A complex form of early colour printing in which a colour transparency was photographed three times, in each case through a different filter. These new negatives were used to prepare further surfaces sensitive to the three subtractive primary colours: cyan, magenta and yellow. The dyes from these surfaces were then transferred one at a time onto gelatin-coated paper, producing very stable results (see Edgerton and Tingaud). The process was introduced by the Jos Pé Company in 1925.

Ektachrome

In 1946 Eastman Kodak began to produce a reversible film incorporating chromogenic couplers. It was very close to Agfacolour, which had been produced for the first time in 1936.

Ektacolor print

A **C-type print** made on Ektacolor paper (see diCorcia and Prince).

Ermanox

A lightweight camera introduced in 1925, the same year as the **Leica**. Its large aperture lens, which was the fastest available, was the f.2 Ernostar, which became the f.1.8. The camera held 4.5 x 6 cm-glass plates and made it possible for the first time to take candid pictures indoors by available light. It was the Ermanox which permitted photographers to shoot the indoor and night-time photo-stories on metropolitan topics which were such a feature of the illustrated magazines of the 1930s.

F.stop

A number that expresses relative aperture, representing the focal length of the lens divided by the diameter of the aperture. (The higher the f.stop number, the smaller the aperture.) A series of f.stop numbers appears around the aperture ring on all lenses.

Film negative

The first film negative was introduced as early as 1886. It was a sensitized gelatin emulsion backed by paper which was soaked off during processing. Paper-backed gelatin film was quite fragile. In the 1890s cellulose nitrate grew in popularity as a film base, and it became the main film-based negative of the inter-war years. It was highly inflammable and therefore a danger in stores and archives. Safety film was introduced in 1937, at first on a diacetate base and from 1947 on a triacetate base.

Fixing

The process of making an image permanent by washing away unaffected silver halides using **hypo** (sodium thiosulfate). The image is thus made insensitive to further exposure to light.

Flashlight photography

Burning magnesium ribbons were first used as a source of light in photography in the 1860s. Magnesium made it possible to take pictures in mines, caves and ancient Egyptian tombs. In 1887 Dr Adolf Miethe and Johannes Gaedicke in Berlin developed the first 'flashlight' powder by mixing powdered magnesium with an oxidizing agent. In 1925 Dr Paul Vierkotter patented a flash bulb with aluminium foil, and in 1929 Harold Edgerton, Kenneth Germeshausen and Herbert Grier developed high-speed electronic strobe lighting. Flash dramatized reportage photography from the 1930s to the 1960s, showing city life in particular as expressive and fantastic.

Fresson print

A proprietary direct carbon process invented by Théodore Henri Fresson around 1899 and still used by his descendants. It was favoured by the great Spanish documentarist Ortiz Echagüe.

Gelatin dry-plate process

In 1871 Dr Richard Leach Maddox announced the invention of an emulsion of silver and bromide which could be heated to increase its sensitivity to light and used for coating glass plates. From 1889 onwards, this emulsion was also applied to celluloid roll film. By 1878 rapid gelatin dry plates were being manufactured on a large scale. Exposures were ten to twenty times faster than with those made using the **wet-collodion process**. Dry gelatin plates revolutionized photography, mainly because of their speed, but also because they could be processed at any time after exposure if carefully packed and stored.

Gelatin silver print

The standard contemporary monochrome print. The paper (first introduced in 1882) is treated with the same gelatin silver emulsion used in the **gelatin dry-plate process**. By 1895 the gelatin silver print had replaced the **albumen print**.

Glass negative

Albumen-on-glass negatives were introduced in 1848 by Niépce de Saint-Victor, and communicated to the Académie des Sciences, Paris, on 12 June 1848. This process provided finer detail than the **calotype**. Glass plates, which could be prepared in advance and developed up to two weeks after exposure, were coated with a thin layer of white of egg containing a solution of potassium iodide. When dry, they were sensitized with an acid solution of nitrate of silver. The latent image was developed with gallic acid. This was a slow process, with between five and fifteen minutes of exposure time, and although useless for portraiture it gave good results with landscape and architecture. The perfect transparency of the medium gave very fine detail. It was superseded by the much faster **wet-collodion process**.

Gum bichromate print

This process had been experimented with in the 1850s, but it was only in the mid-1890s that it became popular amongst artist-photographers (see Hofmeister). The technique made use of the fact that gum bichromate hardens on exposure to light. The paper was coated with light-sensitive, pigmented gum arabic. The emulsion, sensitized by the addition of ammonium or potassium dichromate, was brushed onto paper and dried. Exposure to light through a negative hardened the surface of the print to different degrees, and this variously porous surface could then be brushed or abraded by the photographer. The process could be repeated with different pigments.

Halftone

The photomechanical printing process which made the widespread dissemination of photographs possible. The process involves photographing an image through a fine screen to break it up into dots. The dot-pattern image is then chemically etched onto a printing plate which is inked to transfer the image to paper.

Heliogravure

Nicéphore Niépce invented heliography in the 1820s. A French landowner with interests in lithography, Niépce wanted to fix the images of the **camera obscura** chemically. In 1826 he managed to obtain a faint 'heliogravure' or 'sun drawing' on a pewter plate coated with bitumen of Judaea, a light-sensitive substance. The first heliogravure took eight hours to obtain in full sunlight. Niépce's intention was to etch and to ink his heliogravures and then to print from them onto paper.

Hypo

A professional abbreviation for sodium hyposulfite (now called sodium thiosulfate), which was originally used in the 1840s to increase the clarity and permanence of negatives.

Iris print

A computer-printed colour image (see Krims).

Isochromatic plate see Orthochromatic plate

Kodachrome

Invented by Leopold Mannes and Leopold Godowsky and then acquired and perfected by Eastman Kodak during the 1950s, Kodachrome was the first commercially successful integral tripack colour process. It made use of dyes incorporated into silver-gelatin emulsions. In processing the silver elements are dissolved, leaving a print made up of dyes suspended in gelatin.

Lantern slide

An image on glass, used in early slide projectors to project photographs to audiences.

Leica

Travellers, like theatre and sports photographers, all preferred the Leica, the first lightweight camera to use 36mm film. It was invented by Oscar Barnack, who from 1911 worked for the Leitz organization in Wetzlar, Germany. The Leitz company manufactured ciné cameras and it was Barnack's idea to make a miniature camera to test exposure times. The trial camera took 36mm ciné film and proved so successful in its own right that it was developed by the Leitz company as a separate product, going on sale in 1925. Ten years later it had conquered the world of photography, with total sales of around 180,000 units.

Oil print

This process was introduced in the early years of the twentieth century and was much used by fine-art photographers until about 1914 (see Demachy). Paper coated with bichromated gelatin was exposed under a negative and then immersed in water and dried. This treatment made the surface of the print relatively porous and thus receptive to coloured oil pigments, applied by hand.

Orthochromatic plate

An early type of plate (introduced in the 1870s) that was treated with emulsion sensitive to blue and green light only. Also known as an isochromatic plate.

Panchromatic plate

A plate or film that is sensitive to all the colours of the spectrum. It was first brought into use in the 1910s.

Photogram

A photographic image which has been produced without a camera. It was achieved by placing an object on a sensitized surface (paper or film) and then exposing it to the light (see Moholy-Nagy). Sometimes known as a 'Schadograph' or 'Rayograph' after Christian Schad and Man Ray, who used this technique in the 1930s.

Photogravure

This mechanical printing process was invented by the Viennese Karel Klič in 1879. It made use of a copper plate to which resin dust had been applied through heat. Carbon tissue printed under a diapositive was transferred to the grained copper plate and washed to remove the soluble areas of the carbon image. The plate was then etched in proportion to the tones of the picture, with the deeper shadowed areas holding the most ink. It was widely used from the mid-1890s and was favoured by, among others, Peter Henry Emerson and Alfred Stieglitz for the reproduction of photographs.

Photomontage

The technique of combining one or more photographs (or portions of them) to produce an image not found in reality (see Berman and Heinecken).

Pin-hole camera

The most basic form of camera possible, in which light is introduced into a darkened box via a tiny aperture. Pin-hole images, uncorrected by a lens, look distorted when registered on film (see Fuss). The pictorialist George Davison used a pin-hole camera in the 1890s, and their use has been revived in the 1980s and 1990s.

Platinum print

Also known as a platinotype. Platinum paper was invented and patented by William Willis in 1873, and from 1879 was marketed by the Willis Platinotype Company of London. Papers were prepared with light-sensitive iron salts and platinous potassium chloride. After exposure through a negative, the paper was developed in potassium oxalate, which caused a reduction of the platinum salt to pure platinum. Platinum prints were more permanent than those which depended on silver, and their tonal range was very beautiful and subtle (see Emerson and Modotti). The cost of platinum made the paper prohibitively expensive and production of the paper was finally discontinued in 1936.

Polaroid

An instant photography technique devised by Dr Edwin H. Land whereby synthesized colour dyes pass from a negative onto the surface of a sealed film unit, producing a positive image in about one minute. Dr Land first introduced his technique in 1948 but it was not until the SX-70 Polaroid Land camera came in in 1972 that the process really caught on. It is now used by many distinguished photographers (see Cosindas and Samaras).

Printing-out paper

Introduced in the early 1880s, this was twice as fast as albumen paper and superior in permanence. Printing-out papers began to become popular in the 1890s. These papers did not need to be developed to make the image visible. Printed-out images darken by themselves during exposure and as they darken so light-sensitive chemicals underneath are protected. They are useful for printing negatives of high contrast and have a delicate tonal range. In the 1920s printing-out paper was replaced by developing paper which needed chemical development and which had a pale silvery tone characteristic of modern gelatin silver papers.

Rayograph see Photogram

R-type print

A colour print made from a positive transparency.

Sabattier effect see Solarization

Salted-paper print

The salted-paper print or salt print was announced by Fox Talbot in 1839. In this process a positive print was made without an emulsion or coating on the surface of the paper. Instead, light-sensitive salts were soaked into the paper, which was then sensitized with silver nitrate and exposed to daylight under a negative, with the two held together in a printing frame. The finely divided silver particles on the surface of these prints were sensitive both to atmospheric pollutants and to humidity, and susceptible to fading. They were sometimes coated with a layer of varnish or albumen. Originally paper and negative were held together until an image of sufficient density was produced; then the paper was washed and the image fixed (see Hill & Adamson and Le Secq). The French inventor, Louis-Désiré Blanquart-Evrard, speeded up the process by developing the image in **hypo** baths before fixing.

Schadograph see Photogram

Silver print see Gelatin silver print

Solarization

This phenomenon is also known as the Sabattier effect in honour of Armand Sabattier, the Frenchman who discovered it in 1860. The term describes the partial reversal of tones on film or photographic paper if it is re-exposed to light during development. The phenomenon was observed in 1929 by Man Ray and Lee Miller, who then put it to use in their own photography.

Stereoscope

A binocular device which creates the illusion of three dimensions. It was developed by Sir Charles Wheatstone in 1838 and became popular with the invention of photography. Stereoscope photographs were taken with one exposure through a double-lens camera.

Talbotype see Calotype

Vivex print

A subtractive colour process similar to the carbro process. Vivex negatives were specially processed by the manufacturers. Three separate positives were then prepared and superimposed to produce a richly coloured, permanent colour picture. Vivex was an expensive process, used most notably by Madame Yevonde in portraiture in Britain.

Waxed-paper negative

A modification of the **calotype** process, introduced in 1851 by Gustave Le Gray. The paper was waxed at the start of the process. This made for better detailing and meant that the paper could be prepared up to ten days in advance of use and developed several days after exposure. Fox Talbot himself improved the process in 1843 through an after-treatment of the negative with sodium thiosulfate (**hypo**), which intensified or developed a latent image in the negative. This reduced exposure times.

Wet-collodion process

This process was announced by Frederick Scott Archer in 1851 and had supplanted all other processes by 1860. It was fast, and also the first in England to be free from patent restrictions. Collodion is gun cotton dissolved in ether, which creates a membrane transparent to the touch. To this was added potassium iodide. The mixture was spread on a glass plate and then sensitized in a bath of nitrate of silver and exposed in a camera while still moist. As the plates dried, sensitivity decreased. Plates had to be developed immediately after exposure with either pyrogallic acid or ferrous sulphate and then fixed with sodium thiosulfate or potassium cyanide. Travelling photographers who used this process needed to take with them a dark tent and developing outfit. Exposures were from ten seconds to one and a half minutes. Pre-prepared dry collodion plates were introduced during the 1850s and 1860s, but they were much slower than wet collodion, which remained in general use until about 1880, when it was replaced by the faster and more convenient **gelatin dry-plate process**. Variants included the collodio-albumen process, in which collodion plates were coated with iodized albumen, and a second silver nitrate bath before drying for later use. In the syrup collodion process, prepared plates were kept moist and sensitive beneath a coating of honey and distilled water.

Woodburytype

A (now obsolete) printing process in which a negative was exposed to bichromated gelatin to create a relief mould. In printing, the deepest parts of the mould produced the darkest areas of the print (see Carjat). The process was invented by the Englishman Walter Woodbury in 1865.

Glossary of movements, groups and genres

Aerial photography

In 1858 the French portraitist Nadar took the first aerial photograph from a balloon. Nadar continued to experiment and even suggested a project to photograph the whole of France from the air. Aerial photography was used enthusiastically during World War I, mainly for reconaissance and as a guide to artillery fire. In the 1920s pictures from high vantage points became part of the repertoire of the new photography. The next important stage was photography of the Earth from space, as explored by the Russians and Americans from the late 1950s. Satellite photography and the growth of remote sensing reinvigorated landscape photography in the 1970s and stimulated ecological consciousness.

☛ Gerster, Krull, Nadar

Anthropological photography

Photographs of country people, slum dwellers and non-Europeans were taken during the nineteenth century to introduce such 'outsiders' to educated audiences in London, Paris, Berlin and the other major centres of learning. It was generally believed that tribespeople (such as native North Americans) were doomed to extinction and ought to be recorded for posterity whilst it was still possible. Nineteenth-century photographers also thought that true representations lay in specifics which might be registered and measured – facial and bodily configurations, and the shape of heads, for example. Towards 1920, a new interest in cultural relativism began to make the old specimen photography look archaic. Anthropologists also started to take the view that the truth lay in social patterns and habits too subtle to be recorded by the camera, and so photography mainly certificated the anthropologist's presence in the field. Such pictures foreshadowed some of the new styles of **documentary photography** developed by René Burri and Bernard Plossu in the 1950s and 1960s.

☛ Burri, Curtis, Plossu, Riefenstahl, Rodger, Thomson

Aperture

A magazine dedicated to fine-art photography, established by the American photographer Minor White in 1951. White was commissioned by a committee including Barbara Morgan and Ansel Adams. The first edition was published in 1952. In 1955 White moved from San Francisco to Rochester, New York, taking the magazine with him. Both as a magazine and as the gallery and publishing house of the same name, *Aperture* was from its inception an important force in American and then in world photography.

☛ A. Adams, Morgan, M. White

Camera Work

Alfred Stieglitz founded the magazine *Camera Work* in 1903. It went through fifty issues before it was discontinued in June 1917 and became, deservedly, the most esteemed and famous of all the many photographic magazines. Stieglitz published the work of a broad range of significant photographers and devoted the last issue of the magazine to the pictures of Paul Strand.

☛ Stieglitz, Strand

DATAR

In 1984 the French Ministry of Culture oversaw the creation of a project or mission to photograph France as it was in the 1980s: its towns, suburbs, villages, fields, woods and factories. DATAR (an acronym from the title of the project, Délégation à l'Aménagement du Territoire et à l'Action Régionale), employed the best of Europe's young landscape photographers in a scheme without parallel in the post-war era. Its participants included Werner Hannappel (Germany) and Sophie Ristelhueber (France).

☛ Basilico, Hannappel, Ristelhueber

Documentary photography

Photographers have been documentarists since the invention of the medium. Government agencies, such as the French Commission des Monuments historiques in the early 1850s, tended to think of photographic records as potentially valuable and as supplements to written records. Documentary was always undertaken on behalf of posterity, as opposed to reportage which involves news for contemporaries. Roy Stryker's **Farm Security Administration** (FSA) project in the USA in the 1930s is the most celebrated of all documentary undertakings.

☛ Baldus, W. Evans, Fenton, Le Gray, Marville, Tripe

'Family of Man' exhibition

The showcase for a vast collection of photographers, some known and some soon to be known, the 'Family of Man' exhibition took place at the Museum of Modern Art in New York in 1955. It was organized by Edward Steichen shortly after he became director of the Department of Photography at the museum and consisted of 508 largely photojournalistic images selected from sixty-eight countries. The professed aim of the exhibition was to mark the 'essential oneness of mankind throughout the world'. In the exhibition, as well as in the book that was published at the same time, photographers were given no control over the display and printing of their work, which was used according to a predetermined design.

☛ Hardy, W. Miller, Schuh, Steichen, Unknown

Farm Security Administration

The FSA, as it is usually known, was established in 1935 with a set of responsibilities which included support for small farmers and the refurbishment of land and communities ruined by the Depression. Roy Emerson Stryker was appointed to head the Historical Section and decided to put together a photographic collection. The result was one of the most celebrated archives in the history of the medium. Amongst the photographers were Arthur Rothstein, Walker Evans, Carl Mydans, Ben Shahn, Dorothea Lange, Russell Lee, Jack Delano, Marion Post Wolcott and John Vachon. Although the influence of the FSA photographers was considerable at the time, it was even more noticeable during the 1970s, when many books on its history were published. Several of its photographers moved with Roy Stryker in 1943 to work for a similar recording scheme, known as **The Standard Oil (New Jersey) Project**.

☛ Bubley, Delano, W. Evans, Lange, Lee, Mydans, Parks, Post Wolcott, Rothstein, Shahn, Vachon

Fotografia Buffa

A movement in Dutch photography which flourished in the early 1980s. It drew its name from the phrase *opera buffa* (comic opera) and its inspiration from the staged photography of the 1970s and from the examples of Ger van Elk, Les Krims and Duane Michals in particular. Its principal catalogue, *Fotografia Buffa*, published in connection with the exhibition of that name at the Groninger Museum, Groningen, in 1986, is subtitled 'Staged Photography in the Netherlands'.

☛ Boonstra, van Elk, Hocks, Krims, Michals

Group f.64

Active in the San Francisco Bay area from around 1930 to 1935, Group f.64 took its name from one of the smallest apertures available on the large-format cameras of the period. Use of the f.64 aperture resulted in images of great clarity and depth of field. The group, whose aesthetic was drawn from the idea that a physical response to nature was important, produced 'straight' pictures which contrasted with the hand-manipulated, soft-focus imagery of the Californian Pictorialists of the 1920s. Among the group's principal members were Edward Weston, Ansel Adams, Willard Van Dyke and Imogen Cunningham. Group f.64 exhibited together only once, in 1932 at the M.H. de Young Memorial Museum in San Francisco.

☛ A. Adams, Cunningham, Van Dyke, Weston

Life

In 1936 Henry Luce established *Life* magazine, an illustrated weekly in the style of the German magazines of the 1920s. Its founding photographers were Margaret Bourke-White, Alfred Eisenstaedt, Thomas McAvoy and Peter Stackpole. Kurt Korff, the former editor of the Berliner *Illustrierte Zeitung*, was its picture editor.

☛ Bourke-White, Eisenstaedt

Linked Ring Brotherhood see Pictorialism

Magnum

In 1947 a co-operative agency was founded by Henri Cartier-Bresson, Robert Capa, Maria Eisner, David 'Chim' Seymour, George Rodger and William and Rita Vandivert. They called the agency Magnum Photos Inc., after the extra-large magnum wine bottle. Magnum was established in New York, subsequently opening offices in London and Paris. It remains a co-operative. Previously photographers had had to work under the instruction of editors and publishers; the idea behind Magnum was that its members should report on the kind of events which interested them, and that the agency should distribute the results. Magnum photographers graduate into the organization after a period as nominees.

☛ R. Capa, Cartier-Bresson, Rodger, Seymour

National Geographic

One of the great outlets for **documentary photography** during the twentieth century, *National Geographic* was launched by the National Geographic Society in the USA in 1888 as a popular scientific journal. By 1900 it was making substantial use of photographs as illustrations, and by the mid-1920s it was employing full-time staff photographers. The first colour photographs were printed in *National Geographic* in 1910 and the first **autochrome** in 1914. The magazine, which has been especially associated with colour photography (as opposed to the monochrome of photojournalism), went over completely to colour in 1960. During the 1980s and 1990s the magazine's orientation shifted towards a more radical socio-photography, often touching on ecological issues.

☛ Abell, Allard, Doubilet, Nichols

New Topography

Much landscape photography from the 1970s onwards, in Europe as well as the USA, has been described as New Topography. The term was coined in 1975 by William Jenkins, who organized the exhibition 'New Topography: Photographs of a Man-Altered Landscape' at George Eastman House in Rochester, New York. The style was very objective with respect to even the most barbaric human interventions in nature. The New Topographers asked audiences to exercise their own discernment and to treat pictures as if they were of evidence still to be sorted.

☛ Aarsman, R. Adams, Baltz, Shore

Photojournalism

Technical developments were all-important in the growth of photojournalism. From the 1840s onwards, photographs were reproduced in the press through either wood engraving or lithography. Effective means of photo-mechanical relief printing were developed in the 1880s, and only in the 1890s did photographic illustrations appear in any numbers in the press. Rotogravure, introduced by Karel Klíč in the 1890s, involved cylinder presses which speeded up the process. In 1910 the German Eduard Mertens devised a rotary printing cylinder capable of printing type and illustrations together. The process was rapidly taken up by such journals as *Frankfurter Illustrierte* and *Weltspiegel* in Berlin and by *L'Illustration*, *Le Miroir* and *Sur le Vif* in Paris, as well as by *The Illustrated London News*. The first daily papers to print photographic news pictures were *The Daily Graphic* in New York, *The Daily Mirror* in London and *Excelsior* in Paris. The number of illustrated magazines increased greatly in the 1920s, especially in Germany, providing employment for a growing number of photojournalists. The German magazines attracted photographers from Eastern Europe, many of whom moved to Paris, London and the United States during the 1930s as the new Nationalist Socialist regime clamped down on the press. Photo agencies, often staffed by no more than a handful of people, were established in Berlin in the late 1920s and 1930s. These agencies soon consolidated and traded in pictures on a worldwide scale. Photojournalism in the 1920s and 1930s provided a career open to the enterprising, for it could be undertaken with a minimum of technical training.

☛ Aigner, Bourke-White, R. Capa, Eisenstaedt, McCullin, Magubane, Riboud, Salomon, Silk, Weegee

Photo-plastik

Art photography underwent radical changes in the 1970s. The rise of performance and installation art, and of the various kinds of land art based on walking, meant that photographic records became important. The next step was to stage the event for the sake of the photograph. This kind of staged photography never became known by a generic title in English, possibly because the practice was so diverse.

☛ Appelt, Brus, Morimura, Nauman

Photo-Secession

In 1902 Alfred Stieglitz broke with the New York Camera Club, of which he was Vice-President, and founded the Photo-Secession. He took the title from the various secessionist movements occurring in European fine art at that time. Members included Alvin Langdon Coburn, Gertrude Käsebier and Edward Steichen. With Steichen, Stieglitz opened the Photo-Secession Gallery at 291 Fifth Avenue, New York, in November 1905.

☛ Coburn, Käsebier, Steichen, Stieglitz

Pictorialism

Some photographers in the late nineteenth century began to think of themselves as artists or as makers of pictures rather than documents. They held to the idea that artists should organize their pictures for aesthetic effect. To separate themselves from naive and from trade photography, they set up exhibiting societies. The new art photographers regarded themselves as amateurs, and in 1884 the *Amateur Photographer* magazine was founded in London. Societies proliferated: the Photo-Club de Paris (1883), the Linked Ring Brotherhood (1892) and the Camera Club (1885) in London, the Vienna Camera Club (1891). In 1902, Alfred Stieglitz, editor of *Camera Notes*, founded the American **Photo-Secession**, and in 1903 he established *Camera Work*, the most influential magazine

in the history of the medium. Societies flourished, sub-divided and collapsed – as the Linked Ring did in 1910. Pictorialists were specialist printers who made use of a wide variety of techniques: platinum and gum printing especially. The Pictorial movement survived into the 1920s but a new generation of 'straight' photographers saw it as overly subjective, exquisite and degenerate.

☛ Annan, Brigman, Demachy, Dührkoop, F.H. Evans, Kühn, Sutcliffe, C. White

The Royal Photographic Society

The solicitor and distinguished photographer Roger Fenton was one of the founding members of the Royal Photographic Society, which was set up in 1853 as the London Photographic Society. Patronized by Queen Victoria and Prince Albert, the society became Royal in 1894 and attracted a group of enthusiasts keen to experiment with the new medium. The first golden age of photography was brought to an end by World War I, when the demand for platinum (much used in printing) for munitions manufacture led many photographers to stop taking pictures.

☛ Demachy, F. H. Evans, Fenton

The Standard Oil (New Jersey) Project

In 1943 Standard Oil hired Roy Stryker, head of the photography section of the **Farm Security Administration**, to manage a project intended to document the lives of workers in the oil industry. Stryker decided to interpret the project broadly, and hired a number of photographers who had worked for him at the FSA, including John Vachon, Russell Lee and Gordon Parks. Esther Bubley, one of the project's most distinguished photographers, worked originally for the FSA as a lab technician.

☛ Bubley, Lee, Parks, Vachon

'Subjektive fotografie'

The motto '*subjektive fotografie*' was devised by Otto Steinert around 1950 as a counterpoint to the idea of 'applied' and 'salon' photography. In 1951 he organized an important exhibition of the same name at the Schule für Kunst und Handwerk in Saarbrücken, where he was a teacher. Steinert stressed the importance of the transformation of observed material into symbol, processed and enhanced by the temperament of the photographer. Two more shows followed in 1954 and 1958. Steinert's ideology gave heart to photographers throughout Europe who wanted to escape from the documentary expectations of the period.

☛ Steinert

Surrealism

The Surrealists, grouped around André Breton in Paris in the late 1920s, believed in opposition to the status quo, and they cultivated the darker side of life: dreams, desires, crime, absurdity. Photography, which lent itself to suggestive overprintings and such happy accidents as **solarization**, was a surrealist medium par excellence, and remained so long after the movement had faded in Paris. The original Surrealists in photography were Dora Maar, Man Ray and Maurice Tabard. Their successors in the USA in the 1940s and after were Clarence John Laughlin, Ralph Eugene Meatyard and Jerry Uelsmann.

☛ Laughlin, Maar, Man Ray, Meatyard, Uelsmann

USSR in Construction

The propaganda journal of the Soviet Union, established by Maxim Gorky and published monthly in Moscow between 1930 and 1941. A giant magazine, with each double-page spread measuring 81 x 57 cm (31 x 22 in), *USSR in Construction* advertised socialist

development in Russia and made great use of photographs by such figures as Max Alpert and Alexander Rodchenko.

☛ Alpert, Rodchenko

VU

An important French weekly illustrated magazine, set up in 1928 by Lucien Vogel. *VU* nurtured a new generation of French photojournalists, even if many of them – Brassaï, André Kertész, François Kollar - were from Eastern Europe. It was to *VU* that many of Germany's Jewish photographers defected during the early 1930s.

☛ Brassaï, Kertész, Kollar

War reportage

Pictures from the battlefield remained substantially the same from the Crimean War of the mid-1850s through to World War I. Photographers concentrated on the aftermath: prisoners, sites of battle, captured material, casualties. The development of the **Leica** in the 1920s allowed a new generation of photographers to report on events as they happened at the front. The Sino-Japanese War and then the Spanish Civil War in the 1930s were the first to be reported from a combatant's point of view, chiefly by Robert Capa. Both of those wars were relatively unsupervised and could be reported by outsiders. World War II was entirely reported on by fellow nationals, and it was often heroically staged. The Western democracies granted ready access to their wars of the 1950s and after, on the grounds that their cause was just. Photographers in Korea in the 1950s, and then in Vietnam in the 1960s, were more sceptical, and gave devastating accounts of what they saw.

☛ Burrows, R. Capa, Duncan, Hardy, McCullin, Rosenthal, Ut

Directory of museums and galleries

Australia

Australian National Gallery
Parkes Place
Parkes
Canberra ACT 2600
℡ (61 6) 240 6411

Austria

Neue Galerie der Stadt Linz
Wolfgang-Gurlitt-Museum
Blütenstrasse 15
A-4020 Linz
℡ (43 732) 2393 3600

Österreichische Fotogalerie im Rupertinum
Wiener Philharmoniker-Gasse 9
A-5010 Salzburg
℡ (43 662) 8042 2568

Galerie Ulysses
Opernring 21
A-1010 Vienna
℡ (43 1) 587 1226

Belgium

Museum voor Fotografie
Waalse Kaai 47
B-2000 Antwerp
℡ (32 3) 216 2211

Musée de la Photographie
11 Avenue Paul Pastur
B-6032 Mont-sur-Marchienne
℡ (32 71) 43 58 10

Canada

McCord Museum of Canadian History
690 Rue Sherbrooke Ouest
Montreal H3A 1E9
℡ (1 514) 398 7100

National Gallery of Canada
380 Sussex Drive
Ottawa
Ontario K1N 9N4
℡ (1 613) 990 1985

Vancouver Art Gallery
750 Hornby Street
Vancouver
British Columbia V6Z 2H7
℡ (1 604) 682 4668

Czech Republic

Museum of Decorative Arts
Ulice 17. listopadu 2
CZ-11000 Prague 1
℡ (42 2) 232 0017

Denmark

Museet for Fotokunst
Brandts Klædefabrik
Brandts Passage 37 & 43
DK-50000 Odense
℡ (45) 66 13 7816

Finland

The Photographic Museum of Finland
Tallberginkatu 1 A 3.floor
SF-00180 Helsinki
℡ (358 90) 6851033

France

Musée Réattu
10 Rue du Grand-Prieuré
F-13000 Arles
℡ (33) 90 49 37 58

Musée Nicéphore Niépce
28 Quai des Messageries
F-71100 Chalon-sur-Saône
℡ (33) 85 48 41 98

Musée Cantini
19 Rue Grignan
F-13000 Marseille
℡ (33) 91 54 77 75

Centre National de la Photographie
11 Rue Berryer
F-75008 Paris
℡ (33 1) 53 76 12 31

Galerie Agathe Gaillard
3 Rue du Pont Louis-Philippe
F-75004 Paris
℡ (33 1) 42 77 38 24

Galerie de Photographie de la Bibliothèque Nationale/Galerie Colbert
2 Rue Vivienne
F-75002 Paris
℡ (33 1) 47 03 83 92

Galerie Michèle Chomette
24 Rue Beaubourg
F-75003 Paris
℡ (33 1) 42 78 05 62

Maison Européene de la Photographie
5-7 Rue de Fourcy
F-75004 Paris
℡ (33 1) 44 78 75 00

La Mission du Patrimoine Photographique
62 Rue St-Antoine
F-75004 Paris
℡ (33 1) 42 74 47 75

Musée National d'Art Moderne
Centre Georges Pompidou
19 Rue Beaubourg
F-75004 Paris
℡ (33 1) 44 78 12 33

Germany

Berlinische Galerie, Museum für moderne Kunst, Photographie und Architektur
Martin-Gropius-Bau
Stresemannstrasse 110
D-10963 Berlin
℡ (49 30) 25 4860

Galerie Rudolf Kicken
Bismarckstrasse 59
D-50672 Cologne
℡ (49 221) 51 5005

Museum Ludwig
Bischofsgartenstrasse 1
D-50667 Cologne
℡ (49 221) 22 13619

Stadtmuseum Dresden
Wilsdruffer Strasse 2
D-01067 Dresden
℡ (49 351) 49 8660

Museum Folkwang
Goethestrasse 41
D-45128 Essen
℡ (49 201) 88 8452

Produzentengalerie
Michaelisbrücke 3
D-20459 Hamburg
℡ (49 40) 37 8232

Hungary

Hungarian Museum of Photography
Katona József tér 12
H-6000 Kecskemét
℡ (36 76) 483 221

Italy

Museo Ken Damy, Fotografia Contemporanea
Corsetto S. Agata 22
Loggia delle Mercanzie
I-25122 Brescia
℡ (39 30) 375 0295

Compagnia dei Fotografi
Via Slataper 8
I-20100 Milan
℡ (39 2) 690 01354

Photology
Via delle Moscova 25
I-20100 Milan
℡ (39 2) 659 5285

Japan

Tokyo Metropolitan Museum of Photography
1-13-3 Mita
Meguro-ku
Tokyo 153
℡ (81 3) 3280 0031

Mexico

Centro de la Imagen
Plaza de la Ciudadela 2
Centro Historico
Mexico City 06040
℡ (52 5) 709 5974

Museo de Arte Moderno
Paseo de la Reforma y Gandhi
Bosque de Chapultepec
Mexico City 11560
℡ (52 5) 553 6211

The Netherlands

Torch Gallery
Lauriergracht 94
NL-1016 RN Amsterdam
℡ (31 20) 626 0284

Stedelijk Van Abbemuseum
Vonderweg 1
NL-5611 BK Eindhoven
℡ (31 40) 275 5275

Groninger Museum
Pruediniussingel 59
NL-9711 AG Groningen
℡ (31 50) 183 343

Nederlands Fotoarchief
Witte de Withstraat 63
NL-3012 BN Rotterdam
℡ (31 10) 213 2011

Poland

Muzeum Tatrzánskie
Krupówki 10
34-500 Zakopane
℡ (48) 165 15205

Spain

Posada del Potro
Plaza del Potro 10
E-14002 Cordoba
℡ (34 57) 472000

Instituto Valenciano de Arte Moderno (IVAM)
Calle Guillem de Castro 118
E-46003 Valencia
℡ (34 6) 386 3000

Sweden

Fotografiska Museet i Moderna Museet
Birger Jarlsgatan 57
S-113 56 Stockholm
℡ (46 8) 6664250

Switzerland

Schweizerische Stiftung für die Photographie
Kunsthaus
Heimplatz 1
CH-8024 Zurich
℡ (41 1) 251 6765

United Kingdom

The Royal Photographic Society
The Octagon
Milsom Street
GB-Bath BA1 1DN
℡ (44 1225) 462841

National Museum of Photography, Film and Television
Pictureville
GB-Bradford BD1 1NQ
✆ (44 1274) 727488

Portfolio Gallery
43 Candlemaker Row
GB-Edinburgh EH1 2QB
✆ (44 131) 2201911

Camerawork
121 Roman Road
GB-London E2 0QN
✆ (44 181) 980 6256

Hamiltons Gallery
13 Carlos Place
Grosvenor Square
GB-London W1Y 5AG
✆ (44 171) 499 9493

Institute of Contemporary Arts
12 Carlton House Terrace
GB-London SW1Y 5AH
✆ (44 171) 930 0493

National Portrait Gallery
2 St Martin's Place
GB-London WC2H 0HE
✆ (44 171) 306 0055

The Photographers' Gallery
5 & 8 Great Newport Street
GB-London WC2H 7HY
✆ (44 171) 831 1772

510

The Special Photographers' Company
21 Kensington Park Road
GB-London W11 2EU
✆ (44 171) 221 3489

Victoria and Albert Museum
Cromwell Road
GB-London SW7 2RL
✆ (44 171) 938 8500

Zelda Cheatle Gallery
8 Cecil Court
GB-London WC2N 4HE
✆ (44 171) 836 0506

Impressions Gallery
29 Castlegate
GB-York YO2 2DD
✆ (44 904) 654724

United States

Fay Gold Gallery
247 Buckhead Avenue
Dept PM
Atlanta
GA 30305
✆ (1 404) 233 3843

The Baltimore Museum of Art
Art Museum Drive
Baltimore
MD 21218
✆ (1 410) 396 7100

Brooklyn Museum
200 Eastern Parkway
Brooklyn
NY 11238
✆ (1 718) 638 5000

Weston Gallery
Sixth Avenue between Dolores and Lincoln
Carmel
CA 93921
✆ (1 408) 624 4453

The Art Institute of Chicago
111 South Michigan Avenue
Chicago
IL 60603
✆ (1 312) 443 3600

Museum of Contemporary Photography
Columbia College
600 S Michigan Avenue
Chicago
IL 60605
✆ (1 312) 633 5554

Denver Art Museum
100 West 14th Avenue Parkway
Denver
CO 80204
✆ (1 303) 640 4433

Museum of Fine Arts, Houston
1001 Bissonnet
Houston
TX 77005
✆ (1 713) 639 7300

Grunwald Center for the Graphic Arts
University of California at Los Angeles
Los Angeles
CA 90024
✆ (1 310) 825 3783

The J. Paul Getty Museum
1200 Getty Center Drive, Suite 1000
Los Angeles
CA 90049
✆ (1 310) 459 7611

Museum of Contemporary Art, Los Angeles
250 South Grand Avenue
California Plaza
Los Angeles
CA 90012
✆ (1 213) 621 2766

Walker Art Center
Vineland Place
Minneapolis
MN 55403
✆ (1 612) 375 7600

Gallery for Fine Photography
323 Royal Street
New Orleans
LA 70130
✆ (1 504) 568 1313

The Aperture Foundation/Burden Gallery
20 East 23rd Street
New York
NY 10010
✆ (1 212) 505 5555

Howard Greenberg Gallery
120 Wooster Street
New York
NY 10012
✆ (1 212) 334 0010

International Center of Photography
1133 Fifth Avenue
New York
NY 10128
✆ (1 212) 860 1777

Light Gallery
135 East 74th Street
New York
NY 10021
✆ (1 212) 249 5653

The Metropolitan Museum of Art
Department of Prints and Photographs
1000 Fifth Avenue
New York
NY 10028
✆ (1 212) 879 5500

Museum of Modern Art
Department of Photography
11 West 53rd Street
New York
NY 10019
✆ (1 212) 708 9400

PaceWildensteinMacGill
32 East 57th Street
New York
NY 10022
✆ (1 212) 759 7999

The Staley-Wise Gallery
560 Broadway
New York
NY 10012
✆ (1 212) 966 6223

Whitney Museum of American Art
945 Madison Avenue
New York
NY 10021
✆ (1 212) 570 3600

The Chrysler Museum of Art
245 West Olney Road
Norfolk
VA 23510
✆ (1 757) 664 6200

Oakland Museum
1000 Oak Street
Oakland
CA 94607
✆ (1 510) 238 3401

Camerawork Gallery
2255 NW Northrup Street
Portland
OR 97210
✆ (1 415) 626 7747

California Museum of Photography
University of California at Riverside
Riverside
CA 92521
✆ (1 909) 787 4787

George Eastman House
900 East Avenue
Rochester
NY 14607
✆ (1 716) 271 3361

Museum of Photographic Arts
1649 El Prado
Balboa Park
San Diego
CA 92101
✆ (1 619) 238 7559

Fraenkel Gallery
49 Geary Street
San Francisco
CA 94108
✆ (1 415) 981 2661

San Francisco Museum of Modern Art
151 Third Street
San Francisco
CA 94103
✆ (1 415) 357 4000

G. Ray Hawkins Gallery
908 Colorado Avenue
Santa Monica
CA 90046
✆ (1 310) 394 5558

Scottsdale Center for the Arts
7383 Scottsdale Mall
Scottsdale
AZ 85251
✆ (1 602) 994 2301

Center for Creative Photography
The University of Arizona
843 East University Boulevard
Tucson
AZ 85721
✆ (1 520) 621 7968

Corcoran Gallery of Art
17th Street and New York Avenue North West
Washington, DC 20006
✆ (1 202) 639 1700

Acknowledgements

Texts written by Ian Jeffrey.

The publishers would like to thank Fabien Baron, Chris Boot, Sally Fear, Dennis Freedman, Stephen Gill, Shalom Harlow, Mark Haworth-Booth, Suzanne Hodgart, Liz Jobey, Isabella Kullmann, Martin Parr, Robert Pledge, Stuart Smith and Lee Swillingham for their advice.
And Zafer and Barbara Baran and Alan Fletcher for the jacket design.

Photographic Acknowledgements

Hans Aarsman, Amsterdam: 4; © Abbas / Magnum Photos: 5; photograph by James Abbe / photograph © Kathryn Abbe: 6; Sam Abell / *National Geographic* Image Collection: 8; © Robert Adams: 11; Shelby Lee Adams: 12; The Lucien Aigner Associates: 14; Fratelli Alinari, Florence: 15, 52, 497; William Albert Allard / *National Geographic* Society: 16; © Manuel Alvarez Bravo: 18; © 1979, Amon Carter Museum, Fort Worth, Texas, gift of the Estate of Laura Gilpin: 175; courtesy Galerie Paul Andriesse, Amsterdam: 118; © 1952, Aperture Foundation Inc., Paul Strand Archive: 442; © 1972, the Estate of Diane Arbus / courtesy Robert Miller Gallery, New York: 23; Keith Arnatt: 26; © Eve Arnold / Magnum Photos: 27; Art Institute of Chicago: 322; Art Institute of Chicago, Julien Levy Collection, gift of Jean Levy and the Estate of Julien Levy, 1988.157.1 / © Berenice Abbott, Commerce Graphics Ltd. Inc.: 7; The Associated Press Ltd: 10, 144, 300, 391, 468, 470; © Association des Amis de Jacques-Henri Lartigue: 262; © A.T.E. / Musée de Shkodra: 302; Jane Evelyn Atwood: 29; Austrian Photographic Gallery / National Collection of Fine Art Photography, Museum Rupertinum, Salzburg: 70, 219; © David Bailey: 31; © John Baldessari: 32; © Lewis Baltz: 35; © Micha Bar-Am / Magnum Photos: 36; © Bruno Barbey / Magnum Photos: 37; © Olivo Barbieri: 38; © Letizia Battaglia: 41; courtesy Marion de Beaupré Productions, Paris – styling Michel Bottbol, hair Julien D'Ys, make-up Alice Ghendrih, model Karen Elson (Ford), clothes Thierry Mugler Couture: 394; Gianni Berengo Gardin: 47; Ian Berry / Magnum Photos: 50; Eva Besnyö: 51; Bibliothèque des Arts Décoratifs, Paris: 272; Bibliothèque Nationale, Paris: 33, 126; © Richard Billingham, courtesy Anthony Reynolds Gallery, London: 53; © Werner Bischof / Magnum Photos: 54; Anna and Bernhard Blume: 57; Erwin Blumenfeld / *Vogue*, Paris 1939: 58; © Rommert Boonstra: 59; courtesy Janet Borden, Inc., New York: 186, 424; © Edouard Boubat / Agence TOP, Paris: 61; Samuel Bourdin: 62; Photographie Brassaï © Gilberte Brassaï, all rights reserved: 68; © 1957 Wynn Bullock, courtesy The Wynn and Edna Bullock Trust, collection Center for Creative Photography, The University of Arizona: 73; David Burnett / Contact Press Images: 75; © René Burri/Magnum Photos: 76; Larry Burrows / Katz Pictures Limited: 77; © CNMHS, Paris: 28, 406; © Harry Callahan, courtesy PaceWildensteinMacGill, New York: 78; © Sophie Calle / courtesy Galerie Chantal Crousel, Paris: 79; Camera Press Ltd: 277, 428; © Cornell Capa / Magnum Photos: 82; © Robert Capa / Magnum Photos: 83; courtesy Caponigro Arts: 84; Gilles Caron / Contact Press Images: 86; The Photography Collection, The Carpenter Center for the Visual Arts, Harvard University: 408; © Henri Cartier-Bresson / Magnum Photos: 88; courtesy Leo Castelli, New York: 342; Centro de la Imagen, Mexico: 224; courtesy Teo Allain Chambi, Cuzco: 90; © William Christenberry and PaceWildensteinMacGill, New York: 92; The Chrysler Museum of Art, Norfolk, VA, gift of Mr and Mrs Frederick Herman (82.63): 496; © 1995 Comstock, Inc.: 170; © Linda Connor: 97; Thomas Joshua Cooper: 98; courtesy John Coplans and London Projects: 99; Corbis-Bettmann: 412, 467; © Marie Cosindas: 100; photograph from the *Courier Express* Collection, courtesy of E. H. Butler Library, Buffalo State College and the Buffalo and Erie County Historical Society: 430; © Gerry Cranham: 101; © Donigan Cumming: 102; photograph by Imogen Cunningham © 1970 The Imogen Cunningham Trust: 103; Stephen Dalton / NHPA: 107; ©

Judy Dater 1982, collection Center for Creative Photography, The University of Arizona: 108; © Bruce Davidson / Magnum Photos: 109; © John Davies: 110; © Joe Deal: 112; © Luc Delahaye / Magnum Photos: 113; © Raymond Depardon / Magnum Photos: 116; © Philip-Lorca diCorcia, courtesy PaceWildensteinMacGill, New York: 117; Robert Doisneau / Rapho / Network: 120; © David Doubilet: 121; © David Douglas Duncan: 124; courtesy Diana Dupain: 125; courtesy Galerie Durand-Dessert, Paris: 457; © The Estate of Willard Van Dyke, modern print from original negative, Willard Van Dyke Archive, Center for Creative Photography: 127; courtesy George Eastman House, Rochester, NY: 85, 465; © Nikos Economopoulos / Magnum Photos: 131; © The Harold E. Edgerton 1992 Trust, courtesy of Palm Press, Inc.: 132; William Eggleston / A+C Anthology: 133; Alfred Eisenstaedt/Katz Pictures Limited: 134; Bill Eppridge / Katz Pictures Limited: 138; © Elliott Erwitt / Magnum Photos: 140; courtesy Etherton Gallery, Tucson, Arizona: 74; © Bernard Faucon, Paris: 146; Andreas Feininger / Katz Pictures Limited: 147; © Donna Ferrato: 149; Larry Fink: 150; © Thomas Florschuetz: 151; courtesy Fogg Art Museum, Harvard University Art Museums, gift of Bernarda Bryson Shahn: 410; © Joan Fontcuberta / Pere Formiguera, 1986: 152; courtesy Fraenkel Gallery, San Francisco, CA: 46, 159, 189, 492; © Martine Franck / Magnum Photos: 154; © Robert Frank, courtesy PaceWildensteinMacGill, New York: 155; © Stuart Franklin / Magnum Photos: 156; © Leonard Freed / Magnum Photos: 157; © Gisèle Freund, courtesy Nina Beskow: 158; © Seiichi Furuya: 163; © Paul Fusco / Magnum Photos: 164; © Adam Fuss, courtesy Robert Miller Gallery, New York: 165; Galerie Agathe Gaillard, Paris: 91; © Cristina García Rodero: 166; © Jean Gaumy / Magnum Photos: 168; The J. Paul Getty Museum, Los Angeles, CA: 143, 296, 321, 354; © Archivio Ghirri: 171; © Mario Giacomelli: 172; © Ralph Gibson: 173; John Gichigi / Allsport: 174; Gilman Paper Company Collection, New York: 55, 66, 81, 257, 353, 411, 478; courtesy Barbara Gladstone Gallery, New York/photo Larry Lame: 145, 370; © Burt Glinn/Magnum Photos: 177; © Fay Godwin / Collections: 179; © Jim Goldberg: 180; David Goldblatt: 181; © Nan Goldin: 182; courtesy Alan Govenar and Texas African American Photography Archive: 231; courtesy Govinda Gallery, Washington, DC: 222; courtesy Emmet Gowin and PaceWildensteinMacGill, New York: 183; © Paul Graham: 184; courtesy Howard Greenberg Gallery, New York: 216, 247, 335, 473; © Philip Jones Griffiths / Magnum Photos: 185; © Harry Gruyaert / Magnum Photos: 187; Galleria Studio Guenzani, Milan: 40; © Ernst Haas / Magnum Photos: 190; © Philippe Halsman / Magnum Photos: 192; © Hiroshi Hamaya/Magnum Photos: 193; courtesy Hamiltons Photographers Ltd: 359; © Robert Hammerstiel: 194; © Werner Hannappel, courtesy Galerie Michèle Chomette, Paris: 195; © Paul Harbaugh and Tatianna Baltermants / photograph Victoria & Albert Museum: 34; Studio Harcourt © Ministère de la Culture, France: 196; © Robert Heinecken, courtesy PaceWildensteinMacGill, New York: 199; courtesy Galerie Max Hetzler, Berlin: 444; © John Hilliard: 202; © David Hockney: 204; © Thomas Hoepker / Magnum Photos: 206; Paul den Hollander: 211; Eric and David Hosking: 215; Collection Xavier Hufkens, Brussels: 96; Hulton Deutsch Collection / Corbis: 43; Hulton Getty: 197, 212; The Hungarian Museum of Photography, Budapest: 141, 363; Frank Hurley / Royal Geographical Society: 220; © David Hurn / Magnum Photos: 221; © Axel Hütte: 223; Indiana University Art Museum, Art Sinsabaugh Archive: 422; courtesy Interim Art, London / Andrea Rosen Gallery, New York: 451; Yoshiko Isshiki, Tokyo: 22, 330; Mitsuaki Iwago / Minden Pictures: 225; Photo IZIS: 226; Bob Jackson: 227; Chris Johns / *National Geographic* Society: 228; Markus Jokela / *Helsingin Sanomat*: 230; © Jan Kaila: 232; © Richard Kalvar / Magnum Photos: 234; © Kikuji Kawada: 237; © Seydou Keita, courtesy André Magnin, Paris / Fonds National d'Art Contemporain, Paris: 239; photograph by André Kertész © Ministère de la Culture (AFDPP), Paris: 240; Johan van der Keuken: 241; © Carl de Keyzer / Magnum Photos: 242; courtesy Galerie Rudolf Kicken / purchase 1982 with

assistance from The Friends of Fotografiska Museet, Stockholm: 443; Chris Killip: 243; # 10032 Darius Kinsey Collection, Whatcom Museum of History and Art, Bellingham, WA: 244; The Kinsey Institute for Research in Sex, Gender and Reproduction: 178; Douglas Kirkland / Sygma: 245; photography Nick Knight, art direction Marc Ascoli, client Martine Sitbon: 248; photograph by François Kollar © Ministère de la Culture, France: 249; Sirkka-Liisa Konttinen: 250; © Josef Koudelka / Magnum Photos: 252; George Krause: 253; Les Krims: 254; © Hiroji Kubota / Magnum Photos: 256; David LaChapelle: 258; LA Louver, Venice, CA: 49; Frans Lanting / Minden Pictures: 260; © Sergio Larrain / Magnum Photos: 261; © The Estate of Clarence John Laughlin, courtesy Robert Miller Gallery, New York / © 1997 The Historic New Orleans Collection: 263; Annie Leibovitz / Contact Press Images: 266; Ouka Lele / VU: 267; János Lengyel, Budapest: 269; © Guy Le Querrec / Magnum Photos: 270; © Erich Lessing / Magnum Photos: 273; courtesy David Levinthal and Janet Borden, Inc., New York: 274; © Helen Levitt/Laurence Miller Gallery, New York: 275; Library of Congress: 337, 369; Library of Congress, Washington, DC: 114, 160, 167, 210, 259, 264, 338, 469; Jerome Liebling: 278; © O. Winston Link: 279; © The Herbert List Estate, Hamburg: 281; courtesy Robert Longo and Metro Pictures: 282; Los Alamos National Laboratory / © Jack Aeby: 13; courtesy Luhring Augustine, New York: 93; Markéta Luskačová: 283; © Danny Lyon, courtesy Houk Friedman, New York: 284; Angus McBean/© Apple Corps Ltd: 286; McCord Museum, Montreal, Notman Archives: 349; © Don McCullin / Magnum Photos: 287; © Steve McCurry / Magnum Photos: 288; © Craig McDean: 289; © Peter Magubane: 290; Mari Mahr: 291; Bertien van Manen: 293; courtesy Robert Mann Gallery and Curt Marcus Gallery, New York: 318; © Sally Mann, courtesy Houk Friedman, New York: 294; Constantine Manos / Magnum Photos: 295; © 1983, The Estate of Robert Mapplethorpe / A+C Anthology: 297; Mary Ellen Mark: 298; © Peter Marlow / Magnum Photos: 299; Oriol Maspons: 304; © 1997 Margrethe Mather, collection Center for Creative Photography, The University of Arizona: 305; Roger Mayne: 306; The Estate of Ralph Eugene Meatyard, courtesy Christopher Meatyard: 307; © Steven Meisel / A+C Anthology: 308; © Susan Meiselas / Magnum Photos: 309; Metropolitan Museum of Art, New York, gift of Charles Bregler: 129; Metropolitan Museum of Art, New York, gift of I. N. Phelps Stokes, Edward S. Hawes, Alice Mary Hawes, Marion Augusta Hawes, 1937 (37.14.41): 432; Joel Meyerowitz: 311; MGM / courtesy Kobal Collection: 72; Duane Michals: 312; Boris Mihailov: 313; Gjon Mili / Katz Pictures Limited: 314; © Lee Miller Archives: 315; © Wayne Miller / Magnum Photos: 316; Mirror Syndication International: 64; © Sarah Moon, from the book *Red Riding Hood*: 325; © Charles Moore 1997 Black Star: 326; © Inge Morath / Magnum Photos: 328; The Barbara Morgan Archives: 329; © Daido Moriyama: 331; © Lewis Morley / Akehurst Bureau: 332; courtesy Josephine Morris: 333; Münchner Stadtmuseum: 105; Musée National d'Art Moderne, Paris: 200; Musées de la Ville de Paris: 303; Museum of the City of New York, The Jacob A. Riis Collection (# 232): 383; Museum of Decorative Arts, Prague: 445, 454; courtesy The Museum at F.I.T., New York: 106; Museum Folkwang, Essen: 191, 271, 436; Museum Ludwig, Rheinisches Bildarchiv, Cologne: 56, 63, 218, 235, 255, 360, 388, 398, 401, 407; © 1997 The Museum of Modern Art, New York, gift of Albert M. Bender: 169; © 1997 The Museum of Modern Art, New York, gift of Lincoln Kirstein: 229; © 1997 The Museum of Modern Art, New York, purchase: 203; Jean Luc Mylayne: 339; © James Nachtwey / Magnum Photos: 340; NASA: 25; National Archives at College Park, Maryland: 39, 65; National Gallery of Canada, Ottawa: 19; The Lisette Model Foundation: 319; National Portrait Gallery, London: 48; courtesy NCE, Paris: 317; Nederlands Fotoarchief, Rotterdam: 136; © Arnold Newman: 344; © Helmut Newton: 345; © Michael Nichols: 346; Lennart Nilsson / Bonnier Alba AB: 347; Nimitz Library, Annapolis, MD: 128; photograph by Nicholas Nixon: 348; © Georg Oddner: 350; Ken Ohara: 351; © Cas Oorthuys / Nederlands Fotoarchief: 352; © Bill

511

512

AARSMAN. ABBAS. ABBE. ABBOTT. ABELL. A. ADAMS. E. ADAMS. R. ADAMS.
S.L. ADAMS. AEBY. AIGNER. ALINARI. ALLARD. ALPERT. ALVAREZ BRAVO. ANDRIESSE.
ANNAN. APPELT. ARAKI. ARBUS. ARBUTHNOT. ARMSTRONG. ARNATT. ARNOLD.
ATGET. ATWOOD. AVEDON. BAILEY. BALDESSARI. BALDUS. BALTERMANTS.
BALTZ. BAR-AM. BARBEY. BARBIERI. BARNARD. BASILICO. BATTAGLIA. BAYARD.
BEATO. BEATON. BECHER. BELLOCQ. BERENGO GARDIN. BERESFORD. BERMAN.
BERRY. BESNYÖ. BEVILACQUA. BILLINGHAM. BISCHOF. BISSON. BLOSSFELDT.
BLUME. BLUMENFELD. BOONSTRA. BOSSHARD. BOUBAT. BOURDIN. BOURKE-
WHITE. BRADSHAW. BRADY. BRAGAGLIA. BRANDT. BRASSAÏ. BRIGMAN. BRUS.
BUBLEY. BULL. BULLOCK. BURKE. BURNETT. BURRI. BURROWS. CALLAHAN.
CALLE. CAMERON. DU CAMP. C. CAPA. R. CAPA. CAPONIGRO. CARJAT. CARON. CARROLL.
CARTIER-BRESSON. CHALDEJ. CHAMBI. CHARBONNIER. CHRISTENBERRY.
CLARK. CLIFFORD. COBURN. COLLINS. CONNOR. COOPER. COPLANS. COSINDAS.
CRANHAM. CUMMING. CUNNINGHAM. CURTIS. DAGUERRE. DAHL-WOLFE.
DALTON. DATER. DAVIDSON. DAVIES. DAVISON. DEAL. DELAHAYE. DELANO.
DEMACHY. DEPARDON. DICORCIA. DIJKSTRA. DISFARMER. DOISNEAU. DOUBILET.
DRTIKOL. DÜHRKOOP. DUNCAN. DUPAIN. DURIEU. VAN DYKE. DYVINIAK.
EAKINS. ECHAGÜE. ECONOMOPOULOS. EDGERTON. EGGLESTON. EISENSTAEDT.
VAN ELK. VAN DER ELSKEN. EMERSON. EPPRIDGE. ERFURTH. ERWITT. ESCHER.
F. H. EVANS. W. EVANS. FAAS. FAIGENBAUM. FAUCON. FEININGER. FENTON. FERRATO.
FINK. FLORSCHUETZ. FONTCUBERTA. FOX TALBOT. FRANCK. FRANK. FRANKLIN.
FREED. FREUND. FRIEDLANDER. FRISSELL. FRITH. FUNKE. FURUYA. FUSCO.
FUSS. GARCÍA RODERO. GARDNER. GAUMY. GENTHE. GERSTER. GHIRRI. GIACOMELLI.
GIBSON. GICHIGI. GILPIN. GIMPEL. GLINN. VON GLOEDEN. GODWIN. GOLDBERG.
GOLDBLATT. GOLDIN. GOWIN. GRAHAM. GRIFFITHS. GROOVER. GRUYAERT.
GURSKY. GUTMANN. HAAS. HAJEK-HALKE. HALSMAN. HAMAYA. HAMMERSTIEL.
HANNAPPEL. HARCOURT. HARDY. HAWARDEN. HEINECKEN. HENRI. HILL & ADAMSON.
HILLIARD. HINE. HOCKNEY. HOCKS. HOEPKER. HÖFER. HOFF. HOFMEISTER.
HOLLAND DAY. DEN HOLLANDER. HOPKINS. HOPPÉ. HORST. HOSKING. HOSOE.
HOWLETT. HOYNINGEN-HUENE. HUBMANN. HURLEY. HURN. HURRELL. HÜTTE.
ITURBIDE. IWAGO. IZIS. JACKSON. JOHNS. JOHNSTON. JOKELA. JOSEPH. KAILA.
KALES. KALVAR. KARSH. KÄSEBIER. KAWADA. KEETMAN. KEITA. KERTÉSZ.
VAN DER KEUKEN. DE KEYZER. KILLIP. KINSEY. KIRKLAND. A. KLEIN. W. KLEIN.
KNIGHT. KOLLAR. KONTTINEN. KOPPITZ. KOUDELKA. KRAUSE. KRIMS. KRULL.